Makers of
20th Century Modern
Architecture

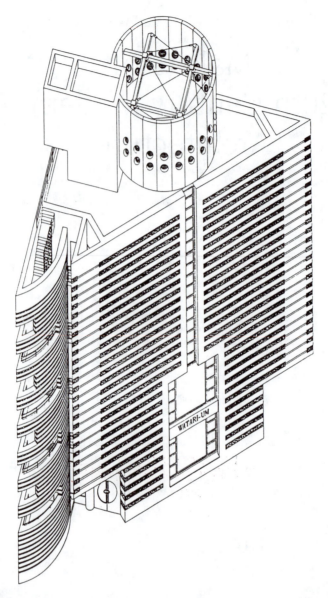

Watari-um Gallery. Tokyo, Japan. 1985–1990. Mario Botta, Architect. *Assonometria* ink drawing. This highly simplified, detextured drawing of the building, shown as a geometric form in irrelevant space, reflects a philosophic reality, according to Botta's emphatically stated intention, by its stance aloof from the chaos of crowded Tokyo. The constraints of a tight corner of the expensive triangular site allowed him to exploit the acute angle and its point by an emphatic curve and horizontality in materials and openings to create "the impression of a wing reaching out into space." Illustration from *Architectural Design* 61 (11/12, 1991).

MAKERS OF
20th CENTURY
MODERN
ARCHITECTURE

A Bio-Critical Sourcebook

Donald Leslie Johnson and Donald Langmead

GREENWOOD PRESS
Westport, Connecticut

Library of Congress (

Johnson, Donald Leslie
 Makers of 20th ce
sourcebook / Donald Leslie Johnson and Donald Langmead.
 p. cm.
 Includes bibliographical references and index.
 ISBN 0–313–29353–8 (alk. paper)
 1. Architects—Biography—History and criticism. 2. Architecture,
Modern—20th century. 3. Architects—Bibliography. I. Langmead,
Donald. II. Title.
NA680.J628 1997
720'.92'2—dc20
[B] 95–46055

British Library Cataloguing in Publication Data is available.

Library of Congress Catalog Card Number: 95–46055
ISBN: 0–313–29353–8

First published in 1997

Greenwood Press, 88 Post Road West, Westport, CT 06881
An imprint of Greenwood Publishing Group, Inc.

Printed in the United States of America

The paper used in this book complies with the
Permanent Paper Standard issued by the National
Information Standards Organization (Z39.48–1984).

10 9 8 7 6 5 4 3 2

Copyright Acknowledgments

The authors and publisher gratefully acknowledge permission to reprint the following:

Selections from *Contemporary Architects*, 2nd ed. Edited by Ann Lee Morgan and Colin Naylor
and copyright © 1987. Reprinted by permission of Gale Research, Inc.

Selections excerpted with permission of Simon & Schuster Macmillan from *Macmillan En-
cyclopedia of Architects*, 3 Vols. Adolf K. Placzek, Editor in Chief. Copyright © 1982 by The Free
Press.

Selections from Joseph Wilkes and Robert Packard, *Encyclopedia of Architecture*. Copyright ©
1988 & 1989 by Joseph Wilkes and Robert Packard. Reprinted by permission of John Wiley &
Sons, Inc.

Selections from a letter of 15 July 1963 from Barry Byrne to W. G. Purcell reprinted by permission
of William Gray Purcell Papers, Northwest Architectural Archives, University of Minnesota
Libraries, St. Paul, Minnesota.

Selections from a 30 November 1922 letter from Frank Lloyd Wright to Hendrik Berlage reprinted
by permission of the Netherlands Architecture Institute.

Every reasonable effort has been made to trace the owners of copyright materials in this book, but
in some instances this has proven impossible. The authors and publisher will be glad to receive
information leading to more complete acknowledgments in subsequent printings of the book and in
the meantime extend their apologies for any omissions.

This book is dedicated to

Ethelann Rindal Cannon
and in memoriam
Kenneth Dean Cannon,

and to
Harold Bruce Allsopp

CONTENTS

ILLUSTRATIONS

Illustrations follow page 160.

READER'S GUIDE

[*An asterisk (*) identifies an architect with a separate entry elsewhere in the book.*]

The curious person: that is to whom this book is directed. It is meant to be a first step to discovering the architects who initiated, developed, or advanced modern architecture during the twentieth century. It is an outline of the milieu in which they practiced their art and it directs the curious to information that will describe and examine the life and creative activities of founding architects and their disciples.

Proof in timber was one requirement for inclusion. But such a criterion can be ascertained only of those aggressive architects whose egos have submitted to professional and public scrutiny, mainly in relevant publications. So like us, all observers remain ignorant of the too shy or the closet artist or paper architect.

It follows, therefore and as part of our selection rationale, that only those architects and engineers whose ideas and buildings—or similar structures—with proven influences on the course of a modern Western architecture are included. By their productive activities, the profession and the public must have agreed—or do agree—that each has made a significant contribution. For purposes of this study that is the crux of proof. The nature and measure of proof is found within each biographic profile.

On the other hand there need not be agreement as to the quality—good/bad/blah—of the product. Such judgments are by definition personal. Yet it was on occasion valuable to present them within the profiles.

Also, to merely talk about or otherwise present a possible architecture is not

sufficient. Architecture is an *experiential art:* like it or not, all senses participate. An example of inclusion and exclusion will illustrate this essential ingredient.

Vienna's MAK—the Austrian Museum of Applied Arts—presented a series of lectures "by those artists who through their work play a decisive part in the architectural discussion of today," in 1990. Selected were Morphosis (Thom Mayne and Michel Rotondi, Southern California), Michael Sorkin (New York), Coop Himmelblau* (as in co-op, Austrian Wolf D. Prix and Pole Helmut Swiczinsky, Vienna), Peter Eisenman* (New York), Zaha Hadid (from Baghdad but usually located in London), Daniel Libeskind* (from Poland but based in Berlin), Jean Nouvel (Paris), and Lebbeus Woods (New York). Except for Eisenman, each of these architects had produced only a few modest buildings small in size. For the most part theirs was paper or computer generated CAD architecture regardless of arguments to the contrary. And since Nouvel's work seems derivative, the decision was to include only Eisenman and two who have since *experienced the construction* of their designs, Libeskind and Coop Himmelblau, in this book.

MAK entitled its show "Architecture Today" and the resulting book *Architecture in Transition* (1991). Hopefully all involved were aware that three decades earlier Constantin Doxiadis* had published a theoretical thesis of considerable substance by the same name. But then architecture must always be in transition, must always be reinvented as Frank Lloyd Wright put it, and must thereby continually be fed and watered or else dry and with unnourished roots wither on intellectual vines.

This study will display architecture's reinventions and satisfy its audience by combining biography with an extensive bibliography of printed material by or about a subject architect. In each case this combination is supported by a critical analysis of some major accomplishments, buildings built or proposed, and where appropriate with illustrations that heighten our understanding of an architect's ideas. There are links to such movements as arts and crafts, Art Nouveau, and Metabolism; to the vernacular; and to such technological applications as shell structures, highrise innovations, and steel space frames.

Because our target reader wears many hats and so that there be no misunderstanding among our peers, there is a concise historical discussion of the evolution of modernism. Additionally, this will eliminate much repetition in the biographies.

The architects, firms, and confederations that are the subjects of the biocritical studies composing this volume were selected as a result of many years of research and extensive reading of respected researchers and observers: some of those historians and critics are listed immediately below. Their judgments influenced our own. We also readily admit that our selections straddle a broad line between the theoretically inclined and more practical architects who admittedly preach by their built product. Always the final selection was made with reference to influence beyond mere region, popularity, or extent of productivity. To repeat: the measure of influence is set out in each critical study. The nature of "found-

ing'' and the idea of extending modernism is set out in the Chronology and Founders section.

Bibliographies are of course not complete but selective. In some cases the extent of published material about an architect is noted. Articles covering more than one work by an architect are often included. In view of the anticipated audience and as information came to light, we favored periodicals that are the more accessible and mainly English language or international editions. The reader is well advised not to rely wholly on periodical publications for information. Current critical analysis or assessment can be found in more recently published surveys as listed immediately below. We include pieces where architects speak their own thoughts.

''Writings'' by the architects biographed are those considered the more valuable as are those by critics, journalists, and other observers under ''Assessment.'' While the ''Bibliographic'' entries are specific, many of the Assessment publications, mainly books, often include bibliographies. This is also true for biographical data; otherwise, we have attempted to isolate those more useful ''Biographic'' essays. The ''Archival'' entries refer only to publications.

It is assumed readers are familiar with compilations such as *Who Was Who* or *Current Biographies* as well as art, biographical, or architectural periodical indexes, printed library catalogs, and so forth, or relevant CD-Roms.

<div align="center">✐</div>

Useful historical or similar surveys that illuminate the introductory essay ''Whither We Went'' and offer evaluations and opinions about the makers— and making—of modern architecture and *not* repeated within the biocritical studies, are:

ADesign. ''Modern Pluralism.'' 62 (January 1992).
———. ''Organic Architecture.'' 63 (November 1993).
Arnason, H. H. *A History of Modern Art. Painting Sculpture Architecture.* New York [1968]; London, 1969; 3d ed., New York, 1986.
Banham, Reyner. *A Concrete Atlantis. U.S. Industrial Building and European Modern Architecture 1900–1925.* MIT Press, 1986.
———. *Megastructure. Urban Futures of the Recent Past.* New York/London, 1976.
———. *The New Brutalism. Ethic or Aesthetic?* New York/London, 1966. Cf. Robin Boyd. ''The Sad End of New Brutalism.'' *AReview* 37 (July 1967).
———. *Theory and Design in the First Machine Age.* London, 1960; reprint, 1972.
Benevolo, Leonardo. *History of Modern Architecture.* 2 vols. Rome, 1960; 3d ed., Rome, 1966; London, 1971.
Boyd, Robin. *The Puzzle of Architecture.* Melbourne, 1965.
Collins, Peter. *Changing Ideals in Modern Architecture 1750–1950.* London, 1965; reprint, 1971.
———. *Concrete. The Vision of a New Architecture.* London, 1959.
Colquhoun, Alan. *Essays in Architectural Criticism: Modern Architecture and Historical Change.* Cambridge: MIT Press, 1981.

————. *Modernity and the Classical Tradition: Architectural Essays 1980–1987.* Cambridge: MIT Press, 1989.

Cuff, Dana. *Architecture. The Story of Practice.* MIT Press, 1991.

Curtis, William J. R. *Modern Architecture since 1900.* 2d ed. Englewood Cliffs, New Jersey, 1987.

De Long, David G., ed. *American Architecture, Innovation and Tradition.* New York, 1986.

Farmer, Ben, and Hentie Louw. *Companion to Architectural Thought.* New York, 1993.

Ford, Edward. *Details of Modern Architecture.* MIT Press, 1991.

Frampton, Kenneth. *Modern Architecture: A Critical History.* London, 1980; 3d ed., New York, 1992.

Giedion, Sigfried. *Mechanization Takes Command.* New York, 1948. Conclusion to Giedion (1941).

————. *Space, Time and Architecture. The Growth of a New Tradition.* Cambridge, Massachusetts, 1941, and later editions.

Gössel, Peter, and Gabriel Leuthäuser. *Architecture of the 20th-Century.* Cologne, 1991.

Heyer, Paul. *American Architecture. Ideas and Ideologies in the Late Twentieth Century.* New York, 1993.

Hitchcock, Henry-Russell. *Architecture: Nineteenth and Twentieth Centuries.* 3d ed. Harmondsworth/Baltimore/Ringwood, 1969, 1971.

Hitchcock, Henry-Russell, and Philip Johnson. *The International Style. Architecture since 1922.* New York, 1932; reprint, 1966.

Ingberman, Sima. *ABC. International Constructivist Architecture, 1922–1939.* MIT Press, 1994.

Jencks, Charles. *Architecture Today.* 2d ed. London, 1988.

————. *Modern Movements in Architecture.* Harmondsworth, 1973.

————. *The Post-modern Reader.* New York, 1992.

Joedicke, Jürgen. *Architecture since 1945. Sources and Directions.* New York, 1969.

————. *The History of Postmodern Architecture.* Wiesbaden, 1984; MIT Press, 1988.

Johnson, Philip, and Mark Wigley. *Deconstructionist Architecture.* New York, 1988.

Kurokawa, Kishio. *New Wave Japanese Architecture.* London/Berlin/New York, 1993.

Larson, Magali Sarfatti. *Behind the Postmodern Facade. Architectural Change in Late Twentieth-Century America.* Berkeley, California, 1993.

Lesnikowski, Wojciech G. *Rationalism and Romanticism in Architecture.* New York, 1982.

Norberg-Schulz, Christian. *Intentions in Architecture.* MIT Press, 1965.

Pehnt, Wolfgang. *Expressionist Architecture.* Stuttgart, 1973.

Peter, John. *The Oral History of Modern Architecture.* New York, 1994.

Roth, Leland M. *Understanding [Western] Architecture.* New York/London, 1993.

Rowland, Kurt. *A History of the Modern Movement Art Architecture Design.* New York, 1973.

Rudofsky, Bernard. *Architecture without Architects.* New York, 1965.

Scruton, Roger. *The Aesthetics of Architecture.* Princeton, New Jersey, 1979.

Smith, G. E. Kidder. *The New Architecture of Europe.* New York, 1961.

Smithson, A., and P. Smithson. "The Heroic Period of Modern Architecture." *ADesign* 35 (December 1965); reprint, London, 1981. And "Heroic Relics." *ADesign* 37 (December 1967).

Stern, Robert A. M., ed. "American Architecture: After Modernism." *a+u.* Extra edition (March 1981).

Stern, Robert A. M., and Raymond W. Gastil. *Modern Classicism*. New York/London, 1988.

Tafuri, Manfredo. *Theories and History of Architecture*. 4th ed. New York/London, 1980.

Tafuri, Manfredo, and Francesco Dal Co. *Modern Architecture*. Milan, 1976; London, 1979; 2d ed., New York, 1986.

Tzonis, Alexander, and Liane Lefaivre. *Architecture in Europe since 1968*. London, 1992.

Venturi, Robert. *Complexity and Contradiction in Architecture*. New York, 1966.

van Vynckt, Randall J., ed. *International Dictionary of Architects & Architecture*. 2 vols. Detroit, 1993.

Whittick, Arnold. *European Architecture in the Twentieth Century*. London, 1974.

Wingler, Hans. *The Bauhaus. Weimar, Dessau, Berlin, Chicago*. MIT Press, 1969.

Zevi, Bruno. *Architecture as Space. How to Look at Architecture*. 2d ed. New York, 1957, 1974; reprint, 1993.

———. *Towards an Organic Architecture*. London, 1950.

Zukowsky, John, ed. *Building in Germany between the World Wars*. New York/Munich, 1994.

❧

Historically significant or so called "landmark" buildings may stand outside and as unique to an artist's oeuvre (like Herbert Greene's own house [1960] in Norman, expressive of the Oklahoma prairie; or the small, elegant glass crystal Wayfarer's—or Schellenberg—Chapel at Rancho Palos Verdes, California [1951] by Lloyd Wright, Frank Lloyd Wright's first son) or they may stand within an oeuvre and be theoretically consistent, such as Luis Barragán's* "Riding School at San Cristobal," Mexico (1962–1968). Greene's house, by the way, predates and adequately anticipates the expressionistic and ad hoc architecture of 1980 onward.

Moreover it is not sufficient merely to have executed designs as theoretical posturing. To most critical observers there must be satisfactory proof of the elusive criterion of quality, regardless of how—or to what—the judgment is applied. (The exception herein is Futurism* and Archigram.*) It is difficult therefore to assign the collective work of many fine architects as influential upon the course of modernism. Comparatively, perhaps 70 percent of Wright's, many of Roche's,* Foster's,* and Ando's* buildings are landmarks. Landmarks (not necessarily paradigms) *may* stand alone, therefore, as ultimate refinements or idiosyncratic or advanced statements. Those buildings are not discussed in these pages.

Authors listed immediately above invariably make such judgments and evaluate in a variety of ways such architectural works, projects, and often verbal propositions. Useful surveys of landmarks—and some paradigms—with little or no critical assessment and *not* repeated in the biocritical studies, are:

Dunster, David. *Key Buildings of the Twentieth Century*. Vol. 1: *Houses 1900–1944*. New York, 1985. Vol. 2: *Houses 1945–1989*. London, 1990.

Groenendijk, Paul, and Hans Vollaard. *Guide to Modern Architecture in the Netherlands*. Rotterdam, 1987.

Hofmann, Werner, and Udo Kultermann. *Modern Architecture in Color.* New York/
 London, 1969.
Le Blanc, Sydney. *20th Century American Architecture. 200 Key Buildings.* New York,
 1993.
Millon, Henry A., and Alfred Frazer. *Key Monuments of the History of Architecture.*
 New York [1965], chapter 28.
Sharp, Dennis. *A Visual History of Twentieth Century Architecture.* New York, 1972.
Sharp, Dennis, ed. *Illustrated Dictionary of Architects and Architecture.* London, 1991.

<center>✧</center>

Valuable collections of verbal declarations, propositions, theoretical treatises,
or position papers also *not* repeated within the biocritical studies, are:

Conrads, Ulrich, ed. *Programmes and Manifestoes on 20th-Century Architecture.* Frank-
 furt, 1964; London, 1970; MIT Press, 1971.
Mumford, Lewis, ed. *Roots of Contemporary American Architecture.* New York, 1952,
 1994.
Ockman, Joan. *Architecture Cultures 1943–1968.* New York, 1993.
Roth, Leland M., ed. *America Builds. Source Documents in American Architecture and
 Planning.* New York, 1983.
Weimer, David R., ed. *City and Country in America.* New York, 1962.

<center>✧</center>

The Pritzker Architecture Prize was established in 1979 by the Hyatt Foun-
dation to honor annually a ''living architect whose built work demonstrates a
combination of those qualities of talent, vision, and commitment which has
produced consistent and significant contributions to humanity and the built en-
vironment through the art of architecture.'' It is known as a prestigious award,
the ''Nobel of architecture.'' Except for Alvar Siza (Portugal, 1992) all recipi-
ents are biographed herein.

While a century bracketed by abstract dates cannot frame the development of something so esoteric and arguable as art, it nevertheless provides handy marks. Twentieth-century architecture was dramatically transformed from dependence on past traditionalized formalizations to an independence that searched for artistic responses to contemporary society, thereby modern. The initial resolutions were given substance by individuals whose personal thoughts and design products generated ideas that, transcending private boundaries, persuaded others. As a result, the art of architecture has often tried to become socially responsive rather than socially elite, most certainly artistically lively. Our century has therefore witnessed a firming of the concept of modern in theory and built product.

So, who were those individuals? What was the historical course and what were the events that confirm the individual's position? What was the milieu? Was there an evolution to or within modern?

WHITHER WE WENT

The only thing that is permanent is change. This seeming paradox points
... at the very heart of 20th century thought, whether expressed in philo-
sophical, scientific, or aesthetic terms. No static, unchanging absolute can
possibly provide a satisfactory view of the moving world of today....
Those who believe in orderly progress toward a definable objective interpret
this flux as some form of evolution; those who accept it at face value ...
believe simply in change.[1]

William Fleming

Simultaneously with the Italian Futurist's* first manifesto Albert Einstein's spe-
cial theory of relativity was published in 1909. Reductivism's practical influence
on art was fleetingly yet almost immediately measurable thereby suggesting an
intellectual and cultural preexistence. But it was not until after the armistices of
1945 that consequences transcended intellectual boundaries as relativism had
predicted. Put simply: many frames of reference, depending on a person's or
group's understanding, are accepted as valid. Conformity through absolutism,
including political or religious totalitarianism, is denied by the active relativism
of modern pragmatic thought enabled by democracy.

The notion of *modern* in art is a twentieth-century phenomenon. Its accepted
meaning refers to works that reflect a moment of cultural satisfaction within a
social environment. Modern rejects the clutches of traditionalism, of mimetic
revivals and the tendency to sentimentality in historicism. With an inherent
relativistic drive it thereby defines all present moments. The term has roots in
nineteenth-century social philosophy and notions of human will, Zeitgeist, and

individualism. The modern interpretation of modern allows architectural modern to begin around the turn of the century, not with the Italian Renaissance as assumed for 400 years. As American architect George Howe quite rightly observed in 1930:

> Modernism is not a style. It is an attitude of mind. . . .
>
> Modernism is as changing as daily life.[2]

We reject as nonsense the notion that *modern* can be identified only with the ideas and products of the European's so-called Modern Movement and therefore a commitment to formalism and internationalism. Modern is one generation's moment.

But also readers must be wary of what they read elsewhere because of confusion brought on by authors who speak of Modernism in a pre-1970 context. They speak, as examples, of freedom from the foundational and formalistic constraints of Modernism, or art after Modernism. (Sometimes the capital ''M'' is used, sometimes not.) Thus terms like ''postmodernism'' have come into existence.

We mean quite simply that to be *modern,* an architectural product does not have a primary foundation in historical precedents. Therefore an architecture of the 1990s that in an obviously idiomatic manner is derivative of the American architect Frank Lloyd Wright's* prairie houses before ca. 1913 or his houses of the 1950s, or of Le Corbusier's* French villas of the 1920s, is not modern: it is eclectic historicism. Three examples will refine the meaning.

In the 1920s the Dutch modernist architect Willem Marinus Dudok* employed and enhanced certain aspects of Wright's pre-1915 work as did the German Ludwig Mies van der Rohe.* They enlivened and extended the meaning of Wright's thoughts and architecture. In the 1970s American architects Peter Eisenman* and Richard Meier* did a similar service to the art by investigatively tearing apart structural and modular aspects of Le Corbusier's buildings—principally the villas—of the 1920s and presenting remnants as separate elements, reformed, with a newish three dimensionality and redefinition of space: they were neutered by being painted entirely white like their predecessors. These and similar works can be usefully compared to musical composers who take as a theme a figure or melody line of the past and explore it by variations.

Postmodernism does exactly that, at least one aspect: ancient, classical architectural elements are unsentimentally mixed in a riot of self-satisfying conglomerations, usually as a pastiche, and distorting original intentions and the meaning of historicism for mere visual effect. Michael Graves grovels in this eclecticism while Thomas Beeby and Robert Venturi* enjoyed it. Lively, delectable, often effeminate and brusquely delicate, but except for its initial value as a philosophical inquiry its ''architectural manifestations are vacuous,'' as Steve Harfield has put it.

Just the few examples noted above present a hint about the depths, shallows,

and flexibility of modern. Its beginning was not easy, philosophically or prac-
tically. Material results foundered on—and proponents struggled with—the ac-
cepted status of absolutism. The products and artifacts of Europe and its debt
to Greece, Rome, and the Gothicists were extant all about Europe in literature,
law, art, and in the cities and on the fields in the form of architecture. How to
grapple with such intellectual and cultural bonds, or more precisely shackles, so
physically present, so psychologically demanding, was a preeminent challenge.

Liberation came from the United States in two forms: the architecture and
theoretical utterances from 1898 to 1914 of Frank Lloyd Wright, and architec-
tural design for industry. Then local European inhibitions were firmly set aside
by the hustling Futurists who were driven by the twitchy urbanite Fillippo Ma-
rinetti. In architecture their visionaries were Mario Chiattone and Antonio
Sant'Elia.

Prior to and even during the process of liberation the Europeans discussed
the "necessity" for a new architecture under the impress of German philosophy
and Lockean notions of individuality. As put by the Viennese in 1898:

> To the Age its Art
>
> To Art its Freedom

It is the inscription on J. M. Olbrich's *Sezesson* building in Vienna, a building
that was an important architectural step forward and one of many attempts to
bridge the gap between historicism and something new, as yet not defined let
alone perceived. That bridging began in architecture with the thoughts of Viol-
let-le-Duc about the naturalness of structure and the meaning of architecture as
an inherently proper product of a particular society. His words uttered in the
1860s were to stir many young architects. Yet he was saturated by and dedicated
to a revived Gothic art or to the application of new materials to revived styles,
only now and then timidly and too academically looking at new materials and
new forms. The great iron bridges and railway sheds of the same period were
ignored.

Brief mention of individual productivity that was impressionable from 1890
to 1905 seems in order. Antoni Gaudi in Barcelona was mentally attached to
his local traditions and to some form of modern adaptation. He tested his
thoughts in a number of buildings that in the end were, with two or three lively
exceptions, dependent upon derivative formulas and forms. He has been rightly
or wrongly associated with Art Nouveau in Belgium (initiated by Victor Horta)
and then in France, mainly by Hector Guimard. The two- and three-dimensional
designs of the sensual Art Nouveau was free of the past, but in architecture the
basic framework upon which the decorative elements, as curly and fanciful as
they may have been, tended to be *applied* to buildings wrought by nineteenth-
century eclecticism. They were essentially decoration and not substantively ar-
chitectonic.

A more interesting product of Art Nouveau was the *Sezesson* movement in

Austria whose gallery by Olbrich drew from French Art Nouveau, from some aspects of English arts and crafts and a so-called free style, and from the baronial architecture of the Scot Charles Mackintosh.

Unfortunately none of that productivity displayed a framework of philosophical rigor, design methodology, or practical potential on which future extensions and orderliness would be possible. It was not sufficiently independent of its eclectic roots and paradoxically it did not show how what had passed might be distilled to extract a liberating essence.

This was true also of the theoreticians and practitioners who proved to be more influential than the decorators of the 1890s and who, it must be added, drew much from Viollet-le-Duc's lectures. They were unfazed by the popularity of Art Nouveau and English arts and crafts, the latter so readily taken up throughout America and Europe, and here the promotions of Henry van de Velde in Belgium, Germany, and France, and the German *Werkbund* come to mind. But there were obvious cloying limitations in those popular idioms, not the least of which was how to employ new materials. This was coupled with architects increasingly reexamining the age-old idea of aesthetic reduction, that is of finding simple ordering principles and three dimensional forms of architecture. If the past could teach, all well and good. But they did so not necessarily as had the Romanticists around the turn into the nineteenth century when dilettantes noted the pure geometric forms of classical antiquity or when simple architectural formulas were put by the French academic J.-N.-L. Durand (influenced no doubt by the encyclopedists and the synthetic work of Carl von Linnaeus or indeed by Goethe).

There were three men whose activity was transitional to a true modern architecture: the Austrian Otto Wagner in later life, the American Louis Sullivan, and the Dutchman Hendrik Berlage. Each man's architecture was based on historical precedents emphasizing, it needs be stressed, a reductivity.

Wagner was rather dependent upon classical forms if not elements and details. Much of his work was influenced by *Sezesson* and to some degree reactions to it by Adolf Loos.* Berlage was dependent upon medieval themes and forms and, after Mies van der Rohe worked in his office, the Hollander slowly developed the more abstract bulkiness of continental European idioms of the 1910s and 1920s. Sullivan was the poetic voice of a democratically persuaded architecture found in tradition. His contribution was in theoretical utterances that attracted a movement about him and in rationalizing the vertical aesthetic of skyscrapers. Each of these men was a great teacher, a true mentor.

Gaudi, Mackintosh, Horta, Olbrich, together with like-minded colleagues and the three teachers, were modernists in very limited, circumscribed ways. They executed a few disparate designs, rather new if not truly modern. Identification of these men as mentors and their roles during the course of the transitional period was made contemporaneously by local colleagues or Europhilic historians.

Architects and theoreticians to introduce a viable—and that factor is essen-

tial—a viable modernism to the world were first and foremost Wright, then Albert Kahn,* then the Futurists. Other later founders were Walter Gropius,* the Dutch De Stijl* group (under the demagogic leadership of Theo van Doesburg*), Le Corbusier, and Mies van der Rohe.

Wright was introduced in a personal manner to younger Europeans by Dutch architects (including Berlage) after the young American had been published in 1908 and in Germany in 1910 and 1911. Kahn, the ultimate pragmatist, refined in an architectural sense the industrial building as a type and was published beginning in 1909. The Futurists began in 1909 to challenge Cubism and all contemporary notions across the arts: literature, poetry, music (noise), painting, design generally, sculpture, and architecture. Gropius developed practical fodder around 1911 based on American industrial building design and the verbal and practical utterances of Wright. De Stijl was the leading theoretical art and architectural movement from 1917 and into the early 1920s when overtaken by individuals and movements in Germany. Le Corbusier and Mies revitalized and redefined modernism in the early 1920s.

The main players were, therefore, people engaged in three distinct activities or movements (from America, Italy, and Holland) and six men (from America in and around Chicago, Germany, and Switzerland). There were of course other influences and players but they were peripheral to—or evolved from—the lineage of these primary sources. For example, ideas developed in the Soviet Union after 1919, principally Constructivism, were locally hybridized by crossing French Cubism and Italian Futurism (and called Cubo-Futurism) to become in the mid-1920s a vital participant in Europe seriously testing—or teasing—everyone, especially the Germans.

To carry forth with the outline of the development of twentieth-century modern architecture, which in turn will provide a context for the various players, it is necessary to carefully outline how it all came to be. Because of his germinal position, a study of Wright's catalytic role will unite the diverse strands that wove a new, a modern, architecture in Europe. As we shall learn, things were already well under way in America.

DISCOVERY

Since the introduction of the French beaux arts system of architectural education to the United States late in the nineteenth century, many American architects took the Grand Tour of Europe and the Mediterranean to see at first hand the greater and lesser monuments of the past. Proportionally, the number of American architects who traveled to Europe was vastly larger than the number of European architects who made journeys to the United States. It was not until the appearance in the 1880s of the rather solid and bulky Romanesque revivalism of New Englander Henry Hobson Richardson that in the 1890s Europe

took note of architectural events in North America. By then that world was no longer new but surely becoming an industrialized power with a culture that Europe could not ignore, in this instance especially the array of building construction taking place holus-bolus in cities.

Richardson's architecture was in high contrast to the technical thrust of the nation and, after all, nearly handmade. At the same moment as Richardson was creating some of his more noble buildings, other engineers and architects were producing an architecture more pragmatically tuned to America's commercial and industrial activities. It was of two kinds: one for industry, manufacturing, the railroad, and later, automobiles; the other for business and commerce, in particular the most prominent form (astonishing to some): the skyscraper, as it was dubbed.

When these various works became better known the more curious among European architects, admittedly a fractional number, traveled to America. Their destinations were the commercial and industrial centers of New York City, Cincinnati, and Detroit (the location of Albert Kahn's buildings for Packard and Ford); they seldom ventured further south or west except to Saint Louis and on occasion to San Francisco. A few of them discovered the buildings of Adler and Sullivan in Chicago.

Fewer still noted the young architect Frank Wright whose work was to be found mainly outside Chicago in communities set upon the rolling prairies. Of those interested only three or four architects returned to Europe to nourish and participate in the architectural revolution about to take place there. Their American experiences were added to the philosophical formulations of a new European "machine age" architecture. While American industrial and commercial architecture was initially to have a profound effect in both theoretical and practical rationalization, it was Albert Kahn and Wright who were the most provocative. They had created a new architecture and had provided the effective means for change in Europe.

Those Europeans who carried home the news that American architects had broken with the past to create a new and personal style came from England and Holland. Although the Englishman Charles Ashbee played a significant role in bringing Wright to the attention of Europe, it was the Dutchmen Robert van't Hoff and especially the venerable Berlage who challenged their peers and colleagues to see the value of Wright's architecture and theories as they were knitted by American pragmatism.

During and after a two-term university career Wright worked part-time before moving to Chicago sometime early in January 1887 to gain employment eventually with a family friend, Joseph L. Silsbee. He worked in that office (and in a few others) until one year later when he began to work for the large and prestigious architectural firm of Dankmar Adler and Louis Sullivan, to be dismissed in 1893.

Any lessons Wright may have learned about elemental or sophisticated design *processes* would more than likely have come from Adler and Silsbee. From

Adler, Wright learned practical and constructional aspects. From Silsbee he learned how an architect's office operated. From Silsbee and Sullivan he came to understand not only the characteristics but also the intrinsic meaning of architectural styles, and conjointly from Sullivan, the poverty of mimetic historicism.

By best accounts it was primarily Adler who put the buildings together, so to speak, while Wright was engaged in his firm as a draftsman and designer. The influence of Adler on Wright was more useful than that of Sullivan. During his formative years Wright was, after all, more a consummate practical architect than a verbal theorist. He did not combine architecture and words until he was confident of his architectural resolutions. That confidence was not evident until after 1898.

Wright made the transition from a struggle with volumetric and stylistic architectonics to a study of a unified architecture—in particular to a style that he could proclaim his own—with the Winslow stables of 1895. Everything about the building foreshadowed his prairie works of the next fifteen years and the work of the Wright School. It is a paradigm.

In 1898 Wright realized the necessity to resolve glaring ambiguities in his architecture. He made a decision of two parts. First, to emphasize individuality, subtlety, and aesthetic precision as exhibited in the stables, and second, to separate his two conflicting aesthetic systems, as it were. He defined one as domestic, the other as nondomestic. This decision was manifested in two works of that year. They were the studio addition to his home in Oak Park and the River Forest Golf Clubhouse.

He described the studio addition as an "early experiment in articulation," of reducing functional parts to their essential architectonic form. Wright "individualized and grouped functions": the separation of the library with a special geometric shape and high windows, the separation of reception and Wright's office. As well, there was the umbilical and entry massing of the drafting room and the library. There were, therefore, three parts to the plan which were individualized.

All plans until the 1930s demonstrated some degree of articulation, always defined in massing and aesthetic detail. A rather blatant example is the Ennis house in Hollywood (1923–1925) that Wright described as "Articulation Emphasized by Texture." That is to say, the bedroom, living-study rooms, dining room, and service rooms, were each built of concrete blocks of slightly different texture, and each was individuated in plan and external massing. Or there was the "zoned house" project of the 1930s, a direct application of plan articulation, of function expressed in form, or as Sullivan had it, "Form follows function." Sullivan's words were distorted, almost perverted by European Modernism when it crammed all functions into a bland box.

The golf clubhouse was domestic in every sense: on the exterior, horizontality was emphasized by large batten-over-boards joints on the cladding; by a continuous window at about elbow height with a sill string course; by a low, shal-

low-pitched shingled roof, with inherent horizontal lines; and by extended eaves with a resulting shadow on the wall below and reflected in the row of windows. All the aesthetic tools used on the stables were applied to the clubhouse but with different materials and with a more exaggerated emphasis upon horizontality. "The horizontal line is the line of domesticity," Wright often said.

It is suggested that in that year, 1898, Wright's designs matured as a result of a methodology composed of three parts. First there was the regional, geographical expression of living on the prairie devised for the Winslow Stables and later reapplied with philosophic rigor at the River Forest Golf Clubhouse. Second, the realization that different aesthetic systems were needed for different building types, an extension of functional expression. "Cubic Purism" around 1900 was a hotly discussed theory about reducing forms in art and architecture to essential cubic or parallelepiped forms. Wright applied the theory to his non-domestic aesthetic reaching an epitome in the Larkin Administration Building (1903–1906, see Plate 2) and Unity Temple (1904–1906). And third, the square was used as a design tool and proportional system for both prairie houses and buildings for other than a domestic purpose.

Wright's buildings were not really well known nationally when the young Austrian architect Adolf Loos* visited America in the 1890s and experienced Wright's and Sullivan's architecture. Loos's influence upon the course of events in European architecture, however, was at one moment critical and determined in large measure by his visit to America.

Loos was trained in architecture and after one year of military service he set out in 1893 to attend the Chicago World's Fair. He remained in the United States until 1896, living mostly in the Philadelphia area although he visited New England and of course Chicago. The specific effect of American architecture upon his own work is a matter of discussion, but not so the overall ambience of American culture and the exercise of elemental freedoms including opportunity and choice. While living with immigrant friends in the City of Brotherly Love, he spent much time within their community. He observed that they tended to put behind bitter national rivalries of the Old World. The Viennese architect Richard J. Neutra,* another Austrian emigrant to America, who had worked with Sullivan and Wright and knew Loos, wrote of his Austrian colleague. To Loos

America was the land of unshackled minds—of people with debunked minds, let us say—of people brought close to life's realities . . . realities in a new time, naively, subconsciously kept in matter-of-fact working order. People here, as he saw them, had reverted to a sound attitude which had been lost in the old country. At the same time they had golden hearts compared to the pettier or more sophisticated quarrellers back home.[3]

Loos's main contribution to European modernism was in the realm of theory and polemics. After 1900 he wrote a few essays in which he reflected upon his American experiences and in response concentrated upon the notion of an Aus-

trian culture responsive to modern needs and aspirations. Increasingly critical of the claustrophobic Austro-Hungarian Empire and Viennese design, represented by the *Sezesson,* Wagner's reductive classicism, and the *Weiner Werkstatte,* Loos's thoughts culminated in the now famous essay "Ornament and Crime" published in 1908. Epigrams such as "Beware of being original; designing may easily drive you towards it," or "As ornament is no longer organically linked with our culture, it is also no longer an expression of our culture," or "Architecture is not an art . . . anything that fulfill[s] a purpose is excluded from the sphere of art," exemplify the verbal weapons of his attacks. So does this: the absence of ornament "is a sign of spiritual strength."[4] The essay was widely reprinted throughout Europe and often met with hostility, although not from everyone. Le Corbusier once referred to it as "an Homeric cleansing" of architecture.

Loos's polemics were given substance, or at least visually on an exterior and with due concern for composition, in the now familiar Steiner house of 1910 built outside Vienna. Its lumpy, unembellished, greyish facades soon became well known, and it has been associated, not without reason, with the modernist houses of the 1920s including those of Le Corbusier and J.J.P. Oud* in Holland.

It needs to be made clear that around 1900 perhaps the greatest difference between the Europeans and Wright was that, while they may have desired change, he—and Kahn—executed change. But how else was Wright's private revolution brought to Europe's attention?

During the first decade of the century two visitors traveled to Chicago and Oak Park to see Wright; each stayed for a few days, saw many of his buildings—and Sullivan's—and had long and serious talks. The first was Charles Ashbee, an English designer, architect, and educator. Ashbee's arrival in the Midwest coincided with the beginnings of Wright's most influential creative activity, a fact recognized by the Englishman.

The other visitor was the German expatriate Kuno Francke, who began an academic career at Harvard University in 1884. His academic specialty was German language and literature supporting aesthetics and philosophy. He maintained close ties with his colleagues in his fatherland and, beyond his writings on literature, made comparisons between German and American culture, or at least between the traits and the characters of the two peoples.[5]

He visited Chicago probably late in 1908. According to Wright, Francke noticed some interesting buildings. Intrigued, he discovered that Wright was their author, so he managed an invitation to visit. He and his wife spent two days with the Wrights. Soon after Francke's visit, or at least about this time, Wright received what he described as "a proposition" from the Berlin publisher Ernst Wasmuth to publish a monograph illustrating his work. Three separate publications were produced by Wasmuth all released in 1911. They had a profound effect on the course of modernism. However they were not the German company's first publication of Wright's work. During 1908 and early 1909 F. Rud. Vogel prepared for Wasmuth what is now a little-known book, *Das Amer-*

ikanische Haus, whose release was delayed to 1910. Among illustrations of many architects' work were Adler and Sullivan's Charnley house of 1890 as well as three Wright houses.

Wright may have dreamed of a trip to Europe, but "Paris? Never!" When time and opportunity—via a client's financial assistance—to travel became available, he went west to the East. While absent from Chicago Wright's architectural practice was managed by Walter Burley Griffin,* a young architect whose work would later impress Berlage.

While Wright preferred to travel west, another Midwestern architect established what proved to be an important contact in Holland. William Gray Purcell made a tour of Europe with fellow architect George Feick. Since Berlage's celebrated Amsterdam Stock Exchange had been completed only a couple of years earlier, the two Americans wished to visit the building and meet its author.

In July 1906 they found a warm friendly Berlage most willing to show them his works in Amsterdam and The Hague. Better still, the Dutch architect spoke English rather well and after giving priority to discussing Theodore Roosevelt he wanted to know more about the architectural works of Sullivan and Wright. Purcell was impressed by how much the Hollander knew about both men. He had studied their work and seemed familiar with their architectural philosophies. Moreover, he had read Robert Spencer's comprehensive article about Wright which had appeared in Boston's *Architectural Review* in 1900. After two days of touring with Berlage, Purcell and Feick departed promising to show him Chicago's architecture whenever he might visit. On their return Purcell sent Berlage a copy of the March 1908 issue of the *Architectural Record* containing Wright's revolutionary article "In the cause of architecture."

Berlage may have been further prompted to make a journey to the United States after seeing Wright's drawings reproduced in the Wasmuth portfolio of 1910 and the subsequent publication of related photographs in 1911. Regardless, toward the end of 1911 and with Purcell's assistance, Berlage undertook a lecture tour of America. In November he was in Chicago and Purcell took him in tow. Berlage visited a host of buildings including most of those by Sullivan and Wright. He met Sullivan but not Wright (who was away) as well as Walt Griffin and wife Marion who were then busily preparing a competition entry for the capital city of Australia, Canberra. Their design impressed Berlage who had a wide experience of town planning. In 1912 the Griffins won first prize.

Anyway, Purcell and Berlage spent several days together after which the Dutchman continued his organized tour. He presented public addresses in New Haven, Boston, Minneapolis (where Purcell was then practicing in partnership with George Elmslie), and two in New York City, and he traveled to Buffalo, New York, where he saw Wright's Larkin Building (a "masterpiece" Berlage said) as well as houses by Wright.

In the interval between Purcell's stay in Holland and Berlage's lecture tour of America, Wright had finally traveled to Europe. In 1909 Ashbee and his wife had again visited Wright at Oak Park and noted the strained atmosphere in the

family home. Finally in October, Wright and Mrs. Mamah Cheney, the wife of one of his clients, abandoned their spouses and children and fled to Germany.

There was only one good reason for undertaking the journey. It was an invitation to Mrs. Cheney from the University of Leipzig. She had received a degree from the University of Michigan in 1892 and a Masters in 1893 majoring in languages (a "language scholar," as Lloyd Wright Jr. has put it) and was a keen student of Ellen Key, the Swedish author and feminist (a word Key disliked) much admired in Germany. Cheney was preparing translations of Key's works from the German for G. P. Putnam's Sons to be included in a series on the "Woman Movement," a term Key preferred. The Leipzig offer presented the opportunity for Cheney and Wright to flee and so hurriedly begin together a life of free association, of free wills.

Another reason for their flight has been offered by Wright: an invitation from Wasmuth to assemble material for the now famous publications of 1911. In spite of his insistence that this was the sole purpose of their travel to Italy, that reason seems unlikely because preparing the drawings, assembling the photographs, and writing the text could have been more easily done in Chicago. Wright lived in Fiesole, just outside of Florence, while Cheney stayed in Leipzig. She joined him in Italy only after her work in Germany was completed.

Wright traveled to Paris but not to Holland or to any other European country. Neither is there any record of personal or written contact with Dutch architects in spite of the fact that Purcell, who knew Wright quite well, would have told him of the interest Berlage evinced in his work in 1906. While in Berlin Wright met some German architects, and Bruno Möring gave a lecture on the American's work.

On return to America Wright gave up his Oak Park home and studio. Leaving his estranged wife in residence he went back to childhood places in rural Wisconsin, to his grandfather's farm at Spring Green. There he began to build for himself a new country house, the plan of which was the basis of nearly all of his house designs thereafter. His architectural productivity was sparse with but few projects realized. There was a modest influence on his architecture as a result of his stay in Europe, but it did not linger. Soon he was offered a commission to design and supervise a new Imperial Hotel in Tokyo. This project consumed his energies from 1915 until 1922, and over that period little was done in the United States. From Wright's Chicago office Antonin Raymond* traveled in 1919 with his boss. In 1920 Raymond set up a separate practice and after a few years he fathered European modernism in Japan. During 1922 and while Wright was in Tokyo, Oud visited Wright's Spring Green home, Taliesin, while on his only journey to America.

Moreover, in mid-1914 the young Dutch architect Robert van 't Hoff had made a pilgrimage to Chicago and Taliesin. Although his father was a bacteriologist in Rotterdam, the family was very interested in the arts. In 1906 at age eighteen Robert began architectural studies at the Birmingham School of Art and then moved to London. While there he moved in art circles, befriending

the painter David Bomberg in 1912. That was the year of a well-attended, teasing, and noisy Futurist presentation in the English capital. In 1913 the young Dutchman was commissioned to design a studio house for the artist Augustus John.

The London years were important for van 't Hoff: he became familiar with English avant-garde artists, knowledgeable in "the most recent developments in the visual arts, received ideological inspiration" from "social-utopian ideas, and was initiated into the principles of the arts and crafts."

In 1913 his father sent him a copy of Wasmuth's *Frank Lloyd Wright Ausgeführte Bauten* containing Ashbee's introductory essay that had been modeled on Wright's 1908 article "In the cause." Ashbee was particularly active in Britain in the early part of this century and no doubt van 't Hoff was acquainted with his various promotions of the arts and crafts, education, social welfare, and, it can be safely assumed, of Wright. In any event, in June 1914 the Hollander traveled to America where he would "see in reality what Wright had built." Van 't Hoff sought out Wright, not only as a spirited student might but also for practical reasons and as a sounding board for his own notions. He had no intention of becoming a *Wrightje* (a little Wright) but rather a colleague whom the American might help.

He saw Unity Temple in Oak Park, the dynamic and recent Midway Gardens, of course Wright's suburban houses, as well as Taliesin and the Larkin Building in Buffalo on the return journey. Van 't Hoff spent many hours in discussion with Wright. Their personalities, however, conflicted and their ideas about the role of architecture differed. Yet they talked of collaboration on a project for a private museum, a commission gained earlier by van 't Hoff in London through the agency of John. Most important, on the Dutchman's return, he carried "an extensive collection of illustrated documentation about Wright's architecture."[6]

At the end of 1914, van 't Hoff received a commission for a villa at Huis ter Heide for J. M. Verloop. That and the Henny house—the better-known "concrete villa"—represent the first rather mimetic designs in Europe of Wright's architecture. Construction of both commenced in 1915. In a letter of November 1922 to Berlage, Wright recalled van 't Hoff's visit: "I remember a young man Van T. Hoff *[sic]* who was filled with high purpose when I met him here seven or eight years ago, whom I expect to find has done some good things."[7] Well, Wright probably would not have been pleased with the somewhat copybook exterior that van 't Hoff executed immediately on return from the United States.

The European to whom Wright was most sympathetic was Mies van der Rohe, who understood the principles underlying Wright's work, taking them in new directions, or at least until 1938.

THEORETICAL FODDER

Just before entering the twentieth century, a new architecture that would symbolize contemporary society was actively discussed, but foundered on senti-

mentality; the material results were disappointing. Most practitioners and theorists argued for an eclecticism ordered by historically acceptable options: in other words a vitalized status quo. A few believed that a new architecture might be formed as a result of one or more of three means:

first Artistic, and Art Nouveau was a manifestation of this;

second Technological, and this appeared in buildings related to commerce and manufacture, or at least more so with them than with other types, and

third Sociological, that at first it was intuitive if not empirical, but soon the impetus was toward resolving in a practical manner social issues, mainly through housing, using data-based information. Thus the embryonic city planning profession began just after 1900.

These means took place naturally in the United States as a result of their reactive pragmatism. Trapped by the historical imperative of peasant and elite social hierarchies, Europe was another matter. So each means played a role. But delightful methods like Art Nouveau seemed even then extraneous and without architectonic potential or a relevant and potent symbolism. They died of impotence, condemned to be defined as merely "aesthetic movements." It remained for technology and social concerns to provide directions and then means to resolutions, not the result of sudden inspiration but of synthesis followed by consensus. Useful foundations were laid in the middle of the nineteenth century in England.

It was the architects "who realized that society itself was the main source of architectural form, and that only in terms of living functions could living form be created": but architects were not the initiators as Lewis Mumford implies. Rather they were persuaded by the philosophies—not the desperate, dehumanizing results—of communitarian planners in the nineteenth century, and by William Morris and people like him. As Mumford has more correctly and significantly said, "By making the dwelling house a *point of departure* for the new movement in architecture, William Morris symbolically achieved a genuine revolution."[8]

Morris reasoned that the focus of community life should not be the factory but the house. Art must therefore begin at home. "We must clear our houses of troublesome superfluities that are forever in our way."[9] To a certain extent this rule was to be reduced to formula by Horatio Greenough and, perhaps independently, Louis Sullivan: "form follows function." Anyway, Morris put that advice into practice for his own Red House designed by Philip Webb in 1861: a sensible, plain, rather medieval-looking house. Later related designs came to the attention of mainland Europe principally through the writings of Hermann Muthesius. While Morris's own design activity was merely aesthetic, it was his words that carried theoretical weight.

It was in the design of domestic buildings that many advances were made toward a new architecture. The homemaker, the employee, the worker were all emblematic of Morris's—and most others'—socialism; in fact they were its ful-

crum. Since the workplace of factory or farm or home was the material focus of most people's being, they became the building types acceptable to any socially or more narrowly, socialist-minded architecture.

Most reformers were desperately concerned about the social and physical well-being of people living in the new, industrialized sections of cities. That is why the Spaniard Arturo Soria y Mata created the Linear City concept of the 1880s and built according to it outside Madrid. More prophetically, in the 1890s the Englishman Ebenezer Howard created a concept for a Garden City that became attractive to Europeans and North Americans. Soria's and Howard's conceptual frames were founded upon a concern for proper housing in new places near clean rural areas and generally away from the dirty, enlarging older cities where factories and dreary industrial housing had been added to the margins.

Indeed, shortly before 1900, England was recognized as the center of rational, acceptable housing reform. Leading the world into the industrial age, England had been the first to encounter its physical and social problems and the first to deal with them. The centralized concentration of industry and attendant population were soon countered by ideas of decentralization such as the Linear and Garden cities. Both were ideas developed by, in, and for free societies in capitalist countries, facts often ignored even today.

With Bolshevik military victories in Russia and subsequently in neighboring countries, the political and sociological emphases of European architectural theorists increased during the next two decades. An architecture that embraced a technology able to produce low-cost housing would win acceptance. It was then, around 1920, that architects in Europe discovered exactly what their Dutch colleagues had seen in Wright's architecture.

It was Wright who *developed* the *architectonic* principles to solve, as it were, those dilemmas that had so occupied his mentor Sullivan and had concerned Europeans. It was Wright who created living forms from living functions. His point of departure or more exactly, his focus was indeed the house. The transmission and transmogrification of his principles and architectonic resolutions in and by Europe is an intriguing story.

As previously outlined, European visitors to America who met Wright or saw his buildings were important in propagating knowledge about his architecture. However, it seems that publications and not people provided the initial curiosity and provocation to discover more. After the travelers had returned with personal, experiential knowledge, publications again came to the fore to have a lasting effect. They were read, republished, and plundered. The evidence suggests there were seven critical essays and presentations: three American, four German.

In May 1900 the American architect Robert Spencer presented "The Work of Frank Lloyd Wright" in the Boston magazine *Architectural Review*. His article not only illustrated many designs of the 1890s but included an essay based on discussions with his good friend Wright. Then, after much negotiation between Wright and the editor of *Architectural Record,* in July 1905 it published

a short essay about him, accompanied by recent illustrations of a few prairie designs.

While Wright rather emotionally and inexactly spoke about his relationship with Sullivan, it was Spencer and Thomas Tallmadge who more clearly linked Wright and the great Chicago architect. Tallmadge's illuminating piece, also written in 1908 but for the April issue of the Boston *Review,* put forth the idea of a "Chicago School"—a school in the traditional sense of the art world. Architect Tallmadge's own contemporary domestic designs were clearly associated with Wright's school.

During 1907 and 1908 Wright produced his most important theoretical treatise, entitled "In the cause of architecture." It occupied sixty-six pages of the March 1908 issue of the *Record* with ten pages of text. The remainder contained excellent photographic illustrations, a few of which were annotated with informative—some provocative—captions. The essay was one source from which Vogel in 1908 selected photographs of Wright's architecture for the Wasmuth book about the American house (*Das Amerikanische Haus*) with at least two of the illustrations supplied independently by Wright. Overall, Vogel offered an attractive and comprehensive presentation of American domestic architecture, giving it a sensible theoretical and artistic context.

After negotiations involving Wasmuth and Leipzig University, Wright and Mrs. Cheney traveled to Europe. From late 1909 until early 1910, he prepared material for what became a folio-sized monograph. It was a two-volume portfolio of loose sheets beautifully printed, some in color, in a short run deluxe edition and a more standard version, both entitled *Ausgeführte Bauten und Entwürfe von Frank Lloyd Wright.* The essay that had appeared in the 1908 *Record* was edited, slightly revised, and enlarged by Wright and included as text and dated May 1910. An American edition with Wright's original English version was prepared and printed in Berlin. (The essay had been translated into German for Wasmuth by Mrs. Cheney.) It was published and distributed by Wright's friend Ralph Fletcher Seymour in Chicago and also dated June 1910 as *Studies and Executed Buildings by Frank Lloyd Wright.*

When the *Ausgeführte* portfolio was finally distributed in 1910, exclusively illustrated with expertly reproduced drawings, with architectural plans dramatically open yet academically formal, Plate 1, with perspectives of buildings set in treed landscapes, it was all a marvelous revelation.

However, in 1911, Wasmuth released a condensed paperbound version of the portfolio as a pamphlet in the *Sonderheft der Architektur des XX. Jahrhundert* series entitled *Frank Lloyd Wright Chicago.* English architect Charles Ashbee wrote a mostly laudatory article—edited by Wright—as an introduction. Concurrently, Wasmuth published a variant of the *Sonderheft* entitled simply *Frank Lloyd Wright Ausgeführte Bauten.* These two pamphlets, with more than 100 photographs and with many related plans (taken from the portfolio), were eagerly read in European architectural circles. They were cheaper, more widely available than the limited editions of the portfolio, and they contained photo-

graphs of plant-enriched and spatially open interiors. Le Corbusier obtained a copy in 1915.

Ashbee studied at the Slade art school and was then articled to the London neo-Gothic architect G. F. Bodley. Ashbee's residence in the Toynbee Hall settlement house had a lasting effect. In 1887 he established the Guild of Handicraft and following its limited success he reformed it in 1904 as a school of arts and crafts in the Cotswold town of Chipping Campden. From 1904 until about 1915 Ashbee's educational, quasi-philanthropic, and design work became known throughout central Europe by means of exhibitions and many publications including among others the German *Moderne Bauformen and Deutsche Kunst und Dekoration.*

Beginning in 1894 Ashbee often made lecture tours abroad. The first to the United States was made in 1900 and included Chicago because he wanted to observe the settlement house establishment Hull-House initiated principally by Jane Addams. It was there over a cup of tea that he met Wright, followed by a long visit at the Oak Park studio, and a friendship was struck. Wright showed off his recent work and over several days they talked about all manner of things including Ashbee's guild.

It was through Wright that Ashbee was challenged to recognize that machines and art must not only coexist but unite, and that only the creative artist "through the thousand pores of the machine" would be able to find a proper expression of the machine in the future; would be the only one to control "all this and understand it."[10] Ashbee remained true to concepts of charity, labor, and religiosity in the face of Wright's criticism of English arts and crafts sentimentality and lack of modern practicality. Within a few months Wright had put his thoughts together and gave his now-famous lecture to the Chicago Arts and Crafts Society at Hull-House entitled "The Art and Craft of the Machine."

Later Ashbee proclaimed that it was he who "discovered" Wright "for Europe."[11] There is no reason to believe he did not. In 1910 Wright invited the Englishman to write an introductory essay to what became the two 1911 Wasmuth publications. Ashbee wrote in part:

> To us, who look at them with the eyes of the old world, American Building [*sic*] connotes . . . a new spirit.
>
> Its characteristics are a departure from tradition, a distinctiveness of surrounding, and a consequent character of its own, a delight in new materials, and an honest use of machinery. . . . Wright has carried the new spirit into domestic work and produced a type of building that is . . . a new architecture.
>
> [Wright has] a determination, amounting sometimes to heroism, to master the machine and use it at all costs, in an endeavour to find the forms and *treatment* it may render without abuse of tradition. In a suggestive and interesting monograph [*sic*] which he contributed in 1908 to the "Architectural Record" of New York, entitled "In the Cause of Architecture", Lloyd Wright laid down the principles that inspired his work . . . [among them]

"Above all integrity. The Machine is the normal tool of our civilization; give it work that it can do well—nothing is of greater importance. To do this will be to formulate the new industrial ideals we need if Architecture is to be a living Art."

Here we are brought face to face with the problem of our civilization, the solution of which will determine the future of the Arts themselves. It is significant that from Chicago, quite independently of England, of France, of Germany or elsewhere, here is a voice calling, offering a solution.

"The machine is here to stay. It is the forerunner of the Democracy that is our dearest hope. There is no more important work before the architect now than to use this normal tool of civilization to the best advantage, instead of prostituting it."

There is greatness in this idea. . . . Out of it has come a different conception as to what constitutes a modern building.[12]

Advisory words repeating revolutionary words. It had been there for all to see in 1908; it was reintroduced in 1911 by Ashbee. And many did see.

IMMEDIATE REACTION

Berlage is another key to the more general knowledge of Wright's ideas, not only through illustrated lectures, but thereafter by word of mouth. It was Berlage's respected authority within the European architectural community that bestowed acceptability on Sullivan's skyscraper aesthetic and on Wright's avant-garde architecture.

Yet it must be emphasized that there is no evidence of *public* debate about Wright prior to 1912. However, that there was private discussion of some kind is clear from Berlage's admission of his own knowledge of Wright and Sullivan made to Purcell as early as 1906. Two further if disparate examples help support this conclusion. Russian architect and later a Constructivist theorist Mosie Ginzberg studied a Wasmuth publication on Wright while a student in Milan, Italy, in 1912. And in Moscow at about the same time Panaleimon Golosov built his own version of Wright's Warren Hickox house of 1900.[13]

Upon Berlage's return to Amsterdam in mid-December 1911, he began to describe his American adventures, the architecture he had seen, and his impressions of the cities, the people, and their culture. He passionately championed Wright in lectures in Amsterdam, Berlin, and Zurich, and also in a number of publications.

His first lecture about American architecture attracted a capacity audience to the Artis-hall in Amsterdam on 30 January 1912. The occasion was reported in three major Dutch architectural journals, *Architectura, Bouwkundig Weekblad,* and *De Ingenieur,* each read, it needs be noted, in German-language countries. Some leaned heavily upon an essay about ". . . Wright: a modern *bouwmeester* in America" that had recently appeared in two successive numbers of *De Bouw-*

wereld, whose principal source was Ashbee's essay in *Ausgeführte Bauten.* As late as the 1960s, Oud "clearly remembered the enthusiasm with which Berlage spoke of Sullivan's Owatonna bank, of the Larkin Building, and of the various country houses" by Wright.[14] Le Corbusier also remembered well as shall be revealed.

This all happened in Holland within two months of Berlage's 1912 illustrated talk in Amsterdam. Then on 30 March 1912, Berlage gave an illustrated lecture to the Zurich Association of Engineers and Architects. A transcript of the lecture was eventually published in three installments in the Zurich German-language journal *Schweizerische Bauzeitung* in the following September. The first two contained only text; the third consisted of large, fine quality plates prepared from his slides. The delay was in a way fortuitous: the editors in the meantime were able to approach Wright, who provided more illustrations. The now-famous edition of *Bauzeitung* was also issued as an offprint, ensuring that its influence would extend well beyond subscribers.

In 1913 Berlage crowned his propaganda for Wright by publishing a book entitled *Amerikaansche Reisherinneringen* (Recollections of an American journey). Almost a fifth of the small volume dealt with Wright, quoting long passages from his 1908 essay as edited for the Wasmuth folio, and providing photographs of Unity Temple, the Larkin Building, and the Robie House (1908–1909). Most important, Berlage pronounced Wright a master "whose equal is yet to be found in Europe."

The Swiss engineer and later art historian Siegfried Giedion knew Berlage, and was a lifelong friend of Le Corbusier and Gropius. Knowledgeable about events and personalities in central Europe, Giedion had discussions with those who were marching in the artistic advanced guard. He became an articulate polemicist for the Europeans' international style and a promoter, apologist, and historian of the so-called Modern Movement. (That was until he visited America in the 1930s.)

Amongst Giedion's friends and confidants was the Belgian modernist architect Victor Bourgeois. Giedion confirms the "deep impression" made by Berlage upon the rising generation in the Low Countries and along the valley of the Rhine. Bourgeois told the Swiss that before 1914, when he was a student in Brussels, "only two names fascinated young men": Berlage and Wright.

Giedion has further confirmed the importance of Berlage's "exhibitions and lectures" of early 1912 and their subsequent publication. Of special significance is his confident assertion, based on conversations, that Le Corbusier first became acquainted with the work of Wright through Berlage's Zurich essay. Because these personal and professional interrelationships within central Europe are crucial to understanding the full impact of Wright and American technology during these prewar moments, another example is valuable.

During 1909 and 1910 Mies van der Rohe was working in the Berlin office of Peter Behrens* at a time when Wright frequented the German capital to discuss matters with Wasmuth and visit his mistress Mrs. Cheney. It is difficult

to believe that someone at Wasmuth, a publisher of the arts, with many col-
leagues and friends in the art world, would not have introduced Wright around
that circle.

Moreover, dissatisfied with Behrens's architectural philosophy, Mies went to
The Hague in 1910–1911 to work on designs for an extravagant villa proposed
to be built for Mrs. Ellen Kröller-Müller. Mies has acknowledged that Berlage's
sincerity and "almost religious faith in his ideal allowed no compromise" yet
he won the "special veneration and love" of young European architects.

As to Wright, Mies was unequivocal. To coincide with the German publica-
tion in 1910 of the portfolio, there was a presentation to Berlin architects of
Wright's drawings. "This comprehensive display," Mies recalled, "and the ex-
tensive publication of his works enabled us really to become acquainted with
the achievement of this architect. The encounter was destined to prove of great
significance to the development of architecture in Europe." Mies continued by
saying that the work of

This great master revealed an architectural world of unexpected force and clarity of
language, and also a disconcerting richness of form. Here finally was a master-builder
drawing upon the veritable fountainhead of architecture. . . . The more deeply we studied
Wright's creations, the greater became our admiration for his incomparable talent, for
the boldness of his conceptions, and for his independence in thought and action. The
dynamic impulse emanating from his work invigorated a whole generation. His influence
was strongly felt even when it was not actually visible.[15]

The "strongly felt" influence on Mies became evident in the decade after the
1918 armistice.

More generally, the Europeans evolved out of Wright's theoretical *principles*
the anonymous—and that nonesoteric, noncultural aesthetic was important—
steel, glass, stucco box. Their answer to the notion of modern was for a "ma-
chine aesthetic." The machine (in architecture for producing new materials like
glass and steel) was the symbol of a modern post-1918, independent Europe.
The almost universal application of the box throughout the Western world meant
to those who so wished, as Gropius (with a political bent) perceived as early as
1925, that it could be a uniting internationalist symbol because of its noncultural
newness. With obvious purpose it was dubbed an "international" architecture,
a new style. Most people who applied or imitated it did not realize the initiating
political implications but accepted it for its modernity or its emphasis on housing
and related urban problems.

While Gropius's design of offices for the Fagus Works in Alfeld (1911 with
Adolf Meyer) contained direct applications of an American industrial architec-
ture, his office building for the *Werkbund* Exhibition in Cologne (1914 with
Meyer), Plate 8, applied many architectural elements taken from Wright's build-
ings as published by Wasmuth in 1910 and 1911 as well as the steel and glass
wall.

PRACTICAL STUFF

It is necessary to return briefly to earlier events because American industrial and commercial architecture was less theoretical fodder, more practical stuff, yet equally crucial to the aesthetic formulas settled by the Europeans.

Nothing attracted the world to American architecture more than the skyscraper, as it was then called. The centralization of industrial and commercial management and consequent real estate speculation caused urban concentrations. Tall buildings could have continued to be built in the traditional manner of piling up masonry, but the higher the building the thicker the lowest walls with a consequent loss of rental space. A famous example is the sixteen-story Monadnock Building in Chicago (1889–1892), designed by Daniel Burnham and John Root, with ground-floor brick-bearing walls eleven feet thick and the exterior and windows devoid of embellishment. (Loos no doubt learned much from its plain facades and fenestration.)

An iron skeletal frame for tall buildings became a practical proposition and began in Chicago. The Reliance Building, Chicago, of 1894 by D. H. Burnham and Company, was the first all-iron structure and its exterior walls were 90 percent clear glass. But the glass and narrow spandrels rested on floor slabs. (Soon steel replaced iron as a principal structure.) It was not until Albert Kahn's Packard Motor Car Forge Shop, Detroit (1905–1911) that an independent wall was used *in front* of the floor and post structure; in other words, it was attached to the structure as a curtain made principally of steel and glass (Plate 4).

Adler and Sullivan's Wainwright Building in Saint Louis, Missouri (1890–1891), defined a vertical aesthetic for skyscrapers, that tall, new building type not found in historical styles. Floor spandrels were recessed and vertical supports were prominently expressed. With Adler and Sullivan's Schlesinger and Mayer Store (1891–1904, now Carson, Pirie, Scott), the horizontal aspect was rather more obvious than the vertical in a very plain facade. And more light was allowed with larger areas of glass. These two buildings, described by Gropius as "epoch making" (in *Scope of Total Architecture,* 1956), were designed in the main by Sullivan, and with the severely chaste Monadnock Building, they stand as landmarks.

With those buildings from the Reliance to Schlesinger and Mayer, the basic means and themes of the American skyscraper were determined—from 1908 until the present day. It was just a matter of refinement whether of structure, response to codes, or aesthetics. One can easily and usefully compare Pietro Belluschi's* Equitable Building in Portland, Oregon (1946–1948), with Kahn's earliest Ford building (1908–1909), Plate 3, and Sullivan's Schlesinger and Mayer. Tall buildings in the hundreds, usually clad in classical or other revival motifs, were illustrated in dozens of publications from 1890 to 1920, so there were plenty of choices. It was a phenomenon difficult to ignore. So too was the American industrial building as conceived immediately after the turn into this century.

Just as slender structures freed the facade to allow more light to offices, shops, exhibition halls, conservatories, and markets, so too did they allow more light within a factory. François Hennebique displayed how concrete industrial architecture might evolve under the impress of beaux arts with his Charles Six spinning mill (1895) at Tourcoing. Albert and Julius Kahn were more practically responsive with their design for Packard Building 10 (1905) in Detroit. Hennebique expressed a hidden structure; Kahn *exposed* structure. (By the way, between 1892 and 1917, Hennebique's construction company had 17,692 building contracts; engineering works were similar in number.)

But it was Albert Kahn's Brown-Lipe-Chapin gear factory of 1908 that became the paradigm. It was followed with almost exactly the same characteristics in the better known first building for the production of the Model T Ford at Highland Park, Michigan (1908–1909), shown in Plate 3. Its facade and that of the Brown-Lipe-Chapin building look almost exactly like modern architecture through the 1950s, at least that promoted by the internationalist's Modern Movement. Kahn's further achievement was to place all manufacturing on one level with roof daylight monitors and all glass walls to provide maximum light at the working level (see Plate 4). In all it was a thoroughly rational response that excited German theorists.

The skyscraper and factory were synonymous with American technological achievement thrust forward in response to necessity. Those building types epitomized and symbolized an architectural response to the machine and the burgeoning industrial and commercial city. The European polemicists based their philosophical *Zeitgeist* urgings on the absolute need of technological expertise. It was a difficult battle because Europe wanted to languidly retain historical glories that poorly served twentieth-century realities. To help with practical stuff, Moritz Kahn wrote a book that effectively showed Britain and Europe how to go about laying out, designing, and constructing an industrial building. There were plans and glossy pictures of mostly American buildings but also some in Britain where the Kahn brothers had acted as design consultants.[16]

EUROPEAN SYNTHESIS

In 1913 the peripatetic Gropius extolled the pure cylindrical geometry and "unacknowledged majesty" of the North American grain silos—an acclamation to be repeated by others including Le Corbusier and Amedée Ozenfant after 1918. Gropius then noted functional forms in twentieth-century transport such as the "railroad car, steamship and sailing vessel, airship and airplane."[17] Yet it was Wright who put into the minds of Gropius and his European counterparts the idea that those great cylinders and transport machines could be interpreted *architecturally*.

Most of Wright's text for the 1910 Wasmuth publication was based upon his thoughts about architecture as previously spoken or published. In the context of this discussion examples can be noted. In his paper to the Architectural League

of America of June 1900 he linked modern social needs to elemental function-
alism by noting that transportation, warehousing, ''manufactories'' (i.e. indus-
trial buildings), elevated railway systems, freight stations, grain elevators, and
office buildings were all rightfully the purview of the architect. They were to
him ''monumental in power and significance stripped and trained to the bone
for action.''[18] In 1908 Wright stated that his Larkin Building

was built to house the commercial engine of the Larkin Company in light, wholesome,
well-ventilated quarters. . . . Therefore the work may have the same claim to considera-
tion as a ''work of art'' as an oceanliner, a locomotive or a battleship.[19]

As far as the eminent historian Nikolaus Pevsner was concerned, *European*
modernism was ''heralded'' by the Larkin Building.[20]

The reduction theory for functionalism was not new but the coupling of it
with nontraditional building types was unique, as if echoing the thoughts of
Viollet-le-Duc. However, when Wright spoke of an indigenous architecture in
1900, 1908, and 1910 it was for a *new* vernacular that would recognize a modern
nation. In one instance in 1900 he said the architect has ''something to say in
noble form, gracious line and living color, each expression will have a 'gram-
mar' of its own'' and speak a ''universal language of beauty in no circumscribed
series of set architectural phrase as used by people in other times, although in
harmony with elemental laws to be deduced from the beautiful of all peoples
in all time.'' This was closely linked to nationalism, to a discovery of an Amer-
ican architecture by the rejection of the narrow ''damned . . . dogmas'' of Vi-
gnola and Vitruvius and a strengthening ''of individuality developed in a free
nation and the richness of our inheritance.'' There the architect ''will find ex-
pression in an art that is indigenous and characteristic as an architecture mea-
sured by the laws of fine arts.''

Again in 1900 Wright put in simple terms the essence of his intellectual
struggle during this critical period of his career: from a national architectural
milieu he hoped for ''a further contribution to the art of the world, not a servile
extraction.''[21] These thoughts had been underlined by Berlage who—like
Loos—had challenged his European colleagues to recognize the originality in
Wright's country houses, that they were a new, native American architecture
''because there is nothing like it in Europe.'' To a pre-1914 Europe, balancing
ideas of nationalism and the frustrations of ethnicity, Wright's and Berlage's
words were usefully attractive. And vitally, they were not merely polemical but
attached to Wright's architecture as built.

These themes are found in his 1908 theoretical treatise in *Architectural Rec-
ord* where he also attempted to clarify his views about the practical example of
his Larkin Building. He described its functional, mechanical, and other unique
attributes. He repeated most of this in 1910, including drawing analogies be-
tween the Larkin and ocean liners, locomotives, or battleships. In Wright's mind
the Larkin was powered (heated) and ventilated and otherwise rationally func-
tional: it *expressed* that functionality.

Almost suddenly, in 1911 Gropius (with Adolf Meyer) completed buildings for the Fagus shoe last factory (manufactory) using Kahn's steel and glass facade (for the administration building and workshop) and Wright's brickwork and other elements on the entry. They designed a model factory complex for the Cologne *Deutscher Werkbund* exhibition (built in 1914) that repeated major elements of Wright's architecture and Kahn's facades. In June 1913 Gropius presented an article about a theory for modern industrial architecture, much of it a rephrasing and personalization of Wright's recent essays.[22]

Wright's son Lloyd has said that he "heard that Gropius' mother gave him one of the collection [of Wasmuth portfolio drawings], he claimed he made it his Bible." And further Lloyd said that "Soon after the work was published in Germany, we found they [Germans] were using the folio and drawings in schools and universities for text books."[23] This is partly confirmed by the American architectural journalist John Boyd who, on a visit to Berlin in 1911, discovered that in architectural circles Wright and Sullivan were the object of some debate as a result of the 1910 and 1911 Wasmuth publications and Berlage's eulogies about both men.

The preeminent challenge to shed the bonds of traditionalism and historicism was accepted by the Italian Futurists. After much publicity and many public verbal and cacophonist performances relevant to the visual, literary, and musical (for them noise) arts, in 1913 Antonio Sant'Elia organized an exhibition and presented perspective drawings of dynamically functional imaginary buildings for, as example, monumental hydroelectric power stations and elevated or depressed transport systems with their urban stations (Plate 6). The Futurists put emphasis on urbanism and Mario Chiattone's vision of a "Modern City" (Plate 7) is typical of his contribution. Their influence was widespread.

Oud put all these materialistic and theoretical considerations into proper—or at least *a*—perspective when he said, "I bow my knee to the wonders of technology but I do not believe that [an ocean] liner can be compared to the Parthenon."[24]

In contradiction, most American colleagues of all architectural persuasions remained unimpressed by Wright's texts. We can only assume that they believed his ideas were patently not about the refined art of architecture or that all those industrial and commercial things were already part of America's landscape and conscious. That would have included the stark, constructional-appearing warehouses and automobile manufacturing plants that provided the paradigm for much of the Modern Movement's structural rationalism.

As a corollary it should be noted that while visiting America in 1911, Berlage was surprised at the conservatism of most American architecture, the domination of beaux arts ideas, the impropriety of Greek temples and Roman thermae rebuilt for new roles as railway stations, and the artistic "barbarism" perpetuated by architects who doggedly stuck to the revival of historical styles. (Sullivan and Berlage were so much alike.) Moreover, Berlage was bemused by the architects' inability to come to terms with necessary urban services: "For traffic and so

on, everything is sacrificed; poles for telephone, telegraph and electrical wiring are placed with no attempt at good positioning or good design."[25] All of this was incongruent with the popular dynamic New World image held by European audiences.

The search led by Wright was complex: he looked at possibilities in unadorned geometrical forms ("cubic purism"), exotic art, innocent vernacular arts, as well as to modern aesthetic responses to new technical achievements and to social responsibilities. Theoretical and practical congruence with contemporary events is clear. This can be further substantiated by the example of Charles-Édouard Jeanneret, who after about 1920 called himself Le Corbusier.

Sigfried Giedion was certain that Le Corbusier was first directed to Wright by a "lecture Berlage delivered in Zurich" in 1912. In view of the close friendship between the two Swiss there is no reason to doubt that assertion. In any event it is confirmed by Le Corbusier's biographical collaborator Willy Boesiger. In 1912 Le Corbusier traveled to Zurich where he heard Berlage lecture on Wright.[26] He then continued on to Paris and Berlin. It is put beyond doubt by Le Corbusier's own words in a letter of August 1925 to H. Th. Wijdeveld in which he stated that he first saw "reproductions of Wright's houses and an office building" before the war.

Le Corbusier's first experiment with Wrightian architectonics was the Jeanneret house of late 1912 built at La Chaux-de-Fonds. Interestingly it exhibited an external character based on just the buildings illustrated in Berlage's lecture and article in *Bauzeitung*. There followed the Dom-ino housing project (also influenced by the architecture of North Africa) of about 1915, a concrete house project of the same year, and the Schwob house also built at La Chaux-de-Fonds (1916–1917).[27] In these houses some three-dimensional, formal, and other elevational aspects were borrowed from Wright and knitted to elements from Swiss vernacular buildings and contemporary European architects such as Josef Franz Maria Hoffmann* and Auguste Perret.*

In 1925 Le Corbusier recalled his first encounter with Wright's architecture: "I still remember clearly the shock I felt seeing those houses spiritual and smiling—with a Japanese smile."[28] Shock? Le Corbusier did not apply such an oriental smile to his early houses. Architectural plans for Jeanneret and Schwob were based upon Wright's house plans, in particular those for Barton (1903), illustrated in Plate 1, and Horner (1908), which was illustrated in *Ausgeführte Bauten* 1911. That suggests that Le Corbusier had access to more tangible repositories of Wright's work than only recollections of Berlage's Zurich lecture.

By his own account in a letter to Wijdeveld, Le Corbusier believed that Wright's architectural plans revealed "good planning" (he underlined those words) and by that he meant "a tendency toward" order, organization, and a "creation of pure architecture." Additionally, Wright "introduced order" (he also underlined those words), but this idea was not amplified. However, in his letter, the Swiss also disparaged "coquettish or decaying old villages," so we

must assume that "disordered regionalism," as he put it, contrasted with Wright's academically secure architecture.

If the Jeanneret, Dom-ino, concrete, and Schwob house plans are compared with Wright's as they appeared in the Berlin and American publications, and those in *Bauzeitung,* one inspiration for Le Corbusier's new theoretical position becomes clear.

Another comparison is perhaps too obvious. Around 1927 Le Corbusier offered his well-known four—sometimes five—points of architectural coherence. First was the free-standing pillar *(piloti)* or independent post; second, the free or open plan; third, the "free" facade. Those three points were exactly related to skeletal frames and to structural and spatial articulation as *initially* revealed in Wright's plans and Kahn's factory structures and walls. Also in Europe, Jan Wils had expertly analyzed Wright's work in such terms. A free facade can occur only as a result of the first two points. And it should be remembered that in the 1920s the industrial wall was well used throughout Europe and America.

The fourth point was the opportunity for a roof garden as one result of using horizontal flat slabs of reinforced clay tile or concrete. But in 1904 Walter Griffin designed for Wright the Lamp house which incorporated a complete roof garden with trellises.[29] Wright did not further develop the idea, but Griffin and his architect wife Marion did and their houses were exhibited in Paris and Vienna in 1913. And anyway, roof gardens were not uncommon in Mediterranean countries. So even the fourth point may have been slightly influenced by Wright (and Griffin). The four points were brilliantly displayed in Le Corbusier's design of the Villa Savoie in Poissy (1929–1931).

Although Le Corbusier told Wijdeveld that he knew "very little" of Wright, the truth was otherwise. Yet the Swiss also would have insisted that inspiration was one thing, copying another.

In 1932 Giedion set down some recollections. He referred to Wright's 1908 "In the cause" article as a manifesto in support of the machine, "this modern tool." He noted that Wright's words were repeated "over and over again in Europe." He believed—and history (until this book) had shown—that Wright's most important contribution to modern architecture was his houses "from 1893 to 1910." It was then that Wright became better known through Berlage's efforts, said Giedion, and Holland's further contribution just after 1914 by those "followers" who elaborated developments. But to "enlarge on his principles" and make them more relevant to Europe was the task for those to follow. That task, Giedion proclaimed, was taken up by Le Corbusier. He "developed Wright's ideas in his work, even though it is not striking [not too obvious]. No architect," said Giedion,

placed the housing problem as much in the center of his work as Wright did. He first showed how to dissolve the rigid house cubes and to destroy the facade idea and how to unite the house into the landscape . . . it is not a coincidence that Le Corbusier starts with the same things.

But what of Mies? Anyway, the route taken in Europe was profoundly influenced by Cubism; one implication would be that Giedion believed that Wright was unaware of Cubism's effects.[30]

But consider this. As previously noted, the theory of Cubic Purism was defined and debated in Chicago architectural circles and published nationally around 1900. Wright applied its principles to the Larkin and Unity Temple buildings and carried it to a personal culmination with the Midway Gardens (1913–1914), as illustrated in Plate 5. And so did Wright's colleague Dwight Perkins, beginning with the Abraham Lincoln Center in Chicago (1903). Was there a relationship between French Cubism (begun 1908) and Chicago Cubic Purism ideas? In any event the effect of Midway Gardens on European events now seems clear. Giedion paraphrased most contemporary European modernists with the observation that Wright's "great and educative influence" was that of "his methods and ideas," as "reflected in his work"—that "Wright's conception of space" was "developed and changed in the hands of its leading figures."[31] Interestingly, the Dutchman Jan Wils made such a prophecy of progress in 1919 and his point of departure was the house plans and the cubic, non-domestic buildings.

Perhaps the most immediate superficial reaction to the Wasmuth publications about Wright took place in Germany. In 1911 the *Werdandibund,* a relatively moderate architectural movement formed in Berlin in 1907, set up what has now become a rather obscure competition in domestic architecture. When organized it was in response to quite heated debates over the place of tradition. One villa entered by Heinz Stoffegren borrowed basic forms and minor elements from Wright's prairie houses. The winning design included a long balcony dripping with vegetation of indeterminate genus, wide eaves, and a facade organization visually reminiscent of Wright: it was submitted by, of all people, Adolf Meyer. Nothing is known of the plans of these buildings.[32] However, it is clear that the impact of Wright's architecture as presented in the American publications was almost instantly influential.

Wright's introduction to Europe via publications, therefore, was through the three American works and Wasmuth's four. After 1911 it was the Dutch who evangelized for him, then De Stijl took up the cause (but not until 1918). Holland became the epicenter of European architectural modernism. Its two streams were the quasi-rationalism and aesthetic reductivism of De Stijl epitomized in the architecture of Gerrit Thomas Rietveld* (Plate 13) and the rather more conservative and expressionistic Amsterdam School, led by Michel de Klerk* (Plate 10). Within a few years the polemical and creative energy shifted to the Germans. It was they who found promise in American industrial buildings.

It was Mies van der Rohe who made the connections between aesthetics of industrial construction and Wright. Mies has mentioned that in the period before World War I and immediately after, "the only valid solutions at that time were in cases such as industrial building." This of course supported the character of his own designs after 1937, but in the 1920s and early 1930s his application of

Wright's spatial effects is well known. He referred to Wright's plans as a "dynamic impulse . . . that invigorated a whole generation."[33] Among those were Erich Mendelsohn,* at the time perhaps the best known German modern architect in the Western world. Wright knew full well the impact of his own work upon Mies when in 1947 he said that Mies was "one of his [Wright's] more talented disciples."[34] A bit conceited but the point was made.

∽

The transition to European modernism had been made. In its initial making it determined what would follow for the next four decades throughout the world. Offices, houses, skyscrapers, apartments, row housing, factories, and all else appeared the same regardless of social or geographic region—much like Kahn's industrial buildings from 1908 to 1917. Or much like Loos's greyish box. Or as a combination of the two mixed with Wright as finally resolved by Mies and Le Corbusier. That their *appearance* was other than that of Wright came about because Europe did not wish to emulate his idiosyncracies. Kahn's aesthetic was technically oriented, the more universal, and without sentiment. Rather, the Europeans absorbed Wright's ideas and abstracted certain three-dimensional forms as, for example, in the controlled and influential work of Willem Dudok (Plate 15).

The general view in Europe was probably much as the one Gropius retrospectively offered in 1934. Wright had inspired "so many European architects in both a spatial and a structural sense." But in the 1920s he "began to manifest a growing attachment to romanticism . . . that was in sharp contradiction to the European development."[35] Romanticism was equated with the subjective, a thing shunned by supposed objectivists who wanted to escape a satiating historicism and to embrace internationalism. Wright was thereafter less attractive as were those who tended toward expressionism.

Evolutionary events prior to 1939 were modest, basic patterns were barely modified. Exceptions were found, for instance, in a dynamic interplay of form, line, and space by Hollanders (Plates 12 and 13), Germans, and some Russian minimalists. But here again the influence of Wright is measurable by visual evidence beginning in 1914: notably the roof forms for his own house and Midway Gardens of which Wright said in 1915, it "is an attempt to *again* orchestrate form, line and color as a unit in a single utilitarian composition. . . . [I]t is an art in a new sense."[36] An uncomplicated statement of functionalist abstraction. "Again" means as he had done it before.

When modernist European patterns became formalized and then relatively popular in America around 1930, most critical observers would note that America's architecture had returned home, albeit somewhat modified. New York architect Ralph T. Walker observed the phenomenon in a paper presented in 1930: "the European architect took over the American factory and the ideas of Frank Lloyd Wright."[37] In 1929 Mumford noted that industrial architecture and Wright were the progenitors of the modern movement in Europe. Then in 1952 he said

that "the new doctrines of architecture . . . came back to America."[38] And the historian Reyner Banham discovered primary sources in industrial architecture as presented in his book *A Concrete Atlantis* of 1986.

Not comparable in America was the social quotient of European modernism as touted by the Congrès Internationaux d'Architecture Moderne* (CIAM) after 1928. Although a few Americans attended CIAM meetings, the socialist agenda and demand for state intervention in urban planning, housing, and the like, as well as the grand, very beaux arts and almost megalomanic schemes of its members, were unattractive to most Americans. So too were formalized artistic groups or an avant-garde, mainly because American ideas are tested rather than remaining theoretical propositions. It was Aldo van Eyck,* Jan Bakema, and Alison and Peter Smithson* as part of Team 10 who, in the 1950s, in an attempt to humanize community planning challenged the pomposity of CIAM. In the 1930s Wright's response to the urban dilemma was to propose something like a revived Garden City, that is a series of loosely organized new towns that he called Broadacre Cities.

When one compares Wright's architecture of the 1930s with his earlier work, only plans and some architectonics survived for refinement. The plan for his own house of 1911 was the paradigm for later houses and all of modern domestic architecture. The three-dimensional character of the Gale house of 1909 became not only the paradigm for much European domestic architecture, in particular that of Mendelsohn, but Wright's own work of 1931 and beyond. Notable is his greatest house design called Fallingwater (1936–1939) (see Plate 18). The abstract essence and spatial dynamics of those plans were critically explored by Mies van der Rohe in projects for villas in the mid-1920s and urban houses in the early 1930s. Wright's architecture of the 1930s was naturally influenced by European events of the 1920s but in this way: they caused him to examine his previous work, isolate essentials, and then proceed . . . as if shadowed by Europe.[39]

❧

While the dissemination of architectural thought and product before 1930 had been difficult to access, thereafter and primarily through magazines both were more readily available and after 1950 prolifically exposed in periodicals and books. To sort out the events from 1893 to 1930 has not been easy for historians; therefore, there is a need to present up-to-date research in the text above and use Wright as the conceptual fulcrum.

The course and therefore the history of architecture after 1930 and especially since 1945 is a more open proposition: publications abound, national and international links are publicly revealed, documentation is more easily confirmed, ideas and appearances are quickly scattered but not difficult to trace. By using the Chronology and Founders section of this book and then examining the individual architects presented in the Biocritical Studies and related illustrations, the details of evolution are made clear.

ORGANIC VERSUS ABSTRACT

Comparison is useful. While rummaging through files I came across a house that is a wonderful summary and exemplification of architecture through the first half of the century—one that is of the kind not wholly related to industrial buildings. It is a landmark of twentieth-century modernism (Plates 22 and 23). A cursory study of the house should clarify as much about the analysis of architecture as about the position of the house historically.

In late 1947 the San Francisco architectural firm of S. Robert Anshen and William Stephen Allen were commissioned to design a house for Sonya Silverstone beside a river on a wooded hillside near Taxco, Mexico. Their response to the site and the client's requirements was direct, the manner not as expected.[40] The site slopes from a power room and shops to a swimming pool made by a dam in the river. The earth was made into platforms or gentle gradients.

On one platform rests the house. The plan recalls Wright's openness and articulation. The three major components are in separate areas: a kitchen flows to dining and living spaces that are linked to private sleeping rooms with a study over the smaller. Terraces are off the kitchen and entertaining space with a private patio next to the sleeping area. The plan is, therefore, an application of Wright's zoned and open plans, particularly the Ennis house (1923–1925) and Fallingwater (1936–1939). Indeed, Anshen and Allen's architecture often referred to Wright but not visually.

The plan also integrates the character of Louis Kahn's designs. Entry is from the rear where cars come to rest. The servants' rooms are tight against the hillside following the gentle curves of the earth's shape. Shops are similarly in line and beyond. Across the river is a garden of vegetables and flowers.

Spatially the interiors are both open and partially closed and directed to the terraces, landscape, and stream. Landscaping is relatively undesigned, or confined by stone and concrete, especially at the river's edge where control of erosion and flooding is necessary. A series of in-line rocks in the river form small pools that culminate at a fairly high rock dam that contains water for a bathing pool. Beside this pool is a stone sunning platform with steps up to the entertaining terrace. In all aspects the landscape evokes not the contrived designs prevalent in the 1930s and 1940s but the informal gardens associated with the influential work of Roberto Burle Marx in Brazil or the later designs of the American James C. Rose.

There are five principal building materials: clay (floor, unglazed roof tiles, and wall screens), stone (walls and exterior floors), glass (walls and skylight), concrete (ground floors, planters, retaining walls, and girders), and wood (roof structure and cedar ceiling). Except for glass and the cement to make concrete all were available on site or made in nearby villages. And except for glass all were left in a rather unrefined, quasi-natural state. Therefore the colors are analogous in contrast to bright locally woven fabrics and the garden's brilliant blossoms.

The great concrete girders were cast in place over a period of four months. Steel wire in tension keeps the cantilever in balance while steel rods resist tipping and absorb lateral forces. The girders do not touch at the apex but stop well short of one another, and so do the wood joists. This allows six feet on either side of the ridge for a 130-foot continuous glass skylight.

The girders are of a free form that visually describe their task in resisting structural forces. They fit contemporary interest in technical and aesthetic structural explorations and recall aspects of Le Corbusier's work of the same period. The free-form kitchen island and dining table were derived from the 1930s sculpture and paintings of Hans Arp and much of modern Mexican art. Together with the stubby tubular wall tiles there is a plasticity of form in contrast to the house's general rectiliniarity. Tradition, the immediate past, and the present resonate through the house and its environment.

Moreover, in spirit and product the Silverstone house is the antithesis of its famous contemporary, the Farnsworth house by Mies van der Rohe (1945–1950), Plate 20. Both are highly organized functionally and structurally, both expressively sophisticated, and both logical in response to their clients' needs, yet they exemplify aesthetic extremes. One is deeply in debt to tradition and contemporary thought; the other attempts to dismiss all that had passed. One is a near perfect fit to the client's home living; the other is a rigidly formal, an abstracted art and, it needs be added, abridgement of home living. One is personable and regional; the other rejects the individual and the region—including its inherent culture—for the universal and the primacy of art in architecture. One is organic; the other not. One is complex; the other minimalist. Neither is definably rational. When taken together they clash and reverberate as theoretical investments in relativism—in what we now call pluralism—beginning at that very moment. Both are thoroughly modern. Either is philosophically, aesthetically, practically valid. Yet the more prophetic is the Anshen and Allen house because it displays potential diversity, reductively and additively. The Mies house seems the ultimate, final refinement: twentieth-century formalism and modern classicism at its finest.

AFTER 1950

One by-product of World War II was an awareness of the planet's wonderfully diverse cultures and, therefore, of art. Returning warriors and the press made it clear that a forced universal absolute in anything, let alone architecture, was ridiculous. Not only was there diversity in peoples but in the people within regions. The umbrella term for cultural idiosyncracies was and is "regionalism," implying a unique local condition. Architecture of the hot deserts was understandably different from that of rain-soaked and wooded mountains. Bernard Rudofsky put together an exhibition and book entitled *Architecture without Architects* in 1965 that adequately highlighted truths and dilemmas of the past decade and vernacular buildings of societies throughout the world. With such

diversely responsive artistic phenomena was it correct to impose one idea on people who *naturally* wanted an individuated and self-directed identity?

Moreover, it soon became evident that there was a new and demanding element in the cause of architecture: the environment. Machine-made materials, machine control of synthetic conditions, and what else?, were ever-increasingly drawing on nature: could that consumption be sustained? The question could be asked only because science was then, in the 1960s, able to synthesize data. The resources provided by Mother Nature were being cataloged and measured against human demands. There was inequality. Questions asked were: Is man a planetary plague? Specifically, what is the ecological position of architecture and the construction industry? Can we design *with* nature? How did humans solve their problems before air conditioning and steel? What are the requirements of enlarging populations?[41]

Reactions to the early phase of modernism's machine-like boxes occurred first in Scandinavia in the late 1930s. Climate, local materials, and traditional building forms were reexamined by Erik Gunnar Asplund* and Hugo Alvar Henryk Aalto.* Yet there was no consistency of product enabling an apparent theory and no verbal support. After 1950 reaction was more obvious. On the Arabian deserts, Hassan Fathy rejuvenated the traditional mud brick architecture of vault, dome, and wall. And in the last years of his prolific career, Raymond similarly responded by invoking Japan's traditions.

In the United States, structural technology drove some architects toward a "sensualism" in organic forms. Eero Saarinen* was one to experiment with large, fluid forms. In Mexico Felix Candela* investigated but with mathematics, engineering, and intuition to produce stable hyperbolic-paraboloid shapes. At times, a building's structure became an end in itself, probably as a reactive gesture. Theoretical substance was given by Saarinen's insistence on recalling the century-old maxim, and one Wright also preferred, that in the problem resides the solution. Each of their buildings appeared different because they solved many different problems.

Structural technology was, however, double edged. Buckminster Fuller* provided the means to span spaces with nondescript domes and space frames. He went as far as to propose spanning Manhattan Island. Frei Otto,* also with mathematical, engineering, and intuitive skill, created great tents that were also physically and aesthetically dominant yet appeared to be effortlessly erected. The ingenuity of these men was a "triumphant vindication of . . . ideas of construction" but also threatened "to make most modern architecture obsolete."[42] No doubt that threat sent architects frantically searching for an *aesthetic* response. The scapegoat became not technology but what was perceived as the sterile aesthetic product of Europe's machine rationalism, principally that architecture representative of Mies van der Rohe.

At this evolutionary juncture Louis I. Kahn* began at the beginning. He asked not how does one react but how does one *make* architecture. Fifty years earlier Wright had also begun at the beginning and through process and practical ac-

cumulation, had created a new architecture. Reaction was immediate. Initially Gropius borrowed from American architecture (Wright's and industrial) and gestalt hands-on education to re-form the architecture of his immediate experience. Le Corbusier did much the same except that gestalt ideas of form dominated his thoughts: he was not an educator. In the 1930s he finally freed himself from the clutches of the new European formalism that he so actively helped to create. Wright made the transition to a socially aware and newly advanced program at about the same moment in the 1930s. It was a transition Gropius was unable to make. And after brilliance in the early 1930s, Mies van der Rohe retreated to the industrial formulas of Alfred Fischer and others of the preceding decade.

The comparison of Kahn and Wright is apropos because both men learned from the past including beaux arts methods, assimilated traditional and current ideas and cultural attributes (not artistic products), infused them with individual interpretations, and then created an orderly set of propositions that were proved by the buildings they constructed. They thereby laid out fundamentals easily understood that, within the notion of progress as evolutionary, became a substantive foundation of future events. In contrast, Le Corbusier's attempts after ca. 1935 to redefine modernism verbally seemed too aesthetically remote.

Therefore, Kahn discovered that in the "making" were the design process, the methodology of that process, the creation of forms to suit particular problems as established by the client and the desired building, and the eventual construction of those forms. He thereby identified certain principles that would allow him to architecturally satisfy these needs. It has been said that to Kahn "buildings were living organisms, with desires and demands of their own. He spoke to them, and they to him."[43] That is not an oversimplification because he did ask, at each instance of the process and with neo-Platonic insight, what a specific condition "wanted to be."

There were many ways in which the process of "wanting to be" was examined and resolved. Initially he found a limited number of ways to express a function, for instance, stairs and elevators and posts are vertical, spaces of repose or contemplation or concentric activity are relatively even-sided and open, and there are spaces or functions that are subordinate to others (in a house, a kitchen to dining, vestibule to chamber). But each wants to be identified as distinct. He therefore proposed served and serving spaces. The most obvious architectural statement of that proposition can be found in the Richards Medical Building at the University of Pennsylvania (1957–1961). Stair, foul air exhaust, and elevators are expressed in solid brick-bearing walls (vertical); laboratories are structure by posts and truss and glass (horizontal). There was therefore the form and structural expression of a function.

When Kahn rediscovered that the symbolic and ritual core of a building needed (wanted) to be more-than-less centrally located, he found that the serving spaces fell into a natural hierarchical order. And within each subordinant could be found a further hierarchy. Concurrently, there was a necessity to give these functional aspects their idiosyncratic form; they wanted to be identified in the

design process and experientially: the making and ordering of first the whole and then of each part. Architecture as process therefore was "the orderly arrangement of forms."[44] The buildings that most emphatically explain this theory are the First Unitarian Church in Rochester, New York (1959–1963), and the Salk Institute in La Jolla, California (1959–1965). Each is explained in plan, elevation, section, and experientially on approaching the building and within. The making of the design (process) was as clear as the making of the parts, forms, spaces.

There remained yet one further step to freedom from the hegemonies of the immediate past. That was to recognize that the theory of a primal form or space ordering subservient relations, if carried one step further, would allow *nearly* unlimited freedom in design, or as Kahn preferred, in "arranging systems." This was made clear again in 1959 with the Goldenberg house in Rydal, Pennsylvania (Plate 27). The central ordering space was bordered by circulation. Proceeding outward were functions serving the served spaces on the periphery. The radiating structure, defined at the core by posts but hidden in bearing walls, was apparent in the form of rooms that reached out for view and light. If the diagonal could be formalized by the power, by the presence of a central space, then any system of forms can be similarly ordered by reference to a similar control.

The opposite of the primacy of a central space is a perimeter or a line, spatial or material. And more loosely and less effectively, by the mere juxtaposition of static forms in confluent space experientially temporal. These systems of design and experiential control are clear in Kahn's works such as the projected site plans for the Inner Harbor Development for Baltimore, Maryland (1969–1974), and aspects of the site plans for the Salk Institute outside San Diego. The notion of compositional pluralism within one design problem had the inevitable effect of strengthening the growing demand for a rejection of absolutist notions.

It follows, therefore, that Kahn's disciples are those who espouse learning from past systems and values and at the same moment allowing a modern interpretation. These are architects as diverse in product as Aldo Rossi,* Charles W. Moore,* Tadao Ando,* and Robert Venturi, who was Kahn's teaching colleague at the University of Pennsylvania and a guru of postmodernism. Or less radical is the architecture of Romaldo Giurgola. In fact, he encompasses most post-1960 architects.

As an example consider just one design aspect. Kahn had rationalized that an exterior wall in a hot humid climate wanted to be of two parts: one to shade the other. This regional and historical observation was given modern clarity with a second free-standing exterior wall to Kahn's U.S. Chancery project for Luanda, Angola (again 1959). Giurgola applied the idea to the two principal facades of the Australia Parliament Building (1978–1988) where it is a historical reflection of the 1927 Parliament Building and shades the vestibule. Also there is Kahn's

Phillips Exeter Academy Library in Andover, New Hampshire (1965–1971), as well as many of Moore's buildings, and a proliferation of other applications.

In the early 1960s, tired of formalism, Philip Johnson,* who was heavily in debt—and later reacted—to Kahn's monumental gestures, asked critics, "Can't we just wander aimlessly?"[45] Can't there be satisfaction with visual pleasures uncomplicated by theory? It was a desire felt by many but not before publicly spoken.

That he could make such a wistful proposal was in part due to the provocative propositions of the Metabolist* group and Archigram.* The Metabolists in 1959 to 1960 drew on thoughts about the organic analogy espoused by Team 10, mainly van Eyck and the Smithsons, about "growth and change," on theory and form as put by Kahn, and about the ephemeral and the transitory. The time around 1960 was one of great curiosity about the Metabolists, Kahn, and the English Archigrammers.[46] The idea of organic growth of a building in relation to function and effected by some universal structural system was one easily accepted. But when knitted to an idea of impermanence and mere transition, the art in architecture was threatened. Architecture might be disjoined from art. Kahn's liberating influence and the culturally neutral expandable structures of Fuller and Otto opened Pandora's box.

Of these moments in the 1960s Manfredo Tafuri has said: "Reestablishing design and the development of form as central criteria of excellence was a restorative strategy. It strengthened the shared and distinctive competence of architects but was unable to reunify the aesthetic codes."[47]

Perhaps it was Johnson's lamentation that sparked Venturi's problematical fires to react to the formal—to him, the austere—character of postwar architecture including the idiosyncratic monuments of Le Corbusier at Ronchamp, France, and Chandigarh, India. Like Johnson, Venturi drew most of his inspiration from Kahn's philosophy and in architecture his compositional *plurality.* Venturi also studied common visual experiences and historical situations and came to advocate something of an ad hoc architecture not conceptually dissimilar to Kahn's Inner Harbor at Baltimore and the Salk Institute. Venturi proposed an "assemblage of cultural signs representing themselves," as put by Aaron Betsky, where "the structure remains invisible, only intimated by the disjunctions in the scale and material of the assemblage."[48] Venturi's concept of assemblage was explained in his influential book *Complexity and Contradiction in Architecture,* in which he spoke of an architecture

based on the richness and ambiguity of modern experience. . . . I like elements which are hybrid rather than "pure," compromising rather than "clean," distorted . . . ambiguous . . . perverse . . . redundant rather than simple, vestigial as well as innovating. . . . I am for messy vitality over obvious unity. I include the non-sequitur and proclaim the duality. . . . I am for richness of meaning rather than clarity of meaning; for the implicit function as well as the explicit function. . . . A valid architecture evokes many levels of meaning and combinations of focus: space and its elements become readable and workable in several ways at once.[49]

Let's wander aimlessly! Anything goes! Not prompted by Johnson, Venturi was nonetheless reacting to the pomposity of so much that was said and built in the names of formalism and monumentality. He wanted an antiheroic architecture assuming it would be in some manner democratic, or at least humble. In practice it was meant to gather mere fragments and thereby present an aesthetics of incompletion.[50] With that idea and in architectural philosophy generally, Venturi was both Kahn's disciple and nemesis. With the introduction of historical pieces Venturi was alone, yet he influenced those who used the idea to extract selected bits from old history books to make their architecture cute.

A theoretical palette was thereby made of almost unlimited hues and variations. It was eagerly studied probably because it said anyone could do anything one desired. And why not? The result was another theoretical proposition giving authority to what was by then obvious (at least to Kahn): to be viable, architecture must actively promote something pluralistic. Again, that it might exist in one building was an idea explored later by Frank Gehry,* Moore, Venturi, Jean Nouvel, Kisho Noriaki Kurokawa,* and the verbose Eisenman. Indeed, it was one of the aspects that led to postmodern disjunctive art. The resulting riot came to include the lingual- and sociological-based "deconstructivism." Note that it and postmodern are negative terms. In architecture they are appellations to catch the unwary; they are plain labeling; they are not architectural terms but borrowed from serious endeavors elsewhere.

Postmodern, more correctly postmodernism is a literary movement not a movement of the visual arts. But it has a context in all arts as being somehow more humane yet funky, more intuitive yet rational, at times even mannerist. It and its children, named deconstruction and destructuralism or poststructuralism, promote the decay of current symbolism but do not promise replacement. Such a psychological void induces individual and cultural anxiety and dislocation— thus, the dislocated architectural forms of Eisenman, Morphosis, Coop Himmelblau,* and Zaha Hadid. The terms not only are negative but induce negative—or at least destabilizing—reactions and ruptures. It is very much a fin-de-siècle hiatus like the one that occurred in Europe around 1800 and, as we've learned, around 1900.

Rather than the term "postmodern" the late historian and critic Tafuri preferred "hypermodern." In that term at least the notion of an evolving modernism (not Modernism) persists. Journalist and architect Charles Jencks, on the other hand, insists on categorizing in a multitude of half-contrived classes every modern architect: this classification in a climate of pluralism. His many charts are supported by a self-righteous text that invariably ignores architectural plan or physical and social contexts to concentrate on nothing more than surface and appearance. But Architecture is not facade, and in that misunderstanding he is not alone among the fraternity of commentators.

Perhaps this freneticism has been a by-product of applied computer technology; but only perhaps. Computer-aided design (CAD) has dramatically quickened the ability to lay down visually, as it were, an idea. Options are therefore

more readily put up for analysis, thereby inducing more options. CAD allows complicated forms and spaces to be studied comprehensively; for example details of fastening and the joints between materials are more easily understood, and buildings can be skeletonized (Plate 48). All this will be of assistance to those with a steady philosophy. Those less resolute will always find an excuse for disappointments.

To sum up, theoretical direction was given by Kahn, and by using his ideas Venturi opened vistas along many possible paths. According to art critic and historian Hal Foster, "Art exists today in a state of pluralism: no style or even mode of art is dominant and no critical position is orthodox. Yet this state is also a position, and this position is also an alibi."[51] A survey of post-1970 architecture confirms its disparate and desperate position and many alibis.

Eisenman has raised the stakes by creating an architecture that visually appears in a state of deterioration, partially disjunctive at best. Many find his designs a frightening comment on the present condition of human dreaming. Followers of Eisenman's anarchy, if not his architectonic forms, like Coop Himmelblau and Daniel Libeskind,* or the art theory–based works of Gehry and Rem Koolhaas,* or the neohistorical monuments of Ricardo Bofill,* Rossi, and Rob Krier,* *intentionally* challenge human sensibilities about elegance and beauty, about sculpture and architectural function, and about history as value not as *event,* as Tafuri has put it.[52]

Others continue to produce an architecture less demanding, without swagger or challenge; such as Santiago Calatrava's* sculpted structures, Ando's gentle geometry, Oscar Niemeyer's* flowing white forms, Mario Botta's* formal discoveries, or the many regionalists such as those found in the American evergreen Northwest, high-plained Southwest, or forested New England.

The low proportion of discussion herein of post-1970 events and people is attributable to the fact that so much of a substantive nature in what now occurs had been tabled. Architecture is—as all art forms must be—in a state of flux. Today it appears to be frenetic, compulsive, self-centered. However, the masculine, finely tuned architecture of Norman Foster* and Richard Meier and the orderly sensitivity of Renzo Piano* and Botta suggest that architecture is not all callously conceived. What will eventuate after the year 2001 is beyond conjecture: so why try? However, it is suggested that if a desirable foundation needs now to be identified it is the humane philosophy and elegant architecture of Tadao Ando.

<div align="right">Don Johnson, 1995

Kangarilla/Seattle</div>

NOTES

See Abbreviations, p. lxi.

1. William Fleming, *Arts and Ideas,* 3d ed. (New York, n.d.), 540–41.

2. George Howe, paper presented to an AIA, *Symposium on Contemporary Architecture* (Washington, D.C., 1931), 5.

3. As quoted in Leonard K. Eaton, *American Architecture Comes of Age* (MIT Press 1972), 139.

4. As quoted in Carter Wiseman, "Adolf Loos," in Macmillan.

5. Arthur Davison Ficke, "The Recollections of Kuno Francke," *Harvard Graduates Magazine* (June 1930); a review of Kuno Francke, *Deutsche Arbeit in Amerika* (Leipzig, 1930); information supplied by Harvard University Archives; and Anthony Alofsin, *FLW. The Lost Years 1910–1922* (University of Chicago Press, 1992), 307–8.

6. Evelien Vermeuen, "Robert van 't Hoff," in *De Stijl. The Formative Years,* edited by Carel Blotkamp (MIT Press, 1986).

7. Letter, Wright to Berlage, 30 November 1922, Berlage Archives, Nederlands Architectuur Instituut, Rotterdam.

8. Lewis Mumford, *The Culture of Cities* (New York, 1938), 406.

9. As quoted in Mumford, *The Culture of Cities,* 407.

10. As quoted in Alan Crawford, *C. R. Ashbee* (New Haven, Connecticut, 1985), 98.

11. Nikolaus Pevsner, "Frank Lloyd Wright's Peaceful Penetration of Europe," *AJournal* (4 May 1939), 731.

12. C. R. Ashbee and Frank Lloyd Wright, *FLW. Ausgeführte Bauten* (Berlin, 1911), n.p.; but see Leland M. Roth, *America Builds* (New York, 1983), 391–98.

13. Donald Leslie Johnson, "FLW in Moscow: June 1937," *JSAH* 46 (March 1987), 73; and see idem, *FLW versus America: The 1930s* (MIT Press, 1990), chapters 15–18.

14. Oud interview with Eaton, *American Architecture,* 216.

15. Ludwig Mies van der Rohe, "A Tribute to FLW," *College Art Journal* 6 (1, 1946), 41–42; cf. Alofsin, *FLW. The Lost Years.*

16. Moritz Kahn, *The Design & Construction of Industrial Buildings* (London, 1917).

17. Walter Gropius, "Die Entwicklung moderner Industriebaukunst," *Die kunst in Industrie und Handel* (June 1913), 17–22, translated in Don Gifford, ed., *The Literature of Architecture* (NY, 1966), 617–23.

18. FLW, "The Architect," *Brickbuilder* 9 (June 1900), 538; condensed in *Construction News* 10 (6 June 1900) and 10 (23 June 1900); condensed as "A Philosophy of Fine Art," in Frederick Gutheim, ed., *FLW on Architecture* (New York, 1941).

19. FLW, "In the Cause of Architecture," *ARecord* 23 (March 1908), 64–65.

20. Nikolaus Pevsner, *A History of Building Types* (London, 1976), 222.

21. FLW, "The Architect," 539.

22. Gropius, "Die Entwicklung," 17–22.

23. Letter of 1966 (n.d.) quoted in Bruce Brooks Pfeiffer, *FLW. Monograph 1907–1913* (Tokyo, 1987), x.

24. As quoted by Helen Searing, "J.J.P. Oud," in Macmillan.

25. R.[?], "De Berlage avond en Berlage's voordracht over Amerika," *Architectura* 20 (1912), 35.

26. Willy Boesiger, ed., *Le Corbusier* (London/Zurich 1972), 247.

27. Jeanneret (signed "Le Corbusier") to Wijdeveld, 5 August 1925, Wijdeveld Archives, The Nederlands Architectuur Instituut, Rotterdam.

28. Paul Venable Turner, "FLW and the Young Le Corbusier," *JSAH* 42 (December 1983), 351.

29. Robert O. Holzhueter, "FLW's Designs for Robert Lamp," *Wisconsin Magazines of History* 72 (Winter 1988), 83–125.

30. "Johannes Duiker," *De 8,* 1 (1932), 177–84. Translation of Giedion's comments

and Duiker's responses in E. J. Jelles and C. J. Alberts, "Johannes Duiker," *Forum* (Amsterdam) 22 (May 1971), 136–37.

31. Sigfried Giedion, *Space, Time and Architecture,* 3d ed. (Harvard University Press, 1956), 424. The literature of Jan Wils is the subject of one aspect of Donald Langmead's research into Dutch modernism before 1940.

32. Richard Pommer, "The Flat Roof: A Modernist Controversy in Germany," *Art Journal* (New York) 43 (Summer 1983), 160–61, cf. 166–67.

33. Mies van der Rohe, "A Tribute," 41, reprint in Fritz Neumeyer, *The Artless Word. Mies . . . Building Art* (MIT Press, 1991), where it states that the text was "for an unpublished catalog of the Frank Lloyd Wright exhibition" at New York's Museum of Modern Art, 1940.

34. As quoted by Harry Seidler in Kenneth Frampton et al., *Harry Seidler* (London, 1992), 391.

35. Walter Gropius, *Scope of Total Architecture* (London, 1956), 69, 73.

36. Frank Lloyd Wright, "In Response . . . on Midway Gardens," *National Architect* 5 (March 1915), 118. Cubistic and abstract dynamic characteristics were best displayed for European consumption as follows: for Midway, *National Architect* (Philadelphia) (1915), plates 41–43; Henry Blackman Sell, "Interpretation not Imitation," *International Studio* (London) 55 (May 1915), 79; H. P. Berlage, "FLW," *Wendingen* (Amsterdam), 11 (1919), 7; for FLW's house, Peter B. Wight, "Country House Architecture in the Middle West," *ARecord* 37 (October 1915), 391; and that same illustration in Berlage, "FLW," 13.

37. Ralph T. Walker, (a paper presented to the AIA, *Symposium on Contemporary Architecture,* (Washington, D.C., 1931), 21.

38. As outlined and quoted in Johnson, *FLW versus America,* 351–52.

39. Cf. Ibid.

40. "Textured Mansion," *AForum* 94 (January 1951), 141–51; and "A New Kind of Beauty," *House Beautiful* (January 1951), 36–46.

41. See as examples Suzanne Stephens, "Before the Virgin Met the Dynamo," *AForum* 139 (July 1973); William R. Ewald, Jr., ed., *Environment for Man* (Bloomington, 1970); *National Academy for Sciences, Resources and Man* (San Francisco, 1969); "Architecture in an Ecological View . . . ," *AIAJ* 54 (November 1970); "Is Man a Planetary Disease?," *RIBAJ* 77 (July 1970); Ian McHarg, *Design with Nature* (New York, 1969, 1971); Paul Ehrlich, *The Population Bomb* (New York, 1970).

42. H. H. Arnason, *A History of Modern Art* (London, 1969), 486.

43. Peter Blake, obituary, *APlus* 2 (April 1974), 29.

44. Donald Leslie Johnson, "Form and Architecture," *PA* 42 (June 1961), 170.

45. As quoted in Robin Boyd, *The Puzzle of Architecture* (Melbourne, 1965), 156.

46. This author was in Louis Kahn's graduate class in 1961 and still vividly recalls conversations about the people (some of whom drop in at the University of Pennsylvania to talk with Kahn) associated with these movements. Dialogue literally pulsed with an energy that embroiled all in the new direction that architecture was taking and in wonderment at what might evolve.

47. Manfredo Tafuri, *Theories and History of Architecture,* 4th ed. (London/New York, 1976), 228.

48. Aaron Betsky, "Beginnings," *DBR Design Book Review* 6 (Winter 1985), 28–30.

49. Robert Venturi, *Complexity and Contradiction in Architecture* (New York, 1966). Selections were first published in *Perspecta* 9/10 (1966).

50. David Bell, "Unity and Aesthetics of Incompletion in Architecture," *ADesign* 49 (July 1979), 175–82.

51. Hal Foster, *Recoding: Art Spectacle, Cultural, Politics* (Port Townsend, Washington, 1985), i. Cf. Peter Brunette and David Wills, eds., *Deconstruction and the Visual Arts: Art, Media, Architecture* (New York, 1994); Mark Wigley, *The Architecture of Deconstruction. Derrida's Haunt* (MIT Press, 1993); Ian Hodder, ed., *The Meanings of Things* (London/Boston 1989).

52. Tafuri, *Theories and History* (New York, 1976), 63.

ABBREVIATIONS

AA	Architectural Association, School of Architecture. London.
AAAB	American Association of Architectural Bibliographers. *Papers.* Charlottesville, later New York. vol. 1 (1965) to vol. 13 (1979). (Note: William B. O'Neal, ed. *Cumulative Index Papers I-X.* vol. 11, 1974.) No illustrations.
AAFiles	*AA Files.* London.
AandA	*Arts and Architecture.* Los Angeles.
a + u	*a + u: architecture and urbanism.* Tokyo.
AAQ	*Architectural Association Quarterly.* London. Formerly *AA Journal,* and *Arena.*
Abitare	Milan.
ADesign	*Architectural Design.* London.
ADigest	*Architectural Digest.* Des Moines, Iowa.
AForum	*Architectural Forum.* New York. Formerly *Brickbuilder.*
AHistory	*Architectural History. Journal of the Society of Architectural Historians.* London.
AIA	American Institute of Architects. Washington, D.C.
AIAJ	*AIA Journal.* Formerly *Journal of the AIA,* since 1983 *Architecture.*
AJournal	*Architects' Journal.* London.
AmericanA	*American Architect.* New York.

APlus *Architecture Plus.* New York.
Architect See *RIBAJ.*
Architecture See *AIAJ.*

Architettura *L'Architettura, Cronache e Storia.* Rome.
ARecord *Architectural Record.* New York.
AReview *Architectural Review.* London.

ArtA *Art in America.* New York, Marion, Ohio.
Aujourd'hui *L'Architecture d'Aujourd'hui.* Boulogne-sur-Seine, Paris.
AVivante *L'Architecture Vivante.* Paris.

Bauen *Bauen + Wohnen.* Munich. See also *Werk.*
Bauwelt Berlin. Full title varies.
BuildingD *Building Design.* London.

CanadaA *Canadian Architect.* Ottawa. Formerly *Royal Architectural
 Institute of Canada Journal.*
Casabella Milan. Full title varies.
Contemporary Ann Lee Morgan and Colin Naylor, eds. *Contemporary Ar-
Architects chitects.* 2d ed., Chicago, London, 1987. Each entry lists
 architectural works. Illustrations.

CPL Council of Planning Librarians. *Exchange Bibliography.*
 Monticello, Illinois. no. 1 (1958) to no. 1565 (1978). Ns.
 Bibliographies. Chicago. no. 1 (1979) to no. 185 (1987).
 No illustrations.
Croquis *El Croquis. Monograph Series.* Madrid.

De8 *De 8 en Opbouw.* Amsterdam.
DesignQ *Design Quarterly.* Minneapolis.
Domus Milan. Full title varies.

GADoc *GA Document.* Tokyo.
Harvard *Harvard Architectural Review.* Harvard University. Cam-
 bridge, Massachusetts.
InteriorD *Interior Design.* New York.

Interiors New York.
JAE *Journal of Architectural Education.* Washington, D.C.
JapanA *Japan Architect.* Tokyo. Also and formerly *Shinkenchiku.*

JSAH *Journal of the Society of Architectural Historians.* Phila-
 delphia.
LA Los Angeles.
Lampugnani Lampugnani, Vittorio M. L., ed. *The Encyclopedia of 20th
 Century Architecture.* Also ... *Modern Architecture.* 4th
 ed., New York, 1985; London, 1986. Illustrations.

LandscapeA	*Landscape Architecture.* Washington, D.C.
Lotus	*The Lotus International.* Milan, Venice, New York. Full title varies.
Macmillan	*Macmillan Encyclopedia of Architects.* 4 vols. New York, 1982. Each entry lists some major works. Illustrations.
Mirmar	London, New York.
MIT Press	Massachusetts Institute of Technology Press, Cambridge, Massachusetts.
MuseumN	*Museum News.* Washington, D.C.
NY	New York.
NYTM	*New York Times Magazine.*
Oppositions	*Oppositions. A Journal for . . .* New York.
PA	*Progressive Architecture.* New York. Formerly *Pencil Points,* and *New Pencil Points.*
Perspecta	*Perspecta. The Yale Architectural Journal.* New Haven, New York.
ProcessA	*Process: Architecture.* Tokyo.
Rassegna	*Rassegna di Architettura.* Milan.
RIBA	Royal Institute of British Architects. London.
RIBAJ	*RIBA Journal.* Formerly *Journal of the RIBA,* now *Architect.*
SpaceD	*Space Design.* Sometimes *SD.* Tokyo.
Techniques	*Techniques et Architecture.* Paris.
Transition	*Transition. Discourses on Architecture.* Melbourne.
Vance	Mary Vance, ed. *Vance Bibliographies. Architecture Series.* Monticello, Illinois. No. A1 (June 1978) to no. A2386 (December 1990). No illustrations.
Wendingen	*Wendingen. Maandlad voor bouwen en sieren.* Amsterdam.
Werk	*Werk, Bauen Wohnen.* Switzerland. Formerly *Werk . . . ,* then *Werk-Archithese.* Munich.
Wilkes	Joseph Wilkes and Robert Packard. *Encyclopedia of Architecture. . . .* 5 vols. New York. 1988–1990.

A

(HUGO) ALVAR (HENRYK) AALTO. 1898 (Kuortane, Finland)–1976. After his widowed father, a surveyor, remarried, the family settled in the central city of Jyvaskyla. Aalto received his basic education at the Normal School and the Classical Lyceum (1910–1916). He moved to Helsinki to study architecture at the Polytechnic, graduating in 1921. After about a year in Sweden, he set up a practice in Jyvaskyla (1923). In 1924 he married architect Aino Marsio, who became his professional partner. The practice moved to Turku (1927), then to Helsinki (1933). Aino died in 1949. Aalto married architect Elissa Makiniemi (1953), and their practice continued in Helsinki until his death. He was a visiting professor of architecture at MIT (1946–1948). His work was published and exhibited internationally after 1933; he received almost countless prizes, honorary degrees, and awards including the Gold Medals of the RIBA (1957) and AIA (1963).

⤦

During most of Aalto's student days, Finland was in political turmoil. Under Swedish rule for centuries, it had been ceded to Russia in 1809. Following the Bolshevik Revolution, independence was declared on 6 December 1917. After a few years of civil strife, during which Aalto served in the militia, there was an uneasy peace with the Soviets from 1920. Aalto's mentor at Helsinki Polytechnic was Armas Eliel Lindgren, sometime partner of Eliel Gotleib Saarinen.* Both were significant in the National Romantic movement in architecture, in part a reaction against attempts to "Russianize" Finland. Its vernacular elements were in tension with the desire—almost the need—for classicism that characterizes new democratic states. In respect of classicism, other inputs must be

noted: among Aalto's teachers were Yrjo Hirn, who taught aesthetics, and architectural historian Gustaf Nystrom, an avowed and evangelical Greacophile. Aalto's own aesthetic was roughly forged in those years: his early experiences and the beliefs of all these teachers greatly influenced his work, even in later life.

Apart from renovations to the family home, and a belfry, his first practical experience was in the office of Carolus Lindberg in 1920, working on designs for the Finnish National Fair. Upon graduation, Aalto went to Stockholm, hoping to enter the office of Erik Gunnar Asplund.* Instead, he worked for Arvid Bjerke, helping to design the Congress Hall for the Gothenburg World's Fair of 1923. And in Finland his earliest independent essays were also exhibition buildings, for the 1922 Industrial Exhibition at Tampere.

Aalto returned to Jyvaskyla in 1923 and set up practice, and for the next five years he had a number of domestic, ecclesiastical, and other commissions with his new wife and partner Aino. They spent their honeymoon in Greece and Italy where the ideas of Aalto's teachers were reinforced: "the classical spirit of the Mediterranean" helped provide "the foundation for their first entry into the realm" of a classical environment being nurtured as a symbol of the new Finland.[1] Their sparsely decorated early work was "exemplary of the classicism found throughout Scandinavia during the 1920s [and] influenced by contemporary Nordic practitioners" like Asplund and Ragnar Östberg.[2] Notable among the works of this phase were the neo-Palladian Workers' Club (1924–1925) in Jyvaskyla and the "deftly refined and detailed" Civil Guards Complex (1927) at Seinajoki. Many biographers make much of the Finnish "habit" of conducting architectural competitions; Aalto entered several between 1925 and 1927, with indifferent results. Success came in 1927. When he won a competition for the South-western Agricultural Cooperative Building in Turku, the firm moved to the coastal city.

There were other reasons for the change. Turku was a metropolis, more sophisticated than Jyvaskyla; its social and cultural milieu would open new vistas for Aalto. It was also traditionally and geographically close to Sweden, which allowed him to widen his professional circle. The Turku years (1927–1933) were critical in the growth of his reputation as he designed the buildings that attracted international interest. The austere classicism of the Agricultural Cooperative evolved into his assimilation of the formal aesthetic and the social and architectural theories of Modernism, including those of Le Corbusier.* Turku was his base from which to travel, making contact with his European peers: Asplund, Sven Markelius, Walter Gropius,* Laszlo Moholy-Nagy, André Lurcat, members of De Stijl,* Johannes Duiker, and the Russian Constructivists. His gregarious personality eventually drew other international artists—Jean Arp, Constantin Brancusi, Fernand Leger, and Jean Sibelius—into his circle of friendship. In 1929 he attended the second meeting of the Congrès Internationaux d'Architecture Moderne* (CIAM).

Under these diverse avant-garde influences and through his friendship with

the older architect Erik Bryggmann, Aalto (briefly) became a vocal champion of Modernism—"functionalism"—in Finland. Changes in his architecture were soon seen: the Standard Apartment Block (1929) and the *Turun Sanomat* Newspaper Building (1928–1930), both in Turku; and especially the Paimio Tuberculosis Sanatorium (1929–1933) are among the best examples. Because his Viipuri Library was under construction near Helsinki (and because he thought there would be more work there), Aalto moved to Helsinki in 1933, but the city yielded no commissions for twenty years. With the library he began to develop a more personal modern style.

Aalto won the 1927 Viipuri Library competition with a proposed and then popular Nordic neoclassical style. By the time construction commenced in 1933, his design had evolved to thoroughly modern plans: open spaces, bulky interlocking blocks à la Corbusier, and interiors filled with light. When it was completed in 1935, it revealed an architect of great competence. Sadly, Viipuri has been in the Soviet Union (now Russia) since their 1939–1940 war, and the library has suffered damage, ugly repairs, and so much neglect that it is falling apart. In 1993 the Finns vowed to finance restoration.[3]

During the economic depression of the early 1930s, architectural work was scarce. The Aaltos sustained themselves with furniture production. In partnership with Otto Korhonen, Aalto had begun experimenting with plywood (1929), producing "modest but brilliant" furniture designs. The Wohnhedarf Furniture Company began production two years later. Following a 1933 London exhibition (organized by the critic P. Morton Shand), the Finmar Company was formed to capture the British market. Aalto and his wife, sponsored by Finnish industrialists Harry and Mairea Gullichsen, opened the Artek furniture and interior design shop and gallery in Helsinki in 1935.

Furniture designs cross-pollinated Aalto's work; after 1933, it developed "romantic humanistic considerations." The rectilinear forms of International Modernism were supplanted by rougher textures, natural surfaces and colors (first revealed in the ceiling of the Viipuri Library lecture hall), exposed curvilinear elements, and "playful spatial arrangements" in buildings full of "picturesque and romantic imagery and composition." Such changes, leading to Aalto's mature style, are seen in his own house (1934–1936) in Munkkiniemi, the Finnish Pavilions for the 1937 and 1939 World's Fairs in Paris and New York, respectively, and the Villa Mairea (1938–1939) at Noormarkku for the Gullichsens.

Beyond their patronage and collaboration in Artek, the Gullichsens introduced Aalto into industrialist circles, ensuring several large commissions, including the Sunila Pulp Mill (1934–1935) and its Workers' Village, which he augmented over the next twenty years (see Plate 19). Sunila and similar complexes (Inkeroinen, Kauttua, Vaasa, Kerhula, Varkhaus), some of which continued through the war years, were Aalto's introduction to planning and urban design.

In mid-1938 Aalto visited the United States for several reasons: a retrospective exhibition of his work was opening at New York's Museum of Modern Art; he wanted to see the World's Fair site; and, most significant, he was seeking

opportunities to move his family and practice to America. He accepted a teaching post at MIT and took up the appointment late in 1940. For political reasons his stay was short. The Russo-Finnish war (1939–1940) and the greater conflict that was raging through Europe raised in Aalto's mind issues of postwar reconstruction. He focused upon that in his research, designs, and writings, believing that Finland could provide a model for the reconstruction of war damaged Europe. His ideas were realized when nationwide rebuilding and urban planning were called for after 1945; all were designed by an office under Aalto's supervision. Thus his oeuvre of the period, apart from work for the Gullichsen-controlled Ahlstrom Company, included many city and regional plans, culminating in his design for the Arctic Circle city of Rovaniemi (1944–1945). Aalto eventually took up a three-year professorship at MIT (1946–1948), during which he designed the Baker House Dormitory (1949), considered by some to be an indicator of his postwar development.

Aino Aalto died of cancer in January 1949 when their practice was very productive. In 1953 Alvar brought his second wife, architect Elissa Makiniemi, into the partnership. Between 1945 and 1960, he produced his most important work. Accepted as his mature style, and probably the most "Finnish" in quality, it was achieved by using natural timber, red brick, and copper. Exemplary works include the Saynatsalo Town Hall (1950–1952), the Public Pensions Building (1952–1956), Rautatalo Office Building (1953–1955), and the House of Culture (1955–1958), all in Helsinki; and the Technical Institute in Otaniemi (1956–1964). According to William Miller,

The picturesque volumetric massing of these buildings, their responsiveness to landscape and site . . . the juxtaposition of materials and textural effects, the rich vocabulary of forms developed to manipulate natural light, and the concern for the smallest detail . . . demonstrate Aalto's maturity. In these works the themes that emerged in the late 1930s matured and solidified, achieving a calm, self-assured realization.[4]

The last two decades of Aalto's career saw the wheel turn full circle. His buildings again expressed the hybridized classical and romantic tendencies of his first work. After 1966 he took less interest in design and detail. His buildings became more austere, but even Helsinki's cultural center Finlandia House (1962–1975), monumental though it is, does not lack humanness.

His contribution was great. Abercrombie observes that his "personal inclinations" and poetic "complexities" separated Aalto from the "mainstream of the modern movement," but the "touches of thoughtfulness and grace" raised his work "above the mainstream of the architecture of any period".[5] In 1963 he was awarded the A.I.A. Gold Medal for "all that he [had] contributed in developing the strong foundations and eloquent philosophy of contemporary architecture and in richly endowing its vocabulary of design with his own warm humanism, ready wit and perceptive use of materials, texture and color."[6]

NOTES

1. Pearson in Macmillan.
2. Miller in Wilkes.
3. Judith Hull, "The Future of Aalto's Vüpuré Library is Now," Society of Architectural Historian's *Newsletter* 39 (August 1995), 2–3.
4. Miller in Wilkes, .
5. Abercrombie in *Contemporary Architects.*
6. Cited in Richard Guy Wilson, *The A.I.A. Gold Medal* (New York, 1984), 198.

BIBLIOGRAPHY

Literature about Aalto continues to proliferate. The abbreviation AA for Alvar Aalto is used below.

Writings

"Designing Today's Furniture." *Interiors* 100 (June 1941).
An Experimental Town. MIT Press, 1940.
"Fine della 'machine a habiter'." *Metron,* Rome (February 1946).
"The Humanising of Architecture." *Technology Review,* MIT (November 1940).
"L'Oeuf de poisson et la saumon." *Werk* 36 (February 1949). English: *ADesign* 49 (December 1979).
Post-War Reconstruction: Rehousing Research in Finland. New York, ca. 1941.
"The RIBA Annual Discourse." *RIBAJ* 64 (May 1957).
"Rovaniemi, a Finnish Reconstruction Project." *Architects' Yearbook* 2 (1947).

Biographical

Schildt, Goran. *AA: The Early Years.* New York, 1984.
———. *AA: The Decisive Years.* New York, 1986.
———. *AA: The Mature Years.* New York, 1991.
Winkler, Oszkar. *AA.* Budapest, 1982.

Assessment

Aalto, Elissa. *AA Furniture.* Helsinki/MITPress, 1985.
Abercrombie, Stanley. In *Contemporary Architects.*
Angeli, Marc M. "Construction deconstructed." *JAE* 40 (Spring 1987).
Baird, G. *AA.* London, 1970.
Baruel, Jean-Jacques. "Venne AA nogle fleve rids." *Arkitekten* (Stockholm) 91 (22, 1989).
Blundell Jones, Peter. "From the Neo-classical Axis to Aperspective Space." *AReview* 183 (March 1988).
Buchanan, Peter. "Aalto Opera Essen." *AReview* 185 (June 1989).
Capitel, Anton. "Forma ilusoria e inspiracion figurativa . . . AA." *Arquitectura* (Madrid) 73 (March 1992).
Davey, Peter, et al. "Finlandia Finland." *Arquitectura Viva* (Madrid) (May–June 1993). The issue.
Finn, Nils C. "The Workers' Club of 1924 by AA." *Perspecta* 27 (1992).
Fleig, Carl, ed. *AA.* 3 vol. Zurich, 1963, 1971, 1978.
———. *AA. Works and Projects.* Barcelona, 1989.
Hewitt, Mark A. "The Imaginary Mountain . . . AA's sketches." *Perspecta* 25 (1989).
McLaren, Brian L. "Other Place(s): . . . 'Place' in the Work of AA and Terragni." *Reflections* (Spring 1990).

Miller, William C. In Wilkes.

————. "Scandinavian Architecture during the Late 1930s: Asplund and AA vs Functionalism." *Reflections* (Spring 1990).

Mosso, L. "La luce nell'architettura di AA." *Zodiac* (Milan) 7 (1962).

Neuenschwander, E. and C. *AA and Finnish Architecture.* London, 1954.

Pallasmaa, Juhani. "From Metaphorical to Ecological Functionalism." *AReview* 192 (June 1993).

Pearson, Paul D. In Macmillan.

Porphyros, Demetri. *Sources of Modern Eclecticism: Studies on AA.* London/New York 1982.

Quantrill, Malcolm. *AA. A Critical Study.* London, 1983.

————. "Lateral-mindedness versus Literal-mindedness in AA's Uses of History." *a + u* 222 (March 1989).

Rautsi, Jussi. "AA's Urban Plans 1940–1970." Department of Architecture, Tampere University of Technology Occasional Papers, 13 (1988).

Roldan, José Miguel, et al. "Sinergia synergism." *Quaderns* (Barcelona) 200 (May-June 1993).

Santini, P. C., and Goran Schildt. "AA from Sunila to Imatra." *Zodiac* (Milan) 3 (1958).

Schildt, Goran, comp. *AA: The Complete Catalogue.* New York, 1995.

Schildt, Goran, and Joakim Hansson. "L'architettura industriale di . . . AA." *Casabella* 53 (March 1989).

Spens, Michael. *The Viipuri Library by AA (1927–34).* London, 1994.

Tuukkanen, Pirkko, ed. *AA. Points of Contact.* Helsinki, 1994.

Warke, Val K. "The Plight of the Object." *Cornell Journal of Architecture* (Fall 1987).

Weston, Richard. *Town Hall, Saynatsalo.* London, 1993.

————. *Villa Maria, Noormarkku.* London, 1993.

Wilson, Colin St. J. "AA and the State of Modernism." *International Architect* (London) 11, 2 (1979).

Wilson, Richard G. *The A.I.A. Gold Medal.* New York, 1984.

Wood, J., ed. "AA 1957." *Architects Yearbook* 8 (1957).

Wrede, Stuart, and Michael Rubinstein. "On Aalto." *PA* 58 (April 1977).

Bibliographical

Beal, P. "Outside Scandinavia: A Short Checklist of Non-Scandinavian Writings about AA." *AAAB* 5 (1968).

Eytan, Omri. "Hugo Alvar Henryk Aalto: A Bibliography." *Affiche* (Maryland) (June-July 1980).

Miller, William. *AA: An Annotated Bibliography.* New York 1984.

Vance: Dale Casper, A1974, 1988; Coppa and Avery Consultants, A172, 1980; Richard Schmidt, A1626, 1986.

Archival

Schildt, Goran. *The Architectural Drawings of AA 1917–1939.* 11 vol. Helsinki/New York/London 1987.

Schildt, Goran, ed. *Sketches AA.* London, 1978.

TADAO ANDO. 1941 (Osaka, Japan)–. Extended travels about Japan, to Europe (where he paid particular attention to the work of Le Corbusier*), around

Northern Africa where he—as Le Corbusier—was drawn to the simplicity of its architecture, and North America (1965–1969), were a pilgrimage that prepared Ando to be a self-taught designer and architect, a unique distinction in this day of closed, state-controlled professional societies. Yet his talent transcends those mundane influences. With no previous professional experience, in 1969 Ando began an architectural practice in Osaka that now encompasses the world. He has held visiting teaching positions in the United States (1980s) and received numerous prizes, awards, and honors including the Gold Medal of the French Academy of Architecture, the Alvar Aalto* Medal of the Finnish Academy, and the 1995 Pritzker Prize.

Sensitive to Japanese cultural and physical nurturing, like so many of his generation Ando came to question the applicability of the internationalist's modernism to local sensibilities. He sought an introspective and internalized architecture that would combat what he perceived as a sensually provocative and physically dense urbanized world. "What I refer to as an enclosed Modern Architecture is a restoration of the unity between house [a building] and nature."[1] He achieves that connection by employing simple comprehensible forms (most usually a cube as highlighted in his Rokko housing 1983), by a layering of walls filtering direct contact with external conditions (disturbing or natural) as transitions to internal places, and by shunning decoration. His aesthetic is a bare simplicity that acknowledges the complexities of nature. Perhaps inversely, commentator Botond Bognar sees Ando as setting "nature against the too often banal and frivolous contemporary mass culture and the megalopolis."[2]

Ando has described a unique attitude to architecture and developed a reductive style quite his own. This is most evident in the Koshino house in Ashiya (1981), a home that rests in a grass-covered dish as if cradled by the earth. Protective parallel walls compose one rectangular box that is for entertaining; another is for privacy and sleeping. Changing light with the apparent movement of the sun bathes walls while other walls are dark, set in high contrast to exterior views. The house is spiritually and architectonically typical of his houses of the period. These include the Azuma (1976) and Hirabayashi houses (1976). All are constructed in concrete, and beginning in 1978 he included glass block walls for privacy while allowing natural light. With the Tezukayama and Matsumoto houses (1977), trabeation begins to influence his work, for the latter two concrete post-and-beam systems are complexly juxtaposed.

For his Museum of Literature, in Himeji (1988–1991), two transitions are evident: one gently from natural earth to built-up earthen forms to the building; the other a buffer of walls. The museum is essentially two squares in plan and of post-and-beam construction, carrying forth from the Tezukayama house schemata, each square divided into nine equal parts that intersect at an obtuse angle with a hemicycle about one square (see Plate 50). Typically the basic construction material is concrete. Internally, the geometry diminishes in emphasis but

remains obvious. The building epitomizes other essential aspects of Ando's skill: a refinement of proportion (and here there is a comparison with Mario Botta's* work), a rationality mixed with whim (but one senses the execution is done without haste), and a monochrome presentation internally and externally. These aspects can be summed by the qualitative word "restraint," something that eludes his Japanese contemporaries and most elsewhere in today's architectural world. (A cautionary note: one senses that to Ando the word "minimalist" would be profane.)

The Chapel on Mt. Rokko (1986), one of a few Christian church commissions, is a classical example of Ando's approach to architecture. From a hotel garden area, a narrow processional walk covered with an opaque segmental arch roof descends with the earth's natural slope to a formal entry. A tiny space within is focused lengthwise with daylight from above bathing plane walls except one to the left. It is a dark surround to daylight from a window that looks out on a semienclosed naturalesque garden.[3] It is a serene place.

The museum in Himeji is situated partly within the earth and so too is Ando's Chikatsu-Asuka Historic Museum, in Osaka (1991–1994). With 2,000 burial mounds and four imperial tombs, the site is an area important to the beginning of Japanese history. Ando placed perhaps 100 processional steps rising up a natural slope before reaching a high but small plaza and outlook. Underneath, the exhibition rooms are enclosed by a series of walls and the stepped earth above. To quote Ando: "Inside . . . darkness spreads. The unearthed objects are exhibited in the same way as they were found. . . . People therefore experience the sensation of entering a kofun," a journey "to the underworld of ancient times. This is a place where the Japanese could encounter their own history; it is a 'tumulus' [kofun] . . . dedicated to the Japanese love of nature."[4] Ando has obliquely suggested, says Cheryl Kent, an "impatience with the particularities of religion, but he is entirely sympathetic to the larger, overarching principle of spirituality. It is the foundation" of all his designs.[5]

Similar links are emphasized in Ando's Buddhist Lotus Temple in Awaji Island (1991) which Bognar believes "expands reality's horizon by encompassing the worlds of emotions and the ephemeral."[6] The building is cut into slightly sloping ground, and one enters from high ground by descending through a large oval dish of water with floating lotuses. A straight and a curved concrete wall lead indirectly and "by gradual disclosure" to the entry stair and water basin. Below is a spare space naturally illuminated by two side windows. The sanctuary complex is painted in traditional vermilion; color seems to saturate the air.

Comparison is always valuable. For example, Ando's Seminar House for Vitra at Weil near Basel (1990–1993) is monochromatic, elegant, mature with "studious control." It rests in refined contrast when compared with Frank O. Gehry's* Vitra Museum (just next door): a fussy, jagged, inelegant silent scream for attention that is also monochromatic. And the Natsukawa Memorial Hall in Hikone (1987–1989) may appear at first glance another box but the experience of entry and procession, the sense of scale and refinement make it special.

"There is something that touches me deeply about Tadao's architecture."[7] Those words of Renzo Piano would satisfy most of those who have experienced an Ando building.

Modernism after 2000 will be best served by a study of Ando's architecture, not only the architectonic forms he uses but their foundation in a plain, holistic philosophy. Surely here is a basis for restoration, for an architecture in a new age of humanism.[8]

NOTES

1. Ando (1982), 9.
2. Bognar (September 1992), 73.
3. Cf. *ARecord* (1978).
4. As quoted in Bognar (1992), 57.
5. Kent (June 1993) 114.
6. Bognar (1988), 14–15.
7. As quoted in Renzo Piano, "Architecture and Poetry," *JapanA* 1 (1991), 95.

8. See Jackie Kestenbaum, ed., *Emerging Japanese Architects of the 1990s* (New York, 1991), where Ando's ideas are noticed, so too are Isozaki's and the forms of, of all people, the Englishman Nigel Coates.

BIBLIOGRAPHY

Writings

"Bansho Residence." *JapanA* 52 (June 1977).
"Description of My Works." *SpaceD* (June 1981).
"The Emotionally Made Architectural Spaces of . . ." *JapanA* 55 (April 1980).
Frampton, Kenneth, ed. *Tadao Ando. Buildings Projects Writings.* New York, 1984; Barcelona, 1985.
"From Self-Enclosed Modern Architecture toward Universality." *JapanA* 37 (May 1982).
"I house." *ADesign* 61 (1/2 1991).
Intercepting Light. Tokyo, 1985.
"Konan University Student Circle." *GADoc* 3 (1992).
"Steps Upward through Light." *JapanA* 55 (July 1980).
"Tadao Ando." *GADoc* 35 (1992).
Tadao Ando—Minimalisme. Paris, 1985.
"The Wall as Territorial Delineation." *Perspecta* 25 (1989).
"Wombless Insemination." *JapanA* 61 (March 1986).
Wrede, Stuart, ed. *Tadao Ando.* New York, 1990.
With others. *The Yale Studio and Current Works.* New York, 1989.

Assessment

Abitare. "Children's Museum." 302 (December 1991).
Akasaka, Y. "From confrontation to liberation." *JapanA* 60 (October 1985).
Architettura. "Order in a Dark Wood." 39 (September 1933).
ARecord. "An Exchange of Vows." 175 (February 1987).
AReview. "The Forest of Tombs." 142 (April 1993).
Aujourd'hui. "Tadao Ando." 255 (February 1988). The whole issue.

Bertrand, Pascal. *Tadao Ando das Haus Koshino.* Tübingen, 1990.

Bognar, Botond. "Between Reality and Fiction." *ADesign* 99 (September–October 1992).

———. *Contemporary Japanese Architecture.* New York, 1985.

———. "Critical Intentions." 62 (March—April 1992).

———. "Latest work of . . ." *AReview* 172 (November 1982).

———. *The New Japanese Architecture.* New York, 1990.

Bognar, Botond, ed. "Japanese Architecture." *ADesign* 58 (May–June 1988).

Croquis. Tadao Ando 1989–1992. 58 (1993).

Dal Co, Francesco. *Tadao Ando: Complete Works.* London, 1995.

Dawson, L. "Studious Control." *AReview* 194 (August 1993).

Dixon, J. M. "Urban Inlay." *PA* 72 (February 1991).

Frampton, Kenneth. *Tadao Ando.* New York, 1991.

Furuyama, Masao. *Tadao Ando.* London, 1993.

Futagawa, Yukio, ed. *GA Details.* Tokyo, 1991.

———. "Glassblock." *GAHouses* 6 (1979).

———. "Koshino Residence." 14 (July 1983).

GA Architect. *Tadao Ando.* Tokyo, 1988.

GADoc. "Fabrica: Benetton Art School." 36 (1993).

Institute for Architecture and Urban Studies. *A New Wave of Japanese Architecture.* Catalog no. 10. New York, 1978.

Irace, F. "Kyoto: Two Additions." *Abitare* 305 (March 1992).

JapanA. "Museum in Kumamoto, Forest of Tombs." 10 (Summer 1993).

———. "Otemae Art Center." 132 (Spring 1994).

———. "Rokko Housing II." 13 (Spring 1994).

———. "Special Feature: Tadao Ando." 37 (May 1982).

———. "Tadao Ando." 1 (1991). The whole issue.

———. "Tadao Ando: Four recent works." 61 (October 1986).

———. "Water Temple." 9 (Summer 1993).

Kenchiku Bunka. "Four Recent Works." (Tokyo) 479 (September 1986).

———. "Y House." (Tokyo) 30 (September 1975).

Kent, Cheryl. "Enlightenment Below." *PA* 74 (June 1993).

———. "A Talk with Ando." *PA* 74 (June 1993).

Kestenbaum, J. E. "A Series of Planes." *AIAJ* 73 (September 1984).

MacNair, A. "The Post Metabolists." *Arquitectura* (Madrid) 216 (January 1979).

Miyake, R. "Water Temple" *Domus* 742 (October 1992).

Morita, K., and A. Pelissier. "Entretien avec Tadao Ando." *Techniques* 34 (December 1982).

Musée National d'Art Moderne. *Tadao Ando.* Paris, 1993.

Nitschke, Gunther. *From Shinto to Ando. Studies in Architectural Anthropology in Japan.* Berlin, 1993.

———. "Tadao Ando." *ADesign* 64 (January 1994).

Okumura, T. "Interview with." *Ritual* (Princeton) 1 (1983).

Pease, V. "Children in a Landscape." *AReview* 189 (August 1991).

Salat, Serge, and Françoise Labbe. *Ando by Ando.* Bordeaux, 1988.

Slessor, C. "Pearl of the Orient." *AReview* 190 (June 1992).

SpaceD. "Special Feature: Tadao Ando." 201 (June 1981).

Takeyama, Kiyoshi. "Tadao Ando." *Perspecta* 20 (1983).

Watanabe, Hiroshi, in *Contemporary Architects.*
Zardini, Misrko. *Tadao Ando. Rokko Housing.* Milan, 1986.

Bibliographical

Vance: Daniel Hodge, A2202, 1989; and Sylvia DeOlmos, A2210, 1989.

Archival

Blaser, Werner, ed. *Tadao Ando Sketches.* Berlin, 1990.
Fields, Darell W. *Tadao Ando: Dormant Lines.* New York, 1991.

ARCHIGRAM. Established in 1961, Archigram was an ephemeral collaborative of radical British architects, a " 'multi-colored umbrella held by sleight of hand' and united by common interests and antipathies.'' Its initiators were Peter Cook,* Michael Webb, and David Greene, all AA graduates about twenty-five years of age. They were soon joined by Dennis Crompton, twenty-six; Ron Herron,* thirty-one; and Warren Chalk, thirty-four. Their cooperation was primarily based on a polemical annual magazine, *Archigram.* After 1970 they more or less dispersed. Greene and Herron (temporarily) left Britain to become teachers in the United States. Crompton, Cook, and Herron then formed Archigram Architects (1970–1974). Herron and Cook finally established independent practices, in various partnerships, which continue. Crompton maintains strong links with the AA, where he is responsible for communications and publishing. Greene turned to writing poetry and practicing architecture, mainly in Dorset, England. Webb moved permanently to America and since 1975 has taught at Cornell and Columbia Universities in New York. Chalk continued writing and teaching in the United States and England, mostly at the AA, until his death in 1987.

✌

The "coalescence" of Archigram, writes Philip Drew, took place through "chance encounters and purposeful introductions."[1] In the immediately "preArchigram" years, some of its potential members met as part of a larger group to "prop one another up against the boredom of working in London architectural offices." When it became obvious that there was a widely diverse outlook within that group, "protoArchigram"—Cook, Webb, and Greene—took another direction in 1961 to produce *Archigram I.* Soon after, the others were invited to collaborate on later publications. Cook and Greene were then working as detail-producing assistants in private practices. The others were employed in the huge architects' office of the London County Council, where Chalk at least was designing, mostly schools. He and Herron began to collaborate on private commissions, designing offices in London and in provincial towns for British Empire Airways (1960–1961). Their most notable building was the South Bank Arts Centre in London (with Webb and Crompton, 1960–1962).

Influences were many. All the initiators had been students at the AA where they had been taught by Peter Smithson* (1955–1960) about democratic principles applied to architecture. James Gowan* also taught at the AA at about that

time (1958–1960). The non-AA graduates willingly absorbed those ideas secondhand. Archigram's creations are clear evidence of the technological impact of R. Buckminster Fuller,* whom they admittedly heroized. From Fuller's British disciple Cedric Price, they learned design logic and flare. Those influences were linked, as Kenneth Frampton points out.[2]

A significant influence—rather an exchange of ideas—came from Japan where Metabolism* gained momentum in the late 1950s. Its "formal" birth in 1960 and its decline at the end of the decade make it the exact contemporary of Archigram. Their impetus may have been different, but their respective solutions to perceived problems were congruous. Arata Isozaki* became aware of the cultural and social importance of the "underground magazine called *Archigram*" in the mid-1960s. He valued its work above all other contemporary efforts to "dismantle the apparatus of Modern Architecture" because it was "consistently counter-cultural in character" whereas the Metabolists, for example, "lacked this perspective on the necessity of discovering counter-cultural values."[3]

What was this powerful publication? First appearing in 1961, *Archigram* went to ten annual issues numbered 1 to 9½. Not so much a journal as a propagandizing broadsheet-manifesto, it preached what someone has described as "aesthetic technocratic idealism."[4] It took and passed to the group a name that combined "architecture" and "telegram" or "aerogramme"—an urgent message about architecture. Believed by some to be the key architectural journal of the decade, it demonstrated by its pop, often comicbook-like format and layout that the group embraced "the optimism and possibilities of technology and the counter-culture of the pop generation." Its target was the smugness of the London architectural profession which had become entangled in modernist orthodoxy. "We have chosen," wrote Greene, "to bypass the decaying Bauhaus image which is an insult to functionalism."[5] *Archigram* also corrected a major lack in the British architectural press by publishing student work. The 1964 issue, following a controversial "Living City" exhibition at London's Institute of Contemporary Arts in 1963, attracted the critic Reyner Banham who became the group's champion.

The collaborative Living City was followed in 1964 by Chalk's *Capsule Homes,* Cook's *Plug-in City* (1964–1966), and Herron's Walking City. Greene designed his Living Pod in 1965, and the group published its Instant City in 1968 (see Plate 30). The titles are eloquent: Archigram's direction was urban, technological, autocratic—and, it might be suggested, inhumane. Critic Peter Blake has defended them against that accusation: "I cannot think of a more humanistic language than the language of poetry; and whether they like it or not, the Archigram gang is a gang of wild-eyed poets."[6]

Cook believed that Archigram's ideas were of little value as long as the concept of the city to which they were to be applied remained static. Permeating all was the belief that technology was the sole source of hope; traditional ways and means of making houses and cities must be superseded. Although emphases

evolved throughout the group's brief history—and that also exposes its ethos—
the key words in its agenda were change, adaptability, flexibility, meta-
morphosis, impermanence, ephemerality. In some ways and perhaps for similar
reasons, Archigram echoed the ideas of Antonio Sant'Elia and Filippo Marinetti;
yet unlike the Futurists,* they saw the means already at hand: *existing* technol-
ogies could facilitate their program: Cook spoke of Archigram as part of the
British continuum of structural innovation.[7] And unlike the Futurists, Archigram
had no manifesto: " 'Theoric propositions'? You . . . must be joking!" ex-
claimed Banham. "Archigram is short on theory, long on draughtsmanship and
craftsmanship. They're in the image business and they have been blessed with
the power to create some of the most compelling images of our time."[8]

Like many significant architectural movements before and since, Archigram
wrote a lot, drew more, but built little. After 1966 their thinking, and the projects
it generated, became increasingly detached from the tradition (some might say,
reality) of architecture and life. Then in 1970 Cook won an international closed
competition to design and build an entertainment center in Monte Carlo. With
Crompton and Herron, he formed Archigram Architects, but the proposal lost
its financial backing. Unable to survive upon projects, the firm was dismantled
in 1975.

Despite its purely theoretical output, Archigram's impact was significant and
international. Other architects would give form to its notions; for example, we
cannot avoid linking the Centre Pompidou, in Paris, by Renzo Piano* and Rich-
ard Rogers* or Isozaki's buildings at the 1970 Osaka World's Fair with the
fantastic schemes generated on Archigram's drawing boards. Hans Hollein,* too,
admits a debt to them. But it is in the realm of ideas that they were most
important. As Charles Jencks says, their major contribution was "to open up
and develop new attitudes towards living in an advanced industrial civilization
where only stereotyped rejection had existed before, to dramatizing consumer
choice and communicating the pleasure inherent in manipulating sophisticated
technology." He adds that even if these strategies do not solve deeper socio-
political problems, they at least indicate "alternative routes for thinking about
consumer society and urbanism."[9]

A contemporary evaluation is perhaps more germane. Drew wrote around
1971 that

Archigram's accumulation of a large body of pattern material inspired by contemporary
experience provides an important source of patterns for use by designers seeking to make
the leap from programme to form. The fresher these patterns are, the greater their value
in terms of experience. Archigram's random pattern explorations are a valuable contri-
bution to third generation consciousness . . . Until design can be simplified to a purely
rational activity, the intuitive approach as exemplified by Archigram will remain an
essential feature of the creative process.[10]

And so it has.
See Cook, Herron.

NOTES

1. Drew (1972), 102.
2. Kenneth Frampton, *Modern Architecture: A Critical History* (London, 1992), 280.
3. Arata Isozaki in Cook (1991), n.p.
4. Dennis Sharp in Sharp (1991).
5. As quoted in Cook (1991), 8.
6. As quoted in Cook (1991), n.p.
7. Cook (1982).
8. As quoted in Cook (1991), n.p.
9. Charles Jencks, *Modern Movements in Architecture* (New York, 1985), 298.
10. Drew (1972), 102–3.

BIBLIOGRAPHY

Writings

Archigram. 10 issues (1–91/2), London (1961–1974).
Chalk, Warren. "Architecture as a Consumer Product." *Arena* (London) 81 (March 1966).
———. "Hardware of a New World." *AForum* 125 (October 1966).
———. "People, Robots, Trees." *ADesign* 42 (November 1972).
———. "Soundbites: Recalling Archigram." *Blueprint* (London) (March 1994).
———. "Up the Downramp." *ADesign* 38 (September 1968).
Chalk, Warren, and Ron Herron. "Things That Do Their Own Thing." *ADesign* 39 (July 1969).
Cook, Peter. *Archigram.* Special issue. London 1972. Reprint Basel/Boston/Berlin, 1991.
———. "Archigram: The Name and the Magazine." *Perspecta* 11 (1967).
———. "Beyond the Normal Limits of 20th-Century Architecture." *AAFiles* 7 (September 1984).
———. "El efecto Archigram." *Croquis* 8 (April–May 1989).
———. "In Memoriam Archigram." *Daidalos* (Guertersloh) (15 June 1982).
———. A letter . . . to Warren Chalk." *ADesign* 41 (February 1971).
———. "Mike Webb: The Story of the Spider." *AReview* 170 (July 1981).
———. "Some Forays by the Archigram Group into the World of Exhibitions." *AAQ* 1 (July 1969).
———. "Unbuilt England." *a + u* 83 (October 1977). The whole issue.
———. "Warren Chalk 1927–1987." *AAFiles* 15 (Summer 1987).
Crompton, Dennis, et al. *A Guide to Archigram 1961–74.* London, 1994.
Herron, Ron [The Archigram men]. *AJournal.* 142 (17 November 1965).
"The Living City." *Architects' Year Book* 11 (1965).
Webb, Michael. *Architecture in Britain Today.* London, 1969.

Assessment

ADesign. "Archigram 1970–71." 41 (August 1971).
———. "Leaves from the Silver Book." 35 (November 1965).
Banham, Reyner. "A Clip-on Architecture." *DesignQ* 63 (1965).
Derossi, Pietro. "Radical Recall." *Ottagono* 99 (June 1991).
Drew, Philip. *Third Generation. The Changing Meaning of Architecture.* London, 1972.

Dumont, Marie-Jeanne. "Shebam Pow Blop Wizz: Archigram a Beaubourg."
 Aujourd'hui 293 (June 1994).
Hogar y Arquitectura (Madrid) 72 (September–October 1967). The whole issue.
Jencks, Charles. *Modern Movements in Architecture.* New York, 1973; 2d ed., 1985.
———. "Pop-Non Pop." *AAQ* 1 (April 1969).
Kenchiku Bunka. "Warren Chalk and Ron Herron, English Architects." (Tokyo) (March
 1968).
Levi, Michel. "Warren Chalk: 1927–1987." *Aujourd'hui* 256 (April 1988).
Scott-Brown, Denise. "Little Magazines in Architecture and Urbanism." *Journal Amer-
 ican Institute of Planners* (Baltimore) (July 1968).
Sharp, Dennis, ed. *Illustrated Dictionary of Architects and Architecture.* London, 1991.
Thomsen, Christian W. "Archigram and Its Predecessors or Did We Really Live in a
 Yellow Submarine?" *a + u* (May 1994).
———. "Projects and Studies . . . The Automobile and Light and Perspective." *a + u.*
 (June 1991).

Bibliographical

Vance: Sara Richardson, A2230, 1989.

ERIK GUNNAR ASPLUND. 1885 (Stockholm, Sweden)–1940. Asplund studied architecture under the neoclassical regime at the Royal Institute of Technology, in Stockholm (1905–1909). After he was awarded the institute's Traveling Scholarship, he visited Germany (1910) before returning to set up, with six other students, the independent but short-lived Klara School of Architecture (1910–1911), where Carl Bergsten, Ivar Tengbom, Carl Westman, and Ragnar Östberg were invited to teach. In 1911 Asplund commenced private practice in Stockholm, which he continued until his death. He held teaching posts in architecture and ornamental art at the Royal Institute of Technology (1912–1913 and 1917–1918), and he became a professor of architecture (1931–1940). He was editor of the Stockholm journal *Arkitektur* (1917–1920). Between 1913 and 1939 he won many local architectural competitions. Asplund is acknowledged as a leader in the development of modern architecture in Sweden but his practice did not extend further. His work was exhibited in New York in 1978 and 1984.

<p style="text-align:center">↢</p>

Since the turn of the century, Scandinavian architecture had seen a melding of vernacular and traditional sources to generate a style best described as Romantic Nationalism. With local variations, it can be seen (for example) in the Finnish work of Alvar Aalto.* Its influence reached Asplund through the significant input of the architects who taught him at Klara (1910–1911), especially Östberg. Several of his smaller buildings and projects, from 1911 to 1914, characterized by "vernacular imagery" are evidence of that. But details of his early career are obscure. While at Klara he worked on domestic projects for I. G. Clason, a "progressive turned conservative"; in 1912 Asplund was employed by the Stockholm municipality, again on domestic designs. He entered several

competitions and won a few major prizes. His success included extensions to the Gothenburg Law Courts (1913), an attenuated, controversial project that led to a complete recasting as late as 1935.

After taking the grand tour in Europe (1913–1914) Asplund returned to enter a new phase of his career: "he had assimilated his Italian studies and combined them with his deep empathy for the Swedish countryside and tradition of small-town building in wood."[1] With Sigurd Lewerentz, in 1915, he won an international competition for Woodland Cemetery, in south Stockholm. Asplund's Chapel (1918–1919), successfully hybridizing romanticism and classicism, revealed his emerging personal style. Other examples include the serene Snellman house (1917–1918) in suburban Stockholm and the Lister County Courthouse (1917–1921). The courthouse embodied a simplified classicism—incidentally, a regional trend—which found its clearest expression in the Skandia Cinema (1922–1923) and the City Library (1924–1927), both in Stockholm. The designs were neither reactionary nor merely eclectic: far from that, Asplund was an innovator and experimenter, and these buildings, while "Swedish in the sweetness and delicacy of the details" were "modernistic in [the] use of simplified classical forms."[2] The library, in fact, marked Asplund's next turning point.

Of great significance to Swedish architecture were his buildings (now destroyed) for the Stockholm Exhibition of 1930. The complex, designed in its totality by Asplund, presented the country's first major essays in what would soon be named the International Style. Functionalism was in the ascendant, and Asplund "boldly but gracefully" seized it. He may thus be identified as the architect who introduced European modernism to Sweden. It was not welcomed by all designers, craftspersons, or the public, especially when the machine aesthetic was applied to artifacts such as furniture, whose form had hitherto been strongly traditional. In a manifesto, *Acceptera* (1931), Asplund, Sven Markelius, and others responded to the wide criticism of modernism. Although he had undergone a partial conversion, Asplund was "too great a creative individualist to become firmly bound by the joyless rigidity of the new movement."[3] He believed that "utility [is not] an end in itself, but merely as a means to increase choice and well-being for people. . . . Technology does not achieve this; what I would call art must also be an ingredient."[4]

Toward the end of the 1930s, there was a resurgence of contextualism and classicism in his work, reasserting Swedishness, as it were. That can be seen in his final designs for Gothenburg Law Courts (1935–1936), but it is best seen in "one of the truly compelling buildings of the 20th century,"[5] Asplund's last work the Forest Crematorium in Woodland Cemetery (1935–1940). It integrated the qualities of the landscape with functionalist, traditional, and classical architectural elements to produce what some regard as *the* icon of Swedish modern architecture. With the other "finishing touches," it completed the scheme begun in 1915, "one of the most seminal total landscapes of this century."[6]

One critic notes: "Asplund held the balance between strength and softness in his architecture with great skill. Exactly how skilful he was became evident

when some of his successors failed to keep the balance and went over the top in softness and sentimentality."[7]

NOTES

1. Bjorn Linn in Cruikshank (1988).
2. Hull in Macmillan.
3. De Mare in *Contemporary Architects.*
4. As quoted in Wrede (1980).
5. Miller in Wilkes.
6. Haag (1993).
7. Cruikshank (1988), 16.

BIBLIOGRAPHY

Writings

Arkitektur (Stockholm ed.), 1917–1920.
Articles in *Byggmasteren* (Stockholm) 1920–1940.
With others. *Acceptera.* Stockholm, 1931.

Biographical

Engfors, Christina, ed. *E. G. Asplund: Architect, Friend and Colleague.* Stockholm, 1990.
SpaceD. "Erik Gunnar Asplund." (October 1982). The whole issue.

Assessment

Anderson, Hendrik. *Nordic Classicism 1910–1930.* Helsinki, 1982.
AReview. "Asplund's Crematorium." 94 (September 1943).
Blundell Jones, Peter. "From the Neo-classical Axis to Aperspective Space." *AReview* 183 (March 1988).
Caldenby, Claes, and Olaf Hultin. *Asplund.* Stockholm/New York, 1985.
Capitel, Anton. "Forma ilusoria e inspiracion figurativa . . . Aalto [with notes . . . on Asplund]." *Arquitectura* (Madrid) 73 (March 1992).
Constant, Caroline. "Stockholm Public Library." *Arquitectura* (Madrid) 70 (September 1989).
Cruikshank, Dan. *Erik Gunnar Asplund.* London, 1988.
Engfors, Christina, ed. *Lectures and Briefings from the International Symposium . . . Asplund.* Stockholm, 1985.
Erik Gunnar Asplund: Mobili e Oggetti. Milan, 1985.
Holmdahl, Gustav, et al. *Gunnar Asplund Architect 1885–1940.* Stockholm, 1943, 1950, 1981.
Frampton, Kenneth, et al. *Asplund.* MIT, 1986.
Futagawa, Yukio, ed. *Woodland Chapel . . . Stockholm Public Library.* Tokyo, 1982.
Haag, Richard. "Woodland Cemetery." *Landscape Journal* (Madison) 12 (Fall 1993).
Hellquist, Thomas. "The Collapse of a Vision . . . Goteborg Town Square." *Lotus* 46 (1985).
Holmdahl, Gustav, et al., eds. *Gunnar Asplund Architect 1885–1940.* Stockholm, 1950; New York, 1981.
Hull, Judith S., in Macmillan.
Knight, Stuart, ed. "Swedish Grace: Modern Classicism in Stockholm." *International Architect* (London) 1, 8 (1982).

Lombardi, Giorgio. "Urban Space and the Contemporary City." *Ottagono* (Milan) (December 1989).

de Mare, Eric S. *Gunnar Asplund: A Great Modern Architect.* London, 1955.

―――. In *Contemporary Architects.*

Miller, William C. In Wilkes.

―――. "Scandinavian Architecture during the Late 1930s." *Reflections* (Urbana) (Spring 1990).

Ortelli, Luca. "Heading South: Asplund's Impressions." *Lotus* 68 (1991).

―――. "Three Projects by Erik Gunnar Asplund." *Lotus* 61 (1989).

Shand, Philip Morton. "E. Gunnar Asplund: A Tribute." *AReview* 89 (May 1941).

Treib, Marc. "Constructing Significance: . . . Sigurd Lewerentz and Gunnar Asplund." *Landscape Australia* (Mont Albert) 16 (February 1994).

―――. "A Reconciliation with History: Gunnar Asplund." *a + u* 247 (April 1991).

―――. "Woodland Cemetery: A Dialogue of Design and Meaning." *LandscapeA* 76 (March 1986).

Warke, Val K. "The Plight of the Object." *Cornell Journal of Architecture* (Fall 1987).

Wilson, Colin St. J. *Gunnar Asplund 1885–1940: The Dilemma of Classicism.* London, 1988.

Wrede, Stuart. *The Architecture of Erik Gunnar Asplund.* MIT Press, 1980.

―――. "Landscape and Architecture: The Work of Asplund." *Perspecta* 20 (1983).

Zevi, Bruno. *E. Gunnar Asplund.* Milan, 1948.

Bibliographical

Vance: Lamia Doumato, A2315, 1990; Robert Harmon, A304, 1980.

B

LUIS BARRAGÁN. 1902 (Guadalajara, Mexico)– . A son of cattle and equestrian ranchers and educated in Guadalajara, Barragán received a diploma in Civil Engineering in 1925. He is otherwise a self-taught landscape and building architect. He traveled in France and Spain (1924 and 1926) and again in France (1931–1932) where, when he was not on the beach at Côte d'Azur, he attended lectures by Le Corbusier* in Paris. Based near Mexico City, Barragán had collaborated with a number of architects before beginning a partnership of convenience with Raul Ferrera (1976–). Barragán received the prestigious Pritzker Prize in 1980, and was an honorary member of both the American Academy and the Institute of Arts and Letters (1984), and made a fellow of the AIA.

<center>❧</center>

Barragán has said: "All architecture which does not express serenity fails in its spiritual mission,"[1] that "Art is made by the alone for the alone."[2] He pridefully states that his own house is a "refuge, an emotional piece of architecture, not a cold piece of convenience. . . . [A]rchitecture should move by its beauty." He added that architects "should design gardens to be used, as much as the houses they build, to develop a sense of beauty and the taste and inclination toward the fine arts and other spiritual values."[3]

Like his contemporary Juan O'Gorman and most other Mexican architects in the 1930s, Barragán applied the architectural forms, if less the urgent philosophy, of Le Corbusier. And like O'Gorman, he dropped that Europeanism in favor of extracting concepts and inventions from the evidence of Mexican history and geography. O'Gorman lamented the attention given to European mod-

ernists rather than to the organic architectural ideas (if not the architectonic forms) of Frank Lloyd Wright* who had argued for an architecture of the Americas wrought from tradition, culture, and geographical place. Barragán wrestled with similar thoughts. "Mark you, I admire Le Corbusier's work enormously, but the concept of building machines for living belittles the human being as well as detracting from, belittling, architecture."[4] Barragán's designs made a marvelous transition to a minimalist, ascetic, suggestively monastic architecture composed of plane, space, color, and rectilinearity. It is an architecture that, since the 1950s, became very attractive to artists—architects—tired of alien steel and glass formulas antithetical to nature, to social place, to humanizing human environments. He preferred to be thought of as a landscape designer.

Those who have discovered Barragán's spare buildings and landscape architecture are persuaded by their introspective lyricism, a flowered architectural prose driven by poetry.

His work is

sumptuous in color and texture, in visual drama and stunning juxtapositions. It is composed with the purest of planes—either wall or water—with intersection walls of strong and stark proportions, and, above all, with a clear sense of the interaction and the union between building components and nature. . . . His most revered projects conjure up images of a roofless Barcelona pavilion [1929, Mies van der Rohe*] worked in adobe"[5]

in soft shades of pinks, magenta, violet, yellow. And reverence does seems to follow the man's image.

Resulting from an "almost redemptive commitment to beauty," each of his architectural creations is an "entity in itself, whose inner principles must be revealed. The procedure demands emotional sensibility and selective intuition . . . [he] deals only with the inner tensions of each element. This has led him to concise and profound creations."[6] The Egerstrom house (1967–1968) is considered to be the finest of those creations. A limited number of historically derived elements are rudimentarily reduced and held in restraint but nonetheless assembled with unerring sensitivity—textured and colored with landscape elements of stone, dirt, grass, and water in contrast. Yet it was but a grand refinement of themes proclaimed in his own house of 1947; he was consistent, deliberate.

Barragán created few works—especially in later years—and nearly all for socially elite clients. This did not harmfully infect his influence, even upon the post-1950 younger generation in all of the Americas, Japan, and sections of Europe where it was and is profound and determined. His following was due in no small measure to the release of a small number of visually wonderful photographs of his own selection; the most relevant, most inspiring, are colored. They would make no sense or receive no pleasure if the buildings and landscapes were anything but outstanding and obviously enriching the physical and cultural landscape. As architect and critic Emilio Ambasz has said with rather emotional force, in Mexico

the past is always present, and its architecture is charged with ancestral presences. Death is its central tragedy . . . Catholic resignation is the silent chorus, the core of its passion. . . . A stoical acceptance of solitude as man's fate permeates Barragán's work.

Barragán's solitude is cosmic; . . . he has created gardens where Man can make peace with himself . . . the garden is the myth of the Beginning and the chapel that of the End. For [him] House is the form Man gives to his life between both extremes."[7]

There is no similar architecture elsewhere, none so deeply committed to a fusion of tradition with notions of modern, verbal explanation unnecessary. In these qualities there is much between Barragán and Tadao Ando.*

NOTES

1. As quoted in Smith (1967), 54.
2. As quoted in Ambasz (1976), 108.
3. As quoted in Ambasz (1976), 8.
4. As quoted in Smith (1967), 74.
5. Smith (*Contemporary Architects*), 76. Observer Charles Jencks attempted to link Barragán, Paolo Soleri, John Hejduk, and Roland Coates, thereby revealing a misunderstanding of all four. Jencks, *Architecture Today* (London, 1993), 178.
6. Ambasz (1976), 107.
7. Ibid., 108.

BIBLIOGRAPHY

The abbreviation LB for Luis Barragán is used below.

Writings

"The Construction and Enjoyment of a Garden Accustoms People to Beauty." *Via* (Philadelphia) 1 (1968).
"Gardens for Environment—Jardines del Pedregal." *AIAJ* 17 (April 1952).

Biographical

Yamazaki, Y. "The Works and Background of LB." *a+u* 119 (August 1980).

Assessment

Abitare. "LB: Architecture of Emotion." (Milan) 186 (July 1980).
Alvarez Checa, José, and Manuel Guerra, eds. *LB Morfín 1902–1988.* Seville, 1991.
Ambasz, Emilio. *The Architecture of LB.* New York, 1976.
Ambasz, Emilio, and Yukio Futagawa. *LB.* Tokyo, 1979.
Anda Alanis, Enrique, ed. *LB Classico del Silencio.* Bogatá, 1989.
ARecord. "Recent Work of a Mexican Architect—LB." 77 (January 1935).
Bayón, Damián. "Luis Barragán y el Regreso a las Fuentes." *Plural* (Mexico City) 48 (September 1975). Also in *LandscapeA* 66 (November 1976).
Cetto, Max L. *Modern Architecture in Mexico.* Stuttgart, 1961.
Dean, A. O. "LB, Austere Architect of Silent Spaces." *Smithsonian* (Washington, D.C.) 11 (November 1980).
Fernández, A. "The Sweet Memory of Fountains." *a+u* 265 (October 1992).
Fortune. "Useless Towers of Mexico: Satellite City." 75 (February 1967).
Katzman, Israel. *La arquitectura contemporánea Mexicana precedentes y desarrollo.* Mexico City, 1964.

Kirby, Rosina G. *Mexican Landscape Architecture—From the Street and from Within.*
 Tucson, 1972.
Lobo, C. "LB." *Mirmar* 43 (June 1992).
Richter, N. "The Haunting Art of LB." *AIAJ* 69 (June 1980).
Saito, Yutaka, ed. *LB.* Tokyo, 1992.
Schjetnan Garduno, Mario. "LB: The Influential Lyricist of Mexican Culture."
 LandscapeA 72 (January 1982).
Smith, C. Ray. In *Contemporary Architects.*
Smith, Clive Bamford. *Builders in the Sun: Five Mexican Architects.* New York, 1967.

Bibliographical

Vance: Robert Harmon, A349, 1980; Florita Louis de Irizarry, A996, 1983; Dale Casper,
 A2019, 1988.

Archival

Armando Salas Portugal Photographs of the Architecture of LB. Mexico City, 1992.

PETER BEHRENS. 1868 (Hamburg, Germany)–1940. The illegitimate son of
a wealthy landowner, Peter Behrens studied, after an elementary education at
the Realgymnasium in Altona, at the School of Applied Art, in Hamburg, the
Karlsruhe Art School (1886), and then privately in artists' studios (until 1889).
He moved to Munich in 1889, where he became very active in its artistic milieu.
In 1899 he joined the artists' group Die Sieben (The Seven) in Darmstadt. A
self-taught architect, he began to design buildings including his own Darmstadt
house (1900–1901). He became director of the Nuremberg Master Course in
architecture (1902) and director of the School of Applied Art, in Düsseldorf
(1903–1907). Behrens established his Berlin architectural and industrial design
practice in 1907, which continued intermittently until his death. Among his
pupils were Le Corbusier * (for five months in 1910), Walter Gropius* (1908–
1910), and Ludwig Mies van der Rohe* (1908–1911). Behrens was director of
the Academy of Art, in Düsseldorf (1921–1922), professor of the Academy of
Fine Arts in Vienna (1922–1927), and head of the Department of Architecture
at the Prussian Academy of Arts, in Berlin (1936–1940). Between 1893 and
1922, his work—notably his industrial design—was exhibited in Germany, Italy,
Belgium, and the United States. Retrospective exhibitions have been held in
Germany since 1966.

<div align="center">✧</div>

"Behrens was an architect who combined modern functional design and the
use of modern materials and methods with a degree of eclecticism, but always
with an underlying classical and monumental determinism."[1] Arnold Whittick's
terse summation takes little account of the strong formative influence upon Beh-
rens of the arts and crafts movement. Orphaned at age fourteen, Behrens inher-
ited considerable wealth from his father. After some academic art training,
he studied painting under Ferdinand Butt in Düsseldorf and under Hugo Kot-
schenreiter in Munich. In 1890 he traveled in the Netherlands where he met
Jozef Israels, a leader of the Luminesten, who were exploring the effects of

light. Behrens' current work was along similar Impressionistic lines in technique and subject matter. One biographer remarks that his paintings of poor people and industrial landscapes anticipated "his engagement with the real industrial world later in life."[2] Be that as it may, after his first visit to Italy (1896), he turned to woodcut as a medium and produced Symbolist, Japanese-influenced works as a reaction against the painting schools of Impressionism and Realism.

After settling in Munich, Germany's principal center of artistic activity throughout the 1890s, Behrens energetically participated in its Secession group (1892), the Free Alliance of Munich Artists, and the United Studios for Art in Handcraft (1896). He also collaborated on the art journal *Pan* (1898). Throughout the decade he continued to produce paintings and woodcuts, but his applied art—glassware, pottery, silverware, and furniture—was the focus of his 1899 exhibitions held in Munich, Berlin, and Darmstadt, and it won him an appointment to the Darmstadt Kunstler-Kolonie under the patronage of Ernst Ludwig, the grand duke of Hesse.

The select group of invited artists included the painters Hans Christiansen and Paul Burck, sculptors Ludwig Habich and Rudolf Bosselt, and architects Joseph Olbrich and Patriz Huber. With Behrens making up Die Sieben, they set out to establish effective relationships between the plastic arts in their commune at Darmstadt. Declining Olbrich's services, Behrens insisted upon designing his own house in Darmstadt (1900–1901). He also designed its furniture, carpets, and glassware. Owing a little to the Scot C. R. Mackintosh and more to Henry van der Velde's Bloemenwerf at Uccle near Brussels (1895), it was, according to Stanford Anderson, an "honorable if not exceptional first work."

What is most remarkable and at the same time characteristic for Behrens is that the house, within the limits of domestic building, produces a microcosm of Behrens' cultural hierarchy: from the ordinariness of the kitchen to the ceremonial music room complete with its image of artists, priestesses, and repeated use of the motif of the crystal.[3]

During his short sojourn at Darmstadt he became, beside Olbrich, a dominant artistic influence. In January 1903, at the instigation of Hermann Muthesius, Behrens was appointed director of the School of Applied Arts in Düsseldorf. Believing them to represent the artistic vanguard in Holland and Vienna, respectively, he tried unsuccessfully to enlist the Dutchman Hendrik Berlage and the Austrians Josef Hoffmann* and Wassily Kandinsky for his faculty. In default he gathered around him young teachers familiar with recent developments surrounding his heroes and addressed in his courses the "internal issues" of architecture and the history of art.

Changes in his own architecture during the Düsseldorf years (1903–1907) resulted from two principal influences as his earlier acceptance of Nietzsche was superseded by the reading of art historian August Schmarsow and Viennese theoretician Alois Riegl. Behrens began to think of architecture as the art of defining space. Although he continued to believe in the virtuosity of the artist/architect, he also espoused the idea of the gestalt, the existence of a Zeitgeist

expressing the collective will. In all his design—book covers, furniture, interiors—he relinquished the Jugendstil forms of his Darmstadt days for severe abstract geometries based on cubes, cylinders, and framed rectangular planes. Those elements are also apparent in several buildings including the Schede house at Wetter an der Ruhe (1904–1905), the Obenauer house near Saarbrücken (1905–1906), a showroom at the Northwest German Art Exhibition at Oldenburg (1905), and the crematorium at Delstern (with E. R. Weiss, 1906–1907) whose form and siting is highly redolent of the Romanesque church of S. Miniato al Monte, in Florence (1018–1062).

In 1907, contemporary with the foundation of the Deutscher Werkbund, Behrens was invited to Berlin to become artistic advisor to the Allgemeine Elektrizitats-Gesellschaft (General Electric Company or AEG) in Berlin. That appointment was a pivotal point in the history of industrial design. Although Behrens's first commission was to design artistic shapes for arc lamps and all the firm's accessories, his general brief was ubiquitous: besides designing offices, factories, shops, and showrooms, he was also responsible for all sorts of electrical equipment—kettles, coffeepots, fans, clocks, radiators, and even dentists' drills—as well as the company's stationery, catalogs, packaging, and advertising leaflets and posters. One writer comments that the association marks the emergence, in the midst of industry, of a desire to humanize technology, explaining that

by employing an architect to ensure a good . . . appearance for their products, the AEG was bringing objects into daily life that were not only functionally efficient, but were harmoniously and sensitively designed as well, permeated as they were by an authentically creative style which . . . projected the brand image of an industrial power.[4]

Behrens's buildings for the AEG have been said to ''represent the first and perhaps the most successful attempt to enable the industrial process via the means at an artist's disposal, such as scale, sequence, proportion, rhythm, light, shade and the play of materials.''[5] Chief among them was his first major architectural work, the now famous Turbine Factory on Huttenstrasse, in Berlin (with engineer Karl Bernhard, 1909–1910), a building remarkable for its clarity and monumentality that has become universally associated with Behrens: '' 'frank industrial architecture' in which engineering principles, material conditions, and functional purpose have won out over traditional forms and elements.''[6] Other commissions in Berlin included the neo-Romanesque pavilion for the German Shipbuilding Exhibition (1908), the rather Berlagian High Tension Plant (1910), the Small Motor Factory on Voltastrasse (1910–1911), workers' apartments in Henningsdorf (1910–1911), and a large machine assembly hall, also on Voltastrasse (1912).

The years from 1910 to 1912 represent the ''most creative and fruitful period'' of Behrens' career. Apart from his work for the AEG, he designed two large neoclassical houses for the Hohenhagen garden suburb near Hagen, another

at Dahlem in Berlin, and the unrealized Kröller-Müller mansion, known as El-
lenwoude, near The Hague, Holland. He also built offices, a water tower, and
various industrial buildings for the Gasgesellschaft, in Frankfurt, and the German
embassy in Saint Petersburg, Russia. Without exception, these buildings and
projects show that he continued to work, albeit inventively, within the classical
tradition. So he did with such later works as the Festival Hall for the Deutscher
Werkbund Exhibition in Cologne (1914).

A leader in industrial design, Behrens was very much a follower in architec-
ture. His buildings after about 1915 reveal diverse and sometimes conflicting
influences. For example, the flat roofs of houses at Henningsdorf (1918–1920)
and the highly utilitarian Hannoversche Waggonfabrik aircraft hangar (1915)
show his debt to Adolf Loos* and emerging modernism, and the Werkbund
pavilion at Berne (1917) and an unexecuted design for terrace houses in Neusalz,
Silesia (1920) are clear evocations of Frank Lloyd Wright.* Second only to the
turbine factory, Behrens' most famous building was the offices of the Hoechst
Dyeworks near Frankfurt (1920–1924). The eclectic design drew upon history
but mostly upon recent Expressionist architecture: Hans Poelzig's* Chemical
Factory at Luban (1912) and the colors, materials, decoration, and texture of the
Amsterdam work of Michel de Klerk* and Piet Kramer are recognizable sources.
By complete contrast, Behrens designed New Ways, the cubic, white, boxlike
Basset-Lowke house in Northampton, England (1923–1925), and terrace houses
at the Weissenhofsiedlung, in Stuttgart (1926–1927), highly redolent of Willem
Dudok's* recently published designs for Hilversum town hall, derived in turn
from Wright.

Behrens' golden age had passed. The years from 1907 to 1912 saw his most
important contributions to modern architecture and design: first, his pioneer role
in healing the rift between art and industry (that mantle fell upon his pupil
Gropius); second, his influence upon Mies van der Rohe (to whom he be-
queathed his love for order and detail) and Le Corbusier, whom he infected
with enthusiasm for ordered industrial production—"a house is a machine for
living in." After 1933 Behrens tried, unsuccessfully, to ingratiate himself with
the Nazis. Their attacks upon artistic radicalism embraced him and although he
held respected academic and professional appointments, including working with
Albert Speer on the replanning of Berlin, through Nazi inquisition he was re-
duced to a persona non grata.

NOTES

1. Whittick in *Contemporary Architects.*
2. Windsor, *Peter Behrens, Architect and Designer* (1981), 5.
3. Anderson in Macmillan.
4. Robert L. Delevoy in Gerd Hatje, ed., *Encyclopedia of Modern Architecture* (Lon-
don, 1963).
5. Iain Boyd Whyte in Buddensieg and Rogge (1984), ix.
6. Anderson in Macmillan.

BIBLIOGRAPHY

Writings

"The Aesthetics of Industrial Buildings." *Scientific American Supplement* 76 (23 August 1913).

Behrens Schrift. Offenbach am Main, 1902.

Beziehungen der Kunstlerischen und Technischen Probleme. Berlin, 1917.

Eine Dokument Deutscher Kunst. Munich, 1901.

Feste des Lebens und der Kunst. Jena, 1900.

"A Letter from Austria." *Architecture* (London) 16 (July 1923).

"Seeking Aesthetic Worth in Industrial Buildings." *AmericanA* 128 (5 December 1925).

Terrassen am Hause. Stuttgart, 1927.

"Work of Josef Hoffmann." *AIAJ* 12 (October 1924).

With H. de Fries. *Das Ethos und die Unlagerung der Kunstlerische Probleme.* Darmstadt, 1920.

———. *Vom Sparsamen Bauen.* Berlin, 1918.

Biographical

Kadatz, H.-J. *Peter Behrens, Architekt, Maler, Grafiker und Formgestalter.* Leipzig, 1977.

Whittick, Arnold. In *Contemporary Architects.*

Windsor, Alan. *Peter Behrens: Architect and Designer 1868–1940.* London, 1981.

Assessment

ADesign. "Peter Behrens. Haus Behrens 1901." 50 (January 1980).

AForum. "Austrian State Tobacco Factory, Linz." 68 (March 1938).

AmericanA. "Administration Buildings for Industrial Plants." 128 (26 August 1925).

———. "A House in the Taunus near Frankfurt." 142 (August 1932).

Ammann, Gustav. "Nochmals Peter Behrens." *Werk* 27 (October 1940).

Ancheschi, G. "First Corporate Image." *Domus* 605 (April 1980).

Anderson, Stanford. "Behrens' Changing Concept." *ADesign* 39 (February 1969).

———. "German Neoclassicism and Biedermeier." *Assemblage* (MIT Press) 15 (August 1991).

———. "Modern Architecture and Industry: Peter Behrens and the Cultural Policy of Historical Determinism." *Oppositions* 11 (Winter 1977).

———. "Peter Behren's Highest Kultursymbol, the Theater." *Perspecta* 26 (1990).

———. In Macmillan.

Baroni, Daniele. "Peter Behrens: The Concrete Revolution." *Ottagono* (Milan) 89 (June 1988).

Berdini, Paolo, et al. "Malattia e salute di Peter Behrens." *Contraspazio* (Bari) 9 (July 1977).

Branchesi, Lida. *Peter Behrens.* Rome, 1965.

Brooklyn Museum Quarterly. "Exhibition of Architectural Projects." 17 (July 1930).

Buddensieg, Tilmann. "Il gaswerk di Peter Behrens." *Casabella* 46 (April 1982).

———. "Peter Behrens and the AEG Architecture." *Lotus* 12 (September 1976).

———. "Peter Behrens e la AEG dei Rathenau." *Casabella* 45 (April 1981).

Buddensieg, Tilmann, and Lothar Juckel. "Industriekultur exposition Peter Behrens et AEG (1907–1914)." *Aujourd'hui* 208 (April 1980).

Buddensieg, Tilmann, and Henning Rogge. *Industriekultur: Peter Behrens und die AEG 1907–1914.* Milan, 1978; Berlin, 1979; *Industriekultur: Peter Behrens and the AEG.* MIT Press, 1984.

Burke, C. "Peter Behrens and the German Letter." *Journal of Design History* (Oxford) 5 (1992).

Casabella 240 (June 1960). The whole issue.

Contraspazio. "Dissegni di Peter Behrens 1920–29." 2 (January 1970).

Cremers, Paul Joseph. *Peter Behrens: Sein Werk von 1909 bis zur Gegenwart.* Essen, 1928.

Filler, Martin. "Fantasms and Fragments." *Art in America* 71 (January 1983).

Gerber, W. *Nicht Gebaute Architektur. Peter Behrens . . . in Hagen.* Hagen, 1980.

Grimme, Karl Maria. *Peter Behrens und seine Wiener Akademische Meisterschule.* Vienna, 1930.

Hoeber, Fritz. *Die Kunst Peter Behrens.* Offenbach, 1909.

———. *Peter Behrens.* Munich, 1913.

Irace, Fulvio. "On the Conservation of Modern Architecture." *Domus* 649 (April 1984).

Koenig, Giovanni K. "Behrens e dintorni." *Casabella* 34 (April 1970).

Kolhoff, Hans, and Fritz Neumeyer. "Big-city Architecture." *a+u* 218 (November 1988).

Leeper, J. "Peter Behrens and the Theatre." *AReview* 144 (August 1968).

Leu, Olaf. "West German Design Today." *Print* 42 (March 1988).

Meggs, Philip B. "Peter Behrens: Design's Man of the Century?" *Print* 45 (March 1991).

Mislin, Miron. "Industriearchitekturgeschichte." *Deutsche Bauzeitung* (Stuttgart) 122 (June 1988).

Moeller, Gisela. "Das Streben nach Einfachheit." *Pantheon* (Munich) 48 (1990).

———. "Der fruhe Behrens." *Wallraf-Richartz-Jahrbuch* (Cologne) 44 (1983).

Negri, Chiara, and Raffaella Neri. "Behrens a Berlino." *Domus* 745 (January 1993).

Neumeyer, Fritz. "In de Schaduw van Zarathoestra." *Archis* (Doetinchem) (November 1991).

Norberg-Schulz, Christian. *Casa Behrens, Darmstadt.* Rome, 1980.

Obata, Hajime. "Modern German Architecture: Jugendstil." *SpaceD* 330 (March 1992).

Onderdonk, Francis S. "The Parabolic Style." *AmericanA* 135 (20 June 1929).

Packard, Robert T. In Wilkes.

Patzwahl, Ingrid. "The Silver Collection." *Weltkunst* (Munich) 63 (1 April 1993).

Polano, Sergio. "I Kroller e i loro architetti." *Domus* 745 (January 1993).

Posener, Julius, and J. Imbert. "Peter Behrens." *Aujourd'hui* 4 (March 1934). The whole issue.

Robinson, Cervin. "Modern Antiques: 20th Century Landmarks." *AForum* 126 (May 1967).

Shand, P. Morton. "The Machine: Peter Behrens." *AIAJ* 827 (January 1959).

———. "Scenario for a Human Drama: III, Peter Behrens." *AReview* 76 (August 1934).

SpaceD. "Hoechst Dyeworks: Peter Behrens 1920–24." 255 (December 1985).

———. "Twelve German Expressionist Architects." 275 (August 1987).

Vogelgesang, Shepard. "Peter Behrens, Architect and Teacher." *AForum* 52 (May 1930).

Weber, Wilhelm, et al. *Peter Behrens (1868–1940).* Kaiserslautern, 1966.

Windsor, Alan. "Hohenhagen." *AReview* 170 (September 1981).

———. "Letters from Behrens to P. Morton Shand." *Architectural History* (London) 37 (1994).

———. "Peter Behrens and the Aesthetics of Engineering." *Transactions RIBA* (London) 4 (January 1985).

———. *Peter Behrens: Architect and Designer, 1868–1940.* London, 1981.

Bibliographical

Vance: Lamia Doumato, A1020, 1983.

PIETRO BELLUSCHI. 1899 (Ancona, Italy)–1994. Belluschi received a degree in civil engineering from the University of Rome (1922) after studies had been interrupted by a stint in the army (1918–1920). Seeking adventure beyond Italian traditions, he traveled to the United States on a scholarship for a second engineering degree at Cornell University (1924). He worked as a mining electrical helper near Kellog, Idaho (1924–1925), and in April 1925 moved to Portland, Oregon, to work for the prolific Albert E. Doyle, first as a draftsman (1925–1927), and then became chief designer (1929–1942). Belluschi was otherwise self-taught in architecture. The firm was reorganized after Doyle's death in 1928 with associate W. H. Crowell in charge. In 1932 Belluschi became a full partner. His independent practice (starting in 1942) lasted until 1950 when Skidmore, Owings, and Merrill* acquired the Doyle firm. At the end of 1950 and with no teaching experience, Belluschi was appointed dean of the School of Architecture and Planning at the Massachusetts Institute of Technology (to 1965) and operated an independent practice but in association with offices mainly in Boston and Portland. After 1938 Belluschi received honors degrees, many national and international awards, teaching and advisory posts, and honors including the AIA Gold Medal in 1972 and Knight Commander of the Republic of Italy.

❧

Belluschi in 1941.

The real function of an architect is one of creative coordination. This task . . . has by degrees become more complex. . . . [My] concept of modern, therefore, will not lead us to expect it to be just another style. It cannot be labeled international style, although certain characteristics are universal. . . . It goes back to fundamentals . . . to nature.[1]

Belluschi independently completed surprisingly few buildings before his appointment to MIT. But conceptually they were influential and of three types: residential, religious, and commercial. With no formal architectural training, his tutelage in architectural design was practical within the Doyle office and derivative of historical eclecticism. When allowed, he reduced buildings to the essential forms of the selected style. His first attempt to break with historicism came with a design for new wings to the Portland Art Museum (1929–1932). The clients wished for something Georgian so Belluschi responded with basic red brick boxes and suggestions of Georgian ornamentation. He had sought the advice of Frank Lloyd Wright,* who had just visited Oregon, and many museum directors. The daylighted interior spaces are the building's most valuable asset.

Attracted by Oregon's natural beauty, to Wright's philosophy and that of

Harry Wentz (a painting teacher at the Portland Art Museum who took students—including Belluschi—on drawing excursions to examine old rural buildings and basic wood construction techniques), to traditional Japanese architecture (as encouraged by colleague John B. Yeon), and to houses in central California designed by William Wurster, Belluschi evolved his own interpretation of a new regional architecture. The first hint of those influences was seen in his own house (1936). The most evocative expression was manifest in the Peter Kerr house beside the beach at Gearhart, Oregon (1941): a neat open plan with one facade of Japanese spirit and proportions facing west to the East, the other facing east and to the Cascade Range as a low-slung rural farm building with a tree stump as a verandah post. His and Yeon's houses before 1950 helped establish what at midcentury became the Pacific Northwest School (the word "style" is much too limiting). Regionalism was an intimate part of a general reaction to universalism if not the political concept of internationalism as put by proponents of the Modern Movement.

Belluschi's religious buildings in the Northwest were, as with housing, similarly influenced in detail, general form, and character with the two dominant determinants being the geographical region and Japan: each tended to be used separately. Saint Thomas More Catholic Church in Portland (1939–1940) established precedents: natural materials (wood in this instance) for construction, simple forms inside and out, and the roof structure exposed within (in this case, scissor trusses). One of the finest examples is the Zion Lutheran Church in Portland (1948–1950). The roof form is taken from local rural buildings and the tower from Scandinavian traditions as found in the region. The interior is plain with light coming from isolated glass blocks set in masonry. The roof is supported by laminated wood posts reaching to the ridge and bent much as Gothic arches. A high level of building craftsmanship was required for this church and all materials are left natural or with clear finishes.

The Central Lutheran Church in Portland (1948–1950) is a tour de force in wood screening (even on the tall, square tower). The rectangular nave faces a hemicycle chancel in masonry. And a gently bent wood portico roof à la Japan graces the entry. The First Presbyterian Church in Cottage Grove, Oregon (1948–1951) is strongly influenced by traditional Japanese architecture in proportion, screening, and landscape design (the nave overlooks a small, serene garden), and by local wood craftsmanship. The building looks as if it had been put together by a cabinetmaker, a look that became an important characteristic of the Northwest School in the 1950s.

These churches received international attention and established national trends. When Belluschi put aside those early influences and became persuaded by Northeast American–styled Europeanism and a growing fetish for structure, his churches were less successful. To test his imagination—and as a reaction to the swinging social concerns of the revolutionary 1960s—he undertook the design of Saint Mary's Cathedral in San Francisco (1963–1971, with McSweeney, Ryan, and Lee). It became a monument in concrete (with structure by Pier Luigi

Nervi*) and to excessiveness, mainly financial. With its ponderous scale, heavy proportions, and massive roof forms, it exemplifies architectural trials at mid-century. Furthermore, it did not meet the quality of its derivation and immediate predecessor, Kenzo Tange's* Saint Mary's Cathedral in Tokyo (1961–1964).

Belluschi treated his commercial building designs antithetically to his domestic and religious architecture (Saint Mary's aside); the dichotomy was never explained. The first building of consequence was the *Oregonian* Building (1948) with a slick exterior that was thin skinned in flush glass and metal. It is comparable to his most influential building of the postwar period, the Equitable Building, also in Portland (1943–1948; construction started in 1946). Constructed of concrete, it was the first tall building to employ a skin of aluminum and glass and to use green glass to filter glare and reflected skylight. It not only employed quick constructional and assembly methods for the facades, but it also established an aesthetic rationale that is still emulated.

Much as was the case with Eero Saarinen* but less successfully, Belluschi's post-1955 architecture was distinguished but without a sustained organic wholeness. Each design project was correctly seen as a different architectural problem, but his response was without an identifiable raison d'être or philosophic knit; it tended to be eclectic of current manners. This may have occurred partly because, with most commissions, he acted as only a consultant or in concert with other architects and was therefore less able to maintain cohesion. (Mies van der Rohe* operated his practice in much the same manner but insisted on full control.) This problem is most obvious in such buildings as Belluschi's rather Miesian First National Bank in Seattle, Washington (1970, consultant to Naramore, Bain, Brady, and Johanson), and the gigantic Pan American Building that looms over Grand Central Station in New York City (1962, consultant with Walter Gropius* to Emery Roth and Sons)—a building hotly criticized on sociological, environmental, and demographical grounds.

There are also exceptions: the Kah-Nee-Ta Hotel at Warm Spring Indian Reservation, Oregon (1972, with Wolff, Zimmer, Gunsul, Frasca, and Ritter, who seem to have been the dominant players); the Juilliard School of Music at Lincoln Center in New York City (1957–1969, with Eduardo Catalano and Hilge Westmann); the Equitable Center Office Building in Portland, Oregon (1966, with Wolff, Zimmer, Gunsul, and Frasca—a Miesian schemata set in concrete); the tall buildings of the Bank of America in San Francisco, California (1970, with Wuster, Bernardi, and Emmons and Skidmore, Owings, and Merrill); and the IBM Center in Baltimore, Maryland (1973, with Emery Roth and Sons).

Belluschi's "belligerently stated" belief, as he put it when confronted with the likes of postmodernism, that architecture has "practical boundaries and *duties*," that one cannot take "flight from the realities of life," from those practicalities, may help explain the diversity of his oeuvre.[2] On the other hand, in 1953 he said that architecture "is more than function and structure; it transcends, transforms, and redeems engineering in terms of human values for the purpose

of giving pleasure to the senses as well as to the mind."[3]

"Redeems engineering": an interesting turn of phrase coming from an engineer, well, a former engineer.

NOTES

1. As quoted in Stubblebine (1953), 28–29.
2. As quoted in Gubitosi (1973), after 109.
3. As quoted by Clausen, in Wilkes.

BIBLIOGRAPHY

Writings

"An Appraisal of Our Contemporary Architecture." *Bulletin of the American Academy of Arts and Sciences* 5 (December 1953).
"The Architect and His Community." *PA* 30 (February 1949).
"An Architect's Challenge." *AForum* 91 (December 1949).
"Architectural Milestones." *AIAJ* 59 (May 1973).
"Architecture as an Art of Time." In *The People's Architects,* edited by Harry S. Ransom. Chicago, 1964.
"Form Givers." *Pacific Architect & Builder* (San Francisco) (November 1960).
"The Meaning of Regionalism in Architecture." *ARecord* 118 (December 1955).

Biographical

Clausen, Meredith L. In Wilkes.
————. *Pietro Belluschi: Modern American Architect.* MIT Press, 1994.

Assessment

a+u. "Lincoln Centre for the Performing Arts, NY." 3 (August 1973).
AForum. "Church by Architect Belluschi." 94 (January 1951).
ARecord. "Building Types . . . Pietro Belluschi." 126 (July 1959).
Church Architecture. The Shape of Reform. Liturgical Conference, Proceedings. Cleveland, 1965.
Clausen, Meredith L. "Belluschi and the Equitable Building in History." *JSAH* 50 (June 1991).
————. *Spiritual Space. The Religious Architecture of Pietro Belluschi.* Seattle, 1992.
Cook, Jonathan. "Postwar Prototype . . . Equitable Savings and Loan Building." *AIAJ* 71 (July 1982).
Creese, William L. "The Equitable Revisited." *AForum* 128 (June 1968).
Gaffey, James P. "The Anatomy of Transition—Cathedral-building and Social Justice." *Catholic Historical Review* 70 (January 1984).
Gordon, Walter. "Designed by Pietro Belluschi." *Pencil Points* 23 (July 1942).
Gubitosi, C[amillo], and A[lberto] Izzo. *Pietro Belluschi Edifici e progetti.* Buildings and plans. *1932–1973.* Rome, 1973.
Hawkins, Lucinda. In *Contemporary Architects.*
Heyer, Paul. *Architects on Architecture.* New York, 1966; 2d ed., 1978.
Hitchcock, Henry-Russell. "An Eastern Critic Looks at Western Architecture." *AandA* 57 (December 1940).
Humphrey, Linda, Fred Albert, and Michael Jensen. *American Design. The Northwest.* New York, 1989.
PA [Pietro Belluschi.] 71 (June 1990).

Peter, John. *Master of Modern Architecture.* New York, 1958.

Ross, Marion D. "The 'Attainment and Restraint.' " *AIAJ* 58 (July 1972).

———. "The Museum Building as a Work of Art." *Notes on the Collection.* Portland Art Museum, 7 (1967).

———. In Macmillan.

Schmertz, M. F. "The Juilliard School. A Conservatory." *ARecord* 147 (January 1970).

Stubblebine, Jo, ed. [with Pietro Belluschi]. *The Northwest Architecture of Pietro Belluschi.* New York, 1953.

Thiry, Paul, Richard M. Bennett, and Henry L. Kamphoefner. *Churches and Temples.* New York, 1953.

Thompson, Elizabeth K. "The 1972 Gold Medalist." *ARecord* 151 (April 1972).

Bibliographical

Clausen, Meredith L. *Pietro Belluschi: Modern American Architect.* MIT Press, 1994.

Vance: Lamia Doumato, A352, 1980; Anthony White, A2129, 1988.

RICARDO BOFILL(-LEVI). 1939 (Barcelona, Spain)– . Claiming Italian and Catalan origins, Bofill was educated at the French Institute of Barcelona before entering the Escuela Tecnica Superior de Arquitectura in that city (1955–1956). He continued, but never completed, his studies at the University of Geneva (1957–1960). Around 1963 he assembled in Barcelona the group of architects that became known as the Taller de Arquitectura. A Paris studio was established in 1971, after which there were commissions in North Africa, northern Europe, and the United States. The Taller's headquarters remains in Barcelona with offices in Paris, Montpellier, France, and New York City and associates in Brussels, Stockholm, Toronto, Houston, and Moscow. Its work has been exhibited in Spain, Italy, France, England, Argentina, and the United States.

❧

Bofill's practice began with apartments and one industrial building in and around Barcelona. He characterizes the Taller as a "multi-disciplinary group involved in proposals and solutions for physical design problems within a broad spectrum of environmental issues. . . . [It includes] people from architectural, artistic, literary, musical, philosophical and mathematical fields."[1] It conducted a parochial Catalan practice until the end of the 1960s, building large residential complexes that became—especially those in nonurban locations, like El Castell in Sitges (1966–1968) and the clifftop La Manzanera (1969–1983) at Alicante—increasingly monumental. One writer assigns them to the "so-called 'School of Barcelona' (neo-realist, brutalist, with strong inspiration in constructive detailing)" derived from the fin de siècle Catalan *Modernisme* seen in the work of Antoni Gaudi and Francesc Berenguer.[2] This is not the place to analyze Gaudi's work. Suffice it to say that he was not, as Bofill seems to be, a plunderer of history but an interpreter into modern terms of the spirit of his region's cultural tradition and a "brutalist" only in the sense of letting the materials of his architecture speak for themselves.

Bofill soon designed megaprojects farther afield, like the unrealized 1,500-

apartment CEEX-1 City in Space, Madrid (1969–1972). That was a testing ground for a design methodology based on geometric formation of elements in space, later applied in the 1,000-residence Walden 7 development in Barcelona (1970–1975). In 1971 a complementary team was formed in Paris to prepare schemes for French new towns. The Taller, introducing symbolic elements related to French monumental architecture—in other words, borrowing motifs from historical architecture—designed "habitable monuments." An unrealized proposal for Cergy-Pontoise typified the approach. Revived in 1976 for a different location, the design (called La Petite Cathédrale) was a

monumental residential complex inspired by the Gothic cathedral with lateral aisles opening at intervals to form streets and squares. One thousand living spaces are built along the side walls, with hotels, offices, schools, parking areas and various public and private facilities included.[3]

It provided a clear signpost to Bofill's megalithic direction. Other French and Spanish projects followed throughout the decade, but little was built: the Emilio Bofill house (1972–1976) at Calella, the Taller's own offices (1973–1976) in a cement factory near Barcelona, and a religious center in Andorra (1973–1978). Indeed, a glance at a list of Bofill's works before about 1980 raises the question: How did the firm survive on so little real work?

From 1978 to 1980 Bofill participated in the Algerian government's urban planning and housing program; the Taller produced several schemes for housing developments and new towns. All that was actually built was the 350-house Houari Boumedienne agricultural village and a 200-room hall of residence at Rouiba, near Algiers. The cultural challenges must have been difficult, if not insurmountable, despite Bofill's protestations about social concerns in architecture, including the wishes and involvement of its users.

There is no evidence that he has come to terms with humaneness in his architecture, or indeed that he *wants* to. For example, it is hard to reconcile Bofill's acknowledgment of Adolf Loos's* dictum that architecture "provokes spiritual reactions in man" with the inhumane twenty-hectare Antigone complex in Montpellier (1980), whose scale makes Bernini look like a cottage builder, or his proposed Versailles pour le Peuple (1980), as grand as Louis XIV's original palace or Speer's Berlin. Perhaps he is not entirely to blame, as Heinrich Klotz has commented: "The fact that Bofill was seduced into building a series of 'Versailles for the bourgeoisie' is due in part to the building program of the French government."[4] It is fortunate for Bofill (or canny of him) that he chose France as the preferred location for his experiments with architectural ideas. As Paolo Portoghesi has observed, he "has succeeded in attracting the attention of the structures of a bureaucratic power as jealous as ever of its own national identity."[5] The monumentality and self-importance built into the French psyche have been architecturally expressed throughout the nation's history from Francis I onward—Chambord, Fontainebleau, the Louvre, Versailles, the Arc de Triomphe, Hausmann's Paris, the Opéra, the Eiffel Tower. They are evoked, inappro-

priately for all but the French, in the houses built by Bofill and the spaces around them.

Since 1979 Taller de Arquitectura's principal sphere of activity has been France. Just then, the construction of four earlier projects was imminent: Les Arcades du Lac and Le Viaduc (designed 1972–1974), both near Versailles; Les Echelles du Baroque Paris (designed 1979); the Antigone complex and Le Palais d'Abraxas, Le Théâtre, and L'Arc in Marne-le-Vallée (designed 1978–1979). Their realization was staged over the next several years. The exterior of the Antigone complex, with its great quasi-Tuscan pilasters towering over ten stories and the overscaled repetitive modules of its facade, quite overwhelms human beings because it is "fortresslike, deterring and intimidatingly alien." For all that, writes one critic, Bofill "has succeeded in producing a sequestered realm that offers a certain refuge from urban chaos."[6]

Biography (and especially autobiography) can become hagiography. David Mackay warns that Bofill is notorious for playing to the gallery when explaining his work, noting that the modern movement has not yet provided a place for his "eclectic decoration, whimsically, albeit intelligently applied, in order to obtain certain theatrical effects upon the urban stage." Because Bofill's work is so provocative, by most definitions it must be art; because of his "innate knack of clear architectural concepts in the basic organization of his compositions" he is, for all his naiveté and theatricity, "still capable of producing architecture."[7]

Bofill expresses his aims in architecture and urban design: "A concern of the firm has always been the common, public space. . . . The goal has been the development of a new typology of urban tissue based on the ambience of the Medieval, Renaissance and Baroque examples of street, square and open space."[8] But form and ambience are not synonymous.

NOTES

1. As quoted in *Contemporary Architects*.
2. Mackay in *Contemporary Architects*.
3. Norberg-Schulz and Futagawa (1985), 194.
4. Heinrich Klotz, *The History of Postmodern Architecture* (MIT Press, 1988), 429.
5. Paolo Portoghesi, *Postmodern. The Architecture of a Postindustrial Society* (NY, 1983), 140.
6. Klotz, *The History of Postmodern Architecture,* 429.
7. Mackay in *Contemporary Architects*.
8. As quoted in *Contemporary Architects*.

BIBLIOGRAPHY

Writings

CEEX 1, City in Space Experience. Barcelona, 1970.
"The Dreams of Ledoux." *New Art Examiner* (Chicago) 10 (June 1983).
Los Espacios de Abraxas—El Palacio—El Teatro—El Arco. Paris, 1981.
Haciauna Formalización de la Ciudad en el Espacio. Barcelona, 1968.
El Jardin del Turia. (Catalog). Valencia, 1982; Rome, 1983.

Projets Français 1978–81—La Cité: Histoire et technologie. Paris, 1981.
Ricardo Bofill—L'Architecture d'un homme. Paris, 1978.
Taller de Arquitectura: City Design, Industry and Classicism. Barcelona, 1984.

Biographical

Mackay, David. In *Contemporary Architects.*

Assessment

Anagyros, Sophie. "Bofill rentre à la maison." *Maison Française* (Paris) 382 (Spring 1984).
Architecture Mediterraneenne. "Catalan Architecture." 40 (April 1993).
Bedarida, Marc. "The Adventures of Urban Design." *Lotus* 51 (1986).
Curtis, William J. R. "Principle versus Pastiche." *AReview* 176 (August 1984).
Dietsch, Deborah K. "Precast Classicism." *ARecord* 174 (January 1986).
Domus. "Ricardo Bofill: Taller de Arquitectura." 668 (January 1986).
Fieldman, Peter. "Frontis (a self-sufficient community)." *RIBAJ* 97 (September 1990).
GADoc 32 (March 1992). The whole issue.
Garcias, Jean-Claude. "Article de Paris." *Aujourd'hui* 253 (October 1987).
International Lighting Review. "Municipal Conference Centre, Madrid." (Eindhoven) 44 (March 1993).
James, Warren A. *Ricardo Bofill . . . 1960–1985.* New York, 1986.
Lahuerta, Juan José. "Barcelona: Aeroporto di Prat de Llobregat." *Domus* 305 (1992).
Meade, Martin, and J.-C. Garcias. "The Acceptable Face of Classicism." *AReview* 171 (June 1982).
Michel, Florence. "À visages decouvertes." *Architecture Intérieure Crée* 247 (March 1992).
Moorhead, Gerald. "Classical Music." *ARecord* 180 (March 1992).
Norberg-Schulz, Christian, and Yukio Futagawa. *Ricardo Bofill.* New York, 1985.
Ricardo Bofill, Espaces d'une vie. Paris, 1989.
Ricardo Bofill Taller de Arquitectura. Tokyo, 1985.
Ricardo Bofill Taller de Arquitectura: Buildings and Projects 1960–84. New York, 1988.
Ryan, Raymond. "Bofill in America." *RIBAJ* 96 (4 December 1989).
———. "Ricardo Bofill." *LA Architect* (January 1989).
Schuman, Tony. "Utopia Spurned: Ricardo Bofill and the French Ideal City." *JAE* 40 (Fall 1986).
Scully, Vincent. "Ricardo Bofill: Housing Projects." *ADigest* 45 (April 1988).
Shrady, Nicholas. "Architecture: Ricardo Bofill." *ADigest* 44 (July 1987).
SpaceD. "Arbraxas Complex in Marne-la-Vallée." 219 (December 1982).
———. "Ricardo Bofill: Taller de Arquitectura." 349 (October 1993). The whole issue.
Taller de Arquitectura, Ricardo Bofill. London, 1981.

Bibliographical

Vance: Mary Vance, A1792, 1987.

MARIO BOTTA. 1943 (Mendrisio, Switzerland)– . Botta's elementary education was gained in Genestrerio, Switzerland. After high school in Mendrisio he was trained in technical drafting (1958–1961) in the Lugano office of Carloni and Camenisch. He studied architecture in Italy, first at Milan's Liceo Artistico

(1961–1964) where he was taught by Guiseppe Mazariol, then under Carlo Scarpa* at the Istituto Universitario di Architettura in Venice (1964–1969). After fulfilling youthful fantasies by working in Le Corbusier's* Venice office (1965) and collaborating briefly with Louis I. Kahn* (Venice, 1969), he started his own practice (1969) in Lugano, from where he continues to work. Most of his buildings are located in Switzerland. He has been involved in architectural education since 1976 and became a professor at L'Ecole Polytechnique Federale in Lausanne in 1983. He has also taught in architectural schools in Europe, Asia, and the Americas, including Yale University. He has been honored by his peers in Switzerland, Germany, Holland, the United States, and Argentina, and his work has been exhibited at New York's Museum of Modern Art.

Whenever the School of Ticino is discussed, Mario Botta's buildings are the center of attention. Since about 1970, there has developed in the Swiss borderland between the Italian- and German-speaking cultures an astonishingly rich architecture—something of an experiment in Postmodernism. The old schemata of functionalism have been questioned not only on paper but also in real practice. Since [Aldo] Rossi's [*] stay in Zurich (1972–1974) this tendency has become even stronger. Mario Botta, however, has generally followed a path of his own, independent of Rossi.[1]

For interwoven linguistic and cultural reasons, Switzerland has always exhibited strong regionalistic tendencies including its architecture. The cantons closest to Italy have seen a persistence of Ticinese regionalism in the face of homogenous modernism. Noting that contemporary Ticinese regionalism "has its ultimate origins in the pre-war protagonists of the Italian Rationalist movement" tempered by the strong influence of Frank Lloyd Wright,*[2] Frampton places Botta in the line of succession of the Italian Alberto Sartoris and the Ticinese Rino Tami and Tita Carloni, Botta's mentor. Others have identified him with the polemical neo-Rationalist group Tendenza (it also includes Rossi) as an architect who actually *builds*—probably because of his attempts to "reconcile traditional architectural symbolism with the severe but rational codes of the Modern movement."[3] In support they cite his first exhibition in Zurich (1975): "Tendenzen—Neuere Architektur im Tessin." But Botta may not be so easily pigeonholed. As Oechslin points out, he is "something of a loner" who, unlike most of his Swiss contemporaries, studied in Italy, repudiated the "over-discussion of architecture" at a time when much debate of modernism saw little actually built, and sought the instruction of Scarpa "long before the latter was 'rediscovered'."[4]

Botta himself stresses the importance of Scarpa to his subsequent development. Naturally, he acquired something different from contact with each of the masters, and he realistically insists that their impact should be considered in the following sequence. From Scarpa, he gained a deep love for materials, their distinctive expressions, and the composition and order they demand, as well as "an understanding" of modern architecture's innovations, "as they were interpreted by the neo-Rationalist movement."[5] From Kahn (whose influence is par-

adoxically strong for such a short contact while helping with the American's Venice exhibition) he learned to ask: "What does the building want to be?" and found its answer, "It is not what you want, it is what you sense in the order of things which tells you what to design." From his observations and readings of Le Corbusier* (whom he never met in person) he gained his earliest impressions of modernism and learned that architecture could benefit society.

Botta recognizes in the house the entire gamut of problems and aims of all architecture. The type therefore demands careful study, especially the relationship between the individual or group user, between the building and the natural or built environment as a place, as a "testimony of history or memory," and in terms of time. "Two traits [in his work] may be seen as critical: on the one hand, his constant pre-occupation with what he terms 'building the site', and on the other, his conviction that the loss of the historical city can only be compensated for by 'cities in miniature'."[6]

Domestic architecture forms a large part of his practice, and a number of houses may be taken as indicators of his development. His first building, at the age of eighteen, was a rectory in Genestrerio (with Carloni, 1961–1963) that drew upon the adjoining historic church for its (regional) form, materials, and construction. Botta's first independent work turned from those standards: clearly if inappropriately influenced by Le Corbusier's La Tourette (1952–1960), the concrete house at Stabio (1965–1966) was "a work of art isolated in the landscape" built in pursuit of uniqueness. There followed a villa at Cadenazzo (1970–1971) that asserted its independence of its geographical and even cultural context (some local people did not realize it was a house). Klotz observes that it "refers only to the work of Louis Kahn." Indeed, Botta transferred to his own domestic milieu elements like oculus windows that the American applied only in public buildings.[7]

This "domestic architecture with an attitude" is consummated in the Casa Rotonda in Stabio (1981) and in the house at Morbio Superiore (1983–1984), that break with the recent and distant past, rejecting the orthodox conventions of modernism and the regional traditions of house typology. Nevertheless, Botta's later houses demonstrate a symmetrical, Palladian organization. "His house forms are simple elementary volumes where the exterior is independent from the interior. Internal planning is developed with a grid and suggests a layering of planes that introduce the carefully framed views and long vistas into the interiors."[8]

In 1977 Botta secured the commission for the State Bank in Fribourg (with E. Hutter and T. Urfer, completed in 1981). It took his practice beyond Ticino and demonstrated that he could bring "the convincing monumentality of his houses [at] a larger scale" to commercial and public buildings. After 1978, without ignoring his domestic practice, Botta began to seek other larger scale commissions through projects and competitions. The Ransila I administration/commercial building in Lugano (1981) and the Bank of Gothard building, also in Lugano (1982) established his national reputation and opened the doors to

an international practice. Proof of his creative ability in nondomestic design is his own office in Via Liano, in Lugano (1987–1990). The twenty-three-meter-tall circular tower is highly redolent of the Casa Rotonda not only in form and detail, but also in the attitude of independence it adopts to its mundane and anonymous neighbors. Epitomizing the "city in miniature" and evoking a fortified town, the multipurpose building houses commercial uses and offices on the first two floors, then four floors of apartments and three floors of the architect's studio, all crowned with a barrel-vaulted roof over the central atrium.

Among his recent works is the magnificent Watari-um Art Gallery, in Tokyo (1985–1990) (see frontispiece). Like the Lugano studio, it stands clearly defined and aloof from the surrounding urban chaos. As Botta said:

For this little museum I followed a strong and precise sign that had to resist the confusion and the contradiction of languages, styles and forms present in Tokyo. [That metropolis] exacerbates the contradictions of modern cities; the dimensional and spatial break of the pre-existent is perceivable at every street corner; next to the lacerations inflicted by new urbanistic actions, a thick pre-industrial urban context survives which offers a contrast between a spatial relationship and urban memory. . . . I wanted to verify what could be the "endurance" of a strong and primary architectural sign and image, generated by a reason inside the building itself and supported by natural light and geometry, suggested by the building rather than with regard to the environmental impact.[9]

The constraints of the expensive triangular site allowed Botta to exploit its very acute corner, "given a plastic form and emphasized by horizontal openings [to create] the impression of a wing reaching out into space" amid the built confusion around.[10]

Botta's San Francisco Museum of Modern Art (1989–1991) is a classic modernist design set among a contemporary concentrated cluster of skyscrapers by Skidmore, Owings and Merrill,* Fumihiko Maki,* and Frank O. Gehry.* It consists of expansive, plain full compact surfaces stepping up to gather around a central cylinder that houses the main circulation atrium whose oblique roof is crowned with trees somewhat in the manner of Boullee's megamonument to Isaac Newton. "This image . . . decisively measures the distance between [the museum] and the vertical architecture of steel and glass of the buildings round about, a divergent image for a building whose function is that of a present day place of culture."[11] Botta believes that a museum plays a role "analogous to that of the cathedral of yesterday" in the modern city. "It is a place of common encounter and confrontation, a place we require in order to challenge the hopes and contradictions of our time."[12] It is intriguing, if not relevant, to this discussion that his design drawings for the gallery are dotted with Le Corbusier's modulor men.

Botta has attracted wide interest and his work continues to be exhibited throughout Europe and in North and Latin America. Despite his preference for expressing himself in buildings, rather than in his words, he has lectured internationally, preaching that "the architectural event today can be fed by its context

... Architecture as the formal expression of history can be the active witness to the aspirations, uneasiness and hopes of our culture."[13]

NOTES

1. Heinrich Klotz, *The History of Postmodern Architecture* (MIT Press, 1988), 270.
2. Kenneth Frampton, *Modern Architecture: A Critical History* (London, 1992), 322.
3. Catherine Slessor in Sharp (1991).
4. Oechslin (1993), 10.
5. As quoted in Wilkes.
6. Frampton (1992), 323.
7. Klotz (1988), 270.
8. Sanders in Wilkes.
9. As quoted in *ADesign* 61 (November 1991), 75.
10. Oechslin (1993), 18.
11. Ibid., 166.
12. As quoted in *ADesign* 61 (November 1991), 79.
13. As quoted in *Contemporary Architects*.

BIBLIOGRAPHY

Writings

"Architecture and Environment." *a+u* 105 (1979).
"The Figure of the Architect Today." *Domus* 762 (July 1994).
"House at Morbio Superiore." *a+u* 184 (January 1986).
With others. "Barcelona after the Olympics." *Lotus* 77 (1993).

Assessment

a+u "The Latest Works of Mario Botta." 220 (January 1989).
ADesign. "The San Francisco Museum of Modern Art." 61 (November 1991).
———. "Watari-um Gallery, Tokyo." 61 (November 1991).
Allies, Bob. "At Home Abroad." *AJournal* 176 (December 1982).
Arnell, Peter. "Mario Botta: Trans-Alpine Rationalist." *ARecord* 170 (June 1983).
Arnheim, Rudolf. "Notes on Religious Architecture." *Domus* 757 (February 1994).
Auer, Gerhard, et al. "In farbe." *Daidalos* (Guertersloh) 15 (March 1994). The whole issue.
Baralli, Rafaella, and Marco Fiorucci. *Mario Botta. Architettura e Tecnica.* Naples, 1993.
Battisti, Emilio, and Kenneth Frampton. *Mario Botta. Architetture e Progetti negli Anni 70.* Milan, 1979.
BuildingD. "European in San Francisco." (16 November 1990).
Cappellato, Gabriele. "Office Residence [Lugano]." *a+u* 251 (August 1991).
Carloni, Tita. "Mario Botta's Movable Tent." *Lotus* 78 (1993).
Croset, Pierre-Alain. "Mario Botta: La casa del libro e altri progetti." *Casabella* 52 (May 1988).
Dal Co, Francesco. "Mario Botta." *a+u.* Extra edition (1986).
———. *Mario Botta: Architettura 1960–1985.* Milan, 1985.
Dimitriu, Livio. "Architecture and Morality." *Perspecta* 20 (1983).
Drenger, Daniel E. "Botta on Botta; Back to Basics." *Columbia Art Review* (Winter 1986).
Frampton, Kenneth. "Botta's Paradigm." *PA* 65 (December 1984).

Futagawa, Yukio, ed. *Mario Botta.* Tokyo, 1984.

GADoc. "Mario Botta." 22 (1989).

Kady, Leonard. "An Interview with Mario Botta." *Fifth Column* (Montreal) 5 (Fall 1984).

Klotz, Heinrich. *The History of Postmodern Architecture.* MIT Press, 1988.

Nicolin, Pierluigi, and François Chaslin. *Mario Botta: Buildings and Projects 1961–1982.* Milan, Barcelona, NY, 1984.

———. *Mario Botta, 1978–1982: Il Laboratorio di Architettura.* Milan, 1982.

Norberg-Schulz, Christian. *Mario Botta.* Tokyo, 1985.

Noschis, Kaj. "L'homme pour l'architecte." *Architecture & Comportement* (Paris) 4 (April 1988).

Oechslin, Werner, ed. *Mario Botta. Architectures 1980–1990.* Barcelona, 1993.

Pelissier, Alain, et al. "Mario Botta." *Techniques* 377 (April 1988). The whole issue.

Pfeiffer, Peter. *Mario Botta Designer.* Milan, 1987.

Pizzi, Emilio, ed. "Commercial and Residential Building . . . Lugano." *GADoc* 35 (1992).

———. *Mario Botta.* Barcelona, 1992.

———. *Botta: Complete Works 1960–1985.* Vol 1. Zurich, 1993.

Polano, Sergio. "Banco del Gottardo, Lugano." *Domus* 704 (April 1989).

———. "Ten Recent Works by Mario Botta." *a+u* 279 (December 1993).

Purini, Franco. "Inner Voices: Observations on . . . Botta." *Lotus* 48–49 (1986).

Richard, Claude, et al. *Mario Botta. Une Architecture, Trois Habitats.* Geneva, 1987.

Rykwert, Joseph. "Mario Botta: Views of a Modernist." *ADigest* 45 (January 1988).

Sachner, Paul M. "A Little Bit Timeless." *ARecord* 175 (September 1987).

Sanders, Linda. In Wilkes.

Silvestrini, Vittorio. "Selection of the Primary Elements." *Lotus* 78 (1993).

Slessor, Catherine, in Dennis Sharp, ed. *Illustrated Dictionary of Architects and Architecture.* London, 1991.

Stein, Karin D. "Ransila Office Building, Lugano." *ARecord* 174 (July 1986).

Wanatabi, Hiroshi. "Watari-um, Shibuya-ku." *GADoc* 30 (1991).

Zardini, Mirko. "Mario Botta." *a+u* 220 (January 1989). The whole issue.

Zardini, Mirko, and Christian Norberg-Schulz. *Mario Botta.* Tokyo, 1984.

Bibliographies

Vance: Carole Cable, A1121, 1984.

Archival

Mario Botta. Preliminary Studies. Tokyo, 1986.

MARCEL (LAJOS) BREUER. 1902 (Pecs, Hungary)–1981. When he found art school in Vienna disappointing, Breuer quickly transferred to the art and craft design course at the Bauhaus in Weimar, Germany (1920–1924) where he later taught (1924–1928) and also took over the carpentry and furniture design program. He was an independent architect and interior designer in Berlin and elsewhere (1928–1936). After emigrating from Nazi Germany he first enjoyed a brief partnership with F.R.S. Yorke in London (1936–1937). When Walter Gropius* was appointed head of Harvard University's Graduate School of Design he asked Breuer to join the faculty (1937–1946). A loose partnership with Gro-

pius in Cambridge, Massachusetts, lasted until 1941. He was naturalized in 1944 during a period of private practice in Cambridge (1941–1946). He finally moved offices to New York City (1946–1976) where nearly all commissions were executed in collaboration with others. Breuer had a number of exhibitions and received many national and international honorary degrees and awards including the AIA Gold Medal (1968) and the Grande Medaille d'Or from the French Academy of Architecture (1976).

✧

"His outstanding quality was his completely unbiased mind and the independence and boldness with which he attacked technical and aesthetic problems": so said a biased Gropius.[1]

Breuer's architecture prior to the 1940s was typical of the transparent and delicate constructional fabric of central European white boxes. Only occasionally did he explore bolder forms such as the step-back floors of the Elberfeld Hospital project (1928), which is indicative of the potent and more general influence of Russian Constructivism on Germans. His work in the United States began with an ardent search for atypical forms derived in large measure by exaggerating functional parts and structural characteristics of materials. His houses of the 1940s, a few with binuclear plans, were his earliest outlet for these investigations.

His big break came in 1953 when as head of a selection committee his mentor Gropius managed to obtain for Breuer, Pier Luigi Nervi,* and Bernard Zehrfuss the new UNESCO headquarters commission for Paris (to 1958). Breuer and Nervi dominated the collaboration, and two major buildings evolved: a secretariat, in concrete and glass, and an assembly hall of exposed, folded concrete slabs. The headquarters marked a change not only in Breuer's professional fortunes but also in his architecture.

For most of his large buildings, Breuer applied to his facades a three-dimensional "molded architectural form," a facade of depth, of "sun and shadow" in concrete. This heavy surface together with the theme of a single and dominant overtly structural three dimensionality carried into all of his works. One result was a noticeable lack of proportional sensitivity in favor of over-articulated and often ponderous shapes, especially those about the ground level that support the upper building. Saint John's Abbey Church, in Collegeville, Minnesota (1953–1961 with H. P. Smith), exemplifies this transformation, as does the IBM Research Centre in La Gaude, France (1960–1961 with R. F. Gatje), which in plan drew from the UNESCO building and from the Department of Housing and Urban Development, in Washington, D.C. (1963–1968 with H. Beckhard and Nolen-Swinburne).

The compact Whitney Museum of American Art, in New York City (1963–1966 with H. P. Smith), was equally bold with floors stepped out and over the entry. Plain walls on the exterior reject the bustle of city streets and are relieved by just a few shaped window frames. The mammoth sloping sculptural shape of the main form of parish church of Saint Francis de Sales in Muskegon,

Michigan (1961–1967 with H. Beckhard), imparts an enduring nobility that is equally grand in scale and size on the interior. In fact sculptural, monolithic monumentality, usually at the expense of human scale, was a hallmark of Breuer's post-1950 architecture.

As an element in architecture generally during the last half of the century, Breuer's idea of a facade of precast concrete elements, with or without textural and/or colored additives, became an essential part of buildings that were by function repetitive—such as dormitories or offices—throughout the world. They stand in contrast to the simplicity of Pietro Belluschi's* model in the Equitable Building (1948) and later Gordon Bunshaft's* Lever house (1952).

Breuer's furniture designs of the late 1920s have stood time's test by mimicry even if most lacked the elegance and refinement of the designs of Ludwig Mies van der Rohe* of the same period (see Plate 17). Also Breuer's well-known tubular steel furniture was not as revolutionary as previously thought, as it was predated by Antonin Raymond's* designs in the early 1920s.

NOTES

1. As quoted by Isaacs in Macmillan.

BIBLIOGRAPHY

The abbreviation MB for Marcel Breuer is used below.

Writings

"Architecture and Material." In *Circle. International Survey of Constructive Art.* London, 1937.
"Beitrage zur Frage." *Die Form* (Berlin) 5 (1930).
"The Faceted, Moulded Façade: . . . Sun and Shadow." *ARecord* 139 (April 1966).
Flaine de Breuer. Paris, 1969.
MB. Architect and Designer, edited by Peter Blake. New York, 1949.
MB: 1921–1961. Buildings and Projects. London, 1962.
MB: 1921–1962. Stuttgart, 1962.
"Metallmöbel." In *Deutsche Werkbund.* Stuttgart, 1925.

Biographical

MB. Sun and Shadow. The Philosophy of an Architect, edited by Peter Blake. New York, London, 1956.
Heyer, Paul. *Architects on Architecture.* 2d ed. New York, 1978.

Assessment

Abercrombie, Stanley, *MB* [GA 5] Tokyo, 1977.
Abitare. "Bijenkorf Department Store." 293 (February 1991).
Bauhaus 1919–1928. New York, 1938.
Blake, Peter. In Lampugnani.
Canty, Donald. *Lasting Aalto Masterwork. The Library at Mount Angel Abbey.* The Abbey, 1992.
Giedion, Sigfrid. "El Arquitecto." *Arquitectura* (Madrid) 3 (1932).
Giovanni, J. "A Grave Situation for MB's Whitney." *Artforum* (New York) 24 (November 1985).
Hitchcock, Henry-Russell. *MB and the American Tradition.* MIT Press, 1928.
Isaacs, Reginald R. In Macmillan.

Jones, Cranston. *MB 1921–1962*. London, 1962.

Jordy, William H. *The Aftermath of the Bauhaus in America: Gropius, Mies, Breuer*. MIT Press, 1968.

Masello, David. *Architecture without Walls. The Houses of MB and Herbert Beckhard*. New York, 1993.

———. *House in the Garden*. New York, 1949.

Museum of Modern Art. *Bauhaus 1919–1928*. New York, 1938.

Papachristou, Tician. *MB. New Buildings and Projects*. New York, 1970.

Porteghesi, Paolo. "MB." *Zodiac* 8 (1961).

ProcessA. "The Legacy of MB." Special issue (September 1982).

Seidler, Harry. In *Contemporary Architects*.

Spring, B. F. "Evaluation. The Whitney Suffers from Success." *AIAJ* 67 (September 1978).

Stoddard, Whitney S. *Adventure in Architecture. Building the New Saint John's*. New York, 1958.

The UNESCO Courier. (Paris) 11 (November 1958). The whole issue.

Wilk, Christopher. *MB. Furniture and Interiors*. London, 1981.

Bibliographical

Vance: Lamia Doumato, A53, 1979; Robert Harmon, A202, 1980; Dale Casper, A2038, 1988.

JOHANNES ANDREAS BRINKMAN and LEENDERT CORNELIS VAN DER VLUGT. J. A. Brinkman (1902 [Rotterdam,] the Netherlands–1949) studied architecture at the Delft Technische Hogeschool and in 1921 entered the Rotterdam architectural firm that his father Michiel (1873–1925) had founded in 1910. Inheriting the practice in 1925, he formed a partnership (1925–1936) with L. C. van der Vlugt, a sometime employee of his father and a gifted designer in the new firm.

L. C. van der Vlugt (1894 [Rotterdam]–1936), possibly upon the advice of his contractor father, studied architecture at the Rotterdam Academy of the Visual Arts and Technical Sciences. He entered Michiel Brinkman's office for a short time (ca. 1915) and over the next ten years his search for experience took him first to Buskens in Rotterdam (ca. 1917) and as far north as Groningen, where he collaborated with Jan Wiebinga on a monolithic building for the Polytechnic College (MTS) (1922–1923). In much the same manner of Albert Kahn's* industrial buildings and Walter Gropius* and Meyer's Fagus factory, the external walls are relieved of load bearing, enabling continuous bands of windows along the symmetrical facade. The MTS is widely considered to be the first fully Functionalist design in Holland. Van der Vlugt early came under the influence of Le Corbusier,* as evidenced by the cubic forms of the Vink house (with K. Siekman, 1924–1925), at Zuidhorn.

That attachment was carried into the partnership he formed with Brinkman. The practice was opposed to traditionalism and decisively committed to industrialized, non-craft design techniques. Their greatest achievements were in Rot-

terdam: the Van Nelle factory (with Mart Stam,* 1926–1929), the Bergpolder flats (with van Tijen, 1932–1935), and Feyenoord stadium (1934–1936).

The Van Nelle factory, for the enlightened client C. H. van der Leeuw, has been called one of the "most important of all twentieth-century industrial buildings, and one of the most elegant."[1] The project was in train when Michiel Brinkman died and the major contributors to its design were the newcomers to the firm—van der Vlugt and Stam—who together made it a tangible expression of modernist thought. Besides optimizing functionality in an essentially utilitarian building, stress was laid upon providing for employees high-quality working conditions hitherto unseen in Holland. The result was the "combination of an objective Functionalism and a humane view of architecture . . . in one of the absolute pinnacles of the *Nieuwe Bouwen* in The Netherlands."[2]

There were other projects for van der Leeuw: a country house at Rockanje (1930) and notably the family villa in Kralingseplaslaan, Rotterdam (1928–1929), in which the debt to Le Corbusier is patent. His *Vers une Architecture* (Paris, 1923) had an immediate impact on Holland's younger architects, displacing (but not in all quarters) the peaceful penetration of Frank Lloyd Wright.* Still in their twenties, and susceptible to winds of doctrine, Brinkman and van der Vlugt embraced some of the Swiss-Parisien's ideas, including the use of his *traces regulateurs* in the facades of the Kralingseplaslaan house. Over the next few years they built more white stuccoed, cubist, detached houses.

Corbusian influence may also be seen in the Bergpolder flats, designed for the Volkswoningbouw Rotterdam Building Society. The idea of high blocks with access to light, sun, and air with verdant spaces between them, part of a broad vision . . . based upon the belief that standardization could solve contemporary housing needs was also Corbusian. Through the use of a steel frame and prefabricated elements (stairs, balconies, access galleries, and external wall units) the building economically provided seventy-two units on nine levels, rising on a *piloti* base. It became a prototype for later slablike housing developments in Dutch cities. As Grinberg points out, Bergpolder is significant because it demonstrated the economic viability of high-rise housing (issues of society and culture and context may not have been considered). It anticipated Le Corbusier's Unite d'Habitation by thirteen years.[3] The building attracted attention in both Britain and the United States, where it was offered as a model by the aficionados of high-density workers' housing.

From 1934 to 1936, Brinkman and van der Vlugt produced the Feyenoord football stadium, also in Rotterdam. Identifying it as "an exceptional example of a large structure significant in the lyrical unfolding of linear wefts," the Italian historian Giovanni Fanelli asserts that their best work was reserved for "industrial buildings or constructions of great size" because they were good at "the coldness of critical, knowing calculation."[4] Much of the international admiration they drew came from Italy, where their work was immediately and frequently published.

After van der Vlugt's early death, Brinkman worked (1937–1948) with J. H.

van der Broek, carrying on the torch of the Nieuwe Bouwen against increasingly conservative opposition. The continuing practice, in place during the apprehensive 1930s and during the German occupation, did not generate the same kind of internationally celebrated modernist icons; most work was modest and domestic, although after World War II they undertook a few industrial buildings.

NOTES

1. Curl in *Contemporary Architects.*
2. Paul Groenendijk and Piet Vollaard, *Guide to Modern Architecture in the Netherlands* (Rotterdam, 1987), 230.
3. Grinberg (1977), 125.
4. Fanelli (1978), 352.

BIBLIOGRAPHY

Writings

With others, *Woonmogelijkheden in het Nieuwe Rotterdam.* Rotterdam, 1941.

Bibliographical

Bakema, J. B. *L. C. van der Vlugt.* Rotterdam, 1968.
Curl, James Stevens. In *Contemporary Architects.*
Housden, Brian. "M. Brinkman, J. A. Brinkman, L. C. van der Vlugt, J. H. van den Broek, J. B. Bakema." *AA Journal* 76 (December 1960). Special issue.

Assessment

Abitare. "Tobacco, Tea and Coffee; the Van Nelle Factory, Rotterdam." 236 (July 1985).
Architect and Building News. "Working Class Flats, Rotterdam." (London) 163, 20 (1940).
ARecord. "House van der Leeuw, Rotterdam." 68 (October 1930).
———. "Van Nelle Factory, Rotterdam." 69 (May 1931).
Beeren, Wim, et al. *Het Nieuwe Bouwen in Rotterdam 1920–1960.* Delft, 1982.
Cahiers d'Art. "Usines de tabac à Rotterdam." (Paris) 4 (1929).
De 8 (October 1936). The whole issue.
Domus. "L'architettura moderna a duratura." 266 (January 1952).
Grinberg, Donald I. *Housing in the Netherlands 1900–1940.* 2d ed. Delft, 1977; 1982.
———. "Modernist Housing . . . the Dutch contributions." *Harvard* 1 (Spring 1980).
Hamlin, Talbot Faulkner. "Rotterdam's Machine for Housing." *AmericanA* 147 (October 1935).
Martin, J. L., et al. *International Survey of Constructive Art.* London, 1937; 1971.
Merkelbach, Ben. "Twee woonhuizen in Rotterdam." *De 8* (November 1934).
Persico, Eduardo, and Leo Lionni. "Brinkman e van der Vlugt architetti." *Casabella* (March 1935).
Roth, Alfred. *The New Architecture.* Zurich, 1940.
Takeyama, Minoru. "Modern Classic: van Nelle Factory." *a+u* 157 (October 1983).
Yashiro, Masaki. "Collective Housing in Holland: Traditions." *ProcessA* 112 (1993). The whole issue.
Yorke, Francis Reginald Stevens and Frederick Gibberd. *The Modern Flat.* London, 1950.

Bibliographical

Fanelli, Giovanni. *Moderne Architectuur in Nederland 1910–1940.* The Hague, 1978.
Vance: Donald Langmead, A1671, 1986; A1672, 1986; A1773, 1987.

GORDON BUNSHAFT. 1909 (Buffalo, New York)–1990. Son of Russian im-
migrants, Bunshaft earned bachelor's and master's degrees (1935) in architecture
at the Massachusetts Institute of Technology. On a Rotch Traveling Fellowship
he toured Europe and North Africa (1935–1937) after which he was hired as a
designer by Louis Skidmore* at the New York offices of Skidmore and Owings
(see Nat Owings), later Skidmore, Owings, and Merrill* (SOM). Upon returning
from service in World War II he was made a partner (1946). In total Bunshaft
remained with SOM for forty-three years. He was a visiting professor in a
number of American universities and his architectural designs have received
many awards. Bunshaft was recipient of a Gold Medal from the American Acad-
emy and was a joint winner with Oscar Niemeyer* of the 1988 Pritzker Prize
in Architecture.

<center>✐</center>

Within the firm of SOM, Bunshaft was the responsible partner and designer
for a number of important buildings that individually established milestones,
indeed landmarks, in the evolution of post-1950 architecture in America and
elsewhere. Most were noted for their two- and three-dimensional conceptual
clarity, uncomplicated plans, structural innovation, appropriate, often rich ma-
terials, and refined detailing. Many of his buildings helped define a progressive
yet stable image for corporate clients.

His first major building was the Lever House in New York City (1952). After
Pietro Belluschi's* Equitable Building (1948, where a flush surface and green-
toned glass were first used), Lever House established the external application of
quickly assembled metal and glass (transparent and opaque) as a skin for sky-
scrapers and other building types of the late twentieth century. Lever also es-
tablished new standards for urban buildings by having an open, accessible
landscaped ground level and a glass-covered tower that occupied only 25 percent
of the airspace above the second level. This was achieved by placing the second
level on posts and on it a garden (see Plate 21).

In the 1950s a number of large corporations moved their offices to semirural
places in landscapes reminiscent of Englishman Capability Brown's eighteenth-
century designs. Among the corporations was Connecticut General Life, which
relocated to outside Hartford (1954–1957). Bunshaft created a complex of build-
ings of two and three stories using the structural and aesthetic system first em-
ployed on the lower part of the Lever building. A similar ground level scheme
was used for the small but elegant—and often copied—Pepsi-Cola office build-
ing (later housing Olivetti) in New York City (1958–1959) where above ground
level the outer skin is of aluminum uncolored and light green glass.

SOM was always searching for new, radical structural systems, and no one

employed those innovations more elegantly than Bunshaft. His Beinecke Library for Yale University at New Haven, Connecticut (1962–1963) is one example. Large welded steel Vierendeel trusses carry five-story exterior walls on four concrete piers. The trusses are covered with grey marble and infilled with reddish marble through which daylight subtly penetrates and colors the interior. The trusses surround an open space devoted to display and a lounge in the center of which are stacks supported on an independent steel structure.

Another example is the Hajj Terminal for the airport in Jeddah, Saudi Arabia, that services only the annual pilgrimage of millions to Mecca (1981–1982 with Gordon Wildersmith and Raul de Armas). Paired tapered masts support tensile steel cables and a series of fiberglass tents.

The monumentality of the solution is given a fresh lightness . . . the translucent conical [tent] tops have, as it were, fallen off the ladder-like supports to be caught in a tight web of angled lines which hover above the vast desert plain.[1]

The terminal received an Aga Khan award (1983).

Historian Charles Jencks has noted that when Bunshaft builds ''in a place like Saudi Arabia he will essentialize history to a sublime degree, so that it takes on an abstract universal power.''[2] Another example of this abstraction is also found in Jeddah: Bunshaft's National Commercial Bank (1979–1984). The plan is of three parts. A five-story circular car park is on axis with a rectangle of vertical facilities (including elevators) that service a giant triangular tower with glass-faced offices facing inward on a central courtyard twenty-seven stories high. Except for one or two large holes the three exterior walls are blank, faced with marble of reddish beige or sun-tanned color. The Hirshhorn Museum, in Washington, D.C. (1974), is a four-story doughnut with glass on the courtyard facing wall; the exterior is solid and windowless.

Around 1960 and perhaps influenced by the ''sun and shadow'' wall system of Marcel Breuer,* there was an increasing attempt to integrate the exterior wall with the structure rather than treat it as an applied skin. With Bunshaft's Banque Lambert in Brussels, Belgium (1958–1960), the ground floor is relatively open and the principal floors above are carried on a concrete slab (attached to the interior vertical core) that sits on posts with iron pin joints. The exterior wall is structural in precast concrete elements in bold relief, separate from the glass wall behind, all rising seven stories. Apartments occupy a recessed top floor. The building achieves a proportional elegance not found in Breuer's work.

These examples confirm the breadth of Bunshaft's design skill and demonstrate that his designs were not only innovative but the quintessence of post-midcentury architecture.

See SOM.

NOTES

1. Charles Jencks, *Architecture Today* (London, 1988), 230.
2. Ibid., 232. See also Krinsky (1988).

BIBLIOGRAPHY

Writings

"Banque Lambert, Brussels." *AReview* 139 (March 1966).

Biographical

Filler, Martin. "Design." *Avenue Magazine* (New York) (September 1976).
Jacobs, David. "The Establishment's Architect-plus." NYTM, 23 July 1972.
Krinsky, Carol Herselle. *Gordon Bunshaft of Skidmore, Owings & Merrill.* New York, 1988.
Spreiregen, Paul. In *Contemporary Architects.*

Assessment

Coles, William A., and Henry Hope Reed, Jr. *Architecture in America: A Battle of Styles.* New York, 1961.
Drexler, Arthur. *Transformations in Modern Architecture.* New York, 1979.
Engineering News-Record. "Glass-Walled Skyscraper." (New York) 148 (1 May 1952).
"House of Glass." In Lewis Mumford, *From the Ground Up.* New York, 1949.
Industrial Design. "The Team Approach." (New York) 5 (September 1958).
McCallum, Ian. *Architecture U.S.A.* New York, 1959.
Mirmar. "Hajj Terminal, Jeddah. Tents for the Future." (April 1982).
PA. "The Library-Museum at Lincoln Center." 47 (April 1966).
———. "Opposite. Expressionism and Formalism at Yale." 45 (February 1964).
Reynolds, Donald Martin. In Macmillan.
Schmertz, Mildred F. "Conserving a Rich Architectural Heritage." *ARecord* 191 (September 1983).

Bibliographical

Vance: Frances Gretes, A2120, 1988.

C

SANTIAGO CALATRAVA (-VALLS). 1951 (Benimanet, Spain)– . Early schooling in art and architecture in Valencia were enhanced by painting and sculptural studies in Paris and then advanced laterally by formal civil engineering at the Institute of Technology in Zurich (1975–1979) from which he obtained a Ph.D. (1981) on the subject of space frames. He immediately established and still maintains a professional office in Zurich. His mentor was Christian Menn, whose father had worked with the prominent Swiss engineer/architect/builder Robert Maillart. During a hitherto brief career he has exhibited often, once at the New York Museum of Modern Art, and has received art prizes and honors including the Gold Medal of the Institute of Structural Engineers, London (1992), and the Auguste Perret Prize of the International Union of Architects (1991).

⌒⌝

In the European tradition, Calatrava is an architect and engineer as were Pier Luigi Nervi* and Jean Prouvé,* both also professional builders. He is not, however, just a technologist but sculptor. Peter Buchanan suggests that Calatrava "tends to the more overtly organic in form and/or metaphor—often with a literalness that, because of its many nostalgic associations, transgresses cautious taste."[1] How very English. Buchanan is quite correct when he identifies biological metaphors. Calatrava's sketches reveal this tendency with their aggressive sweeping lines and curves. The completed structures, large or small, highlight the flow of forces resisting gravity within the materials: his artistic sense sculpts the material to visually soften the unnatural tensions in that resistance. Their sculptural qualities are at times graceful, or delicate, or brusquely

masculine. They can be deceptively simple as with the Alarmillo Bridge, in Seville, Spain (1987–1992), whose great split concrete post leans back to resist the strain of steel wires holding a concrete span. This is one of the few instances in which the visual impact of resistance is not softened.

Simple in form, his bridges usually hang suspended from an arch that is typically made of concrete. The Le Devesa footbridge, in Ripole, Spain (1989–1991), is an excellent example among many. His buildings can be visually complex, however, such as the underside of the roof structure for the Concrete Pavilion for the Swiss Building Fair, in Basel (1989), which in its biomorphic forms and juxtapositions is quite sexual.

He has used steel in tension, as at Alarmillo, and compression and cantilever, as at the Airport Railway Station in Lyon (1989–1992) where the roof of the main building can be likened to a great steel-winged bird about to land. He has also used steel as small, single elements in tightly spaced series; the Wohlen High School Assembly Hall in Switzerland (1984–1988) and the Ernsting Warehouse in Westphalia Germany (1983–1989, with Bruno Reichlin and Fabio Reinhardt) are examples.

When he entered a design competition to complete Saint John's (1892) in New York City (1991), Calatrava reexamined masonry Gothic structures by looking to the stress and force lines and converting them into continuous, thin concrete members. Those ideas were converted into steel for a number of commissions, such as roofing part of Heritage Square, in Toronto (1992–). He seems to prefer the curve as line and form whether rather freely evolved or as a segment of a circle or ellipse. The result is of course all based on engineering principles. The forms themselves, notes Darl Rastorfer, arise out of early sketches of moment diagrams. Then,

Two structural motifs dominate . . . torsion rings and folded girders. . . . Unlike the simple linearity of tension and compression, torsion is a spiraling stress. Calatrava knowingly lifts the locus of the torsion away from the boundary of the structure. The result is a dynamic form whose members radiate, as perfectly balanced vectors, from the torsion ring.[2]

Studies of space frames in graduate school led to a reexamination of segmented and folded frames, which he has lightened and applied to both steel and concrete structures. Calatrava has acknowledged his debt to the empirical studies of Antoni Gaudi, to Nervi, and to Felix Candela,* each more tuned to intuition than most architects. Candela wrote an introductory piece for the recent *El Croquis* monograph about Calatrava.

When Anthony Webster penned the terms "utility, technology, expression," he meant that Calatrava gives them equal weight during the design process. Experientially, "expression" seems to dominate simply because the forms are so elegantly refreshing in their newness. The sculptural rationalism, if you like, of Calatrava's designs can be usefully compared to the aesthetic fancy of his contemporary, Frank O. Gehry.* But why ponder which architectural approach

is the more valid? Architecture is, after all, concerned with all the senses plus the intellect.

NOTES

1. Buchanan (1987), 51.
2. Rastorfer (1986), 137.

BIBLIOGRAPHY

The abbreviation SC for Santiago Calatrava is used below.

Writings

"Asthetik und Geschichtlichkeit." *Werk* 38 (December 1983).
"Das Tor als Skulptur." *Werk* 73 (September 1986).
Dynamische Gleichgewichte . . . Dynamic Equilibrium: Recent Projects. Zurich, 1992.
"Hallenbau zwishern." *Archithesis* (Switzerland) 13 (July 1993).
Ingenieur. Architektur, edited by Werner Blaser. Basel, 1989; 2d ed. as *SC. Engineering Architecture.* Basel, 1990.
"Vordach Nord Postbetriebsgebäude, Luzern." *Werk* 38 (December 1983).
With Peter Nicholin. "Sports Hanger." *Lotus* 48 (1985–1986).

Assessment

a+u. "SC." 192 (September 1986). Anthology.
———. "SC." 224 (May 1989). The whole issue.
ADesign. "SC Leyn Airport." 63 (July 1993).
Architettura. "In the Belly of the Bridge." 39 (December 1993).
Buchanan, Peter. "Artful Engineering." *AReview* 186 (October 1989).
———. "Expressive Engineering." *AReview* 184 (September 1987).
de Carli, G. "Cabaret Tabouretti, Basilea." *Domus* 697 (September 1988).
Croquis. "SC 1989–1992." 57 (December 1992).
Cullen, Michael S. *Calatrava. Berlin: Five Projects.* Boston, 1994.
———. "Stadelhofer Train Station." *a+u* 251 (August 1991).
GADoc. "Science Museum, Valencia, Spain." 36 (1993).
Harbison, Robert, and Paolo Rosselli. *Creatures from the Mind of the Engineer. The Architecture of . . .* Zurich, 1992.
Jenni, B., and M. Steinmann. "Bahn versus Stadt." *Archithesis* (Switzerland) 14 (May 1984).
Lemoine, B. "SC." *Aujourd'hui* 267 (February 1990).
Lotus. "Bridges and Canopies." 47 (1985).
———. "The Stadelhofer Station." 69 (1991). The whole issue.
Metz, Tracy. "Express Track." *ARecord* 179 (August 1991).
Ortelli, Luca, et al. "L'arte della scienza." *Lotus* 45 (1985).
Peter, T. "P/A Technics." *PA* 70 (April 1989).
Pimienta, G. "Plastik und Bauiveise." *Werk* 75 (May 1988).
Ranzani, E. "Ponte de Connessione." *Domus* 696 (July 1988).
Rastorfer, Darl. "The Structural Art of SC." *ARecord* 174 (August 1986).
Russell, James. "Perfect Pitch." *ARecord* 177 (Mid-September 1989).
Slatin, Peter. "Steel Connection." *ARecord* 181 (February 1993).
Slessor, Steven. "Big Bird on a Wire." *AReview* 193 (September 1993).
Tischhauser, A. "Tree of Life." *AReview* 190 (April 1992).

Tzonis, Alexander, and Liane Lefaivre. *Movement, Structure, and the Work of SC.* New York, 1995.
Webster, Anthony. "Utility, Technology and Expression." *AReview* 191 (November 1992).
Webster, Anthony, et al. *Calatrava Bridges.* London, 1993.
Werk. "Dossie Bahnhof." 78 (March 1991).

FELIX (OUTERIÑO) CANDELA. 1910 (Madrid, Spain)– . At Madrid's High School for Architecture, Candela concentrated on engineering and received a diploma in 1935. He attended the Fine Arts Academy at San Fernando, Spain (1936), worked for an engineer, and then served in the Spanish Army (1935) and Republican Army (1936–1939). From a French refugee camp Candela was sent to Mexico (1939) where he immediately began to work as a draftsman. He was in partnership with Bringas (1940–1941) and an associate with Jesus Marti in Mexico City (1941–1944). He then commenced private practice (1944–1969). With his engineer brother, Antonio, he formed a design and—like Jean Prouvé* in France and Pier Luigi Nervi* in Italy—construction firm in Mexico City (1950–1969). In Mexico alone they completed nearly 900 structures. He was an associate architect with Praeger-Kavanagh-Waterbury, in New York (1969–1971), again in private practice in Chicago (1971–1979), and then in Madrid, Spain, from 1980. His travels resulted from many visiting appointments to universities in Mexico, England, North America, and Spain and various consultancies. Candela has received awards and honors including the Auguste Perret Prize of the International Union of Architects (1961), the Charles Elliot Norton Professorship of Poetry at Harvard University (1961–1962), and the Gold Seal of the Mexican Society of Architects (1963).

"There is no spectacle more sad," Candela has said, "than that offered by a triumphant revolution whose ideological content, political and philosophical program, does not withstand the test of reality. Functionalism was . . . the literary justification, of a revolution whose immediate objective was simply the overthrow of historical styles. It very quickly became boring.

Structural design has much more to do with art than with science. . . . I have only tried to develop visual intelligence.

A problem must first be stripped of everything that is unnecessary and superfluous. Once the essence is bared, the rest is easy.[1]

The entirety of Candela's considerable reputation resides not in architectural design but in engineering, in the promotion and construction of light, thin concrete shell structures that begin with the assumption that geometric form, not mass, provides structural resistance. However, his imprint on the pages of architectural modernism was measurable.

During high school he grappled with the Theory of Elasticity and became fascinated with laminated structures. Soon shell structures captured his imagination. He watched the construction of Eduardo Torroja's shell-vaulted roof in

Spain for Frontón Recoletos (1935). No doubt Candela was aware of the giant parabolic barrel vault of the Cement Pavilion at the Swiss Provences Exhibition, in Zurich (1939), by the engineers Robert Maillart and Hans Leuzinger. With further study, perhaps also of the French engineer Eugène Freyssinnet's work with parabolas in the 1920s, Candela concluded that his ideas of and computations for elasticity and rigidity of form were correct and when mixed with intuition the resulting forms could be visually wonderful. When in the 1950s Candela expounded a "New Philosophy of Structures" he broke with conventional analytical methods that had begun in the 1920s.

He first employed a shell for a bowling alley, rather spectacular for its day. He then received the commission for a Cosmic Ray Building for University City (1951) where he constructed the first hyperbolic paraboloid (HP) with a roof thickness of just 5/8 inch. The formwork for a concrete HP shape has the advantage of being made of straight pieces of wood. This simple process together with a minimum of material proved economical and encouraged the Candela brothers to begin their construction business specializing in HPs. Most of their commissions were received from other architects. So, as historian John Winter has said, the disadvantage of being architect and builder is that "the work is often carried out for indifferent architects." As a result, Candela has "confessed to preferring many of his buildings half finished" before "the architecture is added."[2]

Indeed many of his buildings may appear to fussy architects as incomplete, surely unfinished. Their formal character, however, and bold three-dimensional appearance announces a proud, confident designer: embellishment unnecessary. Yet it is just when he is somehow compelled to add to his architecture that there is disappointment. Take for instance the Church of Our Miraculous Lady, in Mexico City (1953), where on the interior the plain underside of the HPs and integrated posts are exposed. On the exterior are ponderous edge beams forming giant inverted V's, bulky walls, unrelated tile infill, awkward and disparate shapes: all to tragic proportions and distracting from—mostly hiding—the graceful shell forms. Similar problems exist in the Santa Monica Church, also in Mexico City (1966).

Candela is at his best when allowing his mathematically stable forms, seemingly sensed with infinity, to be unadorned, where intuition and perception—a viewer's experientially and Candela's—evolves easily and pragmatically to understanding. Examples are the Cabero Warehouse, in Valleyo, Mexico City (1957), where 4 million square feet are roofed by a series of HPs that appear as frozen rectangular umbrellas, and the Los Manatiales restaurant, in Xochimilco, Mexico City (1958, with J. Alvarez Ordonez), roofed with eight shells radiating out from a central point like light three-dimensional petals waved by a breeze. The restaurant was Candela's favorite work. There are the tripartite groined vaults of the small "Candela Shell" in the Flower Fair grounds in Oslo, Norway, and in the Chapel of the Missionaries of the Holy Ghost, in Coyoacán (1956, with Enrique de la Mora), a most restrained church with a single envel-

oping HP: all done with what Hitchcock calls "casual ease and *ad hoc* inge-
nuity."[3]

With few exceptions, Candela's concrete is around 1.5 inches thick. And
architectural elements, including plan, are usually subservient to the thin
membrane structure. One result of his achievements probably inspired closely
related investigations by other researchers into, for instance, plywood vaulting
and warping, domes as pure sections of a sphere (as with Eero Saarinen's*
Kresge Auditorium at the Massachusetts Institute of Technology [1955], or Jørn
Utzon's* Sydney Opera House [1957], that is the forms as created without
engineers Ove Arup), plain barrel vaults, or in particular Eero Saarinen's "sen-
sualist" TWA Terminal at Kennedy Airport, in New York City (1957–1962, a
scientifically illogical building disliked by Candela), or the main building of the
Saint Louis, Missouri, airport by G. F. Hellmuth, Joseph W. Leinweber, and
Minoru Yamasaki (1953–1955). The Saint Louis airport building has a close
affinity with Candela's Church of Saint Anthony of the Orchards, in Tabaca,
Mexico City (1955–1956), with de la Mora and Fernando Carmona), which also
employed three very large groined concrete vaults. (By the way, the Argentinian-
American architect Eduardo Catalano used a single HP for his own house in
1954, but the roof is edged with a steel channel.)

The first decade after the 1945 armistice was a time when architects were
critical of the sterilizing effect of the falsely described functionalist products of
the International Style. Investigations were directed at examining old formulas
and methods in an effort to exploit them, or as Candela had done, to challenge
theories dependent on compressive characteristics as inherent in post, beam, and
masonry arch structures. A major inducement to these efforts was an attempt to
apply new ways of making and applying strengthening steel, new concrete ad-
ditives, and foamed concrete, for example, or simply to reach for new ideas.
Candela's thin shells and HPs were part of those investigations. So too were
advances in steel and wood space frames, lamination (new glues), lamella
trusses, tensile and catenary structures, and so on. All had an impact on the
course of modern architecture midcentury and beyond. All in some manner
added much to a designer's devices and working vocabulary. But none chal-
lenged the imagination quite like Candela's gravity-defying, often elegant forms.

The 1950s were productive years. After 1965 Candela became more intro-
spective. Of all of his intellectual and artistic wanderings Candela has said:

The irrational or intuitive methods of design might not be so illogical after all. They
depend on the capricious and sporadic functioning of the subconscious. . . . The subcon-
scious is much more reliable than usually is thought, as artists and saints have known
for centuries.[4]

NOTES

1. Candela quoted in Smith (1967), 101.
2. Winter in *Contemporary Architects.*

3. H.-R. Hitchcock, *Architecture: Nineteenth and Twentieth Centuries.* 3d ed. (Baltimore, 1969), 565.

4. As quoted in Smith (1967), 120–21.

BIBLIOGRAPHY

Writings

"Architettura e Strutturalismo." *Casabella* 306 (1966).

"Candela. Recent Works." *Zodiac* 22 (October 1973).

Foreword, in Conrad Roland. *Frei Otto: Spannweiten.* Berlin, 1965.

"The Heritage of Maillart." *Archithese* (Niedertaufen) 6 (1973).

Reinforced Concrete Shells. [School of Design] (Raleigh) 9, 2 (1960).

"The Shell as Space Encloser." *AandA* 72 (January 1955).

"Shell Structure Development." *CanadaA.* 12 (January 1967).

Toward a New Philosophy of Structures. [School of Design] (Raleigh) 5, 3 (1956). Part 2: 6, 1 (1956).

"Understanding the Hyperbolic Paraboloid." *ARecord* 124 (July 1958); Part 2: 124 (August 1958).

Biographical

Faber, Colin. *Candela. The Shell Builder.* Munich, 1963.

Smith, Clive Bamford. *Builders in the Sun. Five Mexican Architects.* New York, 1967.

Assessment

AForum. "Shell Concrete Today." 101 (August 1954).

Arquitectura. "Felix Candela." (Madrid). 1 (October 1959).

Cetto, Max L. *Modern Architecture in Mexico.* Stuttgart, 1961.

———. In Lampugnani.

Harris, Elizabeth D. In Macmillan.

Katzman, Israel. *La arquitectura contemporanea Mexicana precedentes y desarrollo.* Mexico City, 1964.

McCoy, Esther. "Mexico Revisited." *Zodiac* 12 (1964).

Nicholson, Irene. "Mexico: Enrique de la Mora and Felix Candela." *CanadaA.* 7 (February 1962).

PA. "Recent Work of Mexico's Felix Candela." 40 (February 1959).

———. "The Work of Felix Candela." 36 (July 1955).

ProcessA. "Modern Mexican Architecture." Special issue (July 1983).

Winter, John. In *Contemporary Architects.*

Bibliographical

CPL: Sara Richardson, 2232, 1989. Design Book Review DBR. "Other Americas." 32/33 (Spring 1994).

CIAM. See Congrès Internationaux D'Architecture Moderne.

CONGRÈS INTERNATIONAUX D'ARCHITECTURE MODERNE (CIAM). In the second half of the 1920s there was a generally free interchange within Europe of the radical ideas of contemporary architecture. This was largely achieved through the modernist domination of journals and other publications, repeating

the phenomenon (in principle if not in matter) which thirty years earlier had spread the Arts and Crafts message. There the similarity ended: whereas the voices of the Arts and Crafts movement had been raised in what was essentially unison, the modernists of Germany, Russia, Holland, and France, seeing the need to adapt to changing social structures and the implications of industrialization, and mutually moved by the perceived urgency to reform urbanistic and especially housing policies, sang the anthem of Internationalism in several part harmony. To paraphrase Karl Marx, should the architects of the world unite, they could apply unified pressure to bring about the changes they all believed necessary.

In 1928 F. T. Gubler, secretary of the Swiss chapter of the Deutscher Werkbund, suggested to Hélène de Mandrot that she offer her castle at La Sarraz, Switzerland, for a meeting of Europe's leading architects. From that 1928 gathering, sponsored (i.a.) by Henry Fruges, Jean Michelin, and Gabriel Voisin, the Congrès Internationaux d'Architecture Moderne, or CIAM, was formed by the twenty-five architects present. They saw rationalization and standardization as priorities in humanely solving the problems each faced in his own country. Austria, Belgium, France, Germany, Holland, Spain, and Switzerland were represented, although some delegates already enjoyed a European, if not a universal, reputation: Berlage, Le Corbusier,* and Mart Stam.*

The La Sarraz meeting, dominated by Le Corbusier, was little more than a clearinghouse for ideas. According to Arnulf Luchinger, "It was Stam, Meyer and Schmidt who created the famous concluding declaration . . . thereby thwarting Le Corbusier's intention of putting forward his own conceptions."[1] The second congress held at Frankfurt in 1929 dealt with more concrete issues and discussion was chiefly about Swiss critic Siegfried Giedion's notion of *existenzenminimum*—low-cost residential units. During its deliberations on urbanism and housing policies, CIAM could not avoid entering the political arena. At the Brussels congress, held in November 1930, the Dutch architect and planner Cor van Eesteren was elected president (1930–1947); the theme was "The Functional City." Tafuri points out that it was Giedion who "gave the real measure of the common aim" when he asserted: "Just as the individual cell of habitation leads to the organization of the methods of construction, so too the methods of construction lead to the organization of the entire city"[2]—a simplistic, materialistic belief that overlooked the complex social interactions that characterize the city, especially the industrial city. CIAM formed a Committee for Resolving the Problems of Contemporary Architecture (French acronym, CIRPAC).

After a conference planned for Moscow was cancelled, CIAM members gathered on the yacht *Patris II* in 1933 for a working cruise between Marseilles and Athens. The resultant Athens Charter, published anonymously in 1943, reviewed the earlier discussions, restated the capitalistic barriers to adequate urban renewal or creation, and identified new problems such as regional planning and urban contextuality. But it offered no solutions except the same generic one: modern technology. The document, the closest thing to a definitive statement by CIAM,

was republished, signed by Le Corbusier in 1957—perhaps a reassertion in response to recent events, as set out below. The importance of the "Athens Charter," and its failings, have been eloquently set out by Tafuri and Dal Co:

To it probably belongs the credit for having founded a large measure of the predominant ideology of modern architecture, endowing architects with a model of action as flexible as it was already out of date.... It was also the most extreme demonstration of the radical diversities and the profound fragmentation of experiences that marked those early heroic years of contemporary architecture. Attempting to synthesize experience in large measure mutually contradictory, the Charter flattened out their originality, ignored their defeats, befuddled their tracks.[3]

The fifth CIAM congress dealt with housing and leisure and was held in Paris in 1937. When CIAM was overtaken by war in Europe, Giedion, Walter Gropius,* José Luis Sert, Richard J. Neutra,* and Stamos Papadaki sustained the group in the United States under the name CIAM, Chapter for Relief and Postwar Planning.

The first postwar conference, organized by the British Modern Architectural Research Group (MARS) at Bridgewater, England in 1947, was followed by others at Bergamo, Italy (1949), Hoddeston, England (1951), and Aix-en-Provence, France (1953). The Dutch architect Aldo van Eyck,* already active in the Amsterdam modernist group De 8 en Opbouw, had been among Holland's delegates at the 1947 Bridgewater meeting. He responded to what he heard there with a "Statement against Rationalism" and in 1956 at Dubrovnik, Yugoslavia, where CIAM was dissolved, he became a founding member of an international group of young architects—"a loose association of friends" of the modern movement—calling itself Team 10. Other instigators included Jan Bakema, Shadrach Woods, Giancarlo de Carlo, Georges Candilis, Alexis Josic, and Alison and Peter Smithson.* At the 1959 conference the old regime was replaced by the new, "setting its own goals for a new, more humane system of public housing."

NOTES

1. Arnulf Luchinger in *Contemporary Architects.*
2. Manfredo Tafuri and Francesco Dal Co., *Modern Architecture* (London, 1980), 219.
3. Ibid., 220.

BIBLIOGRAPHY

ADesign. "The Work of Team 10." 34 (August 1964). The whole issue.
Architect and Building News. "CIAM Arts Council, Bridgewater." 191 (19 September 1947).
Architects' Yearbook. "The Theme of CIAM 10." 7 (1956).
AReview. "CIAM: Resurrection Move Fails at Otterlo." 127 (February 1960).
———. "New Amsterdam School." 177 (January 1985).
Aujourd'hui. "Doctrines." 43 (October 1971). The whole issue.
Bollerey, Franziska. "Cornelis van Eesteren: A Closeup." *Urbanismo Revista* (Madrid) 8 (1989).

Buchanan, Peter. "City as Natural Habitat vs. . . . Cultural Artefact." *AReview* 176 (December 1984).

Cadbury-Brown, H. "Eighth CIAM." *AJournal* 113 (9 July 1961).

La Charte d'Athenes. Paris, 1943; Le Corbusier, Paris, 1957; *The Athens Charter,* New York, 1973.

CIAM. *Die Wohnung fur das Existenzenminimum.* Frankfurt am Main, 1930.

———. *International Congress for Modern Architecture* (proceedings of first nine conferences, facsimile). Cambridge, Mass., 1944.

———. *International Congress of New Building. Dwellings.* Stuttgart, 1933.

———. *Rationelle Bebauungsweisen. Ergebnisse 3.* Stuttgart, 1931.

Crosby, Theo. "Contributions to CIAM 10." *Architects' Yearbook* 7 (1956).

Eardley, Anthony. "Giraudoux and the Athens Charter." *Oppositions* (May 1974).

Forum (Amsterdam.) "De CIAM Groep." 12 (June 1957). The whole issue.

Giedion, Siegfried, ed. *CIAM: A Decade of New Architecture.* Zurich, 1951; New York, 1954.

Lods, Marcel. "L'Architecture entre deux geurres." *AMC* (Paris) 8 (March 1974).

Montaner, Josep Marcia. "La tercera generacion." *Croquis.* 7 (August 1988).

Newman, Oscar, ed. *CIAM: '59 in Otterlo.* London, 1961.

———. *Contemporary Otterlo.* Stuttgart, 1961.

Oberlander, H. Peter. "Twenty Years of Architectural Growth." *CanadaA* 25 (June 1948).

Oxenaar, R. D., and A. van der Woude. *Het Nieuwe Bouwen International; CIAM.* Delft, 1983.

Parametro. (Bologna) "Da Bruxelles ad Atene: La Citta Funzionale." 52 (December 1976).

Scott Brown, Denise. "Team 10, *Perspecta* 10, and the Present State of Architectural Theory." *American Institute of Planners Journal* (Baltimore) 32 (January 1967).

Senn, Otto H. "CIAM und Post-modernismus." *Werk* 71 (October 1984).

Smithson, Alison. "Team 10 at Royaumont, 1962." *ADesign* 45 (November 1975).

Smithson, Alison, ed. "CIAM 10. Habitat 1956." *Integral* (Barcelona) 8 (1956).

———. *Team 10 out of CIAM.* London, 1982.

———. *Team 10 Primer.* London, 1962, 1965; MIT Press, 1968.

Smithson, Alison, and Peter Smithson, eds. "CIAM—Team 10." *ADesign* 30 (May 1960).

Sola-Morales Rubio, Ignasi. "Architecture and Existentialism." *Casabella* 55 (October 1991).

Steinmann, Martin. "Political Standpoints in CIAM, 1928–1933." *AAQ* 4 (October 1972).

Steinmann, Martin, ed. *CIAM; Dokumente 1928–39.* Basel, 1979.

Tyrwhitt, Jacqueline, et al., eds. *The Heart of the City.* London, 1952.

PETER (FREDERIC CHESTER) COOK. 1936 (Southend, Essex, England)– . Following schooling in several southern counties, Cook studied architecture at the Bournemouth College of Art (1953–1958). In London he successfully undertook the AA diploma (1958–1960) and worked in a number of practices (1956–1964), then launched upon an academic career at the AA (1964–1989). In 1960 he helped found Archigram,* the radical group with which he remained

(in various relationships) until 1975. In 1978 he formed a partnership with Christine Hawley (his second wife); they continue their international practice. Cook was appointed professor of architecture at the Staatliche Hochschule fur Bildende Kunst in Frankfurt (1984) and Bartlett Professor at University College London (1991). He has been visiting professor and critic at many universities in the United States, Europe, and Australia. Besides exhibiting internationally with Archigram (1963–1973), Cook's solo work and that undertaken with Hawley has been exhibited in Europe, Japan, the United States, and Australia. He has won several architectural competitions and prizes including the Graham Foundation Award (1970) and the Japan Foundation Award (1977). Cook continues to write prolifically.

<center>~</center>

Toward the end of his Bournemouth course, Cook worked for the provincial firm of Jackson and Greenen as an architectural assistant, designing details; upon graduating from the AA, he worked in a similar capacity in James Cubbitt's London office. In 1962 he became an assistant architect in the Taylor Woodrow Design Group; there, he remained anonymous. With the birth of Archigram, the subsequent propaganda, and especially the 1963 "Living City" exhibition at the Institute of Contemporary Art, that anonymity was forever banished.

As a student at the AA, Cook had been influenced by (among others) James Gowan* and Peter Smithson*; in 1964, he returned to the school as assistant fifth-year studio master, rising to be head of the Diploma School by 1970. In 1973 he became a "unit master." Much of his creative production in those years was theoretical, the result of collaborations with some or all Archigram colleagues. Among them were the group project "Living City," followed by Cook's "Plug-in City" and its ancillaries: "Plug-in University," "Plug and Clip Room," and "Plug and Clip Housing" (1964–1966); and an electric car to serve these Plug-in projects and the group's "Instant City" in 1969. Archigram's work was publicized through exhibitions in London, Paris, and Milan, and its annual broadsheet. Then came a chance to give substance to beliefs: in 1970, Cook (with C. Fournier) won a competition for an entertainment center in Monte Carlo. He formed Archigram Architects with Dennis Crompton and Ron Herron,* to develop the design, but the scheme later lost its financial backing and without other work, the firm was dissolved in 1975.

Cook's first collaboration with the architect Christine Hawley (b. 1949) was on the Shinkenchiku House competition (1976) for which they won second prize. The Trondheim, Norway, Library competition immediately followed, and in 1978 the firm of Cook-Hawley Architects was established. Much of their output continues to be in the form of unrealized projects, although Cook sometimes works alone. In the 1980s they began to explore Deconstruction through several projects including a joint design museum for stained glass at Langen, Germany (1982), and a series of towers exquisitely rendered by Cook (1983–1984). None was built, but their staff and student restaurant at the Frankfurt Hochschule fur Bildende Kunst was realized in 1989. Its glazed roof, redolent

of the Langen museum project, "appears to float above an existing colonnade of classical columns to which it is actually attached by steel tension cables."[1] The fantasy if not the technocracy of the earlier Archigram drawings persists in the delightfully colored and rendered schematics produced by Cook and Hawley, evident in their presentation for housing in West Berlin.[2]

After about 1975 Cook traveled widely in Europe, the United States, and Australia, publicizing himself and Archigram and of course provoking discourse about architecture. His projects, including those with Hawley, have been and continue to be internationally published and exhibited. His polemical and critical writings are prodigious. As Gowan comments, "[Cook has] a formidable commitment, but he brings into this field of the imagination a skill and attack that are a match for it."[3] Cook's personal claim is: "I am the author of many projects that have been published all over the world. I am also a teacher and I lecture all over the world. My projects are much discussed by *other architects*. But I consider myself a designer rather than a theoretician."[4] That is a nice point whose validity hinges upon the definition of "designer": Cook is certainly that in the sense given by Alberti, who believed that the physical act of building is of little consequence to the architect.

See Archigram, Herron.

NOTES

1. Moffett (1993), 173.
2. Perusset (1989), 85–87.
3. James Gowan in *Contemporary Architects*.
4. As quoted in Gowan.

BIBLIOGRAPHY

Writings

"AA School." *Arena* (London) 84 (June 1968).
Archigram. 10 issues (1–9½). London (1961–1974).
Archigram. Special issue. London, 1972. Reprint, Basel, 1991.
"Archigram: The Name and the Magazine." *Perspecta* 11 (1967).
Architecture: Action and Plan. London, 1967.
"Architecture Is on the Wing Again." *AReview* 180 (August 1986).
"An Architecture of Optimism." *Domus* 742 (November 1992).
"Austria Vienna: Graz." *AReview* 184 (December 1988).
"Beyond the Normal Limits of 20th-Century Architecture." *AAFiles* 7 (September 1984).
"El efecto Archigram." *Croquis* 8 (April 1989).
"The Engineers Intervene." *AReview* 174 (July 1983).
Experimental Architecture. London, 1970.
"Formalhaut: Conceptual Games with Norms and Forms." *World Architecture* (London) 13 (1991).
"Gourmet Cook." *Interiors* 144 (December 1984).
"In Memoriam Archigram." *Daidalos* (Guertersloh) (15 June 1982).
"My Favorite Building." *a+u* 129 (June 1981).

"Peter Cook and Christine Hawley 1972–1979." *a+u* 113 (February 1980). The whole issue.

"Peter Cook: The Ark." *ADesign* 62 (January 1992).

Six Conversations. London, 1993.

"Unbuilt England." *a+u* 83 (October 1977). The whole issue.

With Christine Hawley. *Six Houses.* London, 1980.

With Shin Tabamatsu *The Killing Moon.* Folios. London, 1988.

With others. "The Living City." *Architects' Yearbook.* 11 (1965).

Biographical

Gowan, James, in *Contemporary Architects.*

Assessment

ADesign. "Trondheim Library." 49 (December 1979).

Alsop, William. "Cook in Langen." *A Review* 180 (July 1986).

L'Architettura. "A First Work: But by Cook and Hawley." 38 (April 1992).

Aujourd'hui. "Concourse pour la bibliothèque Trondheim." 193 (October 1977).

Banham, Reyner, and Christine Hawley. *Peter Cook. 21 Years—21 Ideas.* London, 1985.

Davey, Peter. "Passing It On." 175 (May 1984).

Derossi, Pietro. "Radical Recall." *Ottagono* (Milan) 99 (June 1991).

Jacobs, Stephen. "Poetry in Motion . . . Flying Words Project." *High Performance* Los Angeles 13 (Fall 1990).

JapanA. "Winners in the Shinenchiku Residential Design Competition." 51 (December 1976).

Melvin, Jeremy. "Layered Quartet." *BuildingD* 1172 (13 May 1994).

Mochida, Hideaki. "Education of Architectural Designing." *Kenchiku Bunka* (Tokyo) 45 (February 1990).

Moffett, Noel. *The Best of British Architecture 1980–2000.* London, 1993.

Nakamura, Toshio, ed. "Peter Cook 1961–1989." *a+u* Extra edition (December 1990). The whole issue.

Pawley, Martin. "Days to Remember and Days Best Forgotten." *Building* 256 (15 March 1991).

Perusset, Luca. "Peter Cook e Christine Hawley." *Domus* 711 (December 1989).

Peter Cook. London, 1993.

Peter Cook: 1961–1989. Tokyo, 1989.

Techniques. "Le laboratoire d'images." 358 (February 1985).

Toy, Maggie. "Michael Rotondi, Peter Cook." *ADesign* 64 (May–June 1994).

Bibliographical

Vance: Sara Richardson, A2230, 1989.

COOP HIMMELBLAU. Coop Himmelblau (literally, sky blue cooperative) was established in Vienna in May 1968 by architects Wolf D. Prix (b. Vienna, 1942) and Helmut Swiczinsky (b. Poznan, Poland, 1944). They opened an office in Los Angeles in 1988. In 1990 Prix became professor of the architecture master class at the Viennese Akademie fur Angewandte Kunst. Their work has been exhibited in London (1988), Paris (1993), Osaka (1990), and at New York's Museum of Modern Art (1989). They have received awards and won competi-

tions in Germany (1982), Austria (1985, 1988), France (1987), and the United States (1989, 1990). Prix, the partnership's propagandist, travels widely in Europe and America and supervises the Los Angeles office. He is also visiting critic at the University of California at Los Angeles. Swiczinsky remains at the Vienna office.

<div align="center">☙</div>

"Coop Himmelblau are a maverick Viennese partnership . . . whose anthropomorphic, aggressive architectural projects anticipated many of the concerns of the prevailing fashion for Deconstruction which has brought them into the international limelight."[1] "Since forming the firm in 1968 [Prix and Swiczinsky] have battled against their adopted city's tradition of recycling architectural styles, waging an ongoing war against historicism."[2] Their design has been called expressionistic, spontaneous, irrational—all, incidentally, characteristic of Deconstructivism and all making objective criticism difficult.

After several years of small-scale, largely interior design commissions, in the late 1970s Coop Himmelblau took a technological stance, drawing "airy therapeutic machines." They now aim, working on as wide a canvas as possible (like urban design), to unsettle and create unrest. Such a diametric contradiction of the ancient goals of architecture—harmony, unity, and clarity—may therefore be regarded as a kind of neo-Mannerism, "breaking the rules for kicks." Known for their "iconoclastic, psychographic approach," their reaction seems to be mostly against the history-plundering aspects of postmodernism: "We are tired of seeing Palladio and historical masks. . . . We don't want architecture to exclude everything that is disquieting. We want architecture to have more. Architecture that bleeds, that exhausts, that whirls and even breaks."[3]

Such slogans have led some critics to group them with the Deconstructivists of the late twentieth century. Otto Kapfinger, on the other hand, has challenged that categorization on the ground that it is merely a "fashionable label hindering more precise confrontation" of their "very specific *oeuvre*" which he then classifies as postindustrial expressionism.[4] Coop Himmelblau have written and drawn more than they have built, especially before about 1985. Some work has been in the form of studies and projects in the fine arts.

Coop Himmelblau achieve feelings of disquiet, discomfort, and disturbance by thrusting spaces or architectural elements through with box girders or more often giant needles, bars, and spikes—"an architecture of the chest spiked by the steering column." Early designs conveying "schism" were the Reiss Bar (1977) and the Red Angel Bar (1980–1981), both in Vienna and both "tumultuous, splintered and skewed interiors with not a single clean right angle in sight"[5] decorated in warm, earthy colors. The interior of the former is rent by a fissure emphasized by black, indented bands and ostensibly held together by massive turnbuckles. The front door is impaled upon two horrendous spikes. In the latter, "tin, steel and glass block embody the form and soul of the hovering angel, the wails of the singers, and the protests of an antiestablishment youth."[6] A penetrating diagonal spike forms the spine of the structure from which wings

spread out to enclose the space—a motif that had appeared in their project for Merz School, in Stuttgart (1981), and recurred in the prizewinning scheme for remodeling and extending the nineteenth-century Ronacher Theater, in Vienna (1987).

Other built Viennese interiors, like the fragile and refined Baumann Studio (1985), in which the internal palette changed to cooler colors including the European standard RAL1515 *himmelblau* (sky blue), and the elegantly lit Iso-Holding Company offices (1987), full of "artful and delicate details," show the development of their Deconstructivist ideas. The approach climaxed in a number of projects and buildings after 1987, including a prizewinning master plan for Melun-Senart, a new town near Paris, France (1987), a proposed city center of Saint Polten, Austria (1989–1990)—urban design schemes for which the comfort of polemic had to be relinquished for the reality of statutory authority—and a large hilltop studio for artist Anselm Kiefer in Buchen, Germany (1990).

Participating in a 1988 "video clips" scheme in Groningen, Holland, with Rem Koolhaas,* Daniel Libeskind,* Peter D. Eisenman,* and others, Coop Himmelblau built a canal-side pavilion in which people could watch video presentations. It looked very much like an exploding (literally, since it actually opens and closes) cathode ray tube supported on stilts in the water and reached by a slender flyover from the top of the dike. A larger commission was for the Funder Factory 3, a paper-processing plant in Saint Viet/Glan, Carinthia, Austria (1988–1989) (see Plate 46). In response to the client company's desire to strengthen its corporate image and improve the morale of its personnel, Coop Himmelblau "dissolved" what could easily have been a conventional long-span industrial shed into "an amalgam of more sculptural, functionally differentiated elements," much as Frank O. Gehry* had done in a number of houses around Los Angeles. The result was spectacular: a main building accented with a red entrance canopy and screen; a detached power plant with three seventy-five-foot-high, eccentrically staggering chimneys; and the production center whose south-facing corner is an exploding steel and glass structure which "seems like the result of a crash [or] like a separate element poised for flight."

That latter image may also be read in a penthouse law office built as an addition to a landmark neoclassical building at Falkestrasse 6, in Vienna (1984–1988). One critic has described it as "biomorphic . . . an exposed exoskeletal structure" whose boardroom, the focal point, looks like a "dissected ribcage."[7] Externally the addition evokes a huge beetle with spread wings, scrabbling for a foothold on the corner of the roof. Perhaps it is an analogy for Coop Himmelblau's attempt to find a place for their renegade architecture in the historic city of Vienna. Or perhaps it is about to fly, signifying the widening of their sphere beyond Vienna.

Their success in Germany, France, and Holland in the later 1980s has been mentioned. They continued to enter international competitions, and in June 1989 they won (with locally based Morphosis and Burton and Spitz) first prize for a pavilion in a performing arts park for Los Angeles. Opening an office in the

city, they secured commissions for the Melrose house, in Los Angeles (1990); the Open house, in Malibu (1989–1991); and the Rehak house, in Topanga Canyon (1990). In 1993 they won a competition for the Jussieu Campus Library of the University of Paris and were commissioned to design galleries for the Groninger Museum, in Groningen, Netherlands (master planner Francesco Mendini, Milan) and the UFA Cinema Complex in Dresden, Germany.

NOTES

1. Kapfinger (1988), 46.
2. Stein (1989), 82.
3. As quoted in *Deconstruction in Architecture* (London, 1988).
4. Kapfinger (1988), 46.
5. Heinrich Klotz, *20th Century Architecture* (London, 1989), 318.
6. Doubilet (1987), 129.
7. Stein (1989), 90.

BIBLIOGRAPHY

Writings

Architecture Is Now. New York, 1983.
Coop Himmelblau—Offene Architekture, Ent Wurfe 1980–1984. Berlin, 1984.
"Three Projects." *a+u* 184 (January 1986).

Assessment

Abe, Hitoshi. "Coop Himmelblau." *a+u* 256 (January 1992).
ADesign. "Crossing Points." 61 (July 1991).
———. "Three Projects." 60 (September 1990).
Antonelli, Paola. "Coop Himmelblau: Cucina MalZeit." *Domus* 721 (November 1990).
a+u. "Coop Himmelblau." 226 (July 1989). The whole issue.
———. "Coop Himmelblau: Campus de Jussieu Library." 283 (April 1994).
Arnold, François, and Florence Michel. "Gaterie Viennoise." *Architecture Intérieure Crée* (Paris) 252 (February 1993).
Aujourd'hui. "Explosion, Implosion, Tension: École Merz, Stuttgart." 233 (June 1984).
Baumeister. "Nach St Polten!" 88 (November 1991).
Beret, Chantal. "Coop Himmelblau: Architects with Attitude." *Art Press* 177 (February 1993).
Constantinopoulos, Vivian. "An *AD* Interview." *ADesign* 61 (November 1991).
Cook, Peter. "Spreadeagled." *AReview* 186 (October 1989).
Deutsche Bauzeitung. "Wie es Euch gefallt [Ronacher Theater]." (Stuttgart) 125 (June 1991).
Doubilet, Susan. "Towards Freedom." *PA* 68 (September 1987).
Farrelly, E. M. "Songs of Innocence." *AReview* 180 (August 1986).
GADoc. [Funder Factory 3 (St Veit/Glan)] 26 (1990).
———. [Gartenhotel Altmannsdorf, Vienna] 29 (1991).
Garcia-Marques, F. "Coop Himmelblau California Projects." *L'Arca* (Milan) 46 (February 1991).
Giovannini, Joseph. "Coop Himmelblau in Los Angeles." *AIAJ* 82 (December 1993).
Haslinger, Regina. "Coop Himmelblau." *Graphis* (New York) 49 (May 1993).

Jodidio, Philip. "Reconstruction l'utopie." *Connaissance des Arts* (Paris) 492 (February 1993).

Kapfinger, Otto. "Utopian and Image." *AReview* 184 (December 1988).

Manfredini, G. Paolo. "Il 'nuovo possibile' in architettura." *Abacus* (Milan) 8 (May 1992).

PA. "Performing Arts Pavilion." 71 (January 1990).

———. "Perspectives—Interview: Wolf D. Prix." 72 (September 1991).

Rattenbury, Kester. "Co-operative Movement." *BuildingD* (14 September 1993).

Robert, Jean-Paul. "Eclats sur ciel d'azur." *Aujourd'hui* 264 (September 1989).

Steiber, Nancy. "An RFQ to the Avant-garde." *PA* 72 (November 1991).

Stein, Karen D. "Atelier E. Baumann, Vienna, Austria." *ARecord* 174 (September 1986).

———. "Over the Edge." *ARecord* 177 (August 1989).

Steiner, Dietmar. "Architecture and Corporate Identity." *Ottagono* (Milan) 98 (March 1991).

———. Coop Himmelblau: Das Projekt Melun-Senart." *Bauwelt* 81 (28 September 1990).

Wigley, M. *Deconstructivist Architecture.* New York, 1988.

LE CORBUSIER (pseudonym for CHARLES-ÉDOUARD JEANNERET). 1887

(La Chaux-de-Fonds, Switzerland)–1965. The son of a watchcase maker and his piano teacher wife, Jeanneret studied engraving at the School of Applied Arts in his hometown (1900–1905). After declining a place in Josef Hoffmann's* Vienna office (1907) he worked part-time for Auguste Perret* in Paris (1908–1910) and briefly for Peter Behrens* in Berlin (1910). He founded and directed L'Atelier d'Art Réunis (1909–1914) and taught at Charles L'Eplattenier's new section of L'Ecole d'Art (1911–1914), both in La Chaux-de-Fonds, where he worked as a painter and lithographer (after 1912). He moved to Paris in 1917 and set up a private architectural practice which continued until his death, known latterly as ATBAT (Atelier des Bâtisseurs), with projects and built works throughout Europe and in India, Japan, and the Americas. He formed a partnership with his cousin Pierre Jeanneret (1922–1940), collaborated with Charlotte Perriand (1927–1929), and devised the Modulor system with Hanning and Elisa Mailard (1943–1948). Le Corbusier was chief planner for La Rochelle-Pallice, France (1945), and architectural adviser for the city of Chandigarh, India (1951–1959). He lectured at universities throughout Europe and the United States (1921–1956) and received honorary doctorates from the University of Zurich (1933), the Eidgenossische Technische Hochschule, in Zurich (1955), and Cambridge University (1959). His prolific work of all kinds has been exhibited internationally since 1902 and continues to be shown. Accolades include three levels of the French Legion of Honor (1937, 1952, 1963) and the Gold Medals of the RIBA (1959) and the AIA (1961).

✑

Andre Wogenscky wrote: "Le Corbusier's architecture . . . reduces the complicated to the simple, chaos to order, all directions to the vertical and to the horizontal, all lines to the right angle, all the noises of space to spatial music."[1]

William Curtis asserts that "it is impossible to understand architecture in the twentieth century without first coming to terms with Le Corbusier."[2] And the citation of the AIA Gold Medal, with not a little license, described him as Planner, Architect, Sculptor, Author, Painter, Poet, Visionary, Teacher, and "man of principle," who was "misunderstood but always respected." By an "insistence on seeking truth and beauty, by his great works," he "led and inspired the dawn of a new architecture."[3]

Lyrical, but it is in part debatable. While Le Corbusier never willingly acknowledged the influence of anyone, the evidence of his debt to others before 1918 is irrefutable. For example, over several months spent in Behrens's office he got to know Ludwig Mies van der Rohe* and Walter Gropius, and it is inconceivable that ideas were not exchanged. And more momentously, the architectural historian Siegfried Giedion asserted that Le Corbusier discovered the work of Frank Lloyd Wright* through Berlage's Zurich lecture of 1912. That is confirmed by Le Corbusier's biographer Willy Boesiger.[4]

The impact of Wright was significant in the first phase of the three phases of the Swiss' architectural career. Jeanneret first experimented with Wrightian architectonics in the Jeanneret house, in La Chaux-de-Fonds (1912). There followed projects for the Dom-ino house and a concrete house (both 1915) and the Schwob house, also in La Chaux-de-Fonds (1916–1917). Some formal, three-dimensional, and other elevational aspects were borrowed from Wright and blended with ideas from Swiss vernacular building and contemporary European architects, such as Josef Hoffmann and Auguste Perret. Plans for the La Chaux-de-Fonds houses were based upon Wright's plans, especially those for the Barton (1903) and de Rhodes (1906) houses, suggesting that Le Corbusier drew upon more tangible sources than his recollections of the Zurich lecture.

The year 1914 was crucial in the development of Jeanneret's architectural thinking. It was then that he began to apply the *principles* inherent in Wright's plans, especially their openness, and the structural articulation—concomitant with spatial definition. Structural rationalism was inherited by both architects from E. E. Viollet-le-Duc. But Le Corbusier's debt to Wright went beyond mere plan and some elevational characteristics: in a 1925 letter to H. Th. Wijdeveld, the Swiss mentioned two specific building types—houses and "an office building" (the Larkin)—and spoke of Wright's imaginative use of reinforced concrete, no doubt referring to Unity Temple.

The Dom-ino skeleton, which occupied Jeanneret's thoughts from about 1914, was a concrete post-and-slab system, standardized to facilitate repetitive use. Le Corbusier believed that Wright's designs revealed "good planning" and by that he meant "a tendency toward" order, organization, and a "creation of pure architecture."[5] If Jeanneret's house plans of 1912–1915 are compared with Wright's plans as published in America and Europe, one inspiration for the Swiss' new theoretical position becomes clear. The other inspiration for Domino was American skeletal framing for factories and skyscrapers.

The skeleton frame, in steel or concrete, was widely discussed and illustrated

before 1910, as Banham and others have explained.[6] Le Corbusier, like many other young European architects, was inspired by aspects of American industrial and commercial architecture generally and, as just argued, by Wright in particular. Moreover, the Wrightian Schwob, concrete project, Jeanneret and Domino structural articulation was employed by Le Corbusier throughout most of his professional life. Exceptions are few.

The other comparison is perhaps too obvious. Around 1927 Le Corbusier offered his five points of architectural coherence. First was the pillar (*piloti*) or post; second, an independent structure and wall; third, the free or open plan; fourth, the "free" facade. Those points were all exactly related to skeleton frames and to structural and spatial articulation as revealed in Wright's plans. A free facade can occur only as a result of the first three. The fifth point was, of course, the opportunity for a roof garden as one result of using flat slabs. But . . . in 1904 Walter Burley Griffin,* then working for Wright, designed the Lamp house, which incorporated a complete roof garden. And Wright's flat roof slabs were patent in various publications from 1905 to 1911; to mention three: the Beye Boathouse, Yahara River, Madison (1902); Unity Temple; and the Elizabeth Gale house, in Oak Park (1909). The similarity between Jeanneret's "concrete houses" and Unity Temple is extraordinary. Even the fifth point was thus a refreshing adaptation of Wright's fundamental architectonics.

Although Le Corbusier protested to Wijdeveld that he knew "very little" of Wright, the truth was otherwise. Yet he would have insisted that inspiration was one thing, copying another. According to Giedion, to "enlarge on [Wright's] principles" and make them more contemporarily relevant was the task of the next generation of European architects. And according to Giedion that work was taken over by Le Corbusier. He "developed Wright's ideas in his work, even though it is not striking. No architect," said Giedion, "placed the housing problem as much in the centre of his work as Wright did. . . . It is not a coincidence that Le Corbusier starts with the same things."[7]

For a while, toward the end of World War I, Jeanneret turned his full attention to painting. He met the painter Amédée Ozenfant, the founder of Purism, in 1917 and was drawn into that post-Cubist movement. In 1918 they wrote its manifesto *Après le Cubisme* and, with Paul Dermee, began to publish the magazine *L'Esprit Nouveau* (1919–1925). Much of its editorial material reappeared in a collection of polemical essays, *Vers une Architecture* (Towards One Architecture) in 1923, soon to be widely read and translated. The book was published under Jeanneret's adopted name Le Corbusier (which he used from then on) and he focused his powers upon the creation of a "radically modern form of architectural expression." Ozenfant, whose collaboration with Le Corbusier ceased in 1925, later laid claim to many of the ideas contained in *Vers une Architecture*.[8] Anyway, Le Corbusier's influence set up a current counter to Wright's "peaceful penetration" into the stream of European architecture, finding its way through literary valleys: first a trickle of images, then a flood of words.

From the mid-1920s until 1944, the second phase of his career, Le Corbusier's

most significant work was in urban planning. In such published plans as *La Ville Contemporaine* (1922), the *Plan Voisin de Paris* (1925), and any number of *Villes Radieuses* of 1930–1936, he developed ideas dramatically contrasting with the low-rise cities projected by the protagonists of the international Garden City movement. Le Corbusier *developed,* but he did not originate those notions of a new urbanism. For example, H. Th. Wijdeveld's 1919–1920 project for the radial city he called Amsterdam 2000—high hexagonal apartment towers, each for 2,000 inhabitants, to be located in a greenbelt around the old city—predated the *ville radieuse* by years. The difference was that nothing of old Amsterdam needed to be destroyed to make way for Wijdeveld's scheme. Le Corbusier's, by contrast, wanted to demolish much of Paris to gain space for highways and tall towers.

In 1928 F. T. Gubler, secretary of the Swiss chapter of the Deutscher Werk-bund, persuaded Hélène de Mandrot to offer her castle at La Sarraz, Switzerland, for a meeting of Europe's leading architects. From that 1928 gathering, the Congrès Internationaux d'Architecture Moderne,* or CIAM, was formed by the twenty-five architects present. Dominated by Le Corbusier, it was a clearing-house for ideas. As the prime mover of its charter—although there was some resistance to his dogmatism—Le Corbusier now became the source.

He planned cities but actually built several villas, small apartment blocks, and office buildings. In their "purist" hard-edged, geometrically smooth volumes he invented a language of "pure prisms"—rectangular blocks of concrete, steel, and glass (and even straw and stucco), often raised above the ground on *pilotis* and exemplifying the five points of architectural coherence. For those seeking an archetype, it is difficult to go past the Villa Savoie at Poissy near Paris (1928–1931), surely one of the most analyzed buildings of the twentieth century. William Curtis comments that the house has "achieved a dual status as a paradigm of modernism and as an assertion of classical values." And he adds, ironically, that although its clones can be found throughout the world "it was the end of line for its own creator, who never used white forms, slender *pilotis* and ribbon windows in this way again."[9]

Imitating his forms, young architects everywhere—and others not so young—began building white stuccoed cubes. Some, and only some, applied parts of his theory like the "lines of regulation" to elevational composition: for example the van der Leeuw house in Rotterdam (1927–1928), by Johannes Andreas Brinkman and Leendert Cornelis van der Vlugt.* Internationally he was feted for giving "the mental impulse to the new functional architecture" and credited with transferring the "ideas of French [*sic*] and Dutch painters (i.e., Mondrian and van Doesburg) to the building world." Suddenly, Berlage, van der Velde, Perret, Wagner, Behrens, Adolf Loos,* Garnier, Wright, and Gropius were designated "older architects," respectfully assembled in Le Corbusier's spreading shadow.[10]

After World War II, Le Corbusier entered the late phase of his career, turning to coarse forms in concrete, stone, stucco, and glass. In 1946 the French gov-

ernment commissioned him to build his prototypical Vertical City in Marseilles, which resulted in the Unité d'Habitation (1946–1952), a huge block of 340 "superimposed villas" standing on inhumanely massive *pilotis* and pierced with internal streets of shops and services, all under a roof-garden community center that included a sculptured playground of rather brutal concrete forms. Impressive to students of architecture, the apartment block was and is unloved by the people forced to live in it.

Le Corbusier's growing reputation, largely established by his flair for self-promotion, led to a commission from the Indian government to plan Chandigarh, the new capital of the Punjab, and to design its Government Center (1950–1970) and several other buildings. According to Peter Blake,

These poetic, handcrafted buildings represented a . . . more humanistic phase in Le Corbusier's work that also was reflected in his lyrical Pilgrim Church of Notre Dame du Haut at Ronchamp (1950–54) in the Vosges Mountains of France; in his rugged monastery of La Tourette, France (1954–59); and in the several structures he designed (from 1958) at Ahmedabad, in India.[11]

The stylistic link cannot be denied. But the claim that the buildings, architecturally attractive as they undeniably are, could be called humanistic must give us pause. Chandigarh remains unfinished and underpopulated. Its public transport system, based on the Parisian model, does not work. Its road system is designed for automobiles in a society where car ownership is well below 10 percent. Its monumental buildings ("handcrafted" was Le Corbusier's concession to the vast pools of unskilled, cheap labor) are unaccepted and abused. The city represents, according to one critic, "a telling statement regarding [the architect's] aspirations and frustrations."[12]

The European examples had a more sympathetic audience, and (it is suggested) one that the architect himself better understood. In buildings whose aesthetic was "made out of the relationships of brute materials," structure and materials were honestly and unambiguously revealed. Well, almost honestly. The Ronchamp chapel, for example, although it appears as "a pulsating, primitive form, a sculpturally active object in the landscape that conversely encompasses and encloses the viewer,"[13] merely *imitates* the vernacular architecture of the Colmar region (see Plates 24 and 25). That massively thick, light-pierced wall of the sanctuary is nonstructural, framed and faced with stucco on birdwire. The Dominican monastery of La Tourette, like the Ronchamp chapel, is a strongly modeled, highly textured building that fits so well into its stunning site. It has been described as "reticent on the austere outside [but] full of visual surprises inside and there is the deceptive nonchalance of a collage about the way in which various geometric and free-form elements are put together and sometimes made to jar."[14]

As widely copied as Le Corbusier's earlier *machine-à-habiter* style, these later products were to lead a generation of architects toward a style which Reyner Banham later formally dubbed as the New Brutalism. They were emulated by

myriad copyists but also embraced by thinking architects, such as Alison and Peter Smithson* or James Stirling* and James Gowan* in their earlier works. ''Brutalism'' and ''humanism'' do not sit easily together.

Only days after Le Corbusier's accidental death, Gropius wrote to their mutual friend Giedion,

It is most tragic that he could not live out his immeasurable potentialities, that he had to break off in a state of bitterness and loneliness. Now his glorification will start all over the world, the echo of which cannot reach him anymore, and how much he would have needed it.[15]

NOTES

1. Andre Wogenscky in Walden (1977), xii.
2. Curtis (1986), 7.
3. As quoted in Richard Guy Wilson, *The A.I.A. Gold Medal* (New York, 1984), 194.
4. Boesiger (1972), 244.
5. Jeanneret [also signed Le Corbusier] to Wijdeveld, 5 August 1925, Wijdeveld archives, Nederlands Architectuur Instituut, Rotterdam.
6. Reyner Banham, *A Concrete Atlantis* (MIT Press, 1986). See also Frank Whitford, *Bauhaus* (London, 1984), 120; Gillian Naylor, *The Bauhaus Reassessed* (New York, 1986); and Baker (1984), 8, 16ff.
7. Johannes Duiker, ''Frank Lloyd Wright's Manifesto,'' *De 8 en Opbouw* 1 (1932), 177–84.
8. Amedee Ozenfant, *Foundations of Modern Art* (New York, 1952), 328.
9. Curtis (1986), 98.
10. J. B. van Loghem, *Bouwen (Built to live in)*. Amsterdam, 1931. This is the argument of the introduction.
11. Peter Blake and Leli Sudler in the *American Academic Encyclopedia* (New York, 1993).
12. Bruce Abbey in Wilson, *A.I.A. Gold Medal,* 195.
13. Ibid.
14. Mary Patricia May Sekler and Eduard F. Sekler in Macmillan.
15. Gropius to Giedion, 3 September 1965, as quoted by Reginald Isaacs in Wilkes.

BIBLIOGRAPHY

The literature by and about Le Corbusier, or that touches upon his influence, continues to proliferate. The abbreviation LC for Le Corbusier is used below.

Writings

Almanach d'Architecture Moderne. Paris, 1927; Turin, 1975.
L'Art Décoratif d'Aujourd'hui. Paris, 1925, 1959, 1978.
''Auguste Perret.'' [English trans.] *JAE* 1 (1983).
La Charte d'Athenes. Paris, 1943, 1957; *The Athens Charter,* New York, 1973.
LC et Pierre Jeanneret: Oeuvre Complet de 1910–1929. Zurich, 1937.
Le Modulor 1948. Paris, 1950; London, 1954; Harvard, 1980.
Le Modulor 2. Paris, 1955; London, 1958; Harvard, 1980.
My Work. London, 1960.

Les Plans de LC de Paris 1922–1956. Paris, 1958.
Poésie sur Alger. Paris, 1950.
Propos d'Urbanisme. Paris, 1946; *Concerning Town Planning,* London, 1947; Yale, 1948.
Quand les Cathédrales Etaient Blanches. Paris, 1937; *When the Cathedrals Were White,* New York, 1947, 1964.
L'Unité d'Habitation de Marseille. Paris, 1950; *The Marseilles Block,* London, 1950.
Urbanisme. Paris, 1925; *The City of Tomorrow and Its Planning,* London, 1929; MIT Press, 1971.
Vers une Architecture. Paris, 1923; 2d ed., Paris, 1924; Stuttgart, 1926; *Towards a New Architecture,* London, 1927; 2d rev. ed., Paris, 1928; New York, 1970, 1986.
La Ville Radieuse. Paris, 1935; *The Radiant City,* New York, 1967.
Le Voyage d'Orient. Paris, 1966.
With Amedée Ozenfant. *Après le Cubisme.* Paris, 1918; Turin, 1975.
———. *La Peinture Moderne.* Paris, 1925, 1927.

Biographical

Besset, Maurice. *LC.* New York, 1976.
Boesiger, Willy. *LC.* Zurich, 1972.
Sekler, Mary Patricia May, and Eduard F. Sekler. In Macmillan.

Assessment

Anderson, Stanford. "Architectural Research Programmes in the Work of LC." *Design Studies* (London) 5 (July 1984).
Assemblage (MIT Press) 4 (October 1987). The whole issue.
Aujourd'hui. "Corbu." 249 (February 1987). The whole issue.
———. "Corbu encore." 252 (September 1987). Anthology.
Baker, Geoffrey Howard. *LC: An Analysis of Form.* New York, 1984; 2d ed., 1989.
———. *LC: The Creative Search.* London, 1994.
Bearn, Gordon. "The Formal Syntax of Modernism." *British Journal of Aesthetics* (London) 32 (July 1992).
Benton, Timothy. "LC 1887–1965." *a+u* 207 (December 1987). Anthology.
Bosini, Giampiero. "Lucien Herve: Fotografo di LC." *Abitare* 309 (July 1992).
Brooks, Harold Allen. "Jeanneret and Sitte: The First Ideas of LC on the Construction of the City." *Casabella* 49 (June 1985).
Casabella. "LC." 52 (January 1987). Anthology.
Chatelet, Anne-Marie. "Loos—LC." *Aujourd'hui* (February 1987).
Cimaise. "Portrait Puzzle: With LC." (Paris) 34 (November 1987). Anthology.
Cohen, J.-L. "Architecture and Modernity in the Soviet Union." *a+u* 251 (August 1991).
———. "LC and the Mystique of the U.S.S.R." *Oppositions* 23 (Winter 1981).
———. "LC: Lessons of a Century." *a+u* 231 (December 1989).
Cohen, J.-L., and C. Devilliers. "Un anno di celebrazion: Lecorbusieriane." *Casabella* 51 (December 1987).
———. "The Publicity of the Private: The Archives of Loos and LC." *Transition* 41 (1993).
Colquhoun, Alan. "The LC Centenary." *JSAH* 49 (March 1990).
Curtis, William J. R. *Le Corbusier: Ideas and Forms.* Oxford, 1986.

Domus. "LC." 687 (October 1987). Anthology.

Eisenman, Peter. "Maison Dom-ino and the Self-referential Sign." *Oppositions* 15–16 (Winter-Spring 1979).

Etlin, Richard A. *Frank Lloyd Wright and LC: The Romantic Legacy.* Manchester, England, 1994.

———. "LC, Choisy and French Hellenism." *Art Bulletin* (New York) 69 (June 1987).

Gattamorta, Gioia, and Luca Rivalta. *LC: Chandigarh.* Florence, 1993.

———. "Poetics of Technology and the New Objectivity." *JAE* 40 (Fall 1986).

Goldberg, Stephanie. "The Origins of Form: Abstraction and History in Modern Architecture." *Crit* (Washington, D.C.) (Fall 1988).

Gresleri, Juliano. "From Diary to Project: LC's Carnets 1–6." *Lotus* 68 (1991).

Gubler, Jacques. "La Chaux-de-Fonds and Jeanneret." *Archithese* (Niederteufen) 13 (March 1983).

Issacs, Reginald. In Wilkes.

Jenger, Jean. *LC: L'Architecture pour L'Emouvoir.* Paris, 1993.

Journal d'Histoire de l'Architecture. "LC le peintre derrière l'architecte." (Paris) 1 (September 1988). The whole issue.

Kuretani, Mitsutoshi. "La chapelle de Ronchamp de LC." *Nihon Kenchiku Gakkai Keikakukei Ronbun Hokoku Shu* (Tokyo) 397 (March 1989).

———. "The Development of Formal Expression and Geometrical Rationalism by LC." *Nihon Kenchiku Gakkai Keikakukei Ronbun Hokoku Shu* 425 (July 1991).

———. "The Geometry and Unity of Dualism . . . of LC." *Nihon Kenchiku Gakkai Keikakukei Ronbun Hokoku Shu* 429 (November 1991).

———. "Symbolism and Geometry of LC's Late Paintings." *Nihon Kenchiku Gakkai Keikakukei Ronbun Hokoku Shu* 420 (February 1991).

Latouche, P. "Les sculptures de LC et de Joseph Savina." *Fifth Column* (Montreal) 5 (Winter 1985).

Lotti, Luca. "LC: Critica alle stanze." *Domus* 691 (February 1988).

McNamara, Andrew. "Between Flux and Certitude." *Art History* (Newark) 15 (March 1992).

Matteoni, Dario. "The 16 Patents of LC 1918–1961." *Rassegna* 13 (June 1991).

von Moos, Stanislaus. *LC: Elements of a Synthesis.* MIT Press, 1979.

Ragot, Gilles, and Mathilde Dion. *LC—Réalisations et Projets.* Paris, 1987.

Sarin, Madhu, et al. "Chandigarh oggi." *Casabella* 52 (October 1988).

Schwarting, Jon Michael. "Ulterior Motives . . . A Second Agenda in Architecture." *Modulus* (Charlottesville, Va) 21 (1991).

Sekler, Mary Patricia May, and Eduard F. Sekler. "Constancies and Changes in LC's Urbanism." *Center: Journal for Architecture in America* (Austin, Texas) 5 (1989).

———. In Macmillan.

Seligmann, Werner. "LC as Structural Engineer." *ARecord* 175 (October 1987).

Shapiro, Barbara E. "Tout ça est foutaise, foutaise et demi!: LC and UNESCO." *Revue d'Art Canadienne* (Montreal) 16, 2 (1989).

Sorkin, Michael. "Dwelling Machines." *Design* 138 (1987).

Speck, Lawrence W. "The Individual and the City." *Center: Journal for Architecture in America* (Austin, Texas) 5 (1989).

Stirling, James. "Ronchamp: LC's Chapel and the Crisis of Rationalism." *AReview* 191 (December 1992).

Tafuri, Manfredo. "Machine et memoire." *a+u* 182 (November 1985).

Tominaga, Yuzuru. "Essays on Residential Masterpieces: LC." *GAHouses* Tokyo 39 (November 1993).

Turner, Paul Venable. *The Education of LC.* New York, 1977.

Vigato, J.-C. "Gefass ohne inhalt: Form und Bedeutung bei Loos und LC." *Werk* (April 1989).

Walden, Russell, ed. *The Open Hand.* MIT Press, 1977.

———. in *Contemporary Architects.*

Ward, Diane Raines. "Up against India." *Connoisseur* 217 (November 1987).

Weiss, Klaus-Dieter. "Die Wohnmaschine: Unités d'Habitation von LC." *Werk* 79 (April 1992).

Zaknic, Ivan. "LC's Epiphany on Mount Athos." *JAE* 43 (Summer 1990).

Bibliographical

Brady, Darlene A. *LC: An Annotated Bibliography.* New York, 1985.

Glagola, John. *LC: A Bibliography of Monographs.* Monticello, USA 1976.

Vance: Lamia Doumato, A117, 1979; Mary Vance, A1809, 1987.

Archival

Boesiger, Willy, et al., eds. *LC: Oeuvre Complète.* 8 vol. Zurich, several eds. 1930–1977.

Brooks, Harold Allen, ed. *LC Archive.* 32 vol. New York, 1982+.

Sekler, Mary Patricia May. *The Early Drawings of Charles Édouard Jeanneret.* New York, 1977.

Tzonis, Alexander, ed. "Drawings from the LC Archive." *ADesign* 55 (July 1985).

Wogenscky, Andre, et al., eds. *LC Sketchbooks.* 4 vol. MIT Press, 1981– .

D

JOHN (GERARD) DINKELOO. 1918 (Holland, Michigan)–1981. After attend-
ing local Hope College (1936–1939), Dinkeloo entered the University of Mich-
igan from which he received a degree in architectural engineering (1942). He
immediately joined the office of Skidmore, Owings, and Merrill* (SOM) in
Chicago, before serving in the Naval Reserve (1943–1946). After returning to
SOM he became chief of production and coordinator of structural and mechan-
ical engineering work (1946–1950). He began with Eero Saarinen* in 1950 and
later became a partner (1956–1966). Upon Saarinen's death in 1961, Dinkeloo
and Kevin Roche,* together with senior partner Joseph Lacy, assumed control
of the architectural practice, completing such works as the TWA Terminal at
Kennedy Airport, in New York (1956–1962), and the CBS headquarters, in New
York City (1958–1962). With no discontinuity they began receiving new and
large commissions. In 1966 the firm became independent of the Saarinen name.

Dinkeloo was the expert in construction and industrial methods; Roche was
the designer. Development of neoprene glazing gaskets, laminated metalized
heat-reflecting glass for a building skin, and corrosion-resistant steel (Cor-ten)
are three widely used industrial developments Dinkeloo oversaw and noted with
pride. He and Roche were an effective team, innovative in design and meticulous
in construction details that clarified architectural intentions.

On Dinkeloo see Walter McQuade, "New Saarinen Office," *AForum* 118
(April 1963); *AForum* 140 (March 1974), the whole issue; Yukio Futagawa, ed.,
Kevin Roche, John Dinkeloo & Associates 1962–1975 (Tokyo, 1975); and Rob-
ert A. Kuhner in Vance, A1522, 1986.

See Roche.

THEO VAN DOESBURG (pseudonym for CHRISTIAAN EMIL MARIE KÜPPER). 1883 (Utrecht, the Netherlands)–1931.

After elementary education, van Doesburg showed a wide interest in the arts, briefly studying drama at Cateau Esser's School of Dramatic Arts in Amsterdam, writing poetry and prose, and (from about 1899) teaching himself to paint and draw. He dabbled in painting (1902–1912) and art journalism (1912–1914), and he came into contact with avant-garde ideas during his military service (1914–1916). He was instrumental in forming the group known as De Stijl* (1916–1925), and he edited the journal *De Stijl* (1917–1931). He traveled widely in Europe (1920–1931) with the De Stijl gospel and almost infiltrated the Bauhaus with his doctrines (1922). Van Doesburg collaborated on architectural projects with J.J.P. Oud* (1916–1919), Jan Wils (1917–1918), Cor van Eesteren (1923–1924), and Jean and Sophie Arp (1926–1928). With the painter Piet Mondrian he developed ideas of neoplasticism and alone, elementarism.

✎

In 1902 Küpper decided upon a free-lance artistic and literary career. His earliest paintings date from 1904, and in 1908 he had an exhibition of over forty conservative, "muddy, Rembrandtesque" works at The Hague Kunstkring, demonstrating his penchant for Dutch impressionism. In 1912 he began publishing art critiques, most frequently in the weekly magazine *Eenheid,* whose readership consisted mostly of Theosophists, Freemasons, and other mystical groups. Its title, *Unity,* enshrined an important idea within Küpper's own emerging philosophy. Until he was thirty years old, he occupied "only a marginal position in the Dutch art world."[1]

Küpper first encountered the artistic avant-garde during military service. While stationed on the Belgian border he met the railwayman-poet Anthony Kok and the shoemaker-philosopher Evert Rinsema; both had a lasting effect upon him. Around then he relinquished his given name for that of his stepfather, Theodorus Doesburg, a "minor Amsterdam industrialist." Back in civilian life, in 1916, he also met the Frank Lloyd Wright*–besotted J.J.P. Oud* (and, through him, Jan Wils), the Hungarian painter Vilmos Huszar, and, near the year's end, architect Bart van der Leck. Van Doesburg was a compulsive founder. In May 1916, with Oud as president and himself as vice secretary, he helped form the Leiden art club De Sphinx. Only three months earlier van Doesburg had set up De Anderen (The Others) in The Hague, with painters Piet Mondrian, Erich Wichman, Louis Salborn, and (for a while) Janus de Winter. Those ephemeral associations coalesced (in one sense) in 1917, when van Doesburg, Oud, Mondrian, Wils, van der Leck, Kok, and Huszar established De Stijl.[2] Its journal, *De Stijl,* "his most significant contribution to . . . modern art,"[3] was published under his garrisoned editorship from October 1917 until his death in 1931 (his sometime peers produced a posthumous memorial issue in 1932). Van Doesburg's position and policy were stated in the first issue: "This periodical hopes to make a contribution to the development of a new awareness of beauty. It wishes to make modern man receptive to what is new in the visual arts."[4]

From the start the Leiden-based group was, at best, loose knit; at worst, internally argumentative—between van Doesburg and others. Inevitably its fabric unraveled as members withdrew, offended and unable to work with the jealous, dogmatic painter. To preserve the illusion of international cooperation, van Doesburg stooped to inventing members, writing under the pseudonyms of I. K. Bonset (a "poet," from 1920) and Aldo Camini (an "Italian philosopher," from 1921).

Although not an architect, van Doesburg deserves a place in the history of modern architecture. His first experience came in 1916 when he collaborated with Oud on a projected house for the mayor of Broek-Waterland (1916). Van Doesburg designed a stained glass rear door. Two realized projects followed: the Villa Allegonda, in Katwijk aan Zee (1916–1917), and the De Vonk holiday house, in Noordwijkerhout (1917). For Allegonda, though wanting to do more, van Doesburg designed the stained glass window in the stairwell; for De Vonk, he designed color schemes, tiled spandrels, and floor tiling in the circulation spaces. In 1919 he again worked with Oud, then Rotterdam's chief housing architect, on the Spangen housing estate. He also worked with other architects, including Wils on the De Lange mansion, in Alkmaar (1917), and renovations to the Dubbele Sleutel Café, in Woerden (1918). Important as they were in attempting to integrate art and architecture, these schemes had little to do with space.

From about 1920, van Doesburg traveled widely—Belgium, France, Germany, and Italy—promoting De Stijl. In Berlin at the end of 1921 he contacted El Lissitzky, Ludwig Mies van der Rohe,* Erich Mendelsohn,* Hans Richter, Hannes Meyer, Hausmann, and Le Corbusier,* and in Weimar, Walter Gropius.* Almost immediately, he founded a group called, simply, "G" with Lissitzky and Mies and he of course wrote polemical articles for its journal, *G*. With Gropius he privately debated, while for other Bauhaus members he held private classes in Weimar. When in 1922 his attempt to become a Bauhaus lecturer was thwarted by Gropius, he responded by setting up a De Stijl course. In the same year, as Bonset, he initiated (with Hausmann, Hans Arp, Tristan Tzara, and Kurt Schwitters) the short-lived journal *Mecano*.

In Weimar he also met the Dutch architect Cornelis van Eesteren, who was then studying north German brick architecture under a Prix de Rome award. There followed a four-year collaboration, at last involving van Doesburg in true spatial design. In 1923 they built the Rosenberg house in Paris (with G. Th. Rietveld*), developed their archetypal De Stijl architectural solutions in two hypothetical houses (a *maison particulière* and a *maison d'artiste*), and designed a university hall. In 1924 van Doesburg produced the color scheme for van Eesteren's waterfront house in Alblasserdam, another for a shopping arcade–restaurant in The Hague (1925) (neither scheme was built), and another for the premiated competition entry for the Unter den Linden redevelopment, in Berlin (1925) (see Plate 12). The encounter with space led van Doesburg to publish De Stijl's architectural manifesto in 1924—rather ironic as most of the previously involved architects had long since left him.[5] Soon after, his break with

Mondrian—a rift had first appeared in 1919—became final. Following a solo exhibition of his paintings at Weimar (1924), van Doesburg developed his theory of elementarism and published it in 1926.[6] In much of his writing after about 1920, grounded in his mystical beliefs about the essential unity of all things (including the arts) and moved by new scientific theories about space and time, van Doesburg fashioned a dynamic concept of reality. This view and its development are beyond the scope of this summary, but others have carefully explored his translation of painting into architecture, theory into practice.[7]

Together with the Rosenburg house, Van Doesburg's lasting architectural monument is the refurbishment of Café L'Aubette, in an eighteenth-century building by J.-F. Blondel in Strasbourg, France (1926–1928). The restaurant-tearoom-cabaret-cinema-dance hall complex was designed with Jean Arp and Sophie Tauber-Arp; its spaces are conceived as a kind of huge walk-in painting. Described by one critic as "the Sistine Chapel of modern art," it was the first major example of nonfigurative painting applied to interior design. In 1929 van Doesburg designed and built his own studio-house in Paris.

He has been called "extraordinarily impulsive" by one biographer, an "overlord" and even a "little dictator" by one of his De Stijl associates,[8] but that simply adds to his color. Brown rather cynically remarks that, while some critics and historians "have visualized and described [him] as a scorned prophet, shouting the truth in a wilderness of conventional deceit . . . others now view him as just one of the many self-proclaimed messiahs who shouted their way through the 1920s."[9] In fact he was a passionate publicist for an art that rejected the past including its artificial partition into academic disciplines. Van Doesburg infused that new art with theoretical vigor and was uncompromising in establishing its proper position in the growing framework of twentieth-century scientific and artistic doctrines. The evidence of his furious energy is his polemical and propagandist writing. Between 1912 and 1931 he produced a dozen books and over 200 journal articles, mostly in Dutch. *De Stijl* was not his only vehicle: *Mecano* and *G* have been mentioned; in 1930, he issued in Paris the first number of *L'Art Concret*. And totally in character, he founded yet another artists' group, Abstraction-Creation, only weeks before his death from a heart attack in March 1931.

See De Stijl, Oud, Rietveld.

NOTES

1. Blotkamp et al. (1986), 5.
2. There is debate over who were the founders. See Fanelli (1978), 256; Warncke (1991), 207; and Blotkamp et al. (1986), 18 for a range of views.
3. Brown in Macmillan.
4. "By Way of Introduction," *De Stijl* 1, 1 (1917).
5. Theo van Doesburg, "Towards a Plastic Architecture." *De Stijl* 6, 6–7 (1924).
6. McNamee (1969) includes "From Composition to Contracomposition." *De Stijl* 7 (1926); "Art of Painting and Plastic Art." *De Stijl* (1926); and "Elementarism and Its Origin." *De Stijl* (1932).

7. For example, Doig (1986).
8. Jan Wils to H. Th. Wijdeveld, 20 December 1968. Wijdeveld Archive, Nederlands Architectuur Instituut, Rotterdam.
9. Brown in Macmillan.

BIBLIOGRAPHY

Van Doesburg wrote profusely and in many languages. This list concentrates upon his monographs and books. The abbreviation TvD for Theo van Doesburg is used below.

Writings

Drie Voordrachten over de Nieuwe Beeldende Kunst. Amsterdam, 1919.
Grondbegrippen der nieuwe beeldende kunst. Amsterdam, 1919; *Grundbegriffe der neuen gestaltenden Kunst.* Munich, 1925; *Principles of Neoplastic Art.* London, 1969.
Klassiek, Barok, Modern. The Hague, 1920; *Classique, Baroque, Moderne.* Paris, 1921.
Naar een Beeldende Architectuur. Facsimile. Nijmegen, 1983.
De Nieuwe Beweging in de Schilderkunst. Delft, 1917.
On European Architecture: Complete Essays from Het Bouwbedrijf 1924–1931. Basel, 1990.
De Stijl. Ad Petersen, editor. Facsimile of journal 1917–1931. 2 vol. Amsterdam, 1968.
Wat Is Dada? The Hague, 1924.

Biographical

Baljeu, Joost. *TvD.* New York, 1974.
Brown, Theodore M. In Macmillan.
van Straaten, Evert, ed. *TvD: Painter and Architect.* New York, 1991.

Assessment

van Adrichem, Jan. "The Introduction of Modern Art in Holland: Picasso as *Pars pro Toto,* 1910–1930." *Simiolus* (Amsterdam) 21, 3 (1992).
AJournal. "Stijlish Recreation . . . TvD." 200 (18 August 1994).
Architettura. "From 'Metron' . . . Critical Teaching of . . . TvD." 40 (June 1994).
Baljeu, Joost. *TvD.* London, 1980.
Bann, Stephen, ed. *The Tradition of Constructivism.* London, 1974.
Blotkamp, Carel, et al. *De Stijl: The Formative Years.* Utrecht, 1982; MIT Press, 1986.
Boekraad, Cees, et al. *De Stijl: Neoplasticism in Architecture.* Delft, 1983.
Doig, Allen. *TvD. Painting into Architecture, Theory into Practice.* Cambridge, England, 1986.
Hedrick, Hannah. *TvD, Propagandist and Practitioner of the Avant-Garde 1909–1923.* Ann Arbor, 1980.
Jaffe, Hans Ludwig C. "The De Stijl Concept of Space." *Structurist* (Saskatchewan) 8 (1968).
Lemoine, Serge, ed. *TvD Peinture, Architecture, Théorie.* Paris, 1990.
McNamee, Donald. "TvD's Elementarism: New Translations." *Structurist* (Saskatchewan) 9 (1969).
Mansbach, Steven A. *Visions of Totality, Laszlo Moholy-Nagy, TvD and El Lissitzky.* Ann Arbor, 1980.
Purvis, Alston. "Dutch Design between the Wars." *Print* (New York) 45 (November 1991).

Sweeny, J. J., ed. *TvD*. New York, 1947.
Troy, Nancy J. *The De Stijl Environment*. MIT Press, 1983.
Warncke, Carsten-Peter. *De Stijl, 1917–1931*. Cologne, 1991.
Wingler, Hans Maria. *The Bauhaus: Weimar, Dessau, Berlin, Chicago*. Cologne, 1962; MIT Press, 1969.
Zevi, Bruno. *De Stijl: The Poetics of Neoplastic Architecture*. London, 1982.

Bibliographical

Fanelli, Giovanni. *Moderne Architectuur in Nederland 1910–1940*. The Hague, 1978.
Jaffe, Hans Ludwig. *De Stijl—1917–1931*. Amsterdam, 1956.
Vance: Donald Langmead, A1671, 1986; A1672, 1986; A1773, 1987.

CONSTANTINOS(APOSTOLOS) DOXIADIS. 1913 (Stenimachos, Bulgaria)–1975. Doxiadis, the son of a pediatrician, was raised in a Greek community in Bulgaria. Educated in Athens, he graduated in architecture and engineering from the National Metsovion Technical University (1935). Continuing his studies in Germany he received a doctorate in civil engineering from Berlin-Charlottenburg Technical University (1936) before entering a long public service career in Athens. After holding several senior city planning positions (1937–1951), he founded a consulting firm for engineering and regional and urban planning (1953) that continues to practice as Doxiadis Associates International, Consultants on Development and Ekistics from offices in Athens and Washington, D.C., with commissions on all continents. As well as holding academic appointments at the Technical University in Athens (1939–1943), Doxiadis lectured at universities throughout the United States, including Harvard University and the Massachusetts Institute of Technology. Accolades are too numerous to list: he was awarded more than a dozen honorary doctorates in the United States as well as many professional and civil honors in Greece, Lebanon, Mexico, the United States, Yugoslavia, Britain, and Germany. He posthumously received the Gold Medal of the Royal Architectural Institute of Canada (1976). Doxiadis's writings proliferate. Significant among them was his foundation of and contributions to the journal *Ekistics*.

↜

"Doxiadis was one of the foremost people of his time, eminent not only as an architect and planner, but also as a philosopher and teacher of young and old of many nations."[1] "Doxiadis deserves to be remembered as one of the imaginative planning theorists of the century."[2]

Although an architect by training, Doxiadis rejected the idea that city planning was (as many of his contemporaries believed) merely architecture written large. He was among the growing number of planners who urged an interdisciplinary approach to urban problems. Upon completing his doctorate, Doxiadis returned to Greece to become director of planning studies for the greater Athens area (1937–1939), but he was soon, at age twenty-six, appointed head of the Department of Regional and Town Planning of the National Ministry of Public Works (1939–1945). As part of his brief, he created the Office for National,

Regional, and Town Planning Studies and Research and an Archive of Greek
Settlements, which documented 11,000 examples: all eventual grist to the mill
of Ekistics.

After serving in the army and the resistance movement throughout World
War II, Doxiadis entered "a brilliantly successful period of service to his coun-
try in the co-ordination of reconstruction plans and programmes." He was first
appointed undersecretary and director general of the Ministry of Housing and
Reconstruction (1945) and then undersecretary and coordinator of the Greek
Recovery Program (1948). That responsibility, comments Gerald Dix, "provided
the apprenticeship for subsequent international activities."[3] Throughout the late
1940s Doxiadis, representing Greece at international conferences on housing,
planning, and reconstruction, "formulated and refined his concept of ekistics,
and his many international contacts gave him a comprehensiveness of vision
and a unique global understanding."[4] Probably for political reasons, his gov-
ernment abolished Doxiadis's post in 1951. He emigrated to Australia with his
family "to take up farming far away from it all,"[5] but he soon returned to
Athens.

In 1953 he formed, with four other architects, Doxiadis Associates, a con-
sulting, planning, and engineering firm. Within less than a decade, it employed
some 500 people, including about 200 planners, engineers, architects, and quan-
tity surveyors and maintained more than a dozen branch offices.[6] Doxiadis al-
ready held a commission for a city development plan for Islamabad, Pakistan
(1947–1960), and for a satellite town near Karachi for 500,000 refugees from
the partition of India. The firm's first collective major foreign project was a
national housing scheme for Iraq (1955). Other international commissions fol-
lowed, including among many a national housing program for Lebanon (1958);
urban development plans (Detroit, 1965–1970); regional plans in Brazil, Ghana,
Saudi Arabia, and Spain; and town plans in countries throughout Africa, Europe,
Asia, the Americas, and of course Greece.

Despite such wide and sustained professional activity, and despite his obvious
concern with practicalities and the (albeit idealistic) pursuit of the attainable,
Doxiadis' major importance is as a theoretician. His most significant contribu-
tion to architectural and, more specifically, to planning and urban design phi-
losophy was the invention or, more correctly, the application of Ekistics—a
word he coined to signify "the problems and science of human settlements."
As he expanded the definition, Ekistics came into being when his

attempt to arrive at a proper conception and implementation of the facts, concepts and
ideas related to human settlements, and the attempt to re-examine all principles and
theories and to re-adjust the disciplines and professions connected with settlements, led
to the need for a special discipline of human settlements.[7]

Believing that no less than a discipline was needed, conducted with objectivity
and a systematic approach that achieves a coordination of knowledge and even-
tually the coordination of ideas that would generate conceptions to guide de-
velopment, Doxiadis began to develop that discipline in the 1960s. He

collaborated with others including (for a short time) R. Buckminster Fuller*
and, under the influence of the ideas of Lewis Mumford and Arnold Toynbee,
Ekistics went beyond merely examining the built form and investigated the
relationship between time, movements, and systems in the built environment.

Doxiadis believed that "the rapid growth of population should be accom-
modated by careful planning on the basis of well-thought-out principles."[8] That
accommodation should be designed to give a high quality of life to the urban
dweller. Within this process, he saw architecture—he used the term "shells"—
as one of the five elements in human settlements beside nature, networks, the
human being—he used the Greek word *anthropos*—and society. Those elements
were acted upon by economic, social, political, technical, and cultural forces to
generate urban patterns. The shells were subdivided into seven activity-based
groups, "coverings for functions." Architecture thus formed only a small part
of the vast scope and great depth of Ekistics.

Doxiadis's evolving notions were analyzed and expounded in any number of
books and especially the monthly journal *Ekistics,* which continues to be pub-
lished in Greece and the United States. They were also delivered as lectures at the
Graduate School of Ekistics founded by Doxiadis at the Athens Technological
University, at the Ekistics Center, and during his extensive lecture tours among
the universities of Europe and North America. One British writer comments, "By
his work and writings, and as host to the Delos Symposia . . . Doxiadis has played
a leading part in making this science a matter of world-wide concern."[9]

His impact upon a world reconstructing after a major war was significant, and
he sustained it even after he lost the power of speech. It is Dix's belief that,

Although . . . he had his critics, and there were those who envied his professional success,
at the end there were few who could not admire his persistence and applaud his courage
as he fought for what he believed in, and struggled to put forward ideas for public
debate.[10]

NOTES

1. Whittick in *Contemporary Architects.*
2. Gerald Dix (1978), vii.
3. Ibid.
4. Phillips in Macmillan.
5. As reported by Ehrenkrantz and Tanner (1961), 116.
6. Watson (1960), 467.
7. Doxiadis (1968), 15.
8. Whittick in *Contemporary Architects.*
9. Llewelyn-Davies (1965), 399.
10. Dix (1978), viii.

BIBLIOGRAPHY

Writings

Action for Human Settlements. Athens, 1976.
Anthropopolis: City for Human Development. Athens, 1974.
Architecture in Transition. London, 1963.

Articles in *Ekistics,* 1959–1975.
Between Dystopia and Utopia. Hartford, 1966.
Building Entopia. Athens, 1976.
Dynapolis, the City of the Future. Athens, 1960.
Ecology and Ekistics, edited by Gerald Dix. London, 1977; Saint Lucia, Australia, 1978.
Ekistic Analysis. Athens, 1946.
Ekistic Policies for the Survival of the Country with a 20 Year Programme. Athens, 1947.
Ekistics: An Introduction to the Science of Human Settlements. London, 1968.
Raumordnung in Griechischen Stadtebau. Berlin, 1937; *Architectural Space in Ancient Greece.* MIT Press, 1972.
A Simple Story. Athens, 1945.
The Two-headed Eagle: From the Past to the Future of Human Settlements. Athens, 1972.
Urban Renewal and the Future of the American City. Chicago, 1966.
With Truman B. Douglass. *The New World of Urban Man.* Philadelphia, 1965.
With J. G. Papaioannou. *Ecumenopolis: The Inevitable City of the Future.* New York, ca. 1974.
With others. *A Plan for the Survival for the Greek People.* 2 vol. Athens, 1950.

Biographical

Deane, Philip. *Constantinos Doxiadis; Master Builder for Free Men.* New York, 1965.
Whittick, Arnold. In *Contemporary Architects.*

Assessment

ARecord. "Constantinos Doxiadis, City Planner." 162 (August 1975).
Ehrenkrantz, Ezra, and Ogden Tanner. "The Remarkable Dr Doxiadis." *AForum* 114 (May 1961).
Llewelyn-Davies, Richard. "Ekistics, the Pattern of Human Settlements." *AReview* 138 (December 1965).
Phillips, Patricia C. In Macmillan.
SpaceD. "Constantinos A. Doxiadis: Projects and Writings." (July 1976). The whole issue.
Tyrwhitt, Jacqueline. "Background to . . . *Ecology and Ekistics." Ekistics* 45 (January 1978).
Tyrwhitt, Jacqueline, ed. "C. A. Doxiadis 1913–1975: Pursuit of an Attainable Ideal." *Ekistics* 42 (June 1976).
Watson, L. K. "Doxiadis Associates." *RIBAJ* 67 (October 1960).
Watterson, Joseph. "Emanation from Athens." *AIAJ* 57 (May 1968).
Wedgwood, R. "Doxiadis' Contribution to the Pedestrian View of the City." *Architects' Yearbook* (London) 20 (1965).

Bibliographical

Vance: Mary Vance, A237, 1980.

WILLEM MARINUS DUDOK. 1884 (Amsterdam, the Netherlands)–1974. After finishing preparatory school and despite his musician parents' hope that he might follow in their careers, Dudok chose the army. From Alkmaar Cadet School

he moved in 1902 to the Breda Military Academy, where he was trained in military engineering. While in various regiments of engineers, Dudok taught himself architecture. In 1913 he left the army to work as deputy director of public works for the municipality of Leiden, moving to Hilversum two years later to become director of public works. In 1928 his role was changed to city architect, a post he held until his retirement in 1958. He conducted a nationwide private practice for about fifty-five years, although most of his work was done in Hilversum. Dudok was internationally copied and internationally honored, receiving the Gold Medals of the RAIA (1935), the AIA (1955), and the French Academy of Architecture (1966). In his native Holland, he received the highest accolades.

<center>◌⌁</center>

As a soldier Dudok studied building under the civil engineer G. N. Itz, receiving "a good technical education." Willem had "above all and very early a great ambition to draw" and although unsure about "which path [building or hydraulic engineering] held most" for him, his "ideal was to become a creative engineer."[1] Around 1908 he began an intensive private study of architecture. His early buildings included fortifications at Uithoorn, Purmerend, and Amsterdam as well as soldiers' quarters at Den Helder (1911), which was a conservative affair, remarkably free of extraneous decoration. Its character perhaps sprang from military austerity although, like most young Dutch architects, Dudok was also inspired by Berlage.

After he left the army in 1913, Dudok spent two years with the Public Works Department of Leiden, where, besides a number of small buildings and bridges, he built a secondary school on Hoge Ringdijk (completed 1917). It owed much to Berlage. But Dudok was simply passing through that phase. He also produced the Expressionistic *Leidsche Dagblad* newspaper offices (1916–1917) collaborating with decorative artist Willem Brouwer.

Its creatively sculptured, imaginative red brick pavilions, picked out with stone dressings, are rich with whimsical decorative elements produced by the versatile Brouwer—terra-cotta ornament, tiled panels, sheetmetal details, and florid wrought iron lettering. The *Dagblad* firmly established a consistent element of Dudok's work: color. In that respect, the interior is more eloquent than the exterior: the major spaces are enlivened by ceramic tile, carefully chosen natural colors of brickwork, and Brouwer's stained glass. It is the best extant example of Dudok's brief experiment with the extravagances (well, some would call them extravagances) of the Amsterdam School.

In Leiden, he met J.J.P. Oud* and in 1915–1916 they designed the Leiderdorp housing estate. In 1915 he successfully applied for the position of director of public works in the burgeoning dormitory town of Hilversum, a few kilometers southeast of Amsterdam. He would remain there for the rest of his life, serving as city architect after 1928.

Perhaps he was already aware of the work of Frank Lloyd Wright,* but it no doubt also arose in conversations with the Wright-besotted Oud. Nothing in

Dudok's 1926 statement that he "first saw [Wright's] work in pictures" and "later learnt more through more detailed publications" indicated when he discovered Wright, and there was no recognizable effect on his own designs before 1919.[2] At the time he was dallying with the Expressionistic handcraft forms of the Amsterdam School: the *Dagblad,* a monument in The Brink (1916) and Geraniumschool (1917), both in Hilversum, all betray that flirtation. By contrast, in 1920 and 1921 he privately designed the Villa Sevensteijn in The Hague. Described by fellow-architect Albert Boeken as an "organization of elementary architectonic masses, determined by practical demands," the house employed cubic forms, foreshadowing many public buildings in Hilversum, including the abattoir (completed 1924), the Boschdrift bathhouse (1921), and a string of schools, as well as the final design for Hilversum town hall. Indeed, his successive designs for the town hall between 1915 and 1924 are a marvelous revelation of his changing ideas about architecture and a clear record of stylistic influences.

Much of his work between 1921 and 1932—buildings widely emulated beyond Holland—shows that he understood and embraced what Wright had achieved with space and form. Dudok soon integrated those ideas with his own to produce an architecture of which Nikolaus Pevsner asked, "Who would be prepared to say what comes from Wright in Dudok's work . . . and what from cubism?"[3] Yet no evidence supports the assumption, repeated ad nauseum since 1935 that Dudok's individualistic manner hybridized Amsterdam School fantasy and De Stijl* neocubism.[4] Elements of Wright in Dudok's buildings were spasmodic: he swept Wrightian detail into his eclectic garner, grist to the mill of his joyous architecture.

While some of his 1930s buildings, like the Rotterdam Bijenkorf department store (1929–1930) and the HAV Bank, in Schiedam (1931–1935), reflected the influence in Holland of the New Objectivity tempered with Le Corbusier's* notions, Dudok's stance against the background of anonymous European modernism was firm.

His independence, his apparent individualism, obviously has its own character. A nonconformist of the first water, [in the early 1920s] he worked carefully through the purity of Berlage, the liberty of the Amsterdam School and . . . Wright, and the clear form-language of Cubism, going his own unique way to create a highly personal synthesis.[5]

It seems that Dudok believed there should be two kinds of architecture. While he adopted a familiar, congenial aesthetic for Hilversum's public housing, made appropriate to the folk by using traditional forms and materials, his sophisticated "cubist" approach was reserved for civic buildings and a few houses for private clients.

The obvious attraction of Dudok for many young foreign architects, itinerant in Europe around 1930, was unparalleled: his work cast a spell over much of Continental Europe, the United States, Australia, and even xenophobic Britain. Hilversum town hall and Dudok's schools were the most widely published of

his buildings and therefore the most copied. The town hall (1924–1931) is composed (almost in the musical sense) of several harmonious elements: carefully proportioned cuboids of bright yellow brick enclosing specific and varied functions, sometimes lightly touching, sometimes interpenetrating, but from every aspect juxtaposed just right, set with counterpoints of turquoise tiles and doors in primary colors, all against a background of lawns and shrubs, bright flowers, a tall fountain, and still water (see Plate 15). The interiors, especially of the public spaces, are rich with colors and finishes inspired by Dudok's construct of Byzantium. All, including the furniture and light fittings, are done to his own design.

For the next decade his work was so widely mimicked that an adjective was coined: "dudoky." Perhaps his power lay in his moderation, what John Betjeman praised as "modernism with manners." The Dutch architectural journalist Hans van Dijk asserted that Dudok's "popularity . . . came out of his 'middle-of-the-road' position between traditionalism and modernism." All this from a self-educated architect working mostly alone from a small office in his suburban house, who produced less than a handful of buildings beyond his native land. Indeed, only a fifth of his buildings were outside Hilversum.

After World War II and in the final phase of his career, Dudok's most significant work was in urban planning. Between 1946 and 1950 he produced a master plan for rebuilding The Hague and development and extension plans for the nearby towns of Voorburg and Velsen, the industrial center of Ijmuiden, and Zwolle. The Hague's main problems were two: first, because most government offices had been destroyed, rehousing the bureaucracy in "borrowed houses" had displaced many people; second, in the war the Germans had demolished large tracts of houses west of the city center. Dudok's task, on a scale he had not before encountered, was urban design and urban housing rather than planning. He addressed it like an architect and expressed his ideas in splendid perspectives, aerial views, and models. The megascheme was widely publicized— The Hague is Holland's "royal" city and seat of government—and professional and public reaction was mixed. Only parts of it were implemented.

His architecture lost its distinctiveness. Buildings like the Amsterdam Harbor Offices (1952–1965), Velsen town hall (1948–1965), and any number of medium-density apartment buildings were bland enough, and many architectural projects were never realized. One biographer writes,

There was a duality in his career after World War II. Dudok tended more and more toward traditional architecture as he applied arches, columns, pillars and even seventeenth century Dutch facades. By the 1950s, his architecture had grown so anonymous that many in The Netherlands questioned whether he was still alive.[6]

Nevertheless, throughout his long career Dudok had

managed to remain . . . beyond factional-fighting. Between functionalism and Delft School traditionalism, he stands an Erasmus-like figure, an architect without a 'school',

a politician without a party, a true believer without a church, led only by his own artistry and his own ideals.[7]

That assessment encapsulated Dudok's view of good architecture: "to build sensibly and well for happy people." But his highest praise came from the accolade accompanying the AIA 1955 Gold Medal:

Aided by your joy in color, you have persevered in a quest of ways to enclose and divide space and endow it with more gracious appeal, in the hope that space might sing again. Your individuality as an artist and the work of your mind, heart and hand have placed our world in your debt.[8]

Dudok's consummate control of architectonic forms, each so clearly expressing the space it enclosed and interacting with each other to form a unified whole, identifies him as a master of what he called "the serious and beautiful game of space."

NOTES

1. As quoted in Werkman (1964).
2. As quoted in Magnee (1954), 40.
3. Pevsner (1939).
4. The idea seems to be based on Oud's accusation that Dudok "falsely interpreted" De Stijl cubism ["Towards a New Architecture," *Studio* 105 (1933)]. The literal claim was made by Bruno Zevi (1953), reinforced by Wolfgang Pehnt (1973), and accepted hastily by later historians.
5. Redering (1964), 3.
6. Cramer and van Grieken in Macmillan.
7. Redering (1964), 3.
8. "The Gold Medal of Honor: Willem Marinus Dudok," *AIAJ* 24 (January 1955), 9.

BIBLIOGRAPHY

Writings

Acceptance speech, AIA Gold Medal. *AIAJ* 24 (August 1955).
"Einige gedanken uber architektur." *Deutsche Bauzeitung* (Stuttgart) (April 1937).
"Forty Years of Hilversum." *Town and Country Planning* (London) 25 (November 1955).
A Short Introduction to the Plans of Extension, Hilversum. Hilversum, 1924.
"To Live and to Build." *AIAJ* 21 (March 1954).
"Town Planning." *AIAJ* 21 (April 1954).
"Town Planning and Architecture as an Expression of Their Time." *RIBAJ* 58 (September 1951).
Town Planning Needs Three Dimensions. London, 1947.
Twee herbouwenplannen voor's-Gravenhage. The Hague, 1946.
With others. *Bouwen en Restaureeren in Oude-Amsterdam.* Amsterdam, 1940.

Biographical

Cramer, Max, et al. *W. M. Dudok 1884–1974.* Amsterdam, 1980.
Friedhoff, Gijsbert. *Nederlandsche Bouwmeesters.* Amsterdam, 1928.

Magnee, Robert M. H., ed. *Willem M. Dudok.* London, 1954; Amsterdam, 1955.

van de Pluym, W. "Willem Dudok." *Maandblad voor de Beeldende Kunsten* (Heerlen) 4 (April and May 1927).

Assessment

AForum. "A Quiet Reminder from The Netherlands . . . Willem Dudok." 100 (February 1954).

van Bergeijk, Herman, et al. "Dudok in Hilversum." *Architect* (The Hague). 24 (September 1993).

Berlage, Henrik Petrus, et al. *Arbeiderswoning in Nederland.* Rotterdam, 1920.

Berlage, Henrik Petrus, ed. *Moderne Bouwkunst in Nederland.* 20 vols. Rotterdam, 1932–1935.

Casciato, Maristella. "Dudok e Hilversum." *Domus* 680 (February 1987).

———. "Dudok in Hilversum: Story of a Silent Worker." *Lotus* 71 (1992).

———. "Il municipio de Hilversum." *Domus* 680 (February 1987).

The City Hall, Hilversum, Holland. New York, 1932.

Curl, James S. "Dudok and the Modern Movement." *Country Life Annual* (London) (1972).

Eibink, Adolf, et al. *Dutch Architecture of Today.* Amsterdam, 1937.

Feenstra, Gerrit. *Tuinsteden en Volkshuisvesting in Nederland, Buitenland.* Amsterdam, 1920.

Holzbauer, Wilhelm, and Yokio Futagawa. *Willem . . . Dudok: Town Hall Hilversum.* Tokyo, 1981.

Jordan, Robert F. "Dudok and the Repercussions of his European Influence." *AReview* 115 (April 1954).

Kloos, J. P. "The Dutch Melting Pot." *AReview* 103 (April 1948).

Koyama, Kazunori, and Kaori Kida. "Hilversum Town Hall." *a+u* 140 (May 1982).

Mieras, J. P., and F. R. Yerbury. *Dutch Architecture of the XXth Century.* London, 1926.

Pehnt, Wolfgang. *Expressionist Architecture.* New York, 1973.

Pevsner, Nikolaus. "Wright's Peaceful Penetration of Europe." *AJournal* 89 (4 May 1939).

Redering, Hans. "Dudok, Hilversum, en het geluk." *Algemeen Handelsblad* (Amsterdam) (25 July 1964).

RIBAJ. "A House at Hilversum." 62 (December 1954).

———. "The Royal Gold Medal Presentation to Dudok." 42 (27 April 1935).

———. "Theatre at Utrecht." 54 (September 1947).

Robertson, Howard. "Dudok and His Work." *Architect and Building News* 138 (June 1934).

Sorgel, Hermann. *Wright, Dudok and Mendelsohn.* Munich, 1926.

Summerson, John. "A Cubist Architect: . . . Schools at Hilversum." *AAFiles* 26 (Autumn 1993).

Vriend, Jacobus Johannes. *Architectuur van Deze Eeuw.* Amsterdam, 1959.

———. *Nieuwere Architectuur.* Bussum, 1957.

Wattjes, Jannes G. "Werken van . . . W. M. Dudok." *Bouwbedrijf* (The Hague) 2 (January 1925).

Wendingen. (Dudok number). (Amsterdam) 6, 8 (1924). The whole issue.

———. (Dudok number). 8, 1 (1924). The whole issue.

———. (Interiors number). 8, 2 (1927). The whole issue.

Werkman, G. "Het spel van de ruimte." *Bouw* (Rotterdam) 19 (1964).
Wilson, Richard Guy. "Willem Dudok: Modernist but Not Mainstream." *AIAJ* 71, 9 (1982).
Yerbury, F. R. *Modern Dutch Buildings.* London, 1931.
Zevi, Bruno. *Poetica dell'architettura Neoplastica.* Milan, 1953.

Bibliographical

Langmead, Donald. *Willem Marinus Dudok, A Dutch Modernist.* Westport, 1996.
Vance: Donald Langmead, A1671, 1986; A1672, 1986; A1773, 1987.

E

PETER D(AVID) EISENMAN. 1932 (Newark, New Jersey)– . After receiving
a Bachelor of Architecture degree from Cornell University (1955) Eisenman did
a stint in the U.S. Army (1955–1957). He earned his master's degree in archi-
tecture from Columbia University (1960), a master's degree in the fine arts
(1962), and a Ph.D. (1963) from Cambridge University, England, where for a
short time he taught architectural design. He worked for Percival Goodman, in
New York (1957–1958), for Walter Gropius's TAC (The Architects Collabo-
rative) in Boston (1959) and then taught design at Princeton and other American
universities. In 1967 he founded and was director of the Institute for Architecture
and Urban Studies (1967–1982) and founded and edited the historical and crit-
ical journal *Oppositions* (1973). He exhibited at New York's Museum of Mod-
ern Art and other galleries and museums (1966–) and engaged in a three-year
study of the urban street, commissioned by the U.S. Department of Housing and
Urban Development (HUD) (1969–1972). He has received a variety of fellow-
ships, prizes, and awards.

ॐ

A polemicist with pen and concrete Eisenman is one of the more controversial
architects of the last three decades. Drawing on ideas outside architecture but
applied theoretically within art, he developed a sophisticated notion about the
meaning of architecture and a means of achievement. Complexity abounds with
verbal references to alienation, rhetorical strategies, loss of center, Corbusian
(see Le Corbusier*) forms, abstraction (art and society), substraction, skepticism
(and its kin, dogmatism), absence, bivalency, text, anticlassicism, and so forth.
More specifically relative to design process and architectural manifestation is

his notion of "deep structure," a proposition that there is an "underlying or-dering device that is the natural and logical generator of a design."[1] The device includes plan, post, space, openness, even color. His first buildings were inves-tigative of early modernists including Le Corbusier and Terragni. Explanation of those buildings was in his mind as theoretically relevant as the material fact, for example his House II, the Falk house, in Hardwick, Vermont (1969–1970), for which he presented twenty-four "transformation drawings" and a verbal demonstration that began: "To articulate . . . ways of conceiving and production formal information in House II, certain formal means were chosen each involv-ing an overloading of the object with formal references."[2] It was, he said, one "formal strategy" to realize design resolution. (On plodding through Eisen-man's extended explanations about one building, a reader should be reminded of Picasso's reply to a Parisian who asked for an explanation of one of his paintings: "You are asking me to paint it again.")

His later houses were more formal with a symmetry of form, such as the "L"'s of a project for Kurt Forster (1978–1980). House VI, the Frank house, in Cornwall, Connecticut (1972–1976), began with a pair of parallel "L"'s in plan. Then Eisenman overlaid a multiplicity of *imposed* configurations, the result a tiny one-bedroom house. The "L" is, he explains, one indicator of incomplete-ness.

Eisenman is often misunderstood or at best ignored and with reason, not the least his tendency toward conceit. When sometime collaborator Jacques Derrida offers that architecture must necessarily be incomplete, he is speaking a philo-sophic truth that has teased theory, process, and product. It is in that context that Eisenman came around to the idea of *de*composing architecture, not nec-essarily to then in some manner resurrect it. It is an additive to his theories that nonetheless sadly and continually fail in his desired communication "to raise our level of consciousness . . . to the point where as designers and users, archi-tecture may have . . . a more enriched meaning."[3] The resulting architectural products in fact confuse. Take for example his House El Even Odd: the title a word game and the design a two-dimensional game awkwardly extended into the third dimension as a two-story house (not to mean "home") devoid of societal let alone historical references.

The wide gaps between architectural reality and verbal (erudition) theory—including visual diagram—Filler correctly calls "disparities" and indicates to Greenspan Eisenman's obsession "with the architecture of nihilism."[4] A skeptic maybe, but perhaps more accurately Eisenman with Derrida would be under-stood as anarchists. And therein is a quandary. His desire to communicate must battle with the fact that the pluralism within which he operates is usually equated with anarchy.

His buildings possess a stunted, inelegant set of proportions, exterior and interior, that not only detract but emphasize that mere paper diagrams are in control rather than the trust of the human senses for art. But then he would argue that there is no such thing as a human sense of art, only an essential art

implying objective perfectness wrought by "ideas independent of man." There is no interest in ideas that might suggest an emotive condition; he claims to be the ultimate rationalist. More architectonic, his ideas might *work* for small houses but they have proven to be unsustainable in larger buildings, an indication of a poverty of limitation, at least until the Wexner Center. In support of that observation one need only compare Eisenman's works of all scales (or size) with his contemporaries with abundant philosophic vigor, which includes humaneness, such as Louis I. Kahn,* Mario Botta,* and especially Tadao Ando.*

Another support is within the competition-winning design for the Wexner Arts Center for Ohio State University (1983–1990, with Richard Trott, Plate 41) where art-theoretical premises have given way to architectonic considerations that *look* derived from others, notably Louis Kahn, Bernard Tschumi, and Robert Venturi* and Denise Scott Brown.* The notion of a deep structure is subsumed by orderliness obtained by line (Kahn) with a skeletal trabeated diagonal by apparently whimsical forms (Tschumi), and by historical references (Venturi). Yet it can be argued that the building is better than the idea as verbalized; much as it is said that "Wagner's music is better than it sounds."

Dissimilarly yet as examples of further support, a fracturing of disparate solid, transparent and translucent, shifted geometric elements floating on the facades (only) characterizes the Koizume Lighting Building in Tokyo (with Kojiro Kitayama, 1990). With this building, he joins British and European theorists who enjoy *de*constructing architecture. Less obvious is a multistoried housing facility on Kochstrasse in Berlin, Germany (1982–1987, with Jaquelin Robertson) with a facade that superficially implies a layering of geometries disconcertingly discontinuous three dimensionally (not penetrating the interior, not "deep") and therefore unrelated to structure or interior. Rectangular forms are set on a skew (for instance some of the top two floors appear as if they had been shifted by an earthquake) for no obvious reason other than to present a haphazard dislocating *facade*.

And his early idea of "deep structure" is set aside for linear dynamics somewhat similar to the projects of Zaha Hadid. This appeared first in the roof scape of the Wexner Center and is carried to extreme in such works as the Columbus Convention Center, in Ohio (1988–1993), where plain, bulky forms progressively overlap: no doubt to delight a bird flying overhead. But at ground level the human experience is that of a disturbed, fractured facade.

The concept of "displacement," as Eisenman calls it, is more adequately developed in such projects as the Barcelona Hotel Competition, in Spain (1988–1992), and The Hague Social Housing, in Holland (1989+), or the pink and white settling—collapsing—Nunotani Building, in Tokyo (1990–1993, with others). Or the College of Design at the University of Cincinnati, in Ohio (1990–), which Paul Heyer describes as derived from existing campus buildings and observes that Eisenman "tilts, overlaps, and shifts," where disjunctions, "fuzzy" by various "formal moves" blur "building both in plan and elevation," and with interiors.[5] (See Plate 49.)

Leon Krier,* who might be termed a *re*constructionist, believes that Eisenman's buildings are immoral, cold, alien. Eisenman believes his architecture speaks of "presentness," of "the now."[6] Indeed, the formalism of his early years has given way in the late 1980s to accepting and modifying ideas of others while still perpetuating his initial foray into symbolizing realistically the frenetic social—and physical—dislocations found in and all about contemporary society. Zaha Hadid and Coop Himmelblau* have much in common with their mentor Eisenman.

NOTES

1. Finken (1985), 127.
2. Kenneth Frampton and Colin Rowe, *Five Architects* (New York, 1972), 25.
3. Eisenman, "Conceptual Architecture," *Casabella* 386 (1974), 25.
4. Filler (1980), 129; and David A. Greenspan, "Views," *PA* 58 (August 1977), 8.
5. Paul Heyer, *American Architecture* (New York, 1993), 234.
6. *ADesign* 9, 10 (1989), 9, 15.

BIBLIOGRAPHY

Writings

"Behind the Mirror: On the Writings of Philip Johnson." *Oppositions* 8 (Fall 1977).
Cities of Artificial Excavation. The Work of Peter Eisenman, 1978–1988, edited by Jean-François Betard. New York, 1994.
"Contrasting Concepts of Harmony." *Lotus* 40 (1983).
"The Effects of Singularity." *ADesign* 62 (November 1992).
"End of the Classical." *Perspecta* 21 (1984).
"Forum Discussion." *Harvard* 1 (April 1980).
"From Golden Lane." *Oppositions* 1 (September 1973).
"From Object to Relationship II." *Perspecta* 13–14 (1971).
"The Futility of Objects: Decomposition and Process of Differentiation." *Lotus* 42 (1984).
Giuseppe Terragni: Transformations, Decompositions, Critiques. New York, 1993.
"Hollein's Cave (at): The Haas Haus." *a+u* 256 (January 1992).
House XI. New York, 1982.
House of Cards. New York, 1985.
"House VI." *PA* 58 (June 1977).
"[R]ecent Projects." *ADesign* 59, 9 and 10 (1989).
Re-working. London, 1993.
"Robin Hood Gardens, London E14." *ADesign* 41 (September 1972).
In Kenneth Frampton and Colin Rowe. *Five Architects.* New York, 1972; 2d ed. 1975.
In *Transition.* "Interview." 3, 4 (April 1984).
With Jacques Derrida. *A Choral Work.* London, 1990.
With Daniel Libeskind. *Chamber Works.* London, 1983.
Founder and editor. *Oppositions* (New York) 1973–1984.

Biographical

Smith, C. Ray. In *Contemporary Architects.*

Assessment

ADesign. "Peter Eisenman versus Leon Krier." 59, 9 (1989).

———. "The Wexner Center." 59, 11 (1989). The whole issue.

a+u. "Columbus Convention." 276 (September 1993).

———. "Peter Eisenman." Extra edition. 8. (August 1988).

———. "White and Grey. Eleven Modern American Architects." 52 (April 1975).

Archer, B. J., ed. *Houses for Sale.* New York, 1980.

Casabella. "Cardboard Architecture." 374 (February 1973).

Ciorra, Pippo. *Peter Eisenman. Opere e progetti.* Milan, 1993.

Davey, Peter. "Urban Eisenman." *AReview* 176 (December 1984).

Derrida, Jacques. "Stichwörter zur Architektur." *Werk* 78 (June 1991).

Doubilet, S. "The Divided Self." *PA* 68 (March 1987).

Filler, Martin. "Polemical House." *ArtA* 68 (November 1980).

Finken, Kathleen Enz. In *The Critical Edge,* edited by Tod A. Marder. MIT Press, 1985.

GADoc. "Emory Center for the Arts." 36 (1993).

———. "Nunatomi Headquarters . . . ,[etc]." 37 (1993).

Gandelsonas, M. "From Structure to Subject." *Oppositions* 17 (Summer 1979).

Ghirardo, D. "The Grid and the Grain." *AReview* 187 (June 1990).

Goldberger, Paul. "House as Sculptural Object." NYTM (20 March 1977).

Goldblatt, D. "The Dislocation of the Architectural Self." *Journal of Aesthetics & Arts Criticism* (New York) 49 (Fall 1991).

JapanA. "Koizumi Lighting Theatre." 2 (Spring 1991).

———. "Nunotani Building." 9 (Spring 1993).

Jodido, P. "Jour de cristal." *Connaissance* (Paris) 494 (April 1993).

Jones, K. B. "The Wexner Fragments." *JAE* 43 (Spring 1990).

Krauss, Rosalind. "Death of a Hermeneutic Phantom." *a+u* 112 (1980).

Kwinter, S. "Challenge Match for the Information Age." *a+u* 276 (September 1993).

Lewis, R. K. "At the Wexner Center." *MuseumN* 70 (July 1991).

Libeskind, Daniel. "The Lamentable Centre: A response to." *AAFiles* 10 (Autumn 1985).

"The OSU [Ohio State University] Center for the Visual Arts." *ADesign* 55 (January 1985).

PA. "Center for the Arts." 74 (January 1993).

———. "House III." 55 (May 1974).

Patin, Thomas. "From Deep Structure . . . Structuralism and Deconstruction." *JAE* 47 (November 1993).

Robertson, Jacquelin T. "Pennsylvania Avenue: What Went Wrong?" *Historic Preservation* (Washington, D.C.) 39 (September 1987).

Stern, Robert A. M., et al. "Five on Five." *AForum* 138 (May 1973).

"Wexner Center of Art." *GADoc* 26 (1990).

Bibliographical

In *a+u* (1988).

Vance: Lamia Doumato, A736, 1982; Patricia Weisenburger and Douglas Levy, A1705, 1986; Dale Casper, A2035, 1988; and Anthony White, A2346, 1990.

Archival

Eisenman, Peter. *An Architecture of Absences*. London, 1986.
Kipnis, Jeffrey, and Nina Hofer. *Fin d'Ou T Hou S*. London, 1985.

ALDO (E.) VAN EYCK. 1918 (Driebergen, the Netherlands)– . Van Eyck spent much of his childhood in England while he received a basic education at King Alfred School, Hampstead, London (1924–1932) and at Sidcote School, Winscombe, Somerset (1932–1935). He began professional studies in the School of Building at The Hague (1938), completing them at the Eidgenossische Technische Hochschule, in Zurich (1939–1943). After working with the Amsterdam Public Works Department (1946–1950), in 1952 he set up a practice in The Hague and Amsterdam. From 1971 until 1982 he formed a partnership with Theo Bosch; after 1982, with his architect wife Hannie van Roojen, whom he married in 1943. Active from 1947 in the Congrès Internationaux d'Architecture Moderne* (CIAM), Van Eyck was a founding member of Team 10 (1956), which displaced CIAM in 1959. He was coeditor of the influential Dutch journal *Forum* (1959–1967), and in 1967 he became a professor at the Delft Technische Hogeschool. Van Eyck is internationally celebrated; he has lectured as widely as he has been published and exhibited. He has been honored by his peers at home, throughout Europe, and in North America. He received the Gold Medal of the RIBA (1990).

⌣

Van Eyck has striven to achieve what English architectural historian Bruce Allsopp has repeatedly pleaded for: a humane architecture.[1] As John Furse writes, his "reputation as a leading architect of the post war European avant-garde is based on his simple concern that a building must not only provide real practical space but also offer the opportunity for possible alternative activities for those who come to use it."[2] Initially drawing upon his experience of designing for children—about 700 playgrounds in the Amsterdam Municipality—he turned away from the formalities of entrenched modernism. This stress upon the imaginative, probably first tested despite a draconian brief in his Nagele schools (with van Ginkel, 1954–1957), was best expressed in the Amsterdam Orphanage of 1955–1960. Van Eyck said that his main purpose in that building was to "untwist these little children" by providing a stimulating spatial environment. The other source for van Eyck as addressed in his writings was the study of primitive peoples, especially the Dogon of West Africa and the Pueblo Indians of North America. Their respective views of place and home were transposed into van Eyck's ideology, in which the home is "the spiritual core of existence allowing for inner experiences." He writes: "Architecture can do no more, not should it ever do less, than accommodate people well, assist their homecoming."[3]

Van Eyck's view of architecture, recognizing contradictions in modernism, has been summarized as follows. First, the complexity of contemporary society

"must not be allowed to disintegrate into rational analyses and arrangements"; rather, architects and planners should express it as a "spatial and social whole." Second, the positivist view of humanity was being replaced by an idealistic vision: regardless of time and space, people have the same "basic needs and intuitions." Third, architects "must resist the idea of a technocracy" in which form is subsumed by bureaucracy and science, and resist the separation of architecture and urban design.[4] He was not alone. In the early 1950s, many European architects wanted to modify (*not* relinquish) the dogmas of modernism to produce buildings that were compatibly modern *and* monumental, objectively functional while responding to spiritual needs—"visually complex, texturally rich, and physically substantial."

In 1947 van Eyck, already active in the Amsterdam modernist group De 8 en Opbouw, had been one of Holland's delegates at the Bridgewater conference of CIAM. He responded to what he heard with a broadside entitled "Statement against Rationalism." In 1956 at Dubrovnik he became a founding member of an international group of young architects—"a loose association of friends" of the modern movement—calling itself Team 10. Other instigators included Jan Bakema, Shadrach Woods, Giancarlo de Carlo, Georges Candilis, Alexis Josic, and Alison and Peter Smithson.* At CIAM's 1959 Otterlo conference the old regime was replaced by the new, "setting its own goals for a new, more humane system of public housing." Van Eyck and Bakema were able to use the pages of *Forum,* the voice of Amsterdam's *Architectura et Amicitia* group, to broadcast their shared beliefs.

Having held various teaching posts in Holland since 1951, as well as visiting lectureships in the United States, Singapore, and Norway, in 1967 van Eyck became a professor at the large Architecture School at Delft. He continued to practice and had a twelve-year association with Theo Bosch. He also worked in partnership with his wife Hannie; among their most noted works are the Hubertus Single Mothers' house, in Amsterdam (1973–1978), and the ESTEC headquarters at Noordwijk, Holland (1986). One writer observes that his "place in architectural history is frequently defined by his contribution to Team 10,"[5] but he has also produced an architecture that possesses, like the man himself, "a rare modesty and is imaginative but at the same time understated, approachable and appropriate."[6]

NOTES

1. Bruce Allsopp, *Towards a Humane Architecture* (London, 1974); *A Modern Theory of Architecture* (London, 1977).

2. Furse in *Contemporary Architects.*

3. As quoted in Furse in *Contemporary Architects.*

4. Paul Groenendijk and Hans Vollaard, *Guide to Modern Architecture in The Netherlands* (Rotterdam, 1987), 156.

5. Frank in Macmillan.

6. Cousins (1991).

BIBLIOGRAPHY

Writings

Aldo van Eyck, Projekten 1948–61. Groningen, 1981.
Aldo van Eyck, Projekten 1962–76. Groningen, 1983.
"Bouwen in de zuidelijke oase." *Forum* (Amsterdam) 8 (January 1953).
"CIAM 1959." In *Contemporary Otterlo,* edited by Oscar Newman. Stuttgart, 1961.
"CIAM 6. Bridgewater: Statement against Rationalism. 1947." In *A Decade of Architecture,* edited by Siegfried Giedion. New York, 1954.
"Dordrecht-Zwolle." *Lotus* 18 (March 1978).
Forum (Amsterdam). Editorials 1959–1967.
"Image of Ourselves." *Via* (Philadelphia) 1 (1968).
"Kaleidoscope of the Wind." *Via* (Philadelphia) 1 (1968).
Niet om het even . . . wel evenwardig, bij en over Aldo van Eyck. Amsterdam, 1986.
"Team 10 in Bonnieux." *Deutsche Bauzeitung* (Stuttgart) (November 1978).
"What Is and Isn't Architecture." *Lotus* 28 (1980).
With Hannie van Roojen. "Un nouveau centre de gravité." *Aujourd'hui* 235 (October 1984).
———. "A propos de non espaces, de roses et de codussi." *Aujourd'hui* 235 (October 1984).

Biographical

Furse, John. In *Contemporary Architects.*

Assessment

Abitare. "Amsterdam, Urban Renewal: Nieuwmarkt." 236 (July 1985).
ADesign. "The Work of Team 10." 34 (August 1964). The whole issue.
Architects' Yearbook. "The Theme of CIAM 10." (London) 7 (1956).
AReview. "New Amsterdam School." 177 (January 1985).
van de Beek, Johan. *Aldo van Eyck—Projekten 1962–1976.* Groningen, 1982.
Brandolini, Sebastiano. "The Blue Church in Deventer." *Casabella* 57 (October 1993).
Buchanan, Peter. "Architect Ludens: Aldo and Hannie van Eyck." *AReview* 187 (February 1990).
———. "*Forum* Fellowship." *AReview* 187 (February 1990).
———. "Humane Face of a Modern Architect." *AJournal* 191 (21 March 1990).
———. "Observations on a Man-made Land." *AReview* 177 (January 1985).
Buchanan, Peter, et al. *Aldo & Hannie van Eyck.* Amsterdam, 1989.
Cousins, Mark, in *Illustrated Dictionary of Architects and Architecture,* edited by Dennis Sharp. London, 1991.
Davies, Colin. "Windows to Another World." *AReview* 190 (April 1992).
Gregotti, Vittorio, and S. Brandolini. "Aldo van Eyck: Architetti e pensieri." *Casabella* 49 (1985).
van Heeswijk, Hans, and Paul de Ley. "Gebouw voor de faculteit der letteren te Amsterdam." *Bouw* (Rotterdam) 41 (21 June 1986).
Hertzberger, Herman, et al. *Aldo van Eyck.* Amsterdam, 1982.
van Heuvel, Wim. *Structuralism in Dutch Architecture.* Rotterdam, 1992.
Koster, Egbert. "Alternatief functionalisme in low-teck en barok." *De Architect* (The Hague) 20 (December 1989).

Lefaivre, Liane, and Alexander Tzonis. "Dragon in the Dunes." *a+u* 247 (April 1991).

Luchinger, Arnulf. *Structuralism in Architecture and Urban Planning.* Stuttgart, 1981.

Pawley, Martin, et al. "Aldo van Eyck." *World Architecture* (London) 22 (March 1993).

Shack, Joel. "Color in Architecture . . . Aldo and Hannie van Eyck." *Structurist* (Saskatchewan) 31–32 (1991–1992).

Smithson, Alison. "Team 10 at Royaumont, 1962." *ADesign* 45 (November 1975).

Strauven, Francis. *Aldo van Eyck.* Antwerp, 1985.

van Velsen, Endry. "Een cultureelcentrum voor Middelburg." *Archis* (Doetinchem) (May 1992).

Welsh, John. "Gold Standard." *BuildingD* 991 (22 June 1990).

Werk. "Structuralism—A New Trend in Architecture." 3 (January 1976). The whole issue.

Yashiro, Masaki. "Collective Housing in Holland: Traditions." *ProcessA* 112 (1993). The whole issue.

Bibliographical

Vance: Lamia Doumato, A1303, 1985.

F

HASSAN FATHY. 1900 (Alexandria, Egypt)– . Raised in a family of modest wealth devoted to literary, artistic, and intellectual modernism, Fathy graduated from the Architecture Section of the School of Engineering at Giza, Cairo (1930) under the influence of the École des Beaux Arts in Paris. He was employed by the Department of Municipal Affairs (1930–1946), taught at the Faculty of Arts (1940–1941) in Cairo, then worked on housing (1946–1953) for the Royal Society of Agriculture and Antiquities Department (1949–1952). Thereafter he became a consultant on housing to the United Nations (1953–1957). After a brief return to the Faculty of Fine Arts and unsettling times during the Nasser government, he joined Constantin Doxiadis* in Athens, Greece, as a consultant architect (1957–1962). This was followed by lecturing on housing at the Athens Technical Institute and conducting research on housing in Athens (1963–1965). On returning to Cairo he held a variety of positions related to cities and housing and served as a delegate to the UN Organization for Rural Development. He held a number of lecturing positions (1970–1980), and in 1977 he founded and was director of the International Institute for Appropriate Technology (to 1980). Fathy received one of the first Aga Khan Awards (1980) and the first Gold Medal of the UIA (International Union of Architects, 1985).

ᴒ

Teacher, philosopher, artist, architect, and poet, Fathy "represents the antithesis of the blind drive toward technology in cultures undergoing rapid modernization by advocating tradition alloyed with today's technology."[1] He has "devoted himself to the task of housing the poor in developing nations. His

work . . . deserves the closest study by anyone involved in rural improvement,''[2] or those involved with architecture for the poor, as Fathy put it.

After a visit to New Gourna the critic J. M. Richards commented that,

In spite of an air of neglect and misuse it was beautiful. . . . Its basic geometry of cube and vault and rectangle, emphasized by the deep shadows cast by the Egyptian sun, appeared as the essence of architecture itself. Wholly modern, with no feeling of pastiche, its combination of repetition and contrast, variety and simplicity . . . it appeared the epitome of the co-ordinated plan.[3]

Gourna is a rural village (1946–1948) near Luxor where Fathy first put into practice his concept of a complete indigenous environment. This included not only the physical but also an acknowledgement of the social structure. He drew ideas from preindustrial building systems and studied the *Mamluk* ventilated two-story halls, screens, courtyards, the *malkaf* (windcatchers), and in rural areas the methods of mud brick construction for walls and leaning vaults.

Community participation in constructing their buildings was a critical part of Fathy's notion of encouraging people toward reliance on their own resources, on self-help. Struck by political and community strife and apathy, New Gourna was only partially built. But Fathy persevered with planning communities for Mit-el-Nasara, Egypt (1954), Bariz Village (1964), and Sidi Crier on Egypt's coast (1971), all partially built.

"Human groups are like individuals," Fathy has said,

each has its own personality and its speciality in the different branches of science and the arts in which it excels. This collective personality is the outcome of the contribution of the mass of individuals that make the group. . . . In consequence, it is the duty of the planner to consider the interaction between the configuration of the city in space and its cultural movement. In other words, to recognise the cultural vitality of the group.[4]

Nature in concert with experiential knowledge can provide the means to better cost-effective and comfortable housing. Fathy provided his own example: aerodynamically that "wind blowing above the house will not enter the courtyard, but will pass over and create eddies inside. Thus the courtyard will retain the cool air that has settled there, and the air will seep into the rooms and walls, cooling the house."[5]

A plain, relatively unadorned square dome, a semidomed alcove, a rectangular vault, and a courtyard were the basic elements of Fathy's architecture in white and subtle cream colors with accents of wood. These are obvious not only in the many buildings for his villages but in a number of houses, a project for a theater at Tarh el-Bahr Island, Luxor (where a large *malkaf* was proposed), or the Mushrabeya Hotel Center, Giza (1976). Or a mud brick mosque in New Mexico.

Abdel-Wahed El-Wakil represents a more traditional approach to the architecture of the Arab countries, for example his Halawa house, in Agamy, Egypt

(1972–1975), or the Corniche Mosque, in Jeddah, Saudi Arabia (1985). Henning Larsen represents another extreme that is technology driven but nonetheless cleverly hints of desert traditions, for example, his Ministry of Foreign Affairs in Riyadh, Saudi Arabia (1981–1984). Fathy's work comfortably resides between those extremes yet is closer to El-Wakil, who was inspired by Fathy. After following more or less the manners of Le Corbusier,* the Indian Charles Correa's architecture has slowly turned closer to Fathy in spirit if not in form.[6]

In acknowledging Fathy's accomplishments the Aga Khan said,

As champion of indigenous building, he has proved the graceful mud brick structures to be both economical to build and admirably suited to the climate. . . . He has taught us the value of the vernacular environment. And he has shown us that the lessons to be learned are modern lessons.[7]

The Aga Khan correctly noted that Fathy's pragmatic and humanistic philosophy has spread worldwide and in countries of differing cultures and climates and not always where Islam is dominant.

NOTES

1. Goethert in Macmillan.
2. Spreiregen in *Contemporary Architects*.
3. Richards (1970), 118.
4. As quoted in Holod (1983), 244.
5. As quoted in Holod (1983), 245.
6. See Charles Correa *Architecture in India.* 2d ed. (London, 1987).
7. The Aga Khan, as quoted in Holod (1983), 239.

BIBLIOGRAPHY

Writings

The Arab House in the Urban Setting. Past, Present and Future. London, 1972.
"Beyond the Human Scale—Hassan Fathy." *AAQ* 6 (3 and 4, 1974).
"Constancy, Transposition and Change in the Arab City." In *Madina to Metropolis,* edited by L. Carl Brown. Princeton, N. J., 1973.
Gourna. A Tale of Two Villages. Cairo, 1969; republished as *Architecture for the Poor. An Experiment in Rural Egypt.* Chicago, 1973.
"Model Houses for El Dareeya, Saudi Arabia." *Ekistics* (Athens) 21 (March 1966).
Natural Energy and Vernacular Architecture. Chicago, 1986.
"Le Pays d'Utopie." *La Revue de Caire* 24 (November 1949).
"Planning and Building in the Arab Tradition." In *The New Metropolis in the Arab World,* edited by Morroe Berger. New Delhi, 1963; New York, 1974.
"Rural Self-Help Housing." *International Labour Review* 85 (January 1962); Abstracted in *Ekistics.* Athens 13 (June 1962).

Biographical

Holod, Renata, ed. *Architecture and Community. Building in the Islamic World Today. The Aga Khan Award for Architecture.* Geneva, 1983.
Spreiregen, Paul. In *Contemporary Architects.*

Assessment

AForum. "Architecture and Energy." 134 (July 1973).
Clark, Felicia. "Appropriate Invention." *ARecord* 167 (January 1980).
Cousin, Jean-Pierre. "Hassan Fathy." *Aujourd'hui* 195 (February 1978).
Curtis, William J. R. "Towards an Authentic Regionalism." *Mirmar* 19 (January 1986).
Dillon, David. "A Mosque for Abiquiu." *PA* 64 (June 1983).
Goethert, Reinard, with Margaret De Popolo, in Macmillan.
Richards, J. M. "Gourna. A Lesson in Basic Architecture." *AReview* 147 (February 1970).
Richards, J. M., Ismail Sergeldin, and Darl Rostorfer. *Hassan Fathy.* Singapore, 1985.
Steele, James. *Hassan Fathy.* London, 1988.
Steele, James, ed. *Architecture for a Changing World.* London, 1992.
Swan, Susan. "Hassan Fathy Demonstrated Ancient Construction . . . New Mexico." *ARecord* 168 (December 1980).

Bibliographical

Holod (1983).
Vance: Lamia Duomato, A1833, 1987.

Archival

Steele, James. *The Hassan Fathy Collection.* Geneva, ca. 1989.

NORMAN (ROBERT) FOSTER. 1935 (Manchester, England)– . Foster studied at the University of Manchester (1956–1961), graduating as an architect and town planner; as a student he won the coveted Silver Medal of the RIBA (1961). Traveling on a scholarship, he successfully completed a master's degree in architecture at Yale (1961–1962). After a short stay in the office of R. Buckminster Fuller* (with whom he formed a lifelong friendship), Foster returned to England (1964) and set up a practice, Team 4, with his architect wife Wendy Cheeseman (whom he had married in 1964), Richard Rogers* (whom he had met at Yale), and Rogers's wife Su. In 1967 that firm was superseded by Foster Associates— more recently called Sir Norman Foster and Partners—which since its inception has won about fifty international awards. Foster has concentrated upon practice rather than polemic or pedagogy, and his work has been widely exhibited in Britain, Europe, Asia, and North America. International accolades were crowned for him, as a Britisher, with the RIBA Gold Medal (1983). He was also awarded the French Academy of Architecture's Gold Medal (1991) and the AIA Gold Medal (1993).

✐

Associated by many with the term "high-tech" because of his consummate use of steel and glass, and dubbed one of the leading British postmodern architects, Foster has called postmodernism "cynical and simplistic." He may be better described as a pragmatic modernist who views the design process as "a means of integrating and resolving conflicts," by which he means accommodating the often contradictory constraints of function, the needs of the spirit, aesthetics and costs, and flexibility of use. In that process, he says, "high tech-

nology is not an end in itself, but rather a means to social goals and wider possibilities," and he points out that high-technology buildings are handcrafted with the same care as those built with traditional means.[1] His buildings consistently demonstrate that belief.

Because structure is the medium by which architects achieve the balance that Foster considers necessary, it inevitably plays a major role in his aesthetic. He was first seriously noticed when he produced the Reliance Controls Factory (with Rogers, 1966) at Swindon, near London. No doubt strongly influenced by Rogers's experiences with Skidmore, Owings and Merrill,* the small building (as a modernist work should) clearly expressed its elegant and immaculately detailed structure. While it represented a partial turning from Team 4's earlier design approach, the factory challenged traditional standards of social organization and articulation of spaces, spatial flexibility, and especially the idea of front and back in industrial buildings. It has been described as a "democratic pavilion embracing the full range of the company's activities."[2]

Similar themes emerged in Foster Associates's modest projects for small office buildings, shops, schools, and factories through the mid-1970s: Deyan Sudjic remarks that

in other hands [these were] conventional enough briefs, but in each case the results were distinguished by the singlemindedness with which Foster pursues an idea. He transforms the ordinary and the everyday by his knack of treating industrial building materials like jewellery, and by his commitment to an unassertive polished elegance.[3]

Examples include the refined dockside amenity center for Fred Olsen Ltd. at Millwall (1969), the studio for Foster Associates in London (1971), where flexibility is optimized by the design of the furniture system and overhead services, the ultra-Miesian offices for IBM Advance at Cosham, Hampshire (1971), whose sophisticated use of the glass external wall is exceeded only by the subtly curved surface of the Wills, Faber and Dumas head office in Ipswich (1975), whose almost featureless skin, reflective by day, becomes diaphanous at night.

There followed the Sainsbury Centre for the Visual Arts (1978) at the University of East Anglia in Norwich. Its vast open exhibition space, spanned by great tubular open-web portal frames clad in anodized aluminum-faced sandwich panels, is divided by a system of display screens and panels to Foster's design. Almost the whole gallery is prefabricated to exacting tolerances, extending "the mainstream of previous projects," although the character of the building is determined by Foster's close association with the Sainsbury art collection and its owners. One writer comments that "the present design would have been inconceivable in isolation from a relationship so far removed from the normal realm of clients and patronage."[4]

Reyner Banham asserted that he once saw Foster in a London airport passenger lounge, coloring presentation drawings of some scheme or other while waiting for a flight. Banham facetiously opined that the colors of Foster's buildings were determined by the few crayons that he carried.[5] Anyway, color is an im-

portant element of Foster's work as evidenced by, for example, the Renault Parts Distribution Centre, in Swindon, Wiltshire (1983). It has bright yellow, treelike steel masts supporting its modular roof—more accurately its canopy—on cables, thus allowing maximum flexibility for expansion. Showrooms, offices, staff training school, and warehouse are achieved by steel-framed glass curtains. The articulated, suspended structural design, responding to a complex network of pragmatic and aesthetic needs, echoes that of the Wills, Faber and Dumas office and to some extent heralds the building that many believe to be Foster's magnum opus: the Hong Kong and Shanghai Bank headquarters (1979–1986), in Hong Kong (see Plate 40).

John Winter calls the bank "the most exciting high-rise building of the decade . . . with its bold structure, great spaces in the air and immaculate detailing [setting] a new world standard for the modern office building—the first time this has been achieved outside America."[6] At forty-one stories it towers above the waterfront skyline of Hong Kong, "a symbolic expression of the bank's power and prestige" and its commitment to the isolated island colony. The most arresting internal feature is the huge top-lit atrium, ten stories high, surrounded by glass-balustraded gallery offices: it maintains absolute transparency with its subtly curved, glass "underbelly" pierced by the escalators from the entrance level, skewed in accordance with Chinese *feng shui* belief; above it, the suspended escalators continue to climb. Throughout the interiors, the boldly visible massive structure reassures staff and client alike of the bank's solidarity. Reviewing the building in 1987, Foster's associate Christopher Seddon wrote that the bank

must be assessed against Foster's original stated aim: the reevaluation of the high rise office building. In terms of a radical rethink of the crushing banality that oppresses this distinctly twentieth century building type, the critical reaction to the Bank has been a huge success. "Foster's response to the commission amounts to nothing less than the reinvention of the skyscraper." By returning to a scale, a massing, a movement strategy which recognizes first the occupant, Foster has struck decisively at the alienation and soul-destroying anonymity of most modern office buildings. . . . [From the first] glimpse across the harbour, to the majestic approach up Statue Square, across the ambiguous threshold of the uncompromising plaza, to the strangely canted escalators and up into the light-filled, mysteriously humming atrium space, the experience for all is reported as awesome.[7]

Norman Foster and Associates grew to be the second largest practice in Britain and now boasts many international clients. Other important commissions of the 1980s included a new Radio Center for the BBC (1983), the Sackler Galleries (1985–1986) for the Royal Academy in London, and the master plan and several buildings for Stansted, London's third airport (1987). The two latter won the RIBA Annual Award for Foster in 1992. Notable among his later British works are the library of the Cranfield Institute of Technology, in Bedfordshire (1992–1993), and the American Aviation Museum, in Duxford, Cambridgeshire

(1992–1993), with its expansive precast concrete shell roof. Current domestic projects include a master plan for the now defunct Manchester 2000 Olympic Games (although Foster's main stadium is being built in collaboration with Arup Associates and the Amec Consortium) and the "millenium plan" for Alberto-polis, a reorganization of London museums incorporating extensions to the British Museum.

Foster entered the world arena in 1974 through his Norwegian shipping client, Fred Olsen Ltd. After a few commissions in Norway (1974–1975), he produced competition entries and projects in the Canary Islands, Germany, and the United States until his reputation was firmly established by winning international competitions for a modern art center in Nîmes, France (1984) and the Hong Kong and Shanghai Bank (see Plate 40). Following projects for a Salle des Spectacles in Nancy, France (1986), a Holiday Inn for The Hague, Holland, and another hotel in Florence (both 1987), and the Appalto Corso at Turin Airport (1987), commissions in continental Europe proliferated. Those of the 1990s include the following: in France, a chain of stores for Cachare Clothing Company (1992–1993), an art center and library dubbed by the local mayor "Beaubourg of the south"—the Carré d'Art, in Nîmes (1984–1993), and the Albert Camus model high school at Frejus (1992–1993); in Germany, a building for the Duisburg Microelectronics Park (1992–1993) and conversion of the Reichstag, Berlin (1993). The three latter commissions incorporated innovative energy-saving devices. He also designed the Coliserola Communications Tower for the Barcelona Olympic Games (1991–1992).

Foster's earliest work in Asia was a planning study of Statue Square, in Hong Kong (1980). His Hong Kong and Shanghai Bank success attracted Japanese commissions, including the Century Tower, in Tokyo (1987–1991), an elegantly spired office building, somewhat redolent of the bank, with twin towers of nineteen and twenty-one stories joined by a glass-roofed atrium (see Plate 44). He also designed the Bunka Radio Station, in Tokyo, and the Kawana house (both 1987). More recent Asian commissions include Hong Kong's Chek Lap Kok airport (1992+) and the "Gate of China," Kowloon Railway Station (1993–1994). Foster has also undertaken projects in the Americas: besides several competition entries, they include proposed extensions to the Whitney Museum, in New York (with Derek Walker Associates, 1978), an International Energy Expo, in Knoxville (1978), and headquarters for *Televisa,* in Mexico City (1986). He also designed extensions to the Joslyn Art Museum, in Omaha, Nebraska (1992–1993).

Combining "prolificacy with innovation," Foster's twenty-nine-year-old practice continues to win international engineering, city planning, and architectural competitions and commissions. He says:

There [should be] no misunderstandings about my own motivations. I practise architecture for the pleasure that I derive from its pursuit—even if, at times, the disciplines and demands seem insuperable. To paraphrase Charles Eames, I like to think that I take my pleasures seriously . . . I am more at home designing than talking about design.[8]

NOTES

1. Winter in *Contemporary Architects.*
2. *a+u* (May 1988), 46.
3. Sudjic (1986), 29.
4. *a+u* (May 1988), 127.
5. Reyner Banham in conversation with Donald Langmead, 1987.
6. Winter in *Contemporary Architects.*
7. Seddon in *a+u* (May 1988), 212.
8. Foster's RIBA Gold Medal Address, June 1983, as quoted in *a+u* (May 1988), 294.

BIBLIOGRAPHY

Writings

"Architektur des machens." *Arch Plus* (Aachen) (January 1990).
"Exploring the Client's Range of Options." *RIBAJ* 77 (June 1970).
"Foster Associates: Recent Work." *ADesign* 42 (November 1972).
"Towards the Modern Vernacular." *Detail* (Munich) 33 (December 1993).
With Reyner Banham and L. Butt. *Foster Associates.* London, 1979.
With K. Sugimura. "Foster Associates: The Architecture of the Near Future." *SpaceD* (March 1982).
With others. "Foster Associates: Hongkong Bank." *a+u* 189 (June 1986).
———. "The Living Legacy of Frank Lloyd Wright." *Blueprint* (London) 94 (February 1993).

Assessment

a+u. Extra edition (May 1988). The whole issue.
A&V. "Norman Foster: 1986–1992." (Madrid) 38 (1992). The whole issue.
Abel, Chris. "The Essential Tension." *JapanA* 3 (Summer 1991).
———. "Maschinenzeitalter: Zum Werk von . . . Foster." *Archithese* (Niederteufen) 17 (November 1987).
———. *Norman Foster.* London, 1991.
L'Arca. "The Gateway to China." (Milan) 81 (April 1994).
Architecture Intérieure Crée. "Discourse de la méthode: Foster." (Paris) 244 (August 1991).
Architecture Today. "Duisburg [Microelectronics Park]." (London) 43 (November 1993).
ARecord. "Whitney Museum of American Art Extension." 166 (August 1979).
Arup Journal. "The Hongkong Bank: The New Headquarters." (London) 20 (Winter 1985).
Aujourd'hui. 243 (February 1986). Anthology.
———. "Norman Foster: Lycée polyvalent à Frejus." 290 (December 1993).
Blaser, Werner, ed. *Norman Foster: Sketchbook.* Basel, 1993.
Bramante, Gabriele. *Willis Faber and Dumas Building: Foster Associates.* London, 1993.
Chevin, Denise. "Sun Worshipper." *Building* (London) 259 (1 January 1994).
Chipperfield, David. "Technology and Architecture." *Quaderns* (Barcelona) 178 (July 1988).
Cohn, David. "Mediterranean Light." *ARecord* 181 (October 1993).

Cooper, Peter. "Chinese Puzzles." *Building* (London) 258 (15 January 1993).

Davies, Colin. "High-Tech Idealist." *AIAJ* 83 (May 1994).

———. *AIAJ* 82 (September 1993). Portfolio of three buildings by Norman Foster and Partners.

Davies, Colin, and Ian Lambot. *Century Tower: Foster Associates Build in Japan.* Weinheim, 1992.

Dodwell, C. R., et al. *Norman Foster: Architect. Selected Works 1962/84.* Manchester, 1984.

Foster, Sabiha, ed. *Architecture as Building: Sir Norman Foster and Partners.* London, 1993.

GADoc. "New Airport at Chek Lap Kok, Hong Kong." 36 (1993).

Garcias, Jean-Claude. "Norman Foster." *Aujourd'hui* 276 (September 1991).

Gregotti, Vittorio. "Confini incalicabili." *Casabella* 55 (March 1991).

Ho, Tao, et al. "Hongkong Bank." *ProcessA* 70 (September 1986). The whole issue.

Inglis, Simon, and Martin Spring. "Four up at Half Time." *Building* 258 (27 August 1993).

Irace, Fulvio. "Six Protagonistes . . . architecture typiquement brittanique." *Techniques* (June 1992).

Isasi, Justo F. "El fantasma del Reich." *Arquitectura Viva* (Madrid) 30 (May 1993).

Jencks, Charles. "The Battle of High-Tech." *ADesign* 58 (November 1988).

Lambot, Ian. *New Headquarters for the Hongkong and Shanghai Banking Corp.* London, 1986.

Lampugnani, Vittorio M., ed. *Hongkong Architecture: The Aesthetics of Density.* Frankfurt, 1993.

———. *Norman Foster, Foster Associates: Buildings and Projects.* 3 vol. London, 1989–1990.

van der Leeuw, Charles. "Norman Foster haalt uit." *Bouw* (Rotterdam) 41 (June 1986).

Loriers, Marie-Christine, et al. "Échanges Européens." *Techniques* 409 (August 1993).

Lupano, M. "The Foster of Nîmes and the Carré-d'Art." *Lotus* 79 (1993).

MacCormac, Richard, et al. "1992 RIBA Awards." *RIBAJ* 100 (January 1993).

McGuire, Penny. "Solid Tradition." *AReview* 192 (June 1993).

Maxwell, Robert. "Projetti urbani di Norman Foster." *Casabella* 53 (May 1989).

Moore, Rowan. *Sackler Galleries: Royal Academy, London.* London, 1992.

PA. "Foster Comes to America." 74 (August 1993).

Pansera, Anty. "Norman Foster per Tecno . . . office furniture." *L'Arca* (Milan) (January 1987).

Pawley, Martin. "Scrap Value." *AJournal* 191 (21 March 1990).

Powell, Kenneth. "Architecture's Highest Flyer." *BuildingD* (10 June 1994).

———. *Stansted: Norman Foster and the Architecture of Flight.* London, 1992.

Rambert, Francis. "Norman Foster." *Architectes Architecture* (Paris) 164 (January 1986).

Rastorfer, Darl. "The Metal-Skin Technology of Foster Associates." *ARecord* 173 (August 1985).

Rayhrer, Andrea. "Schirm und Charme [plans doe Ludenscheid]." *Bauwelt* 84 (22 January 1993).

Renault Centre UK. London, 1993.

Rocca, Alessandro, et al. "Japan: Totem without Taboo." *Lotus* 76 (1993).

Shuttleworth, Ken. "Cranfield Library." *Concrete Quarterly* (London) (Spring 1993).

Sudjic, Deyan. *Norman Foster; Richard Rogers; James Stirling.* London, 1986.
Vitta, Maurizio. "A Model High School [Frejus, France]." *L'Arca* (Milan) 78 (January 1994).
Waters, Brian. "Final Account." *Building* 249 (September 1985).
Winter, John. In *Contemporary Architects.*

Bibliographical

Vance: Valerie Nurcombe, A1396, 1985.

R(ICHARD) BUCKMINSTER (Bucky) FULLER. 1895 (Milton, Massachusetts)–1983. Fuller attended Harvard University in Cambridge (1913–1918) and the U.S. Naval Academy in Annapolis, Maryland (1917) followed by naval service (1917–1919). He then worked for various companies from 1919 to 1927 and with his father-in-law developed the Stockade Building System in Chicago (1922). Thereafter Fuller founded a series of companies, such as the Dymaxion Dwelling Machine Company (1944–1947, later Fuller Houses Inc.) and the Fuller Research Foundation in Wichita, Kansas (1947–1954), which were devoted to his various inventions or promotions; for example, dymaxion, synergetics, plydomes, tetrahelix, and geodesics (1927–1979). He was publisher and editor of *Shelter* (Philadelphia, ca. 1930–1932), consultant to *Fortune* (New York, 1938–1940), where he began his initial examination of world resources, and a contributor to *World Magazine*. During World War II he worked for the U.S. Economic Warfare and later the Foreign Economic Administration. He entered a partnership with Shoji Sadao, in New York, and Sadao and Zung Architects, in Cleveland, Ohio (1979–1983). Nationally and internationally Fuller held various research and teaching positions, many of distinction, at teaching institutions (1959–1983); often exhibited his work (1929+) including the Museum of Modern Art, in New York City, and the Triennale, in Milan, Italy; was often a consultant; and received many honors, degrees, and awards, including the RIBA (1968) and AIA (1970) Gold Medals.

✐

Although "Bucky" Fuller was long ago recognized and embraced by the architectural community and while he identified himself as an architect, he was much more; an author, inventor, cartographer, mathematician, engineer, futurist, philosopher, poet, teacher, and resource expert. . . . His work embrace[d] the principal issues of the twentieth century, and his thinking point[ed] to the future with a sense of constructive reason.[1]

"In his generalized definition of architecture he resolv[ed] the concrete and the abstract without regard to aesthetics. Architecture, [said] Fuller, is the organizing of macrostructures from microstructures."[2] Not meant as derogatory, but as simple fact, he observed that architects were no more than "exterior decorators."

When in time ideas materialize sufficiently to be called in 1934 architecture they are inevitably dead. Architecture is finite—life infinite. Maybe life is an idea—an idea that truth is progressively delightful."[3]

A prolonged depression after the death of a daughter in 1922 saw Fuller ultimately make what he has described as a profound moral commitment to improve the world through his knowledge, by technological determinism. Fuller's particular examinations were of structure, the efficient resistance of gravity and enclosure of spaces for human occupation. The word "efficient" is the clue to nearly all of his investigations: less is more. His structures were efficient in less material in compression, in more use of tensile materials, therefore greater spans with—again—less material. Many of his promotions lead to light frame structures, space frames or interlocked trusses, and to a number of patented systems by others, such as Uni-strut, and further theoretical studies such as those conducted by Conrad Wachsmann at Illinois Institute of Technology where Ludwig Mies van der Rohe* was director. Fuller's own flat space frame was called an octet truss.

In 1929 his proposal for a hexagonal "dymaxion house" had an open ground level; the upper level was the house with floor and roof held at their outer edges by wires from a single, central mast. His aluminum Wichita house of 200 pieces and 6,000 pounds, easily flown anywhere (1944–1945), was more effective with services premolded and preinstalled and based on aircraft construction.

In 1932 he published a proposal for a ten-story hexagonal hotel and apartment building based on the mast system, probably inspired by the apartment house scheme of 1928 by the Rasch brothers in Germany.[4] In 1932–1933 he built two prototypes for a "dymaxion shelter-mobile," or three-wheeled car; he developed a metal prefabricated bathroom (1930 and patented it in 1938); and he devised a new cartographic project map based on polydedrons (1943). These are but examples of the speculations of genius.

In the 1960s he worked with Constantin Doxiadis* on a World Society for Ekistics, based in Athens, Greece. Doxiadis wanted architecture and structure more rigorously applied to city planning. But Fuller found that scale too limiting and ventured again to investigate the world's economic and geographic resources to enable greater understanding toward improving the human environment. At another scale some applications of his microstructures were exhibited as sculptures by New York's Museum of Modern Art.

Most critical and public attention was directed to his geodesic dome. In the 1940s he applied mathematical thinking to an engineering strategy he called "tensegrity," a contraction of "tensional integrity." The resulting system "guarantees" a continuous tension element rather than "discontinuous local compression members." A few large-scale applications soon followed including the Union Tank Car dome (1958).

In 1960 he proposed a 200-foot-high geodesic dome to cover part of New York's Manhattan Island and in the late 1970s a floating Tetrahedral City for one million inhabitants, the "ultimate" architectural artifacts: macro shelters in control of an environment. Domes covered radar installations, industrial workshops, greenhouses, a proposed cinema (with Frank Lloyd Wright* as architect and in collaboration with Kaiser Steel), and, as the symbol of American ingenuity, its Pavilion at EXPO 67, in Montreal, Canada (1967), a "triumphant

vindication of this engineer-architect whose ideas of construction and design threaten to make most modern architecture obsolete.''[5] Perhaps that threat—not yet in abeyance—sent architects in the 1960s madly searching for an *aesthetic* response not technically driven as had been the thrust of European architects' machine-age rationalism. And yet Archigram* and Metabolism* received much value from Fuller's ideas by employing technology in proposals that stretched the architectural imagination.

A doggerel by Fuller more or less to the chorus of "Home on the Range":

> Roam home to a dome
>
> Where Georgian and Gothic once stood
>
> Now chemical bonds alone guard our blondes
>
> And even the plumbing looks good.[6]

NOTES

1. Paul Spreiregen in *Contemporary Architects.*
2. E. J. Applewhite in Macmillan.
3. Fuller (1934), 11.
4. Mumford (1930), 15,19.
5. H. H. Arnason, *A History of Modern Art* (London, 1969), 486. In 1976 the acrylic fabric burned, but the structural skeleton survives.
6. As quoted in Kenneth Frampton, *Modern Architecture. A Critical History,* 2d ed. (New York, 1985), 239. And a special thank you to Bridget Jolly for information and insight.

BIBLIOGRAPHY

Publications about or that significantly include Fuller proliferate.

Writings

And It Came to Pass Not to Stay. New York, 1976.
Earth Inc. New York, 1973.
Education Automation. Freeing the Scholar to Return to His Studies. Carbondale, 1962; New York, 1963.
"Dymaxion Houses. An Attitude." *ARecord* 75 (January 1934).
4D Timelock. Chicago, 1928.
Ideas and Integrities. New York, 1963.
It Came to Pass—Not to Stay. New York, 1966.
Nine Chains to the Moon. New York, 1938; Carbondale, 1970; New York, 1971.
No More Second Hand God and Other Writings. Carbondale, 1963, 1970.
Operating Manual for Spaceship Earth. New York, 1968, 1978; Carbondale, 1970.
Tetrascroll. New York, 1975; reprint, 1985.
Untitled Epic Poem on the History of Industrialization. New York, 1962.
Utopia or Oblivion. The Prospects for Humanity. Toronto, NY, 1969; London, 1970.
With E. J. Applewhite. *Synergetics. Explorations on the Geometry of Thinking.* New York, 1975.
———. *Synergetics 2. Further Explorations.* New York, 1978, 1979.
With Kiyoshi Kuromiya. *Critical Path.* New York, 1981.
With John McHale. *The Dymaxion World of Buckminster Fuller.* New York, 1960; reprint, 1973.

With others. *World Design Decade Documents.* Carbondale, 1965–1975.
———. *What I Have Learned.* New York, 1968.
Kahn, Robert, and Peter Wagschal, eds. *R. Buckminster Fuller on Education.* Amherst, Massachusetts, 1979.
Meller, James, ed. *The Buckminster Fuller Reader.* London, 1970.

Biographical

AForum. "The World of Buckminster Fuller." 136 (January 1972). The whole issue.
Applewhite, E. J. *Cosmic Fishing. An Account of Writing Synergetics.* New York, 1978.
Lord, Athena V. *Pilot for Spaceship Earth. R. Buckminster Fuller, Architect, Inventor and Poet.* New York, 1978.
Marks, Robert W., ed. *Buckminster Fuller. Ideas and Integrities. A Spontaneous Auto-biographical Disclosure.* New York, 1979.
Snyder, Robert. *Buckminster Fuller. An Autobiographical Monologue/Scenario.* New York, 1980.
Spreiregen, Paul. In *Contemporary Architects.*

Assessment

Aigner, Hal. "Relax—Bucky Fuller Says It's Going to Be All Right." *Rolling Stone* (San Francisco), 10 June 1971.
Applewhite, E. J. In Macmillan.
Ben-Eli, M. "Buckminster Fuller Retrospective." *ADesign* 42 (December 1973).
Hatch, Alden. *Buckminster Fuller. At Home in the Universe.* New York, 1974.
———. "Fuller." *ADesign* 31 (July 1961). The whole issue.
Heyer, Paul. *Architects on Architecture.* 2d ed. New York, 1978.
Kenner, Hugh. *Bucky. A Guided Tour of Buckminster Fuller.* New York, 1973.
McHale, John. *R. Buckminster Fuller.* New York, 1962.
Marks, Robert W. *The Dymaxion World of Buckminster Fuller.* New York, 1960, 1973.
Mumford, Lewis. "Mass-production and the Modern House." *ARecord* 67 (January 1930).
Pawley, Martin. "Ps." *RIBAJ* 98 (November 1991).
———. "21st Century Man." *AJournal* 179 (15 February 1984).
Rastorfer, D. "Structural gymnastics . . . [Seoul]." *ARecord* 176 (September 1988).
Robertson, Donald W. *Mind's Eye of Richard Buckminster Fuller.* New York, 1974.

Bibliographical

Close, Gloria, CPL 1349, 1977.
Fuller Research Foundation. *Dymaxion Index. Bibliography and Published Items regarding Dymaxion and Richard Buckminster Fuller 1927–1953.* Forest Hills, N.Y., 1953.
Vance: Mary Vance, A223, 1980, and A1831, 1987; and Dale Casper, A2004, 1988.

Archival

Applewhite, E. J., ed. *Synergetics Dictionary. The Mind of Buckminster Fuller.* 4 vols. New York, 1986.
Buckminster Fuller Sketchbook. Philadelphia, 1980.
Ward, James, ed. *The Artifacts of R. Buckminster Fuller.* 4 vols. New York, 1985.

FUTURISM. Filippo Tommaso Marinetti launched his "Manifesto of Futurism" in the pages of Paris's *Le Figaro* on 20 February 1909. It was a marvelous

piece of revolutionary if illusory literature. Marinetti was taken by the *artistes'* life and graduated from the Sorbonne in letters, not in art. "The era of great mechanized individuals has begun," he said in the manifesto. He was thrilled by the "beauty of speed," the "roaring motor car, which seems to run on shrapnel"; there was the "excitement of Labor, pleasure or rebellion"; he extolled the "nocturnal vibrations of arsenals," the roaring factories "suspended from the clouds by their strings of smoke," bridges, ocean liners, "broadchested locomotives prancing on the rails," aeroplanes, the "triumphant progress of science," and so forth.[1] He condemned museums, illiteracy, historicism: the past was obsolete. There was only the Future.

Marinetti was "animator," the heart, the force of a group of young intellectuals and artists who formulated other manifestos, produced many works of art and other designs, and then traveled around Europe and into Russia offering readings of their poetry, exhibiting their artistic works, giving bombastic and noisy concerts, and lecturing with great gusto. Fellow irritators included Giacomo Balla, Umberto Boccioni, Carlo Carrà, Luigi Russolo (designer of noise machines), and Gino Severini.

Much of their interest centered on the greatest work of art, the city. It was both the symbol of modernism and protagonist. But it was not until Antonio Sant'Elia penned the very brief "Manifesto of Futurist Architecture" on 11 July 1914, with a corresponding exhibition, that the Futurists ventured into the realm of design for city buildings. Sant'Elia [1888 (Como, Italy)–1916] began studying architecture in Como and received a diploma in 1905. He undertook further work at the Accademia de Brera, in Milan, and finally completed a degree at Bologna's Scuola de Belle Arti (1912). Most of his all-too-brief professional career was spent in Milan working for the municipality as well as private architects and a brief solo practice. In 1915 he enlisted in the army and died in battle in 1916.

Italy was at this time dominated by firmly ensconced, elite conservatives. Classicism and Art Nouveau were the prevailing styles and many of Sant'Elia's designs from 1911 and 1912 bear the impression of Italian Secessionism, a style that came not from France, but Vienna.

With extraordinary foresight Sant'Elia and his cowriters—mainly Marinetti but also Mario Chiattone, Maracello Nizzoli, and Ugo Nebbia—wrote in part that they, or "we":

have lost our predilection for the monumental, the heavy, the static, and we have enriched our sensibility with a *taste for the light, the practical, the ephemeral and the swift.* . . . We are the men of the great hotels, the railway stations, the immense streets, colossal ports, covered markets, luminous arcades, straight roads and beneficial demolitions.[2]

Much of what the *Manifesto* rejected, historical and contemporary, was related to formal architectural aesthetics. In that sense it followed close to the themes put by—and on the heels of—Adolf Loos* in Vienna: they both embraced a culture based upon a new technological and social order as they saw it in the promise of America.

Sant'Elia's closest colleague in arms, so to speak, of his Nuovo Tendenze group was Mario Chiattone [1891 (Lugano)–1965] who had also studied at the Brera Academy. He soon came under the influence of Sant'Elia. Together they took part in the crucial "New Tendencies" exhibition held in Milan in 1914. (Chiattone produced no more significant work after 1920.) The Sant'Elia statement was anticipated a year earlier by Boccioni's "Architettura futurista manifesto," but it had been suppressed by Marinetti for his own reasons. Set up after his death as a heroic figure, it is nevertheless an error to assert, as historian Bruno Zevi does, that Sant'Elia was a "jingoistic instrument to forward the absurd notion of Italian supremacy during Fascism and nothing more."[3] And nothing more?

The Nuovo Tendenze's "new city" was indivisible from the general concepts of his Futurist colleagues. The proposals were for new dams, housing, over and under transport and highways, overhead pedestrian ways, vertical space, and intense compactness—the machine everywhere evident. Sant'Elia's loose dynamic drawings contained diagonals, verticals, shafts, and bright color such as that for a hydroelectric scheme (see Plate 6). One of his most daring proposals was a pen-and-ink sketch for a Stazione Aeroplani of 1912, one of a series of sketches derived from the then current problem of rebuilding the Milan central rail station.

Chiattone's proposals are made in tight, exact, rather lifeless drawings (see Plate 7). Yet in the 1920s their architectonic character obviously influenced the Russian Cubo-Futurists and Constructivists, and the German Rationalists. The work of the Futurists was well known in British and Continental avant-garde circles.

Indeed, although the Futurists absorbed much of current avant-garde thinking, less of its productivity, and were aware of the profound changes taking place in the great American cities, they nonetheless put together a widely varied package that contained challenges to music, literature, theater, painting, sculpture, graphic design, clothing fashion, photography, and more. They grappled with Art Nouveau and Sezesson, the Cubists, *Blaue Reiter,* plasticists and neoplasticists, Vorticism in England, and seemingly all else.

NOTES

1. Extracts taken from Northern Arts (1972).
2. As quoted in Northern Arts, 49.
3. Bruno Zevi, *Story of Modern Architecture* (Turin, 1973).

BIBLIOGRAPHY

Writings

Manifesto of Futurist Architecture. Milan, 1914.
Other writings of the period are best bibliographed in Apollonia (1973).

Biographical

Caramel, Luciano, and Alberto Longatti. *Antonio Sant'Elia. The Complete Works.* Como, 1962.

Assessment

Apollonia, Umbro, ed. *The Documents of 20th Century Art: Futurist Manifestos.* New York, 1973.

Architettura. "Il futuro dell'architettura futurista." 35 (June 1989).

———. "Il messagio de Antonio Sant'Elia." 13 (November 1956).

Argan, G. C., et al. *Dopo Sant'Elia.* Milan, 1935.

Banham, Reyner. "Footnotes to Sant'Elia." *AReview* 119 (June 1956).

———. "Futurism and Modern Architecture." *RIBAJ* 64 (February 1957).

———. "Sant'Elia." *AReview* 117 (May 1955).

———. *Theory and Design in the First Machine Age.* London, 1959; 1960+.

Barooshian, Vahan D. *Russian Cubo-futurism 1910–1930.* The Hague, 1974.

Benet, Rafael. *Futurismo y Dada.* Barcelona, 1949.

Birolli, Zeno. *Umberto Boccioni: Altri Inediti e Apparati Critici.* Milan, 1972.

Clough, Rose. *Futurism. The Story of a Modern Art Movement.* New York, 1969.

Coen, Ester. "Les futuristes et le moderne." *Cahiers du Musée National d'art Moderne.* (Paris) 19–20 (June 1987).

Dotorri, Gerardo. "Sant'Elia e la Nuova." *Architettura* (1933).

Etlin, Richard A. *Modernism in Italian Architecture.* MIT Press, 1991.

Feuerstein, Gunther. "Verkehrs-Etage . . . Wagner und Antonio Sant'Elia." *Daidalos* (Guertersloh) 15 (December 1991).

Gerhardno, Maly. *Cubism and Futurism.* London, 1979.

Ghirardo, Diane. In Macmillan.

Hulten, Karl G. *Futurism & Futurisms.* Venice, 1986; London, 1987.

Lampugnani, Vittorio M. "Dal Futurismo all'architettura tecnologica." *Domus* (October 1986).

Marinetti, Filippo Tommaso, et al. *Antonio Sant'Elia. Architetto Futurista, Creatore della Nuova Architettura.* Rome, 1933.

Meyer, Esther da Costa. *The Work of Antonio Sant'Elia.* New Haven, 1995.

Milan, 1931. *Sant'Elia e L'Architettura Futurista Mondiale.*

Northern Arts and Scottish Arts Council. *Futurismo 1909–1919.* Newcastle, 1972.

Rasponi, Tanzi, ed. *Futurismo e Futurismi.* Milan, 1986.

Taylor, Joshua. *Futurism.* New York, 1961.

Terragni, Giuseppe. "Escuela infantil . . . Sant'Elia en Como." *Arquitectura* (Madrid) 69 (July 1988).

Tisdall, Caroline, and Angelo Bozzollua. *Futurism.* London, 1977.

Veronesi, Giulia. In Lampugnani.

Woods, Lebbeus. "Sant'Elia: The Architect and the Manifesto." *a+u* 266 (November 1992).

Zevi, Bruno. "Sant'Elia e l'idiologia futurista." *Architettura* 2 (November 1956).

———. "Sant'Elia non era futurista." *L'Espresso* (Rome) (September 1956).

Bibliographical

Vance: Lamia Doumato, A934, 1983.

Villers, J.–P. A. *Futurism . . . A Bibliography 1959–73.* Toronto, 1975.

G

FRANK O(WEN) GEHRY. 1929 (Toronto, Canada)– . At the University of Southern California, Gehry first studied art (sculpture and painting) and then switched to architecture to receive a professional degree (1954). He worked with Victor Gruen in Los Angeles (1953–1954) and served in the U.S. Army's Special Services Division (1955–1956). This was followed by work in the offices of Robert & Co., architects, in Atlanta (1956); Hideo Sasaki, in Boston (1957); William Pereira & Luckman, in Los Angeles (1957–1958); and again with Gruen (1958–1961). He studied city planning at Harvard University (1956–1957) and after a tour of Europe and a stay in Paris in the office of André Remondet (1961), Gehry opened an office in Los Angeles (1962) joined by USC classmate Greg Walsh. During 1972 and 1973 he taught at USC and received various teaching positions, some of distinction, at American universities. He has received awards, prizes, and honors including the Brunner Prize of the American Academy and Institute of Arts and Letters (1983) and the Pritzker Prize (1989).

⌇

The first building to attract national and international attention to Gehry was his own house in Santa Monica (1978). He refurbished a 1920s pink house and about it added rooms in a linear fashion. As finished, it is an incomplete house with exposed rafters, studs, plywood lateral supporting, walls of corrugated steel, wire fencing mesh, and so on. At the time, he produced a series of buildings that suggest the influence of Charles W. Moore.* Not the formal Moore of the early 1960s when he was heavily in debt to early Louis I. Kahn* (the Moore

house, Orinda, California, 1962, for example), but the Moore of the late 1960s who tended to be spatially complex.

Other influences upon Gehry are of the immediate moment, such as a pool house for the Bourkes, in Greenwich, Connecticut (1974), of plain materials and construction and oddly juxtaposed lines and forms by Robert A. M. Stern and John S. Hagmann. Perhaps one of the more influential buildings on Gehry's development (and later on Deconstructivists) was John Johansen's Mummers Theater in Oklahoma City (1970), where Kahn's idea of served and serving spaces was exploded in plan and three dimensionally into a set of independent structures, carefree forms, and exposed circulation links. Such fragmentation was but one step from *dis*location, two or so steps from *de*construction. But for Gehry that moment was short lived. His other work, before and since, is not like his infamous house of 1978 and, as Tod Marder correctly observes, "continues to elude the critics."[1] Anyway, Gehry has proclaimed: "I am not a deconstructivist! That term really drives me crazy." It is a word invented by nonarchitects after the fact of his work—and that of a few others—in the 1960s.[2]

These ideas became formalized, less disparate in form and material and more informed by art theory. Indeed Gehry soon began to take on the notions of artists such as Claes Oldenburg in creating oversized common objects for fun or as advertisements of building purpose. Of the former there are the collection of three-dimensional sculptural forms in odd juxtaposition and scale (and poorly detailed) in the Winton guest house, in Minneapolis (1986–1987), the Loyola Law School complex, in Los Angeles (1981–1984), and the Wosk residence, in Beverly Hills, California (1982–1984). Of the latter there is the Fish Restaurant, in Kobe, Japan (1986), of a giant fish; and the interiors of Rebecca's restaurant, in Venice, California (1986), with hanging fish that can be usefully compared, though not to imply similarity, to the lavish womb interiors of Nigel Coates of the same period. (Gehry also designed a fish lamp.)

In all instances, from his earliest to latest works, Gehry employed plain materials, simple detailing, and dislocated forms often emphasized by pale colors. As well, many of his exterior forms which may or may not be made of glass, are sculptural elements that reach, rather awkwardly, for daylight to provide interior daylight illumination. All of these characteristics can be seen in the pinkish Wosk house, "a penthouse village," and the busy California Aerospace Museum in Los Angeles (1982–1984), where an airplane is cantilevered from a bluish front facade that appears to be a collection of buildings executed by three different architects of like mind.

This idea of collection is carried to an extreme in his design for the American Center, in Paris (1990–), of theaters, galleries, studios, apartments, and so on, where the spirit and character of a canopied Parisian street of 100 years ago is collected behind a limestone face in one contemporary moment. Gehry described it as "very energetic and very, very three dimensional."[3]

For the Vitra Design Museum, in Switzerland (1988–1990), he used a series

of disparate, idiosyncratically arranged curves, triangles, rectangles with skews, and points that are reflected in a monochrome interior all melded—more or less—into one rather small, all-white building. The disparate scheme was inflated for the Weisman Art Museum, at the University of Minnesota (1994), where exciting interiors belie an exterior of a collection of grotesque silver forms overgrowing plain brick, reaching for the sky, and in the interstices allowing light into, typically, cramped interiors. But as with most of his buildings, the exterior finish of materials is poor, apparently lacking the supervision to refine the material and detail the joints. The effect is of carelessness.

The Walt Disney Concert Hall, in Los Angeles (1993–), will rise in a series of slightly askew forms with comical flair. Little else is known about the proposed building (see Plate 51). However, it reminds the knowledgeable of the fantasy sketches ca. 1919 of the German Expressionist Hermann Finsterlin. With these works one is prompted to ask: When is sculpture not architecture? When is architecture not sculpture? When does it really matter which is which?

I approach each building as a sculptural object . . . a space with light and air, a response to context and appropriateness of feeling and spirit. To this container . . . the user brings his baggage . . . and interacts.''[4]

Indeed, or rather, of course.

NOTES

1. Marder (1985), 110.
2. As quoted in *ADesign* (1990), 74.
3. Ibid., 71.
4. As quoted in Nairn, *Contemporary Architects.*

BIBLIOGRAPHY

Writings

The Architecture of Frank Gehry, edited by Mildred Friedman. New York, 1986.
''Gehry Residence.'' *GAHouses* (Tokyo) 6 (1979).
''Up Everest in a Volkswagen.'' *DesignQ* 155 (Spring 1992).
''Weisman Art Museum, University of Minnesota 1994.'' *a+u* 285 (1994). With working
 drawings.

Biographical

Nairn, Janet. In *Contemporary Architects.*

Assessment

a+u. ''University of Toledo Art Building.'' 273 (June 1993).
ADesign. ''The American Center.'' 69, 7/8 (1990).
———. ''[I]n Collaboration with Claes Oldenburg . . . California.'' 62 (July 1992).
Andrews, Mason, et al., eds. *Frank O. Gehry. Buildings and Projects.* New York, 1985.
Antonelli, P. ''Joel Stearns, Multiples of Fishes.'' *Abitare* 310 (September 1992).
Architettura. ''Play It Again, Frank.'' 39 (October 1993).
ARecord. ''Norton House. Venice, California.'' 173 (Mid-May 1985).
AReview. ''Aerospace Museum.'' 173 (January 1985).

AReview. [Gehry]. 182 (December 1987).
van Baruggen, Cossje. "Waiting for Dr. Coltello." *Artform* (New York) 12 (September 1984).
Boissière, Olivier. *Gehry/SITE/Tigerman—Trois Portraits.* Paris, 1981.
Boissière, Olivier, and Martin Filler. *Frank Gehry—Vitra Design Museum.* London, 1990.
"Boston Children's Museum." *PA* 11 (January 1995).
Crosbie, Michael. "Critique. Village, Not." *PA* 74 (June 1993).
Filler, Martin. "Eccentric Space." *ArtA* 68 (Summer 1980).
————. "Perfectly Frank." *PA* 60 (July 1979).
————. "Sticks and Stains." *DesignQ* 155 (Spring 1992).
GADoc. "Frank O." 5 (1982).
Goldstein, Barbara, et al. "Firm Profile." *PA* 61 (March 1980).
Institute for Architecture and Urban Studies. *California Counterpoint.* New York, 1982.
Knobel, Lance. "Links in a Context of Fragmentation." *AJournal* 176 (December 1982).
Lewis, R. L. "No Brick Lump." *Museum News* (Washington, D.C.) 73 (January 1994).
Lotus. "American Center." 84 (1995).
————. "The Two Cities. . . . at Marne-le-Vallée." 71 (1992).
Marder, Tod A. In *The Critical Edge,* edited by Tod A. Marder. MIT Press, 1985.
Murphy, J. "A Venice Collaboration." *PA* 73 (March 1992).
Newman, Morris. "Rancho Deluxe." *AReview* 191 (September 1992).
PA. "Form Follows Ferment." 66 (February 1985).
————. "Walt Disney Concert Hall." 74 (January 1993).
Pastier, John. "Recent Work." *GADoc* 17 (1987).
Steele, James. *Schnabel House.* London, 1993.
Stein, K. D. "Main Street." *ARecord* 177 (July 1989).
————. "A Separate Piece." *ARecord* 181 (July 1993).
Strathaus, U. J-S. "Frank Gehry." *Werk* 71 (July 1984).
Transition. "Interview." 3 (February 1983).
Truppin, A. "Iowa Enlightenment." *AIAJ* 82 (March 1993).
von Vegesack, Alexander, et al. "The Vitra Design Museum." *ADesign* 60 (9/10, 1990).
Wang, W. "Un'architettura de frontiera." *Domus* 745 (January 1993).

Bibliographical

Vance: Sara Richardson, A1735, 1987.

ALISON MARGARET GILL. See Alison Smithson and Peter Smithson.

BRUCE (ALONZO) GOFF. 1904 (Alton, Kansas)–1982. At age twelve Goff began as a part-time factotum in the architectural office of Rush, Endacott & Rush, in Tulsa, Oklahoma. His first house design was built in Tulsa in 1916. He graduated from high school in 1922, and that year began to work full-time with Rush to become a partner (1929–1933) after passing the examination for registration as an architect. Goff established an independent professional practice and frequently moved office: Chicago (1934–1941), Berkeley, California (1945–1946), Bartlesville, Oklahoma (1956–1964, with offices in Frank Lloyd Wright's* Price Tower), Kansas City, Missouri (1964–1970), and Tyler, Texas

(1970–1982). He served in the U.S. Navy as an architect (1941–1945). Goff received no formal art or architectural education yet he taught part-time at the Chicago Fine Arts Academy (1935–1941) and after one semester of teaching at the University of Oklahoma in Norman, he was invited to head the School of Architecture (1947–1955). Thereafter he became a visiting professor at a number of American universities. Of nearly 500 mainly small commissions through a six-decade career, 140 were built.

<p style="text-align:center">♫</p>

Biographer Jerry Cook has correctly observed: "For well over half of the twentieth century, Bruce Goff generated a world architectural presence based almost exclusively on isolated, idiosyncratic and inaccessible one-family houses."[1]

Three elements excited Goff's architecture: form, color, and materials. All were usually ordered by a strict two-dimensional geometry that was extended three dimensionally in idiomatic and thoroughly unconventional manners. In early years form was derived by T-square and triangle; in later years, more freely and often with humor. And no form would escape his scrutiny: dish and bowl, cube, spiral, pyramid, mast, cylinder, box, hexagon, star, dome, and so on, sometimes many in one building. Color was obtained not only by added colorations but also by the application of surprising materials: pink plastic, clear plastic tubing, blue stones, green marble, striking wallpapers, purple and amethyst tinted glass, pyrites, and much more.

Materials were both conventional, if sometimes used unconventionally, and unique: fish nets, aluminum sheets, floor and built-in seating of goose feathers, cedar shingles on the interior, sewer pipes, exposed styrofoam, glass cullet, walls of various colored laminated sheets of plastic, black glass (as early as 1928), and so on. His was not a limited palette even for an individual building.

As a teenager Goff studied Wright's work and produced his own prairie house for Graves, in Los Angeles (1919). The influence of the master's architectural *style* waned, but not the philosophy. Goff's first major building, the Boston Avenue Methodist Church in Tulsa (1926–1927), assisted by Adah Robinson, was in the popular vertical Gothic but personal rather than derivative elements were clearly evident: a hallmark of his work. His debt to Wright in plan, together with a fascination for plain Southwest Native American adobe architecture (and perhaps in this instance of Irving Gill), is evidenced in the Shriner residence and studio, in Tulsa (1928), where windows step up a facade like musical notes on a scale and the front facade contains an inset square with a large round window in a manner that no doubt would please Mario Botta.*

By the late 1930s Goff found that Wright's latest work contained a fountainhead of ideas. The result was a series of houses that proceeded in spirit and form through the 1970s. There were byways; the most notable was a chapel project for the University of Oklahoma (1950) made of clear plastic triangles set above a three-winged plan that culminated in a single pyramid. Wright's similar *esquisse* for the Beth Shalom Synagogue, in Elkins Park, Pennsylvania

(1954), followed. Another byway was the Bavinger house, in Norman (1949–1953), a spiral plan in the center of which is a bulky core. Off this cantilever pods for sleeping or play that hover above the entertaining areas at ground level. Above is a central mast of fifty-five feet, from which cables support most of the copper-covered roof. The house was and is widely illustrated. The Dewlen house in Amarillo, Texas (1956), is a project of relative free form in plan, using bermed earth. Large tubes were to be used as entrances and light refractors.

The Duncan house, in Cobden, Illinois (1965), is in plan a series in line of linked hemicycles that are formed by walls of stone, and at the center of each hemicycle was a circle that became three dimensionally a cylinder. Another house is linked hexagons; another, of juxtaposed squares. The Harder house is a linear plan anchored centrally and at each end with massive fieldstone fireplaces and tall chimneys. The roof is bright orange, while the chimneys are topped with forms reminiscent of French nuns' coifs.

Goff in the 1960s and 1970s, like the Englishman Nigel Coates in the 1980s, created interiors that were womblike—an effeminately claustrophobic mélange of lavish material and color. As can be imagined, his influence has been both positive and negative. He has never been ignored and many of his students or followers carry on: Herb Greene the more inventive, less dependent; Bart Prince, a former assistant, the more derivatively dependent. Goff's work was one aspect of expressionism, of unconventionalism, to some of eccentricity.

Without urban or rural theories and without apparent connection with current tastes and trends, Goff's work simultaneously epitomizes the vagaries of the century and some of its most creative variants.[2]

Creative variants: nice.

That architecture should often be called "organic" is to misunderstand the term. Yet he was comfortable with it as were those around 1900 for both understood it as Wright first applied it. To infer Goff's designs are "naturalistic" or are a metaphor for nature also misses the mark. The disparate works of Makovecz, E. Fay Jones (AIA Gold Medal 1990), Gregg Burgess, John Lautner (who worked for Wright), and Nari Gandhi make the point. And to call it "kitsch" is naive and too clever. Gerd Hatje's brief description is most apt: "Goff drives poetic impulse to formal caprice."[3]

Fortunately, Goff's personalized innovative style does not encourage imitation. And post ca. 1930 he imitated no one, not even himself. But his architecture was and is a reminder of the need for architects to seek exactly those qualities if their art is to be persistently hybridized and reborn.

NOTES

1. Cook in *Contemporary Architects*.

2. Ibid., 3. See also "Organic Architecture," *ADesign* 63 (November 1993), the whole issue.

3. Gerd Hatje, ed., *Encyclopaedia of Modern Architecture* (London, 1963), 134.

BIBLIOGRAPHY

The abbreviation BG for Bruce Goff is used below.

Writings

BG, Architect. Chicago, 1978.
"A Declaration of Independence." *Western Architect* (Minneapolis) 39 (January 1930).
"Esthetic Qualities in Architecture." *Skylines* (Kansas City) 2 (December 1952).
"Frank Lloyd Wright." *Aujourd'hui* 34 (April 1964).
"Goff on Goff" and "Architecture as Art." *PA* 43 (December 1962).
Harris, Douglas, ed. "Notizen uber das Bauen." *Bauwelt* 49 (January 1958).
"Originality and Architecture." *Kenchiku* (Tokyo) 102 (March 1969).
"Pour L'Architecture." *Aujourd'hui* 39 (September 1968).
"A Young Architect's Protest for Architecture." *Perspecta* 13, 14 (1971).

Biographical

DeLong, David Gilson. *The Architecture of BG: Buildings and Projects 1916–1974.* 2 vols. London, 1977.
Sergeant, John, and Stephen Mooring, eds. "BG." *ADesign* 48 (10, 1978). The whole issue.

Assessment

ADesign. "Organic Architecture." 63 (November 1993). The whole issue.
AForum. "Pride of the Prairie." 88 (March 1948).
———. "Umbrella House." 94 (April 1951).
ARecord. "Methodist Church." 66 (December 1929).
AReview. "Genetrix." 121 (May 1957).
Baukunst und Werkform. "Die Drei Feinde Moderner Kunst." (Berlin) (July 1953). The whole issue.
Conrads, Ulrich. *Utopian Architecture.* New York, 1963.
Cook, Jeffrey. *The Architecture of BG.* New York, 1978.
———. In *Contemporary Architects.*
DeLong, David G. *The Architecture of BG.* MIT Press, 1988.
———. *Bruce Goff. Toward Absolute Architecture.* MIT Press, 1975.
———. In *Macmillan.*
Fiochetta, Rosanna. *BG 1904–1982.* Rome, 1990.
Futagawa, Yukio, ed. *BG, Bavinger House and Price House.* Tokyo, 1975.
Huxtable, Ada Louise. "Peacock Feathers and Pink Plastic." *New York Times,* 8 February 1970.
Kostka, Robert. "BG and the New Tradition." *Prairie School Review* (Chicago) 7 (2d quarter, 1970).
Life. "Round House." (New York) 30 (March 1951).
Lyall, Sutherland. "The Diversity of Bruce Goff." *BuildingD* (13 October 1978).
Mohri, Takenobu. *BG in Architecture.* Tokyo, 1970.
PA. "A Breed Apart." 73 (June 1992).
Park, Ben Allan. "The Architecture of BG." *ADesign* 27 (May 1957). The whole issue.
Sachner, Paul, and Bart Prince. "House of the Tranquil Mind." *ARecord* 176 (September 1988).
Saliga, Pauline, and Mary Woolever, eds. *The Architecture of BG, 1904–1982.* Chicago, 1995.

Shelby, Lon R. "Hugh Duncan's Cave." *Inland Architect* (Chicago) 15 (November 1971).
Thomas, G. S. "Architecture without Style." *Baukunst und Werkform* (Nuremberg) (July 1953).
Waechter, H. H. "The Architecture of BG." *AIAJ* 32 (December 1959).

Bibliographical

DeLong (1977).
Goff (1962).
Vance: Patrick Meehan, A73, 1979.
Weirick, James. "BG." *Building Ideas* (Sydney) 5 (May 1975).

Archival

ADesign. "BG's Working Drawings." 48 (10, 1978).
Ludwig, Delton. *BG, Architect.* Billings, Montana, 1978.
Murphy, William, and Louis Muller. *BG. A Portfolio of the Work of BG.* New York, 1970.

JAMES GOWAN. 1923 (Glasgow, Scotland)– . Gowan studied architecture at the Glasgow School of Art (1940–1942) before joining the Royal Air Force, where he served as a radar instructor (1942–1946). After the war he resumed his professional education on a part-time basis at the Kingston School of Art. His earlier years of practice were spent in London firms: Brian O'Rorke (1946–1950); Powell and Moya (1950–1951); and Lyons, Israel and Ellis (1954–1956); an interregnum was spent with the Stevenage New Town Corporation (1952–1953). In 1956 he formed a partnership with fellow Scot (and fellow employee of Lyons, Israel and Ellis) James Stirling.* When it dissolved in 1963, he set up a sole practice that still continues. Gowan maintains an interest in teaching. He was a tutor at the AA (1958–1960 and 1970–1972) just when Peter Cook* and his Archigram* associates were developing their radical ideas; he has also taught at the Royal College of Art (1983–) and at University College London, where he was Bannister Fletcher Professor in 1975. He was visiting professor at Princeton University, in New Jersey (1965), and at Simon Bolivar University, in Caracas, Venezuela (1982).

<div align="center">✧</div>

Gowan's most celebrated work is the controversial Engineering Faculty Building at Leicester University (with Stirling, 1963). Following a number of mostly domestic commissions by Stirling and Gowan, it took up the New Brutalist themes evident in their apparently crudely finished but carefully detailed Ham Common Flats at Richmond (1958). The Engineering Building significantly marked a repudiation of the dominant influence of Le Corbusier* upon British architecture. Peter Blundell Jones claims (debatably in the case of Stirling) that it represented the pinnacle of Gowan and Stirling's "mutual achievement. Neither architect has since produced its equal."[1] Since 1971 Gowan has either worked alone or in collaboration with other architects, out of the limelight that

flooded Stirling's part of the architectural stage. Many of his projects in the East End of London have achieved high quality on a low budget; he enjoys a reputation within his profession for his efficiency, care, and thoroughness. Some of his work, like the simply geometric Schreiber house, in Chester, described by its project architect as "enigmatic,"[2] and housing schemes at Hanningfield, Essex, all of 1980–1981, have been well publicized in Britain and abroad.

See Stirling.

NOTES

1. Blundell Jones in *Contemporary Architects.*
2. McIntyre (1981), 197.

BIBLIOGRAPHY

Writings

"AA 125: A Decade of AA Architecture." *AAQ* 5 (January-March 1973).
"Chester Villa." *International Architect* (London) 1 (1982).
A Continuing Experiment: Learning and Teaching at the [AA]. London, 1975.
"Le Corbusier: His Impact on Four Generations." *RIBAJ* 72 (October 1965).
"Curriculum." *AReview* 126 (December 1959).
"Design and Circumstance." *ADesign* 53 (December 1983).
"East Hanningfield." *ADesign* 51 (March-April 1981).
"Millbank . . . Reflections on the State of British Architecture." *AJournal* 167 (21 June 1978).
"Notes on American Architecture." *Perspecta* 7 (1961).
Projects: Architectural Association 1946–71. London, 1972.
"Reflections on the Mies Centennial." *ADesign* 56 (March 1986).
"Sketches for the Wall of a Room." *AAQ* 10, 2 (1978).
Style and Configuration—James Gowan. London, 1994.
With others. *Lyons, Israel, Ellis, Gray.* London, 1988.

Biographical

Blundell Jones, Peter, in *Contemporary Architects.*

Assessment

AReview. "Preview 1973: U.K. and E.E.C. Housing." 153 (January 1973).
———. "Temple Hill House." 175 (January 1984).
Arkitekten. "James Stirling of James Gowan." (Copenhagen) 68 (5 September 1966).
Banham, Reyner. *The New Brutalism.* London, 1966.
Blundell Jones, Peter. "Detailed Attention." *AJournal* 167 (21 June 1978).
Cantacuzino, Sherban. "Preview 78." *AReview* 163 (January 1978). The whole issue.
Casabella. "Gowan rapsodia: Architettura—Pezzi di architettura." 36 (October 1972).
D'Avoine, Pierre. "Conveying the Real Essence of Building." *AJournal* 200 (13 July 1994).
Domenech, Luis, et al. "James Gowan, vanguardista respetuoso." *Arquitecturas Bis* (Madrid) (July 1974).
Dunster, David, ed. *James Gowan.* London, 1978.
Finch, Paul. "Academy Forum: POPular [sic] Architecture." *ADesign* 62 (July 1992).

Korn, Arthur. "The Work of [Gowan and Stirling]." *Architect and Building News* 215 (7 January 1959).

Lyall, Sutherland. "Architectural Purist." *New Society* (London) 56 (21 May 1981).

McIntyre, Tony. "House of Mysteries." *AJournal* 173 (4 February 1981).

Melhuish, Clare. "Artistry of the Architect as Draughtsman." *BuildingD* (July 1994).

Pawley, Martin. "Building Revisits: Leicester Engineering." *AJournal* 179 (6 June 1984).

Scalbert, Irenee. "Cerebral Functionalism." *Archis* (Doetinchem) (May 1994).

Venturi, Robert, and Denise Scott-Brown. "Venturi v. Gowan." *ADesign* 39 (January 1969).

Walmsley, Dominique. "Leicester Engineering Building: Its Post-modern Role." *JAE* 42 (Fall 1988).

MARION MAHONY GRIFFIN, née Marion Lucy Mahony. 1871 (Chicago, Illinois)–1961. Daughter of teachers, Mahony's education and childhood were in Chicago and she later received a professional degree in architecture from the Massachusetts Institute of Technology (1894). Her first employment was in Chicago with a cousin, architect Dwight Heald Perkins. She then worked for Frank Lloyd Wright* (see Plate 1) and other Chicago area architects from 1895 until 1911 when she married an ex-Wright employee, Walter Burley Griffin.* Together they operated a landscape, city planning, and architectural practice that flourished in Chicago, Australia, and ended with a momentary flowering in India. The initial plan of Canberra, capital of Australia (1912), was their greatest joint effort, and it received recognition throughout the Western world.

<p style="text-align:center">✑</p>

Mahony began architectural studies at just the moment when women first approached many professions, including architecture. She was the second woman to receive an architectural degree from MIT. Of her role as an architect one of her more astute biographers, James Weirick, has said,

[s]he resolutely resist[ed] a feminist inflation of her reputation. As architectural helpmate to a number of male architects, she continually devalued her own contribution to the process of architectural production. Indeed, in spite of her striking personality and remarkable talent, the story of Marion's architectural achievement is [one] with many silences, [of] self-effacement.[1]

Francis Barry Byrne, who worked in Wright's office beside Marion, noticed that as a partner with Walter she "suppressed" acknowledging "her part in the mutual work."[2] Even when Wright asked her "to take over the office" prior to his departure for Europe (1909–1910) she refused, preferring a supporting role of "Design Architect" to Hermann Von Holst, who undertook oversight of Wright's commissions.[3] As such she carried forward those works stamping each with her own ideas. Walter designed the gardens.

Her independent works before marriage and after returning to the United States upon Walter's death in 1937 were a few buildings and projects of little

merit. Her best design skills were revealed when in collaboration with her husband.

NOTES

1. Weirick (1988), 54.
2. Letter, Byrne to W. G. Purcell, 15 July 1963, in Purcell Papers, courtesy Northwest Architecture Archives, University of Minnesota.
3. Griffin ("Magic of America"), Burnham Library copy, 170; Brooks (1972), 86; and Weirick (1988), 54.

BIBLIOGRAPHY

Writings

"Democratic Architecture . . . and Its Ideals." *Building* (Sydney) 14 (12 June 1914); and "Democratic Architecture II." 14 (August 1914).
"The Fundamental Principles of Architecture." Royal Victorian Institute of Architects, *Journal & Proceedings.* Melbourne, 16 (January 1919).
"Magic of America." Typescript, two very similar versions, Burnham Library, Art Institute of Chicago, and New-York Historical Society. Donated by Marion Griffin, 1949.
Monthly Bulletin, Illinois Society of Architects, "Forty-Third Annual Meeting." 25 (August 1940).

Biographical

Alexander, Finna. "Marion Lucy Mahony Griffin." *Architectural Journalism and Criticism Workshop.* Architectural Association, London, 1975.
Berkon, Susan Fondiler, and Jane Holtz Kay. "Marion Mahony Griffin, Architect." *Feminist Art Journal* (Spring 1975).
Johnson, Donald Leslie. *"Walter Burley [and Marion] Griffin."* In *The Greats. The 50 Men and Women . . . Modern Australia,* edited by Leonie Kramer, et al. Sydney, 1986.
Rubbo, Anna. "Marion Mahony Griffin: A Portrait." In Monash (1988).
Van Zanten, David. In *Architecture. A Place for Women,* edited by Ellen Perry Berkeley and Matilda McQuaid. Washington, D.C., 1989.
Weirick, James. In Monash (1988).
———. "Marion Mahony at M.I.T." *Transition* 25 (Winter 1988).

Assessment

Berkon, Susan Fondiler. In *Women in American Architecture. A . . . Perspective,* edited by Susan Torre. New York, 1977.
Brooks, H. Allen. *The Prairie School . . . Wright and His Midwest Contemporaries.* Toronto, 1972; reprint, New York, 1976.
———. ". . . Wright and the Wasmuth Drawings." *Art Bulletin* (New York) 48 (1966).
Building. "Marion Mahony Griffin." (Sydney) 14 (May 1914).
Johnson, Donald Leslie. *The Architecture of Walter Burley Griffin.* Melbourne, 1977.
Larson, Philip. "Marion Mahony & Walter . . . Drawing and Architecture." *Print Collector's Newsletter* (New York) 13 (May 1982).
Lobell, John. "American Women Architects." *Artforum* (New York) 15 (Summer 1977).
Monash University. *Walter Burley Griffin—A Re-view.* Melbourne, 1988.

PA. "Women in Architecture." 48 (March 1977).

Peisch, Mark L. *The Chicago School of Architecture: Early Followers of Sullivan and Wright.* London, 1964; New York, 1965.

Royal Victorian Institute of Architects, *Journal & Proceedings.* "Exhibition of Mrs Griffin's Work." (Melbourne) 10 (September 1913).

Tyng, Anne Griswold. In *Architecture. A Place for Women,* edited by Ellen Perry Berkeley and Matilda McQuaid. Washington, D.C., 1989.

Van Zanten, D. T. "The Early Work of Marion Mahony Griffin." *Prairie School Review* (Chicago) 3 (February 1966).

Bibliographical

CPL: Carolyn Johnson, 549, 1974.

Johnson, Donald. *Canberra and . . . Griffin. A Bibliography of 1876 to 1976 and a Guide to Published Sources.* Oxford, 1980.

WALTER BURLEY GRIFFIN. 1876 (Maywood, Illinois)–1937. With an architecture degree from the University of Illinois (1899), Griffin worked for architects associated with Frank Lloyd Wright's* school and then with the master (1902–1906). He practiced independently (1906–1911) and then in partnership with his wife Marion Mahony Griffin* (1911–1937). As a result of their winning a competition for the new national capital, Canberra, they traveled to Melbourne, Australia, to oversee the design, landscape, and construction (1913–1920). Their design received international attention. They maintained an independent practice in Melbourne and formed a partnership with a former Wright employee (Francis) Barry Byrne (1914–1916) to oversee work in the United States. Another partnership was formed with J. Burcham Clamp (1914–1915) with offices in Sydney. When Griffin resigned from his position vis-à-vis Canberra the Griffins moved to Sydney and created beside harbor waters a suburb they called Castlecrag. From Melbourne, Eric Nicholls joined them and became a partner (ca. 1925–1939). On invitation the Griffins set up another practice in Lucknow, India (1935–1937). Upon Walter's death Marion returned briefly to Castlecrag and then permanently to the United States.

᪐

America, Australia, and India were the three distinct worlds in which the Griffins practiced their professional arts. Few other architects in history have taken advantage of opportunities arising from their travels as a result of a conservative, rather stolid, profession, one that usually requires tenacious roots to ensure a growing, ever-widening circle of clients. As well they chose to establish a home with each new adventure that helped induce extraordinary careers.

In his role as an architect and landscape architect with Wright,[1] Walter quickly rose to be his confidant and manager. In independent practice he at times tended to mimic Wright but soon resolved his architecture to be more cubic, rather Southwest-adobe in appearance, less reliant on Wright's aesthetics, more influenced by the theoretical utterances of Louis Sullivan for a new American architecture. He developed a substantial reputation in the Midwest before mar-

riage, and it continued with Marion. As almost their first project in 1911 they entered the Canberra competition.

Upon being awarded the Australian prize they received a number of commissions in the United States that demonstrated a distinct character not evident before their partnership. A good example is a series of houses for the community of Rock Crest/Rock Glen in Mason City, Iowa (1912–1914). Their architectural practice in Australia was varied and included many houses that show a wide variety of style and appearance; theaters (especially the Capitol Theatre, a wondrous display of form, line, and color); and the city plans of Leeton and Griffith in New South Wales (1914+). These dissimilar cities were built more or less to designs derived basically from two sources: the English Garden City and the geometry of the American City Beautiful (both prominent at the turn of the century), suburban plans, and so on.

In North America, Byrne assisted the Griffins with projects for the University of New Mexico; a new town of Mossmain, Montana (much like Leeton); and a new community called Vanderhoof, British Columbia, as well as some buildings for the community.

The Canberra plan was an amalgam of City Beautiful ideas (particularly in geometry), Theosophical symbolism, and references to the places and Western traditions of Australia. Griffin's association with the development of the city was not a happy one. There were sequences of political infighting, bitter accusations of ineptitude and malpractice, bureaucratic jealousy, and on and on. Because of America's belated entry into World War I and Australia's immediate costs in supporting Britain, the Canberra proposition was even more difficult. When finally forced from his position as Director of Design and Construction in 1920, it was with a sense of bitterness and probably came as a relief.

The Griffins immediately began to build the infrastructure for their private development of the community of Castlecrag on Sydney's north shore. They enhanced its sylvan landscape and built many houses of varying appearance, some with their newly invented Knitlock concrete block constructional system patented in 1917 and first used that year for a small house in Melbourne they called Pholiota. Their personal involvement with Castlecrag carried on until 1938. Preservation of the Griffins' ideal community has been somewhat successful.

Relief from the effects of the 1929 financial crash came from a most unexpected and peculiar quarter—the desire of Australian municipalities to build incinerators to dispose of household garbage. Built throughout eastern Australia the designs were a chance for the Griffins to test their skills in form, material, and at times extravagant ornament. They ranged from the easy, plain cubic forms of the Thebarton Incinerator, in South Australia (1935), to the large, heavily textured ornament of the Pyrmont Incinerator, in Sydney (1934–1935).

In 1935 the Griffins were asked to submit a proposal for a new library building for the University of Lucknow in India. The resulting design was accepted, and they were asked to supervise construction. Oddly, the library was not built,

but once they were in India they designed houses, museums, public buildings, the *Capitol Journal* printing plant (1936–1939, demolished), banks, manufacturing plants, and so on: six were built. The skills of Marion revived in an astonishing, colorful display of Indian forms and ornament mixed with earlier ideas of Walter when he applied plain, squarish, adobe-like massing. The exception is the United Provinces Exhibition of Industry and Agriculture (1936–1937, demolished) where each building design was quite distinct from each other in a riot of inventive form and ornament drawn from imagination and the two cultures meeting in Lucknow. Sadly all were not built to design, most not in stucco as specified but of canvas on timber.

Judgement or simple observation of the Griffins' architecture must not be swayed by reference to accepted fashionable tastes, to ideas of historical importance and inevitability, or to continuity. Rather it should view the individuals, then their work, then their works in the contextual externalities of their being.[2]

The Griffins wove private paths to achieve their architecture. Their quiet, tenacious naive genius implanted a unique chapter in urban history, in American and Uddar Pradesh (United Provinces) architectural history, and in Australia's architectural and social history.

NOTES

1. Cf. Vernon (1991).
2. Johnson (1977), 139.

BIBLIOGRAPHY

Because of the Griffins' relationship with Canberra publications by, about, or significantly including them number well over 1,000. The abbreviation WBG for Walter Burley Griffin is used below.

Writings

[Architectural Works.] *Western Architect.* (Minneapolis) 19 (August, 1913).
"Building for Nature." *Advance! Australia* (Melbourne) 4 (March 1928).
"Canberra." I–IV. *Building.* (Sydney) 13 (November, December 1913; January, February, March 1914); 14 (April 1914).
"The City Plan of Griffith." *Irrigation Record* (Sydney) 3 (1 June 1915), (15 June 1915).
"Knitlock Construction." *Australian Home Builder* (Melbourne) 1 (August 1922).
"Mr WBG. Architect and Democrat." *Advance! Australia* (Melbourne) 13 (October 1913).
"The Outdoor Arts in Australia." *Advance! Australia* (Melbourne) 3 (1 May 1928).
"The Town Plan of Leeton." *Irrigation Record* (Sydney) 3 (1 May 1915), (15 May 1915).
"Town Planning and Garden Suburbs." *The Salon* (Sydney) (November 1913).

Biographical

Architecture. "Obituary." (Sydney) 26 (March 1937).
Birrell, James. *WBG.* Brisbane, 1964.

Johnson, Donald Leslie. "WB [and Marion] G." In *The Greats. The 50 Men and Women . . . Modern Australia,* edited by Leonie Kramer, et al. Sydney, 1986.
Peisch, Mark Lyons. In Macmillan.

Assessment

ARecord. "Some Houses by WBG." 28 (October 1910).
Brooks, H. Allen. *The Prairie School . . . Wright and His Midwest Contemporaries.* Toronto, 1972; reprint, New York, 1976.
Building. "Buildings That Are Wrong . . . Freak Architecture." (Sydney) 32 (April 1923).
———. "The Federal City. The Departmental Board's Plan." 12 (December 1912).
Burns, Karen. "Prophets and the Wilderness." *Transition* 24 (Autumn 1988).
Castlecrag. Castlecrag, ca. 1982.
Chicago Commerce. "Young Chicago Architect . . . the Great Australian Commonwealth." (February 1914).
Clough, Richard. "Canberra's Landscape." *Architecture Australia* 72 (September 1983).
Cooper, Nora. "Creating a New Type of Suburb in Australia." *Australian Home Builder* 7 (1 October 1929).
Harrison, Peter Firman. "Canberra—An Act of Faith." *Architecture in Australia* 53 (September 1964).
Fitzgerald, Alan. *Historic Canberra 1825–1945. A Pictorial Record.* Canberra, 1977.
Johnson, Donald Leslie. *The Architecture of WBG.* Melbourne, 1977.
———. *Australian Architecture 1901–51. Sources of Modernism.* Sydney, 1980.
———. "The Beginning of an Australian Domestic Architecture." *Art and Australia* 11 (October 1973).
———. "An Expatriate Planner at Canberra." *Journal of the American Institute of Planners* 39 (September 1973).
———. "Notes on WBG's 'Knitlock' and . . . Projects for Canberra." *JSAH* 66 (May 1970).
———. "WBG in India." *Architecture Australia* 66 (May 1977).
Kruty, Paul. "WBG and the University of Illinois." *Reflections* (Urbana-Champaign) (Spring 1993).
McCoy, Robert E. "Rock Crest/Rock Glen. Prairie School Planning in Iowa." *Prairie School Review* (Chicago) 5 (March 1968).
Maldre, Mati, and Paul Krutz. *WBG in America.* Urbana, 1996.
Markham, Michael. "Order and Expression." *Architect* (Melbourne) 8 (May 1984).
Miller, Wilhelm. *The Prairie Spirit in Landscape Gardening.* University of Illinois Agricultural Experiment Station Circular no. 184, 1915.
Monash University. *WBG—A re-view.* Melbourne, 1988.
Muller, Peter. *The Esoteric Nature of Griffin's Design for Canberra.* Canberra, 1976.
———. "The Winning Design and the Griffin Plan." *Architecture Australia* 70 (September 1980).
The Pioneer. "Round the Exhibition. A Supplement to. . . ." (Lucknow) (17 January 1937).
Proudfoot, Peter R. "Ancient Cosmological Symbolism in the Initial Canberra Plan." *Fabrications* (Australia) 4 (June 1993).
———. *The Secret Plan of Canberra.* Sydney, 1994.
Sprague, Paul E. "Griffin Rediscovered in Beverly." *Prairie School Review* (Chicago) 10 (January 1973).

Taylor, Florence M. "Australian Architecture . . . the Melbourne Catholic College." *Building* (Sydney) 15 (January 1916).

Taylor, George Augustine. *Town Planning with Common-Sense.* Sydney, 1918.

Van Zanten, David. *WBG Selected Designs.* Palos Park (Chicago), 1970.

———. "WBG's Design for Canberra." In *Chicago Architecture 1872–1922 Birth of a Metropolis,* edited by John Zukowsky. Munich, 1987.

Vernon, Christopher D. " 'Expressing Natural Conditions . . . , the American Landscape Art of. . . .'' *Journal of Garden History* (London) 15 (Spring 1995).

———. "WBG, Landscape Architect." In *The Midwest in American Architecture,* edited by John S. Garner. Urbana, 1991.

von Holst, H. V. *Modern American Homes.* Chicago, 1912.

Weirick, James. "The Griffins and Modernism." *Transition* 24 (Autumn 1988).

Yeomans, Alfred B., ed. "Competitive Plan by Edgar H. Lawrence. WBG, Advisory." In *City Residential Land Development. Studies in Planning.* Chicago, 1916.

Bibliographical

CPL: Thomas Brereton, 461, 1973.

Johnson, Donald. *Canberra and WBG. A Bibliography of 1876 to 1976 and a Guide to Published Sources.* Oxford, 1980.

Vance: Robert Harmon, A287, 1980; Donald Johnson, A97, 1979; Anthony White, A1752, 1980.

(GEORG) WALTER (ADOLF) GROPIUS. 1883 (Berlin, Germany)–1969. Gropius was born into a middle-class, Prussian, Protestant family. His father Walther and his great-uncle Martin were architects. After elementary school and a time in the Humanistische Gymnasium in Berlin, he enrolled in architecture at the Technische Hochschule in Munich (1903), but for family reasons he had to withdraw after one term. He briefly served as an apprentice with the Berlin architects Solf and Wichards (1904) before returning to professional studies at the Berlin-Charlottenberg Technische Hochschule (1905–1907). After a year of study and travel, he worked in the Berlin office of Peter Behrens* (1907–1910) before establishing a practice with Adolf Meyer (1910–1914). After serving in the cavalry in World War I, Gropius reorganized the Arts School and Crafts School in Weimar (1919), to become the Bauhaus. In 1925 the school was forced to move to Dessau, where its architectural program began (1928–1929). Gropius resigned to pursue his private practice in 1928. He was a founding member of the Congrès Internationaux d'Architecture Moderne* (CIAM) (1928) and a vice president (1929–1957). In 1934 Gropius fled to England from Nazi Germany and worked briefly with Edwin Maxwell Fry (1934–1936). He was appointed to Harvard University to head the architectural program (1937–1952). He founded The Architects' Collaborative (TAC) in Boston (1945–1969). After 1951 he was internationally honored for his contribution to architecture. The RIBA rather belatedly noticed him with its Gold Medal (1956) after which he received many international awards, honorary memberships in learned societies in Germany, Britain, and the United States, including the AIA Gold Medal

(1959). He received honorary doctorates in the same countries, as well as in Australia and Brazil.

<div align="center">✐</div>

The earliest architectural influence upon Gropius no doubt came from his father, an ardent admirer of Karl Friedrich Schinkel. Even before the youth became an office boy (at the age of twenty-one!) for Solf and Wichards, Walther introduced him to Schinkel's design principles and to systems of proportion. After a year as a cadet volunteer in the Wansbeck Hussars, Gropius returned somewhat reluctantly in 1905 to architectural studies at Berlin-Charlottenberg. At the same time he had occasional commissions, mostly of a utilitarian nature for family and friends, which stood in contrast to the more abstract studies at the Hochschule. In 1907 he used a family bequest to finance a protracted study tour of Spain where he met Karl Ernst Osthaus, a major patron of Behrens whom he so impressed that the museum director sent him to Behrens's new Berlin office.

At that time Behrens was employed by Allgemeine Elektrizitats-Gesellschaft (AEG), designing all aspects of what would today be called their corporate image. As chief assistant to Germany's leading architect and designer, Gropius had many opportunities to broaden his own experience. In the twenty months that he was in the office, under the influence of his mentor and in the new field of industrial design, Gropius searched for aspects of industry that contained an aesthetic response to new functional needs. He also met Ludwig Mies van der Rohe* and Charles-Édouard Jeanneret (later known as Le Corbusier*), also employed by Behrens. A significant contribution to his development came from outside Germany—indeed, outside Europe. Gropius's debt to Frank Lloyd Wright* can be measured through the 1910 Wasmuth folio of the American's work, if not through earlier publications. Wright's son Lloyd has said that "I heard that Gropius' mother gave him [one of the folios], he claimed he made it his *Bible*."[1]

Gropius left Behrens in 1910 to work in partnership with Adolf Meyer, who had also been an assistant in Behrens's office. In terms of building, the phase was perhaps the most important of his career. The Fagus shoe-last factory in Alfeld-an-der-Leine (1911) established his reputation (with Meyer) as an important architect; with largely glass external screens clear of the structural frame, the main block facade recalls Albert Kahn's* metal and glass curtain wall for industry. The omission of solid elements at the corners emphasizes the glass-enclosed, transparent space. By 1912–1913 Gropius was lauding the elemental, rational excellence of North American grain elevators, of ocean liners, locomotives, warehouses, and industrial buildings—analogies already presented by Wright in the foreword to the Wasmuth folio. In 1913, and in collaboration with Adolf Meyer, he designed the Deutz Motor Company model factory complex for the Cologne Deutscher Werkbund exhibition (built 1914), in parts echoing the Fagus building but with a main facade evoking major elements of Wright's architecture (Plate 8). In another 1914 Werkbund building, the Administration

Centre for the Cologne Exhibition, Gropius extended the Kahn/Fagus idea by glazing most of the facade including the corner stairwells. He was to become vital to the evolution of the modern European aesthetic and vigorously participated in debates nurturing its development.

Gropius joined the German army as an officer of cavalry in 1914 and was twice awarded the Iron Cross and other decorations. Demobilized in November 1918, he returned to a civilian position as director of two separate schools in Weimar, Saxony: the Grand Ducal Academy of Arts and the Grand Ducal Academy of Crafts. His original appointment, mooted early in 1916, had been made upon the recommendation of the former director, Belgian *jugendstil* architect Henri van der Velde, who was obliged to resign because his country and Germany were at war. Very soon Gropius presented a program to combine the schools and by April 1919 courses commenced at Das Staatliches Bauhaus Weimar.

His 1919 Bauhaus Manifesto called for "the unification of all the creative arts under the leadership of architecture." The most cursory reading of it exposes critical characteristics of Gropius's credo: first, he saw no difference between art and craft; second, he was then enthralled by the handcraft aesthetic. Both tenets were inherited from such nineteenth-century English reformers as Pugin, Ruskin, and Morris, but Gropius went beyond them by aiming to raise the level of product design by combining art and the mechanized processes of industry. Behrens's influence is obvious. The third major plank of Gropius's educational platform was the belief that good art, architecture, and design were the products of collaboration, rather than individual virtuosity. That was a major departure from the approach of his predecessor, who believed that the artist "in his innermost essence" was a "burning individualist, a free spontaneous creator." There was no place for that in Gropius's design by committee under the machine aesthetic.

Gropius's unprecedented formal program for the Bauhaus struck a balance between practical craft training and theoretical design training, on the basis that (as Morris had insisted) one cannot design anything without understanding the process by which it is realized. Therefore, students had two teachers in every course: one a craftsperson, the other an artist. Under the guidance of Johannes Itten, the basic course introduced students to elements of design—size, shape, line, color, pattern, texture, rhythm, and density. This structure is still emulated in design schools throughout the world. There followed advanced work with form and materials, taught in workshops for stone, wood, metal, pottery, glass, painting, and textiles. Among the teachers were Lyonel Feiniger, Gerhard Marcks, Johannes Itten, and Adolf Meyer (1919); Georg Muche (1920); Paul Klee and Oskar Schlemmer (1921); Wassily Kandinsky (1922); and Laszlo Moholy-Nagy (1923). Industrial design became a major concern. Gropius was convinced that the designed object—he cited household appliances and furnishings—must be by "systematic practical and theoretical research into formal, technical and economic fields" derived from natural functions and re

lationships which, by the way, initially excluded architecture. In short, it was an applied design education based on Marxist materialism.

Pedagogical and social issues occupied much of Gropius's time in the decade after 1918. In the contemporary spirit of revolution, he became active in groups of artists and architects, notably the Arbeitsrat fur Kunst and the November-gruppe, reactions to the conservatism of the Werkbund and the German Institute of Architects. A very temporary coalition of the groups brought architecture and art together, prophesying what Gropius would realize at Dessau. Despite these activities and the setting up of the Bauhaus, he found time to practice. Resuming his partnership with Adolf Meyer (until 1925) or sometimes alone, he undertook several competitions, made designs, and built domestic, industrial, and institutional works. Gropius and Meyer's entry in the *Chicago Tribune* (1922), unlike the winner's, was free of eclectic or historical detail. It was a significant European contribution to the design problem posed by the archetypal American structure, the skyscraper.

The unfamiliarity of ideas developed at the Bauhaus had made some members of the Thuringian government uneasy. As time passed, the liberal beliefs and eccentric ways of many of the Bauhaus people turned that unease to increasing opposition. Above all, and despite Gropius's insistence upon an official apolitical stance, their left-wing views were a source of alarm. Obliged to mount an exhibition ''Art and Technics,'' for which they were not ready, the staff made the gesture of resigning in 1923. Gropius eagerly accepted an offer to relocate the school in Dessau. To house it, he designed one of the icons of modern architecture. The asymmetrically composed Dessau Bauhaus (1925–1926) consists of connected blocks, each containing a part of the school, including staff and student housing, administration, classrooms, studios, and workshops. This group of buildings came to symbolize the Bauhaus internationally. Although Gropius often reiterated that he had never intended to create a Bauhaus style, the need for a new architectural image appropriate to a technological Zeitgeist caused the Dessau complex to be adopted as one model for what came to be known as modern architecture.

In 1926 and 1927 Gropius, in accord with his concern for social housing, had designed three stages of the large Toerten housing estate for low-income families in Dessau, a labor exchange, prefabricated housing for the Stuttgart Weissen-hofsiedlung, and some private houses. His most significant commission of the period came when he won a competition for the Dammerstock Housing Estate (1928) in Karlsruhe. He subsequently coordinated the ten collaborating architects—design by teamwork—as well as designing whole sections himself. Gropius resigned from the Bauhaus in April 1928 for two reasons: first (and ostensibly) because he wanted to be fully involved in practice; second, he believed that his resignation would stop the increasingly vicious propaganda attacks of the growing Nazi party upon the Leftist school, and upon him personally. It did not.

On Gropius's recommendation, his successor was the Swiss architect Hannes

Meyer. Strong political pressures continued, exacerbated by Meyer's condoning, even nurturing, communist doctrine within and from the school. Although that overtness was possibly for altruistic reasons, it was disastrous. The mayor of Dessau dismissed Meyer, and Mies van der Rohe was appointed in his place (1930). Under increasing Nazi pressure to close the school, Mies moved it from Dessau to a disused factory in Berlin-Steglitz in 1932, where he persisted for a year. Finally he took the decision to disband it, although not succumbing to pressure from the Nazis in 1933.

The Bauhaus became more influential through the continued activity of its former staff and students. For example Gropius went to Harvard to what became the Graduate School of Design. Mies became dean of architecture at Illinois Institute of Technology, and Moholy-Nagy established the "New Bauhaus" in Chicago. The work and ideas of the Bauhaus have been internationally spread by many publications and exhibitions. A Bauhaus Archive, founded at Darmstadt (1961), was moved in the 1970s to Berlin; another is located at Harvard. The design philosophy and the educational philosophy of the Bauhaus continues to have an impact in the practice and teaching of design; it was Gropius's major contribution to modern architecture.

Gropius moved his office to Berlin in 1928, and the following few years were busy with practice, research, writing, and European lecture tours. He had a number of important commissions, including the Spandau-Haselhorst (1929) and Siemensstadt housing developments (1929–1930), both in Berlin, for which he was project coordinator. By a number of actions—among them a lecture visit to Leningrad, controversial debates with Nazi officials, and the refusal to join the party—he conscientiously distanced himself from the imminent government of the Third Reich. Hitler became Reichschancellor at the start of 1933. Gropius, despite national and international fame, received no work from the party, then the preeminent client in Germany. In October 1934, literally penurious, he left Germany with his wife Ise and daughter Beate. Via Rome and Zurich they fled to England where they were sponsored by the London entrepreneur Jack Pritchard.

Through his host's machinations Gropius formed a partnership (1934–1936) with the English modernist Edwin Maxwell Fry to design a few buildings, notable among them the Impington Village School, Cambridgeshire (1936). A sour note was added when the client committee (the building was funded by subscription) could not afford to pay the architect's fee. While in England, Gropius fit well into Pritchard's elite circle of intellectual and artistic friends. He became involved with the Modern Architecture Research Group (MARS), England's xenophobic subbranch of CIAM. He was also controller of design in Pritchard's Isokon Furniture Company. It was intended to specialize in bent and formed plywood pieces, designed by Marcel Breuer* and approved by Gropius before going into production.

Responding to the strenuous persuasion of Gropius's influential American acquaintances, Harvard University offered him a professorship in April 1937.

He was joined by Breuer and they founded a practice (1937–1941). Gropius became chairman of the Department of Architecture and head of its GDS in 1938. Consistent with his Bauhaus principles, his teaching program emphasized collaboration between students and with other disciplines, such as landscape architecture and city planning. He also designed a number of campus buildings, including the Graduate Center (1949–1950). In 1945 Gropius founded TAC with seven young partners. He would remain with the firm, which implemented his belief in "building as teamwork" until his death. He brought his new partners into his own commissions, and took "early" retirement (at age seventy) from Harvard in 1952 to develop the firm's international practice.

Historian Arnold Whittick writes:

[Gropius] deserves to be considered as one of the chief architectural innovators of this century. He was essentially progressive, making full use of new materials and methods of construction . . . he contributed much towards the transformation of building from an empirical craft to a science in which precise mathematical calculations are possible.[2]

Perhaps Gropius would have preferred the more poetic accolade accompanying the AIA Gold Medal in 1959: to you "have come the usual rejection, ridicule," but your purpose, patience, weaving of practice and principle "have proven" triumphant, student and architect are "aroused by your vision."[3]

NOTES

1. Frank Lloyd Wright, *[FLW] Monographs 1907–1913*, edited by Bruce Brooks Pfeiffer. (Tokyo, 1987).
2. Whittick in *Contemporary Architects*.
3. Cited in Richard Guy Wilson, *The AIA Gold Medal* (New York, 1984), 190.

BIBLIOGRAPHY

Works by, about, or that significantly include Gropius and the Bauhaus continue to proliferate. The abbreviation WG for Walter Gropius is used below.

Writings

Apollo in the Democracy: The Cultural Obligation of the Architect. Mainz, 1967; New York, 1968.
Architecture and Design in the Age of Science. New York, 1952.
Bauhausbauten Dessau. Munich, 1930.
Internationale Architektur. Munich, 1925; Mainz, 1981.
The New Architecture and the Bauhaus. London, 1935, 1956; MIT Press, 1965.
Programm des Staatlichen Bauhauses. Weimar, 1919.
Staatliches Bauhaus Weimar 1919–1923. Munich, 1923.
With Herbert Bayer and Ise Gropius. *Bauhaus 1919–1928*. New York, 1938; Stuttgart, 1955.
With Ise Gropius. *The Scope of Total Architecture*. New York, 1955; Buenos Aires, 1956; Tokyo, 1958; Milan, 1959; New York, 1962.
With Sarah P. Harkness. *The Architects Collaborative 1945–1970*. Barcelona, 1971.

Biographical

Giedion, Siegfried. *WG: The Man and His Work.* Milan, 1954.
——. *WG: Work and Teamwork.* Stuttgart, 1954.
Isaacs, Reginald R. *WG—Der Mensch und sein Werk.* 2 vols. Berlin, 1983–1984.
——. *WG.* Boston, 1991.
Preisich, Gabor. *WG.* Berlin, 1982.
Whittick, Arnold. In *Contemporary Architects.*

Assessment

a+u. "Bauhaus, Dessau." (October 1982). The whole issue.
Architektur der DDR. "WG and the Bauhaus." (East Berlin) (April 1983). The whole issue.
Aschenbeck, Nils. "Monument und Bedeutung . . . Behrens und WG." *Archithese* (Niederteufen) 20 (July 1990).
Bauhaus, FRD. London, 1993.
van Bergeijk, Herman. "De mythes rond het Bauhaus." *Archis* (Doetinchem) (May 1988).
Deutsche Bauzeitung. "Wer war Adolf Meyer." (Stuttgart) 128 (May 1994).
Findeli, Alain. "The Bauhaus: Avant-garde or Tradition?" *Structurist* (Saskatchewan) 29–30 (1989).
——. "Bauhaus Education and After: Some Critical Reflections." *Structurist* (Saskatchewan) 31–32 (1991).
Giedion, Siegfried. *WG: Work and Teamwork.* London, 1954; NY, 1991.
Hartoonian, Gevork. "Poetics of Technology and the New Objectivity." *JAE* 40 (Fall 1986).
Herbert, Gilbert. *The Dream of the Factory-Made House.* MIT Press, 1984.
——. *The Synthetic Vision of WG.* Johannesburg, 1959.
Herdeg, Klaus. *The Decorated Diagram.* MIT Press, 1983.
Herrel, Eckhard. "Vom Jugendstil zur Moderne." *Deutsche Bauzeitung* (Stuttgart) 125 (November 1991).
Lane, Barbara M. *Architecture and Politics in Germany 1918–1943.* Cambridge, Massachusetts, 1968.
Lignel, Thompson Scribner. "From Home to Museum." *Ottagono* (Milan) (December 1987).
Marzona, E., ed. *Bauhaus Photographs.* MIT Press, 1985.
Mumford, Eric. "CIAM Urbanism after the Athens Charter." *Planning Perspectives* (London) 7 (October 1992).
Naylor, Gillian. *The Bauhaus Reassessed: Sources and Design Theory.* New York, 1985.
Nerdinger, Winfried. *The Architect WG.* Berlin, 1985.
——. *Bauhaus—Moderne im Nationalsozialismus.* Munich, 1993.
——. *WG. Opera Completa.* Milan, 1988.
Neumann, Eckhard. *Bauhaus and Bauhaus People.* New York, 1970.
Purini, Franco. "Apparitions in Style." *Ottagono* (Milan) (September 1989).
Rassegna. "WG 1907–1934." (September 1983). The whole issue.
Schier, Luise, et al. "Bauhaus and Beyond." *World Architecture* (London) 12 (1991).
Sharp, Dennis. *Bauhaus Dessau: WG.* London, 1993.
——. "Rebuilding Bauhaus History." *BuildingD* (26 April 1991).

Strathaus, Ulrike. "WG und das Ende der Verschwendung." *Deutsche Bauzeitung* (Stuttgart) 122 (October 1988).

————. "WG's direktionszimmer im Bauhaus." *Werk* (October 1991).

TAC. Teufen, 1966.

Uhlig, Gunther, and Michael Peterek. "60 Years of Siedlung Dammerstock" *Zodiac* (March 1991).

Vitale, Elodie. "De l'oeuvre d'art totale à l'oeuvre totale: Art et architecture au Bauhaus." *Cahiers du Musée National d'Art Moderne* (Paris) (Spring 1992).

Voigt, Wolfgang, and Jürgen Padberg. "Alles aus Glas." *Bauwelt* 83 (17 January 1992).

Weber, Nicholas. "Revisiting WG's . . . Buildings in Dessau." *ADigest* 48 (December 1991).

Weingarden, Lauren. "Aesthetics Politicized: William Morris to the Bauhaus." *JAE* (Spring 1985).

Wilhelm, Karin. "Stefan Sebok e l'idea di 'Totaltheater'." *Casabella* 52 (November 1988).

Wingler, Hans. *The Bauhaus: Weimar, Dessau, Berlin, Chicago.* Cologne, 1962; MIT Press, 1969.

Winkler, Klaus-Jürgen. *Die Architektur am Bauhaus im Weimar.* Berlin, 1993.

————. "The Neues Bauen in Weimar and the Bauhaus Legacy." *Rassegna* 13 (March 1991).

Bibliographical

Cook, R. V., comp. *A Bibliography of WG 1919–1950.* Chicago, 1951.

O'Neal, William B., ed. *WG: A Bibliography.* AAAB 1966, Supplement 1972.

Shillabeer, C., comp. "WG: A Bibliography." AAAB 1 (1965).

Vance: Robert Harmon, A140, 1979; A204, 1979; Wanda Quoika-Stanka, A1813, 1987; Edward Teague, A1193, 1984; Mary Vance, A1830, 1987.

Archival

Bauhaus Archiv-Museum. Berlin, 1981.

H

RON(ALD JAMES) HERRON. 1930 (London)– . Herron studied at various schools near London before entering the Brixton School of Building (1944–1947). After serving with the Royal Air Force in Germany (1948–1949) he returned to evening classes in architecture at Brixton (1950–1954) and completed his professional education at London's Regent Street Polytechnic in 1956. In 1960 he was a cofounder of Archigram.* After eight years as an architect with the Greater London Council (GLC), he was employed by various London firms (1961–1967) before opening his own office in 1968. He joined the Los Angeles office of William Pereira and Partners (1969–1970) before forming Archigram Architects with Dennis Crompton and Peter Cook* (1970–1975). Herron again set up on his own (1975–1977) with various partners, later forming Pentagram (1978–1982). In 1982 the international practice of Ron Herron Associates was established, with his sons Andrew and Simon. His contribution to architecture has not been only in practice, but also in education. He began teaching at the AA in 1965 and has been a visiting lecturer at many American, British, and European universities and colleges. His work has been exhibited in Milan, Paris, London, and New York.

✐

Herron will be remembered for his key part in Archigram. It says a lot for him that with a "night school" education and professional experience only in the public sector (albeit the forward-thinking GLC) he could collude with a number of younger AA graduates to form that "brash, exuberant" group. By then Herron had a few buildings to his credit, which was more than the others (except Warren Chalk) could claim. Anyway, because he was a "witty and

talented draftsman'' he became Archigram's ''leading image maker'' and his exquisite drawings in their annual broadsheet went far toward establishing an international reputation for the group. In his ''Walking City'' project of 1964 he incorporated technology already used by NASA at Cape Kennedy, envisaging such things as forty-story office blocks moving across the landscape.

Herron entered the private sector in the architects' office of Taylor Woodrow Construction. He moved between firms, first as assistant, then associate, then consultant, before establishing his own practice. In 1969 he became director of urban design with Pereira and Partners. When Cook won a closed competition for an entertainment center in Monte Carlo, Herron returned to London, to form Archigram Architects, to develop the design. When the project later lost its financial backing, the firm was dissolved in 1975. Until he formed Pentagram (with Theo Crosby, for whom he had worked in the early 1960s), most of his output seems to have been projected, not realized; *since* then he has built a lot. As colleague Blundell Jones puts it: ''He builds, albeit at a modest scale, and continues to produce visionary drawings in the evenings.''[1] Herron has maintained a friendship and loose professional associations with the ex-Archigrammers. He says that he is ''basically a practising architect'' who attempts to make architecture ''by fusing building, technology and art to make something 'special' for the user.''[2]

In 1990 Ron Herron Associates' Imagination Building, Store Street, London (built 1989) won an RIBA award. The project was in fact the refurbishment of two ninety-year-old buildings and the space between them into the headquarters for the Imagination design firm. By covering the open space with a tent-like, translucent PVC roof, Herron has made the external walls of the buildings into internal walls; the blocks are linked light aluminum and steel gangways at five levels. One critic notes that ''the refurbishment shows how essentially practical the technological superhumanism of the Archigram era really was.''[3]

See Archigram, Cook.

NOTES

1. Blundell Jones in *Contemporary Architects.*

2. As quoted in *Contemporary Architects.*

3. Martin Pawley as quoted in Noel Moffett, *The Best of British Architecture 1980 to 2000* (London, 1993), 149.

BIBLIOGRAPHY

Writings

[The Archigram men]. *AJournal* 142 (17 November 1965).
Contributions to *Archigram,* 1960–1970.
Aujourd'hui. [Projects from Archigram]. 50 (July 1965).
''Building of Distinction.'' *RIBAJ* 99 (February 1992).
''Imaginary Architecture.'' *SpaceD* 156 (September 1977).
''Japan's Arata Isozaki.'' *Lotus* 6 (1969).
With Warren Chalk, ''Things That Do Their Own Thing.'' *ADesign* 39 (July 1969).

With Peter Cook, ed., *Archigram.* London, 1973.
With Diana Jowsey, "Armonizzando Londra." *Casabella* 36 (December 1972).
With Royston Landau, "Milton Keynes vent' anni dopo." *Casabella* 50 (June 1986).
With Paolo Riani, "Imagination Offices, London." *L'Arca* (Milan) 39 (June 1990).
With others. "The Living City." *Architects' Yearbook* 11 (1965).

Assessment

AAQ. "A Portfolio of Drawings: Ron Herron." 9 (3/4, 1977).
Blundell Jones, Peter. In *Contemporary Architects.*
Cook, Peter. "St Pauli-Meillentor-Landungsbrucke Project, Hamburg." *AAFiles* 15
 (Summer 1987).
———. "Unbuilt England." *a+u* 83 (October 1977). The whole issue.
Duncan, Rory. "User-friendly: Herron: Sets and Things." *AJournal* 190 (27 September
 1989).
Hamada, Kunihiro, ed. "London Avant-garde." *SpaceD* 329 (February 1992).
Herron + Cook [catalog]. Berlin, 1981.
Imagination HQ, UK. London, 1993.
Lyall, Sutherland. "The Flight of the Herron." *BuildingD* (November 1980).
———. "Ron Herron." *BuildingD* (6 May 1977).
Lyall, Sutherland, ed. *Herron Notebooks: Buildings in Japan.* London, 1993.
Lyall, Sutherland, and Paolo Rianni. "Una proposa per la sede dell'Oreal." *L'Arca*
 (Milan) 29 (June–July 1989).
Skyline. "Ron Herron—Insertions." New York (August 1978).
Ville-Giardini. "Ron Herron: Robo house e studio strip." (Milan) 252 (October 1990).
Wilford, Michael. "Inspired Patronage." *RIBAJ* 98 (April 1991).

Archival

Ron Herron: 20 Years of Drawings. London, 1982.

HERMAN HERTZBERGER. 1932 (Amsterdam, the Netherlands)– . Hertz-
berger studied architecture (1954–1958) at the Delft Technische Hogeschool.
Immediately upon graduating he established a private practice in Amsterdam
and became a junior editor of *Forum* (1959–1963). He has taught at the Am-
sterdam Academy of Architecture (1965–1970) and since 1970 as a professor
at Delft. He continues to teach and practice from his Amsterdam office. Since
1990 he has been chairman of the Berlage Institute, in Amsterdam. In 1991 he
won the European Prize for Architecture.

 Hertzberger studied at Delft in the years immediately following the retirement
of the antimodernist Professor J. M. Granpré Molière. He thus came under the
progressive influence of Cor van Eesteren (once associated with De Stijl*), Jo-
hannes van den Broek, and Jan Bakema. With Aldo van Eyck,* Alison and
Peter Smithson,* and others, Bakema had been a founding member in 1953 of
Team 10, which succeeded the Congrès Internationaux d'Architecture Moderne*
(CIAM) in 1959. In that year Hertzberger was invited to join the new editorial
board of *Forum,* the organ of the Amsterdam Architectura et Amicitia group
which under van Eyck's and Bakema's leadership became the voice of

an active architectural movement. In keeping with Team 10's aspirations, the journal championed "a fusion of architecture and urban design to represent the 'counterform' for a complex society; to replace a positivist view of man with a vision embracing the transcendental; and to recover the relationship disturbed by bureaucracy and technocracy between man and his environment."[1]

Through his five-year connection with *Forum,* Hertzberger became part of Structuralism, a movement that after 1959 evolved from Functionalism. Going beyond the formal or aesthetic, it rejected the many "isms" and the worn cliché that architecture is a science, to focus upon relationships between plastic form and society. Other architects had a perceptible influence upon Hertzberger: Arnulf Luchinger draws attention to Duiker, Le Corbusier,* Louis I. Kahn,* Kenzo Tange,* and Ricardo Bofill.*[2]

Important to Structuralist doctrine is the idea of "spatial possibility": the architect's role is to produce a spatial framework within which the building's users have room for personal expression. Hertzberger writes:

Designing in such a way that several interpretations are possible should mean not only that the things we make can play several roles, but also that the users themselves are thus encouraged to play more roles. Not only do we interpret the form, it simultaneously interprets us, shows us something of who we are.[3]

Again: "[E]very corner and every space must be programmed for multiple roles."[4] In 1971 he built Diagoon, an eight-unit experimental housing complex in Delft that rejects the "tyranny" of functionally derived areas for living, sleeping, cooking, and so on for a "looser fit" of interconnected spaces at the disposal of the occupants, rather like Renzo Piano's* almost contemporary housing at Cusago, Milan.

The Centraal Beheer Insurance Company's offices in Apeldoorn, Holland (with Lucas and Niemeijer, 1972–1974) is the best example of spatial possibility and its impact upon the building's users (see Plate 34). The office for 1,000 staff members has the lowest absentee rate in the Netherlands; in fact, studies have shown that "on average employees spend more time at the office than at home." Kenneth Frampton comments, "Hertzberger's antipathy to the mechanistic provision of flexibility . . . seems to have been vindicated here by the apparent spontaneity and ease by which the working spaces have been taken over and modified."[5] Centraal Beheer applies all Hertzberger's notions about the social responses of architecture: the design of a building should increase contact between the occupants and obviate inhibiting thresholds; architecture should be devoid of social hierarchies; and each individual's place should be identifiable. He has achieved that in other buildings, including the Vredenburg Music Centre, in Utrecht (1978), and the Willemspark Montessori School, in Amsterdam (1983).

These demonstrate that, as well as being an influential theorist, Hertzberger is a capable, innovative designer and that his work is not static. Since the mid-1970s he has "modified his structuralist paradigm, not only in terms of the

labyrinthine introspective model that has since appeared in an equally complex but spatially more generous [than Centraal Beheer] version . . . but also in terms of the mass forms'' he has employed.[6] The reworking of the ''introspective model'' refers to the Department of Social Services Building on the outskirts of The Hague (1988–1991). The changes in form refers to the circular or segmental perimeters of the Lindenstrasse housing in Berlin (with Heinrich and Inken Baller, 1984–1986) and the freer splayed and curved shell of the Aerdenhout School (1989). In 1994 he built a diaphanous, elegantly framed extension to Centraal Beheer, with a glass-roofed atrium, and linked to the original buildings with bridge-like passages.

One writer believes that Hertzberger's ''greatest talent lies in his ability to translate . . . socially inspired ideas into architectural reality.''[7] While he is admired outside Holland, some of his countrymen, forever cynical, are not so sure about the consistency of his work, citing the Social Services Building as the antithesis of the values enshrined in Centraal Beheer.

NOTES

1. Groenendijk, Paul, and Hans Vollard, *Guide to Modern Architecture in the Netherlands* (Rotterdam, 1987), 31.
2. Luchinger in *Contemporary Architects.*
3. As quoted in *Contemporary Architects.*
4. As quoted in Charles Jencks, *Modern Movements in Architecture* (New York, 1985), 318.
5. Kenneth Frampton, *Modern Architecture. A Critical History* (London, 1992), 299.
6. Ibid., 300.
7. Catherine Slessor in Sharp (1991).

BIBLIOGRAPHY

Writings

''Aesthetics and Design.'' *Forum* (Amsterdam) 22 (February 1970). The whole issue.
''Architects' Approach to Architecture.'' *RIBAJ* 78 (August 1971).
''Building Order.'' *Via* (Philadelphia) 7 (1984).
''Centraal Beheer Office Complex, Apeldoorn.'' *Harvard* 1 (Spring 1980).
''Centre de musique d'Utrecht.'' *Aujourd'hui* 198 (September 1978).
''L'espace de la Maison de Verre.'' *Aujourd'hui* 236 (December 1984).
''Focus on three projects.'' *AReview* 187 (February 1990).
''Hausinterne Stadt: Ministerium fur Soziales in Den Haag.'' *Werk* 79 (January 1991).
''Hertzberger, un mécanicien de l'architecture en mouvement.'' *Aujourd'hui* 257 (June 1988).
''Huiswerk voor meer herbergzame vorm.'' *Forum* (Amsterdam) 24 (March 1973). The whole issue.
''The Language of Architecture.'' *World Architecture* (London) 17 (1992).
Lessons for Students in Architecture. Rotterdam, 1991.

Assessment

a+u. [Herman Hertzberger]. 75 (March 1977).
———. *Herman Hertzberger 1959–1990.* Tokyo, 1991.

————. "Recent Works of Herman Hertzberger." 159 (December 1983).
ADesign. "Herman Hertzberger: Apollo Schools, Amsterdam." 54 (November 1984).
AReview. "Neubau: Housing, Lindenstrasse." 181 (April 1987).
Baumeister. " 'Diagoon' hauser, Delft." (Munich) 76 (January 1979).
Bollery, F. "Ich will den Manschen keine Konzepte aufwingen." *Bauwelt* 78 (8 May 1987).
Buchanan, Peter. "Beheer's Big Brother." *AReview* 189 (March 1991).
————. "Forum Fellowship." *AReview* 187 (February 1990).
————. "Observations on a Man-made Land." *AReview* 177 (January 1985).
van Dijk, Hans. "Hertzberger. Architectural Principles in the Decade of Humanism." *Dutch Art + Architecture Today* (Amsterdam) 6 (December 1979).
Domus. "Old People in Amsterdam." 569 (April 1977).
Duffy, Francis. "Hertzberger and the Language of Time." *World Architecture* (London) 17 (1992).
————. "Hertzberger on the Slow Track." *AJournal* 187 (13 January 1988).
Fillion, Odile. "Herman Hertzberger." *Architecture Intérieure Crée* (Paris) 202 (October 1984).
Forum (Amsterdam). "Een stadthuis voor Amsterdammers." 19 (May 1969). The whole issue.
Grinberg, Donald I. "Modernist Housing . . . the Dutch contributions." *Harvard* 1 (Spring 1980).
van Heuvel, Wim. *Structuralism in Dutch Architecture*. Rotterdam, 1992.
Hoyet, Jean-Michel, and Alain Pelissier. "Hertzberger." *Techniques* 352 (October 1985).
Koster, E. "Van open structuur naar gesloten burcht." *Architect* (Amsterdam) 22 (February 1991).
Leschiutta, F. E. "Herman Hertzberger's Social Itinerary." *Ottagono* (Milan) 22 (March 1987).
Lifchez, Raymond. "Buildings Designed as 'Street'." *ARecord* 144 (July 1968).
Luchinger, Arnulf. *Structuralism in Architecture and Urban Planning*. Stuttgart, 1981.
————. In *Contemporary Architects*.
Luchinger, Arnulf, ed. *Herman Hertzberger: Buildings and Projects 1964–1984*. The Hague, 1987.
Nakamura, Toshio, ed. *Herman Hertzberger 1959–1990. a+u*. Extra edition (April 1991).
Noschis, Kaj. "L'homme pour l'architecte." *Architecture & Comportement* (Paris) 4, 4 (1988).
Reinink, Wessel. *Herman Hertzberger, Architect*. Rotterdam, 1991.
Slessor, Catherine, in Dennis Sharp, ed. *Illustrated Dictionary of Architects and Architecture* (London, 1991).
Spazio e Societa. "L'intervista: Hertzberger." (Milan) 11 (July 1988).
————. "Primary School, Ardenhout." 13 (April 1990).
Wonen-TA/BK. [Muziekcentrum Vredenburg, Utrecht]. (Heerlen) 24 (1979). The whole issue.
World Architecture. "Factory Extension [Amsterdam]." (London) 3 (1966).
Yashiro, Masaki. "Collective Housing in Holland: Traditions." *ProcessA* 112 (1993).

JOSEF (FRANZ MARIA) HOFFMANN. 1870 (Pirnitz, Moravia)–1956. The son of the local burgomaster, Hoffmann was educated at the state school in Iglau

(1879–1892) before studying architecture at the Academy of Art in Vienna (1892–1895). He gained his diploma and the Rome Prize (1895). After returning from a grand tour he worked in the Vienna office of Otto Wagner (1896–1897) before commencing his own practice (1898), which continued until his death. He was a professor at the Academy of Applied Arts in Vienna (1899–1936). A cofounder of several significant Viennese movements, including the *Sezesson* (1897), the *Werkstatte* (1903), the *Kunstschau* (1908–1909), and the Austrian *Werkbund* (1910), he was also director of the *Kunstlerwerkstatte* (1943–1956). Hoffmann's work was exhibited in Vienna and Milan during his lifetime and posthumously in Vienna (1960–1985), London (1977), New York (1975), and Fort Worth, Texas (1983). He was honored by peers in Austria and Germany, and he received honorary doctorates from the Technische Hochschules of Dresden, Berlin, and Vienna as well as Commander of the French Legion d'Honneur (1926).

೭

In 1928 the editors of *Architectural Forum* asserted, "No recent architect has influenced Europe more comprehensively than Hoffmann."[1] He belonged to the "very small group of Austrian architects who influenced the course of architectural history beyond the borders of their own country."[2] Indeed, very little of his extensive ouevre over almost sixty years was outside Vienna, let alone outside Austria. As a rather parochial architect, who nevertheless enjoyed a wide influence, he may be compared to Willem Marinus Dudok.* Historian Giuliano Gresleri writes:

Hoffman's work is as varied and heterogeneous as his culture, and as sophisticated and ambiguous as the period to which he belonged. It is more inclined to interpret than to direct or promote, to subvert without obviously asserting, to seek an isolation that allows it to carry to its extreme consequences, until all values are negated, the crisis of language that is ultimately Hoffman's own crisis: . . . the crisis of tradition.[3]

A student first of Carl Hasenauer and subsequently of Wagner, Hoffmann (with Wagner's encouragement) formed the Society for Austrian Artists—also known as the Vienna Secession movement—with fellow architect Josef M. Olbrich, painter Gustav Klimt, and others (1897). When Olbrich left Vienna in 1899 to help set up the Darmstadt artists' colony with Peter Behrens* and others, Hoffmann became the most important Viennese architect of his generation.

In 1900 he was invited by the director of the Vienna School of the Arts and Crafts to go to London, where he met members of the English Arts and Crafts and C. R. Mackintosh. At the Secession's eighth exhibition (1900) Mackintosh's work, that of C. R. Ashbee's Guild of Handicraft, and Henry van der Velde's were displayed beside the Austrian work.

It became clear that "the redeeming return to craftsmanship was the central theme for Hoffmann"[4] when in 1903, with funding from Fritz Warndorfer and artistic and social inspiration from John Ruskin, William Morris, and the British Arts and Crafts Movement, Hoffmann and Koloman Moser founded the Wiener

Werkstatte to produce commercially marketable, well-designed products of fine craftsmanship. The institution enjoyed artistic if not economic success for over thirty years. Many Viennese artists contributed designs. One writer comments that "it was impossible to maintain the simplicity of design of the original work," and it was Adolf Loos* who was "more influential in the [eventual] move to simplicity and exclusion of decoration."[5]

Hoffmann's deep and continuing involvement with the Werkstatte affected his professional career in two ways: designing furniture; furnishings; table-, china-, and glassware; jewelry; and bookbindings for the Werkstatte to some degree distracted him from architecture. At the same time, his attempts to achieve, through fine craftsmanship, harmony between environment and buildings and the things within them informed (in different ways at different times) the integrated decoration of his architecture.

He designed villas on the Hohe Warte, in Vienna (1901–1903), for several of the Secession and Werkstatte artists. All were redolent of Mackintosh or C.F.A. Voysey, or the young Edwin Lutyens. And all demonstrated a growing reductive tendency in Hoffman's architecture toward a few preferred geometries, mainly that of the square, and to the dominance of black and white in his color schemes. That process was crowned by the Purkersdorf Sanatorium (1904–1908), a severely classical, symmetrical building with a flat roof whose rectilinear forms were originally decorated with checkered bands that became, for a while, Hoffmann's trademark. Much of the interior design and many of the furnishings were done by members of the Werkstatte.

In 1904 the wealthy art collector Adolphe Stoclet and his wife Suzanne commissioned Hoffmann to design a villa in Hohe Warte, but the location was changed to Avenue der Tervueren, Brussels, when the couple returned to Belgium. The huge, sumptuously appointed house (1905–1911) became known as the Palais Stoclet. The ambitious scheme, supervised by the architect Emil Gerzabek, commenced building in 1906; its interior decoration, furniture, silverware, and gardens were designed by Hoffmann and many of the artists— including Moser and Klimt—of the Werkstatte. One biographer accurately comments that the building

does not fit easily into any of the . . . generally accepted stylistic subcategories of the early twentieth century. . . . Client and architect were ideally matched in this project, and the resulting building is completely controlled by the congruity of their intentions, from the palatial scale and disciplined multi-axial layout to the most minute detail. . . . [Internally] everything is controlled in carefully composed sequences of contrasting yet coordinated rooms arranged around a high central hall.[6]

Perhaps because of its size and opulence, perhaps because of the uniqueness of its forms, the house was widely noticed, and it had an impact on later European leaders, especially the De Stijl* group and Le Corbusier.* The richness of its internal color schemes, especially the free use of black and gold accentuating form, influenced the Art Deco movement after about 1925.

Yet Hoffmann's interaction with his contemporaries was two-way. His architectural aesthetic entered a new phase around 1910. With such designs as the neoclassical Ast house (built on the original Stoclet site in Vienna, 1910–1911), the Austrian Pavilion—an abstracted classical temple with fluted piers—at the Cologne Werkbund (1914, destroyed), the idiosyncratically quaint Primavesi house, in Winkelsdorf, Moravia (1913–1915), and the eccentric and only slightly asymmetrical Sonia Knips house, in Vienna (1923–1924), he turned to "a reformulation of classicist and folkloricist themes" embellished with his very personal decoration. After 1924 and under the influence of modernist austerity, Hoffmann designed a number of undecorated buildings, including the Klosehof apartments, in Vienna (1924)—a "mixture of Gothic, German Expressionist, late-Cubist and Wagnerian elements," the comparable Winarskyhof, in Vienna (1924), and the rather remarkable, unrealized proposal for a Palace of the Arts on the Karlsplatz, in Vienna (1928–1929). The latter was a steel and glass affair evocative of Ludwig Mies van der Rohe's* glass skyscraper projects of a decade earlier. Through the 1920s he established and maintained contact with De Stijl and Le Corbusier; both had their influence upon his later architecture.

In 1930 Hoffmann became vice president of the Austrian section of the Werkbund, and two years later he designed low-cost terraced houses for its Vienna exhibition. Soon after, the group asserted its anti-Semitic and extreme right-wing policies and Hoffmann, who had so far remained apolitical, was embroiled in its polemic. When Nazi Germany annexed Austria in 1938 he was appointed to reorganize the arts and crafts, but no architectural commissions were forthcoming. The last phase of his career during the Nazi regime and the immediate postwar years yielded a few unbuilt designs and collaborative, economically driven rehousing schemes. His creative fervor was directed toward highly decorative designs for textiles, wallpaper, furniture, and household items, all for the very rich. Gresleri writes:

The partially "moral" judgement that even recently has been passed on the work of Hoffmann does not take into account [the] cultural diversity born out of the complexity of the historical moment and the specific place in which it took form. . . . Friedrich Achleitner [notes], "Josef Hoffmann did not see (or because of his own talents and ambitions did not want to see) the historical logic of this development. He made the ultimate response to grandiose demands of the dying Austrian monarchy. [Instead of recognizing] the problems and tasks of a social architecture without seeking a formal solution to them, the late works of Hoffmann once again take up the presumptions of a decadent nobility."[7]

NOTES

1. As quoted by Sekler in *Contemporary Architects.*
2. Sekler in Macmillan.
3. Gresleri (1981), 7.
4. Manfredo Tafuri and Francesco Dal Co, *Modern Architecture* (London, 1986), 12.
5. Robert T. Packard in Wilkes.
6. Sekler in Macmillan.
7. Gresleri (1981), 14.

BIBLIOGRAPHY

Biographical

Josef Hoffmann zum 60. Geburtsdag. Vienna, 1930.
Kleiner, Leopold. *Josef Hoffmann.* Berlin, 1927.
Sekler, Eduard F. In *Contemporary Architects.*

Assessment

ADesign. "Josef Hoffmann: Palais Stoclet, 1905." 50 (January 1980).
Alte und Moderne Kunst. Special issue. (Vienna) (November 1970).
Arquitectura. "Werkbund Siedlung 1932." (Madrid) 70 (May 1989).
Baroni, Daniele. *Josef Hoffmann e la Wiener Werkstatte.* Milan, 1981.
Bau. "Josef Hoffmann 1870–1956." (Vienna) 25 (January 1970).
Behrens, Peter. "Work of Josef Hoffmann." *AIAJ* 12 (October 1924).
Beneder, E. "Joseph Hoffmann—Ornament between Hope and Crime." *a+u* 203 (August 1987).
Borsi, Franco, and Alessandra Perizzi. *Josef Hoffmann: Tempo e Geometria.* Rome, 1982.
Cruysmans, Philippe. "Vienne-Bruxelles et les origines du Jugendstil." *L'Oeil* (Lausanne) 387 (October 1987).
Eisler, Max. "Josef Hoffmann 1870–1920." *Wendingen* (Amsterdam) 3 (8–9, 1920). The whole issue.
———. "Neue arbeiten von Josef Hoffmann." *Moderne Bauformen* (Stuttgart) 27 (1928).
Feuerstein, G. "Josef Hoffmann und die Wiener Werkstatte." *Der Afbau* (Vienna) 19 (April 1964).
———. "Ornament und Beschworung." *Transparent* (Cologne) 18 (1987).
Filler, Martin. "Vienna Wood." *House & Garden* (London) 160 (February 1988).
Gebhard, David. *Josef Hoffmann: Design Classics.* Fort Worth, Texas, 1983.
Greenspan, Taube. "Vienna 1900." *American Craft* (Danville) 46 (December 1986).
Greer, Nora Richter. "Furnishings: Josef Hoffmann." *AIAJ* 72 (April 1983).
Gresleri, Giuliano, ed. *Josef Hoffmann.* Bologna, 1981; New York, 1985.
Hollein, Hans, and Catherine Cooke, eds. "Vienna Dream and Reality." *ADesign* 55 (November 1985).
House Beautiful. "Remarkable 'Re-creation.' " (New York) 117 (May 1975).
Interior Design. "Josef Hoffmann: Rediscovered Genius." (New York) 46 (May 1975).
Kossatz, H.-H. "The Vienna Secession and . . . Great Britain." *Studio* (London) 181 (January 1971).
Lane, Terrance. *Vienna 1913. Josef Hoffmann's Gallia Apartment.* London, 1984.
Langseth-Christensen, Lillian. "Silent Lessons." *Art & Antiques* (Des Moines) (December 1987).
Macadam, B. "Josef Hoffmann." *Artnews* (New York) 92 (March 1993).
Meyer, Christian, ed. *Josef Hoffmann: Architect and Designer 1870–1956.* Vienna, 1981.
Moderne Bauformen. "Josef Hoffmann und seine Schule." (Stuttgart) 26 (1927).
Oberhuber, O., and J. Hummel. *Fruhes Industriedesign: Wein 1900–1908.* Vienna, 1977.
Peichl, Gustav, et al. *Josef Hoffmann.* Vienna, ca. 1993.
Pica, Agnoldomenico. "Il centenario di Hoffmann e di Loos." *Domus* 492 (November 1970).

Roberts, Lynn Springer. "A Wiener Werkstatte Collaboration." *Museum Studies* (Chicago) 11 (Spring 1985).
Robertson, Howard, and F. R. Yerbury. "A Pioneer's Achievement." *Architect and Building News* (London) 125 (13 March 1931).
Rochowanski, Leopold W. *Josef Hoffmann.* Vienna, 1950.
Santomasso, Eugene. "Josef Hoffmann's Reliefs . . . Beginnings of Abstraction." *Structurist* (Saskatchewan) 21–22 (1981–1982).
Schmuttermeier, Elisabeth. "Ein Heisses Verlangen nach schonheit." *Du* (Zurich) (June 1985).
Schneider, Romana, "L'opera di Josef Hoffmann." *Domus* 687 (October 1987).
Sekler, Eduard F. *Josef Hoffmann: das Architektonische Werk.* Salzburg, 1982; *Josef Hoffmann. The Architectural Work.* Princeton, N.J., 1985.
———. In *Contemporary Architects.*
———. In Macmillan.
Sekler, Eduard F., and Robert Judson Clark. *Josef Hoffmann 1870–1956: Architect and Designer.* London, 1977.
Shand, P. Morton. "Van der Velde, Hoffmann, Loos and Wagner." *AAJ* 75 (January 1959).
SpaceD. "Stoclet Palace, Brussels." 269 (February 1987).
Steiner, Deitmar. "Die architektur des modernen lebens." *Du* (Zurich) (June 1985).
Taragin, Davira Spiro. "From Vienna to the Studio Craft Movement." *Apollo* (London) 124 (December 1986).
Vergo, Peter. "Fritz Waerndorfer and Josef Hoffmann." *Burlington Magazine* (London) 125 (July 1983).
Veronesi, Giulia. *Josef Hoffmann.* Milan, 1956.
Vetrocq, Marcia E. "Rethinking Josef Hoffmann." *Art in America* (Des Moines) 71 (April 1983).
Vogelgesang, Shephard. "The Work of Josef Hoffmann." *AForum* 49 (November 1928).
Warlick, M. E. "Mystic Rebirth in . . . Klimt's Stoclet Frieze." *Art Bulletin* (New York) 74 (March 1992).
Weiser, Armand. *Josef Hoffmann.* Geneva, 1930.

HANS HOLLEIN. 1934 (Vienna, Austria)– . Hollein's professional training was gained in the Civil Engineering Department of the Vienna Bundesgewerbeschule (1949–1953) and the Architecture School of the Vienna Academy of Fine Arts (1953–1956), where he obtained a diploma. He undertook postgraduate work in architecture and city planning at the Illinois Institute of Technology in Chicago (1958–1959) and the College of Environmental Design at the University of California, Berkeley, whose master of architecture degree he holds (1960). He worked in various practices in the United States, Germany, and Sweden (1960–1964) before establishing his own Vienna practice (1964), which continues to undertake urban, architectural, and industrial design commissions. Hollein acts as a consultant designer for architectural firms in Austria, Italy, Japan, and the United States, and for the furniture manufacturers Memphis, Alessi, Swid Powell, Knoll, and MID Austria. He has been a visiting professor

at Yale University and Washington University in Saint Louis. He became a professor of architecture at the Düsseldorf Academy of Fine Arts in 1967 and has also held teaching posts at the Vienna Academy of Applied Arts since 1976. His work and drawings have been exhibited internationally. He has received architectural and design prizes and awards from many countries, including the seventh Pritzker Prize (1985).

✒

Hollein is perceived by some as the "leader since 1960 of a group of conceptual architects that includes Walter Pichler and Gustave Peichel [who] deny the importance of practical restraints—and even of actual building—preferring to produce exquisite drawings of conceptual projects and models or objects."[1] Others cynically dismiss him as having an "I'll-knock-your-halo-off attitude . . . behind which always lurks Freud's couch."[2] Around 1960 Hollein began to collaborate with Pichler, producing a series of collages and architectural schematics that were effective criticisms of Functionalism, embodying Hollein's maxim that "everything is architecture." One of the best examples was the 1966 collage showing a Rolls-Royce grille as a huge multistory building in a totally dominated urban landscape.

Hollein's first realized building was the seminal Retti Candle Shop, in Vienna (1964–1965), for which he won the R. S. Reynolds Memorial Award (1966). Heinrich Klotz has written of it: "a formal vocabulary was discovered here, which was soon to make an impact on the ideas of a whole generation." It is about contemporary with the emerging pop-polemics of Archigram,* which Hollein knew and admired. Internationally, many architects were seeking ways to sublimate technological expression, "to replace rough Constructivist frameworks with a refined formal vocabulary."[3] Friedrich Achleitner believes that the Retti shop's success resulted from its aesthetic complexity and its new interpretation of a functional problem. Paradoxically, in his abrogation of Functionalism, Hollein turned to what Achleitner calls "a sort of Super-Functionalism."[4] At the nonintellectual level at which (sadly) many architects operate, with this shop and his Richard L. Feigen Gallery, in New York (1967–1969), Hollein introduced a style of industrial design, with rounded edges and polished surfaces, fashionable and much copied throughout the 1970s.

Between 1976 and 1979 Hollein designed four offices in Vienna for the Austrian Tourist Bureau. They are amusing, joyful places, full of the excitement of travel. The pure, often severe geometry of modernism has been displaced by representational elements: for example, the interior of the head office on Openringstrasse has an oasis of metal palm trees and an Indian pavilion, while the Ringturm branch has an avenue of similar palms in front of a screen of tall motifs from the palm capitals of ancient Egyptian columns.

Important among Hollein's innovative works is the Municipal Museum at Mönchengladbach (1972–1982); his first large commission, it won another R. S. Reynolds Memorial Award (1984). Generally subterranean and a rather anonymous sculpture from the outside, the building is entered through a small,

glazed, white marble lobby, after which the visitor discovers "contrast and collisions of form, content and material [pervading] the building's interior. . . . The complexity of the exterior is reflected in the variety and excitement of the interior." In its organization and the way it must be traversed, the museum, a repudiation of conventional gallery design, provides a series of spaces for different activities at different levels, which "does much more than serve a function, it leaves an unmistakable impression and vindicates architecture's right to become an art once again."[5]

Hollein designed the "Vienna Dream and Reality 1870–1930" at the Kunstlerhaus in 1985, and a number of major buildings, including the Frankfurt Museum of Modern Art (1983–1991) on a difficult triangular site in the center of the city, the ambiguous and controversial seven-story Haas-Haus mixed-use building (1985–1990) opposite Saint Stephen's cathedral in the old center of Vienna (see Plate 43), and the Erste Allgemeine-General Insurance Building (completed 1993) in Bregenz, Austria. Hollein's later buildings have been described as "architectural events" and a "deft interweaving" of architecture and urbanism. "Architecture," he says, "is not the satisfaction of the needs of the mediocre, is not an environment for the petty happiness of the masses. . . . [It] is an affair of the elite."[6]

NOTES

1. Ann van Zanten, *American Academic Encyclopedia* (New York, 1993).
2. Manfredo Tafuri and Francesco Dal Co., *Modern Architecture* (London, 1986), 387.
3. Heinrich Klotz, *Postmodern Visions* (New York, 1984), 121.
4. Achleitner in *Contemporary Architects.*
5. Andrea Gleiniger-Neumann in Klotz (1984), 122.
6. As quoted in Charles Jencks, *Modern Movements in Architecture* (New York, 1985), 55.

BIBLIOGRAPHY

Writings

"Alles ist Architektur." *ADesign* 40 (February 1970).
"Une evocation personelle." *Aujourd'hui* (June 1977).
"Frankfurt Museum of Modern Art." *ADesign* 61 (November 1991).
[The Guggenheim Museum, Salzburg]. *GADoc* 29 (1991).
"Transformation, Place and Space." *a+u* (January 1992).
With Rolf Lauter, "The Museum of Modern Art, Frankfurt." *International Journal of Museum Management and Curatorship* 5 (March 1986).
With Catherine Cooke, as ed. "Vienna Dream and Reality" *ADesign* 55 (November 1985). The whole issue.

Biographical

Achleitner, Friedrich. In *Contemporary Architects.*

Assessment

Achleitner, Friedrich. "Viennese Positions: Travel Office, Vienna, 1977." *Lotus* 29 (1980).

————. In *Contemporary Architects.*

ADesign. "Hans Hollein [three projects]." 55 (March 1985).

————. "Stadtisches Museum Arteiberg Mönchengladbach." 53 (July 1983).

a+u. "Hans Hollein. Realized and Unrealized Works." Extra edition (February 1985). The whole issue.

————. "International Building Exhibition, Berlin 1987." Extra edition (May 1987). The whole issue.

————. "Transformation, Place and Space." 256 (January 1992).

Aujourd'hui. [Furniture design]. 236 (June 1984).

Blake, Peter. "Taking a Chance." *InteriorD* 56 (July 1985).

Capezzuto, Rita. "The Mountain in the Museum: Comparisons and Solutions." *Lotus* 70 (1991).

Cohn, D. "The Enchanted Circle." *ARecord* 182 (September 1994).

Davey, Peter. "Complexes of Hollein." *AReview* 184 (December 1988).

van Dijk, Hans. "De weg naar het licht." *Archis* (Doetinchem) (February 1991).

Domus. "Candele a Vienna: Nel Kohlmarkt, il negozio Retti." (May 1966).

Eisenman, Peter. "Hollein's Cave: Haas ruis." *a+u* 256 (January 1992).

GADoc. "Hans Hollein [recent projects]." 30 (August 1991). The whole issue.

————. [Museum for Modern Art, Frankfurt am Main]. 31 (November 1991).

Hannay, Patrick. "Hauchstrasse 8." *AReview* 179 (March 1986).

Hans Hollein. Museum fur Moderne Kunst, Frankfurt am Main. Weinheim, 1992.

Horain, Hansu. *Hans Hollein.* Tokyo, 1985.

Irace, Fulvio. "Berlino 1988." *Abitare* 284 (May 1988).

Jencks, Charles. "Modernism, Postmodernism and Beyond." *ADigest* 46 (April 1989).

Jodidio, Philip. "Hans Hollein entre en scène." *Connaissance des Arts* (Paris) (March 1987).

Klotz, Heinrich. *Postmodern Visions.* New York, 1984.

Lootsma, Bart. "Streven naar het Gesamkunstwerk." *Architect* (The Hague) 22 (September 1991).

Lotus. "Expansions: Hans Hollein's Latest Viennese Designs." 29 (1980).

Matsunaga, Yasumitsu. "Tradition and Context." *JapanA* 59 (October 1984).

Metz, Tracy. "Rewriting the Rules . . . Mall in Vienna." *ARecord* 179 (April 1991).

PA. "Architectural Faberge." 51 (February 1970).

Paczowski, Bohdan. "Hans Hollein." *Aujourd'hui* 279 (February 1992).

————. "Hollein's 'Architecture parlante'—Three Travel Agencies." *AReview* 176 (October 1980).

Pedio, Renato. "An Artificial Hill for a Sophisticated Chalet." *Architettura* 38 (June 1992).

Pettena, Gianni. *Hans Hollein: Opera 1960–1988.* Milan, 1987.

Rykwert, Joseph. "Hans Hollein; Museum fur Moderne Kunst." *Domus* 731 (October 1991).

Spens, Michael. [Insurance offices, Bregenz, Austria]. *ADesign* 63 (December 1993).

————. *Hans Hollein Design.* London, 1994.

Bibliographical

Vance: Carole Cable, A1081, 1983; Teresa Fehlig, A2006, 1988.

I

ARATA ISOZAKI. 1931 (Oita City, Japan)– . With a diploma in architecture from the University of Tokyo (1954), Isozaki joined Kenzo Tange's* office (1954–1963) and then formed his own practice. During this period he completed graduate studies at the University under Tange to receive a master's degree (1956) and PhD. (1961). Since 1966 he has participated in and designed exhibitions of his architecture, prints, and furniture; designed stage sets; and received architectural commissions in Japan and the Western world. He has accepted various short-term visiting teaching positions in a number of American, Australian, and European universities (1969–1982). Isozaki has received many prizes, awards, and honors in his native country and elsewhere, including the RIBA Gold Medal (1986).

❧

As a result of working with Tange on large-scale urban commissions Isozaki has continued those investigations. For instance, the Space City project was a series of tall, cylindrical service pylons with habitable units suspended from cantilevers clustered high above a typical city and was a design related to his participation with the Metabolism* group. His Festival Plaza architectural equipment (1966–1970) for the Osaka world exposition indicates how he interpreted a personal contact with the English Archigram* as does the humorous facade that spells "home bank" in full, story-high letters at ground level of a Tokyo street (1970–1971, with Kijo Rokkaku), one of a series of buildings for the Fukuoka Mutual Bank. In a few years Robert Venturi* and Denise Scott Brown* would glorify building signage.

With his initial major commission, the Prefectural Library, in Oita (1962–

1966), colleague Hiroshi Hara was prompted to announce that Isozaki is "the first really creative architect to appear in this country."[1] Its exposed concrete, dramatic beams, and channels exposing mechanical and structural parts, even in its flat proportions, betrays a heavy debt to Paul Rudolph's* work. That influence is mixed in his next significant work, the Iwata Gauken High School, in Oita (1963–1964), where six-story concrete towers also reflect the work of I. M. Pei.*

Isozaki's architecture contains formality and a stately presence which are more often obvious in his early designs, including the Gunma Prefectural Museum (1971–1974) where the cube is the design module, even in the broken wing of the building. This museum coincides with his break from earlier influences as does the elongated curving barrel vault of the elegant Fujimi Country Clubhouse (1973–1974), a building of some maturity. The barrel vault was also used for the much larger Kitakyushu Central Library (1973–1974), which evidences the fragmentation of form and playful spaces, internal and external, that will come to dominate.

The triangle or pyramid, circle or hemicycle and sphere, and square or cube are used as symbolic geometry, most obviously in a series of plain houses in the 1970s and 1980s. They appear with regularity, if haphazardly, in his Tuskuba Center Building (1979–1983) and in a series of silk screen prints that portray the building in decay. Axiality, diverse texture, and form are at once ambiguous but experientially clear as is the site plan. They consistently appear in his oeuvre after 1978 and especially in the Museum of Contemporary Art, in Los Angeles (1981–1986), a building that also highlights a typical dichotomy, that of a plan playing a subsumed role to the desirability of certain three-dimensional forms in selected places.

In site planning Isozaki's tendency is to embrace buildings about a central open space. This is apparent not only at Tuskuba but also in a project for a Municipal Government Center, in Phoenix, Arizona (1985), and in the cultural complex for Mito (1986–1990) where a massive "folly" tower of solid sheets as triangles sitting on a triangular building rises from the plaza's edge. For Disney at Lake Buena Vista, Florida (1987–1991), Isozaki created a long, narrow building (820 feet) with pedestrian circulation down a central corridor that is broken near the middle by a complex of geometrical forms and a large chimney open to the sky. The entrance canopy is a pair of Mickey Mouse ears. "In attempting to establish 'architecture'," he has said, "[m]y work includes quotations for the whole of our cultural legacy up to the present, bringing forth, hopefully, unique metaphors."[2]

All very well, but the pleasure of architecture is in the stuff of proportion and elegance. Isozaki has always been verbally precocious if not architecturally so. Perhaps that is why the British honored him.

NOTES

1. Hiroshi Hara, "Abundant Creativity," *JapanA* 166 (December 1966), 33.
2. As quoted in Kultermann in *Contemporary Architects.*

BIBLIOGRAPHY

Writings

"About My Method" and "Recent Works." *JapanA* 47 (August 1972). The whole issue.

"A Metaphor Relating with Water." *JapanA* 251 (March 1978).

Architectural Pilgrimage to World Architecture. Series participant. Vol. 1–12. Tokyo, 1980–1984.

"The Current State of Design." *International Design Yearbook 4.* New York, 1988.

"Imaginary Architecture." Series. *SpaceD* (1977–1978).

"Kamioka Town Hall." *JapanA* 54 (January 1979).

Kenchiku no Seijigaku (The politics of architecture). Tokyo, 1989.

Osaka Follies. London, 1990.

"A Rethinking of Spaces of Darkness." *JapanA* 56 (March 1981).

"Uji-an Tea House." *GA Houses* 40 (January 1994).

With O. Sato. *Katsura Villa. The Ambiguity of Its Space.* Tokyo, 1987.

Biographical

Drew, Philip. *The Architecture of Arata Isozaki.* New York, 1982.

Kultermann, Udo. In *Contemporary Architects.*

Assessment

ADesign. "Arata Isozaki." 47 (January 1977). The whole issue.

———. "Japanese Architecture." 62 (September 1992). The whole issue.

Barattucci, Brunilde, and Bianca DiRusso. *Arata Isozaki: Architecture 1959–1982.* Rome, 1983.

Barrenche, Raul. "Bass Museum of Art, Miami." *AIAJ* 82 (November 1993).

Bognar, Botond. *Contemporary Japanese Architecture.* New York, ca. 1985.

———. *The New Japanese Architecture.* New York, 1990.

Boyd, Robin. *New Directions in Japanese Architecture.* London, 1968.

BuildingD. "Arata in America." (11 March 1983).

Crit. "Interview." (Washington, D.C.) (Winter 1983).

Dorigati, Remo. "Una museo di Isozaki." *Arca* (Milan) 68 (February 1993).

Drew, Philip. *Third Generation. The Changing Meaning of Architecture.* Stuttgart, 1972.

Filler, Martin. "Recent Work of Arata Isozaki, Part I." *ARecord* 171 (October 1983); "Part II." 172 (May 1984).

GADoc. "Tsukuba Center." 2 (Autumn 1980).

Institute for Architecture and Urban Studies. *A New Wave of Japanese Architecture.* Catalog no. 10. New York, 1978.

InteriorD. "The Palladium. Manhattan's Hot Night Club." 56 (October 1985).

Interiors. "Electronic Cathedral." 145 (October 1985).

Jahn, Graham, and Scott Grances. *Contemporary Australian Architecture.* Sydney, 1994.

JapanA. "Arata Isozaki." (Part I) 51 (March 1976). The whole issue; (Part 2) 51 (April 1976). The whole issue.

———. "Construction Site: . . ." 12 (Winter 1994). The whole issue.

———. "Oita Prefecture Library." 166 (December 1966).

Kawazoe, Noboru. *Contemporary Japanese Architecture.* Tokyo, 1973.

Kenchiku Bunka. "The Latest Work of" (Tokyo) 383 (September 1978). The whole issue.

———. "Let Set Isozaki." (Tokyo) 40 (October 1985).

Koshalek, Richard, et al. *Arata Isozaki. Architecture 1960–1990.* New York, 1991.
Kultermann, Udo. *New Architecture in Japan.* Tübingen, 1967.
Modo. "Interview." (Milan) (January 1982).
Ross, Michael Franklin. *Beyond Metabolism: The New Japanese Architecture.* New York, 1978.
SpaceD. "Arata Isozaki 1976–1984." (January 1984).
Stewart, David B. *The Making of a Modern Japanese Architecture: 1868 to the Present.* Tokyo, 1987.
Taylor, Jennifer. "The Unreal Architecture of. . . ." *PA* 52 (September 1978).
———. "A Visitation from. . . ." *Architecture Australia.* (Sydney) 66 (September 1977).
Yatsuka, Jahime, and Daniel B. Stewart. *Arata Isozaki Architecture 1960–1990.* New York, 1991.

Bibliographical

Vance: James Noffsinger, A103, 1979; Sara Richardson, A1851, 1987.

Archival

Isozaki, Arata. *Barcelona Drawings.* Barcelona, 1988.
———. *Kenchiku-no-Chiso* (critical essays). Tokyo, 1979.
———. *Kukan-e* (collected writings, 1960–1969). Tokyo, 1975.
———. *Shuho-ga* (collected writings, 1969–1978). Tokyo, 1979.

J

CHARLES-ÉDOUARD JEANNERET. See Le Corbusier.

PHILIP (CORTELYOU) JOHNSON. 1906 (Cleveland, Ohio)– . Johnson studied classics and philosophy at Harvard University, in Cambridge, Massachusetts, where he received an arts degree in 1927. After touring Europe and meeting Ludwig Mies van der Rohe* he became the foundation director of the architecture department at the New York Museum of Modern Art (MoMA) from 1930 to 1936 and again from 1946 to 1954. He designed MoMA's distinctive sculpture garden (1953) and two additions (1950 [demolished 1979], 1964). During the 1930s he honed his architectural knowledge as client, critic, and historian, and then at the age of thirty-four, he returned as a student to the Harvard Graduate School of Design and received a degree in architecture (1943). He was entranced but not persuaded by Marcel Breuer's* teaching. Johnson practiced independently in Cambridge (1942–1946) and then entered private practice in New York City (1954–1964) and was in partnership with Richard Foster (1964–1967). In 1967 he formed a partnership with John Burgee and has been independent since 1993. Johnson has received many national and international awards, degrees, and honors including the AIA Gold Medal (1978) and the Pritzker Architecture Prize (1979).

☙

"An architect's first duty is to his art. The real art of architecture is monumentality—something that will make you gasp," the ubiquitous Johnson has said. "This is what every architect has to think about."[1] His words and works continue to appear throughout the world in diverse publications. Teasing with

words and experimenting with buildings have indeed made fellow professionals and bewildered laypersons struggle for comprehension or rollick with delight at the multimillion-dollar jokes.

Excited by the modern architecture he observed in Europe, upon taking up his position with MoMA in 1930 he became an outspoken advocate of that modernism demanding its adaption in America. With the encouragement of Alfred Barr, director of MoMA and similarly if more politically motivated, the museum mounted an influential modern masters exhibition that included a number of Europeans as well as Frank Lloyd Wright.* His inclusion side by side with the internationalists must have been at the persuasion of Lewis Mumford, another organizer of the show.

Johnson's first building of consequence was his own house in New Canaan, Connecticut (1949). Entirely glass walled and with the only enclosure a toilet/ shower in a solid cylinder, it was inspired by Mies van der Rohe's residential work, particularly the Farnsworth house. Ironically, Johnson's was built before its main source of inspiration was complete. With promotion of Mies by publication of an excellent book and through the publicity of his own house, Johnson began a long career that evolved seemingly willy-nilly, shaped and colored by "his keen taste and effervescent wit."[2]

In the 1950s his architecture continued to employ Miesian paradigms, including the campus and buildings for the University of Saint Thomas, in Houston, Texas (1957). The culmination of his association with Mies was the Seagram Building, in New York City (1956). By the late 1950s Johnson was persuaded less by Mies, although retaining the German's formalism and monumentality, and more by Louis I. Kahn.* This is evident in such works as the structural and spatial rationale of the Boissonnas house in New Canaan, Connecticut (1956), or the spatial simultaneity of the buildings for the multistoried IDS Center in Minneapolis (1973) and similarly the Pennzoil Place in Houston, Texas (1973–1976). They otherwise do not appear to be inspired by Kahn for they are buildings wrapped in transparent and opaque glass. More faithful to Kahn's influence were a series of museums of the early 1970s as well as the plan and scale-exploding, large-sized volumes of an addition to—and looming over—the Boston Public Library (1971–1973) and the small, plain Kevorkian Center for Near Eastern Studies at New York University (1972) in New York City.

In the 1960s Johnson became even more possessed by the notion of symmetrical formalism and the attempt to knit transparent glass walls with Islamic or Eastern arcading in lightweight concrete. This resulted in some ambivalent messages, but all was still dominated by grand proportions and size. Because of his association with MoMA, Johnson designed a number of art museums. Those of the 1960s displayed that obsession, for instance the Sheldon Memorial Art Gallery for the University of Nebraska in Lincoln (1960–1963), the Amon Carter Museum of Western Art at Fort Worth, Texas (1961), and his own miniature Garden Pavilion, in New Canaan (1962).

These quasi-romantic inclinations resulted in a constant investigation of form,

seemingly ignoring appropriateness to the client's needs or structural rationalism. They therefore tended to embody personal reflections on the art of architecture rather than its social or technical necessities. These include the Kline Science Center, at Yale University (1962–1965), beautifully detailed in brick; and the Epidemiology and Public Health Building at Yale University (1965) of similar function, size, and overstructured but in concrete; and the Boston Public Library addition.

Much of his high-rise architecture is meant to break away from the typical post-1945 box. An early example was his Pennzoil Place, in Houston (1972–1976), a double building with steeply sloping roofs and a sloping space frame, all-glass roofed entry between at ground level.

Johnson believes people "gasp" at an architecture imbued with monumentality; all cultures desire it. To Johnson "the drive for monumentality is as inbred as the desire for food and sex."[3] His New York State Theater at Lincoln Center (1964), the most traditional of this group; the Niagara Falls Convention Center, in New York (1971–1974), with its gigantic steel trusses as segmental arches spread over a central space (as with Kahn); and the all-glass and all-exposed-steel space frame "Crystal Cathedral" for Robert Schuller, in Garden Grove near Los Angeles (1980), diversely but representatively outline Johnson's gasping philosophy.

"In the decade following the completion of the Seagram Building Johnson's enlarged practice and lionized status in New York society enabled him to develop both an oracular style of speech and argument, and an increasingly monumental body of work."[4] (In 1984 the Burgee/Johnson office had $2.5 billion in commissions.) No one, not even Johnson, can escape the word, perhaps because "monumentality" is one of few cohering factors in his eclectic oeuvre. Moreover, "Whatever we may take of his flamboyant later buildings, consistent qualities remain. A certain exquisiteness, an instinctive understanding for quality in artificial lighting, and a sure sense of the way a building is walked throughout,"[5] of promenade and procession.

The American Telephone and Telegraph (AT&T) skyscraper, in New York City (1978–1984), "dispenses with the glass envelope . . . in favor of masonry clad, vertical mullioned, pedimented tower that evokes . . . [counterparts] of nearly a century before." (See Plate 37.) The critic and historian John Jacobus continues,

AT&T represents but one more turn in Johnson's embracing of history, and another perplexing, unforeseen twist in the career of this paradoxical designer who has so effectively surprised and irritated and instructed his contemporaries.[6]

The respected critic Ada Huxtable's analysis was that "from that Pop pediment on down," Johnson produced "a pastiche of historical references . . . blown up gigantically in unconventional and unsettling relationships. . . . The more arcane the borrowings of design elements, and more perverse their combination, the more provocative and progressive the result."[7]

Paul Goldberger observed that the AT&T "is a serious and earnest attempt to reinterpret historical form in a way that will never be directly imitative . . . nor conventionally modern." He suggests that the move away from Miesian and modernist design "is now something more than an academic crusade. . . . Johnson has stretched out an arm of the architectural establishment to embrace it."[8] (Of the establishment?)

Another unconventionality is his Pittsburgh Plate Glass headquarters, in Pittsburgh, Pennsylvania (1979–1984), a complex of buildings whose facades are all glass (of course), including pointy pinnacles and a tower that emulates the quasi-Gothic Parliament House in London of the mid-nineteenth century.

Because of Johnson's "experiments," a kindly word, his architectural oeuvre embodies all the wanderings and paradoxes of the last half of the twentieth century. Historian Charles Noble put it well when he observed that one part of the American

nation's consciousness rejects utterly the kind of physical determinism which Johnson sees as the great achievement of historic architecture; an arrangement of buildings which subliminally compels certain directions and courses of action compels also attitudes of respect and wonder, perhaps even love. There is growing . . . today both a repudiation of such reinforcement of power by form, and an increasing reliance upon it by those institutions and individuals who in the past received respect as a matter of course.[9]

However, when through mere visual images one "deconstructs" social and aesthetic sensibility what is offered as a positive alternative? Johnson's detractors have proposed no effective answer. If they were to do so, he would ignore them.

NOTES

1. As quoted in *Time* (14 December 1953), 84.

2. Jacobus in Macmillan. See also Heyer (1978), and esp. Cook and Klotz (1973) on Johnson's speaking manners, sharp wit, and attitude to architecture.

3. Johnson, "Beyond Monuments," (1973), 54.

4. Noble (1972), 16.

5. Winter in *Contemporary Architects*.

6. Jacobus in Macmillan.

7. Ada Louise Huxtable, "Johnson's Latest—Clever Tricks or True Art," *New York Times* (16 April 1978), D26, 31.

8. Paul Goldberger, "Design Direction—Other Voices," *AIAJ* 67 (May 1978), 162.

9. Noble (1972), 17–18. John (Henry) Burgee received an architecture degree from the University of Notre Dame, in Indiana (1956), worked in Chicago and became a partner (1958–1967) with C. F. Murphy Associates. During 1967 he began with Johnson and became a partner (1968–1993) in the firm known as "John Burgee Architects with Philip Johnson" with offices in New York. See "Garden in the Sky," *Connoisseur* (London) 219 (August 1989); Nory Miller, *Johnson/Burgee Architects* (New York, 1980); and Barbaralee Diamonstein, *American Architecture Now II* (New York, 1985).

BIBLIOGRAPHY

Works by, about, or that significantly include Johnson number in the hundreds world-wide. The abbreviation PJ for Philip Johnson is used below.

Writings

"Architectural Details: 3. PJ." *ARecord* 135 (April 1964).
"Beyond Monuments." *AForum* 138 (January 1973).
"Frontiersman. Frank Lloyd Wright." *AReview* 106 (August 1949).
"Johnson." *Perspecta* 7 (1961).
Machine Art. New York, 1934.
Mies van der Rohe. New York, 1947; 2d ed., 1953; Stuttgart, 1956; Buenos Aires, 1960.
"The Museum of Television." *a+u* 268 (January 1993).
"A Personal Testament." In *Four Great Makers of Modern Architecture,* Columbia
 University. New York, 1961.
PJ/John Burgee Architecture 1979–1985, edited by Ivan Zadic. New York, 1985.
"PJ's Lecture with Jeffrey Kipnes." *JapanA* 7 (7, 1992).
"The Responsibility of the Architect." *Perspecta* 2 (1954).
"The Seven Crutches of Modern Architecture." *Perspecta* 3 (1955).
With Henry-Russell Hitchcock. *International Style. Architecture since 1922.* New York,
 1932; enlarged, New York, 1966.
———. "The Buildings We See." *New World Writing* New York 1 (April 1952).
———, et al. *Modern Architecture. International Exhibition.* New York, 1932.

Biographical

Jacobus, John M. *PJ.* New York, 1962.
Schulze, Franz. *PJ—Life and Work.* New York, 1994.
Winter, John. In *Contemporary Architects.*

Assessment

a+u. "Crystal Cathedral Tower." 247 (April 1991).
ARecord. "Lincoln Center, NY." 128 (September 1960).
Aujourd'hui. "Dynastie." 252 (September 1987).
Barnett, Jonathan. "The New Collegiate Architecture at Yale." *ARecord* 131 (April
 1962).
Blake, Peter. *The Master Builders.* New York, 1960.
Cook, John W., and Heinrich Klotz, eds. *Conversations with Architects.* London, 1973.
Drexler, Arthur. "Seagram Building." *ARecord* 124 (July 1958).
Eisenman, Peter. "Interview with PJ." *Zodiac* 9 (March 1993).
Gilbert, Gregory. In *The Critical Edge,* edited by Tod A. Marder. MIT Press, 1985.
Goldberger, Paul. "Form and Procession." *AForum* 138 (January 1973).
Heyer, Paul. *Architects on Architecture.* 2d ed. New York, 1978.
Hitchcock, Henry-Russell. "Current Work of Philip Johnson." *Zodiac* 8 (1961).
———. "PJ." *AReview* 117 (April 1955).
———. *PJ. Architecture 1949–65.* New York, 1966.
Interiors. "New Canaan. Architecture Opaque." 109 (October 1949).
Jacobus, John M. In Macmillan.
Joedicke, Jürgen. *Architecture since 1945. Sources and Directions.* Stuttgart, 1969.

Jones, Cranston. *Form Givers at Mid-Century.* New York, 1959.

Jordy, William H. "Mies-less Johnson." *AForum* 111 (September 1959).

————. In Lampugnani.

Kipnis, J. M. "PJ." *a+u* 259 (April 1992).

Lewis, Hilary, and John O'Connor. *PJ: The Architect in His Own Words.* New York, 1994.

Marks, Marcia B. "Theatre for Dance at Lincoln Center." *Dance Magazine* (New York) 35 (May 1961).

Matthews, H. "The Promotion of Modern Architecture . . . 1930s." *Journal of Design History* 7 (1, 1994).

Miller, Nory. *Johnson/Burgee. Architecture.* London, 1980.

Noble, Charles. *PJ.* Tokyo, 1968; 2d ed., London, 1972.

Nuestra Arquitectura (Madrid) 382 (September 1961). The whole issue.

Pommer, Richard. "Johnson and History." *Artforum* (New York) 17 (October 1978).

Rodman, Selden. *Conversations with Artists.* New York, 1957.

Saarinen, Aline B. "Four Architects." *Vogue* (New York) 126 (1 August 1955).

Scully, Vincent, Jr. *Modern Architecture.* New York, 1961; 2d ed., New York, 1974.

Werk. "PJ Kunstfigur." 78 (September 1991). Anthology.

Whitney, David, and Jeffrey Kipnes, eds. *PJ. The Glass House.* New York, 1993.

Wilson, Forrest. "PJ's Modern Art." *Interiors* 124 (July 1964).

Bibliographical

AAAB: William O'Neal, comp. *Papers I,* 1965; and *Papers II,* 1966.

Hurrah, Elizabeth V. *A Further Bibliography of Publications by and about PJ.* Charlottesville, 1955.

O'Neal, William. *A Bibliography of Publications by and about PJ.* Charlottesville, 1955.

Vance: Robert Harmon, A138, 1979; Bibliographic Research Library, A1394, 1985; Dale Casper, A1984, 1988.

Archival

PJ. *PJ Writings.* New York, 1979.

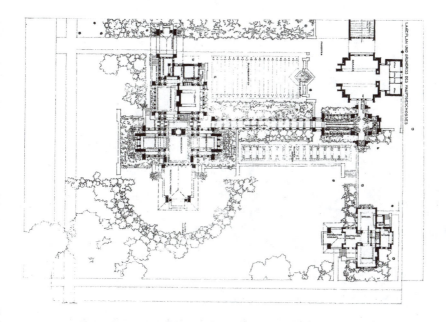

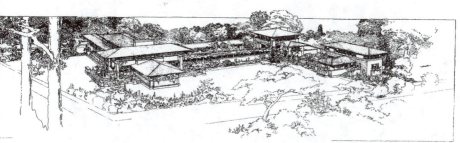

Plate 1. Martin and Barton houses. Buffalo, New York. 1902. Frank Lloyd Wright, Architect. Ground floor plans and aerial perspective. The house for Martin's son-in-law, Barton, is lower right in the plan and above it the stable, later the garage, for both houses. The Martin house is to the left in the perspective. Every functional and structural part of the Martin house is independently defined in plan and boldly extrapolated three dimensionally in brick. The general schemata of the open plan is typical of some of Wright's larger so-called prairie houses, while the Barton plan is a classic prairie composition. The drawings were made by Wright and Marion Griffin and have been widely published since 1910.

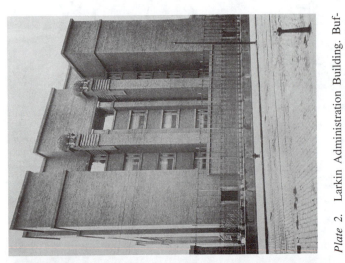

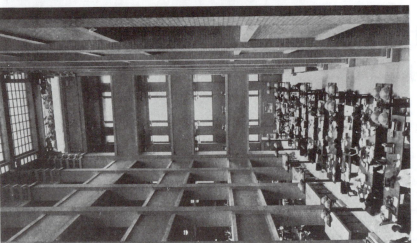

Plate 2. Larkin Administration Building. Buffalo, New York. 1903–1906. Frank Lloyd Wright, Architect. Interior and exterior photographs were, like those of his Unity Church (Oak Park, Illinois, 1904–1906), widely published throughout the world from 1910 onward with many other interior and exterior photographs and plan drawings. The relationship of functional parts in plan and their extrapolation three dimensionally as "cubic purism" is plain.

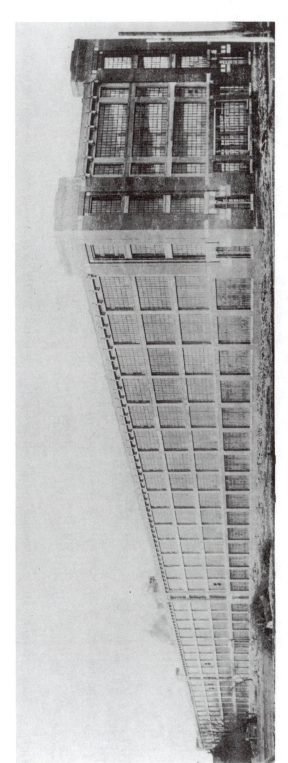

Plate 3. Ford Plant at Highland Park. Detroit, Michigan. First unit built 1908–1909. Albert Kahn, Architect, with Edward Grey. Exterior. The building is narrow to allow daylight to penetrate the interior from each side; the concrete floors and posts are exposed; the glass walls are framed in steel sash; and the brick piers are for lateral stability, aesthetically to break the repetitive facade, and terminate the building composition. Julius Kahn's trussed concrete structural system was employed. As published in *American Architect & Building News* (1909) and *Jahrbuch des Deutschen Werkbundes* (1913).

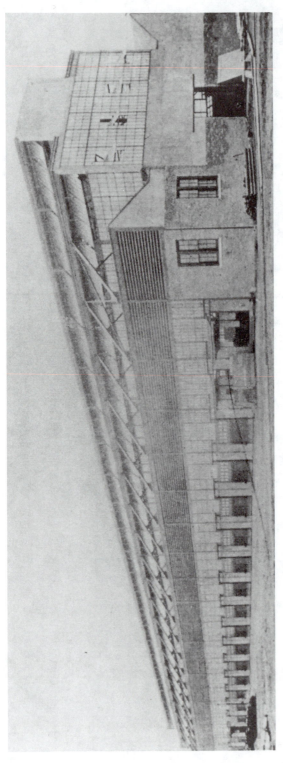

Plate 4. Packard Motor Car Company, Forge Shop. Detroit, Michigan. 1910–1911. Albert Kahn, Architect. As published in *American Architect & Building News* (1911).

4a. Exterior. Glass and louvres pass in front of the structure as a nonload-bearing curtain wall. The partly exposed steel trusses span the width of the building to carry the roof and a ten-ton electric crane.

4b. Architect's section drawing indicating possible air ventilation (curve dashed lines) and the distribution of daylight to work level. Total vertical glass area including louvres is greater than the height of the building.

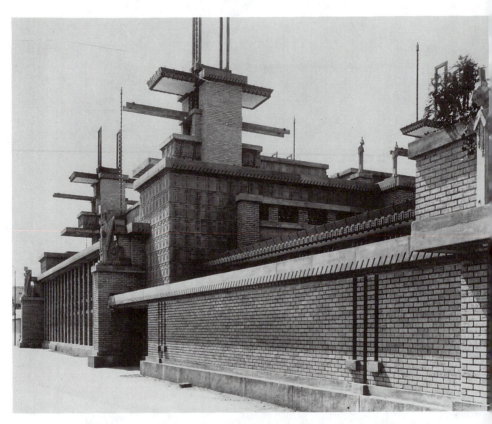

Plate 5. Midway Gardens. Chicago, Illinois. 1913–1914. Frank Lloyd Wright, Architect. Note the plain massing; dynamic roof planes, balcony and decorative elements, some open and vertical; geometric rhythms; clarity of structure that visually organizes elements; and a persistent horizontality. Many similar views of the building were published during the period from 1915 to 1923 and they highlighted these characteristics. Photograph Courtesy The Frank Lloyd Wright Foundation.

Plate 6. "La Centrale Elettric," project. 1914. Antonio Sant 'Elia, Architect. Drawing, pencil, ink, and watercolor. Simple forms of the plant (washed yellow/orange), the dam (in grey/white) and sky (in blue/green) are set against the dominant diagonal, all contrived to suggest dynamics and unleashed power. The diagonal became a theme in early Constructivist sculpture, stage design, and architecture. The forms predict much of European Expressionism of the 1920s and effects in the 1930s. See also Plate 7. Widely published since the early 1920s.

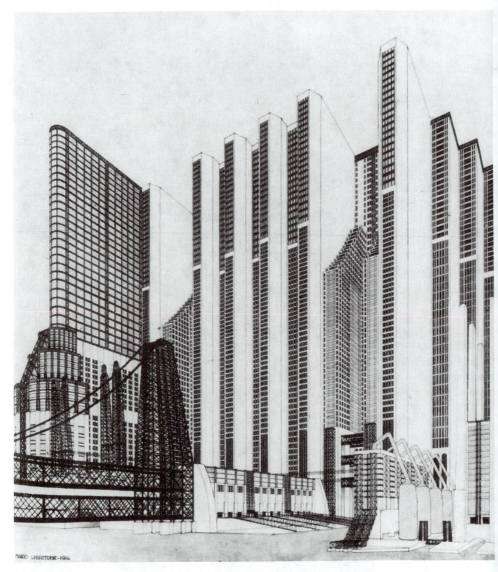

Plate 7. "Buildings for a Modern City." 1914. Mario Chiattone, Architect. Perspective drawing, pen and ink wash on paper. A two-level bridge, power plant, factory, tall office, and apartment buildings, frankly exposed steel trusses, all prophetic images of a future city and European architecture. Soviet Constructivist architecture of the late 1920s looked similar to these proposed buildings, even in rendering style; and the round corner became popular in the 1930s. See also Plates 6 and 14. Widely published since ca. 1922.

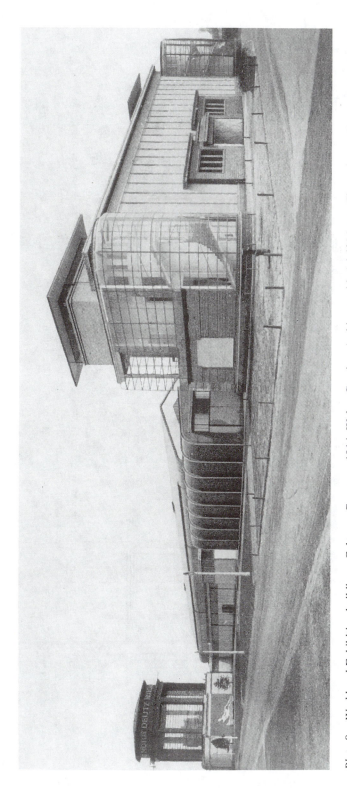

Plate 8. Werkbund Exhibition buildings. Cologne, Germany. 1914. Walter Gropius, Architect, with Adolf Meyer. The main or office building in brick is composed of elements from Wright's architecture except for the unique employment of the industrial all-glass wall that encloses the semicircular concrete stairs and then continues to the rear of the offices where it faces an interior court. The various other buildings resulted from a requirement to use industrially made components, mainly of metal. Photograph widely published since ca. 1914.

Plate 9. Facade of "A Villa," project. 1916. Charles-Édouard Jeanneret (later Le Corbusier), Architect. Ink drawing. The composition of the elevation is generated by mathematical formulae with an imposition of "lines of regulation" (the diagonals) determined by the architect to curb artistic willfulness and arbitrariness. Le Corbusier later adopted a similar neo-Rennaissance system—a "biological analogy"—in his *Le Modulor* studies in the 1940s. From Le Corbusier, *Towards a New Architecture* (London, 1927) and since widely published.

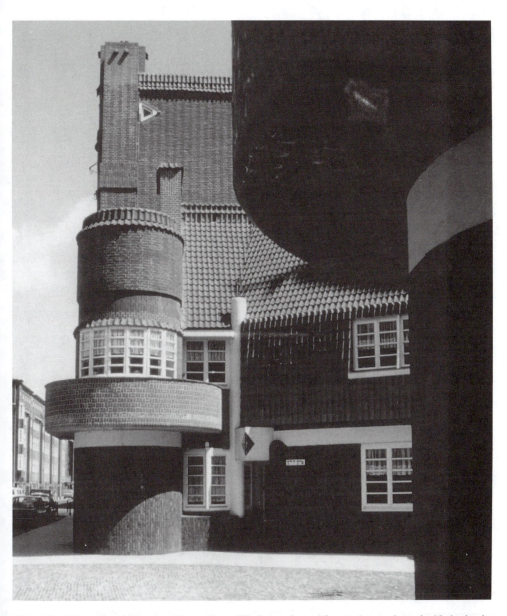

Plate 10. Eigen Haard Housing Estate, Stage III. Spaarndammerbuurt, Amsterdam, the Netherlands.
1917–1920. Michel de Klerk, Architect. In this final phase of a workers' housing development for
the Eigen Haard (Our Own Hearth) Housing Cooperative, de Klerk designed the back of the buildings,
earlier left to contractors. The fluid, so-called Expressionistic decorative forms exploit the brick and
terra-cotta used to achieve them: combinations of color and of bonding and structural possibilities are
taken to their limit in oriels, galleries of windows, turrets, and a subtle swelling of walls. Courtesy
of Donald Langmead.

Plate 11. Possible buildings. 1917–1918. Erich Mendelsohn, Architect. Ink drawings: top, a film studio; center, an "industrial building"; bottom, a "house of friendship." These imaginative and dynamically powerful sketches, usually less than a couple of inches across, were made when the architect was on active service in World War I. They predict the character of one aspect of central European Expressionism and aspects of American Art Deco of the 1930s (see also Plates 6 and 7). Widely published since the early 1920s.

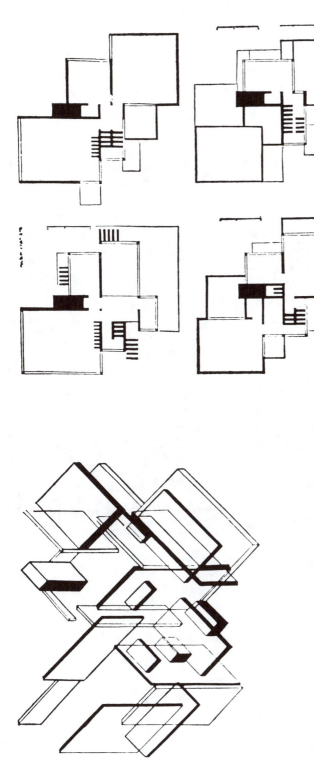

ARCHITECTUUR : MAISON PARTICULIÈRE
Contra-Constructie. (Zie blz. 80 bovenaan)

THEO VAN DOESBURG

C VAN EESTEREN.

Plate 12. Design for a private house, project. 1923. Theo van Doesburg, Designer, and Cornelis van Eesteren, Architect. Irrespective of what was built or not, the van Eesteren/Doesburg collaboration was an important step in the development of De Stijl's notions of architectural form and the relationship between architecture and space. There is a noticeable influence of Frank Lloyd Wright's open house plans at the turn of the century, in the spaces defined by planes rather than rooms, and of interlocking forms which here are essentially abstracted. This project and others were exhaustively analyzed by the Dutchmen by means of plans, axonometric drawings, scale models, and even paintings. Their—and Wright's—impact on Mies van der Rohe (Plate 16) is clear in the visual evidence. Widely published since the early 1920s.

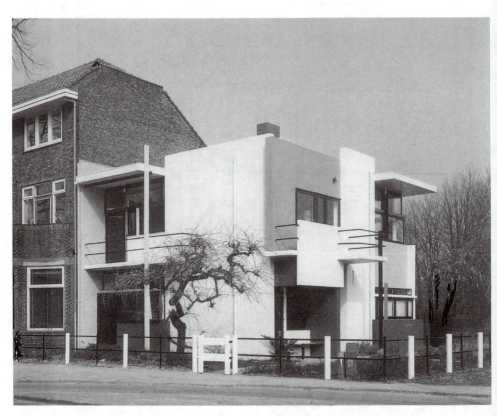

Plate 13. Mrs. Schröder-Schräder house. Utrecht, the Netherlands. 1924. Gerrit Rietveld, Architect, with Truus Schröder-Schräder. Paradoxically, the tiny house represents the entire constructed architectural output of the influential De Stijl. Even then it was designed some time after Rietveld withdrew from van Doesburg's loosely defined group. Grey, primary, and white painted colors look like a Mondrian painting projected into space: and in a sense that is what was intended. The planes and forms can be usefully compared to the van Doesburg/Eesteren project, shown in Plate 12. Courtesy of Donald Langmead.

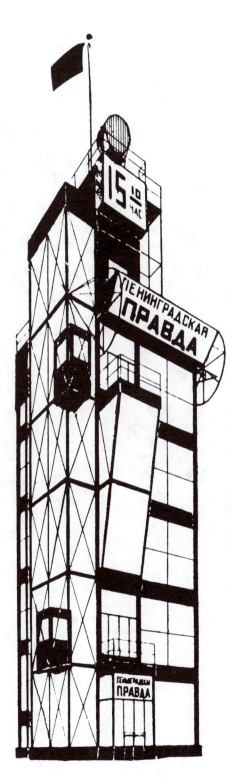

Plate 14. Leningrad Pravda building, project. Moscow, Russia. 1924. Alexandr and Viktor Vesnin, Architects. Perspective. Not in plan but in overall character, in structural and functional expression, theoretical clarity, and symbolism, the tiny building is the canon of Russian Constructivist architecture. Even the style of drawing, such as black lines as floors' edges suggesting steel or concrete (as first executed in drawings by Chiattone in 1914, Plate 7) was copied. A model and preliminary drawings are illustrated in Andrews and Kalinovska (1991, p. 194), a most comprehensive survey. This drawing was rather crudely reproduced when first published in Europe in *Architecture Vivante* (1930, Part 2).

Plate 15. Town Hall. Hilversum, the Netherlands. 1924–1931. Willem Marinus Dudok, Architect. Detail of entrance and porch. The horizontality of the forms and detailed elements, the interplay of mass and void are lessons that Dudok learned from Wright; the dynamics of line from de Stijl. The colors—yellow bricks, turquoise tiles, earthy paving slabs, black plinths, and metal frames picked out in bright primary hues—are all Dudok's own. As Talbot Hamlin observed, Dudok's buildings "have to be seen under cloud or in sun or even at night; they have to be walked around and through and even touched to savor this quality of both visual and tactile imagination." Courtesy of Donald Langmead.

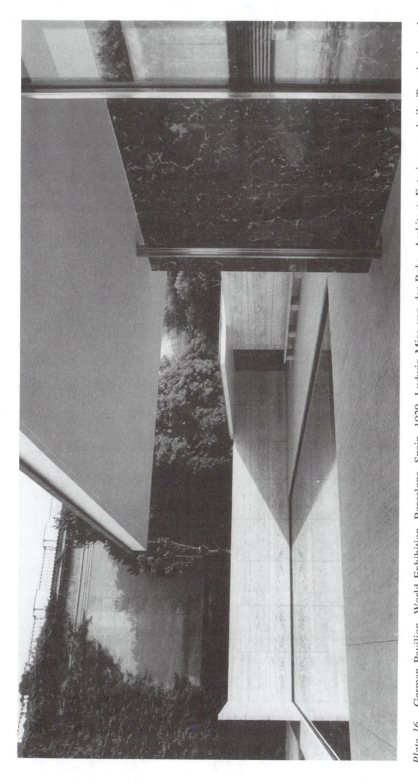

Plate 16. German Pavilion, World Exhibition. Barcelona, Spain. 1929. Ludwig Mies van der Rohe, Architect. Exterior as rebuilt. Two horizontal planes act as roofs that gently rest on vertical grey and green marble-faced wall planes and, on the main building (right), six stainless steel posts while horizontality dominates: all in minimalist abstraction. Compare with Plate 12. Photograph by Botond Bognar.

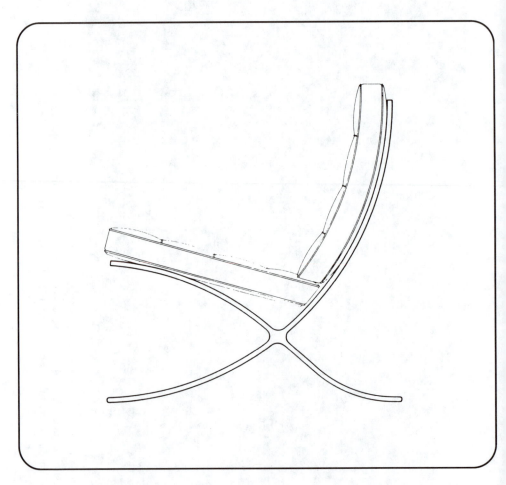

Plate 17. "Barcelona chair," leather and stainless steel. 1928. Ludwig Mies van der Rohe, Design. Side elevation. The ultimate in graceful line, proportional elegance, and sensitive use of materials, it is the icon of twentieth-century furniture. See also Plate 16. Drawing by John Fleming, from W. Blaser, *Mies van der Rohe* (London, 1972).

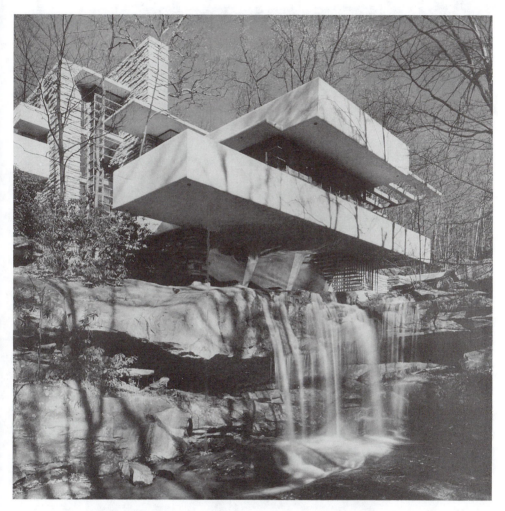

Plate 18. Kaufmann house, Fallingwater. Bear Run, Pennsylvania. 1935–1937, 1939. Frank Lloyd Wright, Architect. The influence of his Gale house (1909) and the Europeans' interpretation in the 1920s are knit with his love of natural materials. Other than stone the construction material is cream-colored concrete which complements and dramatically heightens the building's effective intrusion on the sylvan site. Photograph by Hedrich Blessing, probably the most widely published photograph of the house since 1938.

Plate 19. Row houses for professional staff, Cellulose Factory. Sunila, Finland. 1937–1938. Alvar Aalto, Architect. The passage of years has allowed the careful planting to almost subsume the buildings, creating a rural ambience in a quite toxic industrial zone. Entered from their backs, the boxy houses look over extensive gardens, separated by tiered brick walls and low hedges. Photo from *Alvar Aalto Complete Works*, edited by Karl Fleig, original edition 1963, © 1995 Birkhäuser-Verlag für Architektur AG, Basel/Switzerland.

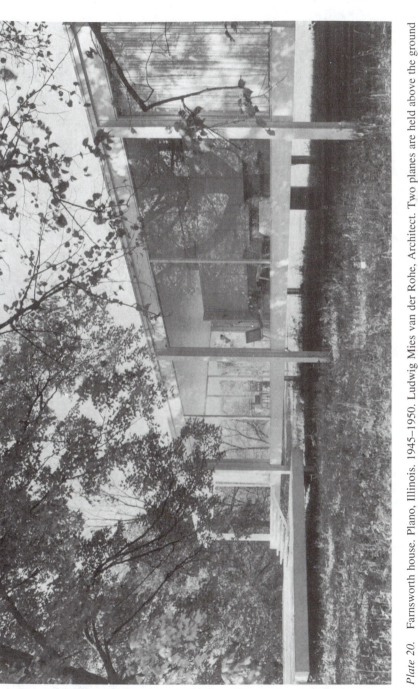

Plate 20. Farnsworth house. Plano, Illinois. 1945–1950. Ludwig Mies van der Rohe, Architect. Two planes are held above the ground by eight exposed, white I-beam posts. Exterior walls are all glass. In the interior only toilets and heating are enclosed by reddish plywood paneling. The verandah is held by six I-beam posts. Steps are planes (treads) without risers. The concept therefore is of horizontal planes, translucent/opaque/reflective exterior walls, and one solid in an open interior. Similar views widely published since 1950.

Plate 21. Lever house. New York City. 1948–1952. Skidmore, Owings, and Merrill, Architects, Gordon Bunshaft, Design. The ground floor is open except for an entrance lobby and landscape. The roof of the next floor is landscaped around a large hole allowing daylight into the heavily used ground level. The narrow tower is relieved from the second level, and sheathed in aluminum and two shades of green glass. Buildings in the left background are typical in appearance of the 1930s and 1940s. Photograph by Botond Bognar.

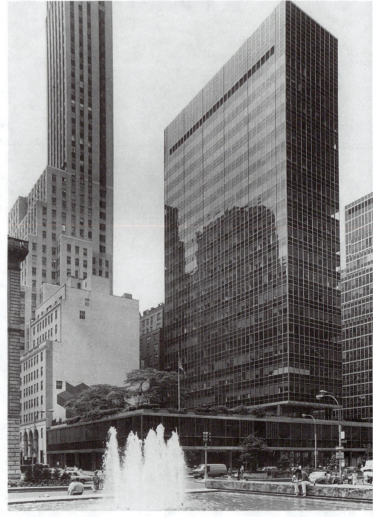

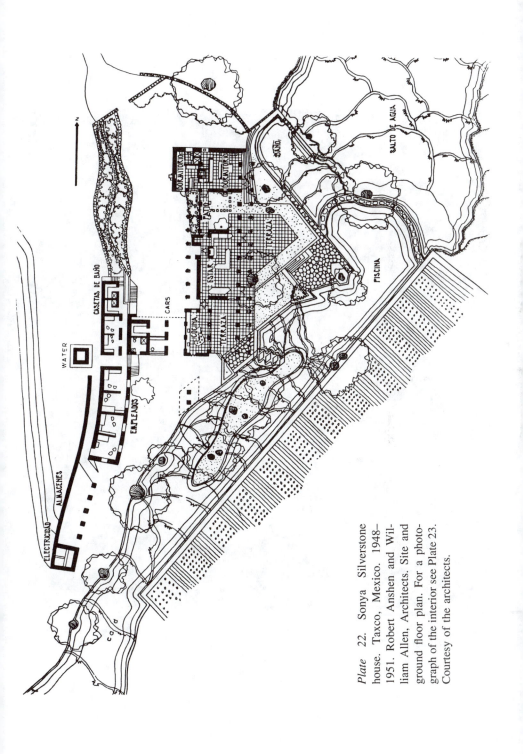

Plate 22. Sonya Silverstone house. Taxco, Mexico. 1948–1951. Robert Anshen and William Allen, Architects. Site and ground floor plan. For a photograph of the interior see Plate 23. Courtesy of the architects.

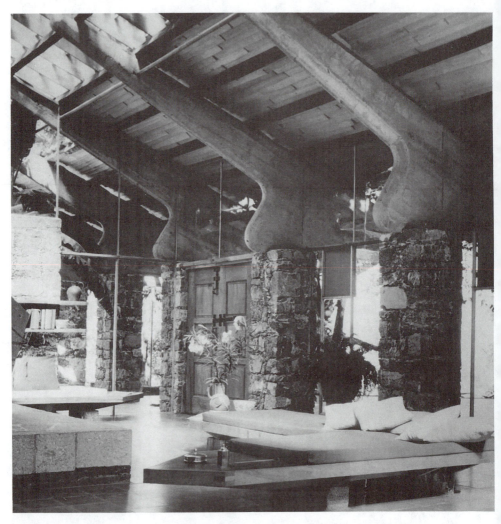

Plate 23. Sonya Silverstone house. Taxco, Mexico. 1948–1951. Robert Anshen and William Allen, Architects. Interior. The building exemplifies major aspects of architecture at midcentury. See "Whither We Went" text and the plan, Plate 22. Courtesy of the architects.

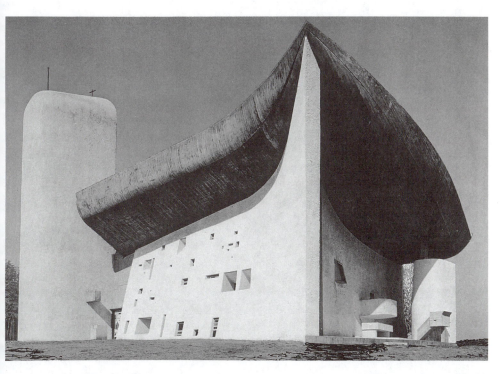

Plate 24. Notre Dame du Haut. Ronchamp, France. 1950–1954. Le Corbusier, Architect. In the late phase of his career Le Corbusier turned from sterile pseudo-objectivity to coarse forms in concrete, stone, stucco, and glass. Among those poetic, handcrafted buildings was the Pilgrim Church in the Vosges Mountains of northeastern France. Exciting in form, attractive in proportion, bathed in sunlight atop a hill, it appears to be ''a pulsating, primitive form, a sculpturally active object'': the church abstractly *imitates* a regional vernacular architecture. The massively thick, pierced wall and its painted glass windows provide otherworldly light to the sanctuary. For a plan and isometric see Plate 25. A typical, widely published photograph. Courtesy of Rachel Hurst.

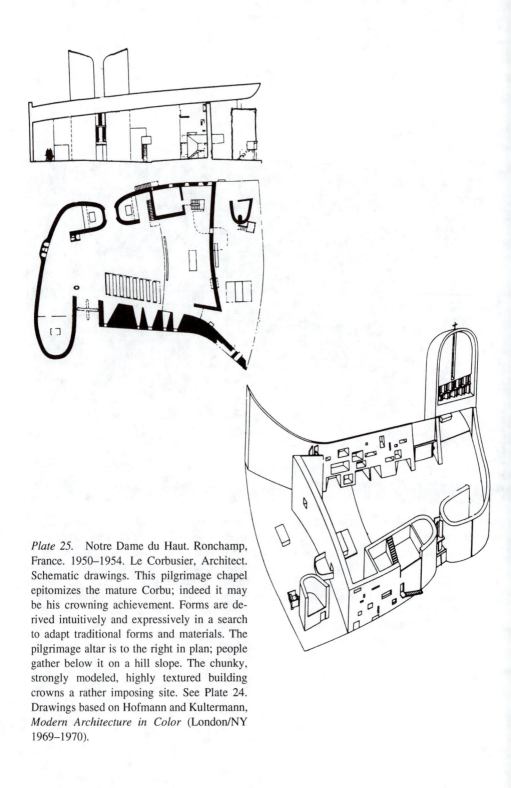

Plate 25. Notre Dame du Haut. Ronchamp, France. 1950–1954. Le Corbusier, Architect. Schematic drawings. This pilgrimage chapel epitomizes the mature Corbu; indeed it may be his crowning achievement. Forms are derived intuitively and expressively in a search to adapt traditional forms and materials. The pilgrimage altar is to the right in plan; people gather below it on a hill slope. The chunky, strongly modeled, highly textured building crowns a rather imposing site. See Plate 24. Drawings based on Hofmann and Kultermann, *Modern Architecture in Color* (London/NY 1969–1970).

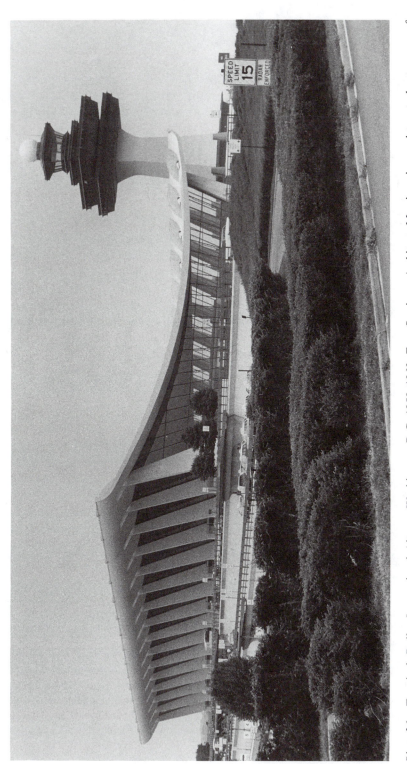

Plate 26. Terminal, Dulles International Airport. Washington, D.C. 1958–1963. Eero Saarinen, Architect. Massive piers resist a steel catenary roof structure that carries concrete pads in compression. All is exposed, enhanced, and made readable through glass and expressed expertly in a romantic yet dynamic manner. The building in the background is an air traffic control tower, the prototype first designed by I. M. Pei (1967). Photograph by Botond Bognar.

Plate 27. Goldenberg house, project. Rydal, Pennsylvania. 1959. Louis I. Kahn, Architect. The architectural plan *(a)* of this simple house contains conceptual potency. Widely published since 1959. Courtesy of the Louis I. Kahn Collection, University of Pennsylvania and Pennsylvania Historical and Museum Commission.

Schematic plan *(b)* shows a central space with radiating elements that maintain compositional unity and experiential cohesion regardless of what happens in the four radiant quadrants. Schematic plan *(c)* explains the obverse, that is how a perimeter can control a series of buildings, or disparate elements of a single building (for a crude comparison consider urban buildings bound by city streets). Plan *(d)* explains how a line, space, or structure can hold disparate elements in compositional unity (here an avenue of trees comes to mind).

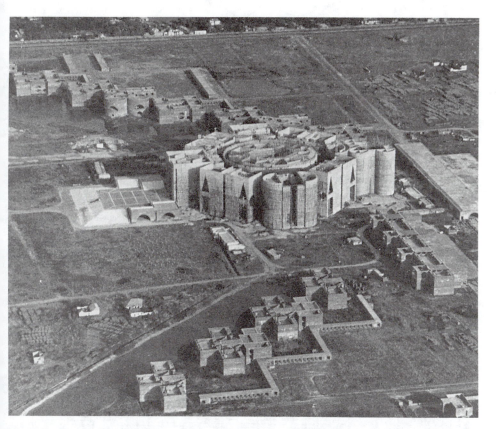

Plate 28. National Assembly (Sher-e Bangla Nagar). Dacca, Bangladesh. 1962–1974. Louis I. Kahn, Architect. Aerial view including attendant buildings with Assembly Building under construction. While appearing large the brick and concrete building is only 140 feet wide and ten stories; the sense of monumentality is gained by the bulk of the major parts in relation to the whole. Arranged concentrically in nearly separate buildings are similar functional parts (see plan Plate 29). Residences of officials range outward from the central Assembly Building and its great plaza. Courtesy of the Louis I. Kahn Collection, University of Pennsylvania and Pennsylvania Historical and Museum Commission.

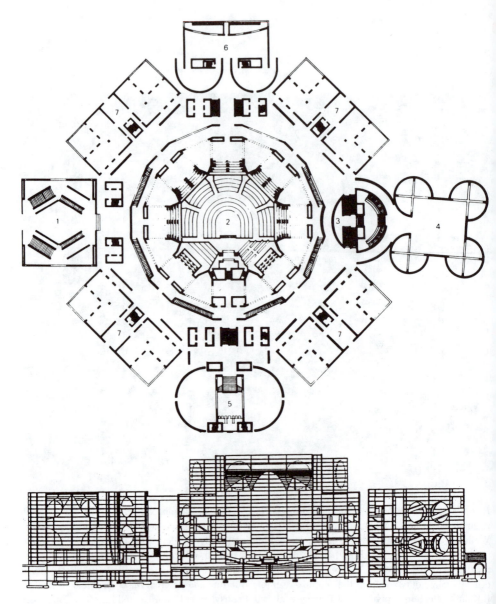

Plate 29. National Assembly (Sher-e Bangla Nagar). Dacca, Bangladesh. 1962–1974. Louis I. Kah
Architect. Schematic plan and section. The mosque is slightly askew to axis for orientation to Mecc
The ancillary (serving) functions are collected about the ambulatory of an assembly room (as a gre
"served" space) with the mosque an extension of the ambulatory. In section the entry foyer is to th
right; mosque to the left. See Plate 28. Courtesy of the Louis I. Kahn Collection, University
Pennsylvania and Pennsylvania Historical and Museum Commission.

Plate 30. Capsule Pier, project. 1965. Ron Herron, Architect. Ink drawing. The Archigram group experimented with several alternatives to the traditional house as "living units," among them a living "suit" to be worn about a single person, and capsules of some variety mounted on different structures. Here they and connecting walkways hang from masts imbedded in the sea beside a shore (note the underwater entrances). About contemporary with this agglomeration was the Gasket Homes project (Herron and Warren Chalk, 1965) and the Hornsey Capsule (Peter Cook, 1965–1966) which was the module of the threateningly named "family cages." Illustration from *Archigram*, edited by Peter Cook, reprinted by Birkhäuser Verlag Basel in 1991 (first published in Great Britain by Studio Vista Publishers 1972).

Plate 31. Ford Foundation Headquarters. New York City. 1966–1968. Kevin Roche and John Din-
keloo, Architects. View of interior courtyard that functions as a glass-enclosed foyer with view from
and to the urban street environment. The steel-and-glass facade of the offices is typical of the period
from 1945 to 1970. Note the roof skylight. Courtesy of the architects.

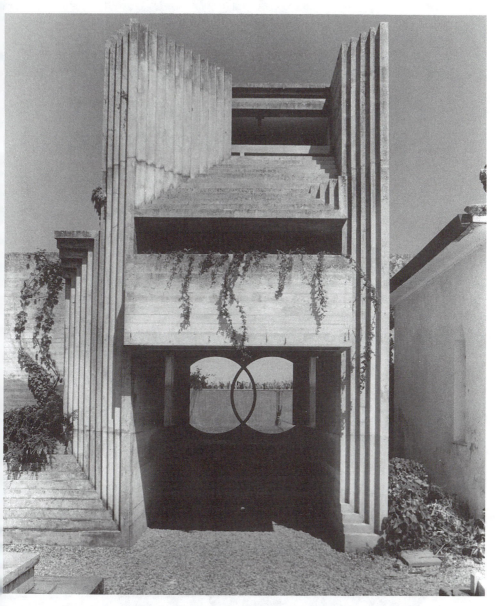

Plate 32. Brion-Vega Cemetery. San Vito di Altivole, Italy. 1970–1978. Carlo Scarpa, Architect. Built beside and around a village cemetery, Scarpa believes this design for the Brion family's private burial place is, in Italian tradition, an iconographic commentary on the journey of life into death. Architectonically and in varying degrees it extracts and abstracts Roman and regional elements (a ''regional inflection'') as blocky, solid forms (showing something of Le Corbusier and postobjective art), with little linearity yet a strong romanticism under the impress, oddly, of Wright. Scarpa's architecture and gentle arguments persuaded many to reevaluate historical roots, to discover their essentiality and their relationship to new materials; much as did William Wurster and Pietro Belluschi in America in the 1930s. Photograph by Botond Bognar.

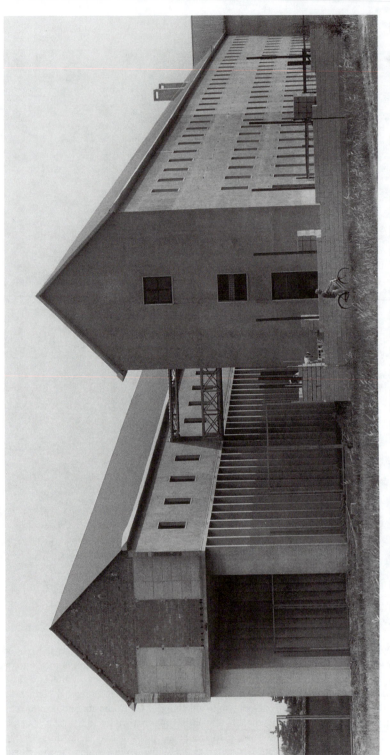

Plate 33. Municipal Cemetery, San Cataldo. Modena, Italy. 1971–1976. Aldo Rossi, Architect, with Gianni Braghiera. The ossuary building. The simple geometric forms of the ossuaries—long rooms with shelves for repositories—emphasize the weightiness of the colonnaded space beneath, a character imposed by its great height and large-scale detailing. Perceived as a city of the dead and heavy with morbid sociocultural symbolism of much Italian rationalist architecture, the bare, essential architectonic forms demonstrates Rossi's exploration of building typology beyond, he believes, the material realm. Photograph by Botond Bognar.

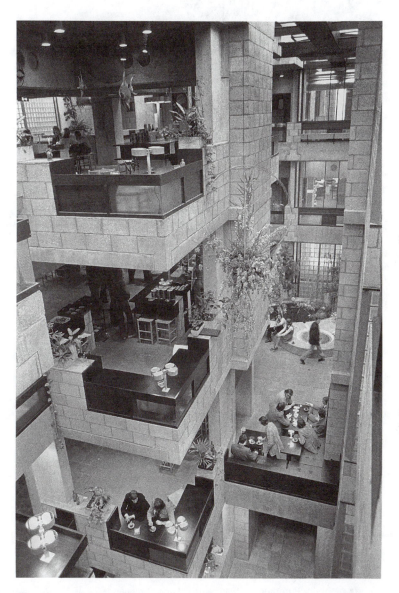

Plate 34. Centraal Beheer Insurance Company. Apeldoorn, the Netherlands. 1972–1974. Hertzberger, Lucas, and Niemeijer, Architects. This office building applies all of Hertzberger's notions about the social responsibility of architecture: a building should increase contact between the occupants and obviate inhibiting thresholds; architecture should be devoid of social hierarchies; and each individual's place should be identifiable. The cantilevered floors are taken from the work of Louis Kahn, while the interior spatial characteristics are reminiscent of Rudolph, especially his Art and Architecture building at Yale University. Photograph by Willem Diepraam. Courtesy of the architect.

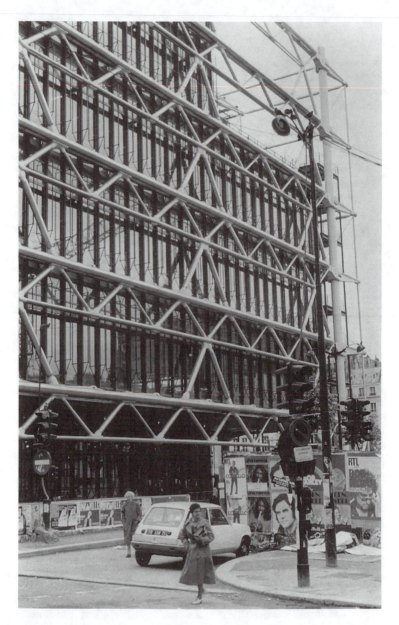

Plate 35. Centre Georges Pompidou (Beaubourg). Paris, France. 1974–1977. Renzo Piano and Richard Rogers, Architects; Ove Arup and Partners, Structural Engineers. Beaubourg is probably the most recognizable icon of the late twentieth-century high-tech architecture. It emphasizes the notion of a cultural machine. In this instance the structural (stainless steel) and mechanical technologies (varied systems are identified with differing bright colors) are exposed on the exterior and interior. The large full-width trusses allow internal flexibility, vertically and horizontally. The emphasis on structure and expressing functional zones, based on Louis Kahn's ideas, became one element in English Modernism (see Plates 40 and 44). The Anglo-Italian partnership was short lived; each man continued on the path of structural rationalism but Rogers was more devoted to exposing in form Kahnian served/servant elements. Courtesy of Donald Langmead.

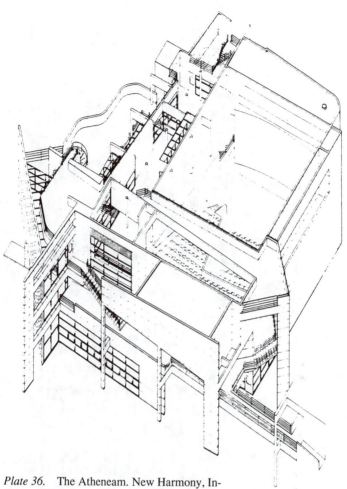

Plate 36. The Atheneam. New Harmony, Indiana. 1975–1979. Richard Meier & Associates, Architect. An orientation center for visitors to a historic town, the building is internally a complex circulation system (leading to a theater and four exhibit galleries) of overlapping ramps and spaces and juxtaposed forms. In this view the roof of the main theater is removed. The three-dimensional design and structural grid is at once obvious and teasingly deferred or absorbed. As with all of Meier's buildings the exterior and interior surfaces are white, in this case made of porcelain enamel panels set on steel frames. This remains one of Meier's best works, devoid of a recent, too resolute formality. Courtesy of the architect.

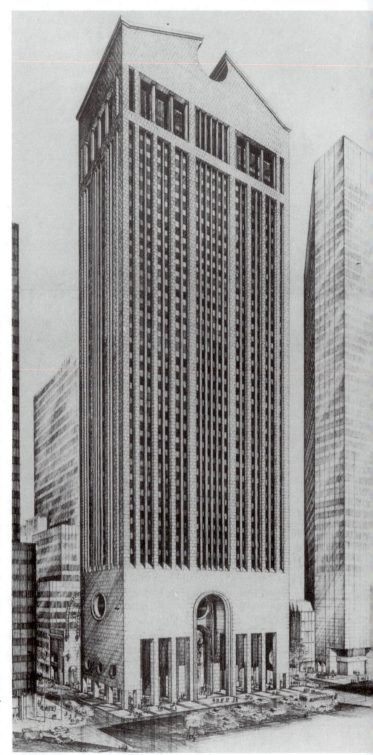

Plate 37. AT&T Corporate Headquarters. New York City. 1978–1984. Johnson/Burgee Architects, with Alan Ritchie. London's *Architectural Design* described it as "an articulated masonry frame culminating in a pitched roof of classical provenance. Various historical [things] underlie this form including the column (i.e., base, shaft, capital, entablature), the Pazzi Chapel (base), the Chippendale highboy (top), and the Rolls Royce radiator" (11/12, 1978, p. 593). This drawing portrays best the building without its shouldering neighbors. The tiny smudges at the base of the building are people. Courtesy of the architect.

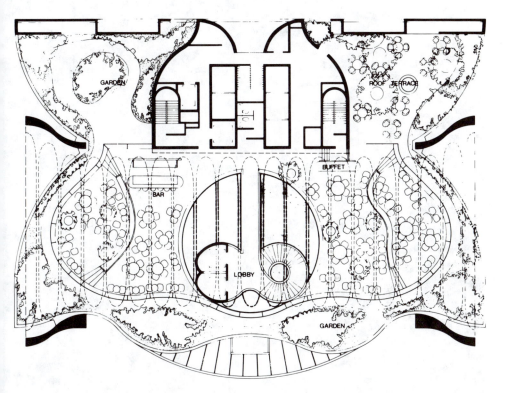

GARDEN

ROOF TERRACE

BUFFET

BAR

LOBBY

GARDEN

FOURTH FLOOR GARDEN LOUNGE

Plate 38. Hong Kong Club and Office Building. Hong Kong, China. 1980–1984. Harry Seidler, Architect. Plan of Garden Lounge or fourth floor. Graceful curves abound in an axially symmetrical plan including the concrete T-beam floor system. The central stair and paired elevators serve only the exclusive club and rise through a complex of openings that penetrate four floor levels. See Plate 39. The seventeen floors of rental spaces are served by vertical systems centered at the rear. Courtesy of the architect.

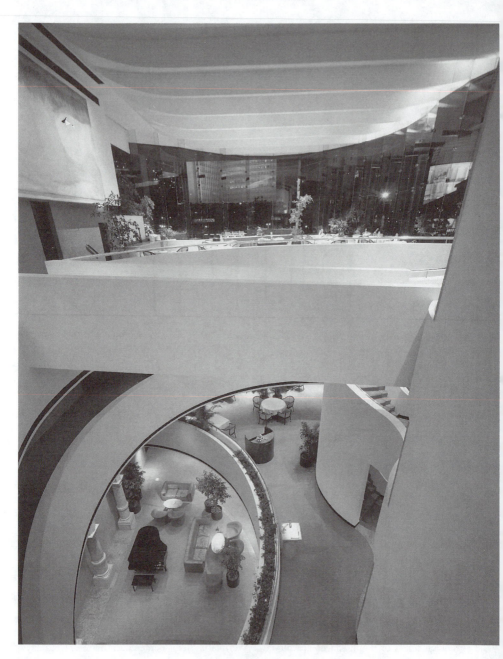

Plate 39. Hong Kong Club and Office Building. Hong Kong, China. 1980–1984. Harry Seidler, Architect. Interior of club from the Garden Lounge level adequately displays Baroque forms and spaces about the central lobbies, and interior architectural elements that have become characteristic of Seidler's work. The structural T-beams developed by Nervi for earlier Seidler buildings, here exposed as the ceiling, further enhance an overall curvilinear three dimensionality. See Plate 38. These spaces are somewhat typical of architectural interiors of the last fifteen years; however Seidler's are more elegant and considerably less jagged than most. The buildings in Plates 38, 39, and 40 are in close physical proximity in central Hong Kong; their human scale can be easily compared. Photograph by John Gollings, courtesy of the architect.

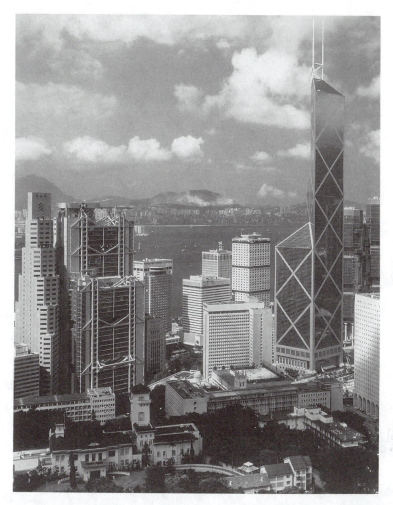

Plate 40. On the left: Hong Kong and Shanghai Bank. Hong Kong, China. 1979–1985. Norman Foster, Architect. The exterior of the building clearly exposes the massive and complex structure that is boldly open internally to a ten-story, top-lit atrium surrounded by glass-balustraded gallery offices to maintain absolute transparency above a lower internal roof of subtly curved glass pierced by skewed escalators from the entrance level. Suspended escalators continue to climb through the atrium. Louis Kahn's notion of served and serving space is clearly evident with toilets, stairs, and vertical mechanical systems at the end of open office spaces arranged in two ranks. Ex-Archigrammers should be pleased. See also Plate 44.

On the right: Bank of China/Hong Kong Branch. Hong Kong, China. 1984–1992. I. M. Pei, Architect (later Pei, Cobb and Freed). The boldly exposed triangular members act as wind and earthquake bracing for a building that, like all tall structures, is cantilevered from the earth. It is an adaption of the exposed X-bracing first employed externally by Bruce Graham and Fazlur Khan of SOM for the John Hancock Center in Chicago (1965–1970). Between the external structural members of this tower is opaque or clear—actually, silver-coated reflective—glass. The other buildings in the photograph have a nice human scale in size and of parts, aspects totally lacking in Pei's tower. Photograph courtesy of Paul Warchol.

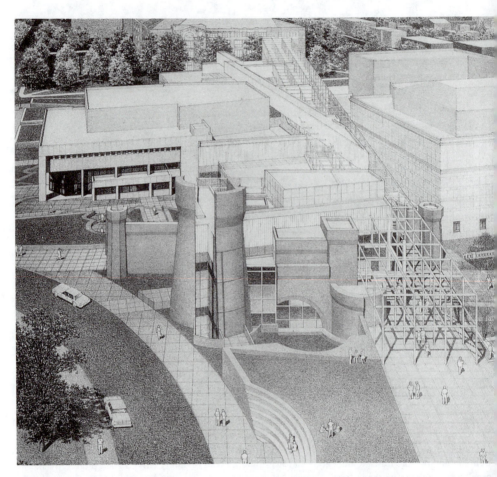

Plate 41. Wexner Center for the Visual Arts. Ohio State University. Columbus, Ohio. 1983–1990.
Peter Eisenman/Robertson, Trott, Architect. Aerial view drawing by Brian Burr that shows the center
stretched between two existing buildings by a connecting lattice, by a series of exposed monitor roof
forms containing mechanical equipment, and with attendant circular brick forms of historical reference
fractured by steel-framed fenestration between. The finished building looks much like this perspective
drawing. Reprinted with permission of *Progressive Architecture,* Penton Publishing.

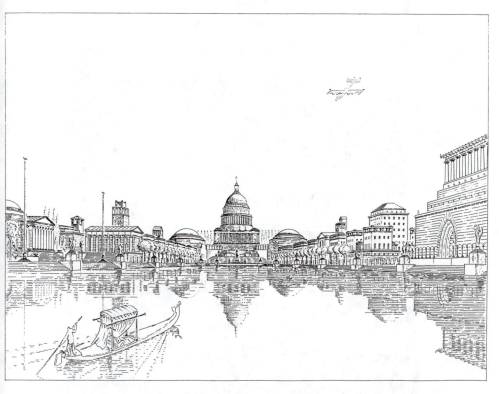

Plate 42. Master plan project for completing Washington, D.C. 1984–1985. Leon Krier, Architect. Perspective, ink drawing. Krier's Washington bears little resemblance to present reality, evoking rather a continuation of the city's neoclassical monuments of the 1920s and 1930s. The scheme eclectically blends Roman temples, Tuscan *palazzi,* and Palladian Vincenzan villas, all standing before a flooded mall, and paradoxically bringing together a modern—not to say, modernist—aircraft and a romantic gondola. The project epitomizes with some humor his belief that ''a new generation is now discovering the urban culture of pre-industrial Europe as documents of intelligence, memory and pleasure.'' Courtesy of the architect.

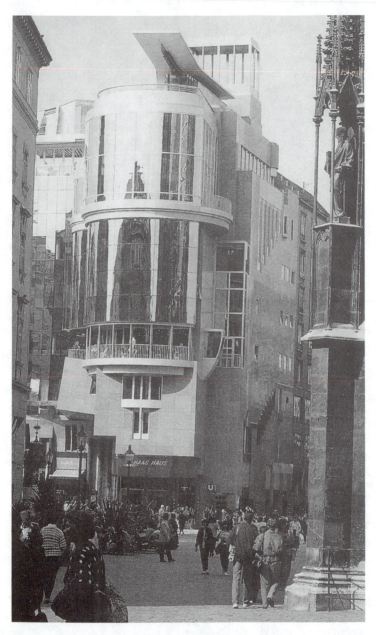

Plate 43. Haas-Haus. Vienna, Austria. 1985–1990. Hans Hollein, Architect. The bla-
tantly schizophrenic and controversial seven-story mixed-use building stands opposite
Saint Stephen's cathedral in the old city center. While being in one sense contextual in
terms of size and overall scale in relation to the plaza (and because the mirrored glass
partly reflects the environment) it is ambiguous and jarring in terms of conflicting surface
materials, a layering of those materials as if the solid wall was yet complete in covering
the glass, and a fragmentation of forms, line, and geometry, some would say unsym-
pathetic to the older buildings. The building is an example of the freneticism of much
present-day architecture. Illustration from *Architectural Design* 60 (9–10[11–12] 1990).

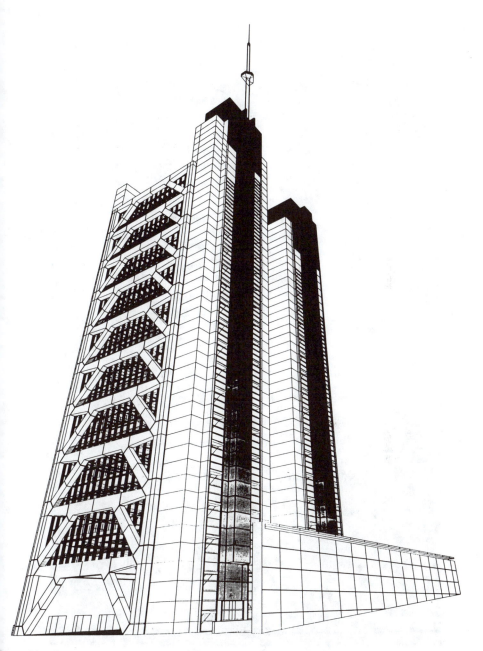

Plate 44. Century Tower. Bunkyo-ku, Tokyo, Japan. 1987–1991. Norman Foster Associates, Architects. Worm's-eye perspective. The elegantly spired office building, the boldly exposed external frame, redolent of Foster's Hong Kong and Shanghai Bank, comprises a pair of towers, one of twenty-one stories joined to a nineteen-story neighbor by a *full-height* atrium. The office floors are arranged as double-height structural units. The crowning radio mast is painted in broad bands of white and red in contrast to the sober grey of the building's frame and cladding. See also Plate 40. Courtesy of the architect.

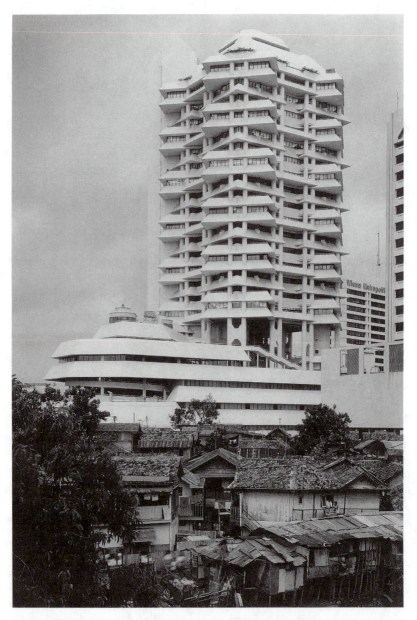

Plate 45. Wisma Dharmala Sakti. Jakarta, Indonesia. 1988. Paul Rudolph, Architect. A tropical urban context is patent in the photograph yet all the elements introduced in Rudolph's earliest work are clear: deeply sculptured exterior (in part meant to shade windows) and interior (that on the lower levels is dramatically spatial), exploitation of exposed vertical and horizontal structure of finished concrete, and a generally open ground floor with tall legs carrying upper floors. This is yet another example of a consistently applied philosophy. Photograph © Peter Aaron/Esto.

Plate 46. Funder Factory 3. St. Veit/Glan, Carinthia, Austria. 1988–1989. Coop Himmelblau, Architects. This design for a paper-processing plant avoided a long-span industrial shed in favor of this spectacular ensemble of functionally defined parts that proclaim the frenetic discordants of modern urbanism. The main building is accentuated with a red entrance canopy and screen; a detached "energy center" (power plant) has three seventy-five-foot-high, eccentrically "dancing" chimneys; and the production center's south-facing corner is a scattered steel-and-glass structure. Photograph by Gerald Zugmann, courtesy of the architects.

Plate 47. Jewish Museum, an extension to the Berlin Museum. Berlin, Germany. 1989– . Daniel Libeskind, Architect. The powerful, incomprehensible events and ideas behind the extension and the deep emotions it expresses are discordantly gathered in the tortured, jagged block that uncomfortably lurches away from the regular classical composure of the original museum. Explanation of the design fails. Like all Expressionist architecture the museum—more so because of its poignant purpose—must be experienced in situ. Understanding therefore must be private. Courtesy of the architect.

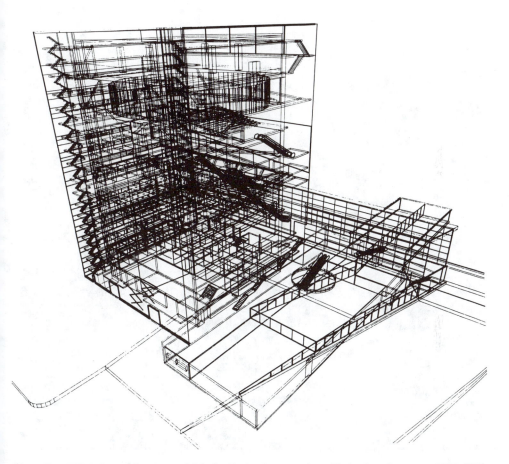

Plate 48. ZKM Center for Art and Media Technology, project. Karlsruhe, Germany. 1990–1991. Rem Koolhaas/OMA, Architects. Computer-generated drawings have become a valuable tool in the architectural design process. This computer-aided design (CAD) perspective shows hidden lines that demonstrate the vertical circulation systems and internal partitions (note the circular display room) without visual interference of floors, exterior walls, or structure. Illustration from *Architectural Design* 61 (3–4 1991).

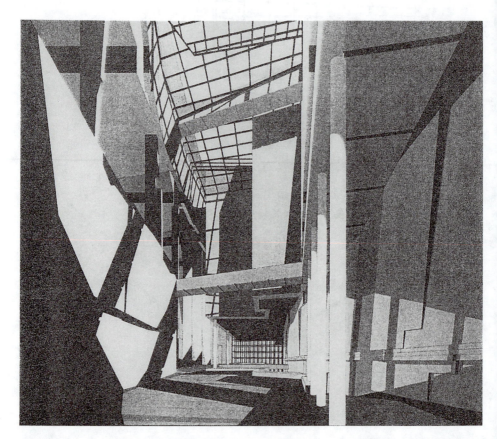

Plate 49. College of Design, Architecture, Art and Planning. University of Cincinnati, Ohio. 1990– . Eisenman Architects, Architect. Interior perspective; colored silk screen print, John Nichols. The three-dimensional character of Eisenman's layering and torquing of form and space is patent in this interior view of the proposed overhead sky- or daylit long gallery. A shift in design philosophy is seen by comparing this with Plate 41. Courtesy of the architect.

Plate 50. Museum of Literature. Himeji, Japan. 1991. Tadao Ando, Architect. Interlocking squares (in plan) are developed three dimensionally with an implication of a series of open cubes. These plain unadorned forms and a limitation on the exterior and interior to constructional materials of concrete and paving stone assists in a visual and experiential quality of dignity—this refinement in spite of some complexity of line and form. The entry ramp at left carries over a stepped water terrace over-looked by the narrow balcony that also offers views of a shallow valley. Photograph by Botond Bognar.

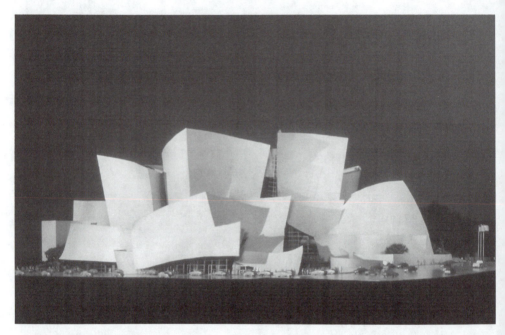

Plate 51. Walt Disney Concert Hall. Los Angeles, California. 1993– . Frank O. Gehry, Architect. Photograph of model. The two high, large forms outline the stage house (about 110 feet tall) while the intermediate forms elaborate the house. The structure—the means of enclosure to resist gravity—is not evident or overtly implied. Entry is by stairs to the right. As this photograph is of the northeast side, the sun would cast light mainly on the rear of the proposed building. Photograph by Joshua White, courtesy of the architect.

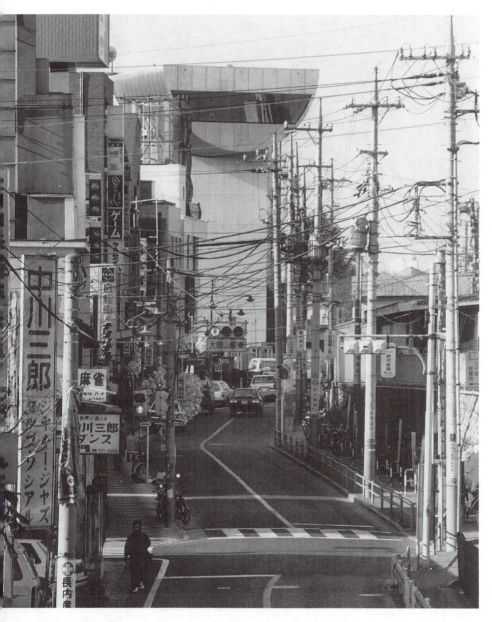

Plate 52. The Contemporary Urban Context. In the distance is the Tokyo Institute of Technology
Centennial Hall (Kazuo Shinohara, Architect, 1987), a 'machine aesthetic' or what the architect has
described as a 'Zero Degree Machine.' More obviously it is a composition of stable—if architecturally
unfamiliar or inversed—forms in an unstable, ad hoc, congested, cluttered, and familiarly temporary
environment. It is a contribution to what Shinohara describes as Japanese urbanism's ''progressive
anarchy.'' The upper half-circle form contains one room with concave interior walls. Photograph by
Botond Bognar.

K

ALBERT KAHN. 1869 (Rhaunen, Germany)–1942. Son of a rabbi and teacher, Kahn's early schooling was interrupted when the family emigrated to Detroit, Michigan, in 1880. Kahn apprenticed in the Detroit firm of George DeWitt Mason and Zacharias Rice and was otherwise self-taught (1884–1896). With a European travel scholarship he toured in part with American architect Henry Bacon (''together we traveled and he taught me,''[1] 1890–1891). Partnerships were with Alexander B. Trowbridge and George W. Nettleton (1896–1897), with Nettleton (1897–1900), and with Mason (1900–1902); he was independent thereafter. His younger brothers soon participated in the professional practice as partners: Julius was chief structural engineer, Moritz oversaw European commissions—mainly British and Soviet—and Louis attended to administration. Albert received honorary degrees and national and international awards including Chevalier of the French Legion of Honor. Quite possibly because he specialized in factories the AIA virtually ignored Kahn except in 1942 when he was given an award for contributions to the field of architectural practice.

The venerable academic Paul Philippe Cret said in a tribute that Kahn ''was not a theorist: the 'architecture of tomorrow' had little interest for one so engrossed in creating the architecture of today.''[2] When in 1941 Frank Lloyd Wright* was asked whom he regarded as the best architect in America, unhesitatingly the reply was ''Albert Kahn.''[3]

A great pragmatist no doubt, but Kahn nevertheless consistently maintained a notoriously split design philosophy. To manufacturing buildings he applied one idea directed to uninhibited problem solving, and these were aesthetically

without precedent. To nonindustrial structures he applied another idea: a historically derived eclecticism. It is, therefore, to his factories that Wright, if less so Cret, and nearly all other observers were attracted.

Kahn's first factory design was a small mill for Joseph Boyer in Detroit (1900). Together with the Packard Motor Car Company buildings (1903–1910), it used the standard multistory factory arrangement of the previous 100 years but with the structure exposed or expressed. Building Number Ten (1905), one of the earliest reinforced concrete structures made for industry, used a system patented by Julius. After the turn of the century Julius' Trussed Steel Concrete Company (later Truscon) was one of the leading builders and engineers in concrete, bridges, and buildings. But Albert preferred the more quickly assembled and therefore less expensive steel truss.

The Pierce Plant in Buffalo, New York (1906), was the first proposed in the world for a single-story factory with daylighting from above. It employed a modular structural system potentially of limitless extension that incorporated circulation of manufacturing and contiguous relationships among the various processes. All these prototypical features are found in the Packard Forge Shop, Detroit (1910–1911) (Plate 4) and onward into the 1930s throughout North America, Britain, and the Soviet Union. Kahn's architecture epitomizes, perhaps defines, the motto "form follows function."

His major industrial client was the Ford Motor Company. Ford began producing his Model T in 1907, and with its success all manufacturing was moved in 1910 to a new plant in Highland Park designed by Kahn. Ford's innovative moving assembly line and Kahn's architectural scheme, introduced with the Pierce Plant, were perfectly suited. Every car was identical and of prefabricated parts and thereby the price was steadily reduced: $850 in 1908; in 1914, $490; and in 1926, the lowest figure yet, $260: this against an upward inflation curve. The comparison was made by Ford in relation to Kahn's buildings and that is why he remained the company's architect.

The two systems, his and Ford's, Kahn adapted when working with other clients. He also encouraged the Ford method of programming. For a new building a variety of Ford people produced a plant layout indicating process direction (flow), estimating sizes and weights, locating workers' amenities, and so forth. Then the architect was brought in to coordinate all of Ford's needs and other relevant expertise including engineering. (Similar design methodologies such as "critical path" were developed much later.) Eventually Kahn provided designs, engineering, and supervised construction of more than 1,000 buildings for the Ford Company. The most celebrated is the first shop building constructed at Highland Park (1908–1909) (see Plate 3). Yet its direct predecessor and one of modern architecture's paradigms was Kahn's design of the Brown-Lipe-Chapin gear factory of 1908.

The principal features of his typical factory design were an internally exposed steel structure, some form of roof monitors allowing clerestory daylighting that were combined with large window walls, natural ventilation, and standardized

prefabricated elements that permitted rapid, low-cost construction (during the two world wars the latter feature was critical). If of two stories or more, the structure was concrete. All of these features are illustrated in Moritz's handy book of 1917.

In the 1930s Kahn's office was planned and laid out in relation to work patterns, flow, and job progress, together with the input of human skills and talents. But he was personally always involved with all aspects of design for each building. The Kahns' streamlined office management was relayed in an article of 1918 to a profession steeped in nineteenth-century ways and social hierarchies who ignored it as peculiar.

Ernest Wilby answered Kahn's advertisement for an educated assistant. Trained in his native England, Wilby was a good designer who worked with Kahn from 1902 to 1922; from about 1906, he was an associate. Wilby may have had much to say about the architectural ornament, so reminiscent of Louis Sullivan, on the interior and exterior of the Hill Memorial Auditorium, at the University of Michigan, in Ann Arbor (1911, accoustical consultant Hugh Tallant).

The rather Baroque, free-styled National Theater (1910) displayed Wilby's talent and flair when he was not hampered by the rather cumbersome proportions and bulky forms evident in most of Kahn's nonindustrial buildings regardless of the historical style adopted. Examples can be seen in the large, Lombardesque Kiefer Hospital, in Detroit (1930), the stripped classicism of Ford's New York offices (1919), and the Americanized Georgian of the Joy residence, in Detroit (1908–1909). For the Detroit Athletic Club (1913–1915), there was Kahn's interpretation of McKim, Mead, and White's interpretation of a quattrocento Italian villa, and the *Detroit News* warehouse (1919) had hints of Wright's E-Z Warehouse (1905) and other earlier storage buildings.

Seldom did Kahn's architecture reach the subtlety of the early Florentine Renaissance refinement found in his Clements Library (1920–1921), also for the university at Ann Arbor. He confessed it to be his favorite creation perhaps because it had a basis in the work of Charles McKim, who held Kahn's esteem. Few architects received commissions as large as the General Motors Building (1917–1921) or responded as Kahn with gargantuan proportions, classical elements, and a bulky austerity in its seventeen stories and occupation of two city blocks. It can be compared to J. A. Holabird's Stevens (now Hilton) Hotel in Chicago (1927). Kahn's Fisher Building (1927–1929), a design transitional from historicist to modern, drew much of its style and refinement from a skyscraper design for the *Chicago Tribune* competition of 1922 by the Finnish expatriate Eliel Saarinen,* whom Kahn admired.

All of these commissions were common practice compared to the labyrinthine and frustrating events experienced in the USSR. Contact with Ford by the Soviet government was first made in 1926 in an attempt to gain advice on industrialization. The Soviets were enthralled by Henry Ford the man, his managed productivity and inventive application of technology. They implored Ford to build

plants in the Soviet Union. Finally in 1929 a complex agreement saw a Fordson tractor assembly plant based on a Kahn design built in Moscow (1929–1930) and another at Stalingrad. When the Soviets got Ford they knew they got Kahn and the engineering expertise of Julius, too. It was brother Moritz who directed work in the Soviet Union.

It was not long before the Kahn brothers became discouraged by the manipulations of the Communist Party hierarchy. When in 1932 they could no longer obtain payments in gold, the Kahns' Moscow office was disbanded, but only after they had designed 521 factories, had educated over 1,000 industrial designers as their successors, and had helped train farm peasants when they became forced labor for construction work: all in just three years. Around 1931 several European architects, such as Mart Stam,* André Lurçat, and Hannes Meyer, traveled to the Soviet Union hoping to direct their new architecture in a new society. But the Soviets were primarily interested in new technologies and organizational expertise as only the Kahns could provide. With negligible productivity the disillusioned idealists soon departed. The Kahns' contribution was well remembered in 1942. On Albert's death the Russian architect Viktor Vesnin* cabled Mrs. Kahn saying, in part, that her husband "helped us to assimilate the American experience in the sphere of building industry."[4] Sensible analysis of the Kahn brothers' contribution to the Soviet Union awaits— indeed demands—proper research.

In the 1930s the Kahns continued to produce industrial buildings; for example, the Chevrolet Commercial Body Plant, in Indianapolis (1935); the DeSoto Press Shop, in Detroit (1936); the Curtiss-Wright Shops and Storage, in Buffalo (1938); and the Glenn Martin Plants, in Baltimore, Maryland (1937–1939). Engineering and architectural refinement culminated in the Chrysler (Dodge) Half-Ton Truck Plant in Warren, Michigan, completed in 1938, which is his best known building, of which the architectural historian Wayne Andrews has said, "A shed of glass and steel, this was as graceful as it was spare."[5] With nearly 600 staff in 1937, Albert Kahn, Inc., was receiving 19 percent of all architect-designed industrial commissions in the United States.

<center>✐</center>

"Though Albert Kahn is a member of six golf clubs, he has never played golf, and still thinks a niblick is a small lunch eaten with a glass of beer," said Clair W. Ditchy in 1939.[6] Kahn was obsessively dedicated to the art and profession of architecture.

"When I began," he oft repeated, "the real architects would design only museums, cathedrals, capitols, monuments. The office boy was considered good enough to do factory buildings. I'm still that office boy designing factories. I have no dignity to be impaired."[7] Of his factories he has said,

a straightforward attack of the problem . . . that avoidance of unnecessary ornamentation, simplicity and proper respect for cost of maintenance, make for a type which, though strictly utilitarian and functional, has distinct architectural [aesthetic] merit."[8]

Yet his nonindustrial architecture was contrary; he never said why.

The influence of Kahn and of American industrial architecture on early developments of European modernism is outlined in this book's introduction. Here the comments of Grant Hildebrand are apropos:

It should be clear that [Tony Garnier, Peter Behrens,* Auguste Perret,* and Walter Gropius*] saw the challenge of industrial architecture . . . in essentially artistic terms and were profoundly concerned with making it the standard-bearer for a new message about architecture's formal potential. . . . For Kahn such matters were subsidiary to a thorough grasp of practical considerations.[9]

After the turn into the century many American architects participated in the technical revolution then under way. No one was more identified with those affairs than the practical and inventive Albert Kahn. His industrial architecture was one of the foundations of modernism.

NOTES

1. Hildebrand (1974), 9.
2. Hildebrand (1974), 21.
3. As quoted in Donald Leslie Johnson, *Frank Lloyd Wright versus America. The 1930s* (MIT Press, 1990), 320.
4. Telegram, V. Vesnin to Mrs. A. Kahn, 16 December 1942, as quoted in Hildebrand (1974), 132 n6.
5. Wayne Andrews, *Architecture, Ambition and Americans* (New York, 1955), 159.
6. As quoted in *AForum* 71 (February 1939), 131.
7. "Albert Kahn," *AForum* 69 (August 1938), 89.
8. Hildebrand (1974), 65.
9. Hildebrand (1974), 64. See also Reyner Banham, *A Concrete Atlantis* (MIT Press 1990), throughout.

BIBLIOGRAPHY

Writings

Architecture by Albert Kahn, Inc. New York, 1948.
"Federal Aid to the Social Welfare." *AForum* 57 (August 1932).
"Fisher Building." *American Architect* (New York) 132 (20 February 1929).
"How Russian Architects Work." *American Architect* (New York) 141 (May 1932).
Industrial and Commercial Buildings. Detroit, 1925; new ed., 1937.
"Industrial Architecture." *AForum* 71 (February 1939).
"Industrial Architecture: An Opportunity and a Challenge." *AForum* 73 (December 1940).
By Julius Kahn. "A Plea for Reenforced [*sic*] Concrete." *American Architect & Building News* (New York) 83 (3 January 1904).
By Moritz Kahn. *The Design and Construction of Industrial Buildings.* London, 1917.
———. "Planning of Industrial Buildings." *AForum* 51 (September 1929).

Biographical

"Albert Kahn: Biographical Sketch." *Michigan Architect and Engineer* 29 (December 1954).

Ferry, W. Hawkins. *The Legacy of Albert Kahn.* Detroit, 1970.

Hildebrand, Grant. *Designing for Industry. The Architecture of Albert Kahn.* MIT Press, 1974.

Nevins, Allan, and Frank Ernest Hill. *Expansion and Challenge 1915–1933.* New York, 1957.

———. *Ford. The Times, the Man, the Company.* New York, 1954.

Withey, Henry, and Elsie Withey. *Biographical Dictionary of American Architects.* Los Angeles, 1970.

Assessment

ARecord. "Albert Kahn, Architect, 1869–1942." 93 (January 1943).

Baldwin, George C. "The Offices of Albert Kahn, Architect, Detroit, Michigan." *AForum* 29 (February 1918).

Boles, Daralice Donkervoet. In Macmillan,.

Bucci, Federico. *Albert Kahn: Architect of Ford.* New York, 1993; trans. of *Architetto de Ford.* Milan, 1991.

Ferry, W. Hawkins. *The Buildings of Detroit. A History.* Detroit, 1968.

Fisher, Fred J. *The Fisher Building.* Detroit, 1928.

Hildebrand, Grant. "New Factory . . . 1906." *JSAH* 29 (March 1970).

Kopp, Anatole. "Foreign Architects in the Soviet Union during the First Two Five-Year Plans." In *Reshaping Russian Architecture. Western Technology, Utopian Dreams,* edited by William C. Brumfield. MIT Press, 1990.

Meyer, Katharine Mattingly, ed. *Detroit Architecture A.I.A. Guide.* Detroit, 1971.

Moore, Charles J. "The Modern Manufacturing Building." *American Architect & Building News* 99 (14 June 1911).

Nelson, George. *Industrial Architecture of Albert Kahn, Inc.* New York, 1939. An edited reprint of "Albert Kahn." *AForum* 69 (August 1938). The whole issue.

Reid, Kenneth, comp. *Industrial Buildings.* New York, 1951.

Sande, Theodore A. "American Industrial Architecture . . . to the Mid-twentieth Century." *JSAH* 35 (December 1976).

Smithsonian. (Washington D.C.) 25 (November 1994). Anthology.

Swales, F. S. "Master Draftsman." *Pencil Points* (New York) 6 (June 1925).

Tallant, Hugh. "Accoustic Design in the Hill Memorial Auditorium." *Brickbuilder* (New York) 22 (August 1913).

Bibliographical

Aronin, Jeffrey Ellis. *Rise of the Factory Style in the USA.* Charlottesville, 1956.

Vance: Lamia Doumato, A2096, 1988.

LOUIS I(SADORE) KAHN. 1901 (Saaremaa, Estonia)–1974. The Kahn family emigrated to the United States in 1905, and Louis was educated in the arts of painting and music in Philadelphia, Pennsylvania. Naturalized in 1915, he received a bachelor of architecture degree from the University of Pennsylvania in 1924. Kahn worked in Philadelphia for architects and within or as a consultant to government agencies (1921–1933). He has said he was "Chief of Design" for the Sesquicentennial Exposition, in Philadelphia (1925–1926). A private practice was established in 1934 and he "associated in practice," as Kahn has put his partnerships, with George Howe (1940–1942), with Howe and Oscar

Stonorov (1941–1943), and with Stonorov (1943–1948). European travel during 1928 and 1929 was extended when he was awarded a fellowship to the American Academy in Rome (1950–1951) and when he served as a consultant on housing to the government of Israel (1950). Kahn held teaching positions at Yale University (1947–1957) and the University of Pennsylvania (1957–1974). He has received many national and international honorary degrees, as well as awards and honors, including the AIA Gold Medal (1971). In 1989 his capital complex at Dacca won an Aga Kahn award.

❧

"To Kahn, buildings were living organisms, with desires and demands of their own. He spoke to them, and they to him."[1]

His architecture was about visualizing abstract theories for us, about playing with the dialectic of shapes, of assumptions; it hoped for more than the sterile logic of functional reason, or the caricature of our careless environment, [because architecture] . . . was too important in every man's life.

Kahn made architecture "for us to believe . . . *buildings among people,* an architecture full of old and new things, done by a man who knew their passions, their wits, their particulars, and their glory."[2]

The above eulogies are typical of those bestowed during the full bloom of his career and upon his death. He was a giving and caring man, without egocentric tendencies, a theorist, and an architect. And indeed his architecture energized future events, in fact the whole of architectural theory.

His tour of Europe in the late 1920s and all his productivity in the 1930s was focused on improving public housing. He was a socially concerned practitioner. Until the mid-1950s his architecture was noticeably average. Maturity came from the necessity to reduce architecture to its essence for explanation to students. As Frank Lloyd Wright* had sought an architecture derived from the American geographical place and culture, Kahn dreamed of an architecture that came from all people and spoke to itself as a demonstration for people. As Wright had done, Kahn began at the beginning with one fundamental question: what *makes* architecture?

His first commission of significance—at age fifty—was an addition to the Yale University Art Gallery (1951–1953). He received the work not because of his past accomplishments but because of a latent potential as discerned by his old friends George Howe and Vincent Scully, colleagues at Yale, and Eero Saarinen.*[3] The gallery was a subtle break from past influences, not the building's skin (he was still in debt to European facadism) but the plan and interior: independently functioning parts were defined by structure and form. When extrapolated to all aspects of a building the result was the Richards Medical Research Building, at the University of Pennsylvania (1957–1961). Extracting from the wants of a client's program and a building's parts he evolved the idea of served and serving functions. This idea can be explained as follows.

Because the Richards building is concerned with chemicals, the used foul air

needs to be moved out and up to disperse in the atmosphere. Human circulation in a tall building is up (and down). Both movements want to be vertical and individuated; they are serving spaces to the peopled spaces of the laboratories that also want identity. They too receive a structure separate from the vertical towers. Thus things more similar than dissimilar want comparable expression.

This notion was given its first expression in the Adler and de Vore houses of 1954 and again, if with less verve, in the Trenton Jewish Community Bath House (1955–1956), a modest building but of almost monumental character. The bath house structural module and its academically symmetrical plan were carried to extremes in a number of subsequent projects, notably the Mellon Center for British Art (1969–1974) at Yale University, in New Haven. Wright came to the same conclusion and expressed it in a similar manner (1898–1902). He "articulated," to use his word, both spaces (functions) and their *independent* structure. The prime example is the famous Martin house, in Buffalo, New York (1902). Kahn has acknowledged his debt to the nineteenth-century French theorist J. A. Gaudet, to beaux arts training, to Wright, and in the 1930s to the socialist aesthetic of Le Corbusier.*

Persuaded by a beaux arts training, when he rediscovered that the symbolic and ritual core of a building needed to be centrally located, Kahn found that the subordinates (serving) assumed a natural order. And within each subordinate could be found hierarchies. Concurrently and of necessity he believed that these functional aspects wanted to be defined by their idiosyncratic form just as *visual* awareness of architecture was in "the orderly arrangement of forms" revealed in light.[4]

The exemplars were the First Unitarian Church, in Rochester, New York (1959–1963), and the Salk Institute, in La Jolla, California (1959–1965). In the Salk building the horizontal service spaces between floors to and from the laboratories were elaborately defined in form and expressively exact detail. The resulting architecture was visually and experientially noncultural, yet it responded to specific human activities and was in that sense regional.

For Kahn order was "a number of systems that work in harmony," while designing was "the designation of systems." The systems and their order were, with neo-Platonic insight, a personal derivation. To be of value they needed to respond to what those systems "wanted to be" and then be assigned a visual, architectonic order. His reinvention of rationalism freed him to act in concert with—and interpret—its measurable qualities.

Most of this is best revealed in his design for the controversial National Assembly in Dacca, Bangladesh (1962–1974). (See Plates 28 and 29). "Talk to a brick and it will tell you it likes an arch." More generally, "A building will tell you how it is made."[5] The design of each part is based on the historical and cultural imperative of the country, on traditional building methods—a building built of small pieces by many people. Comparison with the campus complex of the Indian Institute of Management at Ahmedabad, India (1962–1974) is instructive. In contrast was the Richards Medical Research building where high

technology was needed to construct the laboratories. Immense cranes lifted pretensioned concrete trusses into place, a fact difficult to rationalize until he understood the cranes as extensions of his drawing hand, of his arm. Design and construction, he believed, must be the artist's most personal acts.

Collectively the small masonry pieces at Ahmedabad and Dacca achieved a monumentality of apparent size. Usually his buildings *seemed* monumental, but it was sensed as a result of the major forms' power, derived from and emanating a kind of dynamic bulk as a result of axial symmetry, primarily of parts.

Kahn was the major figure at mid-century. His highly personal verbalization about methodology and theory confused some: architectonics as a built fact inspired most. His theoretical position that a primal form or space orders subservient relations allowed *nearly* unlimited freedom in design, in arranging systems. This was made clear again in 1959 with the Goldenberg house, in Rydal, Pennsylvania (see Plate 27). The central space was bound by circulation, then the serving functions, and on the periphery the served spaces. The radiating structure, defined at the core but hidden in bearing walls, was reflected in the form of rooms that reached out for view and light. If a diagonal can be formalized by the power of a central space then it follows that any system of forms can be similarly ordered by reference to a similar control; they can inflate or deflate without altering the formal concept.

The opposite of the primacy of a central space is a perimeter or a line, either spatial or material, and more loosely and less effectively by the mere juxtaposition of static forms in confluent space that are experientially in time. These are apparent in projects such as the site developments for the Philadelphia College of Art (1964–1966), the Inner Harbor Development for Baltimore, Maryland (1969–1974), and aspects of the site plans for the Salk Institute and the capitol at Dacca. The notion of pluralism within one design problem had the inevitable effect of strengthening the growing demand for a rejection of absolutist notions. Therefore Kahn's followers are those who espouse pluralism, such as Richard Rogers,* Norman Foster,* Robert Venturi,* Romaldo Giurgola (the most faithful and a teaching colleague at the University of Pennsylvania), Aldo Rossi,* those who chant postmodernism, and those on the frontier to deconstruct (another negative apellation), and so on.

Kahn was a much admired teacher and loved Socratic discourse, but he tended to answer his own questions.

When I place the first line on paper to capture the dream, the dream becomes less.

This is a question of the unmeasurable and the measurable.

Nature, physical nature, is measurable.

Feeling and dream has no measure, has no language, and everyone's dream is singular.

Everything that is made, however, obeys the laws of nature.[6]

As put by Donald Leslie Johnson, ''Although one may sit around a rather dingy table in a depressing room, as a student one feels the coolness of shade under

a giant tree against the trunk of which Kahn sits, eager to give, willing to discuss his 'realization,' architecture."[7]

It would be fair to say that Kahn's greatest wish was that his architecture would inspire people to search for "human agreement," to use his words, to achieve that "sense of rapport, of commonness, of all bells ringing in unison." It was to encourage people to be conscious of what he called an "existence will."[8] "Man is motivated by three things," Kahn has said, "his reasons for living: the inspiration to learn, the inspiration to meet, the inspiration to well-being."[9]

Detractors found an aspect of Kahn's architecture that also often worried Kahn. Macy DuBois put it like this: Kahn "spoke like a Moses but designed as if for a Pharaoh."[10] But as noted, for the most part that was a visual trick, an overt announcement of artistic and philosophic purpose, educative, urgent. As Aaron Betsky has said, Kahn's architectural "gestures . . . want[ed] to change the world, to imbue it with meaning."[11]

The AIA's citation of 1971 said in part that the AIA honors "a man whose architectural genius is equalled only by his tireless generosity in sharing his wealth of ideas with colleagues and students."[12]

> Design is not making Beauty
>
> > Beauty emerges from
> >
> > > selection
> > >
> > > integration
> > >
> > > love[13]

NOTES

1. Peter Blake, obituary, *APlus* 2 (April 1974), 29.

2. Emphasis Romaldo Giurgola, "Louis I. Kahn, 1901–1974," *PA* 55 (May 1974), 4–5.

3. Much of this essay is based on the personal notes and recollections from 1959 to 1961 of Donald Leslie Johnson. On Howe, see Robert A. M. Stern, *George Howe. Toward a Modern American Architecture* (New Haven, 1975); Macmillan; "A New Shelter for Savings," *AForum* 57 (December 1932); and *Perspecta,* "The PSFS Building, Philadelphia," 25 (1989). Howe, a close friend of Kahn's, became head of the Yale department of architecture in 1950, founded *Perspecta,* and died suddenly in 1955. See also Lamia Duomato in Vance, A872, 1982. On Stonorov, see Frederick A. Gutheim, "Special Issue Dedicated to the Work of Oskar Stonorov," *Architettura* (Milan) 18 (1972); and Macmillan.

4. Johnson (1961), 170.

5. As quoted in *House & Garden* 142 (October 1972), 124.

6. Kahn (February 1961), 14.

7. Donald Leslie Johnson, "Recollections." *PA* 42 (August 1961), 158.

8. Kahn (1971), 33. On Kahn's meaning of "ina," see Johnson above, 158.

9. Kahn in *House & Garden* (1972), 219.

10. Macy DuBois, *PA* 55 (October 1974), 10.
11. Betsky (1985), 29.
12. As quoted in Richard Guy Wilson, *The AIA Gold Medal* (New York, 1984), 212.
13. Kahn (1955), 59.

BIBLIOGRAPHY

Publications by, about, or that include Kahn rightly continue to proliferate.
The abbreviation LIK for Louis I. Kahn is used below.

Writings

"Kahn." *Perspecta* 7 (1961).
"On the Responsibility of the Architect." *Perspecta* 2 (1953).
"Order in Architecture" and "Architecture is the Thoughtful Making of Spaces." *Per-specta* 4 (1957).
"Order Is," "Order and Form," and "Two Houses." *Perspecta* 3 (1955).
"Remarks." *Perspecta* 9/10 (1965).
"The Room, the Street and Human Agreement." *AIAJ* 56 (September 1971).
"A Statement." *AandA* 78 (February 1961). Partly reprinted in Scully (1962).
"Structure and Form." Voice of America *Forum Lectures*. Architecture Series. Wash-ington, D.C. (1960). Reprinted in Scully (1962).
With Oscar Stonorov. *You and Your Neighborhood . . . A Primer*. New York, 1944.

Biographical

Giurogola, Romaldo, and Jaimini Mehta. *LIK, Architect*. Boulder, 1975.
Latour, Alesandra. *LIK, l'momo, il maestro*. Milan, 1986.
Rouda, Michael B. In *Contemporary Architects*.

Assessment

AForum. "The Mind of LIK." 137 (July 1972). The whole issue.
Banham, Reyner. "On Trial 2: LIK the Buttery-hatch Aesthetic." *AReview* 131 (March 1962).
Betsky, Aaron. "Beginnings." *Design Book Review* (MIT Press) (Winter 1985).
Brownlee, David B., and David G. De Long. *LIK: In the Realm of Architecture*. New York, 1991.
Büttiker, Urs. *LIK: Light and Space = Licht und Raum*. Basel, 1993.
Chang, Ching-Yu, ed. "LIK, Architect." *a+u*. Memorial issue (1975).
Cook, John W., and Henrich Klotz. *Conversations with Architects*. London, 1973.
Davey, Peter. "The Aga Khan Awards for Architecture." *AReview* 186 (November 1989).
Giurogola, Romaldo. *louis i. Kahn*. Barcelona, 1989.
———. In Macmillan.
Heyer, Paul. *Architects on Architecture*. 2d ed., New York, 1978.
"Hommage a LIK (1901–1947)." *Werk* 7 (1974).
Huff, William S. "Kahn and Yale." *JAE* 35 (1, 1982).
Jacobus, John M., Jr. In Lampugnani.
Johnson, Donald Leslie. "Form and Architecture." *PA* 42 (June 1961).
Jordy, William H. "Medical Research Building for Pennsylvania University." *AReview* 129 (February 1961).

Kieffer, J. "A Reading of Kahn . . . Salk Institute." *a+u* 271 (April 1993).

Ksiazek, Sarah. "Architectural Culture in the Fifties: Louis Kahn and the National Assembly Complex in Dhaka." *JSAH* 52 (December 1993).

Lobell, John. *Between Silence and Light. Spirit in the Architecture of LIK.* Boulder, 1979.

Loud, Patricia Cummings. *The Art Museums of LIK.* London, 1989.

"Louis I. Kahn. Oeuvres 1963–1969." *Aujourd'hui* 142 (February 1969). The whole issue.

McCoy, Esther. "Dr Salk Talks about His Institute." *AForum* 126 (December 1967).

Marlin, William. "Within the Folds of Construction." *AForum* 138 (October 1973).

Moneo-Valles, Rafael. "Special Issue. LIK." *A & V Monografias* (Madrid) 44 (November 1993).

PA. "Dissecting the Salk." 74 (October 1993). Anthology.

Petruccioli, Attilio. In *The Islamic Heritage of Bengal,* edited by George Michell. Paris, 1984.

Prown, Jules David. "The Architecture of the Yale Center for British Art." *Apollo* (London) 105 (April 1977).

Rowan, Jan C. "Wanting to Be. The Philadelphia School." *PA* 42 (April 1961).

Scully, Vincent, Jr. *LIK.* New York, 1962.

———. "Wright, International Style and Kahn." *Arts Magazine* (New York) 36 (6, 1962).

Scully, Vincent, Jr., and K. Larson. "A Virtual Landmark." *PA* 74 (September 1993).

Seymour, A. T. III. "The Immeasurable Made Measurable: Building the Kimbell Art Museum." *VIA* (Philadelphia) 7 (1984).

Tyng, Alexandra. *Beginnings. LIK's Architectural Philosophy.* New York, 1984.

———. "Kahntext." *AForum* 138 (January 1973).

Bibliographical

AAAB: Jack Perry Brown, 12 (1977).

———. Jack Perry Brown, "LIK. A Bibliography." 2d ed., 12 (1977).

Smith, Charles R. *Paul Rudolph and LIK: A Bibliography.* Metuchen, New Jersey, 1987.

Vance: Gloria Close, A190, 1980.

Archival

Hockstim, Jan. *The Paintings and Sketches of LIK.* New York, 1991.

Holman, William G. *The Travel Sketches of LIK.* Philadelphia, 1978.

Latour, Alesandra, ed. *LIK: Writings, Lectures, Interviews.* New York, 1991.

The LIK Archive. Buildings and Projects. 7 vols. New York, 1987.

Ronner, Heinz, Sharad Jhaveri, and Alessandro Vasella, eds. *LIK Complete Work 1935–1974.* Zurich, 1969; Stuttgart, 1977; 2d ed., Basel, 1987.

Wurman, Richard Saul, ed. *What Will Be Has Always Been. The Words of LIK.* New York, 1986.

Wurman, Richard Saul, and Eugène Feldman, eds. *The Notebooks and Drawings of Louis I. Kahn.* Philadelphia, 1962; 2d ed., MIT Press, 1973.

MICHEL DE KLERK. 1884 (Amsterdam, the Netherlands)–1923. The twenty-fifth child in his family, de Klerk was a self-taught architect. He studied at night at B. W. Wierink's Trade School while working from the age of fourteen in the Amsterdam firm of Eduard Cuypers (1898–1910), also gaining on-site experi-

ence (Laren, 1902–1903). He unsuccessfully sought work in England (1906). Returning to Cuypers' office he entered several design competitions (1906–1910) before resigning to visit Scandinavia (1910–1911). After setting up practice in Amsterdam, de Klerk secured his first commission in 1911, followed by the now famous Spaarndammerbuurt development in Amsterdam (1913–1920). As well as doing his own commissions and projects (1911–1923) he also worked for van der Meij on the Scheepvaarthuis, in Amsterdam (1913–1916), the Amsterdam Public Works Office (1915), and in temporary association with the firm of Herman and Jan Baanders (1916–1917) and Piet Kramer (1919–1921). Since childhood de Klerk was a consummate draftsman and a ubiquitous designer who produced architecture, interiors, furniture, light fittings, decorations, posters, bookplates, and even postage stamps.

<div align="center">❧</div>

Between 1910 and 1930, the Netherlands saw the simultaneous rise of several schools of architectural thought: De Stijl,* the New Objectivity and the Delft School reaction, and Amsterdam School Expressionism. The last (not the same kind of Expressionism seen in the works of, say, Hans Poelzig* or Hans Scharoun*) was deeply impressed by the work of Frank Lloyd Wright,* interpreting it in a poetic and emotional way. Just as *De Stijl* was launched (January 1918) *Wendingen* replaced *Architectura* as the voice of the Amsterdam group *Architectura et Amicitia*. De Klerk was the most important figure, and his designs were published in Europe and in English and American journals as early as 1922. Through the *Wendingen* years (1918–1931), justifiably fearing that architecture would be subsumed by science, its members regarded themselves as artists, not technologists. But their style, depending largely upon brick craftsmanship for its forms and unique ornament, reached full bloom just as the machine aesthetic, brassily heralded by newness, functionalism, and objectivity, was gaining ground, and industrialization's social problems were receiving attention. Thus, despite the beauty of *Wendingen* and its energetic propagandizing, the Amsterdam School became moribund following de Klerk's early death.

De Klerk's unbuilt competition projects reveal a number of sources. His block of four laborers' houses (1908) demonstrates a fascination with sculptural forms. A year later, he designed a seaside hotel in which he combined a formal rectilinear plan with highly complex, plastic massing redolent of the Art Nouveau architect Willem Kromhout; indeed, elements of the style—the Dutch called it the Belgian Style—including frequent use of the parabola, can be found in many of de Klerk's earlier designs. Yet in 1910 he produced a neoclassical project for a cemetery that, despite its formality, held some inventive decoration. In 1911 Herman and Jan Baanders provided a room in their offices from which de Klerk could start his own practice. His first built work (1911–1912) was a five-story block of middle-class flats in Vermeerplein, Amsterdam, for the building contractor Klaas Hille. It was a symmetrical building but some of its decorative elements (especially the iron handrails and balcony brackets) were prophetic.

The greatest achievement of de Klerk's short career was a sequence of three

blocks of workers' housing around the Spaarndammerplantsoen in Amsterdam. The first (1913–1915) was commissioned by Hille and his partner Kamphuis. The second (1915–1916), for the Eigen Haard Building Cooperative, exploited local materials and craft skills, providing distinctive surface decoration through color and brick bonding; there were also sculptural functional/decorative elements added to the surface. The final phase (1917–1920), also for Eigen Haard, while using those devices, went far beyond them in two major ways: first, de Klerk also designed the backs of the buildings, which earlier had been left to the contractors; second, the fantastic decorative forms are integral with the structure and the space that it defines—oriels, galleries of windows, turrets, and the subtle swelling of the walls (Plate 10).

De Klerk's later housing, such as the Vrijheidslaan housing (1920–1922) and the Takstraat/Henriette Ronnerplein precinct for the De Dageraad Housing Cooperative (with Piet Kramer, 1921–1923), followed the same approach as Spaarndammerbuurt III, but added little to it. De Klerk's contribution was to find a modern expression for workers' housing, so that, through his design, "no thought of workers' housing occurs." He "felt that a housing block could be artistic [as a town hall]" and that "workers' dwellings can be the subject of monumental solutions."[1] His buildings were criticized by his modernist contemporaries, especially by Theo van Doesburg,* as willful, romantic, individualistic, and "stinking baroque." But in the end, architecture should please its users, and one resident of the Spaarndammerbuurt wrote,

How can we wives of workers thank this sturdy worker [de Klerk] for what he has done for our men and children? Is it not glorious to come home after a tiring day to a house built for pure joy and domestic happiness? Is it not true that each stone calls out to you: come all you workers and rest in your house which has been built especially for you? Isn't the Spaarndammerplein like a fairy tale which you have dreamt about when you were a child because it did not exist then?[2]

Characteristically, de Klerk's other design—interiors, decoration, furniture, and furnishings—reflects the general mode of his architecture. As Fanelli comments, internal space "is conceived as ambience . . . due to the presence of expressionistically defined forms."[3] That was the manner of his "auxilliary" design.

The influence of de Klerk—indeed, of the Amsterdam School at large—was not wide, even at home. Some historians believe that its protagonists "sought a relationship of continuity with the traditional city" and that de Klerk in particular achieved "a pleasingly unreal physiognomy" which fully expressed the "ideals of ambiguous suspension in historical time."[4] This view is now outmoded. For many years a strident, exclusive propagandist of the Modern Movement, American architect Philip Johnson* wrote in 1984,

My loyalty to J.J.P. Oud,[*] my friendship with Mies, kept me from appreciating de Klerk's genius. Now all is clear. I love his mature and wilful forms and above all the

great brick craftsmanship that . . . we have lost. Sixty years have straightened my spectacles. Hurrah to the Amsterdam School![5]

NOTES

1. Huib Hoste, as quoted in Grinberg (1977), 49.
2. As quoted in Grinberg (1977), 50.
3. Fanelli (1978), 344.
4. Manfredo Tafuri and Francesco Dal Co, *Modern Architecture* (London, 1986), 145.
5. As quoted in de Wit introduction to (1983).

BIBLIOGRAPHY

Writings

With others. *De Socialistische Gids.* Amsterdam, 1924.

Biographical

Frank, Suzanne. *Michel de Klerk (1884–1923), Architect of the Amsterdam School.* New York, 1970.

Assessment

Amsterdam, Stadterweiterung, Wohnungswesen. Amsterdam, 1928.
Baroni, Daniele, and Antonio d'Auria. "Michel de Klerk." *Ottagono* (Milan) 17 (March 1982).
Bergvelt, Elinoor, et al. *Amsterdamse School 1919–1930.* Amsterdam, 1975.
Bilancioni, Guglielmo. "De Klerk: Il proprio focolare." *Eupalino* (Rome) 5 (1985).
Casciato, Maristella. "Michel de Klerk's Three-sided Block." *Ottagono* (Milan) 22 (March 1987).
Dudok, Willem Marinus. "[In memoriam] M. de Klerk." *Architectura* (Amsterdam) 27, (38, 1923).
Fawcett, Chris. "Michel de Klerk: Tales of the Supernatural." *a+u* 122 (1980).
Frank, Suzanne. "Michel de Klerk's design for . . . Spaarndammerbuurt 1914–1920." *Nederlandse Kunsthistorisch Jaarboek* 22 (1971).
Futagawa, Yukio. *Michel de Klerk: Eigen Haard Housing.* Tokyo, 1977.
Futagawa, Yukio, and Kenneth Frampton. *Modern Architecture 1851–1919.* Tokyo, 1981.
———. *Modern Architecture 1920–1945.* Tokyo, 1983.
Gorst, Thom. "Amsterdam School: Housing Associations and the Municipality." *AAQ* 2 (April 1979).
Grinberg, Donald I. "Het bereik je op groote schaal individuele architectuur?" *Wonen TA/BK* (Heerlen) 2 (1975).
———. *Housing in the Netherlands 1900–1940.* Delft, 1977, 1982.
Holzbauer, Wilhelm. "Two Housings by Michel de Klerk." *Global Architecture* (Tokyo) 56 (1980). The whole issue.
Ons Amsterdam. "Amsterdamse School." (Amsterdam) 25 (October 1973). The whole issue.
Polano, Sergio. "Borghese, olandese, teosofico: Michel de Klerk." *Lotus* 38 (1983).
Robertson, Howard. "Modern Dutch Architecture." *AReview* 52 (August 1922).
de Roy van Zuydewijn, H.J.F. *Amsterdamse Bouwkunst 1815–1940.* Amsterdam, 1970.
Schurmann, W. "M. de Klerk und W. M. Dudok." *Deutsche Bauzeitung* (Stuttgart) 22 (August 1925).

Searing, Helen E. "Eigen Haard Workers' Housing and the Amsterdam School." *Architectura* (Munich) 1 (February 1971).
———. "With the Red Flag Flying." In *Art and Architecture in the Service of Politics,* edited by Henry A. Millon and L. Nochlin. MIT Press, 1978.
Sharp, Dennis. *Modern Architecture and Expressionism.* London, 1966.
Tummers, Nic H. M. "Michel de Klerk en de streetparade van de Amsterdamse School." *Wonen TA/BK* (Heerlen) 19, (1973).
Vriend, Jacobus Johannes. *Amsterdamse School.* Amsterdam, 1970.
Wendingen. [Middle-class housing in Amsterdam South]. 5 (4, 1923). The whole issue.
———. "Werk der afgevaardigde leden." 4 (4/5, 1921). The whole issue.
de Wit, Wim, ed. *The Amsterdam School 1915–1930.* MIT Press, 1983.

Bibliographical

Fanelli, Giovanni. *Moderne Architectuur in Nederland 1910–1940.* The Hague, 1978.
Vance: Donald Langmead, A1671, 1986; A1672, 1986; A1773, 1987.

Archival

Wendingen. [Executed buildings]. 6 (9/10, 1924). The whole issue.
———. [Furniture and interiors]. 7 (10, 1925). The whole issue.
———. [Portrait drawings]. 6 (7, 1924). The whole issue.
———. [Restoration of Ijsselstein tower]. 12 (4, 1929).
———. [Travel sketches]. 6 (2, 1924). The whole issue.
———. [Unexecuted projects of Michel de Klerk]. 6 (4/5, 1924). The whole issue.
———. [Work of de Klerk]. 2 (2, 1919).

REM(MENT) KOOLHAAS. 1944 (Rotterdam, the Netherlands)– . After an early childhood in Indonesia (1950–1956), Koolhaas was educated in Amsterdam (1958–1962). He worked for the *Haagsche Post* as a journalist (1962–1967) before studying architecture at the AA School in London (1968–1972). From 1973 he was a visiting fellow on a Harkness Fellowship at the Institute for Architecture and Urban Studies in New York City. He gained practical experience at Cornell University with the postmodernist Oswald Mathias Ungers (1972–1973). In 1975 he established the Office for Metropolitan Architecture (OMA) in partnership with his painter wife Madelon Vriesendorp, and architect Elia Zenghelis and his wife, Zoe, also a painter. The four spent some time lecturing in New York and elsewhere in the United States (1976–1979). In 1980 Koolhaas and Zenghelis set up offices in Rotterdam and Athens, respectively, to pursue their own commissions. Both continued to teach at the AA (where they had met in 1972) and used London as a base for their collaboration in competitions. Since 1990 Koolhaas has been a visiting professor at Harvard Graduate School of Design. The firm continues to practice from Rotterdam, Amsterdam, London, New York, and Berlin.

᪐

Kenneth Frampton equates the "neo-avant-garde" artistic and intellectual efforts of Koolhaas in Europe to those he calls the "New York Five" in the United States: Peter Eisenman,* John Hejduk, Michael Graves, Richard Meier,*

and Charles Gwathmey. All "ground their work in the aesthetic and ideological premises of the 20th century avant-garde." Specifically, OMA "predicated [its] urban projects on the Suprematist architecture of Ivan Leonidov" while drawing upon Surrealism.[1] Certainly Koolhaas studied Leonidov, and he admits that his rather cynical definition of architecture ties him to Dali and Surrealism. For him architecture is "the imposition on the world of structures it never asked for and that existed previously only as clouds of conjecture in the minds of their creators. Architecture is inevitably a form of Paranoid-critical activity."[2]

Other critics believe that he "comes very close to the theoretical position of Venturi[*] and Scott-Brown[*] while self-consciously absorbing aspects of De Stijl,[*] Constructivism and the Bauhaus." OMA represents an "altered, 'second modernism', looking beyond a purely pragmatic functionalism to an architecture charged with references and associations, an architecture defined in a narrative and a fictional sense. . . . Koolhaas's *oeuvre* holds reality and fiction, history and modernism, effectively in balance."[3] Heinrich Klotz summarizes Koolhaas'

revival of Modernism is not a lapse into the historic movement [and he] has repeatedly attempted to give content to the forms of the Modern tradition and free them from the confines of straight geometric abstraction. . . . Koolhaas formulated the stylistic techniques of Deconstructivism and so paved the way for a—fictionalised—'Second Modernism'.[4]

Koolhaas's professional collaboration with Vriesendorp and the Zenghelises began in 1972, and the relationship between them all and other collaborators and assistants remains complex. Nevertheless he fair-mindedly insists that in publications credit is given where it is due. Most of his work before about 1980 was in projects or competitions, including a house in Miami, Florida, with Laurinda Spear of Arquitectonica (1974). Success came only once: extensions to Holland's Parliament House in The Hague (with Zenghelis and Zaha Hadid, 1978). In the next few years OMA's efforts generated an ambitious portfolio of competition entries, exhibition installations, building designs, and master plans. Little was constructed.

For the International Bauausstellung (IBA) competition in West Berlin (1979–1980), Zenghelis produced a housing scheme for Ludzowstrasse and Koolhaas another for Kochstrasse/Friedrichstrasse (with Stefano de Martino). Both rejected the IBA's preference for "contextual" perimeter blocks and offered modernist, free-standing slabs. Both were unsuccessful. But the IBA invited OMA to design a building for a small site near the Berlin Wall to incorporate housing units and Checkpoint Charlie. The building (completed in 1990), originally presented in a surrealistic perspective, consigned the checkpoint to small pavilions in a kind of undercroft and provided three types of dwelling: terrace houses with gardens, duplex apartments, and penthouses. Koolhaas prophesied, "One day when the checkpoint pavilions are no longer needed and the ground floor has been converted to a supermarket the cantilever roof will remain as a memory of the Wall."[5]

Koolhaas's respect for modernism was enshrined in La Casa Palestra, a "model home" projected for the 1986 Milan Triennale that reinterpreted Ludwig Mies van der Rohe's* 1929 Barcelona Pavilion into a "sensual" house for a bodybuilder. He says, "It has always been our conviction that Modernism is a hedonistic movement; that its abstraction, rigor and severity are in fact plots to create the most provocative settings for the experiment that is modern life."[6] Again, given the chance to express that idea, Koolhaas reinterpreted the Barcelona Pavilion as the Music Video Bus Stop in the Dutch city of Groningen (1988), surely the most elegant bus shelter in the world.

Koolhaas disagrees with such contemporaries as Leon Krier* and Rob Krier,* Aldo van Eyck,* Alison and Peter Smithson,* and Team 10 about the need for small-scale contextualism in the maintenance of cities. He insists through polemic and projects that a realistic solution to urban problems lies in coming to terms with modernist ideas, including the "tower in the park" as proposed by Wijdeveld (Amsterdam, 1919–1922) and Le Corbusier* (Paris, 1925). In a 1980–1983 proposal for Amsterdam-Bijlmermeer, a notorious 1960s high-rise housing estate known locally as the "concrete jungle," Koolhaas proposed infill development to increase the density while generating human scale among the relentless towers that had no park around them. In April 1987 OMA won a competition for a new town hall and library in The Hague, only to be displaced through political finagling. Koolhaas's scheme was inspired by the Manhattan skyline, a near-realization of OMA's dream of "a great metropolis of fragmented towers devoted to pleasurable pursuits."

But he has another dream of cities, exemplified in the competition entry for the Parc de la Villette, in Paris (1982–1983), placed second to Bernard Tschumi, and an unrealized 1987 project for the new town of Melun Senart, southeast of Paris. The latter was an unorthodox proposal for decentralization predicated by a forested landscape that accepted and abetted urban sprawl. Within a network of open spaces for recreation, industry, and agriculture, defined by wide boulevards and highways, are residual areas (an "urban patchwork") to be built up for residential and commercial use in response to the demands of growth.

Koolhaas's first major built work was The Netherlands Dance Theater in The Hague (1984–1987). Reminiscent of Checkpoint Charlie in the agglomeration of slabs and pavilions, accentuated by the choice of diverse facing materials (polished granite, marble, burnished brass, glass, and a mural by Madelon Vriesendorp), the asymmetrical masses "accentuate the idea of congestion, chaos [and] movement." The whole is an unmistakable reference to the 1920s avant-garde in which the performing arts predominated. The theater established Koolhaas's "specific cultural, and professional place in Dutch architectural culture."[7] Other commissions followed including the KunstHal, in Rotterdam (with Fuminori Hoshimo, 1992), an art museum used solely for transient shows. Likened by one critic to Mies van der Rohe's Neue Nationalgalerie in Berlin,[8] the proportion and serenity of its garden front also indirectly evokes the nearby Boy-

mans Museum (van der Steur, 1935) and strongly contrasts with its other faces and complex spatial organization.

Since 1990 Koolhaas' branch of OMA has worked beyond Holland, beginning with the Center for Art and Media Technology in Karlsruhe, Germany (Plate 48). The firm has won a number of international competitions including Chunnel City, a commercial complex around the mainland terminal of the Chunnel railroad at Lille, France (1993), and the Sea Trade Centre, Zeebrugge, Belgium (1991+), a great domical structure with ramps and ducts that looks rather like Max Ernst's painting *L'Elephant Celebes* (1921).

NOTES

1. Kenneth Frampton. *Modern Architecture: A Critical History* (London, 1992), 311–12.
2. Koolhaas, "Dali and Le Corbusier," 206.
3. Fischer in *Contemporary Architects.*
4. Heinrich Klotz, *20th Century Architecture: Drawings—Models—Furniture* (London, 1989), 324.
5. As quoted in Dietsch (1988), 107.
6. As quoted in Dietsch (1988), 97.
7. Barbieri (1987), 47.
8. Metz (1993), 68.

BIBLIOGRAPHY

Writings

"The Architects' Ball—A Vignette 1931." *Oppositions* (May 1974).
"Beyond Delirious." *CanadaA* 39 (January 1994).
"Bigness; The Problem of Large." *Weiderhall Architectural Serial* (Netherlands) 17 (1994).
"Dali and Le Corbusier: The Paranoid-critical Method." *ADesign* 48 (February–March 1978). no 2–3.
Delirious New York: A Retroactive Manifesto for Manhattan. New York, 1978.
Rem Koolhaas: Urban Projects 1985–1990. Barcelona, 1990.
Small, Medium, Large, Extra-large. New York, 1995.
"Surrealism and Architecture." *ADesign* 48 (March 1978).
With Gerrit Oorthuys. *Ivan Leonidov.* New York, 1981.

Biographical

Fischer, Volker. In *Contemporary Architects.*

Assessment

AAFiles. "Two Libraries for Jussieu University, Paris." 26 (Autumn 1993).
a+u. "Rem Koolhaas—OMA." 217 (October 1988).
———. "Euralille [anthology]." 280 (April 1992).
ADesign. "Office for Metropolitan Architecture." 47 (May 1977). The whole issue.
———. "OMA: Checkpoint Charlie." 61 (January 1991).
Allain-Dupré, Elisabeth, and Odile Fillion. "La ville des architectes." *AMC* (Paris) 49 (March 1994).
Barbieri, Umberto. "From the bridge to the tower." *Lotus.* no. 47 (1985).

———. "Teatro di Danza [The Hague]." *Domus.* no. 689 (December 1987).

Boyer, Charles-Arthur. "Koolhaas: Dessiner, entre indétermination et spécificité." *Aujourd'hui* 269 (June 1990).

Buchanan, Peter. "OMA at The Hague." *AReview* 181 (June 1987).

———. "Rotterdam Rationalists." *AReview* 177 (January 1985).

Casabella. "Bijlmermeer/Amsterdam; modificazione delle reti." 53 (January 1989).

Chaslin, F. [Rem Koolhaas drawing for Paris University library competition]. *Aujourd'hui* 286 (April 1993).

Cohen, Jean-Louis. "Suburban Subversion." *PA* 73 (April 1992).

Croquis. "Rem Koolhaas/OMA 1987–1992." 53 (2, 1992). The whole issue.

Dietsch, Deborah K. "Modern Romance." *ARecord* 176 (March 1988).

van Dijk, Hans. "Rem Koolhaas: Architectonic Scenarios and Urban Interpretations." *Dutch Art and Architecture Today* (Amsterdam) 12 (December 1982).

Fisher, Thomas R. "Projects." *PA* 71 (April 1990).

Fortier, Bruno. "Le grande ville." *Aujourd'hui* 262 (April 1989).

Frampton, Kenneth. "KunstHal at Rotterdam." *Domus* 747 (March 1993).

van der Glas, Marijke, et al. "De ontplooiing van de architectuur." *Architect* (The Hague) 25 (January 1994).

Harvard. "Project for the Parc de la Villette, 1982–1983." 5 (1986).

Hubeli, Ernst. " 'Hot Spots'." *Werk* 77 (March 1990).

———. "Zentrum fur Kunst und Medientechnologie [Karlsruhe]." *Werk* 78 (November 1991).

Ingersoll, Richard. "Rem Koolhaas and Irony." *Casabella* 58 (March 1994).

JapanA. "Rem Koolhaas Block." 4 (Autumn 1991).

Jencks, Charles. "Deconstruction: The Pleasures of Absence." *ADesign* 58 (March 1988).

Lucan, Jacques. "Le concourse de Jussieu compétition." *AMC* (Paris) 38 (February 1993).

Lucan, Jacques, ed. *OMA-Rem Koolhaas.* Princeton, New Jersey, 1991.

———. *Rem Koolhaas/OMA.* New York, 1993.

MacGowan, Temple. "Parc de la Villette, Paris." *Landscape Australia* (Mont Albert) 6 (February 1984).

de Maeseneer, Martine, and Dirk van den Brande. "Sea Trade Centre at Zeebrugge; a Working Babel." *ADesign* 62 (July 1992).

Malfroy, Silvain, et al. "Instabiles ordnen?" *Werk* 4 (April 1994).

Merkel, Jayne. "Architecture: Not So Delirious Modernism." *ArtA* 76 (April 1988).

Metz, Tracy. "Showpiece: Kunsthal, Rotterdam." *ARecord* 81 (March 1993).

Meuwissen, Joost. "Koolhaas in Europe." *Kunst en Museumjournaal* (Amsterdam) 2 (3, 1990).

———. "X-filled room." *Weiderhall Architectural Serial* (Amsterdam) 16 (1994).

Polonyi, S. "An Interview with Rem Koolhaas." *Lotus* 79 (1993).

Steiber, Nancy. "An RFQ to the Avant-garde." *PA* 72 (November 1991).

Stein, Karen D. "The Image according to OMA." *Interior Design* (New York) 38 (January 1992).

Sudjic, Deyan. "Chunnel City; Masterplanner . . . Koolhaas." *Blueprint* (London) 108 (June 1994).

Welsh, John. "Class Walls: A New Flemish School?" *RIBAJ* 100 (September 1993).
Werner, Frank. "The Magic Die with the Enchanted Cloak." *Lotus* 70 (1991).

Bibliographical

Vance: Sara Richardson, A1976, 1988.

LEON KRIER. 1946 (Luxembourg)– . Leon Krier's basic architectural training
was provided by his older brother, architect Rob Krier.* Leon attended the
University of Stuttgart for only six months (1967–1968) before he moved to
England (1968). He worked as an assistant in the office of James Stirling*
(1968–1970 and 1973–1974) and was in the interregnum a "project partner"
with Josef Paul Kliehues in Berlin (1971–1972). He commenced his own Lon-
don practice in 1974, which still continues. Krier has held several teaching posts:
AA School, London (1973–1976); Royal College of Art, London (1977); and
Princeton University (1977). In 1982 he was a visiting professor at the Univer-
sity of Virginia and in 1986 he was appointed first director of the Skidmore,
Owings, and Merrill* Research Institute, in Chicago. Leon Krier remains, how-
ever, London based. In 1988 he became an architectural champion of the Prince
of Wales, at whose alternative architectural school he conducted experimental
summer courses (1990–1991). He continues to teach there.

Believing that "a new generation is now discovering the urban culture of pre-
industrial Europe as documents of intelligence, memory and pleasure," Krier
has concluded that there is a concomitant necessity for a "plan of reconstruction
to oppose the global destruction of European cultures through industrializa-
tion."[1] Not surprisingly he shares an "anti-Modernist ideology of public spaces
and monuments" with his brother Rob's mentor, Oswald Ungers, and his own
erstwhile employer Stirling (although at the time of their association Stirling
was still seeking an appropriate architecture). But unlike his brother, until 1988–
1989, when he produced a house at Seaside, Florida, Leon built nothing. Ac-
cording to Robert Stern, that was because he "refused to compromise his vision
of the Modern Classical city" since no thinking architect can build "in a world
where the rules of zoning and construction were made by short-sighted Mod-
ernists."[2] His sociopolitical response to that state of affairs is a plea for the
dezoning of cities, which he regards as "the first step in an antimonopolistic
and democratic planning policy."[3]

Krier's surrogate buildings have been the beautiful and articulate drawings in
which his imaginative cities are the result of carefully—sometimes confus-
ingly—blending monumental classical architecture with vernacular building
types. After 1980 his designs became increasingly classical, as in his unrealized
proposal for the reconstruction of Pliny's Villa Laurentium (1981). Even there
classicism was flavored with romantic picturesqueness. Such ambiguity is com-
mon in his words and works. Paradoxically, some of his projects (he calls them
"a series of polemical statements") even pay homage to the Modernist ideas

he continually attacks: for example, his perspectives of the Spitalfields Market project (ca. 1986) include 1930s automobiles and even zeppelins, which must be allusions to Le Corbusier.* Other schemes are fraught with overt Grand Romanticism: his unbuilt master plan for completing Washington, D.C. (1984–1985) included flooding the eastern end of The Mall and floating gondolas on it (see Plate 42).

Krier's professional and social positions were established in 1988 when he was commissioned by the Prince of Wales to prepare a master development plan for the urbanization of Charles's 400-acre Poundbury Estate in Dorset (completed 1989). Support from such a powerful patron gave weight to the anti-Modernist cause in British architectural circles and upset many in the profession represented by the RIBA and the AA. Eventually a third system of architectural education, the Prince of Wales School, was established.

Although he has built very little, Krier's imaginative, immaculately rendered architectural drawings have been influential through their widespread exhibition in Europe since 1973, and increasingly in the United States since 1975. He has also lectured in Europe and America, stimulating much debate about the future of architecture. Leon Krier has contributed fresh ideas to the field of architecture, especially in the urban context. An important part of his philosophy has been the concentration of urban activities of people in *quartiers,* as opposed to the orthodox Modernist compartmentation of cities into functionally determined "zones." As Hans-Peter Schwarz has commented, "Nowadays, the idea of repairing towns has become part of general practice, and [Krier's] conception of the city as a 'federation of quarters' is of special importance. . . . In spite of the visionary rhetoric of their presentation [his proposals] represent a completely practical and rational counteraction to the irrationality of a city seen in terms of centralized bureaucracy."[4]

NOTES

1. As quoted in *Contemporary Architects.*
2. Stern (1988), 256.
3. Kultermann in *Contemporary Architects.*
4. Klotz (1985), 135.

BIBLIOGRAPHY

Writings

"An Architecture of Desire." *ADesign* 56 (April 1986).
Atlantis. New York, 1993.
"The Authority of the Architect in Democracy." *ADesign* 58 (July 1988).
"The Completion of Washington, D.C. . . . an Opinion Statement." *ADesign* 56 (September 1986).
"For the New Federal City [Washington, D.C.]." *Lotus* 50 (1986).
"God Save the Prince!" *Archives d'Architecture Moderne* (Brussels) 38 (1988).
"Leon Krier: La forma della mostra 'imago'." *Domus* 742 (October 1992).
"The Lesson of the Urban Block." *Lotus* 18 (1978).

"The Love of Ruins, or the Ruins of Love." *Modulus* (Charlottesville) 16 (1983).

"Master or Servant?" *Lotus* 71 (1992).

"Poundbury Masterplan." *ADesign* 63 (September 1993).

The Reconstruction of the European City. Brussels, 1978.

"The Reconstruction of the European City." *International Architect* (London) 7 (1958).

"The Reconstruction of Vernacular Building and Classical Architecture." *AJournal* 180 (13 September 1984).

"Traditional Ideas for Today's Towns." *City Magazine* (Winnipeg) 10 (Fall 1988).

"Urban Components." *ADesign* 54 (July 1984).

"Visionary Architecture: The Completion of Washington, D.C." *a+u* 182 (November 1985).

As ed., *Buildings and Projects of James Stirling.* New York, 1974.

————, *The City within the City.* Rome, 1979.

With L. O. Larsson, *Albert Speer: Architecture 1930–1942.* Brussels, 1986.

Biographical

Kultermann, Udo. In *Contemporary Architects.*

Assessment

ADesign. "Classical Architecture and Vernacular Building." 52 (May 1982).

————. "Leon and Rob Krier." 49 (January 1979).

————. "Leon and Rob Krier." 63 (September 1993).

————. "Paternoster Square." 58 (January 1988).

————. "Peter Eisenman versus Leon Krier." 59 (September 1989).

AJournal. "Classics Debate." 187 (16 March 1988).

Allain-Dupré, Elisabeth, and O. Fillion. "La ville des architectes." *AMC* (Paris) 49 (March 1994).

Archives d'Architecture Moderne. "Amiens: Deux projets de Leon Krier." (Paris) 39 (1989).

————. "Leon Krier et Peter Eisenman: Entrieten." 28 (1985).

Chevin, Denise, and Martin Spring. "The Poundbury Effect." *Building* (London) 259 (1 April 1994).

Cruikshank, Dan. "Imago Luxemburgi." *Baumeister* (Munich) 89 (February 1992).

Davey, Peter. "Prince's Political Manifesto." *AReview* 186 (August 1989).

Drijver, Peter. "Stad, architectuur, geweten: Leon Krier." *Bouw* (Rotterdam) 46 (12 July 1991).

Dutton, Thomas A. "Cities, Cultures and Resistance: Beyond Leon Krier and the Postmodern Condition." *JAE* 42 (Winter 1989).

Economakis, Richard, ed. *Leon Krier: Architecture and Urban Design 1967–1992.* London, 1993.

Eddy, David Hamilton. "Authentic city/ . . . Leon Krier and Aldo Rossi." *RIBAJ* 92 (July 1985).

Eisenman, Peter. "Interview with Leon Krier." *Skyline* (New York.) (February 1983).

Ellis, Charlotte. "Prince Charles Unveils Krier's Dorset Masterplan." *AIAJ* 78 (September 1989).

Kelly, Brian. "In Search of a Critical Middle Ground." *Reflections* (Urbana) 8 (Spring 1991).

Klotz, Heinrich, ed. *Postmodern Visions.* New York, 1985.

Latham, Ian. "Leon Krier: A Profile." *ADesign* 57 (January 1987).
Leon Krier: Architecture and Urban Design 1967–1992. London, 1993.
Lotus. "Berlin Tiergarten; Proposal for a Metropolitan Park." 31 (1981).
Messerschmidt, Eric. "Honi soi qui mal y pense." *Architekten* (Stockholm) 92 (March 1990).
Murphy, James A. "A Gate at Seaside [Florida]." *PA* 70 (December 1989).
Nicolin, Pierluigi. "Leon Krier: Atlantis, Tenerife." *Domus* (May 1988).
Pavan, Vincenzo. "Le teofanie di Leon Krier. His theories." *Eupalino* (Rome) 6 (1985).
Porphyrios, Demetri, ed. *Leon Krier. Building and Rational Architecture.* London, 1984.
———. *Leon Krier: Houses, Palaces, Cities.* London, 1984.
Powell, Ken. "A Chance to Restore Balance." *Country Life* (London) 180 (13 November 1986).
Powell, Ken, et al. "New Practice in Urban Design." *ADesign* 63 (January 1993).
Rabaneck, Andrew. "The American Invasion." *AJournal* 191 (28 March 1990).
Shields, James W. "The Building as Village." *Reflections* (Spring 1989).
Steil, Lucien. "Projects in Florida and Amiens." *ADesign* 58 (September 1988).
Stern, Robert A. M. *Current Classicism.* London, 1988.

Bibliographical

Vance: Edward Teague, A1435, 1985; Mary Vance, A2098, 1988.

ROB(ERT) KRIER. 1938 (Grevenmacher, Luxembourg)– . After receiving his schooling at the Echternach Classical Lyceum, in Luxembourg (1951–1959), Krier studied architecture at the Technical University, in Munich (1959–1964), where he received a diploma in architectural engineering (1964). He worked in the Berlin and Cologne offices of the postmodernist Oswald Ungers (1965–1966), then in Berlin and Stuttgart for Frei Otto (1967–1970). He taught at the University of Stuttgart (1973–1975) while developing his urban design theories. He was a guest professor at the École Polytechnique Fédérale, in Lausanne in 1975. Since 1976, he has conducted his private practice in architecture and urban planning from Vienna. He is a professor and head of the Design Institute of the Technical University of Vienna (1976–), where he has also been dean of architecture and interior design (1979–1981). His work (mostly lively, compelling, and exquisite drawings) was first exhibited in Stuttgart (1968), then through the 1970s in Italy, Austria, Germany, Switzerland, France, Belgium, and in the east coast and west coast of the United States. In 1980 to 1983, a major exhibition, "City Segments," toured the same locations, as well as others in the United States and London, establishing him as a serious polemicist and theorist.

☙

Rob Krier asserts:

We must always be aware that whatever we do in architecture must be such that it can be handed on. Only then can the chain of experience, of learning from our heritage, be further developed and improved. . . . The struggle for the basic truth of things, to whose

articulation our profession is dedicated, and the longing for beauty, which can enclose our life in the walls we have constructed—these strengthen me.[1]

He has built little. Yet, as Udo Kultermann points out, "in the . . . re-evaluation of urban reality [his] work proposals and research analyses are of fundamental importance."[2] With his younger brother, Leon Krier,* he has developed an "anti-Modernist ideology of public spaces and monuments"[3] that repudiates the domination of technical means.

Rather than merely criticize the disintegration of the modern city, Krier proffers attainable solutions, springing from his training in Ungers's office. Aiming to revive a city according to its original outlines, he developed an urban design system expounded in *Stadtraum in Theorie und Praxis* (1975). He believes that, in the light of history, a city should be conceived in terms of the experiences it offers, not (as in the modernist approach enshrined in zoning) the functions it performs. For Krier, people are the important element in cities, and he emphasizes the creation of spaces for changing, multiple human uses. His theories have been given substance in a number of achievable (though unrealized) projects; notable among them are his immaculately drawn "macro-structure" proposals for remodeling Stuttgart's inner city (1973–1974); Rennweg and the Federal Offices, in Vienna (1977); and Tauentzienstrasse, in Berlin (1980).[4]

Krier's first realized design was the Siemer house (1968–1973) at Warmbronn near Stuttgart, soon followed by the Dickes house (1974–1975) in Luxembourg. Their morphologies differ widely, although Krier followed the same design process and system of classical proportion for each. The Siemer house is dynamic, site related, and spatially articulated by the transparency of its skin; the Dickes house is static, ubiquitous, seemingly impenetrable—"an amiable monument to the introverted intimacy of a family house." The most celebrated of Krier's buildings are the public housing schemes designed in the context of the International Building Exposition in Berlin (1977–1985).

Robert Stern believes that Rob Krier has had more opportunities to build than his brother Leon because "his more pragmatic philosophy of building allows for the creation of traditional urban spaces and monuments without the use of traditional building technologies." His neoclassical apartment blocks on the Ritterstrasse (1977–1982), including Schinkelplatz, were followed by the master plan for Rauchstrasse site in the Tiergarten (1980–1985). Within its typological constraints—Krier's flexible "macro-structure"—other architects, including Hans Hollein* and Aldo Rossi,* were invited to design individual, five-story apartment buildings. The courtyard project, entered through Krier's own elegantly simple, sweeping Gateway Building with its low, sculpture-crowned arch, vindicates his urban design principles.

NOTES

1. Krier (1983), 10.
2. Kultermann in *Contemporary Architects*.

3. Stern (1988), 252.
4. Klotz (1985), 141ff.

BIBLIOGRAPHY

Writings

Architectural Composition. London, 1985.
"The Architecture of Gustav Peichl." *ADesign* 60 (March 1990).
"Cas Siemer, Warmbronn, 1968–1973." *Lotus* 9 (1973).
The Elements of Architecture and Selected Projects. London, 1983.
Notizen am Rande: Sketch Book. Berlin, 1975.
"The Planning Process . . . Viewpoint of an Urban Development Coordinator." *GA Houses* (Tokyo) (August 1988).
"The Rauchstrasse Houses . . . Berlin." *Lotus* 41 (1984).
Rob Krier. New York, 1981.
Rob Krier on Architecture. London, 1982.
Stadtraum in Theorie und Praxis. Stuttgart, 1975; Barcelona, 1976; Tokyo, 1980; *L'Espace de la Ville.* Brussels, 1981; *Urban Space.* London/New York, 1979, 1980.
Urban Projects 1968–1982. New York, 1982.
With Leon Krier. "Leon and Rob Krier." *ADesign* 63 (September 1993).

Biographical

Kultermann, Udo. In *Contemporary Architects.*

Assessment

a+u. "Focus Rob Krier." (June 1977).
———. "International Building Exhibition, Berlin 1987." Extra edition (May 1987).
ADesign. "Leon and Rob Krier." 49 (January 1979).
———. "Rauchstrasse Berlin." 53 (January 1983).
———. "Revision of the Modern." 55 (March 1985).
———. "Rob Krier: 10 Theses on Architecture." 52 (November 1982).
Baumeister. "Dachbodenhausbau in Wien." (Munich) 83 (May 1986).
Booth, Guy. "Rob Krier Goes Back to Basics." *RIBAJ* 96 (July 1989).
Deutsche Bauzeitung. "Haus in Warmbronn." (Stuttgart) 107 (1973).
Drews, David [Review Urban Space, Stadtraum]. *Harvard* no. 2 (Spring 1981).
Fifth Column. "A Discussion with Rob Krier." (Montreal) 3 (Autumn 1982).
Frampton, Kenneth, and Deborah Berke, eds. *Rob Krier: Urban Projects 1968–1982.* New York, 1982.
Garcias, J.-C., et al. "Urbano, troppo urbano . . . progetto per Amiens." *Casabella* 49 (May 1985).
Gough, Piers. "Town Krier." *AJournal* 180 (15 August 1984).
Hannay, Patrick. "Rauchstrasse 9." *AReview* 179 (March 1986).
Irace, Fulvio. "Berlino 1988." *Abitare* (May 1988).
Kikuchi, Makoto, and Atsushi Katagi. "Six Works of Rob Krier." *SpaceD* (October 1978).
Klotz, Heinrich. *The History of Postmodern Architecture.* MIT Press, 1988.
Klotz, Heinrich, ed. *Postmodern Visions.* New York, 1985.
Lotus. "Berlin: South Friedrichstadt . . . 1977–1980." 28 (1980).
———. "Urban Construction on Roadway: Plan for Rennweg, 1977." 29 (1980).
McKean, J. "Krier Communicates." *AJournal* 176 (17 November 1982).

Nicolin, Pierluigi. "Rob Krier's Walks: From Landscape to Treatise." *Lotus* 68 (1991).
Nueva Forma. "The Work of Rob Krier." (Madrid) (April 1973).
Patrascu, Dragos. "Urban Proportions." *Reflections* (Urbana) 6 (Spring 1989).
Portoghesi, Paolo. *Postmodern. The Architecture of a Postindustrial Society.* New York, 1983.
Rob Krier. London, 1993.
Schreurs, Jan. "Reconstructie gedeconstrueerd." *Archis* (Doetinchem) (February 1988).
Shane, G. "Krier's *Stadtraum in Theorie und Praxis.*" *ADesign* 46 (November 1976).
SpaceD. "Ritterstrasse Housing; Rob Krier." (December 1984).
Spinadel, L. P. "Wettbewerb Forellenweg, Salzburg." *APlus* 77 (November 1984).
Stadtbauwelt. "Rob Krier: Interview." (Berlin) (December 1983).
Steiner, Dietmar. "Rob Krier, sur le chemin de Camillo Sitte." *Aujourd'hui* (September 1989).
Stern, Robert A. M. *Current Classicism.* London, 1988.

Bibliographical

Vance: Carole Cable, A1200, 1984.

CHRISTIAAN EMIL MARIE KÜPPER. See Theo van Doesburg.

KISHO NORIAKI KUROKAWA. 1934 (Nagoya, Japan)– . The son of an architect, Kurokawa received a professional degree from Kyoto University (1957) and took a master's degree in architecture (1959) and a doctorate in architecture (1964) under Kenzo Tange* at the University of Tokyo. He traveled to various destinations in the world in 1958, 1961, and 1962 to learn, to attend Team 10 meetings, and to spread the gospel of Metabolism.* He worked in Tange's office until opening his own practice in 1962. Kurokawa has won many competitions throughout the world, has had exhibitions since 1962, and has received awards and honors including a gold medal from the French Academy of Architecture and in 1990 a member of the French Ordre des Architects.

Kurokawa sees his architecture as developing from Metabolism, of which he was a founding member, to Symbiosis, an intercultural and, in a geographical sense, a global philosophy that melds Japanese and Eurocentrism in architecture. This philosophy allows a variety of revived elements to freely mix. During this transformation his architecture retained much of its organic foundation as it evolved during the decade of Metabolism through studies of biological and chemical structures to a rather technologically driven symbolism somewhat akin to the idealized interpretations of Shin Takamatsu. Much of this has a relationship to Buddhist philosophy, which he believes was his major contribution to Metabolism.

The biological nature of his Helix City project (1960) gained world attention and was exhibited at New York's Museum of Modern Art (1960). His short-lived passion for prefabricated capsules of discrete functions is apparent in their attachment to the rather elegant Sony Tower, in Osaka (1976), and the appli-

cation within his space structure for the Takara Group Pavilion, Expo'70, in Osaka, and the Nakagin Capsule Tower, in Tokyo (1972), which clusters about large, central circulation posts. Like most prewar Japanese architects, he was influenced by Louis I. Kahn's* theories if not so much by his architecture.

Parallel with his more formal Kahnian works was the Yamagata Resort Centre (1967), which contains all types of resort activities including a sandy beach. The plan is amoebic in shape with a large, central open space. Future extension was to be of similar shapes fitted like large biological cells. An early indication of investigating once again more formal geometries can be seen in his Saitama Museum of Modern Art (1981–1982) where cube and square dominate yet do not control as the modules angle away at the precise points where a wavy glass wall is introduced. It is to this period of Kurokawa's architecture that commentator, one hesitates to say historian, Charles Jencks draws parallels with the designs of Fumihiko Maki* and Richard Meier* and describes their methodology as "intuitive."[1] It is at this moment that his designs become more mature and, again like much of Japanese architecture after 1980, demonstrate a series of interesting contrivances.

There are many examples, but the Sporting Club (1988) is a white steel-and-glass complement to Chicago's drab colors, and the geometry is only subtly fractured. The Chinese-Japanese Youth Center, in Beijing, China (1986), exploits circle and square, provides an *en* (semipublic or private meditating) space, and has a diagonally attached, football-shaped (in plan and three dimensionally) swimming pool facility. The building can be usefully compared to Hisada & Associates 1150, 18th Street Building, in Washington, D.C. (1991). His Pacific Tower, in Paris (1986–1989), is a twenty-plus-story tower that is in plan but a segment of a circle with a large diagonal hole through the lower two-thirds of the building again describing an *en* space.

The full gamut of geometries plus his growing fascination with independent facades, cones, and pyramids is found in the urban complex of Melbourne Central, in Australia (1986, with Hassell and Bates, Smart & McCutcheon), the tower of which rises majestically high with a facade of bright aluminum and dark glass. Recalling Takamatsu's work is Kurokawa's Wacoal Building, in Tokyo (1982–1985), looking like a slick, oversized sewing machine. Much of his architecture has elements of the surreal, of playfulness, of recollection. As a result, his work of the late 1980s onward rightly defies categorization: All in support of his commendable idea of symbiosis. A further example is the Memorial Museum, in Honjin (1991). A circle in plan with a wedge segment removed, it is a small, solid, two-story building he describes as "a symbiosis of universal form of a circle and Japan's tradition of assymmetry."[2]

Kurokawa is a prolific writer, and in Japan a highly visible and self-promoting public commentator on the arts (and much more). Critics Kawazoe and Drew correctly advise readers of Kurokawa's verbalizations not to "be taken in by the words, but should *feel* the theory behind them."[3] Better yet just experience the buildings.

NOTES

1. Charles Jencks, *Architecture Today* (London, 1988), 244.
2. Kurokawa (11, 1991), 27.
3. Kawazoe (1962), and Drew (1972), 68.

BIBLIOGRAPHY

The abbreviation KK for Kisho Kurokawa is used below.

Writings

Action Architecture. Tokyo, 1967.
Architectural Creation. Tokyo, 1969.
"The Architecture of Action." *ADesign* 34 (December 1964); also in *Kenchiku Bunka* (Tokyo) 215 (9, 1964).
Architecture of the Street. Towards Intermediate Space. Tokyo, 1983.
"Architettura in Giappone." *Arca* (Milan) 67 (January 1993).
From Metabolism to Symbiosis. London, 1992; an elaboration of "From Metabolism." *ADesign* 61 (11, 1991).
Intercultural Architecture—The Philosophy of Symbiosis. Washington, D.C., 1991.
KK. . . . Tokyo, 1975.
KK architettura e design. Milan, 1983.
KK. Recent Work and Projects. Tokyo, 1986.
Metabolism in Architecture. London, 1977; in part this contains many reprints of earlier articles.
New Wave Japanese Architecture. London, 1993.
"The Philosophy of Coexistence." *JapanA* 52 (October 1977).
The Philosophy of Symbiosis. New York, 1987.
"Le poetique in Architecture: Beyond Semiotics." *JapanA* 349 (May 1984).
Rediscovering Japanese Space. New York, 1988.
Thesis on Architecture. Towards Japanese Space. Tokyo, 1982.
"Towards the Evocation of Meaning and "Works of *KK.*" 64 (August 1989).
"Two Systems of Metabolism." *JapanA* 137 (December 1967).
Works of KK. Tokyo, 1970.
With Kiyonori Kikutake, et al. *Metabolism. Proposals for a New Urbanism.* Tokyo, 1960.

Biographical

Ross, Michael Franklin. In *Contemporary Architects.*

Assessment

ADesign. "Learning from Tokyo." 64 (January 1994).
ARecord. "Kurokawa: A Study in Cultural Connections." 166 (August 1979).
Bognar, Botond. *Contemporary Japanese Architecture.* New York, 1985.
———. *The New Japanese Architecture.* New York, 1990.
Boyd, Robin. *New Directions in Japanese Architecture.* London, 1968.
Drew, Philip. *Third Generation. The Changing Meaning of Architecture.* Stuttgart, 1972.
Gaskie. M. "Buried Treasure." *ARecord* 179 (June 1991).
Gazzaniga, L. "Museo della fotografie." *Domus* 753 (October 1993).
JapanA. "Melbourne Cathedral." 9 (Summer 1993).
———. "Nara City Museum of Photography." 7 (Summer 1992) and 9 (Spring 1993).
———. "National Ethnological Museum." 53 (April 1978).

Jencks, Charles. "Enigma of Kurokawa." *AReview* 159 (March 1976).

Kawazoe, Noboru. "The City of the Future." *Zodiac* 9 (1962).

"KK." *GADoc* 25 (1990).

Knobel, Lance. "Tokyo Metabolism." *AReview* 170 (September 1981).

Papa, Lisa, and Vincenzo Manocchio. *KK I. Futuro nella Tradizione.* Naples, 1984.

Purver, Kate. " 'Japan Bridge,' Paris . . . and Peter Rice." *Arup* (London) 28 (4, 1993).

Rambert, Francis "A new internationalism." *Architectes* (Paris) (August 1982).

Ross, Michael Franklin. *Beyond Metabolism: The New Japanese Architecture.* New York, 1978.

Tempel, Egon. *New Japanese Architecture.* Stuttgart, 1969.

Veda, K. "Kumamoto Museum." *JapanA* 54 (January 1979).

Watanabe, Hiroshi. *Amazing Architecture from Japan.* Tokyo, 1991.

Bibliographical

JapanA. "List of [literary] Works." 51 (October 1977).

Vance: James Noffsinger, A65, 1979.

L

DENISE LAKOFSKI. See Denise Scott Brown and Robert Venturi.

DANIEL LIBESKIND. 1946 (Lodz, Poland)– . After spending some time at the Lodz Conservatorium, Libeskind continued his music studies at the America-Israel Cultural Foundation in Israel. He moved to the United States, where he obtained a bachelor of architecture (1970) at Cooper Union University, in New York. He gained a master of arts in history and theory of architecture at the University of Essex, England (1971), was artist in residence at the Cranbrook Academy of Art (1978–1985), and was a visiting scholar at the Center for Arts and Humanities of the John Paul Getty Foundation (1986–1989). Libeskind has taught widely in North America, Europe, and Japan since 1986. After working for architectural firms in The Hague, New York, and Toronto, he established a practice in Milan, Italy, where he founded Architecture Intermundium (1986–1989), conceived as an experience-based way of teaching architecture. He has won several awards and scholarships, and was elected to the German Akademie der Künste and the German Society of Architects (1994). A successful participant in many open and limited competitions, he won first prize for an extension to the Berlin History Museum with a Jewish Museum and moved his practice to Berlin (1989). His models and drawings have been exhibited in Europe, Japan, and the United States. His inclusion beside Peter Eisenman,* Rem Koolhaas,* Frank O. Gehry,* and Coop Himmelblau* in the New York Museum of Modern Art's "Deconstructivist Architecture" exhibition (1988) enhanced his reputation while his writings have been widely translated.

✧

If nothing else Libeskind is a controversial figure. He is summarily (and rather unfairly) dismissed by some as an "arcane theoretician" who postulates "non-architecture" and hailed by others as an architectural prophet. Whatever the case, Libeskind is among the best-known (or most propagandized) Deconstructivist architects of the late twentieth century who "started from the Modern, took stock of the imperfect world they had set out to tidy up, and consequently veered towards what [Philip] Johnson[*] calls 'the pleasures of unease'."[1] From a base of 1920s Soviet Constructivism, they replaced the "grand old ideals" of harmony, unity and clarity with discord, fragmentation and mystery, seeking "not perfection any more . . . but perfection violated."[2]

Libeskind states that his projects are "a critique and an alternative to the now exhausted problem of styles; they are concerned with the specific meaning of metaphorical and indeterminate construction—architecture—and its capacity to reveal the truth of dwelling." He calls his audience to "remember, that it's not the object, it's the experience"[3] because he does not himself differentiate between "drawings, models, metaphors" and built work.[4] That may be because his entire opus, before the Berlin Jewish Museum, consisted of exquisite, highly complex drawings, stunning sculptural models, and expressionistic, often almost inscrutable writings.

Libeskind first attracted international attention with some architectural drawings produced in 1979. Exhibitions entitled "Micromegas" were held in Helsinki (1980) and Zurich (1981). The name was changed to "End Space" for a show at the AA, in London (1980). The ten, very large, incredibly intricate exploding disassemblages of mechanical (not architectural) drawings—for all the world like insoluble picture puzzles—bore such evocative names as "The Garden," "The Burrow Laws," "Time Sections," "Maldoror's Equation," and "Dream Calculus." One writer comments, that "drawings in which pieces of an architectural structure seem thrown asunder are common in [his] work."[5] Libeskind described "Micromegas" as an attempt to express the "inadequacy at the heart of perception for which no (final terms) are provided"; the drawings were developed "in an area of architectural thinking which is neither a physics nor a poetics of space."[6]

He won first prize in the Leone di Pietra at the Venice Biennale (1985) for his "Three Lessons in Architecture." Also called "three machines" for reading, remembering, and writing architecture—really large, moving da Vinciesque sculptures of wood, metal, paper, and graphite—the pieces were intended to draw the public into participating and experiencing architecture. Libeskind's esoteric rationale of the work does little to enlighten the conscientious reader.[7]

Libeskind was unanimously awarded first prize in the final urban design competition (1987) of the Berlin International Bauausstellung for a megadeconstructure (to coin a word), a "massive bar angled up from ground level" whose title describes part of its purpose—City Edge—presented in an attractive series of dramatic perspectives, plans, elevational drawings, and an ambiguous collage-

cum-model. It has the hypertechnical complexity of the contrivances of Archigram* a quarter-century earlier sans the composure or finesse. In Libeskind's own words; "The building as a 'city-edge' emerges along the Flottwellstrasse and gives a view of the park along its entire edge, while simultaneously unifying Block 228/240 into an urban structure for dwelling, commerce and public activity."[8] It was never built, mainly for economic reasons.

As noted above, his first realized work was the Jewish Museum to extend the Berlin History Museum (1989; due to open in late 1996), for which he won an international competition (Plate 47). The powerful ideas and incomprehensible events behind the Jewish Museum and the deep emotions it expresses are discordantly gathered in the tortured block that uncomfortably lurches away from the regular classical composure of the original museum building. Libeskind's explanation of the design, fraught with sadness, anger, and bitterness, is an attempt to identify the paths that led to the form.[9] He fails: like all Expressionist architecture, the museum must be experienced in situ to be understood; that is all the more so because of its poignant purpose.

His other projects include, among many, a winning competition entry for the UNY Corporation Pavilion, in Nagoya (built 1989–1990), a masterplan and elements of a "City Boundaries" urban design scheme for Groningen, in the Netherlands (with Fokko van der Veen, 1988), an urban design competition for the Potsdamerplatz area in Berlin (1991), and a garden for the Polderlands, in the Netherlands (under construction, 1995). He has won first prize in several open and invited competitions since 1993, including that for the Felix Nussbaum Museum in Osnabrück, the construction of which will begin in 1996.

NOTES

1. Lampugnani (1991), 16.
2. Richter and Foster (1988), 46.
3. As quoted in Hodge (1990), 1.
4. Lampugnani (1991), 17.
5. Hodge (1990), 2.
6. Libeskind, *Countersign* (London, 1991), 15.
7. Ibid., 37–55.
8. Ibid., 63–84.
9. Ibid., 86–99.

BIBLIOGRAPHY

Writings

"Architecture Intermundium." *Threshold* New York 4 (1988).
"Between the Lines." *ADesign* 60 (September 1990).
Between Zero and Infinity: Selected Projects in Architecture. New York, 1981.
Chamber Works. London, 1983.
Countersign. London, 1991.
"Daniel Libeskind: Three Projects." *ADesign* 59 (January 1989).
Daniel Libeskind: Traces of the Unborn. Ann Arbor, Michigan, 1995.

Judisches Museum Berlin. Berlin, 1992.
"Libeskind on Berlin." *BuildingD* (April 1994).
Line of Fire. Milan, 1988.
"The Maledicta of Style." *Precis* (New York) 5 (Fall 1984).
Marking the City Boundaries. Groningen, 1990.
"Notes for a Lecture: 'Nouvelles Impressions d'Architecture'." *AA Files* 5 (1984).
"Perspective—Emblem of Sacrifice." *Daidalos* (Guertersloh) (March 1984).
Theatrum Mundi. London, 1985.
"Uber den Linden." *ADesign* 61 (July 1991).
[Various essays]. *DesignQ* 122 (1983).
With Alain Pelissier, "L'architecture aux limites." *Techniques* 399 (December 1991).
With others. "Theory + Experimentation." *ADesign* 62 (November 1992).

Assessment

a+u. "Architect-designed Birdhouses." 275 (August 1993).
———. "Daniel Libeskind." 215 (August 1988).
———. "Daniel Libeskind." 257 (February 1992).
ADesign. "Daniel Libeskind: An *ADesign* Interview." 60 (September 1990).
———. "Daniel Libeskind: . . . Writings and Projects." 58 (January 1989).
Architettura. "Libeskind: Casa senza muri." 37 (June 1991).
———. [Special issue]. 40 (July 1994).
Arkitekten. "Book of Copenhagen." (Copenhagen) 96 (January 1994).
van Berkel, Ben, and Caroline Vos. *Delinquent Visionaries.* Rotterdam, 1993.
Bunschoten, Raoul. "Wor(l)ds of Daniel Libeskind." *AAFiles* 10 (Autumn 1985).
Cusvelier, Sjoerd. "Omgekeerde archeologie." *Architect* (The Hague) 23 (April 1992).
Esche, Jan. "Bauen gegen die Geschichte." *Architektur & Wohnen* (Hamburg) (April 1992).
Giovannini, Joseph. "Breaking All the Rules." NYTM (12 June 1988).
Gubitosi, Alessandro. "Il projeto invisible." *L'Arca* (Milan) 65 (November 1992).
Hinson, Mary A. D. "Erasing the Ghost of Perrault." *Harvard* 5 (1986).
Hubert, Christian. "Memories and Machines." *UCLA Architecture Journal* 2 (1989).
Isozaki, Arata. "The Game of Individual Expressions." *Lotus* 71 (1992).
Jarzombek, Mark. "Ready-made Traces in the Sand." *Assemblage* (MIT Press) 19 (December 1992).
Johnson, Philip, and Mark Wigley. *Deconstructivist Architecture.* New York, 1988.
Lampugnani, Vittorio. "Libeskind: Tra medoto, idea e desiderio." *Domus* 731 (October 1991).
Oechslin, W. "From Piraniesi to Libeskind: Explaining by Drawing." *Daidalos* (September 1981).
Papadakis, Andreas, et al., eds. *Deconstruction: Omnibus Volume.* New York, 1989.
Richter, Alexander, and Kurt W. Foster. "Buildings . . . Berlin." *Domus* 696 (July 1988).
Rodermond, Jenny. "De boeken van Groningen." *Architect* (The Hague) 22 (February 1991).

Bibliographical

Vance: Daniel H. Hodge, A2379, 1990.

ADOLF LOOS. 1870 (Brno, Moravia)–1933. Loos was introduced early to the building crafts through his father's stonemasonry business. In 1887 he entered

the Bohemian Royal and Imperial State College at Reichenberg. His education was interrupted by conscripted army service (1888–1889), but in 1890 he began four years of architectural studies at the Dresden Technical College, where he was enthralled by the writings of Vitruvius and Schinkel. Upon graduation he visited the United States (1893–1896). Full of admiration for most things American, in 1896 Loos moved to Vienna where he worked in the building firm of Carl Meyreder. Soon he began to make his major contribution to architecture— his polemical writings—and to practice. His radical theories were architecturally expressed in houses built in and around Vienna between 1909 and 1912. For a decade his career remains in obscurity, until in 1922 he became chief architect of Vienna's Housing Department. He moved to France in the same year, where he stayed on and off until 1927. Well received by the French, he produced some significant work there and in Austria and Czechoslovakia until 1932.

<p style="text-align:center">✑</p>

Loos's influence upon European (indeed, international) Modernism was largely determined by his American sojourn, partly inspired by a desire to attend the 1893 Chicago World's Fair. He remained in the United States for three years, mostly near Philadelphia. The effect of American architecture upon Loos's work is a moot point, but the overall impact that American culture, especially the general enjoyment of basic freedoms, is clear. He observed, as one has commented, that "the bitter national rivalries of the Old World" had been put behind emigrants to the New. Architect Richard J. Neutra,* himself an Austrian emigrant, wrote: "To [Loos] America was the land of unshackled minds . . . of people brought close to life's realities. . . . People here, as he saw them, had reverted to a sound attitude which had been lost in the old country."[1]

Loos's main contribution to Modernism was in the realm of theory. From 1897 he published in Vienna's *Neue Freie Presse* the first polemical articles, not on architecture, but on the social problems that he believed were the "motivating factors" in the struggle for the transformation of "everyday life."[2] He concentrated upon the idea of an Austrian culture responsive to contemporary aspirations. Those essays, which reflected his American experiences, would establish Loos's international reputation.

A friend of the Expressionist painter Oskar Kokoschka, innovative composer Arnold Schoenberg, and philosopher Ludwig Wittgenstein—all part of an artistic and intellectual elite with shared notions—he assumed the role of an enigmatic maverick, "the leading figure in fin-de siècle Vienna," not within the art community but parallel to it. He published a periodical intent upon "the introduction of western civilization into Austria" and named it *The Other*.[3] The attitudinal implications of the title vis-à-vis the Austro-Hungarian Empire and subsequent events in the arts are obvious.

Loos's writings increasingly condemned the "excessive" decoration of Viennese architecture, both traditional and of the Secession, whether in the reductive classicism of his erstwhile mentor Otto Wagner or in the *Weiner Werkstatte*.

In 1898 he wrote an essay entitled "Principles of Building" for *Ver Sacrum* (ironically, published by the Secession), the first of many expressing his theoretical argument against the Art Nouveau; a decade later his views were raised to the status of a manifesto in his most famous essay, "Ornament and Crime." Such epigrams as "Beware of being original; designing may easily drive you towards it," or "As ornament is no longer organically linked with our culture, it is also no longer an expression of [it]," or "Anything that fulfils a purpose [like architecture] is excluded from the sphere of art," or the claim that the absence of ornament "is a sign of spiritual strength" were all part of his well-supplied verbal armory.[4] The piece, widely reprinted throughout Europe, often met with hostility, yet not from all. Le Corbusier* once called it "an Homeric cleansing" of architecture.

Loos's polemic was given substance in his buildings. His assertion that the vocabulary of architecture lay in the materials (an idea not unlike Frank Lloyd Wright's*) and that the exterior of a building should be "dumb" led Loos to build stark exteriors, articulating the direct assemblage of materials but enfolding sumptuous spaces. An early example was the so-called Cafe Nihilismus, whose nickname says all there is to say about its facade. One writer commented that the cafe, officially the Cafe Museum in Vienna, also "affirms his aesthetic equation of beauty and utility by bringing every object back to its purely utilitarian value."[5] Other demonstrations followed. The reductive simplicity of his unpopular Looshaus, an apartment building on the Michaelerplatz in Vienna's old quarter (1910–1911), caused a public outcry leading to municipal intervention, an angry mass meeting, and a reluctant compromise on the part of the architect.

Of the same puritanical character was Loos's most famous residential work: the Steiner house, outside Vienna (1910). It was an emphatic break with Europe's clinging past. Its unembellished white facades soon became well known and have always been associated, not without reason, with the Modernist houses of the 1920s, including those of J.J.P. Oud* in Hoek van Holland, Rotterdam Kiefhoek, and Stuttgart. Tafuri and Dal Co claim that Loos's "antistylistic polemic" was even more radically expressed in two other Vienna residences: the Scheue house (1912) and the house on the Sauraugasse (1913): "There is no continuity between the domestic world and everything outside of it. In the interiors, he literally *composes,* and an exhaustive invention of spatial aggregations and volumetric compenetrations is enriched by refined materials whose beauty lies in their specific qualities."[6] The Strasser house in Vienna (1922) carried the separation of interior and exterior to a conclusion.

After 1919, "the extraordinary tension of the course [Loos had taken] cracked."[7] The year 1922 was a watershed. Appointed chief architect of the Commune of Vienna's Housing Department, he soon relinquished the post because he could not accept its policies and priorities; neither could he agree with the prevailing Marxist ideologies. In 1922 he submitted his ironically fanciful Doric column design for the *Chicago Tribune* competition. At year's end he moved to France and for the next five years spent his time between Paris and

the Riviera, building very little. Some scholars believe that, after 1926, Loos, "linking his fortune to that of the modern movement," sailed out of the professional doldrums to again take up cudgels with the already moribund Art Nouveau. For the rest of his life, his monolithic architecture in such buildings as the Tzara house, in Paris (1926–1927), the Villa Moller, in Vienna (1928), and the Villa Winternitz, in Prague (1931–1932) marked his "posture of contentious indifference to fluctuations in current taste," standing out against the contemporary glass boxes of the New Objectivity.

Unable to "construct the image that would convey his intuition," Loos was unable to carry on to define his ideas rigorously with architectural clarity. That was achieved by his friend Wittgenstein in the Vienna house he designed in 1928 for his sister Margarethe, and it would be repeated by others elsewhere in Europe. Loos's lasting and significant contribution to architecture remains his passionate literary polemic and discourse.

NOTES

1. Leonard K. Eaton, *American Architecture Comes of Age* (MIT Press, 1972), 139.
2. Wadkins in Wilkes.
3. Leonardo Benevolo, *History of Modern Architecture* (London, 1960) vol. 2, 298.
4. Wiseman in Macmillan.
5. Wadkins in Wilkes.
6. Manfredo Tafuri and Francesco Dal Co, *Modern Architecture* (London, 1986), 104.
7. Ibid.

BIBLIOGRAPHY

The abbreviation AL for Adolf Loos is used below.

Writings

Ins Leere Gesprochen. Paris, 1921; 2d ed., Innsbruck, 1932; *Samtliche Schriften.* Vol. 1, edited by Franz Glick. Vienna, 1962.
"Ornament und Verbrechen (1908) [reprint]." *Baumeister* (Munich) 83 (May 1986).
Die Potemkinsche Stadt: Verschollene Schriften 1897–1933, edited by Adolf Opel. Vienna, 1982.
Trotzdem 1900–1930. Innsbruck, 1931; *Samtliche Schriften.* Vol. 2, edited by Franz Glick. Vienna, 1962.

Biographical

Fanuele, Felice, and Patrice Verhoeven, eds. *AL 1870–1933.* Berlin, 1983.
Rukschcio, Burkhard, and Roland Schachel. *AL, Leben und Werk.* Salzburg, ca. 1982, 1987.
Tournikiotis, Panayotis. *Loos.* Paris, ca. 1991; *AL.* New York, 1993.

Assessment

Akademie des Kunste. *AL 1870–1953. Raumplan Wohnungsbau.* Berlin, 1983.
AL, zum 60. Vienna, 1930.
Ale, Francesco. "Loos e Vienna: Itinerario no 55." *Domus* (March 1990).
Anderson, Stanford. "Critical Conventionalism in Architecture." *Assemblage* (MIT Press) 1 (October 1986).

———. "The Legacy of German Neoclassicism." *Assemblage* (MIT Press) 15 (August 1991).

Arquitectura. "Werkbund Siedlung [Vienna] 1932." (Madrid) 70 (May 1989).

Bhavnani, Ashok. "The Architecture of AL: Vogue or Omen?" *Sites* (New York) 20 (1988).

Cacciari, Massimo. *AL e il Suo Angelo: Das Andre e Altri Scritti.* Milan, 1994.

Chatelet, Anne-Marie. "AL—Le Corbusier." *Aujourd'hui* 249 (February 1987).

Colomina, Beatriz. "Intimacy and Spectacle: The Interiors of AL." *AAFiles* (Autumn 1990).

———. "The Publicity of the Private: AL and Le Corbusier." *Transition* 41 (1993).

Furudate, Katsuaki. "The Early Twentieth Century Masters Who Adorned Vienna." *SpaceD* 290 (November 1988).

Gluck, Franz. *AL.* Paris, 1931.

Grassi, Giorgio. "On the Question of Decoration." *ADesign* 54 (May 1984).

Gravagnuolo, Benedetto. *AL: Theory and Works.* Milan, 1982.

Grimaldi, Alberto. "The Influence of AL on Contemporary Design." *Ottagono* (Milan) 17 (June 1982).

Hines, Thomas S. "Historic Architecture; AL in Paris." *ADigest* 48 (April 1991).

———. "Radical Residences for Josephine Baker and Tristan Tzara." *ADigest* 48 (April 1991).

Hofmann, Werner. "L'emancipation des dissonances." *Gazette des Beaux-Arts* (Cedex) 108 (December 1986).

Kleinman, Kent, and Leslie van Duzer. *Villa Muller: A Work of AL.* New York, 1994.

Leatherbarrow, David. "Interpretation and Abstraction . . . AL." *JAE* 40 (Summer 1987).

Linazasoro, James. "Ornament and Classical Order." *ADesign* 54 (May 1984). ˙

Lubbock, Jules. "AL and the English Dandy." *AReview* 174 (August 1983).

Makela, Taisto. "Modernity and the Historical Perspective of Nietzsche and AL." *JAE* 44 (May 1991).

Markalaus, B. *AL.* Vienna, 1931.

Masiero, Roberto. "In Praise of Decoration against Superficiality." *Rassegna* 12 (March 1990).

von Moos, Stanislaus. "Le Corbusier and AL." *Assemblage* (MIT Press) 4 (October 1987).

Munz, L., and G. Kunstler. *AL: Pioneer of Modern Architecture.* London, 1966.

Oechslin, Werner. "Raumplan versus plan libre." *Daidalos* (Guertersloh) 42 (December 1991).

Safran, Yehuda. "Ornamento e tempo." *Ottagono* (Milan) (December 1990).

Steiner, Dietmar. "AL ist Blade Runner." *Bauwelt* 76 (27 September 1985).

———. "Die Architektur des modernen Lebens." *Du* (Zurich) 532 (June 1985).

Wilson, Colin St. J. "The Play of Use and the Use of Play." *AReview* 180 (July 1986).

Bibliographical

Vance: Lamia Doumato, A195, 1983.

Archival

Spoken into the Void: Collected Essays 1897–1900. Milan/MIT Press, 1982.

M

MARION LUCY MAHONY. See Marion Mahony Griffin and Walter Burley Griffin.

FUMIHIKO MAKI. 1928 (Tokyo, Japan)– . Maki obtained an architecture degree from the University of Tokyo (1952) under Kenzo Tange,* and a masters of arts degree from the Cranbrook Academy of Arts in Michigan (1953), followed by a master of architecture degree from Harvard University (1954). Thereafter he worked with several firms including Skidmore, Owings, and Merrill* (SOM) in New York; J. L. Sert, in Boston; and with Tange, in Tokyo (1960–1962). He taught architectural design full-time at Washington University, in Saint Louis, Missouri (1956–1962); his time was divided by a Graham Foundation grant to tour Europe, West Asia, and Asia (1958–1960). Together with Kiyonori Kikutake, Kisho Noriaki Kurokawa,* Matsato Otaka, and the critic Norboru Kawazoe, Maki was a founding member of Metabolism* (1960). He then taught at Harvard (1962–1965) before opening a practice in Tokyo (1965). Since 1979 he has been a professor of architecture at Tokyo University and a visiting professor at various universities in North America and Europe. Maki has received national and international prizes, honors, and awards, including the 1993 Pritzker Prize.

✧

While with Tange, Maki acted alone as an architectural consultant to Takenaka Construction Company for the Toyda Auditorium, at Nagoya University (1960), and there he created a building typical of his early work indicating a debt to such Western architects as Walter Gropius's* The Architect's Collabo-

rative and Paul Rudolph.* This debt can also be seen in his first major commission, the Rissho University campus plan and many of its buildings at Kumagaya near Tokyo (1965–1967).

It is quite likely that Kikutake and Maki were the principal theorists of the Metabolism group. Indeed, Maki's early contribution to twentieth-century architecture is his and Otaka's much reprinted article about collective or group form. Cities are hopelessly chaotic, they argued, ideas have been set by dogmatists, they lack individuality, and so forth. Group form "is determined by several buildings and their relationship to each other," not fixed, static edifices, but new spatial entities with form in balance with its separate elements.[1] There is much in the idea that can be matched with later theorists, such as Peter D. Eisenman* and his fellow anarchist, the nonarchitect Jacques Derrida.

Maki, like Tange, is literate and urbane. He has taught design and has been widely influential on theoretical matters while his architectural productivity is qualitatively uneven. They both concentrated on teaching and less on developing a professional practice, at least until the late 1980s. Unlike Tange, Maki is bicultural and moves with ease between East and West.

Maki's architecture was little different from the Westernized style of Junzo Sakakura or Maekawa or Tange. For example, Maki's Elementary School, in Kato (1972), also derives much from Louis I. Kahn,* as well as the Hillside Terrace Apartments, in Tokyo (1972–1979). And there is the "small glassy mountain"—the Central Building—for Tsukuba University (1972–1974) with its dark interiors full of spatial interplay and an orderly glass block facade. But his architecture of the 1980s onward reflects the idea of collective form brought to just a single building and, it must be added, imitates typical messy Japanese cities regardless of Group Form. Nevertheless, Maki argues that "each part is a small realized whole" and "the composite whole is suggested by its parts."[2]

The most popular example of his later work is the Spiral Building, or the Wacoal Arts Center, in Tokyo (1983–1985), a joyful, articulated, less dark edifice. Observer Charles Jencks refers to the building as "white, silver, and gray, moving in outline, full of square motifs used at different scales, and terribly complex."[3] A disparity and deliberate chaos (a piano shape outlines the bar) of exterior elements refer to much of modern facadism that contrasts to a rather serene, "peaceful," whitish interior. The Spiral Building is opposite to his Kyoto Museum of Modern Art (1984–1987), a flush-skinned box with an interior that is reminiscent of the Tsukuba University building and comparable to his equally reserved Tepia Science Building, in Tokyo (1989–1991). These designs have much in common with Eisenman's shambled architecture.

Two sports halls of similar size and general character exhibit high-tech steel truss construction. Arata Isozaki's* Sant Jordi Sports Hall, in Barcelona (1983–1990), used a symmetrical constructional system that is obvious on the bulky exterior; and Maki's Tokyo Municipal Gym (1988–1992) uses a stepped truss system that, on the exterior, has afforded a variety of facades. Yet the related swimming pool and small arena buildings and other facilities on the site de-

signed by Maki have an affinity with his more formal architecture pre-1983 or the many orderly arranged buildings for the new Keio University campus (1992). In the early 1990s, Maki started obtaining work in Europe and America.

NOTES

1. Kultermann (1967), 28.
2. As quoted in Ross (1978), 113.
3. Charles Jencks, *Architecture Today* (London, 1988), 232.

BIBLIOGRAPHY

Writings

"At the Beginning." *JapanA* 50 (April 1975).
"Collective Forms." *Spazio e societa* (Milan) 62 (April 1993).
"Dialogue on Architecture," with Richard Meier. *SpaceD* (January 1978).
"Dialogue Series." *JapanA* 48 (September 1973).
"Fumihiko Maki." *GADoc* 25 (1990).
"Fumihiko Maki." *JA* 16 (Winter 1994). The whole issue.
"Harry Weese." *SpaceD* (February 1976).
Investigations in Collective Form. St. Louis, 1964; partially republished in Reyner Banham. *Megastructure.* London, 1976.
"Maki & Associates." *PA* 64 (May 1983).
Miegakure suru Tohi. Tokyo, 1980.
Movement Systems in the City. Cambridge, Massachusetts, 1965.
"New Congress Center." *GADoc.* 36 (1993).
With Noboru Kawazoe. *What Is Urban Space.* Tokyo, 1970.
With Otaka. "Some Thoughts on Collective Form." In *Metabolism 1960.* Republished in Gyorgy Kepes, ed., *Structure in Art and in Science.* New York, 1965.
With others. *Metabolism 1960—The Proposals for New Urbanism.* Tokyo, 1960.
Translation. Paul and Percival Goodman. *Communitas.* Tokyo, 1967.
————. Spiro Kostof. *The Architect.* Tokyo, 1981.

Biographical

Ching-Yu Chang. In *Contemporary Architects.*

Assessment

a+u. "The Recent Work." 273 (June 1993).
Bognar, Botond. *Contemporary Japanese Architecture.* New York, ca. 1985.
————. "Critical Intentions in Pluralistic Japanese Architecture." *ADesign* 62 (March 1992).
Bognar, Botond, ed. *The New Japanese Architecture.* New York, 1990.
Boyd, Robin. *New Directions in Japanese Architecture.* London, 1968.
Breslin, Lynne. "Tokyo College." *ARecord* 177 (October 1989).
Casabella. "Opere recenti." 55 (July 1991).
Cohen, J.-L. "Recent Work of. . . ." *a+u* 273 (June 1993).
Goody, J. E. "Rare and Rich. . . ." *ARecord* 171 (May 1983).
Hollein, Hans. "Kongresshaus, Salzburg." *Zodiac* (Milan) 10 (1993).
JapanA. "Austrian Embassy in Tokyo." 51 (November 1976).
————. "Keio University . . . Campus." 9 (Summer 1993).

———. "Kumagawa Campus of Rissho University." 43 (October 1970).

———. "Special Feature: . . . Maki." 58 (March 1983).

———. "Special Issue: Maki." 54 (May 1979).

———. "YKK R&D Center." 13 (Spring 1994).

Kultermann, Udo. *New Architecture in Japan*. Stuttgart, 1967.

Mandrelli, Doriana. "Tradizione e modernite." *Arca* (Milan) 78 (January 1994).

Pollock, N. R. "Silver Palette." *ARecord* 182 (March 1994).

Ross, Michael Franklin. *Beyond Metabolism: The New Japanese Architecture*. New York, 1978.

Salat, Serge. *Fumihiko Maki. An Aesthetic of Fragmentation*. Milan, 1987; New York, 1988.

Suzuki, Hiroyuki, et al. *Contemporary Architecture of Japan 1958–1984*. New York, 1985.

Treib, Marc. "Sports Cathedral." *PA* 66 (June 1985).

Woodbridge, Sally. "Urban Helix." *PA* 67 (April 1986).

Bibliographical

Vance: James Noffsinger, A307, 1980; Carole Cable, A1122, 1984; Dale Casper, A2023, 1988.

RICHARD (ALAN) MEIER. 1934 (Newark, New Jersey)– . With a degree in architecture from Cornell University, in Ithaca, New York (1953–1957), Meier worked in New York City for Davis, Brody, and Wisneiwski, for Skidmore, Owings, and Merrill* (SOM), and for Marcel Breuer* (1957–1963); since then he has had a private practice. He was also a visiting professor at a number of universities in New England (1963–1981) and a resident architect at the American Academy, in Rome (1973). He has exhibited widely (1963–) and received awards, prizes, and honors, including the Brunner Prize of the National Institute of Arts and Letters (1972), the Pritzker Prize (1984), and the AIA Gold Medal (1988).

"Architecture is the subject of my architecture"[1]—a unique confession in the 1990s. On another occasion he stated,

Beyond theory, beyond historical reference, my meditations are on space, shape, light and how to make them. My goal is presence, not illusion, and I pursue it with an unrelenting vigor."[2]

Initially Meier used compositional "patterns" (juxtaposition, hierarchy, axial organization, transparency, repetition, reciprocity [or counterpoint]) as tools for architectural expression—not as things in design procedures, but as ways of communicating ideas. He believed as well that "each structure receives instruction from all that went before, and uses that knowledge to discover its own uniqueness."[3] He did not refer to past styles but to known, almost symbolic, patterns. To emphasize their place in his work he then and now prefers his buildings to be all white so that all melds into one. Yet the order and each part are defined as form and transparency without embellished instruction by means

of color or texture. (In any event, he believes buildings receive many colors by their situation.) His buildings therefore possess an obvious clarity of intention.

One of his first compositions, the classic, suave, and widely published Smith house, in Darien, Connecticut (1965), informs the user and observer with that clarity. Like so much of his architecture, it uses the concept of a spatially layered linear system of circulation and similar functional parts and a layering of planes solid to transparency. A number of his houses and smaller buildings are of similar characteristics, including the Douglas house in Harbor Springs, Michigan (1971–1973), and the Saltzman house in Long Island, New York (1967); the latter employs curves and diagonals, elements that occur in his architecture of the next decades.

Early in his work, Meier took Le Corbusier's* systems but imbued them with a higher orderliness and a more carefully disposed syntax. They were as well more expertly detailed thereby encouraging fine craftsmanship. But Meier soon matured beyond a rather soft dependence to an independent language. This is revealed early in his Bronx Developmental Center (1970–1976), a residential facility for retarded children where a grid for the complex building of private apartments and public facilities was not allowed to control, and dissimilar functions were allowed to take their own form. Rather than a white building Meier chose a natural colored aluminum, sheet butt-jointed for a tight silvered surface. The building has received criticism not only because it institutionalizes child care but for its "unhomelike appearance" and bright, reflecting exterior surface.[4]

With the Atheneum, in New Harmony, Indiana (1975–1979), (Plate 36), Meier was no doubt in concert with Peter D. Eisenman* but less influenced by Michael Graves (before he became regressively eclectic), both architects of the New York Five heralded by a book, yet with a more refined sense of proportion, dynamics, and individuality. Here Meier created a conglomerate of forms, planes, layering, and diagonality that is both monumental yet self-explaining not only of its structure but also of its complex parts. The informal nature of his plans (always ordered by an obvious module) and resulting forms are balanced by a sense of formalism, asymmetrical and just short of monumental. Diverse examples are the Museum für Kunsthandwerk in Frankfurt, Germany (1985), the Bridgeport Center project in Connecticut (1984–1989), the Ackerberg house in Malibu, California (1984–1986), and more emphatically the extensive Pirelli Bicocca project in Milan (1986), as well as various elements of the Santa Monica Beach Hotel project in California (1987), hard against ocean's shore.

His Madison Square Towers in New York (1987), two of which are massive buildings, more than adequately display the functional, visual, experiential, and architectonic difficulties inherent in form *dis*location and reveal that at moments he desires to work with elements of Eisenman's *de*construction notion. And then for the Ulm Exhibition building (1986–1991), Meier uses the circle and layer walls of Tadao Ando.* It recalls the Gotta house, in Harding Township, New Jersey (1984–1989). It is difficult for a designer not to be swayed by the excellence of colleagues.

As Kevin Roche* consolidated a revived modernism in the 1960s and 1970s, Meier did so in the 1980s and 1990s. Where Roche's architecture is obvious and muscular, "Meier's work is lyrical, sensuous and striking;" he is a "lover of abstraction."[5] Meier is becoming a prolific architect who is taking on a wide variety of commissions and dabbling in industrial design, all with ease and apparently boundless imagination.

NOTES

1. As quoted in "Tate Gallery Discussion," *ADesign* 60 (7/8, 1990), 45.
2. As quoted in Ching-yu Chang, in *Contemporary Architects,* 536.
3. Futagawa (1976), 7.
4. Harvey (1985), 63.
5. Editorial to Frampton (1990), 11.

BIBLIOGRAPHY

The abbreviation RM for Richard Meier is used below.

Writings

Building for Art. Berlin, 1990. Anthology.
A Communication Theory of Urban Growth. MIT Press, 1962.
"Dialog" (with Arata Isozaki). *a+u* (August 1976).
"Essay." *Perspecta* 24 (1987).
"Guest Speaker." *Architectural Digest* (New York) 38 (June 1981).
"Museum . . . Barcelona." *ADesign* 61 (3/4, 1991).
"My Statement." *a+u.* (April 1976).
"Project Documentation: The Atheneum, New Harmony . . ." *Harvard Architectural Review* 2 (spring 1981).
RM Architect. Buildings and Projects 1966–1976. New York, 1976.
RM Architect. Buildings and Projects 1979–1989. London, 1990.
RM Architect. 1985/1991. New York, 1991.
RM Architect. 1964–1984. New York, 1984.
RM Sculpture. 1992–1994. New York, 1994.
"White Existence." *SpaceD* (January 1978).
In Frampton, Kenneth, and Colin Rowe, *Five Architects.* New York, 1972; 2d ed., 1975.
Foreword, *Willmotte. Realisations et projects.* Paris, 1993.
With Paul Goldberger. *Douglas House.* Tokyo, 1975.

Biography

Ching-yu Chang. In *Contemporary Architects.*
Sacchi, Livio. *RM: Architettura.* Milan, 1993.

Assessment

a+u. "RM. Latest Two Works." 275 (August 1994).
ARecord. "New Furniture for Knoll." 170 (November 1982).
———. "Private Residence." 161 (Mid-May 1977).
Beaudouin, L. "Canal + Headquarters." *a+u* 268 (January 1993).
Brawne, Michael. *Museum für Kunsthandwerk: RM.* London, 1992.
Brenner, D. "Two Projects in Context." *ARecord* 169 (April 1981).
Canty, Donald. "Shining Vessel of Religious Thought." *AIAJ* 71 (Mid-May 1982).

Cohen, E. L. "RM." *Interior Design* (New York) 59 (May 1988).
Davies, Colin. "Spatial Assets: Hypolux Bank." *AIAJ* 83 (June 1994).
Diamonstein, Barbaralee. *American Architecture Now.* New York, 1980; *American Architecture Now II.* New York, 1985.
―――. "Frankly Speaking." *Interiors* (New York) 140 (October 1980).
Domus. "Whiter Shade of Pale." 629 (June 1982).
Doubilet, S. "Seminary, Hartford." *Interiors* (New York) 140 (October 1980).
Filler, Martin. "Modernism Lives." *ArtA* 68 (May 1980).
―――. "Splendid Spinoff . . . Guggenheim Museum." *PA* 59 (October 1978).
Frampton, Kenneth. ". . . and the City in Miniature." *ADesign* 60 (7/8 1990).
―――. "High Museum . . . Atlanta." *Casabella* 46 (November 1982).
Futagawa, M. *Douglas House.* Tokyo, 1975.
―――. *Smith House . . . Old Westbury.* Tokyo, 1976.
Gazzanigo, Luca. "Edifico per una banca, Lussemburgo." *Domus* 755 (December 1993).
Goldberger, Paul. *The Atheneum . . . GA60.* Tokyo, 1981.
Harvey, Tana L. In *The Critical Edge,* edited by Tod A. Marder. MIT Press, 1985.
Knobel, L. "Museum, Frankfurt." *ARecord* 170 (July 1981).
Mas, J. "RM." *Aujourd'hui* 271 (April 1991).
Murphy, J. "A Collaboration." *PA* 71 (November 1990).
PA. "Eye Center." 70 (January 1989).
Parent, V. "L'important, c'est l'espace." *Aujourd'hui* 281 (June 1992).
Pearson, C. A. "Unveiling a Modern Classic." *ARecord* 129 (October 1991).
Richards, Ivor. "Interactive Language." *AReview* 193 (April 1993).
Rykwert, Joseph. "New Harmony Propylaeon." *Domus* 603 (February 1980).
SpaceD. "White Existence . . . 1961–1977." Special feature. (January 1978).
Stephens, Suzanne. "Architecture Cross-Examined. Bronx." *PA* 58 (July 1977).
Tafuri, Manfredo. *Five Architects.* Rome, 1976.
Ullmann, Gerhard. "Vergnugliches Schauen centre." *Werk* (June 1994).
Welsh, J., and Nicholas Stungo. "Modern Markitecture." *RIBAJ* 100 (November 1993).

Bibliographical

Vance: Bibliographic Research Library, A1257, 1984; James Coniglio, A1462, 1985.

ERICH (Eric) MENDELSOHN. 1887 (Allenstein, East Prussia)–1953. The son of a Russo-Polish Jewish businessman, Mendelsohn worked his way through university, studying economics at Munich (1907) before changing to architecture at the Berlin Technische Hochschule (1908–1910), then under Theodor Fischer at the University of Munich (1911–1912). That education may have led to the observation that he combined an "exuberant, intuitive creativity with sound business sense."[1] After graduating Mendelsohn worked in various design fields before setting up his Berlin architectural practice (1919–1933). He fled from Germany and after six months in Amsterdam, he moved to London, where he collaborated with Serge Chermayeff (1933–1939). Finding no niche in England, nor later in Palestine (1939–1940), he emigrated to the United States in 1941, settling first in New York State but moving later to San Francisco in 1945, to enter a partnership with Dinwiddie and Hill. But he was by nature a "loner," as he said: "God had no associates when he created the world, so why should

I?'' Mendelsohn's work was exhibited in Berlin (1919 and after 1960), London (1931, 1962), Rome (1972), New York (1929, 1952), and throughout the United States.

<p style="text-align:center">✧</p>

Early influences are clear. Mendelsohn entered his profession just as Art Nouveau was being eclipsed by Expressionism, yet he remained an avowed (if anachronistic) admirer of the Viennese Secessionist architect Joseph Maria Olbrich. He worked in Munich as a theater designer and interior decorator (1912–1914) after which he attached himself to the Expressionist *Blaue Reiter* group that included Wassily Kandinsky, Franz Marc, Paul Klee, and Alexey von Jawlensky. Following two years of army service on the Eastern Front in World War I he commenced his Berlin practice as an Expressionist.

The Dutch polemicist H. Th. Wijdeveld saw an exhibition entitled "Architecture in Steel and Reinforced Concrete" at Paul Cassirer's Berlin gallery in spring 1919. Enthralled by Mendelsohn's "tiny sketches of expressionistic architecture" (said to be inspired by the music of Brahms and especially Bach) (Plate 11), Wijdeveld "introduced" the German to the world by devoting the October 1920 issue of *Wendingen* (which he edited) to images of Mendelsohn's work, discussed in essays by J. F. Staal, Mendelsohn's art historian "champion" Oskar Beyer, and the architect himself.

Interaction with the Dutch deeply affected Mendelsohn. His domestic designs changed after a 1922 visit to Amsterdam as a guest of Wijdeveld, who would certainly have discussed the work of Frank Lloyd Wright* with him. When Mendelsohn visited Wright three years later, he carried a letter of introduction from Wijdeveld. In 1925 he contributed to *Wendingen*'s series on Wright. There were other Dutch connections: after a second visit to Holland, Mendelsohn undertook to reconcile Constructivism (as he saw it in J.J.P. Oud's* application of De Stijl* ideas) and Expressionism, to be found first in Berlage's "evocative romanticism" and extended by the Amsterdam School. In his own architecture, he wanted to combine the "vision" of Amsterdam with the "objectivity" of Rotterdam. Mendelsohn believed function to be "the primary element in architecture . . . but function without sensibility remains mere construction," adding that "if the rationalist's blood does not freeze and mere imagination goes a step further towards [the rational], then they may unite. Otherwise both will be destroyed—the functionalist by a deadly chill in his veins, the dynamicist by the heat of his own fire."[2]

The impact of the Dutch, and the ambiguity it created, is best seen in Mendelsohn's hat factory at Luckenwalde (1921–1923). The no-nonsense, utilitarian, cubic form of the power house serves as a solid terminus to the sculptured almost wave-like forms of the factory itself. His most remarkable product of the commission-starved early 1920s was the Einstein Tower at Potsdam (1920–1924). It expressed the tension between romantic vision and economic and technological reality: current building methods and materials could not achieve (at least without compromise) the forms that Mendelsohn wanted, and its fluid curves

had to be built in stuccoed brickwork. Albert Einstein's opinion was stated in a word: "organic."

Until 1932 Mendelsohn's successful and frenetic Berlin practice included many industrial and commercial buildings, a few houses, and the Universum Cinema, in Berlin (1926–1929). Tafuri and Dal Co assert that, in the cinema, part of the larger WOGA precinct of shops, offices, apartments, and other entertainment functions, Mendelsohn "refined his syntax, based on the complex play of forms that was concentrated at the sensitive points of volumes." Such a comment tends to reduce a building whose essential quality was internal—an auditorium—to a minor element of urban design. Nevertheless, what they say is true enough: there is a complex play of forms on the peninsular city site redolent of the contemporary work of Willem Marinus Dudok* and through him the massing of Wright. The Universum was patently a model for myriad cinemas worldwide.

Mendelsohn also built a number of seminal department stores in Germany and elsewhere, including influential buildings for the Schocken chain in Nuremberg (1926), Stuttgart (1926–1928), and Chemnitz (1928–1929). These demonstrated characteristics of his continuing work: a balance between solid and transparent wall that inevitably evokes Sullivan's Carson, Pirie, and Scott retail store in Chicago (1899) and a carefully established relationship between curves and rectangles that would be widely copied, or at least emulated. Mendelsohn was successful in Germany and publicized in European, British, and American journals. That changed suddenly. The day after Adolf Hitler became Reichschancellor, Mendelsohn fled Germany with his wife Louise and their daughter Esther. Welcomed at Wijdeveld's home, they remained from early February until June 1933. Then Mendelsohn began a London partnership with the interior designer Serge Chermayeff.

The visionary Wijdeveld wanted to start the Académie Européenne Méditerranee, a kind of artistic kibbutz on the French Riviera. Its poignant story is too complex to even summarize here, except to note that he drew Mendelsohn and others, including Le Corbusier's* sometime collaborator Amedée Ozenfant and Chermayeff, into his plans. But Mendelsohn's long-term goal, never disclosed to Wijdeveld, was to settle in Palestine, where he had been designing projects since 1923. Moving to the Mediterranean coast would be "the first step towards a return to that country, to that final stage" where he belonged.[3] For many reasons, some tragic, Wijdeveld's Académie failed.

Mendelsohn and Chermayeff won the competition for the De La Warre Pavilion (1933–1935) in Bexhill, Sussex. The curve of the glass-enclosed stairwell projecting from the facade of the entertainment center—a "milestone of modernism"—is unmistakably of Mendelsohn's invention. There were few other commissions. Of the handful actually built, most were domestic. Mendelsohn later claimed that "England's [conceited], parochial, nationalistic xenophobia" prevented any foreigner's practice from succeeding there.[4]

After about 1934 he received a number of commissions from Palestine: the

Chaim Weizmann house at Rehoboth (1934–1936) and the Salman Schocken house (1935–1936) and the Schocken library (1935–1936), both in Jerusalem, are important among the earlier ones. The classicism in some of his responses to them evidenced a fascination with Greek art. Soon he was given educational, institutional, and public buildings to design. His later designs in Palestine developed what has been described as "a strong indigenous character." Mendelsohn moved to Jerusalem in 1939, but within two years he had tired of "Palestine's narrowmindedness" and emigrated to the United States to settle in New York State.

America was on the verge of entering World War II, and despite a 1941 retrospective exhibition of his work at New York's Museum of Modern Art (the show moved to Chicago and San Francisco in 1942 and to Saint Louis in 1944), commissions were scarce. Having lectured on the West Coast a year or so earlier, Mendelsohn left the Hudson Valley at the end of 1945 to set up an office in San Francisco.

Beginning with the Maimonides Health Center in San Francisco (1946–1950), the final phase of his career was dominated by commissions for synagogues, community centers, and other buildings for the Jewish communities of Cleveland, Saint Louis (both 1946–1950), Grand Rapids (1948–1952), Saint Paul (1950–1954), and other cities. Many of them were realizations of ideas that Mendelsohn had "in an ecstasy of vision" when in the trenches in 1916, of which he had made tiny expressionistic sketches on whatever scraps of paper were at hand. As Arnold Whittick observed: "The ideas such as dignity, aspiration, power, repose, solemnity, and gaiety suggested by the purpose and character of buildings imply symbolic shapes to which Mendelsohn gives dramatic emphasis, while taking these shapes as subjects for aesthetic effect."[5]

NOTES

1. Von Eckardt in Macmillan.
2. "Dynamics and Function," in Conrads (1970).
3. Mendelsohn to Louise Mendelsohn, 30 May 1933, in Beyer (1967), 135–36.
4. Mendelsohn to Wijdeveld, 25 December 1945; Wijdeveld Archive, Nederlands Architectuur Instituut, Rotterdam.
5. Whittick in *Contemporary Architects*.

BIBLIOGRAPHY

Writings

Amerika, Bilderbuch eines Architekten. Berlin, 1926; many editions, e.g., New York, 1976.
"Architecture in a Changing World." *Arts & Architecture* Los Angeles 65 (April 1948).
"Architecture of Our Own Times." *AAQ* (June 1930).
Bauten und Skizzen. Berlin, 1923; *Structures and Sketches.* London, 1924.
Eric Mendelsohn (1887–1953) Portfolio. San Francisco, 1955.
Erich Mendelsohn's Amerika: 82 Photographs. New York, 1993.
Das Gesamtschaffen des Architekten, Skizzen, Entwurfe, Bauten. Berlin, 1930.

Neues Haus—Neue Welt. Berlin, 1932.
Palestine and the World of Tomorrow. Jerusalem, 1940.
Russland, Europa, Amerika: Ein Architektonischer Querschnitt. Berlin, 1929.
Three Lectures on Architecture. Berkeley, California, 1944.

Biographical

von Eckardt, Wolf. *Eric Mendelsohn.* New York, 1960; Barcelona, 1964.
Whittick, Arnold. *Eric Mendelsohn.* London, 1940; London, 1956, 1965; Bologna, 1960.
———. In *Contemporary Architects.*

Assessment

Adiv, Uriel M. "Erich Mendelsohn's Carmelstadt." *a+u* 196 (January 1987).
AForum. "Eric Mendelsohn." 86 (May 1947).
———. "Eric Mendelsohn." 98 (April 1953).
Ahronov, Ram, and Christina Toren. "The Lost Genius of Erich Mendelsohn." *Blueprint* (London) (November 1987).
AJournal. "De la Warr Pavilion, Bexhill." 82 (12 December 1935).
———. "The Universum Cinema, Berlin." 75 (9 March 1932).
Architect & Engineer. "Eric Mendelsohn, Architect AIA." (San Francisco) 176 (January 1949).
Architettura. Mendelsohn issue. 95 (September 1963).
AReview. "House at Rehoboth, Palestine." 82 (October 1937).
Badovici, Jean. *L'Architecture Vivante en Allemagne, Erich Mendelsohn.* Paris, 1932.
Baer, H. "Erich Mendelsohn: Lichtspielhaus 'Universum'." *Das Kunstblatt* (Berlin) 14 (April 1930).
Duesel, K. K. "Drie kaufhauser Schocken." *Moderne Bauformen* (Stuttgart) 27 (November 1930).
Filler, Martin. "Fantasms and Fragments: Expressionist Architecture." *ArtA* 71 (January 1983).
Jung, Karin C., and Dietrich Worbs. "Funktionelle Dynamik." *Bauwelt* 83 (17 January 1992).
Obata, Hajime. "Mendelsohn's Einstein Tower." *SpaceD* (February 1992).
Palterer, David. "Tracce di Mendelsohn: Dal disegno dell'universo." *Domus* 646 (January 1984).
Posener, Julius. *Erich Mendelsohn.* Berlin, 1968.
Rykwert, Joseph. "Mendelsohn . . . Modern Movement in Palestine." *ADigest* 46 (October 1989).
Scheffauer, Herman G. "Activist Architecture." In *The New Vision in the German Arts.* New York, 1924; Port Washington, 1971.
———. "Erich Mendelsohn." *AReview* 53 (March 1923).
Shapiro, Irving D. "Eric Mendelsohn." *AIAJ* 29 (June 1958).
Slapeta, Vladimir. "Neues bauen in Breslau." *Rassegna* 11 (December 1989).
Smith, Kendra S. "Architectural Sketches and the Power of Caricature." *JAE* 44 (November 1990).
Soergel, Hermann. *Wright, Dudok and Mendelsohn.* Munich, 1926.
Stevens, Russell, and Peter Willis. "The Competition for the Bexhill Pavilion." *AHistory* 33 (1990).
Tilson, Barbara. "Form and Function." *BuildingD* (4 December 1987).

Wendingen (Amsterdam) 3 (October 1920). The whole issue.

Zevi, Bruno. *Erich Mendelsohn: Opera Completa.* Milan, 1970; New York, 1985.

Zevi, Bruno, et al. "Universum Mendelsohniano." *Domus* 629 (June 1982).

Bibliographical

Vance: Hans Morgenthaler, A1966, 1987.

Archival

Architettura. (Approximately 1,200 Mendelsohn sketches) 79 (May 1962)–98 (December 1963).

Beyer, Oskar, ed. *Briefe eines Architekten.* Munich, 1961; *Letters of an Architect.* London, 1967.

King, Susan. *The Drawings of Eric Mendelsohn.* Berkeley, California, 1969.

Schiller, Lotte. *Eric Mendelsohn. Catalog of Sketches.* Mill Valley, California, 1970.

METABOLISM. The Metabolism group was composed of young Japanese interested in architecture who formalized a relationship in 1960. Disturbed by the inherent cultural schizophrenia of emulating if not copying European architecture, as Mayekawa and Kenzo Tange* had done when they promoted the philosophy of the Congrès Internationaux d'Architecture Moderne* (CIAM) and the architectural style of Le Corbusier,* and forgetting the early influence of Frank Lloyd Wright* and sadly ignoring four decades of work by Antonin Raymond* simply because he was not Japanese born, the young men searched out their own postwar philosophy. It drew on thoughts about organic analogy and the philosophy of Team 10, principally Aldo van Eyck* and Alison and Peter Smithson,* about growth and change, on theory and form as put forward by Louis I. Kahn,* and about the Japanese experience.

During discussions beginning in 1958 in planning a World Design Conference to be held in Tokyo in 1960, the architectural critic Noboru Kawazoe and architects Kiyonori Kikutake and Kisho Noriaki Kurokawa* found themselves sharing ideas relevant not only to architecture but also to a responsible and modern Japanese culture. Other like-minded architects who joined in discussions included Fumihiko Maki,* Masato Otake, Tange, and Arata Isozaki,* together with the graphic designer Kiyoshi Awazu. It was agreed that the group should collaborate on a manifesto to be presented at the conference. By mutual agreement, the group selected as a metaphor for their goals the word "metabolism," from the Greek meaning change, that beyond its biological connotation it has come to refer to alteration, variation, and cyclic transformation.

Their declaration was entitled *Metabolism 1960–a Proposal for a New Urbanism.* Kurokawa outlined the important elements of the proposal which as his major contribution, draws on Buddhism.

First, it reflects our feelings that human society must be regarded as one part of a continuous natural entity that includes all animals and plants. Second, it expresses our belief that technology is an extension of humanity. This belief contrasts with the Western belief that modernization is a repetition of a *conflict* between technology and humanity.[1]

Contemporarily, historian Udo Kultermann summarized: "their premise is that the human community is a living perpetuum, a continuous biological process, which does not allow for the application of rigid, schematic principles."[2] Their ideas anticipated industrial and commercial success and a resulting population dislocation and resettlement. Thus they also sought to accommodate the accelerating flow of population, materials, and information.

Preceeding the 1960 manifesto was Kikutake's megastructure proposal for floating marine cities and another for tower cities that reached into the clouds, both published in 1959 in the English language journal *Japan Architect*. Megastructures were one reaction to anticipated high population densities on the Japanese islands as well as advances in technologies. Parallel with the 1960 Tokyo conference was Tange's now famous proposal (published in 1961) for a city that stretched across Tokyo Bay between Yokohama and Tokyo. These projects introduced new ideas for urban planning and boldly announced the arrival of a new architectural force. The presence at the conference of architects from around the world, including the Smithsons from England, Louis Kahn and Paul Rudolph* from America, and Jean Prouvé* from France, ensured exposure.

The Metabolists predate London's effervescent Archigram* people, who shared the principle of extending technology in the service of architecture if less an attempt to humanize the art, facts Eurocentric observers are unwilling to acknowledge. Indeed, the role of Metabolism in the development of Archigram's initial works in 1961 needs careful investigation. Robin Boyd put it like this: "The basis of both movements is impatience with the way the world has been picking at the problem of the modern city and playing around the edge of constructional technology."[3] While serious, the Tokyo, and in particular the London, designers engaged in what historian Reyner Banham called "Fun and Flexibility."[4]

Metabolism's ideas were realized in bits and pieces. There was, for instance, Tange's Yamanashi Press and Radio Center, in Koju (1967), and his Symbol Zone megastructure of Osaka's Expo'70. Part of the acceptance of technology was to further investigate prefabrication. Space frames of various kinds were built, so were capsules for habitation that were attached to parent serving structures. They became almost symbolic of Metabolism because so many ideas for structural frames were put forth. Some were built, for example Kurokawa's capsule house hung from the Expo'70 space frame megastructure, his tiny Nakagin Capsule Tower in Tokyo (1972), and Tange's Shizuoka building, in Ginza, Tokyo (1967). Separate careers and perhaps some disillusionment saw an end to collaboration.

Drawing on Louis Kahn's idea of served and serving spaces and his unlocking of past theories and hegemonies for a new design methodology, the Metabolists and Archigram discovered yet further *means* for liberation and a joyful, unfettered architecture. This was Kahn's and their major contribution to late twentieth-century design: a release allowing a pluralistic modernism. And that is as it must be. The Metabolist course was set when in 1959 they rejected tradition.

Tange announced their position at the 1959 CIAM—and last—conference, and they took their ideas to Team 10 meetings.[5] By the 1980s the global impact of Japanese architecture was measurable thanks in large measure to the efforts of the Metabolists. In the 1990s English academic dilletante and ex-Archigrammer Peter Cook* noted: "Where do we go for the most important information? . . . that is Japan."[6]

NOTES

1. Kurokawa (1977), 27, emphasis added. See also Joan Ockman, *Architecture Culture 1943–1968* (New York, 1992), 320ff.
2. Kultermann (1967), 27.
3. Boyd (1968), 15.
4. Banham (1976), 84.
5. Kultermann (1970), 9.
6. As quoted in Botond Bognar, "Between Reality and Fiction. Japanese Architecture in the 1990s," *ADesign* 58 (May 1988), 11. See also "Japan Architecture III," *ADesign* 64 (January 1994), the whole issue; "Special Issue. Giappone." *Casabella* 58 (January 1994), the whole issue; and *GADoc,* "Japan '94," 39 (1994), the whole issue.

BIBLIOGRAPHY

Banham, Reyner. *Megastructure. Urban Futures of the Recent Past.* London, 1976.
Bognar, Botand. *The Japan Guide.* New York, 1995.
Boyd, Robin. *New Directions in Japanese Architecture.* London, 1968.
Jencks, Charles. *Modern Movements in Architecture.* Harmondsworth, 1973.
Kawazoe, Noboru. "The City of the Future." *Zodiac* (Milan) 9 (1962).
Kultermann, Udo, ed. *Kenzo Tange 1946–1969 Architecture and Urban Design.* Zurich, 1970.
———. *New Architecture in Japan.* Tübingen, 1967.
Kurokawa, Kisho. *From Metabolism to Symbiosis.* London, 1992.
———. *Metabolism in Architecture.* London, 1977.
Kurokawa, Kisho, and Kiyonori Kikutaki. [Articles in] *ADesign* 34 (December 1964).
Nitschke, Günter. *From Shinto to Ando. Studies in Cultural Anthropology in Japan.* Berlin, 1993.
Ross, Michael Franklin. *Beyond Metabolism: The New Japanese Architecture.* New York, 1978.
Stewart, David B. *The Making of a Modern Japanese Architecture 1868 to the Present.* Tokyo, 1987.
Suzuki, Hiroyuki, et al. *Contemporary Architecture of Japan 1958–1984.* New York, 1985.
Watanabi, Hiroshi. *Amazing Architecture from Japan.* Tokyo, 1991.

Bibliographical

Vance: Michael Hugo-Brunt, A1447, 1978; Mary Vance, A1770, 1987; and James Noffsinger, "Lesser Published Japanese Architects" series, 1981–1983.

(MARIA) LUDWIG (MICHAEL) MIES VAN DER ROHE. 1886 (Aachen, Germany)–1969. After attending the Aachen Trade School, Mies worked in his

father's stonemasonry business and then drafted in a local stucco ornament company. From 1908 to 1912 he worked in Berlin as a draftsman for Bruno Paul and then for Peter Behrens.* He was otherwise self-taught in architecture. His independent architecture practice began in The Hague, Holland (1912–1913), followed by a practice in Berlin (1913–1938). During this period, Mies was an organizer of exhibitions for the November Group (1921–1925); a founder of the Berlin "Ring of Ten," in charge of Deutscher Werkbund exhibition of "The Dwelling," in Weissenhof, Stuttgart (1926–1927); vice president of D. Werkbund (1926–1932); a director of the Bauhaus at Dessau and in Berlin (1930–1933), and the head of Werkbund's Berlin Building Exhibition (1931). Anxious to leave Germany and Europe, in 1937 he traveled to England and America where he visited Frank Lloyd Wright,* and soon was invited to be the director of the architecture school at the Armour (now Illinois) Institute of Technology (IIT) in Chicago (1938–1958). He began a new practice that included a master plan of IIT's new campus and there erected a number of buildings (1942–1956). In seeing his diverse commissions to reality, he collaborated with a number of architectural firms. Mies received numerous national and international awards and honors including Gold Medals from the RIBA (1959) and AIA (1960).

☙

One of this century's most notable architects, Mies's background was in the construction industry and with architects and industrial designers Bruno Paul and Behrens, with whom he became disgruntled preferring the Dutch *bouw-meester* Berlage. But he had worked on detailing the iron structural frame and full height glass wall of Behrens's design for the AE-G Turbine Factory, in Berlin (1909). Mies was to later note that when he began to seriously contemplate a career as an architect

it was the industrial and other purely technical buildings that were the greatest achievements of the period. . . . [T]here could be no architecture of our time without the prior acceptance of . . . new scientific and technical developments. . . . Today [1964], as for a long time past, I believe that architecture has little or nothing to do with invention of interesting forms or with personal inclinations."[1]

Mies's contribution to European architecture began after Dutch and German promotions of Wright, after the heady years of Dutch De Stijl,* and during the rise of German Expressionism. His inventiveness was introduced by a series of five projects from 1919 to 1923, two for skyscrapers of glass (inducing light reflection and effect of depth), one a concrete-and-glass seven-story office building (realized more or less by Bruno Paul for the Sinn Department Store, 1925–1927), and two houses. Another skyscraper had an articulated triangular plan; the other was in plan made of circles and meant for the *Chicago Tribune* competition (1922). The influence of American factory architecture (noticed by Berlage and emulated by Behrens and Walter Gropius*) over a decade earlier is patent in the steel-and-glass detailing and concrete structure. The villa project

of 1923 was an exploded Wrightian plan reduced to brick-and-glass planes with flat roofs.

The German Pavilion at the 1929 World Exhibition in Barcelona carried on from the brick villa but furthering a spare, reductive manner (see Plate 16). It was and is a material summation of Mies's pre-American philosophy, outlined in generality by Kevin Harrington: space and light were Mies's central metaphor of "chaos and order." Steel and glass symbolized order from "the most common and chaotic" materials.[2] For it he designed the elegant Barcelona chair, stool, and ottoman (see Plate 17).

The small information pavilion, designed and constructed within six months, was soon dismantled; the parts and marble were returned to Germany to decorate the houses of various bureaucrats and generals. Powerful in its abstraction, dynamics of plane and space, and utter simplicity, it made a lasting impact on modernism. It was reconstructed (1985–1986) at the original site from Mies's original drawings available only after the fall of East Germany. During the early 1930s Mies had few commissions and therefore engaged in another series of projects based on the Barcelona pavilion, mainly houses.

The Nazi government closed the Bauhaus but Mies, unwilling to bow to coercion, obtained a reversal of the decision. With that victory he was then morally free to close the school.[3] As a result even fewer commissions came his way. Opportunities to reside permanently in the United States came with a visit. He refused the chair of the Architecture Department at Harvard University but accepted to direct what became the IIT School of Architecture and, possibly as an inducement, to design a new campus and some of its buildings. The result was a series of buildings that announced the highly formal, axially symmetrical brick, steel, and glass designs that dominated his work for the remainder of his career. The first built at IIT were almost replicas in form and *detail* of the steel, brick, and glass buildings constructed for an iron works in Cologne by Albert Fischer (1927).[4]

His crowning achievement on the IIT campus was Crown Hall (1950–1956) of steel mullions, posts, and exposed up-ended roof beams with full-height glass walls encompassing an open space. The Crown Hall formula was a theme oft repeated: the New National Gallery, in Berlin (1962–1968), where the up-ended beams were replaced by a steel box space frame; or the Bacardi Administration Building, in Mexico City (1957–1961), where the space frame was enlarged as a second floor; or the impeccable Farnsworth house, beside the Fox River at Plano, Illinois (1945–1950), where an open plan was between two concrete slabs rimmed by steel and supported on only eight I-beam posts. The verandah was another, but lower, plane, and the steps' treads were thin slabs with no apparent risers (see Plate 20). Wright's houses tended to blend with the natural environment; the Farnsworth house is a contrast. When inside, the glass walls allow a person to see *all* of the exterior; one is inside a building yet *within* the landscape. A Wright house is of the landscape. Depending on one's philosophical position, each acknowledged and enhanced our intellectual appreciation of nature.

After a lapse of three decades, the tall building was to again test Mies. The dynamic interplay of reflected or rejected light, of plane as interior floors and partitions, or of the exterior as a flat or curvilinear wall as proposed in the 1920s was abandoned. In its place was a formal, tactile, rectilinear box extruded vertically, relatively free at ground level, capped by a textured facade containing mechanical services. The formal announcement was 860 Lake Shore Drive Apartments, Chicago (1948–1951, sans top service floor). The refinement was the Seagram Building, in New York City (1954–1958, in association with Philip Johnson*). The Chicago and New York buildings also set a precedent in their setback at ground level. Again, his tall building formula was often repeated.

Indeed, it was the formula of plan and facade and their easy imitation that made him one of the most copied (directly or indirectly) architects. Perhaps the best exponents in America were the firms of Skidmore, Owings, and Merrill* and C. F. Murphy Associates, although it needs to be remembered that Pietro Belluschi* had set the aesthetic standard for tall buildings.

To professional and lay audiences, Mies's ascetic aesthetic was seen as the *ultimate,* irreducible refinement of the European machine aesthetic as well as, in its pristine condition, a denial of human participation. Some critics and architects could see plainly the result of its limiting universality, and they swiftly reacted: critics such as Lewis Mumford, architects such as Eero Saarinen* and Louis I. Kahn,* and the engineer Pier Luigi Nervi.* As an example of a reaction, as early as 1960, historian James Fitch publicly stated what many felt: the *size* of Mies's talent was immense but the *shape* was "Platonically narrow and restricted."[5] Historian Donald Hoffmann observed that the "high abstraction" of Mies's buildings "often looks grim and void. Relentless grid patterns . . . anonymous . . . bureaucratic, rather than any noble aspirations for individual or communal life."[6] Mies's buildings were an easy target.

That sense of a relentless and imposing presence was first disclosed in his competition design for the Reichsbank, in Berlin (1933). Axially symmetrical on principal facades and in all parts of the plan, the project foreshadowed his future approach. After 1938 Mies took a new path to architecture, rejecting much of the three-dimensional dynamism of his early projects and buildings. Those products are patent, and we can hearken to Mies's own words about Wright's stimulus:

The more deeply we studied Wright's creations, the greater became our admiration for his incomparable talent, for the boldness of his conceptions, and for his independence in thought and action. The dynamic impulse emanating from his work invigorated a whole generation.[7]

The "dynamic impulse" was manifest in the spatial interplay of open plans, thrusting planes, asymmetry, and articulated forms. What might have occurred if Mies had not taken the new constricting path is beyond conjecture. However, one can say with conviction that the conception of a total, flexing architecture

as revealed in the 1920s and early 1930s, had given way to axiom, symmetry, and static monumentality.

Mies seldom verbalized his philosophy, but in 1963 as a clear summation he said: "Construction is the truest guardian of the spirit of the times because it is objective and is not affected by personal individualism or fantasy." (He therefore rejected all Wright's architectural and social propositions and most of the tenets of twentieth-century Modernism.) Further and more emphatically, Mies, the great minimalist, said,

The physicist Schroedinger said of general principles, "the creative vigor of a general principle depends precisely on its generality," and that is exactly what I mean when I talk about structure in architecture. It is not a special solution. It is a general idea.[8]

Less abstract was Mies's language of construction. His method of detailing was exquisite, fully responsive to shop fabrication of units for site construction. His visual documents were spare, neat, exact, a design vocabulary in themselves and fortunately often published (for example, *ARecord,* 1963).

Biographer Franz Schulze concluded, in part, that Mies's "place in history is assured not so much by the infallibility of his thinking as by the subtlety and refinement of his art." Infallibility? Schulze continued: "Pluralistic as world architecture is near the end of the twentieth century, it is made more so, paradoxically, by the memory of Mies's singlemindedness."[9]

NOTES

1. As quoted in Blaser (1972), 10.
2. Kevin Harrington, in Richard Guy Wilson, *The AIA Gold Medal* (New York, 1984).
3. Mies in discussion with Donald Leslie Johnson, 1966. Some of this essay is also based on discussions with Earl Bluestein, a former student, an architect and associate of Mies.
4. As reported to U.S. professionals in Shepard Vogelesang, "Architect versus Engineer," *AForum* 51 (September 1929), 371–80, a summary of Fritz Schupp and Martin Kremmer's book of the same name (Berlin, 1929).
5. James Marston Fitch, *Architecture and the Esthetics of Plenty* (New York, 1961), 170.
6. Hoffmann in *Contemporary Architects.*
7. Mies (1946), written in 1940 for an unpublished Museum of Modern Art, New York, exhibition catalog.
8. Mies (1963), 149.
9. Schulze (1985), 325.

BIBLIOGRAPHY

Publications by, about, or significantly including Mies number in the hundreds. The abbreviation MvdR for Mies van der Rohe is used below.

Writings

"Architectural Details 1. MvdR." *ARecord* 133 (October 1963).
"Hochhausprojekt für Bahnhof Friedrich-Strasse in Berlin." *Frühlicht* 1 (1922); reprinted in Peter Carter (1974).

"Introduction to Issue Devoted to 'Werkbundausstellung die wohnung Stuttgart 1927'."
 Die Form (Berlin) 9 (1927).
"A tribute to . . . Wright." *College Art Journal* (New York) 6 (Autumn 1946).
"Where Do We Go from Here?" *Bauen und Wohnen* (Berlin) 15 (11, 1960).
With others. *Bau und Wohnung.* Stuttgart, 1927.

Biographical

Hochman, Elaine S. *Architect of Fortune. MvdR and the Third Reich.* New York, 1989.
Hoffmann, Donald. In *Contemporary Architects.*
Lane, Barbara Miller. *Architecture and Politics in Germany, 1918–1945.* Cambridge, Massachusetts, 1968.
Schulze, Franz. *MvdR. A Critical Biography.* Chicago, 1985.

Assessment

Abercrombie, Stanley. "Barcelona Rebirth." *Interior Design.* (New York) (August 1986).
AForum. "Farnsworth House." 95 (October 1951).
Anderson, Stanford. "Behrens's Changing Concept." *ADesign* 39 (February 1969).
Behrendt, Walter Curt. "Skyscrapers in Germany." *AIAJ* 11 (Summer 1923).
Bier, Justus. "MvdR's Reichspavillon in Barcelona." *Die Form* (Berlin) 4 (15 August 1929).
Bill, Max. *MvdR.* Milan, 1955.
Blake, Peter. *Masters of Modern Architecture.* New York, 1960.
Blaser, Werner. *After Mies. MvdR. Teaching and Principles.* New York, 1977.
———. *MvdR. The Art of Structure.* Zurich, 1965; 2d ed., *MvdR.* London, 1972; New York, 1994.
———. *MvdR. Furniture and Interiors.* Woodbury, New York, 1982.
———. *MvdR. Principles and School.* Basel, 1977.
Bonta, Juan Paul. *An Anatomy of Architectural Interpretation . . . Barcelona 1929.* Barcelona, 1975.
———. *MvdR and His Work.* Barcelona, 1975.
Boyken, I. "MvdR and Egon Eiermann: The Dictate of Order." *JSAH* 49 (June 1990).
Carter, Peter. *MvdR at Work.* New York, 1974.
Cohen, Jean-Louis. *MvdR.* Paris, 1994.
Dal Co, Francesco. *Mies Reconsidered.* Chicago, 1986; 2d ed., *Figures of Architecture and Thought.* New York, 1990.
Dearstyne, Howard. "Mies at the Bauhaus . . . Student Revolt and Nazi Coercion." *Inland Architect* (Chicago) 13 (August 1969).
Domer, D. "MvdR and Visual Training at [IIT]." *Structurist* (Saskatchewan) 31–32 (1991–1992).
Drexler, Arthur. *ludwig mvdr.* New York, 1960.
Evans, Robin. "MvdR's Paradoxical Symmetries." *AA Files* 19 (1990).
Glaeser, Ludwig. *Ludwig MvdR: Furniture and Furniture Drawings.* New York, 1977.
———. In Macmillan.
Graeff, Werner. "Concerning the So-Called *G* Group." *Art Journal* (New York) 23 (Summer 1964).
Hilberseimer, Ludwig. *MvdR.* Chicago, 1956.
James, Warren A. "Barcelona." *PA* 67 (August 1986).

Johnson, Philip. "The Berlin Building Exposition of 1931." *Shelter* (Philadelphia) (January 1932).
———. *MvdR.* New York, 1947; reprint, 1978; 2d ed., 1953.
Jordy, William H. "The Aftermath of the Bauhaus in America: Gropius, Mies, and Breuer." *Perspectives in American History* 2 (1968).
———. In Lampugnani.
van Kooten, Toos. "The Kroller-Mullers." *Rassegna* 15 (December 1993). The whole issue.
Mertins, Detlef, ed. *The Presence of Mies.* New York, 1994.
MvdR European Works. London, 1986.
Neumeyer, Fritz. *The Artless Word. MvdR on the Building Art.* Berlin, 1986; MIT Press, 1991.
Pawley, Martin, and Yukio Futagawa. *MvdR.* New York, 1970.
Pickard, J. "Mies' Miraculous Survivor." *AReview* 193 (April 1993).
Schulze, Franz. *MvdR. Interior Spaces.* Chicago, 1982.
Schulze, Franz, ed. *MvdR. Critical Essays.* New York, 1989.
Spaeth, David. *MvdR.* New York, 1985.
Tegethoff, Wolf. *MvdR. The Villas and Country Houses.* New York, 1985.
Wingler, Hans Maria. *The Bauhaus. Weimar, Dessau, Berlin, Chicago.* MIT Press, 1969.
Winter, John. "Follow Mies." *AReview* 154 (July 1973).
———. "Mies Dominion." *AReview* 151 (January 1972); and "The Measure of Mies." 151 (February 1972).
Zukowsky, John, ed. *Mies Reconsidered . . . and Disciples.* Chicago, 1986.

Bibliographical

Grady, James. *MvdR.* Charlottesville, 1963.
Spaeth, David. AAAB, no. 13, 1979.
Vance: Robert Harmon, A933, 1983, and A102, 1979; Mary Vance, A1829, 1987.

Archival

Glaeser, Ludwig. *Ludwig MvdR. Drawings in . . . the Museum of Modern Art.* New York, 1969.
The MvdR Archive. Arthur Drexler and Franz Schulze eds. and annotators. 4 vols. *Part I: 1907–1938.* 6 vols. New York, 1988–1989. *Part II: 1938–1969.* Franz Schulze and George Danforth, eds. 14 vols. New York, 1989.
Protech, Max. *MvdR Drawings from the Collection of A. James Speyer.* Catalog. New York, 1986.
[Written works.] Neumeyer (1986, 1991).

CHARLES W(ILLARD) MOORE. 1925 (Benton Harbor, Michigan)–1993. A bachelor of architecture degree from the University of Michigan (1947) qualified Moore for the Army Corps of Engineers (1948–1950) during the Korean War. After the war, he taught at the University of Utah, in Salt Lake (1950–1952), and then earned a doctorate in architectural history from and also taught at Princeton University (1958), where Louis I. Kahn* was teaching design. After taking up a position at the University of California, Berkeley (1959–1962), the MLTW partnership was formed in San Francisco (1962–1970) with Donlyn Lyndon and William Turnbull, Jr., fellow students at Princeton, and Richard R.

Whitaker. He was chair of the Berkeley school (1962–1965). Upon Paul Rudolph's* retirement as head of architecture at Yale University, Moore accepted the position (1966–1971) and remained teaching design until he again taught at the Berkeley school. Beginning in 1978 he became principal of Moore, Rubble, Yudell & Partners as well as the Urban Innovations Group, both in Los Angeles. Moore spent his last years at the University of Texas, Austin. He has received many prizes and honors including the AIA Gold Medal (1991).

<center>❧</center>

Moore's own house in Orinda, California (1964–1965) was a delightful interpretation of Kahn's ideas of space and structure articulation with sliding exterior walls and an independent building within a building defining separate functions. The idea of one building within another was used by Oswald Mathias Ungers for the German Architecture Museum, in Frankfurt (1979–1984), where a three-story, neoclassical villa (1890) was gutted and replaced by a white building within. In the 1960s Moore designed the Kresge College, at the University of California at Santa Cruz (1965–1974), which is a village with a main "street" off which are a series of separate structures of obvious similarity all in white with spots of primary colors in a semiforest of dark green. It was his first use of a double exterior wall to invoke the idea of transition and separateness.

The Piazza d'Italia (1975–1978 with the Perez Group) was a controversial competition in which the winner and the runner-up joined talents to create a piazza for the Italian community.[1] A map of Italy was in outline relief in plan with a water fountain suggesting the sea. The map intrudes upon concentric circles that are partly enclosed with screens of Roman columns and entablatures that are behind free-standing, plain trabeated walls. In many ways, it presages the ideas of Robert Venturi* about the past, and, like Venturi, it does so in a flippant, close to derogatory, way. The piazza is enhanced with modern elements and bright colors. Yet to be completed, the remainder of the area is forlorn, surrounded by parking lots and a hulking office building on one side. Called both a monstrosity and a masterpiece it is Moore's most widely known work, and he loves it for its freedom from orthodoxy and its sheer exuberance of design. It best displays his natural talents.

While the core of his philosophy comes from Kahn, Moore nonetheless strived to encompass much that is of the contemporary architectural scene. Sometimes he was a leader, as with his own house at Orinda or the Xanadune building project for Saint Simon Island, in Georgia (1972), where the building's exterior walls take on the character of berms and a central space organizes the whole. Sometimes he followed, as with the regressive quasi historicism of the Tegel Harbor Housing in Berlin (1992, with Rubble and Yudell), which appears to take something from a typical nineteenth-century German country house inflated and particled.

Moore was commissioned to design an expansion to the Beverly Hills Civic Center (1982–1992, with A. C. Martin Associates). The result was additions and separate buildings that took much from the original Spanish revival City Hall

(1932) and with a Spanish-styled cortile of an updated 1930s *moderne* in soft creams and accents in pale pinks and turquoise. But there are elements of a Baroque fetishistic character that approach the Hollywoodish vulgarity of most of Michael Graves's latest work, such as that at Disney World, Florida (1990).

Moore and Chicagoan Stanley Tigerman are of a comparable mold. This can be seen in their style and their easy—perhaps too easy—flair and a similar humor if Moore's is the more ironic. While Tigerman's architecture is slick and refined, it is less theoretically persuasive, perhaps because his designs appear to be more derivative, at least to the more astute.

NOTE

1. On the roles of the various architectural firms, see Toher (1985).

BIBLIOGRAPHY

Writings

"After a New Architecture . . . Chimera." *Oppositions* 3 (May 1974).
"Architecture: Art and Science." *AIAJ* 19 (June 1965).
"Chaos as Architecture . . . Venturi." *Art in America* 58 (July 1970).
"Complexity Becomes the Order of the Day." *AIAJ* 74 (May 1985).
"Hadrian's Villa." *Perspecta* 6 (1960).
Moore Ruble Yudell: Houses & Housing. Oscar Riera, ed. Rockport, Massachusetts, 1994.
"Plug It In, Rameses." *Perspecta* 11 (1967).
"Sagamore." *JAE* 167 (Summer 1961).
"Southernness." *Perspecta* 15 (1975).
Transition. "Interview One: Charles Moore." 2 (June 1981).
The Yale Mathematics Building Competition. New Haven, 1974.
"You Have to Pay for the Public Life." *Perspecta* 9–10 (1965).
"Where are We Now, Vincent Scully?" *PA* 56 (April 1975).
The Work of Charles W. Moore. Toshio Nakamura, ed. *a+u.* Extra edition (May 1978).
With Gerald Allen. "Church Street South Housing." *Architect's Yearbook* (London) (1971).
————. *Dimensions. Space, Shape and Scale in Architecture.* New York, 1976.
With Gerald Allen and Donlyn Lyndon. *The Place of Houses.* New York, 1974.
With Kent Bloomer. *Body, Memory, and Architecture.* New Haven, 1977.
With Jane Lidy. *Water and Architecture.* London, 1994.
With Donlyn Lyndon. *Chambers for a Memory Palace.* MIT Press, 1994.

Biographical

Aujourd'hui. "Dossier: Charles W. Moore." 184 (March 1976). The whole issue.
Littlejohn, David. *Architect. The Life and Work of Charles W. Moore.* New York, 1984.
Spreiregen, Paul. In *Contemporary Architects.*

Assessment

Abitare. "Hood Museum of Art." 247 (September 1986).
ADesign. "Piazza d'Italia." 50 (5/6, 1980).
AForum. "Concrete Cascade in Portland." 125 (July 1966).
Allen, Gerald. "Biloxi Library." *ARecord* 163 (May 1978).

————. *Charles Moore.* New York, 1980.

Archer, B. J., ed. *Houses for Sale.* New York, 1980.

Aujourd'hui. "Habitations et Villages . . . [etc.]." 138 (April 1967).

————. "Moore Is More." 184 (March 1976). Anthology.

Cheek, L. W. "A Great Deal Going on. . . ." *AIAJ* 78 (June 1989).

Cook, John W., and Heinrich Klotz. *Conversations with Architects.* London, 1973.

Diamonstein, Barbaralee, ed. *American Architecture Now.* New York, 1980.

Dreyfuss, John. "Architecture. Charles Moore." *ADigest* 36 (March 1980).

Filler Martin. "House Vernacular." *Art in America* 68 (October 1980).

————. "Magic Fountain. Piazza d'Italia." *PA* 59 (November 1978).

Futagawa, Jukio, ed. *MLTW: Houses, 1959–75.* Tokyo, 1975.

————. *Moore, Lyndon . . . Sea Ranch.* Tokyo, 1970.

Gebhard, David. "Pop Scene . . . Faculty Club." *AForum* 130 (March 1969).

Goldberger, Paul. "Architecture: Charles Moore." *ADigest* 45 (June 1988).

Interiors. "On-Campus Living." 134 (November 1974).

Jencks, Charles, and Nathan Silver. *Adhocism. The Case for Improvisation.* New York, 1972.

Jodidio, Philip. "Tout Oser." *Connaissance des Arts* (Paris) 379 (September 1983).

Johnson, Eugene J., ed. *Charles Moore. Buildings & Projects 1949–1986.* New York, 1986.

Misawa, Hiroshi, et al. "Charles W. Moore." *JapanA* 112 (September 1965).

Nesmith, L. "Civic Collaboration." *AIAJ* 80 (September 1991).

PA. "Condominium at Sea Ranch." 53 (May 1966).

————. "Making the Ordinary Extraordinary." 57 (February 1976).

————. "PA Profile." 68 (October 1987). Anthology.

————. "P/A Design Citation." 50 (January 1969).

————. "P/A Thirteenth Annual Design Awards." 47 (January 1966).

Pearson, C. A. "About Face." *AReview* 182 (March 1994).

ProcessA. "Zimmerman House." 7 (1978).

Schmertz, Mildred. "Two Houses." *ARecord* 161 (June 1977).

Schulze, Franz. "Chaos as Architecture." 58 (April 1970).

Scott Brown, Denise. "Team 10 . . . Architectural Theory." *American Institute of Planning Journal* 33 (January 1967).

Stern, Robert. *New Direction in American Architecture.* London, 1969.

————. "Towards an Architecture of Symbolic Assemblage." *PA* 56 (April 1975).

Toher, Jennifer C., In *The Critical Edge,* edited by Tod A. Marder. New Brunswick, New Jersey, 1985.

Truppin, A. "With a Career." *Interiors* 147 (September 1987).

Werk. "Robert Venturi, Charles Moore." 69 (May 1982).

Zabel, Craig. *Palmer Museum of Art.* University Park, Pennsylvania, 1993.

Bibliographical

In Littlejohn (1984).

Vance: Marianne Dale, A130, 1979; F. Louis de Malave, A1344, 1985.

N

PIER LUIGI NERVI. 1891 (Sondrio, Italy)–1979. Nervi studied civil engineering at Bologna and graduated in 1913. His ten-year apprenticeship in the Bologna office of the Società per Costruzioni Cementizie (1913–1923) was interrupted by World War I, during which he served in the engineers (1915–1918). In 1923 he moved to Rome to establish the architectural, engineering, and construction firm of Nervi and Nebbiosi (1923–1932); after that, he was senior partner in the firm of Nervi and Bartolia (1932–1960) until he formed Studio Nervi with his three sons, Antonio, Vittorio, and Mario (1960–1979). He was a professor of construction technology and technique of construction in the Architecture School of the University of Rome (1947–1961). With a practice extending to the United States, South America, the Middle East, Africa, and Australia, Nervi received many international honors and awards, including the coveted Gold Medals of the RIBA (1960), the AIA (1964), and the French Academy of Architecture (1971).

✧

Nervi is unequivocally recognized as the most influential designer in reinforced concrete of the twentieth century. Early influences upon him are obscure, but his extended stay in the Società per Costruzioni Cementizie must have been important. There seems to be little of note in his oeuvre in the first six years of his Rome practice, but in 1927 he won a competition for the 30,000-seat Giovanni Berta Stadium in Florence (1929–1932). His elegant, innovative, curved concrete structure (completed 1932) consisted only of frankly exposed structural elements and it established his reputation. Also in 1932 he designed

(but did not build) circular aircraft hangars in steel and reinforced concrete, forerunners of the delicate weblike concrete hangars he built at Orvieto (1936) and Orbetello (1941) for the Italian Air Force.

These structures were his first experiments with roofs built up from a series of load-bearing joints that would eventually generate the magnificent prefabricated roof of Salone B of the Turin Exhibition Hall (1948–1949), a space that Ada Louise Huxtable has called "one of the most impressive interior[s] of the century."[1] The structures also demonstrate that Nervi was in the vanguard of innovative concrete engineering, marching only a little behind the Frenchman Eugène Freysinnet (1879–1962), famous for his bridges and vast parabolic dirigible hangars at Paris-Orly (1916–1924)—bound to have influenced Nervi's airplane hangars—and the Swiss bridge builder Robert Maillart (1872–1940), whose Cement Pavilion at the Provinces Exhibition in Zurich (with Hans Leuzinger, 1939) was also a parabolic structure.

Beyond what had become orthodox concrete construction, Nervi conceived in the early 1940s of lightweight steel grids held together by very thin layers of concrete—*ferro-cimento*—whose lightness and flexibility would enable him to produce structures of strength and gracefulness hitherto unimagined using conventional technology. So complex was their structural behavior that they could not be calculated by mathematical analysis; Nervi had developed a design system based upon stressed perspex models under polarized light. Several unrealized projects were followed by buildings that vindicated the material *and* the design approach—three venues for the 1960 Rome Olympic Games: the Palazzetto dello Sport (1957, with Annibale Vitellozzi); the Palazzo dello Sport (1959, with Marcello Piacentini), and the Flaminio Stadium (1959, with Antonio Nervi). The rational structure of the Palazetto is so lucidly expressed that one can almost see the loads being gathered and guided to the ground in an evocation of the fan vaulting of the late middle ages. The building is crowned with a sinuous, folded-plate roof. Unfortunately, the same clarity is obscured in the Palazzo by a surrounding colonnade, perhaps at the insistence of the architect.

Nervi's repertoire was not limited to *ferro-cimento*. In 1960 he designed and built in a very short time the Palace of Labor in Turin. Its prefabricated roof consists of tapered steel beams radiating from sixteen tall concrete mushroom columns to frame a glass roof. The perimeter of the vast light and airy space is enclosed by a glass curtain wall. The structural systems of the Pirelli Tower, in Milan (with Gio Ponti, 1955–1959), and the Place Victoria Tower, in Montreal (with Luigi Moretti, 1962–1966), are both innovations in concrete and differ from each other. In his later commissions, Nervi often collaborated with others: for example, with Marcel Breuer* and Bernard Zehrfuss on the Paris Headquarters of UNESCO (1957); with Gio Ponti and others on the Pirelli Building; and with Pietro Belluschi,* McSweeney, Ryan, and Lee on Saint Mary's Cathedral, in San Francisco (1971); and with Harry Seidler.

Nervi believed that

a technically perfect work can be aesthetically expressive, but there does not exist, either in the present or in the past, a work of art which is accepted and recognized as excellent from an aesthetic point of view, which is not excellent from a technical point of view. Good technology seems to be a necessary, although not a sufficient condition for good architecture.[2]

For him, design was a tripartite process: architectural concept, structural analysis, and construction technology held in near-perfect balance. One ramification of that fundamental belief was his espousal of the "designer-builder" view of the architect—in one sense, a medievalist anachronism—so that the architect retained control of the work until it was completed. It was therefore inevitable that he formed a construction company, employing highly trained technicians to see to the details, to build his designs. Given Nervi's formal educati n and his early office experience, the pedantic may argue that he was not an architect, but an engineer. The point, as one biographer remarks, is academic: by looking at his buildings one realizes that they are articulated masterpieces. Their "sweep and scale" are bold, imaginative, in some cases radical experiments.[3] Charles Jencks believes that, with a few exceptions, Nervi's architecture was

visually convincing enough to persuade many that a modest and inquiring approach towards function and [what Nervi called] 'the laws of nature' (in his case structure and logistics) would result inevitably in 'majestic eternity' or at least beauty.[4]

NOTES

1. Huxtable (1960) as quoted by Menendez in Wilkes.
2. As quoted in Macmillan.
3. Henry J. Lagorio and Carlo Pelliccia in Richard Guy Wilson, *The AIA Gold Medal* (New York, 1984).
4. Charles Jencks, *Modern Movements in Architecture* (Harmondsworth, 1985), 73.

BIBLIOGRAPHY

Writings

Aesthetics and Technology in Building. Cambridge, Massachusetts, 1966.
Art o Scienza del Costruire. Rome, 1954.
Concrete and Structural Form. London, 1955.
Costruire Corretamente. Milan, 1955; *Structures* New York, 1956.
"The Influence of Reinforced Concrete." *AandA* 78 (December 1961).
El Lenguaje Arquitectonico. Buenos Aires, 1950.
New Structures. London, 1963.
Nuovo Strutture. Milan, 1963.
"Piccole onde in ferro-cimento." *Rassegna* 24 (December 1985).
"The Place of Structure in Architecture." *ARecord* 120 (July 1956).

Biographical

Argan, G. C. *Pier Luigi Nervi.* Milan, 1955.
Huxtable, Ada Louise. *Pier Luigi Nervi.* London, 1960.
Pica, Agnoldomenico. *Pier Luigi Nervi.* Rome, 1969.

Assessment

AForum. "Powerful Tower, Delicate Shell . . . [Pirelli Building]." 114 (February 1961).
———. "UNESCO's Cheerful New Home." 109 (December 1958).
Architect and Building News. "Olympic Buildings in Rome." (London) 217 (6 January 1960).
———. "Two Hangars near Rome." (London) 196 (26 August 1949).
ARecord. "St Mary's Cathedral, San Francisco." 150 (September 1971).
———. "Three Stadiums by Nervi." 124 (December 1958).
AReview. "Nervi in Sydney." 136 (November 1964).
Argan, G. C. "The Architecture of Nervi." *Architects' Yearbook* 6 (1955).
Blake, Peter. "Concrete Parthenon." *AForum* 112 (May 1960).
Builder. "Buildings for the 1960 Olympic Games, Rome." (London) 199 (26 August 1960).
CanadaA Yearbook. "Place Montral, Victoria." (1965).
Desideri, Paolo, et al., eds. *Pier Luigi Nervi.* Bologna, 1979.
Domus. "Nervi a New York." 400 (March 1963).
Macci, Loris G. "Civic Stadium of Florence." *L'Arca* (Milan) 38 (May 1990).
Menendez, Francisco. In Wilkes.
Pica, Agnoldomenico. *Architectural Engineering: New Structures.* New York, 1964.
———. *Architettura Moderna in Milano.* Milan, 1964.
———. *Pier Luigi Nervi.* Rome, 1969.
ProcessA. "Pier Luigi Nervi." (April 1981). The whole issue.
Rassegna. [Pier Luigi Nervi]. 6 (April 1954). The whole issue.
RIBAJ. "Presentation of Royal Gold Medal . . . Nervi." 67 (May 1960).
Rogers, Ernesto N. *The Works of Pier Luigi Nervi.* Milan, 1957.
Salvadori, Mario G. In Macmillan.

Bibliographical

Vance: Florita Z. De Irizarry, A1140, 1984.

RICHARD J(OSEF) NEUTRA. 1892 (Vienna, Austria)–1970. After serving in the Austrian army (1914–1917), Neutra obtained a diploma in architecture from Vienna's Technische Hochschule (1918). He worked in Switzerland and Germany (1919–1921), including in the office of Erich Mendelsohn* (1921–1922). A friendship with Adolf Loos* no doubt was one factor that led Neutra to emigrate to the United States (1923) where he worked first in New York, then in Chicago (1924) seeking out Louis Sullivan and working for (John Augur) Holabird and (Martin) Roche (1923–1924). Immediately after meeting Frank Lloyd Wright* at Sullivan's funeral, he went to work for Wright (1924–1925). Encouraged by his friend and Viennese colleague Rudolf Schindler (who had served his American apprenticeship under Wright from 1917 to 1920 in Wisconsin and Southern California) Neutra moved to Los Angeles in 1925 and shared offices and often collaborated with Schindler (to 1929). Together they entered the 1927 League of Nations competition. He also collaborated with urban planner Carol Aronovici (to ca. 1931).[1] His independent practice began in 1927 and a partnership was formed with Robert E. Alexander (1949–1958)

and Neutra's son Dion (1965–1970). Neutra received many national and international awards, degrees, and honors, including doctorates and the Cuban Association of Architects Gold Medal (1958), the AIA Gold Medal (posthumously, 1977), and the Gold Medal, Ethiopia (1967).

☞·

In 1926 Schindler, Aronovici, and Neutra formed the Architectural Group for Industry and Commerce to see but one work completed: the Jordinette Apartments, in Los Angeles (1927), a mix of De Stijl* and Soviet Constructivism. Although the work of Schindler and Neutra has much in common and although their experiences and inspirations were rather similar, Neutra possessed an élan and sophistication not found in his friend's designs.

Thereafter Neutra's work was much influenced by Mendelsohn, especially his interpretation of Wright, and his studies of De Stijl. The general European view of his work can be outlined by historian Jürgen Joedicke's observation that, if Neutra's buildings pre-1939 had been built ten years earlier, they "would have caused a sensation."[2] No doubt. But none of his European predecessors *or* contemporaries displayed Neutra's elegant refinement of scale, proportion, and material. This was especially true of his crowning achievement before the mid-1930s, the Health house for Dr. Phillip Lovell, in Los Angeles (1927–1929). Steel framed and finished with stucco and glass and drawing much from Wright and Schindler, it has been described as the "apotheosis of the International Style."[3]

As an independent practitioner in the 1930s, Neutra's fascination with industrial products saw the creation of many buildings finely detailed in steel and glass; for instance the Von Sternberg (later Ayn Rand) house in Northridge, California (1935), where ribbed sheet steel formed exterior walls and fencing while the bathroom walls were full-height mirrors. The dynamics of Wright's open plans and spatial interpenetrations were knitted to the plain, white European aesthetic in nearly all of Neutra's domestic works throughout the 1950s.

The apogee of his career came in the late 1940s with a series of houses. The most refined were those for Kaufmann in Palm Springs, California (1946–1947), and for Tremaine in Montecito, California (1948). Together with the Lovell Health house, these are Neutra's best-known buildings and with good reason. All are a sophisticated interplay of horizontal and vertical planes, of textured masonry, and of interior and exterior allowed by transparency through glass. Equally important, his reputation grew as an architect for whom the site had as much meaning as the structure.

The indoor/outdoor concept of classrooms in the round for the Corona Avenue School in Los Angeles (1935) was unaffectedly resolved, while the Laemmle Office Building, also in Los Angeles (1935), was pure De Stijl circa 1920. His other nondomestic architecture was uneven as an oeuvre, particularly after 1960, yet always full of restless vitality and inventiveness. This is evident in such designs as the Community Church, in Garden Grove, California (1966), and the Los Angeles County Hall of Records (1962, with Alexander).

Neutra was well received in Europe from the 1920s onward and had a no-

ticeable influence on the immediate course of post-midcentury architecture.[4] This resulted as much from his architecture as from his theoretical utterances; he loved to write. It helped expose an extensive breadth of reading and his great drafting ability, and no doubt promote Neutra the architect. Initially his writing was about technology in the service of design, the theme of his *Wie Baut Amerika?* (1927). The book helped maintain contacts with European colleagues and to present West Coast American architecture. Most of his later writings were directed to arguing for a more responsible and humane architecture.

Neutra condemned the European Modern Movement as it had evolved by midcentury for its failure to acknowledge the human condition and for what historian Kenneth Frampton called its "exclusively formal motivations." Neutra's major opus was a thesis entitled *Survival through Design.* In it, he formulated "the designer's professional task:" that person "must attempt to strike a happy medium between those physiological imperatives that are the *constants* of life, on the one hand, and on the other, the *acquired* responses" and "should pledge himself to serve wholesomeness honestly. If physicians take such a humane oath, the designer must too."[5] Such a professional responsibility is an aspect of human social and physical well-being, and he referred to it as "biorealism," a notion derived in part from his client Dr. Lovell, as well as from John Dewey's theories on education. The book had wide influence, and it sounded real warnings unheeded by most architects then and now.

"Celebrating the machine and its place in modern life," biographer Thomas Hines observed, "Neutra was ever the romantic engineer, searching for the nexus of art, technology, and life."[6]

NOTES

1. On Schindler, see David Gebhard, *Schindler* (London, 1971); David Gebhard, ed., *The Architectural Drawings of R. M. Schindler.* 4 vols. (New York, 1993–); Esther McCoy, ed., "Letters from Louis H. Sullivan to R. M. Schindler," *JSAH* 10 (December 1961); Esther McCoy and Randell L. Makinson, *Five California Architects* (New York, 1960, 1975); Lionel March and Judith Sheine ed., *R. M. Schindler* (London, 1993); and August Sarnitz, *R. M. Schindler, Architect 1887–1953* (New York, 1988).

2. Jürgen Joedicke, *Architecture since 1945* (New York, 1969), 62.

3. Kenneth Frampton, *Modern Architecture: A Critical History.* 2d ed. (London, 1985), 214.

4. A thank you to Isabella Gournay for information on Neutra's reception in France; cf. Hines (1982).

5. Neutra (1954), 325, his emphases.

6. Hines in Macmillan.

BIBLIOGRAPHY

Publications by, about, or that significantly include Neutra number in the hundreds. The abbreviation RN for Richard Neutra is used below.

Writings

Amerika. Die Stilbildung des Neuen Bauens in den Vereinigten Staaten. Vienna, 1930; Los Angeles, 1979.

"Architecture and the Community." *CanadaA* 32 (February 1955).
The Architecture of Social Concern in Regions of Mild Climate. São Paulo, 1948.
"Epoch—RN Describes His Early Years and Contacts with Members of the Bauhaus."
 CanadaA (May 1970).
"Human Setting in an Industrial Civilization." *Zodiac* (Milan) 2 (1957).
Mysteries and Realities of the Site. New York, 1951.
"Social Cohesion and Technical Spread." *Zodiac* (Milan) 3 (1958).
Survival through Design. New York, 1954; Hamburg, 1955.
Wie Baut Amerika? Stuttgart, 1927; Los Angeles, 1979.
With Willy Boesiger, ed., *RN. Buildings and Projects.* Vol. 1, *1927–1950.* Zurich, 1951;
 London, 1965. Vol. 2, *1950–1960.* Zurich, 1959; London, 1965. Vol. 3, *1961–*
 1966. London, 1966 (aka *Life and Human Habitat.* Stuttgart, 1956): *World and*
 Dwelling. Stuttgart, 1962; Barcelona, 1963. *Building with Nature.* Stuttgart, 1970;
 New York, 1971.
With Dione Neutra. *Pflansen, Wasser, Steine, Licht.* Berlin, 1974.

Biographical

Hines, Thomas S. *RN and the Search for Modern Architecture. A Biography and History.*
 New York, 1982.
Neutra, Richard. *Life and Shape.* New York, 1962; Buenos Aires, 1973.
Spreiregen, Paul. In *Contemporary Architects.*

Assessment

Barr, Alfred H., Jr., et al. *Modern Architecture.* New York, 1932. See also Henry-Russell
 Hitchcock and Philip Johnson. *The International Style. Architecture since 1922.*
 New York, 1932, 1966.
Betsky, A. "Selling Modernism." *ARecord* 180 (July 1992).
Drexler, Arthur, and Thomas S. Hines. *The Architecture of RN. From International Style*
 to California Modern. New York, 1982.
Gournay, Isabel. "L'architecture américaine . . . 1920–1940." *Gazette des Beaux-Arts*
 (Paris) 117 (April 1991).
Heyer, Paul. *Architects on Architecture.* 2d ed. New York, 1978.
Hines, Thomas. "Architecture: The Neutras at Silver Lake." *ADigest* 47 (May
 1990).
———. "Designing for the Motor Age." *Oppositions* (Summer 1981).
———. In Macmillan.
Jackson, N. "Metal-frame Houses . . . LA." *AHistory* 32 (1989); Part 2, 33 (1990).
Jacobus, John M., Jr. In Lampugnani.
Klemmer, Clemens. "Miester . . . RN." *Werk* 9 (September 1993).
McCoy, Esther. *RN.* New York, 1960.
Niedenthal, Sinon. "Glamorized Houses: Neutra . . . Kaufmann House." *JAE* 47 (No-
 vember 1993).
Pawley, Martin. *RN.* London, 1971.
Sack, Manfred. *RN.* Zurich, 1992.
Schiattarella, Amedeo. *RN: 1892–1970.* Rome, 1993.
Spade, Rupert, and Yukio Futagawa. *RN. 1892–1970.* London, 1971.
Zevi, Bruno. *RN.* Milan, 1952.

Bibliographical

Vance: Lamia Doumato A288, 1980; Robert Harmon, A323, 1980.

Archival

Hines, Thomas. "Masterful Renderings." *ADigest* 50 (March 1993).

McCoy, Esther. "Letters between R. M. Schindler and RN 1914–24." *JSAH* 33 (October 1974).

————. *Vienna to Los Angeles. Two Journeys. RN and Rudolph M. Schindler.* Santa Monica, California, 1979.

Neutra, Dione, comp. *RN. Promise and Fulfillment, 1919–1932. Selections from the Letters and Diaries of Richard and Dione Neutra.* Carbondale, Illinois, 1986.

OSCAR NIEMEYER (SOARES FILHO). 1907 (Rio de Janeiro, Brazil)– . Niemeyer received a diploma from the National School of Fine Arts in Rio (1934), while also working in Lucia Costa's office. He worked briefly for Le Corbusier* in Rio (1936) before he began an independent practice in Rio (1937). Later he served on the advisory committee of the United Nations Building in New York City (1947–1955) and founded *Modulo* in Rio after extensive travel in Europe and the Soviet Union (1955). Niemeyer was chief architect for the capitol Brasília (1956–1961) and then returned to Rio and private practice. International commissions came his way, but an intense fear of flying disallowed many. Notable and one of his favorites was the Communist Headquarters (1968–1975) in Paris where he lived and practiced, as he did in Israel (1962–1971). Niemeyer has received awards and been honored nationally and internationally, including the Lenin Peace Prize (1962), the AIA Gold Medal (1970), and the Pritzker Prize (1988, shared with Gordon Bunshaft*).

Costa, the father of modernism in Brazil, was asked in 1926 to revamp the architecture discipline in the National School: Niemeyer entered in 1930. The following year, Costa was dismissed as too radical; the students revolted and won, and the program remained, but not Costa. (The presence in Rio of Frank Lloyd Wright* during the "strike" may have provided added encouragement.[1]) The new curriculum was based somewhat on the Bauhaus system (post–Walter Gropius*) and incorporated a study of European Modernism.

Architecture in Brazil . . . is now in search of plastic expressions. It is the extreme malleability of present construction methods together with our instinctive love for the curve . . . which suggests the unfettered forms of a new and amazing plastic vocabulary.[2]

So said Niemeyer in 1950. "The distinctive traits of Niemeyer [are] his facility of invention and boldness of line," according to Jürgen Joedicke in 1969; but what of form![3]

Niemeyer embraced ideas that would become elements in "adaptation to local conditions, an imaginative and creative exuberance, and a typical lightness of touch," colleague Henrique Mindlin has noted.[4] Indeed it was Niemeyer's attention to the historical and regional conditions and the free application of circle and curvilinear lines ("plastic expressions") and forms that distinguished his architecture and made it a unique, dynamic challenge to theorist and practitioner

at midcentury. The other principal inductive influences were Brazilian artists, Costa's expert knowledge of Brazilian historical architecture, and contact with Le Corbusier.

Although he practiced for most of his life, Niemeyer's design brilliance lit the international stage for a mere twenty years. To strict rationalists he was irresponsible. Unprecedented shapes were mixed with the right-angle matrix of industrial facades—shapes like bubbles, bowls, free forms, undulations (on a couple of occasions exposed beams that look frighteningly in the process of collapse), sharp countering angles, circles and squares, wandering Baroque-inspired lines, pyramids, arches, and thin multi-story slabs.

Niemeyer's was a "lyrical architecture" and idiosyncratic. The rationalist Joedicke perhaps expressed the view of many when he likened some of Nie-meyer's designs to over-sized models, to a built *esquisse,* an "idea realized without proper study of their use," or construction.[5] That is oversimplified. In the postwar decade, Niemeyer boldly attempted to integrate the arts. He was not afraid of reduction and always gave due consideration to environmental controls. When he was in North America the emphasis was on technological solutions. Because the applicable technology was not available in Brazil, Nie-meyer needed to employ constructional therefore plastic solutions, such as breezes trapped and/or channeled, selected vegetation, and sun control.

The Swiss-Parisian architect Le Corbusier made a short visit to Brazil in 1929. His next visit was at the request of the government, at Costa's urging, to consult on the design of the Ministry of Education building in 1936. Niemeyer was transformed by Le Corbusier's four-week presence and by his designs for the ministry (1937–1943, with Eduardo Reidy, et al.) and a master plan for the University of Rio de Janeiro (1936, project). It was while working with the master on the university project that Niemeyer gained valuable knowledge which he later applied to large scaled schemes including residential or office complexes, the IV Centenary Exposition in São Paulo (1954), and the Aeronautical Training Center campus at São José dos Campos (1947, project).

The ministry had nearly all the elements to reappear in his designs: a multi-story office slab countered at ground level by a lower building, tall columns free until the second or third story, sun control by louvres, diagonals, an auditorium following its seating shape, functional elements on the roof, and integration of art (wall tiles, sculpture) and landscape. Some of these appeared in his first independent commission, a day nursery at Govea in Rio (1937). Derived from Le Corbusier, it is a boxy building with a series of facades, the principal of which has tall, vertical shading louvres.

With useful family connections, Niemeyer soon secured a number of large private and government commissions; the Brazilian Pavilion for the New York World's Fair (1939) is one example. Prominent are free columns on the ground floor (Le Corbusier called them *pilotis*), curved and free form shapes in plan, large sun control vanes, and a diagonal ramp. And there was a housing scheme first designed for a master plan project for the University of Rio, that reappears

with the Hotel at Ouro Preta, that is rooms stepped back against a hillside. This scheme was reused many times for housing and hotel designs.

Perhaps one of Niemeyer's more famous early works is the Baile restaurant on a small island at Lake Pampulha (1942). In plan, a circular kitchen and seating area is covered by a thickish roof that has a spermlike free-form tail reaching out along the edge of a lake and covering outdoor eating and seating. And quite opposite in form was his project for a modern art museum for a promontory beside Carácas in Venezuela (1955). It was to be an inverted pyramid six stories in height balanced on a small base, teasing one's empathy.

Three works stand out. First is the Church of Saint Francis at Lake Pampulha (1943). A Latin cross plan is roofed by a large concrete parabolic vault over the nave with four small vaults over the crossing. The west facade has tall, vertical louvres above door height and a rising plane of concrete that partially covers the entry while connecting with a bell tower that is square in shape, larger at the top. It appears as a point of a spear jammed into the ground. What is equally important and most often photographed is a large, colorful, semirealistic mural by the artist Portinari that covers the rear (or east) facade.

Second, and while a member of an international team, is his scheme for the United Nations Headquarters in New York (1947) that, in combination with Le Corbusier's idea, formed the basis of the final design.

Third is his site and architectural work for Brasília. When Niemeyer's close friend Jouscelino Kubitschek became president of the republic and was insistent on building a new capitol city, Brasília, Niemeyer was appointed chief architect and became responsible for the design of all major buildings (1957–1964). The principal focus of the city plan, initially by Costa, was the Congress building complex. Between two parallel roads he placed a large plaza upon three stories of parking and public functions, among them the Senate Chamber (whose roof appears above the plaza as a dome without a drum) and the Representative Chamber (again rising above the plaza but as a solid bowl). Behind were two slick towers side by side on axis between the legislative chambers. Perhaps as a result of its simple forms, the scale of the complex defies sensible human proportions.

The themes of the various buildings at Brasília vary. There are slabs of mid-high office buildings in ranks either side of the parallel roads before the Congress complex (recalling the emulative and even more gargantuan mall before the State Capitol building in Albany, New York, 1962–1979). There is the pyramid shape for the National Theater that is half in the earth. The Foreign Office is square with a periphery of free-standing piers that, with the roof, shade an industrial glass facade. The idea for the Presidential (Alvorada) Palace is similar, except that the exterior piers are white inverted arches. And as a last example the cathedral is below a plaza while above concrete arches open out and lean against one another suggesting a crown of thorns. Brasília was Brazil's Versailles: it bankrupted the country to satisfy egos. It also gave Niemeyer an international reputation.

To say that Niemeyer was reacting to what he perceived as the Modern Movement's sterility, that he disregarded the tenet of orthodox functionalism, is not sufficient. Many reacted similarly: Eero Saarinen,* Felix Candela,* Paul Rudolph,* and Louis I. Kahn* come to mind. As with Saarinen and Rudolph, the full measure of his influence has yet to be made. That he enlivened and energized the art of architecture by freeing it of a dreary rectilinear geometry is unquestionable. That he failed to provide a composite theory in words and deed enabling analysis, like Kahn, is also clear. This can be noted in his last works that also reveal an even more sculptural and painterly quality eschewing geometrical orderliness, for example, the white and flowing Latin American Memorial, in São Paulo (1989).

NOTES

1. Bruce Brooks Pfeiffer, ed., *Frank Lloyd Wright Collected Writings. (1931–1939).* Vol. 3 (New York, 1993), 118–19.
2. Papadaki (1960), 5. On the shy, retiring Costa see Macmillan and *Contemporary Architects.*
3. Joedicke, *Architecture since 1945* (New York, 1969), 68.
4. Mindlin in Lampugnani.
5. Joedicke (1969), 68.

BIBLIOGRAPHY

Because of Niemeyer's association with Brasília, publications that are about or include him proliferate.

Writings

"Brasilia." *Aujourd'hui.* 29 (October 1958).
A forma na architectura. Rio de Janeiro, 1978; Paris, 1979.
"Ce quie manque a notre Architecture." In *Le Corbusier. Oeuvres Complètes,* edited by Willy Boesiger. Zurich, 1938.
Oscar Niemeyer. Milan, 1975; Lausanne, 1977.
Rio: de provincia a metropole. Rio de Janeiro, 1980.
With Lionello Puppi. "Memorial da America Latina." *Zodiac* 9 (1993).
As editor, author, mentor. *Modulo, a Magazine of Brazilian Architecture.* (Rio de Janeiro) 1955–1980.

Biographical

Bailby, Eduard. *Neimeyer par lui-même.* Paris, 1993.
Minha Experiencia em Brasília. Rio de Janeiro, 1961.
Quase memories: viagens, tempos de entusiasmo e volta, 1961–1966. Rio de Janeiro, 1968.
Seidler, Harry, in *Contemporary Architects.*

Assessment

AandA. "Project for a House in Santa Barbara." 66 (March 1949).
AReview. "Headquarters for the French Communist Party, Paris." 151 (March 1972).
Bullrich, Francisco. *New Directions in Latin American Architecture.* London, 1969.
Campofiorito, Itado. "Oscar Niemeyer." *World Architecture* 26 (1993).
Emery, M. "Oscar Niemeyer." *Aujourd'hui* 171 (January 1974). The whole issue.

Evenson, Norma. "The Architecture of Brasília." *CanadaA* Part 1, 18 (November 1973); Part 2, 19 (January 1974).

―――. *Two Brazilian Capitals: Architecture and Urbanism in Rio de Janeiro and Brazília.* New Haven, Conn., 1987.

Fils, Alexander, ed. *Oscar Niemeyer.* West Berlin, 1982.

―――. *Brazília. Modern Architecture and Stadtplanning in Brazilian Düsseldorf.* 1987.

Goodwin, Philip L. *Brazil Builds.* New York, 1943; 3d ed. 1944.

Harris, Elizabeth D. In Macmillan.

Joly, P. "Niemeyer." *Oeil* (Paris) 219 (October 1973).

Luigi, Gilbert. *Oscar Niemeyer: Une esthetique de la fluidité.* Marseilles, 1987.

Marx, Roberto Burle. In *The Changing Shape of Latin American Architecture,* edited by Damián Bayón and Paolo Gasparini. Paris, 1977; New York, 1979.

Mindlin, Henrique E. *Modern Architecture in Brazil.* New York, 1956.

―――. In Lampugnani.

PA. "Interview." 72 (October 1991).

Papadaki, Stamo. *Oscar Niemeyer.* New York, 1960.

―――. *Oscar Niemeyer—Works in Progress.* New York, 1956.

―――. *The Work of Oscar Niemeyer.* New York, 1954.

Richards, J. M. "Brasília." *AReview* 125 (February 1959).

Sodré, Nelson Werncek. *Oscar Niemeyer.* Rio de Janeiro, 1978.

Spade, Rupert, and Yukio Futagawa. *Oscar Niemeyer.* Tokyo, 1969; London, 1971.

Toca, Antonio, ed. *Neueva arquitectura en América Latina: Presente y futuro.* Mexico City, 1990.

Underwood, David. *Oscar Niemeyer and Brazilian Free-Form Modernism.* New York, 1994.

O

FREI OTTO. 1925 (Siegmar, Germany)– . The son of a sculptor, Otto trained as a stonemason (1931–1943), was in the German army (1943–1947), and then received a degree from the Berlin Technical University (1952) and a subsequent doctorate (1954) on "The Suspended Roof." During studies he spent 1950–1951 in the United States, where he met Eero Saarinen* and the engineer Fred Severud, whose work he avidly studied. After formal studies Otto immediately set up an architectural and engineering practice in Berlin (1952–1969), then in Warmbronn with Leonhard Behnish, and in time many others (1969–). He founded the Development Center for Lightweight Construction (1957). He became a visiting professor at a number of American universities, in Germany, and the National Institute of Design, Ahmedabad, India, and Director of the *Institute fèr Leichte Flìchentragwerke,* University of Stuttgart (1964–). Otto has exhibited in Stuttgart and at the Museum of Modern Art, New York (1970), with a tent structure in the courtyard. He has received honorary degrees and a number of prizes and awards, including the Auguste Perret Prize (1976) and the Aga Khan Award (1980), both with Rolf Gutbrod. Otto retired in 1970 but maintains an "Atelier."

෨

When a prisoner of war, Otto was placed in charge of building and repairs of the camp, where he had to cope with severe shortages of materials. This experience, together with his hobby of gliding, in which a frame is covered with a stretched skin, influenced his decision to study building construction using the least possible material. Moreover, on his American study tour architect Mat-

thew Nowicki and Severud were working on the State Fair Arena, Raleigh, North Carolina, which employed a great suspended roof.

With the tent making Stromeyer Company Otto pursued lightweight and tensile structures. His bandstand covers for exhibitions in Kassell, Germany (1955), and Cologne (1957, using cables), and a series of connected exhibition buildings for Hamburg (1963, with peaked tents) adequately displayed the potential of some type of tent structure. Using either cables or a tent, a flexible system is necessary to stabilize tensile forces with resulting shapes of hyperbolic paraboloids and anticlastic (or saddlelike) curves. The only compressive forces are in masts or poles.

The West German pavilion at Montreal's Exposition (1967, with Tarnowski and Eber), was the first grandly scaled application, and this led to his commission to cover several of the sports structures, including the major seating area of the Munich Olympic Games (1972, with Behnisch and Partners).

Otto then studied lightweight metal structures, something like expanded metal and not dissimilar to works of R. Buckminster Fuller.* But even lighter structures were to come when Otto looked into pneumatic enclosures. These included split membrane roofs where the inner space was filled with air that supported the membrane or with air below and inside the building to support the membrane, and towers filled with liquid or gas.

Critical to the success of his structures was the design of various new connections necessary to resist gravity, tension, puncture, or whatever, and to study new materials or old materials used in new ways. The result had a significant impact on the steel and plastics industries and revolutionized structural engineering and our sensibilities about architecture. As a result of his work, companies devoted to just tents or pneumatics have since proliferated throughout the world, as have their applications. Otto's architectural and engineering studies, far more than Fuller's, have positively affected the architectural landscape.

BIBLIOGRAPHY

There are many articles (mainly technical) by or about Otto and the Development Center for Lightweight Construction, mostly in German language publications.

Writings

"The Congress Hall Debate." *AForum* 108 (January 1958).

Das higende Dach. Gestalt und Struktur. Berlin, 1954; Madrid, 1958; Warsaw, 1959; Moscow, 1960.

"Development of Lightweight Construction." *AandA* 80 (October 1963).

"Idea." *Architecture, Formas, Fonctions* 16 (1971). The whole issue.

"Imagination et Architecture." *Aujourd'hui* 102 (June 1962).

"Light Structures." *Zodiac* 21 (1972). The whole issue.

Lightweight Structures. Berkeley, California, 1963.

"Shells and Membranes." National Academy of Sciences, Proceedings. Washington, D.C., 1964.

Structures. Traditional and Lightweight. New Haven, 1961.

Tensile Structures. Design, Structure, and Calculation of. . . . Vol. 1, with Rudolf Trostel;
 vol. 2 with Friedrich-Karl Schleyer. Frankfurt, 1962–1966; MIT Press, 1967–
 1969. (Total of 2,600 illustrations.) Translation of *Äber Zugbeanspruchte Kon-*
 struktionen. Berlin, 1962.
With J. G. Helmcke. "Structures vivantes." *Aujourd'hui* 108 (June 1963).
With Peter Stromeyer. "Pneumatische Konstruktionen." *Deutsche Bauzeitung* (Berlin)
 66 (July 1961); and *AIAJ* 37 (April 1962; and *Column* (Tokyo) 9 (1964).
――――, "Tents." *AandA* 74 (November 1957); and *AIAJ* 35 (February 1961); and *Col-*
 umn (Tokyo) 7 (1963).
With others. *Grundlogen: Form-Kraft-Masse.* Stuttgart, 1979.
As editor. Paul Otto. *Handbuch fèr Steinmetzen.* 3d ed., Ulm, 1958.

Biographical

Roland, Conrad. *Frei Otto: Tension Structures.* Frankfurt, 1965; London, 1970.

Assessment

Abitare. "Bad Münder." 275 (June 1989).
Boyd, Robin. "German Pavilion at Expo." *AReview* 142 (August 1967).
――――. "Under Tension." *AReview* 134 (November 1963).
CanadaA. "Expo67." 43 (July 1966).
"Comportamento statico." *Casabella* 307 (July 1966); and Part 2, 309 (September 1966).
Conrads, Ulrich, and Werner Marshall. *Contemporary Architecture in Germany.* Stutt-
 gart, 1962.
Drew, Philip. *Frei Otto. Form and Structure.* London, 1976.
Feuerstein, Günther. *New Directions in German Architecture.* London, 1968.
Glaeser, Ludwig. *the work of frei otto.* New York, 1972.
Jodidio, P. "Otto." *Connaissance* 336 (February 1980).
Medlin, Richard L. "Designs 1.864 Million Cubic Feet of Air." *AForum* 126 (April
 1967).
Minke, Gernot. "Tensile Structures." *ADesign* 38 (April 1968).
Pearson, Cliff. In Macmillan.
Sebestyen, Gyula. *Lightweight Building Construction.* New York, 1977.
Severud, Fred N., and R. G. Corbelletti. "Hung Roofs." *PA* 37 (March 1956).

Bibliographical

Otto (1962–1969).
Roland (1970).
Vance: Edward Teague, A1452, 1985.

J(ACOBUS) J(OHANNES) P(IETER) OUD. 1890 (Purmerend, the Nether-
lands)–1963. Born into a middle-class family, Oud studied at the Quellinus
School of Decorative Arts, in Amsterdam (before 1907). He worked for Joseph
Cuypers and Jan Stuyt (1907) but left to attend the National School for Art
Education in Amsterdam and the Delft Technische Hogeschool (1907–1911).
Possibly on Berlage's advice, he sought experience in the Munich office of
Theodor Fischer (1911). Returning to Holland after only three months, he set
up his own practice in Purmerend (1913–1914), then in Leiden (1915–1916).
He founded the De Stijl* group (1916) with Theo van Doesburg* and others

but quit in 1920. Oud became chief housing architect of Rotterdam (1918–1933) and later returned to private practice in that city (1933–1954). He moved to Wassenaar, near The Hague (1954–1963). Oud's work has been exhibited in the Netherlands (1951 and 1982), New York (1932), London (1979), Munich (1965), and Berlin (1966). He was awarded an honorary doctorate by the Delft Technische Hogeschool in 1955.

<p style="text-align:center">✎</p>

Oud's first building, a house in Purmerend, was designed when he was only sixteen years old and probably while he was studying at the Quellinus School. His work for Cuypers and Stuyt was mostly domestic, but he left after six months to return to his studies. Around 1910 he met Berlage, perhaps through Berlage's daughter, a fellow student at the National School for Art Education. Oud next tried lectures at the Delft Technische Hogeschool, again to be disappointed. Through Berlage's ideas and his own convictions, Oud was determined to produce an architecture that exploited new construction and materials. Dabbling in a one-man practice, he produced little architecture until 1915–1916, when he designed the conservative Woonwijk Leiderdorp housing estate near Leiden with Willem Marinus Dudok.*

In 1916 Oud also met van Doesburg; there followed a number of collaborations—among them the holiday house De Vonk at Noordwijkerhout (1917) and the villa Allegonda at Katwijk aan Zee (1917–1927) with M. Kamerlingh Onnes. Around the turn of the year, Oud introduced the young architect Jan Wils to van Doesburg. The three formed an artist's club De Sphinx in Leiden, and they soon founded the loosely knit group of avant-garde artists known as De Stijl. Wils was Europe's first serious expositor of Frank Lloyd Wright's* architectural theories. He and Oud had met through Berlage for whom Wils had worked. Oud had heard about Wright from Berlage, around 1912 at the latest. His reaction is noteworthy: "I was delighted: it was a revelation to me."[1]

Oud was more interested in Wright's technology than in his philosophical and aesthetic responses. They shared a desire for an architecture based on the needs and possibilities of the present time, "satisfying its requirements of general economic feasibility, universal social attainability, in general of social-aesthetic necessity, and compactness, austere, exact, simple and regular in form."[2] Yet none of Oud's work before 1917 showed an affinity for Wright. Then he designed "a double workers' house in reinforced concrete." He believed that, because of its tensile strength, concrete would liberate architecture from limiting brick construction, achieving "a purer planar definition of the building, more monumentality [in the De Stijl sense of plasticity] and better synthesis." The stocky, charmless building—not realized—was a parody of Wright's pre-1910 work. Oud produced two more designs, also unbuilt, *visually* related to Wright. As manager of the family distillery, Oud's father was the client. Projects for a warehouse (1918) and a factory and offices (1919) at Purmerend exuded Wrightian elements. The former also evoked the office wing of Walter Gropius* and Adolf Meyer's model factory at the 1914 Cologne

Deutscher Werkbund exhibition. Wright was the unmistakable source of all. Of the De Stijl architects Oud broadcast Wright most widely in Europe, well into the 1950s.

In 1918 and through Berlage's influence, Oud became chief architect of the Rotterdam Municipality and thus had to face the inevitable conflicts between conservative officialdom and radical theories. His last collaboration with the fiery van Doesburg was on the Tusschendijken apartment block, in Rotterdam (1920). He also continued to experiment with the design of concrete dwellings; the Dutch building industry developed a workable concrete technology after 1920, and Oud's first use of it was for workers' houses in Hoek van Holland (1924–1927). The designs were in every apparent way dissociated from De Stijl *and* from Wright.

He had refused to sign De Stijl's "November Manifesto" of 1918, and those that followed. In 1921 he parted company with De Stijl altogether. Like Wils and others, he had offended them by his independently expressed views: in February 1921, Oud addressed Opbouw, a society of modernist architects in Rotterdam that he had helped form, on "the future architecture and its architectonic possibilities" and the talk was published in the *Bouwkundig Weekblad*. Van Doesburg interpreted the action as disloyalty; Mondrian was annoyed because Oud had not mentioned Neoplasticism.

Oud's buildings of the early 1920s are confusing. For example, there was little congruence (in form *or* theory) between the conservative forms of his "semipermanent" houses of the Oud-Mathenesse Witte Dorp (1923) and the site office of the same development. And the Café De Unie, in Rotterdam, of the following year, is unique. There is in Oud's work of the *later* 1920s— including his "model dwelling" (1927) for the Weissenhofsiedlung at the International Exhibition in Stuttgart organized by Ludwig Mies van der Rohe*—a confluence of ideas, including those of Adolf Loos* and Le Corbusier.*

Loos's polemical arguments against ornament, applied in his Steiner house (1910), soon became well known and have always been justifiably associated with the unembellished white facades of Modernist houses, including Oud's. Although Oud described Wright as towering "above the surrounding world" and his work as "flawless," he thought the American's influence in Europe was not "happy . . . in all respects." The problem lay in the "pernicious" effects of mindless mimicry upon the development of European architecture, which Oud believed to be, quite apart from Wright's ideas, in "a state of ferment, and Cubism"—Oud's Cubism—"was born." Oud's construct of Cubism was not equatable with the French school of painting and sculpture nor the Purist notions preached through *L'Esprit Nouveau* by Amedee Ozenfant and Le Corbusier. Oud used the term to describe De Stijl Neoplasticism, which he claimed was so important to modern architecture. Le Corbusier had set up currents counter to Wright's in Europe. Le Corbusier's competition entry for the *Chicago Tribune*

tower had appeared in *Bouwkundig Weekblad* and *Wendingen* in 1923. And within months of the publication of *Vers une Architecture,* Oud reviewed it in Holland.[3] Dutch architects began building white stuccoed cubes.

Le Corbusier did not turn Oud's head completely, but there are clues indicating a strong response. Not least are the cubic forms of the Hoek van Holland houses, and those at Kiefhoek, in Rotterdam (1925–29), described by Oud as "dwelling Fords". Yet he put all this materialism and theory into proper perspective with, "I bow my knee to the wonders of technology but I do not believe that [an ocean] liner can be compared to the Parthenon."

Because he fit the perceptions of what a Modernist should be, Oud was greeted abroad as Holland's contributor to the so-called International Style. Its chief American apostles, Alfred Barr, Henry-Russell Hitchcock, and Philip Johnson,* singled him out for attention and praise in 1932.[4] And Johnson commissioned him to design a house in Pinehurst, North Carolina, for his parents (1931), but it was never built. In 1936 Oud was invited to a permanent teaching post at Harvard; when he declined, the offer was extended to Gropius.* After beginning with such a bang, Oud's career whimpered along through the remainder of the depressed 1930s, with many projects but few realized buildings. Only a fit out (1937) for the liner *Nieuwe Amsterdam* and a new headquarters (1938–1942) for the Bataafsche Import Maatschappij—later the Shell Company—were implemented.

The headquarters marked a dramatic digression from Oud's angular, undecorated, sharply defined architecture. Because of the German occupation of Holland, the building was not seen by British and American architectural critics until after World War II. The British response to the great Dutch modernist's vigorous use of decoration (especially around the main entrance) was polite. The American press subtly implied its disapproval by the headline: "Mr. Oud embroiders a theme."[5] In 1956 Oud began his last major project, a National Congress Centre in The Hague. In a way, it is truly international: it could have been built by anyone, anywhere. Soon after Oud's death in 1963, an obituary in the London *Architectural Review* remarked that the "convincing modernity" of his earlier work was only in part attributable to the influence of van Doesburg and the other members of De Stijl, and that his fame was due more to his publicists than to his own ability. It also accused him of lacking vision, of being too pragmatic: he had "compromised the lofty principles of Modernism."[6]

NOTES

1. Oud, obituary for Wright. *Groene Amsterdammer,* 18 April 1959, 8.
2. Oud (1925), 85.
3. Oud, review of *Vers une Architecture. Bouwkundig Weekblad* 45 (1924), 90–94.
4. Alfred Barr, Philip Johnson, and Henry-Russell Hitchcock, *Modern Architects* (New York, 1932); and Hitchcock and Johnson (New York, 1932).
5. *ARecord* 100 (June 1946).
6. *AReview* 134 (1963), 310.

BIBLIOGRAPHY

Writings

Architecturalia, voor Bouwheren en Architecten. The Hague, 1963.
"Architecture and the Future." *Studio* (London) 100 (December 1928).
Building and Teamwork. Rotterdam, 1951.
"Clarity in Town Planning." *RIBAJ* 58 (May 1951).
"The European Movement towards a New Architecture." *Studio* 105 (April 1933).
Hollandische Architektur. Munich, 1926; 2d ed., 1929; Mainz, 1976.
"The Influence of . . . Wright on the Architecture of Europe." *Wendingen* (Amsterdam)
 7 (6, 1925).
Mein Weg in De Stijl. The Hague, [1960].
Nieuwe Bouwkunst in Holland en Europa. The Hague, 1935.
Ter Wille van een Levende Bouwkunst. The Hague, 1962.
Woningbouw te Hoek van Holland. Rotterdam, 1927.

Biographical

Hitchcock, Henry-Russell. *J.J.P. Oud.* Paris, 1931.
Oud, Hans. *J.J.P. Oud. Architect 1890–1963.* The Hague, 1984.
Weikart, Karel. *J.J.P. Oud.* Amsterdam, 1965.

Assessment

Abitare. "Rotterdam, Kiefhoek, 1925–1930." no. 236 (1985).
Barbieri, Sergio Umberto. "La demolizione di un luogo del moderno; i Witte Dorp di
 Oud." *Domus* 707 (July 1989).
———. "Oud and Holland." *Domus* (January 1990).
———. "A Rotterdam, Oud-Oud." *Casabella* 51 (May 1987).
———. "Spangen: Un frammento di Rotterdam." *Casabella* 49 (July 1985).
Blotkamp, Carel, et al. *De Beginjaren van De Stijl.* Utrecht, 1982; *De Stijl: The For-
 mative Years.* MIT Press, 1986.
Hitchcock, Henry-Russell, and Philip Johnson. *The International Style.* New York, 1932,
 1966.
Jaffe, Hans Ludwig C. *De Stijl 1917–1931.* Cambridge, Massachusetts, 1986.
J.J.P. Oud, Bauten 1906–1963. Munich, 1965.
van der Lugt, Reyn. "La riconstruzione del Cafe de Unie." *Domus* 685 (April 1987).
Metz, Tracy. "De Stijl Distilled: A New Look at . . . J.J.P. Oud." *ARecord* 174 (Novem-
 ber 1986).
Overy, Paul. *De Stijl.* London, 1969, 1991.
Polana, Sergio. "Notes on Oud: Re-reading the Documents." *Lotus* 16 (1978).
Rebel, Ben. "The Housing of J.J.P. Oud." *Nederlandse Kunsthistorisch Jaarboek* (The
 Hague) 28 (1978).
RIBAJ. "Head Office, Shell Company, Den Haag." 53 (May 1946).
Scully, Vincent. *Modern Architecture.* New York, 1961; London, 1968.
Stamm, Gunther. *The Architecture of J.J.P. Oud 1906–1963.* Tallahassee, 1978.
Troy, Nancy. *The De Stijl Environment.* MIT Press, 1983.
Veronesi, G. *J.J.P. Oud.* Milan, 1953.
Weissing, H.P.L. "J.J.P. Oud." *Building* (London) 13 (July 1938).

Yashiro, Masaki. "Collective Housing in Holland: Traditions." *ProcessA* 112 (1993). The whole issue.

Bibliographical

Fanelli, Giovanni. *Moderne Architectuur in Nederland 1910–1940.* The Hague, 1978.
Jaffe, Hans Ludwig C. "J.J.P. Oud." *Zodiac* 12 (1963).
Vance: Donald Langmead, A1671, 1986; A1672, 1986; A1773, 1987.

Archival

Beckett, Jane, et al. *The Original Drawings of J.J.P. Oud, 1890–1963.* London, 1963.

NAT(HANIEL ALEXANDER) OWINGS. 1903 (Indianapolis, Indiana)–1984. Owings' studies at the University of Illinois, Urbana (1921–1922), were abandoned in favor of Cornell University in Ithaca, New York, where he received an architectural degree (1927). He worked as Louis Skidmore's* assistant on Chicago's Century of Progress Exposition (1932–1933) and then formed a partnership with Skidmore (1936), which John Merrill joined in 1939, to form Skidmore, Owings, and Merrill,* or SOM. Initially offices were in Chicago with Owings in charge and in New York City, Skidmore's domain, but soon branches were established in other American cities. In 1950 Owings set up the basic office organization based on a team system to process commissions within the firm. Other than his work with SOM he was involved with commissions and committees in Chicago and California, with the AIA, but especially in relation to planning developments for Washington, D.C. He believed his major contribution to architecture, planning, and the wider community was as an organizer and, to use his word, a "facilitator," not as a designer. Owings received the AIA Gold Medal (1983).

See Skidmore, Owings, and Merrill (SOM).

BIBLIOGRAPHY

Writings

The American Aesthetic. New York, 1969.
"Economics in Department Store Planning." *ARecord* 101 (February 1947).
"New Materials and Building Methods . . . Chicago Exposition." *ARecord* 71 (April 1932).
The Spaces in Between: An Architect's Journey. Boston, 1973.
"Two Looks at Preservation." *AIAJ* 37 (February 1962).

Other

ARecord. [Portrait]. 96 (August 1944).
Current Biography Yearbook. New York, 1972.
Stephens, Susan. "Monumental Main St. Pennsylvania Ave." *PA* 60 (May 1979).
Vance: Lamia Duomata, A355, 1980.

P

1917 (Canton, China)– . Pei spent his childhood in Canton and in Shanghai, where he attended Saint John's Middle School. He soon decided to construct buildings and intended to study at the University of Pennsylvania (1935). Dismayed by its artistic beaux-arts approach, he entered the Massachusetts Institute of Technology and graduated with an architectural engineering degree (1939). Pei remained centered at Cambridge, Massachusetts (to 1942) and during World War II he served with the National Defense Research Committee. He taught at the Harvard University Graduate School of Design (1945–1948) from which he obtained the master's degree in architecture. He married Harvard landscape architect student Eileen Loo, and they were naturalized in 1954. He was hired to direct the architectural division of William Zeckendorf's real estate development firm Webb and Knapp (1948–1955), and he completed some highly regarded urban development schemes, including Mile High Center in Denver; the Place Ville-Marie in Montreal (with Raymond Affleck); and the Kips Bay Plaza apartments in New York City, where the load-bearing—or window-truss—wall developed by Pei and engineer August E. Kommendant was first used.[1] In 1955 he began an independent practice, and in 1989 the firm became Pei, (Henry) Cobb, and (James) Freed, with notable works since executed by Pei's long-time associates and eventual successors. He has received many national and international honors, degrees, and awards including the AIA Gold Medal (1979) and Japan's Praemium Imperiale (1989), and he was the fifth recipient of the Pritzker Prize (1983).

℘

Pei's buildings "don't represent manifestos," says critic Ching-yu Chang. Nonetheless, a "cohesive philosophy" is evident, rational, yet "seldom stated

verbally.''[2] Observer Charles Jencks believes that Pei is one of the "prime exponents of American formalism,'' a Walter Gropius* Harvard formalist.[3] Yet others such as Judith Hull believe that Pei "departs from the tradition of Gropius in that he does not have a polemical bent nor is he concerned with theory. . . . Pei expresses ideas through building and through collaborative efforts with clients, varied interest groups, and members of his own office.'' Moreover, Zeckendorf's lessons were seeds that fell on fertile ground''[4] and provided Pei entrée to other developers and corporations.[5]

Shortly after leaving Zeckendorf, Pei designed a number of buildings that in general were treated rather typically for the day. These included the three Society Hill apartment towers in Philadelphia (1964–1965), where Ludwig Mies van der Rohe's* steel-structured Lake Shore Drive apartments (1948–1951) were sensitively translated into concrete, and the Pei/Kommendant window-truss wall was again employed. Pei's break with typicality and stereotype was revealed in two commissions. First was the Everson Art Museum at Syracuse University, in New York (1966–1968), where four boldly plain, rectangular forms in off-form concrete define the four internal gallery spaces that rise above the lower elements and a plaza containing a pool. A penchant for drama was apparent in a contemporary design for the National Center for Atmospheric Research outside Boulder, Colorado (1966–1967), where "chiseled cylinders and tower, bush hammered in red concrete'' starkly contrast with background mountains.[6] The Colorado and Syracuse buildings, similar in many ways, announced Pei's talent and his dissatisfaction with formula.

There were moments of reversion, such as the dark, all-glass facade to a parallelogram plan for the John Hancock Tower in Boston (1973), which looms rather menacingly over H. H. Richardson's Trinity Church (1873–1877) and plaza. Generally, Pei's buildings responded to what he perceived were the internal and public symbols inherent in a building's purpose. Therefore there is no stylistic consistency in his oeuvre. Invariably his perception of a building included three-dimensional form, public procession, and materials plainly applied, and in that sense there is an organic perseverance. This is most notable in his East Building for the National Gallery of Art in Washington, D.C. (1968–1978). Connected underground to the main neo-Roman gallery (of little distinction), Pei's building's central skylit space serves as a pedestrian extension to the Mall, galleries, and a separated administration area. Despite the critical flak that such a public building must endure, the sharp triangular forms rising out of the earth reflect Pei's earlier Everson Gallery. They are severely plain on interior and exterior, classical in composition, yet truly modern.

His perception tends to resolve into monumentality, and in that his work can be usefully compared to the public and commercial works of Leandro Locsin in the Philippines during the Marcos reign and to the contemporary buildings of Australian Harry Seidler,* Pei's classmate at Harvard. But there is no formula to Pei's formalism. Take as examples of diversity the seven-story inverted pyr-

amid of the brooding Dallas City Hall, in Texas (1977); or the simple circular and right-angled, multistoried white forms and multifaceted glass wall supported by a space frame for the John F. Kennedy Memorial Library at Harvard University (1979); or more expansively the all-space-frame walls of the all-glass facade of the immense Jacob K. Javits (or New York City) convention center; or the triangular steel braces exposed above a square plan for the very tall, dynamic skyscraper for the Bank of China, in Hong Kong (1984–1992) (Plate 40), which is so reminiscent of Seidler's Capita Centre towers in Sydney (1984–1989). Both expose the X-bracing for tall buildings which first appeared in the 1960s.

If one were to select a building representative of his architecture in all aspects, including an environmental—in most cases urban—situation, it would be the Christian Science Church Center in Boston, Massachusetts (1963–1973). A complex of buildings and landscape (no doubt influenced by Eileen) sensitive to existing urban places and buildings, it is his best work. The details and overall character of the center's tower were further developed for the OCBC building, in Singapore (1970–1976).

Much of Pei's success as an architect is a popular belief that his individuated buildings are just that, and that even if they are suave and restrained they are for the most part joyful experiences. As Jacqueline Kennedy Onassis said when Pei was selected as the architect for her late husband's memorial: Pei!, "he loves things to be beautiful."[7] That and a thoroughly professional attitude helped him to secure the job of designing for François Mitterand (who as president of France had personally selected Pei) additions to the Louvre in Paris. His solution (1983–1988, with Michel Macary, J.-M. Wilmotte, and Peter Rice) was a series of underground connections below the Cour Napoléon with only a relatively small glass pyramid rising from the floor of the central court giving daylight to an underground promenade and at night casting light all about. Although it was a controversial undertaking, the design proved Pei can restrain his love of the grandly monumental.

NOTES

1. Carl W. Condit, *American Building* (Chicago, 1968), 246.

2. Ching-yu Chang in *Contemporary Architects*.

3. Charles Jencks, *Modern Movements in Architecture* (Harmondsworth, 1973), 122, 190.

4. Hull in Macmillan.

5. The "Zeckendorf education," as put in Pei (1978), 33.

6. With Araldo Cossutta; cf. Marlin (1973).

7. As quoted in Arthur Herzog, NYTM (14 August 1965), 34f. Relevant to Cobb and Freed, see Barbaralee Diamonstein, ed., *American Architecture Now II* (New York, 1985).

BIBLIOGRAPHY

Writings

"A House Must Make People Feel Good," and "The House Designed by I. M. Pei." *House & Garden* (New York) 138 (November 1970).

Ransom, Harry S., ed. *The People's Architects.* Chicago, 1964.

"The Sowing and Reaping of Shape." *Christian Science Monitor* (Boston), 16 March 1978.

Biographical

Abercrombie, Stanley. "A Gentle Master Builder." *Horizon* (New York) 21 (April 1978).

Ching-yu Chang. In *Contemporary Architects.*

Dean, A. O. "Conversations with I. M. Pei." *AIAJ* 68 (June 1979).

Slesin, Suzanne. "The Man Who Designed It." *Esquire* (New York) 89 (June 1978).

Zeckendorf, William, and Edward McCreary. *Zeckendorf.* New York, 1970.

Assessment

AandA. "East West Center in Honolulu, Hawaii." 81 (February 1964).

Abitare. "Hotel of the Fragrant Hills [Peking, China]." 219 (November 1983).

Adams Davidson Galleries. *I. M. Pei . . . Drawings for East Building of the National Gallery of Art.* Washington, D.C., 1979.

ADesign. "I. M. Pei. The Battle of the Pyramid." 61 (1/2, 1990).

AForum. "Chapel for China . . . Taunghai University." 106 (March 1957).

———. "Towers in the Sky." 127 (October 1967).

ARecord. "Vast Space Frame Wraps New York's Convention Center." 168 (August 1980).

Bailey, J. "Concrete Frames for Works of Art." *AForum* 130 (June 1969).

Bernsteen, R. "I. M. Pei's Pyramid." NYTM, 24 November 1985.

Blake, Peter. "I. M. Pei & Partners." *APlus* 1 (February 1973).

Brown, J. Carter. "The Designing of the National Gallery." *Studies in the History of Art* (Washington, D.C.) 30 (1991).

Canty, Donald. "Additions of Space, Light, and Life . . . Boston Museum of Fine Arts." *AIAJ* 71 (May 1982).

Cannell, Michael T. *I. M. Pei: Mandarin of Modernism.* New York, 1995.

Diamonstein, Barbaralee. "I. M. Pei. The Modern Movement Is Now Wide Open." *Art News* (New York) 77 (Summer 1978).

Fish, Marilyn B. In *The Critical Edge,* edited by Tod A. Marder. MIT Press, 1985.

Heyer, Paul. *Architects on Architecture.* 2d ed. New York, 1978.

Hull, Judith S. In Macmillan.

Huxtable, Ada Louise, and Hilton Krammer. "A Capital Art Palace." NYTM, 7 May 1978.

Interior Design. "Interview with I. M. Pei." (London) 49 (October 1978).

Jodidio, Philip. "Un seul Louvre." *Connaissance des Arts* (Paris) 500 (November 1993).

———. "Vers l'aile Richelieu." *Connaissance des Arts* (Paris) 491 (June 1993).

Jordy, William. "Bank of China Tower." *a + u* 249 (June 1991). The whole issue.

Lampugnani, Vitatorio. *Hong Kong Architecture. The Aesthetics of Density.* Frankfurt, 1993.

Leifer, L. "Upward Mobility . . . Mobile Research Division Lab . . . Texas." *Interiors* 163 (March 1981).

Lynes, Russell. "National Gallery's New Building." *Smithsonian* (Washington, D.C.) 9 (June 1978).

McLanathan, Richard. *National Gallery of Art, East Building. A Profile.* Washington, D.C., 1978.

McQuade. Walter. "Pei's Apartments round the Corner: Kips Bay." *AForum* 115 (August 1961).

Marlin, William. "Formed up in Faith, the Christian Science Center." *AForum* 139 (September 1973).

———. "In Remembrance." *AIAJ* 84 (July 1993).

———. "Some Reflections on the John Hancock Tower." *ARecord* 161 (June 1977).

Monfried, A. "Metropolitan Health." *AIAJ* 82 (March 1993).

PA. "New Landmark for MIT. Center for Earth Sciences." 46 (March 1965).

Reinshagen, P. "Everson Museum of Art in Syracuse [University]." *Werk* (Stuttgart) 52 (June 1965).

Rissell, J. "Permanent Witness." *ARecord* 181 (July 1993).

Schmertz, Mildred F. "Form and Figure. The Portland Museum of Art . . . Maine." *ARecord* 171 (November 1983).

———. "Getting Ready . . . Kennedy Library." *ARecord* 156 (December 1974).

Scott, David W. "Plans and Programmes—the National Gallery's East Building." *Connoisseur* (London) 178 (December 1971).

Suner, Bruno. "Une . . . défi chinois." *Techniques* 46 (July 1989).

———. *Pei.* Paris, 1988.

Techniques. "Montreal, Canada. Place Ville-Marie." 23 (May 1963).

Wiseman, Carter. *The Architecture of I. M. Pei.* New York, 1990.

———. *I. M. Pei.* New York, 1990.

Bibliographical

Vance: James Starbuck, A21, 1978; Lamia Doumato, A1645, 1986; Dale Casper, A1975, 1990.

AUGUSTE PERRET. 1874 (Ixelles, near Brussels, Belgium)–1954. Perret's father, Claude, a political exile since 1871, took his family back to Paris (1881), where Perret was educated at L'École Alsacienne. He studied architecture at L'École des Beaux Arts (1891–1895) under Julien Guadet. Although Perret won five medals at the school's highest level, and the Reconnaissance des Architectes Americaines prize, he decided not to graduate since that would have prevented him from entering his father's building firm, where he worked from 1897 to 1905. Upon Claude's death in 1905 he became a partner with his brother Gustave in Perret Frères. Although he never became an architect in the academic sense, Perret was one of the pioneers of French Modernism. He accepted a teaching position at the Special School of Architecture in the Boulevard Raspail, in Paris (1932–1940), and a professorship at L'École des Beaux Arts (1940–1954). In 1941 he was elected foundation president of the French Order of Architects. He continued to design and build, mostly around Paris but also throughout France, North Africa, and the Near East. Internationally feted, Perret received the Gold Medals of the RIBA (1948) and the AIA (1952) and the

Medal of the Academy of Fine Arts of Denmark (1949), as well as many civil honors at home and abroad. He received an honorary doctorate at the Helsinki Polytechnic in 1949.

ℴ

With his work "the first really rational and effectual expression of reinforced concrete was presented to the world."[1] Perret developed the structural system initiated by François Hennebique in 1892. Hennebique had swathed reinforced concrete structural frames in masonry, but Perret expressed the frame as an element of the architecture (although he usually covered it with a facing material, such as faience tiles); the walls were simply infill panels, some solid, some glazed. The first such attempt at lightening and opening the facade was made in an apartment building at 22b rue Franklin, in Paris, in 1903. There followed a four-story garage at 51 rue de Ponthieu, in Paris (1905), in which the cars were mechanically stacked. Without the need to maintain privacy, the plain, symmetrical facade was mostly fixed glass in story-height infill panels between the columns. The spandrel above the central door was glazed with a geometric pattern of concentric squares, the sole concession to decoration. He developed the straightforward aesthetic of the garage in an artist's studio for Chan Orloff, in Paris (1926), and others in Boulogne-sur-Seine (ca. 1928).

For the next twenty-five years Perret and his brother, working with the engineer Louis Gellusseau, experimented with the new structural technique. Styling themselves "builders in reinforced concrete" they began by building for other architects. Remarkably free of ornament for its date and type, an early success was the Théâtre des Champs Élysées (1910–1913) on a restricted site in Paris. The Perrets were originally hired as contractors to execute in reinforced concrete a design by Roger Bouvard and Henri van der Velde. But they soon supplanted the original architects with a structure-driven design of their own, and van der Velde was retained only as consultant. The stone-clad exterior of Perret's neoclassical building was restrained, its moldings were minimal and elegant, but it did not really reflect the structural inventiveness of the internal disposition. A direct relation to means is to be seen in the three auditoriums and foyers that must have inspired Victor Horta's central railroad station in Brussels thirty years later.

"Secondary" involvement in other designers' schemes could not satisfy Perret's creative genius: many architects with whom he worked were disinterested in integrating structure and form, and they certainly did not care about expressing the structure. By contrast, he was intent upon addressing the architectural problems engendered by the new material. A number of industrial buildings give evidence of that quest. Esders Clothing Factory, in Paris (1919), serves to illustrate this point. Its vast uncluttered work space was achieved by sixty-five-foot semicircular concrete arches supporting the secondary frame and in turn a fully glazed flat ceiling that ensured even, adequate light. That roof and the galleries surrounding the central "atrium" are in some ways redolent of Frank

Lloyd Wright's* Larkin office building in Buffalo, New York (1904). Perret used a different approach to enclose space for apparently Spartan scene-painting studios in the rue Olivier-Metra (ca. 1923): a segmental circular barrel vault springs from beams carried by elegant arches all in reinforced concrete. The space is lit by a continuous north light.

Perret best answered the question of how to build with reinforced concrete as a visible material, not only in the structure but also in the other elements of the building in his design for the war memorial church of Notre Dame du Raincy, in Paris (1922–1923), a building made entirely of exposed concrete and "the most pure formulation of his ferroconcrete style."[2] The incredibly light, simple, basilican space is articulated by slender, monolithic, cylindrical columns supporting a segmental shell roof over the nave; an opposed but similar vault covers each bay of the aisles. The nonstructural walls are finely filigreed precast panels with stained glass infills, and the exterior simply expresses the spaces within. Historian Richard Guy Wilson refers to the church as "symbolic and traditional" as a "cross between the structural armature of the Gothic" and the "order of classicism."[3] Raincy served in whole or in part as a model for other churches, including Sainte Therese, in Montmagny (1925), a chapel at Arcueil (1925), and Saint Joseph, in Le Havre (1950+).

In part, Perret's alleged concession to tradition lost him the admiration of the Modernists, particularly Le Corbusier,* who had worked in his office. But through the 1920s, their paths diverged from Perret's for other reasons. With their socialistic impetus, they sought ways to apply reinforced concrete to mass-produced houses for the proletariat; Perret's own search was for refinements of formwork, better precasting techniques, better surface finishes—all to make concrete a more elegant material and a rational expression of the building process. He wrote that

in the beginning architecture is only wooden framework. In order to overcome fire one builds in hard material. And the prestige of the wooden frame is such that one reproduces all the traits, including the heads of the nails.[4]

That axiom may have led to the use of off-form finishes, but it might well have been spoken by a fourth-century B.C. Greek architect explaining the sources of the Doric order. It reflects Perret's belief in the great timeless truths of architecture.

The issues of concrete construction were explored in two Paris buildings of the early 1930s: apartments at 51–55 rue Raynouard (1932) and the National Guard Building (1934). In the former there is unsurpassed proof that concrete can be elegant: the sinuous, liquid stair that ascends to the drawing office in Perret's own apartment. Anyway, both buildings had the advantage of mechanical vibration of the concrete, which increases compaction; on the former, Perret exposed the aggregate in places, prophesying a technique widely used later. His careful design of formwork, giving final off-form finishes, would be employed

in the so-called Brutalist buildings of James Stirling* and Alison and Peter Smithson* in the late 1950s and by any number of Japanese architects.

Perret's powerful but delicate neoclassical Museum of Public Works, in Paris (1936), was also maligned by the avant-garde as anachronistic. Yet, as Collins points out, it is important in the architect's oeuvre as "a sort of manifesto against the International style . . . that the architectural truths [resulting from new technology] do not necessarily produce unprecedented compositions and details, and that the quality of an environment is more important than any assertions of personal originality."[5] Perret's major post–World War II work was the reconstruction of Le Havre, largely destroyed in the conflict, after 1952. There, his influence upon a generation of French architects is patent. Of his contribution to modern architecture, Kenneth Frampton writes,

Apart from the lucidity of his architecture, and the extraordinary refinement attained in his built work, Perret's significance as a theoretician lay in his aphoristic, dialectical turn of mind—in the importance that he attached to such polarities as order versus disorder, frame versus infill, permanent versus impermanent, mobile versus immobile, reason versus imagination and so on.[6]

NOTES

1. Collins (1959), 148.
2. Kenneth Frampton, *Modern Architecture: A Critical History* (London, 1992), 108.
3. Richard Guy Wilson, *The AIA Gold Medal* (New York, 1984), 177.
4. Perret (1952), as quoted in Frampton (1992), 105.
5. Collins in Macmillan.
6. Frampton (1992), 108.

BIBLIOGRAPHY

The abbreviation AP for Auguste Perret is used below.

Writings

"Architecture: Science et poesie." *La Construction Moderne* (Paris) 48 (2 October 1932).
Contribution à une Théorie de l'Architecture. Paris, 1952.
"Le musée moderne." *La Construction Moderne* (Paris) 48 (16 October 1932).

Biographical

Badovici, Jean. "A. et G. Perret." *AVivante* (Summer 1925). The whole issue.
Collins, Peter. In *Contemporary Architects*.
Gargiani, Roberto. *AP 1874–1954: Teoria e Opera*. Milan, 1993.
Mayer, Marcel, et al. "AP, l'homme et sa vie." *Techniques* 9 (15 October 1949). The whole issue.

Assessment

a + u. "Apartment Building, rue Raynouard, Paris 1932." Extra edition (September 1990).
———. "Le Raincy, Church of Notre Dame" 135 (December 1981).
Abram, Joseph. "AP and Le Havre: Utopias and Compromises" *Lotus* 64 (1989).

———. "Le fin du 'cycle' Perret: L'école du classicisme structurel [1950s]." *AMC* (Paris) (April 1986).

———. "Un savoir urbain implicite" *Cahiers de la Recherche Architecturale* (Paris) 22 (1988).

AMC. "Perret." (November 1975). The whole issue.

D'Architectures "Auguste, architecte AP." (Paris) (November 1993).

Badovici, Jean "A. et G. Perret." *AVivante* 3 (Summer 1925).

Bressani, Martin. "The Spectacle . . . from 25 bis rue Franklin." *Assemblage* (MIT Press) (August 1990).

Cent Ans de Béton Armé, 1849–1949. Paris, 1949.

Champigneulle, Bernard. *Perret.* Paris, 1959.

Cohen, J-L., and M. Eleb. "L'esperienza urbana di Casablanca." *Casabella* 56 (September 1992).

Collins, Peter. "The Classicism of AP." *JSAH* 29 (October 1970).

———. *Concrete: The Vision of a New Architecture.* London, 1959.

———. "The Doctrine of AP." *AReview* 114 (August 1953).

———. "The New Brutalism of the 1920's . . . Notre Dame du Raincy." *JSAH* 33 (October 1974).

———. In Macmillan.

Le Corbusier. "AP." *JAE* 1 (1983).

Dormoy, M. "Auguste & Gustav Perret." *Das Kunstblatt.* (Berlin) 7 (October 1923).

Gregotti, Vittorio. "AP 1874–1974: Classicita e razionalismo di Perret." *Domus* (May 1974).

———. "Perret: 25 bis rue Franklin." *Rassegna* 8 (December 1986). The whole issue.

Jamot, P. *A. et G. Perret et l'Architecture du Béton Armé.* Paris, 1927.

Prousse, Jean-François. "Constructivisme . . . à la folie." *Techniques* 365 (April 1986).

Reichlin, Bruno. "Une Petite Maison on Lake Leman." *Lotus* 60 (1989).

———. "Pros and Cons of the Horizontal Window" *Daidalos* (Guertersloh) (15 September 1984).

Rogers, Ernesto. *AP.* Milan, 1955.

Saint, Andrew. "Notre Dame du Raincy." *AJournal* 193 (February 1991), 26–45.

Schaffer, Sylvie. "Le Havre: Un projet urbain." *D'Architectures* (Paris) 42 (January 1994).

Techniques. Special double issue. 9 (January–February 1949).

Vago, Pierre. "Perret . . . l'oeuvre complet." *Aujourd'hui* (October 1932). The whole issue.

Zaher, Marcel. *D'une Doctrine d'Architecture: AP.* Paris, 1959.

Bibliographical

Pettengill, George E. *AP: A Partial Bibliography.* AIA Library, 1952.

Vance: Lamia Doumato, A873, 1982.

RENZO PIANO. 1937 (Genoa, Italy)– . Born into a family of building contractors, Piano was at least aware of the industry before he studied architecture at the University of Florence and subsequently graduated from the Milan Politecnico (1959–1964). After joining the family firm, and with his father's support, he sought experience in Italy and abroad (1965–1970). He taught at the Poli-

tecnico until 1968 when he set up his own Studio Piano near Genoa. He formed a partnership (1971–1978) with Richard Rogers,* the magnum opus of which was the Georges Pompidou Center, in Paris (1973–1978). Piano has worked with the engineer Peter Rice (1978–1980) and as Renzo Piano Building Workshop since 1981. The firm relocated in Genoa's old quarter in 1985 (associates, Shunjii Ishida and Flavio Marano) with offices in Paris (associate Bernard Plattner) and Osaka (since 1989, associate Noriaki Okabe). Piano has had many accolades, including France's Commandeure des Arts et des Lettres (1984) and the Legion d'Honneur (1985), the RIBA Gold Medal (1989), and Italy's Cavalieri di Gran Croce (1989). He has been a visiting professor in the United States, Japan, Norway, Germany, Hungary, Britain, and the Netherlands, and he holds an honorary doctorate from the Delft Technische Universiteit (1992). His work continues to exhibit internationally.

<p style="text-align:center">✐</p>

Hailed by some as superlative—"the most innovative architect in Europe"[1]— and by others as unique—the "only Italian of international class among contemporary architects—",[2] Piano is neither. It is impossible to fit him into any facile classification of late twentieth-century architecture, not least because he has chosen not to deliver any definitive polemical statement about his theoretical position. It is easier to say what he is not. Although he is often grouped with such high-tech architects as Norman Foster,* Nicholas Grimshaw, and Michael Hopkins, he differs from them in the way in which he integrates technology and design. One critic considers the impetus for Piano's aesthetic to be technological function, "tempered by a concern for accommodating the user's needs,"[3] an approach epitomized in his own open-plan studio (1968) near Genoa and the Italian Industry Pavilion at the Osaka World's Fair (with Rogers, 1969–1970). And he clearly has no place with the formalist postmodernists because, although he respects historical architecture, he does not replicate or reinterpret its elements.

At the Milan Politecnico he studied under Franco Albini, for whom he subsequently worked. He also sought experience internationally in the offices of Louis I. Kahn* (Philadelphia), Z. S. Makowski (London), and Marco Zanuso (Milan). Albini gave him a love for detail and a methodical approach to design,[4] and his association with the others inevitably influenced his work. Piano is an admirer of the fifteenth-century Florentine architect Filippo Brunelleschi, another structural innovator. And it is by structure that Piano was first, and continues to be, enthralled. Indeed, he acknowledges as his principal mentor the French architect-engineer, Jean Prouvé,* who began experimenting with prefabricated construction techniques in 1925 in collaboration with Aluminium Française, Citroën, and Renault. His ideas were applied to several of his buildings: the covered market (1936–1938) and Maison du Peuple (1937–1939) in Clichy, the French pavilion at the Brussels World's Fair (1958) and an office building in Neuilly-sur-Seine (1963). Inspired by Prouvé, Piano's earliest experiments with materials—at first timber and steel but especially reinforced polyesters and

other plastics—generated temporary, extendable, lightweight structures, often in geometric modules and capable of nonrepetitive, industrialized production: barrel vaults, pyramids, and domes.

In 1969 Piano began working with Italian-born English architect Rogers, who had recently been a member of England's Team 4 with Foster, the archetypal high-tech architect. As well as their Osaka collaboration, Piano and Rogers produced the ARAM Medical Center, in Washington, D.C. (1970); the Fitzroy Street Commercial Centre, in Cambridge, England (1970); and offices for the B and B Upholstery Company in Como, Italy (1971–1973). The office was in several aspects—the totally flexible plan, the external steel structure as the basis of the aesthetic, and the use of strong color—a harbinger of their controversial yet widely acclaimed Beaubourg—the Georges Pompidou Center, in Paris (with Ove Arup and Partners, completed in 1977) (see Plate 35).

Perhaps becoming an architectural emblem of Paris like the high-tech Eiffel Tower of about eighty years earlier, Beaubourg is probably the most recognizable icon of the late twentieth-century high-tech school of architecture. Piano and Rogers's design, redolent of the futuristic dreams of Archigram,* was chosen from nearly 700 entries in an international competition. The imposing six-story building, at first perceived as incongruent in the historic Marais district of Paris, emphasizes the notion of a "cultural machine" whose technology is expressed (and its internal spaces made flexible) by placing the structure and the services on the outside. The idea was not altogether new; the proximity of a Gothic church reminds one that French medieval architects also achieved highly sophisticated external structural frames. Beaubourg is not universally appreciated. Italian modernist historians Tafuri and Dal Co see in it "superfluous metaphors" translated from the "technological overemphasis of . . . younger architects."[5] Nevertheless, it remains at the end of the twentieth century the most visited building in Paris, and it has influenced designs elsewhere, such as van den Broek and Bakema's Central Library, in Rotterdam (1977–1983).

Is there life after Beaubourg? Piano continues to work across a broad spectrum. In architecture, he developed the structural experiments of Paris, often working in collaboration with the late Peter Rice of Ove Arp and Partners. He has also designed housing schemes incorporating the open plan that had been taken to its practical conclusion in Beaubourg: in the dwellings at Cusago, Milan (1972–1974), internal subdivision was left entirely to the occupants; at Corciano, Perugia, Piano set up a "neighborhood workshop" to develop and guide interior planning, a process that characterized his later urban renewal and rehabilitation projects in Burano, Venice (1980), Japigia, Bari (1980–1982), and Molo, in Genoa (1981). Other work has included industrial design for the Fiat automobile company (1978–1980).

The Renzo Piano Building Workshop was formed in 1981 in association with the Genoese engineer Flavio Marano (with whom Piano had worked since 1968), the Swiss architect Bernard Plattner, and Japanese architects Shunjii Ishida and Noriaki Okabe, all of whom had worked for Piano and Rogers. Other architects

who later joined the truly international firm came from France, Scotland, Argentina, Morocco, the Netherlands, and the United States. Obtaining the commission to revitalize the old center of Genoa in preparation for the 500th anniversary of Columbus's voyage, the workshop moved there in 1985.

As well as "transforming" the old quarter of Genoa (1985–1992), the Renzo Piano Building Workshop has executed a wide variety of commissions, including the rehabilitation of old industrial buildings in Montrouge, Paris (1981–1984), a demountable exhibition pavilion for IBM (1984), and large-scale urban design projects in Turin, Genoa, Lyon, and Rhodes, Greece. The workshop also produced the "reticent, elegant" clapboard-clad museum—in total contrast to Beaubourg, the technology is concealed—to house the Menil Collection (with Richard Fitzgerald, 1980–1986) in Houston, Texas; the Synchrotron Radiation Facility in Grenoble, France (1987), and the San Nicola soccer stadium in Bari, Italy (with Peter Rice, 1987–1990) for the 1990 World Cup. In 1988 the firm won the commission for the Kansai International Airport in Osaka, Japan. These recent works, writes Barbara Chabrowe, exhibit a "compact, powerful design" that "integrates the technology and maintains the continuity with the environment."[6]

NOTES

1. Amery (1989), 43.
2. Donin (1982), 3.
3. Catherine Slessor in Sharp (1991).
4. Chabrowe in Wilkes.
5. Manfredo Tafuri and Francesco Dal Co, *Modern Architecture* (London, 1986), 364.
6. Chabrowe in Wilkes.

BIBLIOGRAPHY

Writings

Chantier Ouvert au Public. Paris, 1985.
Dialoghi di Cantiere. Bari, 1986
"Renzo Piano." *Harvard* 7 (1989).
With M. Arduino and M. Fazio. *Antico e Bello.* Rome, 1980.
With Richard Rogers. *Du Plateau Beaubourg au Centre Georges Pompidou.* Paris, 1987.

Assessment

a + u. "Renzo Piano." 206 (November 1987).
Amery, Colin. "The Golden Touch of Renzo Piano." *RIBAJ* 96 (May 1989).
Arup Journal. "The San Nicola Stadium." (London) (Autumn 1990).
Banham, Reyner. "Piano and Rogers, Architectural Method." *a + u* 6 (1976).
Brandolini, S. "Lo stadio di Bari e il sincrotrone di Grenoble." *Casabella* 51 (June 1987).
Buchanan, Peter. "Piano's Magic Carpet." *AReview* 190 (January 1992).
———. *Renzo Piano Building Workshop: Complete Works.* London, 1993; New York, 1994.
Castellano, Aldo. "Renzo Piano, aeroporto Kansai." *Abitare* 305 (March 1992).

Centre Georges Pompidou. London, 1977.

Chabrowe, Barbara. In Wilkes.

Davies, Colin. "Piano Quartet." *AReview* 186 (October 1989).

Dini, Massimo. *Renzo Piano: Projects and Buildings 1964–1983.* Paris, 1983; London, 1984.

Donin, G. *Renzo Piano—Piece by Piece.* Rome, 1982.

Drijver, Peter. "Renzo Piano: Architectuur is een rustige spel." *Bouw* (Rotterdam) 48 (9 April 1993).

Duparc, C., et al. "Beaubourg: L'art du siècle." *L'Express Internationale* (Paris) (30 June 1994).

Ellis, Charlotte. "Pompidou Revitalized." *AReview* 194 (May 1994).

Exhibit Design: Renzo Piano Building Workshop. Milan, 1992.

Farrelly, E. M. "Tecnica: The Quiet Game." *AReview* 182 (September 1987).

Ghirardo, Diane Y. "Piano Quays." *AReview* 185 (April 1989).

Glancey, Jonathan. "Arcadian Machine." *AReview* 176 (May 1984).

Kestenbaum, Jackie. "Renzo Piano and the Joy of the Hand-crafted Machine." *JapanA* 64 (1989).

Lampugnani, Vittorio. M., and Ermanno Ranzani. "Renzo Piano: Sovversione, silenzio e normalita." *Domus* 688 (November 1987).

Lotus. "The Construction of the De Menil Museum." 78 (1993).

Nakamura, Toshio, ed. *Renzo Piano Building Workshop 1964–1988.* Tokyo, 1988.

———. *Renzo Piano Building Workshop: Buildings and Projects 1971–1989.* Tokyo, 1989.

Pawley, Martin, et al. "The Creativity of Renzo Piano." *World Architecture* (London) 24 (1993).

ProcessA. "Renzo Piano Building Workshop: 1964–1991." (January 1992). The whole issue.

Prusicki, Marco. "Progetto Lingotto, Torino." *Domus* 675 (September 1986).

Ranzani, Ermanno. "La transformazione della citte: Genova." *Domus* 731 (May 1991).

Renzo Piano. Paris, 1987.

Renzo Piano: Buildings and Projects 1971–1989. New York, 1990.

Renzo Piano, Il Nuovo Stadio di Bari. Milan, 1990.

Renzo Piano: The Process of Architecture. London, 1987.

Rice, Peter. *An Engineer Imagines.* London, 1994.

Romano, Luca, and Bernardo Secchi. "Vicenza: Projetta sospesi." *Casabella* 54 (June 1990).

Rush, Richard. "Buy Now, Pay Later." *PA* 76 (April 1995).

Silver, Nathan. *The Making of Beaubourg.* MIT Press, 1994.

Slessor, Catherine. In *Illustrated Dictionary of Architects and Architecture,* edited by Dennis Sharp. London, 1991.

Bibliographies

Vance: Phyllis Harland, A2034, 1988; Mary Huls, A1673, 1986.

HANS POELZIG. 1869 (Berlin, Germany)–1936. After a preliminary education in Potsdam, Poelzig studied architecture at the Berlin-Charlottenburg Technische Hochschule (1888–1889). He passed the state board examinations in 1889 and began to work in the Ministry of Public Works' Technical Office; eventually he

became assistant to Hugo Haring in Berlin (1893–1894). After military service (1894–1895) Poelzig settled in Breslau, where he practiced architecture and taught at the Royal Art and Craft Academy (1898), of which he later became director (1903–1916). He was appointed city architect in Dresden, and he also taught at its Technische Hochschule (1916–1920). Taking up an appointment as director of architectural studies, at the Berlin Kunstakademie (1920–1924), he next became a professor at Berlin-Charlottenburg (1925–1930) only to be dismissed for political reasons. Hounded by the Nazis when they came to power in 1933, Poelzig fled to Turkey (May 1936) where he had commissions. Although he had accepted the directorship of the Ankara Architecture School, failing health forced him to return immediately to Germany, where he died only weeks later.

<p style="text-align:center">✐</p>

Around 1918 "Poelzig was continually being mentioned in the same breath with the Expressionist painters, as an Expressionist among Expressionists."[1] His sometime pupil Julius Posener claims that Poelzig holds a position of his own in Germany amongst the fathers of the Modern Movement because, unlike many of his contemporaries, "he freed himself of any kind of formalism and tried to develop, in the years preceding the First World War, an architecture in accordance with contemporary needs based upon a careful consideration of structural elements,"[2] and continued to produce throughout his career an architecture of consistent *character* (not form) despite changes around him.

As a student Poelzig came under the influence of the neo-Gothicist Karl Schafer. Although never himself a revivalist, Poelzig acknowledged his debt to historical architecture, especially the Gothic. He entered private practice in Breslau in 1899, producing in the next few years buildings that were free of precedent. Notable among them was his "tactful, yet fresh and lively" extension (1903–1906) to the Loewenberg town hall in Silesia; the steel-framed Upper Silesia Tower at the Posen Industrial Exhibition (1911), with its varied and colorful patterns of ornamental brickwork; and the stepped proto-Expressionist chemical plant at Luban (1911–1912).

Around the turn of the century, German reaction against *Jugendstil* had become pervasive. Many architects and designers were beginning to attach "importance to the facts of daily life and how one should build for them." In 1907 twenty-four of them, under the aegis of the bureaucrat Hermann Muthesius, formed the Deutscher Werkbund. Part of the Werkbund's mission was to improve the quality of both hand-crafted and industrial products by familiarizing designers with manufacturing processes. That principle, established by William Morris, had been introduced by Poelzig in the Breslau Academy's design courses when he became director in 1903, anticipating Walter Gropius's* Bauhaus policy by about fifteen years. Poelzig soon joined the Werkbund, later to become chairman (1919). When he left Breslau in 1916, he recommended Gropius as his replacement.

Poelzig's architecture changed with his move to Dresden. Early in his career

he had come under the influence of the architect-theorist Hugo Haring, and when the horrors of the Great War demolished the Werkbund's optimistic expectations of a better Europe, Expressionist architecture was born. Of great importance was Poelzig's 1916 entry in a closed competition sponsored by the German-Turkish Union for a so-called House of Friendship, a German cultural center in Istanbul.

The huge building, rising in four arcaded terraces (appropriately dubbed "hanging gardens" by the Werkbund's secretary), was very different from the other entries, most of which were either neoclassical or pseudo-oriental. It was a truly Expressionist design, yet not Expressionist in the same sense as Erich Mendelsohn's* dreams of new forms achieved through concrete construction, or Bruno Taut's proposed "temples to fellowship," or the visions of Hans Scharoun.* Constructed upon an "eminently rational plan," the "stark, tense and daring" rectilinear forms were drawn from historical Middle Eastern sources and naturally fit the context of the Eastern city. Moreover, it was buildable using contemporary technology.[3] But it was never built.

Neither were many of Poelzig's other projects during that socioeconomic crisis in Germany, including public buildings for Dresden and a Baroque-influenced Festspielhaus (1920–1922) for Salzburg, preliminary drawings for which vaguely resembled Brueghel's image of the Tower of Babel. His only realized design of the period, probably his best-known work, was a conversion-cum-extension: the Grosses Schauspielhaus in Berlin's Friedrichstadt (1918–1919). Pehnt writes, "No other building . . . in the Germany of those years captured the public imagination to the same extent. . . . It was the first prestige building of the young republic, an exotic bloom in the grey landscape of the post-war period."[4] Enveloping the dilapidated, iron-framed Zirkus Schumann, the Theatre of the Five Thousand had a semielliptical auditorium surrounding a promontory forestage, behind which stretched an unconventionally panoramic (30 metres) proscenium stage. "The arena and auditorium undivided by balconies suited [Reinhardt's] fondness for vast colorful productions and an atmosphere of festivity and magic."[5] The magic was invoked by the famous "stalactite dome," a stunningly brilliant response to impresario-client Max Reinhardt's request for a central cupola above the auditorium, echoing the vault of the sky in classical theaters. Much more than mere decoration, the "stalactites" were used by Poelzig to tune the acoustics of the huge space. One critic remarked that "the stage decoration began in front of the curtain." The expansive main facade of the theater was an almost flat, rather Italian Romanesque affair painted burgundy red, to some conservative souls "a threatening image of red revolution."[6] It was Poelzig's last Expressionist work.

He built little over the next few years. Commissions had been scarce enough during the war, and Germany's economic depression deepened well into the 1920s. As he had done at his Breslau Academy, Poelzig continued to stress the importance of handicraft to art, a position that he never completely relinquished. However, such later works as the Capitol Cinema, in Berlin (1925), the Deli

Cinema, in Breslau (1926), a "model" single-family house in the Stuttgart Weissenhofsiedlung (1927), and the I. G. Farben Administration Building, in Frankfurt-am-Main (1928–1930) demonstrate that he came to terms, in a measure and uncomfortably, with the modern movement. Yet all these designs remain separated from orthodox modern architecture by their "grand spatial concept."

By 1933, when the Nazis seized political power in Germany, Poelzig had become a venerable figure in his profession: professor of architecture at Charlottenburg Academy (1925–1933) and recently made an associate of the Fine Arts Academy (1933); he had been chairman of the Bund Deutscher Architekten (1926) and held an honorary doctorate from the Stuttgart Technische Hochschule. But his history of socialistic affiliations (including the 1918 Arbeitsrat für Kunst and the Novembergruppe, the Circle of Friends of the Bauhaus, and Der Ring) alarmed and displeased the Nazis. They immediately forced him to resign the headship of the combined State Schools of Architecture, Free, and Applied Art in Berlin and then systematically hounded him until he quit Germany altogether. Gropius observed that "Poelzig was not young enough to start again. The poverty of spirit in Germany could not be shown more clearly . . . if work or honor for a man like him were not provided."[7] The harassment caused the great teacher to die, as Posener believes, of despair.

NOTES

1. Pehnt (1973), 9.
2. In James Maud Richards, *Who's Who in Architecture* (London, 1977), 286.
3. Posener (1992), 10.
4. Pehnt (1973), 13.
5. Ibid.
6. Karl Scheffler as quoted in Pehnt (1973), 13.
7. As quoted in Macmillan.

BIBLIOGRAPHY

Writings

Der Architekt. Stuttgart, 1931; Tübingen, 1954.
"On Hans Poelzig." *AmericanA* 128 (23 September 1925).
Die Plane und Zeichnungen aus dem ehemalingen Verkehrs- und Baumuseum in Berlin. Weinheim, 1989.
"Rede gehouden ter gelegenheid van de herleving van den Werkbund." *Wendingen* 2 (11, 1919).

Biographical

Heuss, Theodor. *Hans Poelzig: Lebensbild eines Baumeister.* Tübingen 1948, 1955, 1966.
Isaacs, Reginald R. In Macmillan.
Posener, Julius. *Hans Poelzig: Reflections on His Life and Work.* MIT Press, 1992.

Assessment

AVivante. Poelzig; miscellaneous work. 7 (January 1924–1925).

Borsi, Franco, and Giovanni Klaus Konig. *Architettura dell'Espressionismo.* Genoa, n.d. [1967].

Clarke, John R. "Expressionism in Film and Architecture." *Art Journal* (New York) 34 (Winter 1974).

Gregotti, Vittorio. "L'architettura dell'Espressionismo." *Casabella* 254 (August 1961).

Heuss, Theodor. *Hans Poelzig: Bauten und Entwurfe.* Berlin, 1939, 2d ed., *Lebensbild eines Baumeister.* Tübingen, 1955.

Kokusai Kenchiku. "Hans Poelzig 1869–1936." (Tokyo) 12 (September 1936).

Pehnt, Wolfgang. *Expressionist Architecture.* New York, 1973.

Posener, Julius. "Due maestri: Hans Poelzig e Heinrich Tessenow." *Lotus* 16 (1977).

———. *Hans Poelzig: Gesammelte Schriften und Werke.* Berlin, 1970.

———. "Hans Poelzig, tre progetti per Berlino 1927–30." *Casabella* 54 (December 1990).

———. "Haus des Rundfunks, Berlino 1929–1931." *Domus* 702 (February 1989).

———. "Poelzig." *AReview* 133 (June 1963).

Scheffauer, Herman George. "Hans Poelzig." *AReview* 54 (October 1923).

Schirren, M. *Hans Poelzig . . . Drawings from the . . . Verkehrs und Baumuseum.* Berlin, 1989.

Schmal, Peter. "Heimatkunde [IG Farben HQ, Frankfurt]." *Bauwelt* 85 (7 January 1994).

Sharp, Dennis. *Modern Architecture and Expressionism.* London, 1966.

Slapeta, Vladimir. "Neues bauen in Breslau." *Rassegna* 11 (December 1989).

Stahl, Fritz. "Hans Poelzig." *Wasmuth's Monatshefte für Baukunst* (Berlin). 4 (1919–1920).

Worbs, Dietrich. "Heimatkunde [Cassirer and Co cable works]." *Bauwelt* 85 (29 April 1994).

JEAN PROUVÉ. 1901 (Paris, France)–1984. Son of the leading Art Deco painter Victor Prouvé, Jean was educated around Nancy. He trained as a blacksmith and metalworker under Émile Robert and Szabo in Paris (1916–1923). Collaboration with a number of architects (1923+) moved him to a private study of architecture. He operated an atelier-workshop in Nancy (1923–1940) and in Nancy-Maxeville (1944–1953). He became director of the Architectural Department of the Compagnie Industrielle de Transport (CNIT) in Paris (1954–1966) before he established an engineering consultancy there (1966–1984). Prouvé was a consultant engineer to CNIT (1966–1970) and to UNESCO (1957–1970). He was a founding member of the Union des Artistes Modernes, in Paris (1930), and president of the Cercle des Études Architecturales, in Paris (1971–1977). Highly respected in architectural circles throughout Europe, he received prizes and awards in France, as well as honorary membership in the RIBA (1982) and honorary doctorates from the Lausanne Polytechnique (1969) and the University of Stuttgart (1976). His work was exhibited (1925–1983) in France, Denmark, Germany, Belgium, Italy, Switzerland, the Netherlands, and Austria. He also received civil honors in Belgium and France, including the Officier de la Legion d'Honneur (1975).

‿

"For Jean Prouvé the perfection of construction processes implied an authentic industrialization of the building sector. His attention, too, to the formal quality of manufactured products was fundamental to the modern movement in the 1950s and 1960s."[1] "[Prouvé] deeply, wholly and completely possesse[d] 'the knowledge of how to industrially produce a building in every detail and as a whole'."[2] It may seem remarkable that a blacksmith and steel fabricator should have a place among the makers of modern architecture, but his influence and significance, especially in the last third of the twentieth century, is undeniable. And the recognition he enjoyed is best demonstrated by the fact that he chaired the jury that assessed the 700 entries in the international competition for the Georges Pompidou Center in Paris (1971). Indeed, Renzo Piano* of the winning team of Piano and Richard Rogers* acknowledges Prouvé as his principal mentor.

After spending some years making iron grilles and other decorative features for many French architects including Rob Mallet-Stevens and Tony Garnier, Prouvé began experimenting with prefabricated construction techniques in 1925 in collaboration with Aluminium Française, Citroën, and Renault. His ideas were liberated by the development of electric welding, and after 1931 he diversified his activities to manufacture individual building elements and entire prefabricated structures. "These metal parts were cleverly shaped so that they achieved a maximum of stability per unit volume of material, according to a technology devised by Prouvé and a growing number of associated engineers and fabricators."[3] In that quest he can be compared with R. Buckminster Fuller.*

In collaboration with the architect Eugene Beaudouin and his engineer partner Marcel Lods, Prouvé built a relocatable, multipurpose structure for the Rolland Garros Aeroclub in Buc, France (with aviation engineer Vladimir Bodiansky, 1935). It was followed by the Maison du Peuple in the Paris suburb of Clichy (with Beaudouin and Lods, 1936–1939).

The Maison could be adapted, within 45 minutes, for use as a covered market, a 2,000-seat meeting hall, or a 700-seat cinema, all achieved by a system of movable floors, sliding partitions, and openable glass roofs that could also be blacked out for daytime film shows. It anticipated the flexibility of the Pompidou Center by thirty years. Prouvé commented in 1981,

The Maison du Peuple sought to provide an everyday cultural and communication venue for local people, a free forum for our epoch. No doubt the design was ahead of its time and, to begin with, the administration of so versatile a building was a difficult matter. As it reaches its prime of life [techniques and people] have matured to the point that this building could now hope to meet its calling as a people's palace.[4]

The plan was a typical beaux-arts U about a central well, and the exterior and interior aspects of the Maison, for all their great refinement and elegance, were naturally mechanistic, crisp, and austere. But both plan or appearance changed with the varying uses and the significance of the building lies in its structure

and construction. Moreover, the success of the project gave Prouvé the confidence to design and build alone.

Prouvé fought in the French Resistance in World War II (1940–1944) then relocated his workshops to Maxeville in 1944. He participated in the French reconstruction program (1945–1954), mass-producing quickly assembled houses, such as those at Meudon near Paris, in which he applied his structural interpretations of ''tree'' buildings: a central steel portal carried flexed, thin aluminum roofing strengthened by profiling and held by stretched external ''buffers.'' The wall panels were hung as ''curtains'' from the buffers. Although the firm expanded in those years to produce buildings, building components, and furniture for clients throughout France and her colonies, because of conflicts between economic management and technological developments, Prouvé abandoned it in 1953 and moved to Paris. ''From then on he found himself carrying out facades for buildings that weren't his, earning notwithstanding the title of inventor of the curtain wall.''[5]

The cladding systems he devised were sophisticated in their fabric and fixings but also in the mechanical devices they incorporated for window and shutter opening systems. The best examples include the Mozart Square apartment building, in Paris (with Mirabaud, 1953), the Communist Party Headquarters, in Paris (with Oscar Niemeyer* and others, 1966), Building V for UNESCO, in Paris (with Bernard Zehrfuss, 1968) and New University, in Berlin (with Candilis, Josic, and Woods, 1968).

Although after 1966 Prouvé undertook many independent commissions, his major role in modern architecture is his participation in ''a kind of collective production of architecture'' like that promoted by Walter Gropius* as ''necessary in the context of an industrialized society.''[6] As he said himself in 1980,

We owe the rationalization and the simplicity of the motor car to the recognition by the constructor of that which is technically possible. The same is now true for works of art, even for household items. Shall we remain incapable of perception in regard to that which is the framework of our lives—our accommodation?[7]

John Winter points out that Prouvé has ''not adapted building to machine processes; he has worked it all out from scratch as if no one had ever built a building before.''[8]

NOTES

1. Barello and Marsaglia (1989), v.
2. Ionel Schien in Clayssen (1983), as quoted in Barello and Marsaglia (1989), v.
3. Willis in Macmillan.
4. Prouvé to the mayor of Clichy, 18 February 1981, as quoted in Ellis (May 1985), 5.
5. Romanelli and Visconti (1989), 80.
6. Willis in Macmillan.

7. As quoted in *Contemporary Architects.*
8. Winter in *Contemporary Architects.*

BIBLIOGRAPHY

Writings

"Constructions scolaires préfabriquées." *Techniques* 11 (September 1952).
"Elements de facade en aluminium." *Aujourd'hui* 26 (February 1955).
"French System of Prefabrication." *AJournal* 103 (27 June 1946).
"L'habitation de notre époque." *AA Journal* (London) 81 (December 1965).
"Le metal." *L'Art International d'Aujourd'hui* (Paris) 9 (ca. 1930).
[Prefabrication of industrial buildings]. *Werk* 21 (February 1967).
"Les rapports entre l'architecte et l'ingenieur." *Architecture: Formes et Fonctions* (Paris) 7 (1960).

Biographical

Winter, John. In *Contemporary Architects.*

Assessment

ADesign. "The Work of Jean Prouvé." 33 (November 1963).
Architect and Building News. "French prefab." (London) 186 (18 October 1946).
Arena. [Industrialization special number]. London 81 (December 1985). The whole issue.
AReview. "Headquarters for the French Communist Party, Paris." 151 (March 1972).
Aujourd'hui. "Groups d'habitations Meudon-Paris." 23 (November 1952).
Banham, Reyner. "Jean Prouvé: The Thin, Bent Detail." *AReview* 131 (April 1962).
Barello, Luca, and Aline Marsaglia. "Prouvé e Parigi." *Domus* 706 (June 1989).
Beeren, W.A.L., et al. *Jean Prouvé Constructeur.* Delft, 1981.
Burkhardt, François, et al. *Jean Prouvé Constructeur.* Paris, 1990.
Clayssen, Dominique. "Un entretien avec Jean Prouvé." *Techniques* 327 (November 1979).
———. *Jean Prouvé: L'Idée Constructive.* Paris, 1983.
Cohen, J.-L. "Jean Prouvé, 1901–1984: Il construttore fogorato." *Casabella* 48 (July 1984).
Coley, Catherine. *Jean Prouvé.* Paris, 1993.
———. *Jean Prouvé en Lorraine.* Villers-les-Nancy, 1990.
Connaissance des Arts. "Jean Prouvé." (Paris) 507 (June 1994).
Dardi, Costantino. "A Green Thought in a Green Shade." *Domus* 628 (May 1982).
Domus. "Casa in alluminio." 288 (November 1953).
———. "Elementi d'arredamento per la serie." 253 (June 1953).
———. "Prouvé; a House Like a Village." 452 (July 1967).
Ellis, Charlotte. "Jean Prouvé: A Man of Parts." *AJournal* 181 (20 February 1985).
———. "Prouvé's People's Palace." *AReview* 177 (May 1985).
———. "Prouvé's Prefabs." *AJournal* 181 (3 April 1985).
van Geest, Jan. *Jean Prouvé. Furniture.* Cologne, 1991.
Helwig, Jean-Marie. "Gitter und tore von Jean Prouvé." *Werk* 72 (January 1985).
Huber, Benedikt, and J.-C. Steinegger, eds. *Jean Prouvé: Structures and Elements.* New York, 1971.
Jean Prouvé. *Une Architecture par l'Industrie.* Zurich, 1971.

Klein, Richard, and Axel Venacque. "Pavillon d'aluminium." *Aujourd'hui* 283 (October 1992).

Lavalou, Arnelle. "L'idée constructive de Jean Prouvé." *Aujourd'hui* 271 (October 1990).

Lesnikowski, Wojciech. "Bank Machines." *PA* 73 (March 1992).

Levasseur, J. P. *Jean Prouvé cours du CNAM 1961–62.* Yvetot, France, 1983.

Rabaneck, Andrew. "Jean Prouvé." *ADesign* 41 (July 1971).

Reichlin, B. "Maison du Peuple at Clichy." *Daidalos* (Guertersloh) 18 (15 December 1985).

Romanelli, M., and M. Visconti. "Jean Prouvé: Il progetto della facciata." *Domus* 706 (June 1989).

———. "Jean Prouvé: Sedie tra il 1924 e il 1930." *Domus* 697 (September 1988).

Shien, Ionel. "Jean Prouvé." *Bauen und Wohnen* (Ravensburg) 18 (November 1964).

Sulzer, Peter. "Prouvés anpassungsfahige elemente." *Werk* 73 (October 1986).

Vernes, Michel. "Jean Prouvé: Architect-mechanic." *AReview* 174 (July 1983).

Willis, Alfred. In Macmillan.

R

ANTONIN RAYMOND (Rajman). 1888 (Kladno, Bohemia [Czech Republic])–
1976. Immediately after graduating in architecture from the University of Prague
(1909), Raymond emigrated to the United States, where he worked in a number
of the larger offices, including Cass Gilbert's. In 1914 he went to Europe to
study painting in Italy and then returned to New York to marry the designer
Noèmi Purnessin, who thereafter collaborated on much of his architectural, tex-
tile, and furniture designs. He worked for Frank Lloyd Wright* (1916–1920)
with an interlude after being drafted into the U.S. Army's Intelligence Corps
and serving in Europe (1917–1919). In 1919 the Raymonds joined Wright in
Japan to work on the Imperial Hotel and several other commissions, but Ray-
mond resigned to form American Architects-Engineers in Tokyo (1920–1923)
and then establish an independent practice in Tokyo (1923–1937). He was ap-
pointed honorary consul of Czechoslovakia in 1926. With war threatening in
1937, the Raymonds wisely accepted an architectural commission in Pondi-
cherri, India, then went back to the United States where they began a new,
independent architectural practice in New Hope, Pennsylvania (1938–1948). For
convenience, Raymond associated in name with a few architects, most produc-
tively with Ladislav L. Rado (1945–ca. 1958). The Raymonds returned to Japan
in 1948. Raymond received various honors and awards, including the Order of
Rising Sun (1964) and the Chevalier of the Legion of Honor, France.

Raymond's early work in Japan shows the influence of Wright (if heavier in
detail), regardless of building type. His own house of 1924 was a dramatic break
from that hegemony and a prescient experiment. It was built of concrete to a

U-shaped plan and otherwise showed something of the fussiness of French modernist architect Robert Mallet-Stevens. Also in the early 1920s he revealed an infatuation for the concrete architecture of Auguste Perret* in form, ornament, and detail, at times—he admitted—too mimetic. This is evident in the Saint Luke's Hospital project, in Tokyo (1923), Saint Joseph's Church, Negros Island, in the Philippines (1948, with Rado), and the auditorium and chapel for Tokyo Women's Christian College (1934). Raymond did the original college campus layout in 1921, and over many years he designed many of the buildings employing a variety of styles.

More faithful to the internationalist style were a series of houses, small commercial buildings, schools (especially notable is the refined Gymnasium for Sisters of the Seishin Gakuin, in Osaka [1931–1936]), and the Tokyo Golf Club (1930), a building Raymond considered his finest. His architecture of the 1930s was eclectic, derivative of most Modernist European factions. He willingly explored their ideas and methods. Therefore, when he designed an office building to house Julius Kahn's Truscon Steel Company in Tokyo (1931), it was similar to the industrial buildings designed by Kahn's brother Albert Kahn,* with whom Raymond was associated for a Ford assembly plant in Tsurumi (1934). After the war he assumed the rectilinear idiom persuaded by the works of Ludwig Mies van der Rohe.* This can be seen in Raymond's campus plan and in his buildings for Nanzan University in Nagoya (1960–1962).

But he was also inventive. With the counterthrust to Modernism moving away from rigid boxes, so to speak, to more exotic forms, Raymond responded with concrete idioms of structurally derived shapes: giant, curved concrete trusses span the Yawata Memorial Hall (1954); intersecting concrete ellipses and conical shapes form the Society Verbi Divini Seminary Chapel in Nagoya (1963); great concrete parabolas form the chapel at Rikkyo High School in Shiki (1961); and mammoth, coarse concrete folds span the Gunma Music Center, in Takasaki (1955). Raymond's concrete structures predate those of Marcel Breuer* and adequately support Felix Candela's* theory that shape can resist gravity. Michael Czaja correctly labeled Raymond a "violent evolutionary." His inventiveness was well received in Europe, especially in France, where Jean Badovici published plates of Raymond's early work in L'Architecture Vivante (1920s) and in Morance's later series, the Encyclopédie de l'Architecture (1930s), and in the United States from the 1930s.

Like Schindler and Richard J. Neutra* in the United States, Raymond was European trained, worked for Wright, and introduced European modernism to another country. But Raymond also kept the tradition of Wright alive in Japan for many years. Not only did the Raymonds personify modern Western art and architecture, but Antonin fathered an indigenous modernism in Japan.

A number of young architects came to Raymond, for instance, Kunio Maekawa worked in his office (1932–1935) after working in Paris with Le Corbusier.* Le Corbusier's pupil and another Czech, François Sammer, worked with Raymond (1937–1938). Craftsman, architect, and Massachusetts Institute of Technology graduate George Nakashima worked for Raymond in Tokyo (1935–

1938) and in the United States (1941). Junzo Yoshimura worked for Raymond (1926–1940) and, after the war, did some work in the United States, including the design for a Japanese tea house at New York's Museum of Modern Art.

Thoroughly absorbed by and comfortable with Japanese culture, the Raymonds vigorously promoted the maintenance of the traditions of their adopted country. Although Antonin designed and supervised construction of buildings in North America, the Philippines, India, and on Guam, his finest architecture is in Japan: more exactly, it is those buildings that blend traditional architecture and construction methods with modern Western ideas. They are the one organic consistency to flow through his oeuvre. They began with the Raymonds' summer house at Karuizawa (1932) and include the small and wonderfully naive Saint Paul's Church, also in Karuizawa (1934), the Raymonds' office and house (1953), the Moji Golf Club (1959), and the marvelous Adachi house in Karuizawa (1965), which shows in plan the influence of Louis I. Kahn* while being reminiscent of the American Pacific Northwest School of the same period, as introduced by John Yeon and Pietro Belluschi.*

Raymond was nominated for the 1953 AIA Gold Medal but, to quote him, it was "given to a businessman": William Delano. Raymond's supporters rallied to see him presented with the first Medal of Honor of the AIA's New York chapter (1956).

BIBLIOGRAPHY

Writings

Antonin Raymond. An Autobiography. Rutland, Vermont, 1973.
Antonin Raymond. His Work in Japan 1920–35. Tokyo, 1936.
"An Architect Comes Home from Japan." *AForum* 70 (February 1939).
Architectural Details 1938. Tokyo, 1938; 2d ed., as *Architectural Details.* New York, 1947.
[*Collection of Antonin Raymond's Work.*] Tokyo, 1931.
"Concrete for New Designs." *ARecord* 79 (January 1936).
"The Doctrine of Auguste Perret." *ARecord* 115 (January 1954).
"A Portfolio of Recent Work." *AForum* 75 (November 1941).
"The Spirit of Japanese Architecture." *AIAJ* 20 (December 1953).
"Structures for Transient Living." In *Forms and Functions of 20th Century Architecture,* edited by Talbot Hamlin. New York, 1947.
"Toward True Modernism." *Pencil Points.* (New York) 23 (August 1942).
"Working Drawings." *ARecord* 79 (January 1936).
With L. L. Rado. "Cable Station . . . Sea-girt Guam." *AForum* 87 (July 1947).
———. "Projects from a Master Plan." *AandA* 72 (June 1955).

Biographical

Czaja, E. Michael. "Artist and Dreamer." In Killick (1962).
Misawa, Hiroshi. "[From Taliesen to Takasaki]." *Kindai Kenchiku* (Tokyo) 15 (October 1961).
Nakamura, K., ed. "Antonin Raymond. His work in Japan 1920–35." *AForum* 67 (supp. August 1935); reprinted and expanded as a monograph, Tokyo, 1936.
Winter, John. In *Contemporary Architects.*

Assessment

Bognar, Botond. *Contemporary Japanese Architecture.* New York, 1985.

Ferris, Hugh. "An American Architect in Japan." *ARecord* 73 (January 1933).

Killick, John, ed. "Antonin Raymond Architect." *AAQ* 78 (August 1962). The whole issue.

Konetsu Tsushin. "[Antonin Raymond, AIA Medal of Honour]," 8 April 1956.

Kultermann, Udo. *New Architecture in Japan.* Stuttgart, 1967.

Maekawa, Kunio. "Antonin Raymond." *Kenchiku Bunka* (October 1961).

Marlin, William. "A Conversation with Ladislav Rado." *ARecord* 163 (May 1978).

[Modern Furnishings. Series 10.] Tokyo, 1937.

Ross, Michael Franklin. *Beyond Metabolism. The New Japanese Architecture.* New York, 1978.

Sato, Hiromi. ["Design Philosophy."] *Shin Kenchiku* (July 1959).

Stewart, David B. *The Making of a Modern Japanese Architecture: 1868 to the Present.* Tokyo, 1987.

Sugiyama, Masanori. ["My Reminiscences."] *Kenchiku Bunka* (October 1961).

Yamaguchi, Hiroshi. In Macmillan.

G(ERRIT) TH(OMAS) RIETVELD. 1888 (Utrecht, the Netherlands)–1964. During his elementary schooling, Rietveld started work in his father's furniture workshop in Utrecht (1899–1906). He attended drawing and design classes at the Utrecht Museum of Arts and Crafts (1904–1908) and studied architectural drawing under P.J.C. Klaarhamer (1909). While working as a draftsman (1906–1911) for the jeweler C. J. Begeer, he began to diversify artistically after 1909. Rietveld established his own joinery shop in Utrecht (1917). In 1918 he became involved with the De Stijl* group, and then established his own architectural practice in Utrecht (1919–1960), although most of his work was in furniture, branching into interior design after 1920. Rietveld was one of the signatories to the La Sarraz charter (1928) of the Congrès Internationaux d'Architecture Moderne* (CIAM). He left De Stijl in 1923 and collaborated on the famous Schroderhuis (1924) with Truus Schröder-Schräder. The association continued its generally domestic work until 1960. After a few years of informal cooperation with the younger architects, he formed the partnership Rietveld, van Dillen, and van Tricht, in Utrecht (1960–1964). He taught architecture and industrial design in various art and design academies in Rotterdam, The Hague, Amsterdam, and Arnhem (1942–1958). His work was exhibited in Moscow (1927), Vienna (1932), Venice (1953), London (1971–1972), and throughout Holland (after 1958). In 1964 he received an honorary doctorate from the Delft Technische Hogeschool.

ᴄᴧ

Rietveld was first a furniture designer. It is probable that his first realized design, at the age of twelve, was a table and chairs for the gatehouse at Zuilen Castle. While studying design and drawing and working as a draftsman for Begeer, he designed a tombstone for E. Nijland (1909)—the lettering is redolent

of the Amsterdam School—and in 1911 he became an active member of the "Love of Art" painting and drawing association. As soon as he started his own joinery shop in Utrecht, Rietveld "had the opportunity to create furniture to his own taste."[1] The prototype of his now famous red-blue chair (which had come to fruition by 1923) was created in 1918. It is among the most familiar icons of Modernism.

That was the year he met Theo van Doesburg,* J.J.P. Oud,* Jan Wils, and Vilmos Huszar—all members of the incipient, loosely knit group of avant-garde artists and architects known as De Stijl. They were probably introduced by the architect Robert van 't Hoff, who in 1915 had commissioned Rietveld to make furniture in the style of Frank Lloyd Wright* for the Wright-clone Verloop house he was building at Huis ter Heide. In 1919 Rietveld joined De Stijl, although "from the very beginning [he] stood out from his colleagues in two particular ways; he published very little and he avoided quarrels and intrigues."[2]

At the same time, he established an architectural practice in Utrecht, where he remained for the rest of his life. By the end of 1919 he had produced two more objects, now regarded as seminal in the history of modern furniture: the buffet and the prototype of the *kinderstoel* (baby chair). Willem Marinus Dudok's* associate, Robert Magnée, recalls Rietveld's confession that the design was partly a result of the plain materials he had on hand at the time.[3] Several commissions followed: a shop for his ex-employer, Begeer, in Utrecht (1919); domestic interiors for Dr. Hartog, in Maarsen (1920); refurbishment of G.Z.C. Jewellers' Calverstraat store in Amsterdam; interior redecoration of the Schröder family's Utrecht house (both in 1921); and a plethora of furniture designs.

In 1921 he began a collaboration with the interior designer Truus Schröder-Schräder that soon led to his most celebrated building. The tiny Schröder House, Prins Hendriklaan, in Utrecht (1924), for the widowed Mrs. Schröder, is possibly the best-known Dutch example and icon of twentieth-century architecture (see Plate 13). Since there has been so much analysis and discussion, there is little need to say more here except that it represents, as Warncke notes, "the most distinct implementation of De Stijl principles . . . the most resolute application of De Stijl's principles of form."[4] Earlier, Rietveld had collaborated (as second fiddle) with Oud, van Doesburg, and Cor van Eesteren on fragments of schemes and unrealized projects, such as the Rotterdam Spangen housing and the Rosenberg house. What they had been able to only dream of and explore in scale models, Rietveld built as his *first* complete architectural work.

In 1923 he had invoked van Doesburg's wrath by (as the latter mistakenly believed) associating with the Weimar Bauhaus—a lapse that the jealous van Doesburg regarded as treason. Although he remained friendly toward the painter, the incident marked Rietveld's withdrawal from De Stijl; his new work was still published in its journal. After building "the paragon of De Stijl architecture," Rietveld continued to practice architecture and interior design with Truus Schröder-Schräder throughout the 1920s, mostly domestic commissions, mostly around Utrecht. Toward the end of the decade he built a number of small

commercial projects in Germany, and even one in Vienna. But the Schröder house had been the high point of his career. After that, and perhaps because of his association with CIAM, his work tended toward international functionalist anonymity. Houses designed with Schröder-Schräder (like those in Erasmuslaan, Utrecht, of 1930–1931) or alone (like the Lommer house, in Wassenaar, 1927, and the Hillebrandt house, in The Hague, 1935) demonstrate that shift in aesthetic.

Rietveld never completely forsook De Stijl's conception of space, line, and plane. That was borne out by his 1954 sculpture pavilion at Sonsbeek, Arnhem, in which the continuity of the volumes is interrupted by fragments of what may be considered infinite planes; that freedom could be achieved because the exhibition spaces were not necessarily restricted by day-to-day functionality. After an active career, at age seventy-two, he formed an association with J. van Dillen and J. van Tricht, with whom he produced a few conservatively modernist buildings, notably his last work, the serene Vincent van Gogh Museum, in Amsterdam (1963–1973).

NOTES

1. Marijke Küper in Blotkamp (1982), 262.
2. Ibid., 260.
3. Conversation with Donald Langmead, Naarden, August 1987.
4. Warncke (1991), 134.

BIBLIOGRAPHY

Writings

"Interieur." In *Internationale Leergang voor Nieuwe Architectuur.* Delft, 1930.
Levenshouding als Achtergrond van Mijn Werk. Amsterdam, 1957.
Nieuwe Zakelijkheid in der Nederlandsche Architectuur. Amsterdam, 1932.
"Nut, Constructie; Schoonheid, Kunst." *i10* (Amsterdam) 1 (1927).
"Over Architectuur Gezien als een der Plastische Kunsten." *De 8* 10 (June 1939).
Over Kennis en Kunst. Amsterdam, 1946.
Rietveld 1924. Schröder House. Amsterdam, 1963.
"A View of Life." *Delta* (Amsterdam) 1 (March 1958).
Petersen, Ad, ed. *De Stijl.* Facsimile of journal 1917–1931. 2 vols. Amsterdam, 1968.

Biographical

Bless, Frits. *Rietveld 1888–1964. Een Biografie.* Amsterdam, 1982.
Blotkamp, Carel, et al. *De Beginjaren van De Stijl.* Utrecht, 1982; *De Stijl: The Formative Years.* MIT Press, 1986.

Assessment

Arquitectura. "Werkbund Siedlung [Vienna] 1932." (Madrid) 70 (May 1989).
Baroni, Danielle. *The Furniture of Gerrit Thomas Rietveld.* Milan, 1977; New York, 1978.
Bless, Frits. "Rietveld: Myth and Reality." *Forum* (Hilversum) (May 1981).
Bliss, Anna Campbell. "Art, Color, Architecture." *AIAJ* 71 (February 1982).

Brown, Theodore M. "Rietveld and the Man-made Object." In *The Man-made Object*, edited by G. Kepes. New York, 1966.
———. "Rietveld's Egocentric Vision." *JSAH* 24 (4, 1965).
———. *The Work of G. T. Rietveld*. Cambridge, Mass., 1958.
Buffinga, A. *G. Th. Rietveld*. Amsterdam, 1971.
Building. "G. T. Rietveld, 1888–1964." (London) 222 (July 1972).
Burton, Scott. "Furniture Journal: Rietveld." *ArtA* 68 (September 1980).
Dumont, Marie-Jeanne. "Rietveld ou la vie après le chef-d'oeuvre." *Aujourd'hui* 287 (June 1993).
Forum (Amsterdam) (March 1958). The whole issue.
Industrieel Ontwerpen. "The Real Rietveld." (Amsterdam) (March 1993).
Kuper, Marijke, and Ida van Zijl. *Gerrit Rietveld: The Complete Works 1888–1964*. New York, 1993.
Overy, Paul. "Equipment for Utopia." *ArtA* 82 (January 1994).
Overy, Paul, et al. *The Rietveld Schröder House*. MIT Press, 1988.
Schaafsma, G. *Rietveld: Bouwmeester van een Nieuwe Tijd*. Utrecht, 1959.
Sembach, Klaus-Jürgen, et al. *Twentieth Century Furniture Design*. Cologne, 1989.
Szenassy, Istvan L., et al. *G. Rietveld, Architect*. Amsterdam, 1973.
Tucker, William. "The Object." *Studio* (London) 185, 952 (1973).
Voge, Peter. *The Complete Rietveld Furniture*. Rotterdam, 1993.
Warncke, Carsten-Peter. *De Stijl 1917–1931*. Cologne, 1991.
Wood, James. "Two Exhibitions, 1955." *Architects' Yearbook* (London) 7 (1956).

Bibliographical

Fanelli, Giovanni. *Moderne Architectuur in Nederland 1910–1940*. The Hague, 1978.
Vance: Lamia Doumato, A954, 1983; Donald Langmead, A1671, 1986; A1672, 1986; A1773, 1987.

KEVIN (EAMONN) ROCHE. 1922 (Dublin, Ireland)– . After receiving a beaux arts training for his professional degree from the National University of Ireland (1945), Roche worked in Dublin and in London before a move to the United States to study at the Illinois Institute of Technology (1948), but only for one semester because "Mies's [van de Rohe*] school was an update of the Beaux Arts tradition; instead of drawing acanthus leaves we drew bricks."[1] He "fled" to Eero Saarinen* in Bloomfield Hills, Michigan, and in 1950 he became a principal design associate (1954) and full partner (1961). In 1964 Roche was naturalized. On Saarinen's sudden death in 1961, Roche assumed control of the firm jointly with John Dinkeloo,* who had also begun with Saarinen in 1950 and had become a full partner in 1956. Upon completion of Saarinen's outstanding work, on which Roche had acted as principal designer, the two men formalized independence (1966–) with offices outside New Haven in Hamden, Connecticut. Roche has received many national and international awards, including the prestigious Pritzker Prize (1982) and the AIA Gold Medal (1993).

ᴄᴇ̓·

Having worked with Eero, as well as with Charles and Ray Eames, I discovered my definition of Modern architecture, which is . . . a total immersion in the substance of the problem in order to arrive at a solution that is based on the specific circumstances.[2]

The end result, of course, is a series of buildings that *look* different one from the other, with no apparent consistency in oeuvre except formalistic orthodoxy. The "stylistic evolution" of the repetitive industrial glass facade "served as a counterfoil to Saarinen's dynamic imagery. Somewhere between the attractions of these two expressionist polarities, Roche was able to define his sovereign interests."[3]

All this is apparent in his first independent works; for example, Lee High School in New Haven (1963–1969), constructed in one of his favorite materials, concrete, on a site and to a building plan that is symmetrical about two axes; or the Cummins Engine shop for Darlington, England (1964–1967), constructed of other favorite materials, noncorrosive steel and glass, again to an axially formal plan. Yet the Oakland Museum in California (1964–1969) is a type of design that does not again appear in his work. Called an urban oasis by most, it is a garden park set among concrete forms most of which are below one story. In its general contours the building exaggerates the natural slope of the ground with parking, offices, and museum spaces below.

The idea of a private, urban park was carried to the Ford Foundation Headquarters in New York City (1965–1968) (see Plate 31). It contains a series of gardens at ground level and on various roofs as the building steps back. All is enclosed, on two sides by offices and on two sides by a glass wall. The top two floors contain more offices, but on four sides and the cantilever beyond the facade below. The cantilevers and full-height grey-red granite supports suggest a subtle influence of Paul Rudolph's* Art and Architecture building at Yale University. The internal garden is private, not public. The concept of the Ford and Oakland buildings permeates much of the urban design and architecture of the last half of the century. If their work with Saarinen had not already done so, these first independent works would have established Roche and Dinkeloo as preeminent architects. Public and corporate commissions and bold responses followed.

The Knights of Columbus Headquarters in New Haven (1966–1970) embodies what Vincent Scully discerned from his studies of interviews with Roche: each design "embodies a large and simple *Idea:* not, it must hastily be said, a sentimentally literary one . . . or an agonizingly sculptural one" but one that is abstract, "a rigid *schema* beyond qualification."[4] Thus the square Knights of Columbus building has a square core of elevators with other serving functions in masonry-clad cylinders at the corners. Steel frames the floor systems. The adjacent rectangular Veterans' Memorial Coliseum building has parking with circular car ramps at each end constructed in exposed steel over public transport and public spaces with masonry exteriors. In so much of Roche's work of the 1960s and 1970s the influence of Louis I. Kahn* is patent in parti and form.

The exit of large corporations from city to country began in the 1950s, including Connecticut Life's headquarters by Gordon Bunshaft* of Skidmore, Owings, and Merrill.* Roche was involved with a number of such shifts: the College Life Insurance Company, which relocated outside of Indianapolis, Indiana

(1967–1971), where Roche placed nine pyramidal eleven-story towers; or Cummins Engineering, which took its headquarters and one plant to the outskirts of Columbus, Indiana. The building (1972) was completely roofed in tinted glass. The plant (1970–1973) had parking on the roof of a one-story facility. Union Carbide's world headquarters moved beyond Danbury, Connecticut (1977–1982). Roche placed beside a through street three stories of parking to which clusters of offices were attached. Roche's use of glass as a roof was taken on by others to become a hallmark of Modernism during the last two decades.

Roche's later work succumbed to the infection of postmodernist contrivances. Tall buildings such as the Conoco Petroleum Headquarters in Houston, Texas (1972), and two highrises projected as the Denver Towers in Colorado (1984–1985), were by Roche's admission meant to be abstracted, megalarge classical columns: shades of Adolf Loos's* entry in the *Chicago Tribune* competition in 1922. Less diminished by mere aesthetics but nonetheless derivative of things distantly past was the E. F. Hutton building in New York City (1980). One can understand Roche's distraction after the banal and geometric rigidity of the One United Nations Plaza building of highrise hotel and offices (1966–1976), but the Houston and Denver buildings lack the intellectual rigor of his oft-stated philosophy.

Because of axiality and boldly confronting single forms, monumentality dominates most of Roche's work. Seldom does it possess delicacy; exceptions are few. Additions to the Irwin Union Bank at Columbus, Indiana (1966–1972), are one example where glass and steel, a pedestrian promenade, and the landscape are deftly knitted to human scale.

Another is the General Foods headquarters outside Rye, New York (1977–1982), where axial formality, a sense of appropriate materials, and an elegant refinement of proportion and detail are all expertly combined. Three levels of parking are surmounted by offices that formally overlook reflecting waters of a lake. Roche had a fine sense of plan arrangement with an individual debt to beaux-arts formalism and of interior excitement; they return in this building. The usually quiet Roche observed that when one approaches the visitor's entrance at the lowest level, in front is the receptionist,

directly overhead, a distraction: you can see right through the garage [and office floors], about fifty feet up, to the great [skylit] central space. And just as you are grappling with this image the receptionist says, "May I help you please?"

Roche's bent to beaux arts formality is vulgarly displayed in the Bouygues World Headquarters, near Paris (1983–1987); an all-glass rococo assemblage of buildings restates the authority of French seventeenth-century gardens à la Richelieu and Le Notre. Conversely, the De Witt Wallace Museum of Fine Arts, in Williamsburg, Virginia (1986), is a rather small nonbuilding of four walls in a long rectangle placed only near the old mansion, exhibiting finesse and restraint.

The answer is inherent in the client's brief, in the question; so said Roche, after Frank Lloyd Wright.*

NOTES

1. De Long (1986), 225.
2. De Long (1986), 225.
3. Drew (1972), 160.
4. *AForum* (1974), 19.
5. De Long (1986), 230.

BIBLIOGRAPHY

Writings

"Aquarium. National Fisheries Center." *ADesign* 39 (February 1969).
"Central Park Zoo." *a+u* 235 (April 1990).
"Charles Eames." *Zodiac* 11 (March 1994).
"A Conversation." *Perspecta* 19 (1982).
David G. De Long, et al. "Statement." *American Architecture. Innovation and Tradition,* New York, 1986.
Kevin Roche—John Dinkeloo & Associates 1962–1975. Tokyo, 1975.
Cook, John W., and Heinrich Klotz. *Conversations with Architects.* New York, 1973.

Biographical

Smith, C. Ray. In *Contemporary Architects.*

Assessment

AForum. "Kevin Roche, John Dinkeloo . . . [1964–74]," edited by William Marlin. 140 (March 1974). The whole issue.
Barreueche, R. "Computer-aided Gothic." *AIAJ* 82 (November 1993).
Canty, Donald. "Roche in Versailles." *AIAJ* 78 (January 1989).
Crandell, Gina M. "In Capability." *Landscape* (Berkeley) 74 (May 1984).
Dal Co, Francesco. *Kevin Roche.* New York, 1986.
Drew, Philip. *Third Generation Architects.* Stuttgart, 1972.
Futagawa, Yukio, ed. *Kevin Roche, John Dinkeloo & Associates 1962–1975.* Vol. 1. Tokyo, 1975.
GADoc. "General Foods Corporation." 9 (February 1984).
Heyer, Paul. *Architects on Architecture.* 2d ed. New York, 1978.
Hozumi, Nobuo. *The Ford Foundation.* Tokyo, 1977.
———. "Latest Works of Kevin Roche." *a+u* 211 (April 1988).
JapanA. "Yurakucho 1-chome Building." 3 (Summer 1991).
Knight, C. "Serene Pavilions Traversing a Lake." *AIAJ* 75 (December 1986).
McQuade, Walter. "The New Saarinen Office." *AForum* 118 (April 1963).
Temko, Allen. "Evaluation: A Still-Remarkable Gift of Architecture to Oakland." *AIAJ* 66 (June 1977).
———. "Visionary Architecture in the Napa Valley Landscape." *ADigest* 49 (August 1992).

Bibliographical

Vance: Lamia Doumato, A115, 1979; Robert Kuhner, A1522, 1986.

RICHARD (GEORGE) ROGERS. 1933 (Florence, Italy)— . Because of the expansion of fascism in Italy, Rogers' wealthy middle-class British family re-

turned to England in 1938. Following a youthful desire to become an architect, after two years of national military service (1951–1952), Rogers studied at the AA school in London (1953–1959). He worked for a while in the Middlesex County Council's architects' office before going to the United States as a Fulbright, Edward Stone, and Yale University scholar (1961); he gained a master's degree at Yale (1962). When he returned to England, he became part of Team 4 (1963–1968) with his architect wife Su Brumwell (m. 1960) and Norman Foster* and his wife Wendy. When the firm was dissolved, Richard and Su Rogers conducted a practice (1968–1970) until they were succeeded by Renzo Piano* and Rogers (1971–1978). The Richard Rogers Partnership (1978–) continues to practice from London. Rogers has held high office in several professional bodies, including the RIBA and the United Nations Architects' Committee. He has won numerous international competitions and has received many prizes and awards, including the RIBA Gold Medal (1985) and Chevalier of the French Legion of Honor (1986). His work has been widely exhibited in Europe and North America.

Rogers' frank expression—some would say, emphasis—of structure has inevitably earned him a niche in the school of modern architecture known as "high tech." He repudiates that categorization, insisting that he is simply employing *appropriate* technology to generate an aesthetic totally relevant to the late twentieth century. That is, he affirms the modernist notion of Zeitgeist, the "spirit of the epoch" insisted upon by Le Corbusier* in *Vers une Architecture*. He also, perhaps without the social overtones, embraces the optimistic view of the future held by the early modernists.

Encouraged by modernist architect and polemicist Ernesto Rogers (an Italian cousin), Rogers entered the AA school where he learned from Peter Smithson* that buildings should be of "uncompromising clarity and honesty in the presentation of structure."[1] Although Rogers won the first-year prize (1953), he struggled through the course hampered by his poor drawing skills, due in part to dyslexia. A sojourn in America (1961–1962) exposed him to many ideas, which had a lasting effect on his work. Vincent Scully, who was teaching in the masters' program at Yale, introduced him to the architecture of Frank Lloyd Wright*; Serge Chermayeff taught him about community and privacy; and Craig Ellwood made him aware of postwar experiments with steel structures in West Coast America. Perhaps most important, at Yale he met and worked with fellow Britisher Foster. Together, they investigated the work of leading American architects, and were impressed with Eero Saarinen's* use of industrial materials and Louis I. Kahn's* theories of served and servant spaces in architecture. Upon graduating from Yale, Rogers worked for a short time in the San Francisco office of Skidmore, Owings, and Merrill* (1962).

In 1963 Team 4 was established in London. Among its first domestic work was Rogers's Creak Veen, a house for his parents-in-law in Cornwall (1963), which won the 1969 RIBA award for work of "outstanding quality." It was

followed by the Jaffe house, in Radlett (1966), prophetic of Rogers' search for flexible, expandable architecture, and the almost contemporary Murray Mews, in London, in which problems with traditional construction methods steered him toward a more controllable way of building. Team 4 was seriously noticed when it produced the Reliance Controls Factory (1966) in Swindon. Influenced by Rogers' experiences with Skidmore, Owings, and Merrill, the small building clearly expressed its elegant, immaculately detailed structure.

Team 4's two husband-wife groups went their own ways in 1967, and the Rogers partnership was formed, further exploring the same means to architecture:

general-purpose rather than tailor-made building designs; maximum flexibility for future growth and change; speed of erection; minimum maintenance; use of the minimum number of prefabricated steel components; and the use of maximum spans with minimum internal structure to obstruct flexibility of partitioning.[2]

Such an objective approach, containing nothing of a spiritual nature nor any mention of art or delight or beauty, derives its aesthetic content solely from satisfying prosaic functional demands and puts Rogers' work firmly in the mainstream of European modernism. Nor did it remain an idea; it was applied in two factory-fabricated steel frame residences: the Spender house in Ulting, Essex (1968), and the Wimbledon house Rogers designed for his parents (1969).

Rogers' interest in industrialized construction brought him to the attention of the Genoese architect Renzo Piano, who at the same time was experimenting with light, prefabricated structures. They worked together in 1969 on the Italian Industry Pavilion at the Osaka World's Fair and formed the Piano and Rogers partnership in 1971. Piano and Rogers produced the ARAM Medical Center, in Washington, D.C. (1970); the Fitzroy Street Commercial Centre in Cambridge, England (1970); and offices for the B and B Upholstery Company, in Como, Italy (1971–1973). The offices foreshadowed their controversial yet widely acclaimed Georges Pompidou Center, in Paris (with engineers Ove Arup and Partners, completed 1977). Now an emblem of Paris, the building is also the most recognizable icon of high-tech architecture (see Plate 35). The imposing six-story building, at first perceived as incongruent in the historic Marais district of Paris, emphasizes the notion of a "cultural machine" whose technology is expressed (and its internal spaces made flexible) by placing the structure and the services on the outside. The architects further experimented with similar flexible, highly serviced envelopes in other contemporary designs: for example, the Universal Oil Products headquarters, in Tadworth, Surrey (1973), and the PA Technology Laboratory, in Cambridge, England (1975).

The Rogers and Piano partnership ended in 1978. Rogers has continued to develop the architectural axioms that informed his earlier work. Typical examples of the Richard Rogers Partnership (if typicality is admissible) are the IN-MOS Microprocessor Factory, in Gwent, South Wales (1982); the PA Technology Laboratory, in Hightstown, New Jersey (1982); extensions to the Na-

tional Gallery, in London (1982); and the Lloyds of London Building, in London (1978–1986). All conform to Rogers's notion of immediately legible, flexible, extendable architecture, structurally determined and all (by the way) influenced by Kahn's idea of servant and served elements of a building. The two London examples were at the forefront of a controversy stirred by Charles, Prince of Wales in the late 1980s about the future of British architecture.

While Rogers acknowledges that social change must be socially and politically induced, he believes that some betterment of the human condition will come through "rational research and practice." He adds that "the aim of technology [which can never be an end in itself] is to satisfy the needs of all levels of society"; in terms of architecture, ecological and social stability can be maintained by "a new distribution of ends and means"; and he concludes that "it is as difficult to create a truly socially oriented brief as it is to adapt and translate it by the use of the correct technological means."[3]

NOTES

1. Hunt in Wilkes
2. Appleyard (1986), 139.
3. As quoted in *Contemporary Architects.*

BIBLIOGRAPHY

Writings

"Architects' Approach to Architecture." *RIBAJ* 77 (June 1970).
"Architects' Approach to Architecture." *RIBAJ* 84 (January 1977).
Architecture: A Modern View. London, 1990; New York, 1992.
"Belief in the Future Is Rooted in the Memory of the Past." *Royal Society of Arts Journal* (London) 136 (November 1988).
"A Case for Modern Architecture." *RIBAJ* 97 (March 1990).
"Royal Gold Medal Address 1992." *RIBAJ* 99 (September 1992).
"Streets for People." *APlus* 105/106 (October 1990).
With Mark Fisher. *A New London.* London, 1991.
With Renzo Piano. *Du Plateau Beaubourg au Centre Georges Pompidou.* Paris, 1987.
With others. *The Building of Beaubourg.* London, 1979.
———. "New Headquarters for Lloyd's." *RIBA Transactions* (London) 4 (January 1985).
———. "Prince Charles and the Architectural Debate." *ADesign* 59 (May 1989).
———. "Visions of Britain and the Academy Forum." *ADesign* 58 (November 1988).
As editor, with B. Cole. *Richard Rogers + Architects.* London, 1985.

Biographical

Appleyard, Brian. *Richard Rogers: A Biography.* London, 1986.
Silver, Nathan. In *Contemporary Architects.*

Assessment

a+u. "Richard Rogers: New Architecture of the 21st Century." 236 (May 1990).
ADesign. "Piano and Rogers . . . [their] Approach to Architecture." 45 (May 1975).
AJournal. "A Purpose-built Television Station." 199 (April 1994).

Amery, Colin. "L'architecture brittanique d' aujourd'hui." *Techniques* 402 (June 1992).

Banham, Reyner. "Piano and Rogers, Architectural Method." *a + u* 6 (1976).

Barbie, Campbell Cole, and Ruth Elias Rogers, eds. *Richard Rogers + Architects*. London, 1985.

Blueprint. "Projects, Japan: Richard Rogers Partnership." Extra edition. (London) (1991).

Centre Georges Pompidou. London, 1977.

Champenois, Michele, et al. "Richard Rogers [anthology]." *Aujourd'hui* 258 (September 1988).

Cowan, Robert, and Leslie Gallery. "Designing London." *AJournal* 193 (17 April 1991).

Davies, C. "Airport, Marseilles." *AReview* 193 (September 1993).

Davies, Michael. "Changes in the Rules." *ADesign* 63 (July 1993).

Dietsch, Deborah K. "Heroic Transformations." *ARecord* 177 (September 1989).

Ellis, Charlotte. "Pompidou Revitalized." *AReview* 194 (May 1994).

Glancey, Jonathan. "High-tech Midas." *RIBAJ* 92 (June 1985).

Hunt, Gregory K. In Wilkes.

Loriers, Marie-Christine, et al. "Echanges Europeens." *Techniques* 409 (August 1993).

Maxwell, Robert. "Richard Rogers and the Space Machine." *Casabella* 58 (April 1994).

Nakamura, Toshio, ed. "Richard Rogers 1978–1988." *a+u*. Extra edition (December 1988).

Pawley, Martin. "Scrap Value." *AJournal* 191 (21 March 1990).

———. "Sir Richard Rogers: Global Architect." *World Architecture* (London) 18 (July 1992).

Powell, Kenneth. *Richard Rogers*. MIT Press, 1994.

Rambert, Francis. "Rogers L'Europeen." *Architectes Architecture* (Paris) 192 (November 1988).

Ryan, Ray. "Richard Rogers." *LA Architect* (September 1988).

Sharp, Dennis. "Inside out." *Building* (London) 236 (6 April 1979).

Silver, Nathan. *The Making of Beaubourg*. MIT Press, 1994.

———. "Royal Gold Medal . . . 1985." *Architect and Builder* (London) (March 1985).

Slessor, Catherine. "Richard Rogers and the Modernist Inheritance." *Planning* (Johannesburg) 125 (January 1993).

Sudjic, Deyan. *Norman Foster; Richard Rogers; James Stirling*. London, 1986.

———. *Richard Rogers: Bauten und Projekte*. Weinheim, 1994.

Bibliographical

Vance: Phyllis Harland, A2034, 1988; Valerie Nurcombe, A1496, 1985.

ALDO ROSSI. 1931 (Milan, Italy)– . Rossi was educated in Como at the School of the Somaschi Fathers (1940–1942) and at the Collegio Alessandro Voltas, in Lecco (1943–1946). He studied architecture at the Milan Politecnico, where he received his diploma of architecture (1949–1959). After experience in a couple of Milan practices (1956–1957) he started his own firm in 1959. He later formed an association with Gianni Braghiera (1971). Rossi has been teaching since 1963, holding several permanent or visiting academic appointments in architecture and planning in Europe and the United States. He is now well established as an important and widely published urban theorist, having begun

as a contributor to *Casabella Continuata* His work has been published internationally and exhibited in Europe and America. In 1990 he won the Pritzker Prize.

<p style="text-align:center">✔</p>

Rossi has been described as "one of the most influential architects" of the late twentieth century, one who has "accomplished the unusual feat of achieving international recognition in three distinct areas: theory, . . . architecture [and drawing]."[1] In his youth Rossi was looked upon as "a man of letters and not as an architect," for him "something to be proud of."[2] As a student he came under the influence of the modernists Ernesto Rogers (cousin of Richard Rogers*) and Guiseppe Samona. He sought to broaden his horizons in several ways. In 1955 he was delegate to the International Student Union in Rome, then traveled to Prague and the Soviet Union for "study and cultural encounters," and obtained professional experience in Milan studios, first with Ignazio Gardella and later Marco Zanuso (1956–1957). While still a student, he was invited by Ernesto Rogers to contribute to the Milanese journal *Casabella Continuata*—at first, as a collaborator (1955–1958), then as a member of the study center (1958–1960), and eventually as an editor (1961–1964).

His international reputation was established with the publication of *The Architecture of the City* in 1966, soon translated into several languages. The city, not the individual building, is the datum of Rossi's theories and therefore his architecture; his public buildings are not "autonomous solitaires" but in effect microcosms of the city which is to Rossi "the most complete expression of architecture." Charles Jencks identifies him, with Rob Krier* and Leon Krier* and Colin Rowe, as a source of a "city-based morphology known as contextualism."[3] Rossi's analysis of the city, analogous with architecture, is in typological terms: elements are grouped according to their similarities (streets, lanes, courtyards, plazas are analogous with passages, corridors, lobbies, foyers), not by function, but by their human associations. Typical elements are then combined to create new forms, and

the city is seen as one vast, solid mass of building from which public space is hollowed. The buildings become an arcaded margin between empty but geometric voids. Meaning derives from the play of tried and tested classical types against surreal dadaesque juxtapositions.[4]

City and building become a theatrical set, its inhabitants the players with walk-on parts. They have no lines and make no contribution to the environment the designer thrusts upon them.

Humaneness seems to be lacking in Rossi's architecture. That is perhaps excusable in some public buildings, where he repudiates the (often insincere) anti-monumental stance of Modernism with the argument that monuments, recalling the past, give structure to the city. But there are building types in which monumentality and the analogy of the city are inappropriate. That can be seen in the schools at Broni (1969–1970) and Fagnano Olona (1972–1977), where Ros-

si's search for meaning produces architecture of a scale threatening to little children, and the Gallaratese housing estate in Milan (with Carlo Aymonino, 1972–1977), whose residents complained that space had been stolen from their tiny flats to provide a wide corridor through the spine of the attenuated building. One must question the social propriety of any architectural theory by which "people become mere abstractions to be neatly fitted into platonic forms, like broken statues in a surrealist painting."[5]

When he began to create buildings from his well-developed theoretical base, Rossi was greeted by many critics as the initiator of "the contemporary school of Rational architecture during the 1960s and 70s."[6] Indeed, he expressed such ideas in a 1973 publication, *Rational Architecture*. Some of his earlier designs draw on earlier twentieth-century Italian Rationalists—they wanted to reduce a plethora of complex stylistic forms to a few basic types—as well as the work of eighteenth-century French architects Boullée and Ledoux, whom Rossi had carefully studied. For him, the essential reductive solids—cube, cylinder, prism, pyramid—have assumed a precise meaning through their historical application. The role of the architect is to assemble the appropriate elements according to some logical system of order: a geometric organization, the coordination of units within the articulation of the building's integral mass, or the appropriate relationship between the structural system and the building's purpose.

That belief was embodied in his extensions to the municipal cemetery of San Cataldo at Modena (with Braghiera, 1971–1976) (see Plate 33). Perceived as a city of the dead, and heavy with the morbid sociocultural symbolism of much Italian Rationalist architecture, its essential architectonic forms reflect Rossi's "ongoing investigations into building typology . . . beyond the particular and the concrete."[7] But the building that epitomizes Rossi's theories is the floating Teatro del Mondo (1979) for the 1980 Venice Triennale, at once a model of city and archetypal Rationalist monument. Mark Cousins observes that preoccupation with urban monuments, morphology, and typology are evident throughout the architect's built work. It "focuses on nostalgia and memory, exploiting a vocabulary of forms largely derived from the buildings of Rossi's youth—arcades, galleries, grain silos and farm buildings of the Lombardy countryside."[8] Rossi continues to design in many fields: industrial design; urban design (The Hague, 1988); public housing in Berlin (with Braghieri, 1981–1988); and individual buildings such as the Hotel II Palazzo, in Fukoka, Japan (1988–1990). His work was described by the Pritzker jury in 1990 as "at once bold and ordinary, original without being novel, refreshingly simple in appearance but extremely complex in content and meaning." There could not have been a more fitting summary of the intent of Rationalism.

Rossi is as well known for his drawings and paintings as he is for his theories and architecture. Indeed, they enjoyed an international reputation before he won architectural commissions beyond Italy. First exhibited in Milan in 1960, they have since 1967 been shown throughout Italy and in most of Europe, Iran, Ireland, and extensively throughout North America. His long involvement with

architectural education began in 1963 when he became an assistant in Ludovico Quaroni's urbanism course at the Scuola Urbanistica in Arezzo. He also acted as assistant for Carlo Aymonino at the Istituto Universitario di Architettura in Venice (1963–1965). He has held permanent or visiting professorships in architecture and planning at the Milan Politecnico (1965), the Zurich Eidgenossische Technische Hochschule (1972–1974), Venice (1975+), Cooper Union (1977), Cornell University, and Yale University (1980).

Kenneth Frampton has observed that

Rossi attempts to evade the twin chimeras of modernity—positivistic logic and a blind faith in progress—by returning to both the building technology and the constructional forms of the second half of the 19th century. . . . [An] analytical approach, suspended, as Rossi himself said, between "inventory and memory," permeates his entire oeuvre.[9]

NOTES

1. Ghirardo in Wilkes.
2. Lampugnani, (1990), 24.
3. Charles Jencks, *Modern Movements in Architecture* (New York, 1985), 374.
4. Dunster (1977), 82.
5. Dinar (1980), 10.
6. Cousins in Sharp (1991).
7. Ghirardo in Wilkes.
8. Cousins in Sharp.
9. Kenneth Frampton, *Modern Architecture. A Critical History* (London, 1992), 295.

BIBLIOGRAPHY

Writings

Aldo Rossi, Architect. Milan, 1987.
Aldo Rossi. Buildings and Projects 1981–1991. New York, 1991.
Aldo Rossi: Selected Writing and Projects, edited by Paul Keogh. London, 1983.
L'Analisi Urbana e la Progettazione Architettonica. Milan, 1970.
"Architektur in der Po-Ebene." *Daidalos* (Guertersloh) (15 June 1989).
L'Architettura della Citta. Padua, 1966; *The Architecture of the City.* MIT Press, 1983.
Bonicalzi, Rosaldo, ed. *Scritti Scelti sull Architettura e la Citta 1956–1972.* Milan, 1975, 1978.
"Bonnefantenmuseum a Maastricht 1990–1991." *Zodiac* 6 (March 1991).
"Gabriele Basilico fotografo." *Domus* 725 (March 1991).
"Invisible Distances." *Via* (Philadelphia) 11 (1990).
"Looking at These Recent Projects." *Lotus* 57 (1988).
"On Architectural Schools." *Domus* 760 (May 1994).
With others. *Hotel Il Palazzo.* Tokyo, 1990.
As editor. *Architettura Razionale.* Milan, 1973.

Biographical

Braghieri, Gianni. *Aldo Rossi.* Milan, 1981; Barcelona, 1991.
Rossi, Aldo. *A Scientific Autobiography.* MIT Press, 1981.

Assessment

a+u. "Aldo Rossi." Extra edition (November 1982).

———. "Conception and Reality of Aldo Rossi." 65 (May 1976).

———. "Housing in Berlin." 186 (March 1986).

———. "Recent Works of Aldo Rossi [anthology]." 213 (June 1988).

ADesign. "Aldo Rossi: Casa Aurora and Other Recent Projects." 58 (January 1988).

Adjmi, Morris, ed. *Aldo Rossi: Architecture 1981–1991.* New York, 1991.

ARecord. "Tempus Rossi [anthology]." 176 (August 1988).

Arnell, Peter, and Ted Bickford. *Aldo Rossi, Projects and Buildings 1959–1983.* New York, 1985.

Aujourd'hui. "Aldo Rossi [anthology]." 263 (June 1989).

Bandini, Michael. *Aldo Rossi. Architecture and Urbanism.* London, 1983.

Caldenby, Claes. "Venturi och Rossi." *Arkitektur* (Stockholm) 92 (October 1992).

Cohen, Jean-Louis. "Aldo Rossi en France, l'incompris intime." *Aujourd'hui* 263 (June 1989).

Cook, Linda J. "The Italian Way of Death." *LandscapeA* 81 (February 1991).

Cooper, Maurice. "Rossi and the Tragic View of Architecture." *Blueprint* (London) 42 (November 1987).

Cousins, Mark. In *Illustrated Dictionary of Architects and Architecture,* edited by Dennis Sharp. London, 1991.

Dinar, Moshe. [Letter to editors]. *PA* 61 (December 1980).

Dunster, David. "A Comeback for Architectural Theory." *PA* 58 (May 1977).

Eddy, David Hamilton. "Authentic City/Thoughts on . . . Leon Krier and Aldo Rossi." *RIBAJ* 92 (July 1985).

Fera, Stefano. "Aldo Rossi, Reelaborations: Journey and Palimpsest." *Lotus* 68 (1991).

Ferlenga, Alberto, ed. *Aldo Rossi: Architetture: 1988–1992.* Milan, 1993.

Frampton, Kenneth, ed. *Aldo Rossi in America 1976–1979.* New York, 1979.

Frieman, Ziva. "The Architect of the City." *PA* 72 (February 1991).

———. "The Theaters of the Architect." *Perspecta* 26 (1990).

Geisert, Helmut, ed. *Aldo Rossi: Architect.* London, 1994.

Huet, Bernard. "After the Glorification of Reason: Aldo Rossi." *Lotus* 48–49 (1985–1986).

Huet, Bernard, et al. "Form zwang, freiheir der form." *Werk* (October 1993).

Irace, Fulvio. "Berlino 1988." *Abitare* no. 251 (May 1988).

———. "Rossi versus Rossi." *Abitare* 286 (June 1990).

Jiminez, Carlos. "El guardian de la memoria." *Arquitectura Viva* (Madrid) (September 1990).

Lampugnani, Vittorio Magnano. "Colloquio con Aldo Rossi." *Domus* 722 (December 1990).

Morton, David. "Italian Rationalism: Rossi and Aymonimo: Tendenza. *PA* 61 (October 1980).

Moschini, Francesco, ed. *Aldo Rossi, Projects and Drawings 1962–1979.* New York, 1979.

Olmo, Carlo. "Across the Texts." *Assemblage* (MIT Press) 5 (1988).

di Pietrantonio, Giacinto. "Aldo Rossi." *Flash Art* (London) 149 (November 1989).

Savi, Vittorio. *L'Architettura di Aldo Rossi.* Milan, 1976.

Scully, Vincent. "Aldo Rossi: Architect of Love and Memory." *ADigest* 45 (October 1988).
Sola-Morales Rubio, Ignasi. "Neo-rationalism and Figuration." *ADesign* 54 (May 1984).
Spinadel, Laura Patricia. "Wettbewerb Forellenweg, Salzburg." *APlus* (November 1984).
Wortmann, Arthur. "Aldo Rossi's ontwerp voor Den Haag." *Archis* (Doetinchem) (September 1988).

Bibliographical

Vance: Lamia Doumato, A646, 1982; Sara Richardson, A1925, 1987.

Archival

Adjmi, Morris, and Giovanni Bertelotto, eds. *Aldo Rossi: Drawings and Paintings 1949–1993*. New York, 1993.
————. *Aldo Rossi: Drawings and Projects*. New York, 1993.

PAUL (MARVIN) RUDOLPH. 1918 (Elkton, Kentucky)– . Rudolph attended Athens College, in Alabama (1934–1936), received a bachelor of architecture degree from Alabama Polytechnic Institute, in Auburn (1940), and then entered the master's program under Walter Gropius* at the Graduate School of Design of Harvard University, in Cambridge, Massachusetts, in 1941. He spent from 1943 to 1946 in the U.S. Navy and then returned to finish his degree (1947). He established a partnership with Ralph Twitchell in Sarasota, Florida (1947–1951) before setting up independently (1947–1951). A small number of commissions and but two nationally recognized designs surprisingly led to his appointment as chairman of the Yale University School of Architecture. Almost immediately, he vitalized the school and began to design a new Art and Architecture building (1959–1963). In 1965 he resigned and established an independent practice in New York City and soon received commissions from countries on the Pacific Rim. Rudolph has received a number of honorary degrees, honors, and awards including the Brunner Prize of the American Academy of Arts and Sciences (1958).

✧

Rudolph is "doggedly persistent" in a "quest for an architecture whose richness came not from applied ornament but from the spatial complexities developed from structure" and three-dimensional elaborations.[1] Like Eero Saarinen* (sometimes), Felix Candela,* and others, Rudolph was recoiling from the internationalists. "By 1955," he declared in 1959, "the limitations of the European architectural philosophies of the first part of the 20th century were crystal clear." A designer needs to create different kinds of space—mysterious, quiet, shaded, hustling, dignified, transitional, and as fundamental, architecture needs "visual delight."[2]

All this was revealed in the earliest major commissions that led to the Yale appointment. His first designs, mainly residential, were characterized by a certain delicacy. Oddly, that, together with an idiosyncratic overworked fussiness on the exterior, was carried into the major works; for example, the twelve-story

Blue Cross–Blue Shield offices in Boston (1957) and the Jewett Arts Center for Wellesley College (1955–1958), both with architects Anderson, Beckwith, and Haible. The arts center rather expressively refers to the existing neo-Gothic buildings and exemplifies another attribute: he tends to draw ideas from the existing architectural context.

His landmark building remains the school at Yale (aka A&A). It is a material argument against the tepid rationalism espoused by Gropius in America. The muscular, furiously ambitious building has been described by Vincent Scully as a "primary act" with the "spectacular lift of its upper floors" that project beyond lower parts, sit on "continuous piers of vertically striated concrete." It is "splendidly designed for its corner site and in relation to the pre-existing university buildings." On "axis of the sidewalk [it] complements and completes the chopped-off box of [Louis I.] Kahn's[*] new Art Gallery" (1953).[3] (Rudolph's A&A was partially burned in 1969 during the period of student uprisings throughout the world; the cause was determined to be an accident.) It is the antithesis of Ludwig Mies van der Rohe's* architecture building at Crown Hall (1956), yet the physical dominance of both buildings tests the patience and aesthetic sensibility of student users as well as critics and architects.

That top heaviness in conjunction with tall, oversized piers, became a prominent, often-used element as illustrated in the concrete rectilinearity of buildings for the Southeastern Massachusetts Technological Institute in North Dartmouth (1963–1972, with Lord Desmond), where certain upper floors jut out in cantilever.

Rudolph's virtuosity in handling interior spaces, often illuminated by daylight from above and bold concrete forms, was immediately influential and measurable; for instance, with Kallman, McKinnell, and Knowles on the Boston City Hall (1964–1969, also in debt to Le Corbusier*) and the inventive John M. Johansen's Clark University Library at Worcester, Massachusetts (1966–1969), with a sizable conceptual debt to Louis I. Kahn. Like Kahn, Rudolph believes in the primacy of the individual artist eschewing Gropius's collective (team) approach.

One of the principal features of European Expressionism of the 1920s was the application of unique, rather organic forms. With technical improvements in concrete, it became easier to apply expressionistically. Rudolph, along with Eero Saarinen and Jørn Utzon* (for the Sydney Opera House), boldly manipulated the material. Nothing better illustrates Rudolph's manner than the curved forms of the multistoried parking garage for New Haven, Connecticut (1959–1963); the Tuskegee Institute Chapel, in Alabama (1960–1969, with Welch Fry); the sinuous and curved forms dominating the Boston Government Service Center, in Massachusetts (1962–1971) in plan and three-dimensionally; or the complex and three-dimensional forms and planes of the Creative Arts Center, at Colgate University, in New York (1967). Less typical is the Deane house on Long Island, New York (1969), with its incessantly repetitive, ungainly concrete Y-frames

throughout. All reveal what Peter Collins called a "novelty" of "enterprising architectural shapes."[4]

But there was much more to Rudolph's architecture. Interior and exterior spaces interpenetrate and expand; pedestrians are invited to participate. There is as well an exaggeration of form and oversized structure that quite often induces problems of scale. These characteristics, as with all of his buildings, prompted critic Mildred Schmertz to correctly observe that Rudolph's buildings are "heroic, humanistic, and sculpturally alive. His buildings are powerful interventions, creating new scale relationships in their surroundings . . . his work is highly personal, competitive, and aggressive."[5]

After about 1965, his ideas for multiunit housing followed a pattern. Typically curved or meandering site plans accommodated pyramids of set-back house units randomly arranged; diagonal walls were inherent. The immense resort community project for Stafford Harbor in Virginia (1966), or the Buffalo, New York, waterfront with 7,200 units (1969–1972), exemplify his organic yet humanely picturesque approach. Rather more dynamic was a proposal he worked on for the Ford Foundation (1967–1972) that would cover many miles of the Lower Manhattan Expressway in New York City, and that incorporated mass transit and great ventilators.

His other major contribution was for isolated urban situations. His preference is to place low buildings—perhaps from three to seven stories and containing shops, parking, and offices—as a rim surrounding a large, open pedestrian space out of which rises a tall building. The concept is first revealed in the Boston Government Center, where the plaza and ground floors are an interplay of levels and forms that focus the yet-to-be-built highrise. At ground level, it nicely relates to the nearby plaza before the new Boston City Hall. The street facades open now and then to allow vistas or entrances to the plaza and relieve the typical bleak flush face of cities. The concept and the attributes of his architecture are evident in his latest contributions to cities, principally the massive Colonnade Condominiums in Singapore (1979); the bulky, articulated, paired glass towers of Bond Center in Hong Kong (1984, as design consultant); and the Dharmala Sakti building in Jakarta, Indonesia (1988), which draws much from the urban context. Its columns rise nearly 100 feet before the tower begins (see Plate 45).

Described as "articulate, inventive, mercurial, tough" (and a marvelous draftsman), his designs in the late 1950s were seen as a possible "beginning of a new curve in the track of modern architecture."[6] Rudolph was probably satisfied that his designs did not presage a new popular track. He has been assiduously avoided by critics and mainstream historians only because his architecture remains outside easy fashion. "I don't know any other architect," Philip Johnson* has said, "who is so off by himself and so successful."[7] Rudolph is always moving on, experimenting, expanding his—and our—architectural vocabulary.

NOTES

1. Bruegmann (1987), [3].
2. Rudolph (1961), 3.
3. Vincent Scully, *American Architecture and Urbanism* (New York, 1969), 203.
4. Collins (1961), 130.
5. Mildred Schmertz in *Contemporary Architects.*
6. Johnson (1960), 70.
7. As quoted in Schmertz (1989), 74.

BIBLIOGRAPHY

The abbreviation PR for Paul Rudolph is used below.

Writings

"Alumni Speech. Yale . . . 1958." *Oppositions* 9 (October 1975).
"Architectural Education in the United States." *Zodiac* (Milan) 8 (1961); and *Forum Lectures. The Voice of America.* Washington, D.C., ca. 1961.
"Excerpts." *Perspecta* 22 (1986).
PR. Designs d'Architecture. Fribourg, 1974, 1979.
"Regionalism in Architecture." *Perspecta* 4 (1957).
"The Six Determinants of Architectural Form." *AReview* 120 (April 1956).
With Ulrich Franzen and Peter Wolf. *The Evolving City. Urban Design Proposals.* New York, 1975.
With Yukio Futagawa, ed. *Kaufmann House . . . Wright.* Tokyo, 1970.
As editor. "The Spread of an Idea [Gropius]." *Aujourd'hui* 20 (February 1950). The whole issue.
Crosbie, M. J. "PR on A & A." *AIAJ* 77 (November 1988).

Biographical

Bourne, Russell. "Yale's PR." *AForum* 108 (April 1958).
Moholy-Nagy, Sibyl. *The Architecture of PR.* New York, 1970.
Schmertz, Mildred. In *Contemporary Architects.*

Assessment

a+u. "100 by PR/1946–1974." 80 (July 1977). The whole issue.
———. [Rudolph.] 233 (February 1990).
ARecord. "The Current Work of PR." 121 (February 1959).
Becherer, Richard. In Macmillan.
Black, Carl John. "A Vision . . . Boston State Service Center." *ARecord* 154 (July 1973).
Bruegmann, Robert. *PR. Recent Projects in Southeast Asia.* Chicago, 1987.
Collins, Peter. "Whither PR." *PA* 42 (August 1961).
Cook, John W., and Heinrich Klotz. *Conversations with Architects.* London, 1973.
Futagawa, Yukio. *PR.* Tokyo, 1968; translated by Rupert Spade, New York, 1971.
Futagawa, Yukio, with Carl Black. *PR. Interdenominational Chapel.* Tokyo, 1973.
GAHouses. "NY Apartment." 6 (1979).
Giovannini, Joseph. "PR Exhibits in NY City." *AIAJ* 82 (December 1993).
Goldberger, Paul. "Yale Art Building—Decade of Crisis." *NY Times,* 30 April 1974.
Heyer, Paul. *Architects on Architecture.* 2d ed. New York, 1978.
Huxtable, Ada Louise. "The Building You Love to Hate." *NY Times,* 12 December 1971.

Johnson, Philip. "Three Architects." *ArtA* 48 (Spring 1960).
Miller, Ross. "Perspectives." *PA* 71 (December 1990).
Mirmar. "Dharmala Sakti Office . . . Jakarta." 30 (December 1988).
Pommer, Richard. "Building at Yale, Once Again." *Burlington Magazine* (London) 114
 (December 1972).
"PR's Manhattan Apartment." *ARecord* 162 (January 1978).
Schmertz, Mildred F. "From Object to Space: An Interview." *ARecord* 173 (June 1985).
———. "Resolutely Modernist." *ARecord* 177 (January 1989).
Scully, Vincent. "Art and Architecture Building." *AReview* 135 (May 1964).
Spade, Rupert. *PR.* New York, 1971.
Veronesi, Giulia. "PR." *Zodiac* (Milan) 8 (1961).

Bibliographical

Smith, Charles R. *PR and Louis Kahn: A Bibliography.* Metuchen, New Jersey, 1987.
Vance: Lamia Duomato, A33, 1979.

Archival

Futagawa, Yukio, ed. *PR "Drawings."* Tokyo, 1972, 1974.
Marlin, William. "PR. Drawings." *AForum* 138 (June 1973).
Rudolph, Paul. *Architectural Drawings.* London, 1974.

S

EERO SAARINEN. 1910 (Kirkkonummi, Finland)–1961. During his childhood and after early schooling in Finland, the family emigrated (1923) to Detroit, Michigan, when his architect father Eliel Saarinen* took up a new career. Saarinen studied sculpture in Paris (1929–1930), received a fine arts degree from Yale University (1934), and worked and traveled in Europe on a fellowship (1934–1936). He and his father formed a partnership (1937–1950), which was joined by his brother-in-law J. Robert F. Swanson (1941–1947). (Eero's sister Pipsan Swanson and Robert were also professional interior designers.) Naturalized in 1940, from 1942 to 1945 Saarinen served in the Office of Strategic Services (OSS) in Washington. He succeeded the partnership (1950–1961), and during the 1950s Saarinen also designed furniture. He received honorary degrees and awards including posthumously the AIA Gold Medal (1962).

❧

Saarinen's better buildings were innovative, "proud" solutions to the "problems posed by the physical and spiritual requirements of the client."[1] That theoretical position was adopted by his successors, Kevin Roche* and John Dinkeloo,* as was the following. "His buildings exhibit a range of attitudes from the most severely classical to a very personal romantic expressionism."[2] He was a dominant figure at midcentury, pursuing an architecture of forms wrought from structure paralleled by a search for a symbolism that would evoke a building's purpose. Each commission was approached with those somewhat nebulous foci and as a result each was dramatically different from the others.

Saarinen and his father were given the task of designing the General Motors Technical Center near Detroit, Michigan (1945–1955). It was intentionally de-

rivative of architect-designed industrial buildings just after the turn of the century—if much more colorful—like those of Albert Kahn* all about the Detroit area. Although Eliel died in 1950, it was a collaborative effort in the early phases and can be considered Eero's first major work. Eero's first independent commission resulted from a winning design for the Jefferson Memorial Competition for St. Louis, Missouri (1949). Beside the Mississippi River a simple, giant, stainless steel parabolic arch rises 130 feet high—and 130 feet wide at the base—as a symbolic entry to the American West.

A skin of modular steel and glass was carried to an extreme with his highly formal Bell Telephone Laboratories in Holmdel, New Jersey (1956–1961, with Roche and Dinkeloo). He had taken the industrial facade to its repetitive limit. This left little to stretch his imagination and so he began a search for an evocative architecture, one with fewer strictures. This was evidenced with the Kresge Auditorium at the Massachusetts Institute of Technology (1952–1955). The roof is a triangular segment of a sphere made of thin shell concrete (as promoted by Felix Candela*) carried on only three steel points. Underneath this simple roof is a complex of rooms, stage, and public spaces walled from the exterior by glass. It was an inversion of and conceptually opposite to Hans Scharoun's* Berlin Philharmonic Orchestra Concert Hall (1956–1963), where the complex forms related to various internal functions are externally expressed in form. He too had tired of repetitious facades.

Another inventive evocation of purposes was the Ingalls Hockey Rink at Yale University (1959) where, rather than supporting the roof across the short span, Saarinen used a giant, single concrete arch that swoops over the ice and seating on the long axis to then reach over the entrance. From this arch, catenary steel cables stretch to the perimeter to carry a ceiling of wood slats that support the roofing. It and the Kresge Auditorium enclosed a dominant single space while the terminal building at Dulles International Airport near Washington, D.C. (1958–1962) needs to house many small functions plus a vast array of pedestrian space. Saarinen used a giant, single structure whose roof is also supported by steel cables in tension in a more or less natural catenary, slung between tall massive, out-slanting concrete piers (see Plate 26). The effect is thoroughly modern, compellingly monumental.

Smaller in scale, the TWA Terminal at Kennedy Airport near New York City (1962) is more intimate. Concrete (almost totally) was used in a most Expressionistic manner, popularly described as a bird in flight. Saarinen believed the challenge was to create a building that would be "distinctive and memorable" and "itself would express the drama and specialness and excitement of travel." Moreover he "wanted to counteract the earthbound feeling and the heaviness that prevails too much in the MIT auditorium."[3] The structure dominates; the roof is four "interacting" barrel vaults fluidly forming shells supported on four Y-shaped posts. Some commentators linked the building to a desire for "sensualism."

Opposite to all was the John Deere Administration Building, in Moline, Illi-

nois (1961–1964), a frenzied post-and-beam, right-angled structure expertly detailed in earth tones of exposed Cor-ten steel, its first architectural use. (Cor-ten was developed in 1933 for railroad hopper cars. An oxide forms an impervious covering to prevent further chemical action, like rust.) It was no doubt derived from Eiermann's German Federal Republic Embassy in Washington, D.C. (1958–1964). And when Saarinen received his first commission for a tall building, the CBS headquarters in Manhattan (1960–1964), he integrated the windows and external structure of dark-granite-covered triangular piers rising full height to make an uncompromised "perhaps unequalled, vertical statement."

In the late 1950s, there was a growing popular, professional, and academic reaction to the massive destruction of buildings that were replaced by slick modern boxes in the name of renewal. Saarinen responded to this concern and attempted with some success to fit new buildings into existing env ronments. One example is the Morse and Stiles colleges at Yale University (1958–1962), a rather organically shaped—in plan and form—Modernist interpretation of "collegiate Gothic." It has satisfactorily mellowed with an environmental patina. Less successful is the American Embassy in London (1955–1960), which boldly faces Grosvenor Square with a modern facade meant to blend with Georgian finery.

Many aspiring young architects were attracted to Saarinen's office, among them the notable Gunnar Birkets, Cesar Pelli, Anthony Lumsden, Roche, and Dinkeloo. Eero did not attend his father's Cranbrook Academy, but many notables did: Charles Eames, Carl Feiss, Harry Weese, the sculptor Harry Bertoia, and the interior/furniture designer Florence Knoll. The Saarinens' contribution to the twentieth-century arts is considerable.

Never content with formula, Eero was the embodiment of the postwar architectural polemical turmoil during his brief professional life. Historian John Jacobus correctly observed that he "produced a sequence of influential if not organically related buildings that have been much discussed, and which surely illuminate the direction taken by modernist architecture in the 1950s."[4] In many ways Saarinen's architectural forms anticipated later architectures rife with less romantic but more confusing symbols. His architecture was structurally dominant and knit to a romantic, very personal expressionism, to a philosophy antithetical to that of Ludwig Mies van der Rohe.* That was a leadership role Saarinen knowingly assumed.

NOTES

1. William Leobovich in Richard Guy Wilson, *The AIA Gold Medal* (New York, 1984), 196.

2. J. M. Richards, *Who's Who in Architecture* (London, 1977).

3. Aline Saarinen (1962), 60.

4. John M. Jacobus, Jr., in Lampugnani.

BIBLIOGRAPHY

Writings

"Campus Planning." *ARecord* 128 (November 1960).
"The Changing Philosophy of Architecture." *ARecord* 116 (August 1954).
"Function, Structure and Beauty." *AIAJ* 28 (July 1957).
"Our Epoch of Architecture." *AIAJ* 18 (December 1952).
"Six Broad Currents of Modern Architecture." *AForum* 99 (July 1953).

Biographical

Hunt, William. In *Contemporary Architects.*
"Milwaukee's Proposed Memorial Center." *ARecord* 102 (November 1947).
Temko, Allan. *Eero Saarinen.* New York, 1962.

Assessment

AForum. "Saarinen Challenges the Rectangle." 98 (February 1953).
Boyd, Robin. "Counter-Revolution in Architecture." *Harper's Magazine* (New York) 112 (September 1959).
Dean, Andrea O. "Eero Saarinen in Perspective . . . His Work and Influence." *AIAJ* 70 (November 1981).
Halck, Nancy Liberman. "The Eero Saarinen Spawn." *Inland Architect* (Chicago) 25 (May 1981).
Heyer, Paul. *Architects on Architecture.* 2d ed. New York, 1978.
Iglesia, E. J. *Eero Saarinen.* Buenos Aires, 1966.
McQuade, Walter. "Eero Saarinen. A Complete Architect." *AForum* 116 (April 1962).
Meyerowitz, Joel. *St Louis and the Arch.* Boston, 1980.
Miller, R. Craig. In *Macmillan.*
Morgan, Ann Lee, ed. *Contemporary Design.* New York, 1984.
PA. "Landmarks. TWA." 93 (May 1992).
———. "Long-span Concrete Domes on Three Pendentives [*sic*], Auditorium." 35 (June 1954).
Papademetriou, P. C. "Coming of Age. Eero Saarinen and Modern American Architecture." *Perspecta* 21 (1984).
Saarinen, Aline, ed. *Eero Saarinen on His Work. A Selection . . . 1947 to 1964 with Statements by the Architect.* New Haven, 1962; 2d ed., 1968.
Schwartz, Adele. "Washington Dulles Expanding Terminal according to Original Masterplan." *Airport Forum* (Bonn) 23 (June 1993).
Spade, Robert, and Yukio Futagawa. *Eero Saarinen.* New York, 1971.
Temko, Allan. "Something between Earth and Sky." *Horizon* (New York) 3 (July 1960).
Zodiac. "Recent work of *Eero Saarinen.*" (Milan) 4 (1959).

Bibliographical

O'Neal, William B. *Eero Saarinen: A Bibliography.* Charlottesville, 1963.
Vance: Dale Casper, A2042, 1988; Lamia Doumato, A331, 1980.

(GOTTLEIB) ELIEL SAARINEN. 1873 (Rantasalmi, Finland)–1950. Saarinen studied painting at Helsinki University and architecture at the Polyteknish In-

stitut. He then had an independent practice before and after a partnership with Herman Gesellius and Armas Lindgren (1896–ca. 1908) and until he had a partnership with his son Eero Saarinen* (1937–1950). Prompted by placing second in the *Chicago Tribune* competition (1922), he emigrated the next year to Detroit, Michigan, to begin anew his profession. He taught at the University of Michigan in 1924 and in that year became director of the Cranbrook Academy of Art in Bloomfield Hills, Michigan, where he also introduced and taught architecture.

✐

Saarinen was one of the leaders of the National Romantic movement in Finland. His architecture was deeply influenced by traditional vernacular architecture, English Arts and Crafts, French Art Nouveau, the American H. H. Richardson, and aspects of what was then known as the Chicago School. All this is evident in the group of house and studios at Hvitträsk near Helsinki (1902) built by—and homes and offices for—his sculptor and weaver wife and Helsinki partnership. His most important independent commission was the railway station at Helsinki (1910–1914), which displays aspects of those various influences as well as elements of the Sezessonist work of Otto Wagner in Vienna.

As a result of his vertical Gothic *Tribune* design he was encouraged to emigrate to the United States. He quickly obtained a commission from philanthropist George G. Booth to design buildings for his Cranbrook Academy. Over the years those buildings were a pleasant mixture of his earlier work, something of the ideas of Dutchman Willem Marinus Dudok* and elements of Frank Lloyd Wright,* and later a reduced classicism—modernistic in appearance.

The severe and brutally plain interior and exterior of Christ Lutheran Church in Minneapolis, Minnesota (1949–1950), with the greater influence of Eero, is not typical of either man. It is however indicative of the influence of the postwar concrete-and-masonry Protestant church architecture in Europe that was seen on Eero's earlier sojourn.

Community planning occupied Saarinen for most of his career. For instance, he entered the Canberra competition in 1911 (won by Walter Burley Griffin* and Marion Mahony Griffin*) and was a planning consultant for several Finnish and American cities. His theoretical position was extracted from Camillo Sitte's idea of designing cities and their buildings based on an organic fusion of traditional influences to building form and space, and on similar notions within the polemics of the English Garden City movement such as those put forward by Raymond Unwin. He supported the proposition of "organic decentralization" that was sadly ignored in preference to a pathological destructiveness in the name of urban renewal begun in the 1950s. Although not attributed to him or Sitte, many of the principles explained in his book *The City* became part of planning practice beginning in the 1970s.

With quiet respectability, Saarinen participated in the transition to architec-

tural modernism and promoted a more thoughtful and humane approach to city planning. He received the 1947 AIA Gold Medal.

BIBLIOGRAPHY

Writings

The City. Its Growth, Its Decay, Its Future. New York, 1943.
The Cranbrook Development. Bloomfield Hills, Michigan, 1931.
Search for Form. New York, 1948.
The Search for Form in Art and Architecture. New York, 1984

Biographical

Bacon, Edmund N. In *Contemporary Architects.*
Christ-Janer, Albert. *Eliel Saarinen.* Chicago, 1948.
Gardner, C. "Romantic Residence" *RIBAJ* 100 (March 1993).

Assessment

AForum. "The Kingswood School for Girls, Cranbrook, Michigan." 56 (January 1932).
Balmori, Diana. "Cranbrook: The Invisible Landscape." *JSAH* 53 (March 1994).
Eaton, Leonard K. *American Architecture Comes of Age.* MIT Press, 1972.
Finnish Architectural Museum. *Saarinen 1907–1923.* Helsinki, 1984.
Form Function Finland. "Eero Saarinen." (Helsinki) 2 (1984).
Gill, Brendan. "At Cranbrook, Restoring the Finnish Architect's 1930 Residence." *ADigest* 50 (April 1993).
Hausen, Marika. "Gesellius-Lindgren-Saarinen vid sekelskiftet." *Arkitekti-Arkitekton.* With translation (Helsinki) 9 (1967).
Marder, Tod A. "Design in America. The Cranbrook Vision 1925–1950: A Consideration." *Arts Magazine* (New York) 59 (April 1985).
Mikkola, Kirno. "Interpreter of Urban Planning" *Arkkitehti* (Helsinki) 4 (1982).
Miller, R. Craig. In Macmillan.
Richards, J. M. *A Guide to Finnish Architecture.* London, 1966.
Tilghman, Donnell. "Eliel Saarinen." *ARecord* 63 (June 1928).
Wickberg, Nils Erick. *Finnish Architecture.* Helsinki, 1962.

Bibliographical

CPL: Robert Kuhner, 836, 1975.
Vance: Lamia Doumato, A364, 1980; Dale Casper, A2042, 1988.

Archival

Hausen, Marika, et al. *Eliel Saarinen. Projects 1896–1923.* Helsinki, 1990.

CARLO SCARPA. 1906 (Venice, Italy)–1978. Educated at the Technical School, in Vicenza (1917–1919), Scarpa entered the architecture course at the Accademia di Belli Arti, in Venice (1920–1925) and received a diploma in 1926. While studying he worked for the Venetian architect Vincenzo Rinaldi (1922–1924). After military service (1926) Scarpa commenced a fifty-year practice as architect, designer, and graphic artist. Initially in Venice (1927–1962), he moved to Asolo (1962–1972) and later to Vicenza (1972–1978). His professional life was equally committed to practice and education. Besides other commissions he was

artistic consultant to Murano Cappellin and Company Glassworks (1927–1930) and Venini Glassworks (1933–1947), both in Venice, and design consultant for the Venice *Biennale* (from 1941) and for two Italian furniture companies, Cassina and B&B (1969). A teacher rather than a writer, he had a distinguished academic career. From 1926 to 1929 and from 1932 to 1933 he was teaching assistant to Guido Cirilli at the Istituto Universitario di Architettura, in Venice, where he became a professor (1933–1976), an emeritus professor (1976–1977), and director (1970–1978). He was also head of the design course at the Istituto Artistico Industriale, in Venice (1945–1947), and head of the visual studies course at the Istituto Superiore di Disegno Industriale, in Venice (1960–1961). After 1960 his work was shown in England, the United States, Spain, France, and Italy, including posthumous retrospectives. Between 1934 and 1978 he won many architectural and design awards in Italy.

Scarpa lived and designed in an era of revolution, counterrevolution, and war. In terms of architecture, the era was no less turbulent: great changes in Europe swept aside long-standing traditions as never before. Scarpa's attitude to history was at odds with most of his more prominent contemporaries. He saw himself as part of a continuous line of architectural development, not as a revolutionary, and in his work can be seen strong relationships between old and new, between established tradition and invention: "I would like some critic to discover in my works certain intentions I have always had. I have an immense desire to belong inside tradition, but without having capitals and columns, because you just cannot do them any more."[1] Beginning his professional career in the year that Benito Mussolini became prime minister of Italy, Scarpa became a passionate supporter, "albeit with a florid bent," of rationalist architecture, promulgated at that moment by such bodies as Gruppo 7 and the Movimento Italiano per l'Architettura Razionale. He shed a "perfectly mastered" academic training and identified himself with the modern movement.

A self-proclaimed modern architect, he nevertheless personified the modern dilemma: which road to take? His work is antiauthoritarian in its approach to form and has, because of his wide spectrum of interests, a rather mystical air about it. Any attempt to wedge him into the ranks of a particular "ism" is futile. Standing outside all of the mainstream dogmas, he expressed a very personal worldview in his architecture. In the early part of his career, while all Europe was seeking a style, he was developing his own vocabulary that in time would contradict any impulses of the quick-fix mentality that was emerging in some places. That vocabulary reflected many ancient and modern languages including Futurism, Cubism, De Stijl,* and more personal "dialects."[2] And expectedly, Scarpa derived much from the Venetian tradition, having been described as a "poet-architect" within that milieu, perhaps because of his passion for decoration and his stress upon carefully crafted detail. Although his earlier works demonstrate an affinity for Adolf Loos,* Walter Gropius,* Ludwig Mies

van der Rohe,* and Le Corbusier,* and their "programmatic statements and trends," he was also greatly influenced by Frank Lloyd Wright.*

One critic poetically suggests that Scarpa found "the garments for [his] design incantations" in Wright.[3] Not only did his drawings emulate Wright's (as, for example, sketches for the Villa Zoppas, Treviso, of 1953), but he wholeheartedly embraced the American's idea of architecture as a "plastic, intensely three-dimensional art." Michael Brawne further observes that Scarpa inherited from Wright and C. R. Mackintosh "a belief in a kind of visual density that derives from both form and materials and the way in which they are detailed."[4] Wright's impact is particularly noteworthy in the context of Bruno Zevi's post–World War II propaganda for organic architecture, especially through *Poetica dell'architettura Neoplastica* (Milan, 1953). Tafuri and Dal Co note that "among the few serious attempts to approach anew the language of Wright are . . . the masterful interpretations by Carlo Scarpa."[5]

Scarpa began to come into national prominence with several designs for exhibitions. The first were in Venice: "Paul Klee" (1948), for the 1949 *Biennale;* "Giovanni Bellini" (1949), at the Ducal Palace; "Toulouse Lautrec" (1952), at Napoleon Palace; and "Tiepolo" at the 1952 *Biennale.* Others followed: "Quattrocento" (1953), at Messina Town Hall, and "Piet Mondrian" (1956), at the Gallery of Modern Art, in Rome. Such commissions eventually led him into the design of museum interiors: among many, his most celebrated were the Museo dell' Accademia (1952–1956) and the Museo Correr (1953–1960), both in Venice; the Palazzo Abbatellis (1953), in Palermo; and the Museo di Castelvecchio (1958–1964), in Verona. Scarpa's exhibit designs and museum interiors present a different way of seeing. On the one hand, seeing the object through provision of a sympathetic setting for it; on the other, seeing contemporary—"modern"—architecture in the context of the cultural continuum that has carried it to where it now momentarily hovers.

The Museo di Castelvecchio was developed on the bombed ruins of the Scaligeri family's medieval castle near Verona. First commissioned to redesign the oldest section of the building, Scarpa was later asked to complete the museum. The work is a monument to Scarpa's sensibilities about time and place. According to critic Nory Miller, he

achieved an extraordinary coexistence involving architecture of different centuries, including this one . . . without the crutches of "neutral" glass linkages, uniform materials, or "historical" references." . . . Each angle, shape, surface is chosen to engage the attention or participation of the visitor.[6]

Indeed, the symbiosis between Scarpa's work and the surviving fabric is such that differences are hardly apparent. With his infinite capacity for fine detailing, he touched the past lightly; because he was so conscious of continuity the museum gives the "sense that construction has been suspended."

Scarpa's acknowledged masterpiece is the Brion-Vega Cemetery, in San Vito di Altivole, Italy (1970–1978) (Plate 32). Built to partly enfold the village cem-

etery, the Brion family's private burial place is Scarpa's complex iconographic commentary on the journey of life into death. Miller comments that the "images are disparate, often multiple, sometimes elusive: drawn from the mythic symbolism of many cultures, meticulously and instinctively wrought." The design cannot be described in the limited space here available: that must be left to others. It has been noted that

Scarpa's architecture is rigorously self-absorbed, yet in its tireless refusal to accept cliche or formula, makes us reconsider the place of death. The ... cemetery is a thoroughly modern piece of architecture: sensual, monumental, and made with the authority and conviction of a master builder.[7]

Ironically, Scarpa's own funeral was the first to be held in the serene, geometric funerary chapel he designed. His grave is located between the village cemetery and the Brion site.

The three-story annex to the Banco Popolare, in Verona (constructed 1974–1981), was Scarpa's last work. The piazza facade continues the Renaissance tradition of the original bank in that it is quite flat, tripartite, and crowned with a deep cornice. At that point, the similarity ends because Scarpa's divisions of dense base wall, punched screen wall, and light ribbon window are convincingly modern. He achieves modeling, not with texture of stone and moldings, but by a "densely packed series of layers." Moreover, his facade is arhythmic, contrasting with the original bank. The main entrance, "a study in geometric counterpoint," seems almost incidental. Inside and out, closest attention is paid to detail; Scarpa's "differentiations of material, form and pathway permeate every crevice" as the spaces open out and close in to articulate the user's movement through the building.

Scarpa's ubiquitous and busy practice, pursued until his death at the age of seventy-two, included architecture, interior design, restoration and extension work, exhibit design, furniture, glassware, and silverware. In the year after his death, the journal *L'Architettura* hailed him as "the greatest designer of contemporary Italian architecture." Rather than succumbing to the tide of revolt, Scarpa demonstrated a strong sense of individuality. Throughout his life he was interested in revealing truth by logical disputation. He did not reject new technologies or attitudes but sought to understand them. He took ideals of purist intent to a level where they were revealed for exactly what they were. The evidence suggests that his motives were honest and sincere. He rarely passed judgments. That was not for him to do: his was the task of seeing reality expressed in architecture. At whatever scale we examine his work the same vigilant search for truth is apparent. He said that "a construction can be called architecture when it pertains to the truth. What truth is, is difficult to establish: mountains, water and sun are true."[8]

NOTES

This entry was written in collaboration with Shay Howell of the University of South Australia.

1. Scarpa, as quoted in Fung (1992), 5.
2. Soroka (1989), 44.
3. Ambasz (1981), 117.
4. Brawne in *Contemporary Architects.*
5. Manfredo Tafuri and Francesco Dal Co, *Modern Architecture* (London, 1986), 334.
6. Nory Miller in Ambasz (1981), 122.
7. Nory Miller and George Ranalli in Ambasz (1981), 131. The description, images, and critique on pp. 124–131 are valuable.
8. Scarpa, as quoted in Fung (1992), 8.

BIBLIOGRAPHY

Writings

As editor. *Memoriae Causa.* Verona, 1977.

Biographical

Brawne, Michael. In *Contemporary Architects.*

Assessment

a + u. Extra edition (October 1985). The whole issue.
―――. "Banca Popolare di Verona." 137 (February 1982).
Abitare. "Palace Garden Designer." 242 (March 1986).
ADesign. "The Museo Correr, Venice." 32 (March 1962).
Albertini, Bianca, and Sandro Bagnoli. *Carlo Scarpa: Architecture in Details.* MIT Press, 1988.
Ambasz, Emilio, et al. "Carlo Scarpa." *PA* 62 (May 1981).
AMC. "Les années 70 de . . . Scarpa [anthology]." (Paris) 50 (December 1979). The whole issue.
L'Architettura. "Scarpa; The Greatest Designer of Contemporary Italian Architecture." (January 1979).
Bettini, Sergio. "L'Architettura di Carlo Scarpa." *Zodiac* (Milan) 6 (1960).
Bottero, Maria. "The Brion Family Cemetery, a Poetic Oasis." *Abitare* 272 (March 1989).
―――. "Italy: Carlo Scarpa the Venetian." *World Architecture* (London) 2 (1965).
Brusatin, Manlio. "Carlo Scarpa: Architetto Veneziano." *Contraspazio* (Bari) (March 1972).
Cappellato, Gabriele. "Carlo Scarpa: Tra immaginazione e realta." *Parametro* (Bologna) 129 (August 1984).
Crippa, Maria Antoinetta. *Carlo Scarpa: Theory, Design, Projects.* Milan, 1984; New York, 1986.
Dal Co, Francesco, and Guiseppe Mazzariol, eds. *Carlo Scarpa: Opera Completa 1906–78.* Milan, 1984.
Duboy, Philippe. In Macmillan.
Edilizia Moderna. "Architettura Italiana 1963." (Milan) 82–83 (1964). The whole issue.
Frascari, Mario. "The Body and Architecture in the drawings of . . . Scarpa." *Res* (Harvard) (Autumn 1987).
―――. *The Carlo Scarpa Guide.* New York, 1992.
―――. "The Tell-tale Detail." *Via* (Philadelphia) 7 (1984).
Fung, M. *The Luminous Environment in the Architecture of Carlo Scarpa.* Cambridge, England, 1992.

Futagawa, Yukio, ed. "Carlo Scarpa." *GADoc* 21 (September 1988).

Itoh, Tetsuo. "Architecture à la Carte: Brion Family Cemetery." *a + u* 184 (January 1986).

Kahn, Andrea. "Disclosure: Approaching Architecture." *Harvard* 8 (1992).

Kahn, Louis, and Sherban Cantacuzino. *Carlo Scarpa.* London, 1974.

Lange, Bente. "Carlo Scarpa." *Architekten* (Stockholm) 88 (11 June 1986).

Los, Sergio, and Klaus Frahm. *Carlo Scarpa.* Cologne, 1993.

Marciano, Ada F. *Carlo Scarpa.* Milan, 1984.

Mazzariol, G. "Opera dell' architetto Carlo Scarpa." *Architettura* (March 1955).

Muret, L. M. "Scarpa la mise en scène des oeuvres d'art." *Techniques* 326 (September 1979).

Nicolin, Pierluigi. "His Most Important Work." *Lotus* 38 (1983).

Noever, Peter, ed. *Carlo Scarpa: The Other City.* Weinheim, 1989.

Polano, Sergio. "Sicilian Fragments: Scarpa and Palazzo Abatellis." *Lotus* 53 (1987).

Polano, Sergio, and Marco Mulazzani. "Forgotten Works of Carlo Scarpa." *a + u* 204 (September 1987); 207 (December 1987); 228 (September 1989).

Portoghesi, Paolo. "Cemetery Brion-Vega." *GA Houses* (Tokyo) (October 1982).

Pozza, Neri. *Carlo Scarpa.* Vicenza, 1947.

———. *Carlo Scarpa.* Padua, 1978.

Radice, Barbara. "Interview with Carlo Scarpa." *Modo* (Milan) (January 1979).

Santini, Pier Carlo. "Carlo Scarpa." *Global Architecture* 51 (1979).

———. "Ricordando Carlo Scarpa." *Ottagono* (Milan) 14 (December 1979).

Scalvini, Maria Luisa. "Carlo Scarpa. God Is Also in the Details." *Domus* (June 1985).

Seddon, George. "The Brion Cemetery." *Landscape Australia* (Mont Albert) 13 (May 1991).

Smetana, Donatella. "Carlo Scarpa Revisited." *PA* 65 (July 1984).

Soroka, Ellen. "Point and Counterpoint." *Modulus* (Charlottesville) 19 (1989).

Stern, Michael A. "Passages in the Garden." *Landscape Journal* (Madison) 13 (Spring 1994).

Stewart, David. "Casa Ottolenghi, Bardolino." *GAHouses* (Tokyo) (October 1982).

Toyoda, Hiroyuki, et al. "Drawings of Carlo Scarpa." *SpaceD* 328 (January 1992). The whole issue.

Valeriana, Enrico, and Antonella Greco. *Carlo Scarpa Designi.* Rome, 1981.

Yokoyama, Tadashi, et al. [Carlo Scarpa]. *SpaceD* 153 (June 1977). The whole issue.

Zambonini, Guiseppe. "Notes for a Theory of Making in a Time of Necessity." *Perspecta* 24 (1988).

———. "Process and Theme in the Work of Carlo Scarpa." *Perspecta* 20 (1984).

HANS SCHAROUN. 1893 (Bremen, Germany)–1972. The second of three sons in a middle-class family, Scharoun was educated in Bremerhaven before studying architecture at the Technische Hochschule, in Berlin-Charlottenburg (1912–1915) while employed in the office of one of his teachers, Paul Kruchen (1913–1915). Volunteering for the army, he worked with Kruchen on the East Prussia Rebuilding Program (1915–1918). Scharoun conducted a practice in Insterburg, Germany (1919–1925), before he went to Berlin to form a partnership with Alfons Rading (1926–1928). Scharoun established a private architectural and town planning practice in Berlin (1932) which flourished from the end of World

War II until his death. He was a professor of architecture at the Academy of Arts, in Breslau (1925–1932), senior professor of town planning at the Berlin Technical University (1946–1958), and head of the Institute of Building Studies, in Berlin (1947–1951). Scharoun's work was exhibited in Germany (1927–1931) and after 1967, as well as in London (1971). He won first prize in many architectural competitions between 1919 and 1965, and received honorary doctorates from Stuttgart and Rome. In 1971 he was awarded the French Prix Erasmo.

℘

One of Scharoun's biographers calls him "the most significant German Modernist to establish himself before the Nazi takeover, remain in Germany, then re-emerge to a major career in the 1950s and 60s; he was also the most important German exponent of "Organic" architecture."[1] For all that, throughout his long professional career he was little known in the English-speaking world.

Throughout that time a passionate socialist, Scharoun participated in the Arbeitsrat für Kunst in 1919 and joined other groups, such as the Glaserne Kette (Glass Chain) (Berlin, 1919) and Der Ring, founded in 1926. This brought him into contact with a number of radical, avant-garde architects, including Hans Poelzig,* Max and Bruno Taut, Hugo Haring, Walter Gropius,* Erich Mendelsohn,* and Ludwig Mies van der Rohe.* Their bond was a belief in the need "to overcome what they perceived as a bourgeois preindustrial society," and to "build up a new art and architecture, akin to the social and economic conditions of modern times."[2]

In terms of building, 1918 to 1924 were barren years in Germany and the creative impulse of many architects was satisfied through rhetorical and polemical writing, drawings, and sketches. Scharoun was no exception, and his Expressionistic watercolors of this period (after 1918), no doubt influenced by Bruno Taut and his circle, are redolent of some of Mendelsohn's sketches. Of all the Berlin Ring, Scharoun was most influenced by Haring, not in respect of form, but of approach. Like Haring, he was able to "integrate principles of orthodox modernism, Expressionism, and the tenets of [the New Building]"; he rejected aesthetics "as the determinant of architectural form" and committed himself to "an organic ideal according to which form becomes an expression of function."[3] That idea had been tendered by Frank Lloyd Wright* twenty years earlier and was well known in Berlin's avant-garde circles. Anyway, that integration was seen in Scharoun's later between-wars work and is foreshadowed in the reinforced concrete, detached house he built for Mies van der Rohe's "Weissenhofsiedlung" exhibition, in Stuttgart (1927), and the three irregular blocks of flats in Gropius's Siemensstadt housing estate (1930) in Berlin.

Because of its "hybrid" nature, Scharoun's architecture of the period from 1924 to 1932 was criticized by his peers, most of whom (whether rationalistic or organic) held exclusivist views. More significantly, his work and theirs was regarded by the Nazis as degenerate. The Schminke house (1932–1933) at Lobau in Saxony, his "last work in the modernist idiom," typifies Scharoun's developing aesthetic at the moment when the Third Reich "abolished" modern

architecture. The subsequent repression and persecution of intellectual progressives, including the closure of architecture schools, compelled many architects to flee Germany. Scharoun, already a prominent Berlin practitioner, elected to remain and maintain what is now called a low profile.

Immediately after the war he became city planning officer for Berlin (1945–1947) but he lost the appointment for political reasons and before any of his ideas had been implemented. In 1946 he founded the Planungskollektiv in Berlin and accepted a senior teaching post (1946–1958) in town planning at his old school, which he helped to reestablish. In 1955 he also helped to refound the Berlin Arts Academy. Because of his age and professional pedigree, and particularly because he had stayed in Germany without cooperating with the Nazis, Scharoun enjoyed great prestige. Nevertheless, he built little in the economically stringent period immediately after the war, when the focus of reconstruction was upon inexpensive mass housing. His career burgeoned in the mid-1950s when he was over sixty years old. He is therefore a major linking figure between German modern architecture on either side of the Third Reich.

The Romeo and Juliet flats at Stuttgart-Zuffenhausen (1954–1959) "established him as the Expressionist of the age." The plan rejects the "cubic" rectilinearity of orthodox modernism (there are very few right angles) to point in nine different directions, "while odd-shaped curved and pointed balconies add to the startling and dramatic silhouette."[4] In 1956 he won the competition for what many regard as his magnum opus: the Philharmonic Concert Hall (opened 1963) in the Tiergarten, Berlin. Called by one critic "perhaps [his] most complex and ambitious realization," the Philharmonie "best represents his understanding of architecture as an answer to the spiritual and material dimension of the building task."[5] The rather dull, monolithic, sculptured exterior masks the intricacy of the planning of the corridors, foyers, and ancillary spaces around the revolutionary concert hall, in which terraces of seats surround the orchestra located in the center of the room. His credibility confirmed by this much-copied building, Scharoun was inundated with commissions for the rest of his life. In 1964 he won the competition for the Staatsbibliothek der Stiftung Preussischer Kulturbesitz in Berlin, built from 1967 to 1978. It was completed by Scharoun's associate Edgar Wisniewski, as were a number of buildings and extensions (1971–1988) associated with the Philharmonie and the National Maritime Museum (1970–1975) at Bremerhaven.

As Blundell Jones so succinctly puts it, "In a period when most architects allowed space to be dictated by the construction grid, Scharoun's work stood out in its specificity and individuality, and many of his ideas retain their relevance."[6]

NOTES

1. Blundell Jones in Sharp (1991).
2. Cuadra in Wilkes.

3. Strauss in Macmillan.
4. Goulden in *Contemporary Architects.*
5. Cuadra in Wilkes.
6. Blundell Jones in Sharp (1991).

BIBLIOGRAPHY

Writing

"A Master Plan for Berlin." *AJournal* 109 (17 February 1949).
"Struktur in Raum und Zeit." In *Handbuch Moderner Architektur.* Berlin, 1957.
"Tendenzen der Zwanziger Jahre: Briefe, Glossen, Kritiken." *Bauwelt* 68 (2 September 1977).

Biographical

Bouwkundig Weekblad. "Hans Scharoun 70 jaar." (Amsterdam) 81 (4 October 1963). The whole issue.
Burkle, Johann Christoph. *Hans Scharoun.* Zurich, 1993.
Geist, Johann Friedrich, et al. *Hans Scharoun. Chronik zu Leben und Werk.* Berlin, 1993.
Goulden, Gontran. In *Contemporary Architects.*

Assessment

ADesign. "Flats 'Romeo and Juliet' Stuttgart." 33 (June 1963).
———. "The *Philharmonie,* West Berlin." 35 (March 1965).
AJournal. "Ruthless Pursuit of the Plan." 168 (27 September 1978).
Architettura. "Canto postumo di Hans Scharoun." 31 (October 1985).
———. "L'opera di Hans Scharoun e la sua influenza a Lunen." 9 (October 1963).
Aujourd'hui. "Hans Scharoun." 57–58 (October 1967). The whole issue.
Der Bauhelfer. "Scharoun sprach zur eroffnung der Berliner ausstellung." (Berlin) 5 (September 1946).
Bauwelt. "Projektzeichnungen für die neue Staatsbibliothek, Berlin." 58 (9 October 1967).
———. "Schiffahrtmuseen." 66 (18 July 1975). The whole issue.
Blundell Jones, Peter. "Departure from the Right-angle." *AReview* 190 (February 1992).
———. "From the Neo-classical Axis to Aperspective Space." *AReview* 183 (March 1988).
———. *Hans Scharoun: A Monograph.* London, 1978.
———. "Hans Scharoun: An Introduction." *ADesign* 48 (July 1978).
———. "Late Works of Scharoun." *AReview* 157 (March 1975).
———. "Organic versus Classic." *AAQ* 10 (January 1978).
———. "Scharoun at Weissenhof." *AReview* 193 (September 1993).
———. "Scharoun, Haring and Organic Functionalism." *AAQ* 5 (January 1973).
———. "Shipshape Scharoun . . . Maritime Museum, Bremerhaven." *AReview* 159 (March 1976).
Cuadra, Manuel. In Wilkes.
Futagawa, Yukio, and Hiroshi Sasaki. *The Berlin Philharmonic Concert Hall.* Tokyo, 1973.

Janofske, Eckerhard. *Architekture-raum: Idee und Gestalt bei . . . Scharoun.* Braun-
schwieg, 1984.

Kidder Smith, George E. "New German Theaters and Concert Halls." *ARecord* 134
(October 1963).

Kirschenmann, Jorg C., and Eberhard Syring. *Hans Scharoun, 1893–1972.* Stuttgart,
1993.

Lotus. "Staatsbibliothek, Berlin." 3 (1966–1967).

Lampugnani, Vittorio M. "La ricostruzione impossible." *Domus* 695 (July 1987).

Oxenaar, R. D., and A. van der Woude. *Het Nieuwe Bouwen International; CIAM.* Delft,
1983.

Pfankuch, Peter. *Hans Scharoun: Bauten, Entwurfe: Texte.* Berlin, 1974.

Pfankuch, Peter, ed. *Hans Scharoun.* Berlin, 1967.

Posener, Julius. "Philharmonie Concert-hall, Berlin." *AReview* 135 (March 1964).

Posener, Julius, et al. "From Schinkel to the Bauhaus." *AAPapers* 5 (1972). The whole
issue.

Segal, Walter. "Scharoun." *AReview* 153 (February 1973).

Strauss, Susan. In Macmillan.

Threuter, Christine. *Hans Scharoun Archiyekturzeichnungen . . . 1939 bis 1945.* Frank-
furt, 1994.

DENISE (née LAKOFSKI) SCOTT BROWN. 1931 (Nkana, Zambia)– .
Raised in South Africa, she studied architecture at the University of Witwaters-
rand in Johannesburg (1948–1951) before transferring to the AA school in Lon-
don, where she received a diploma (1955) and a certificate in tropical
architecture (1956). She married Robert Scott Brown in 1955, who died in 1959.
After work in London and Rome and travel about Europe and Africa, she studied
at the University of Pennsylvania ("the most interesting intellectual environ-
ment" she "had ever encountered"[1]) and received a master's degree in planning
(1960); she also studied architectural design with Louis I. Kahn* (1965). She
taught urban planning and architecture at the University of Pennsylvania (1960–
1965) and briefly at the Universities of California at Los Angeles and at Berke-
ley (1965–1968) and at Yale University (1968–1970). She was naturalized in
1967 and in that year married Robert Venturi* to then become a partner with
Venturi and John Rauch, a Philadelphia practice. She has stated that since 1973
she has been offered a number of deanships and departmental chairs.

✎

In urban planning and architecture Scott Brown was among the intellectual
activists of the so-called New Left that promoted some form of advocacy plan-
ning in the 1960s. Concerned that planning had too long been the domain of
upper-middle-income thinkers, she was attracted in England to the communist
Arthur Korn and the ideas of neighborhood and community redevelopment as
put by Alison and Peter Smithson* (all at the AA) and by other Team 10 people.
She was not impressed by the narrow pretentiousness to rebuild as put by the
Congrès Internationaux d'Architecture Moderne* (CIAM) and executed by Brit-

ish and European planners. The "CIAM visions and their simple-minded do-goodism," she has said, "were more harm than help, particularly in urbanism for the poor."[2]

She then became persuaded by theorists on the margins of American planning, including urban sociologist Herbert Gans, social planner Paul Davidoff, and the practical planner David A. Crane (all at the University of Pennsylvania), and to "social and economic aspirations" and realities rather than technological or architectural fantasies, to paraphrase her words. In this she reacted as many did to the pompous new monumentalism that had taken hold of architecture in the 1960s as a reaction to the repetitive monotony of the Modern Movement as it infected American architecture after 1945.

An irritating self-righteous attitude is apparent in her more autobiographical writings but should not dissuade readers. The measure of her contribution to planning is, at one extreme, in advancing and legitimizing "advocacy planning" by placing it within the realms of practicality and knitting it with the remnants of a historical place. At another is her and Venturi's architecture, which at times highlights everyday signs and symbols found ad hoc in American cityscapes. This knit was adequately revealed in *Learning from Las Vegas,* a student project conducted by Scott Brown and Venturi, and followed by a series of plans usually related to city streets or precincts. The pragmatic and profoundly influential book by Jane Jacobs, about *The Death and Life of Great American Cities* (1961), was no doubt one factor prompting their studies. But the complexities of planning are always evident: public and private transport, land use, housing, and so forth. Their work is not wholly academic. (She is also very experienced in gender discrimination.[3])

As to the art of architecture, Scott Brown's role within the partnership cannot be isolated, but it seems to an outsider the more relevant. In any event, Venturi acknowledges that "it is impossible to define where her thought leaves off and mine begins."[4] She continues to act as an industrial designer for major companies.

See Venturi.

NOTES

1. Scott Brown in Ellen Perry (January 1990), 10.
2. Ibid., 11.
3. See "Coda" herein. See also, "Gender and Design," *Design Book Review DBR* Cambridge, Mass. 25 (Summer 1992).
4. Venturi, Izenour, and Scott Brown, *Learning from Las Vegas* (1972), xii.

BIBLIOGRAPHY

Writings

"Architectural Taste in a Pluralistic Society." *Harvard* 1 (Spring 1980).
"Invention and Tradition in the Making of American Place." In *American Architecture: Innovation and Tradition,* edited by David G. De Long, et al. New York, 1986.
"Looking for the Future into the Immediate Past." *AIAJ* 76 (May 1987).

Nakamura, T. "Robert Venturi & Denise Scott Brown." *JapanA* 65 (May 1990).
"On Architectural Formalism . . . for Social Planners and Radical Ohio Architects." *Op-positions* 5 (1976).
"On Pop Art, Permissiveness and Planning." *Journal of the American Institute of Plan-ners* 35 (May 1969).
"Room at the Top? Sexism" In *Architecture: A Place for Women,* edited by Ellen Perry Berkeley and Matilda McQuaid. Washington, D.C., 1989; *ADesign* 69 (January 1990).
"Talking about the Context" *Lotus* 74 (1992).
"Team 10, Perspecta 10, and the Present State of Architectural Theory." *Journal of the American Institute of Planners* 33 (January 1967).
"Urban Concepts." *ADesign* 60 (January 1990). The whole issue.
"A Worm's Eye View of Recent Architectural History." *ARecord* 172 (February 1984).
With Steven Izenour. *Signs of Life. Symbols in the American City.* New York, 1976.
With Robert Venturi. "Architecture as Shelter . . . of the Ordinary in Architecture." *a + u* 1 (1978).
———. "Choosing Richness." *Domus* 747 (March 1993).
———. *Complexity and Contradiction in Architecture.* 2d ed. New York, 1977.
———. "Symposium." *Harvard* 9 (1993).
With Steven Izenour and Robert Venturi. *Learning from Las Vegas.* MIT Press, 1972; 2d ed., 1977.

Biographical

Cowell, S. Fiske. In *Contemporary Architects.*
Larsen, Jonathan Z. "Portrait. Robert Venturi and Denise Scott Brown." *Life* (New York) 7 (November 1984).
Scott Brown, Denise. "Between Three Stools." *ADesign* 60 (January 1990).

Assessment

a + u. "Venturi, Rauch and Scott Brown." 12 (1981). The whole issue.
Abitare. "Learning from Philadelphia." 312 (November 1992).
Cohen, Stuart. "Physical Context/Cultural Context. Including It All." *Oppositions* 2 (1974).
Colquhoun, Alan. "Sign and Substance. Reflections on Complexity, Las Vegas, and Oberlin." *Oppositions* 14 (1978).
Cook, John W., and Heinrich Klotz. *Conversations with Architects.* New York, 1973.
Dean, Andrea O. "Women in Architecture." *AIAJ* 71 (January 1982).
Fitch, James Marsten. "Single Point Perspective." *AForum* 140 (March 1974).
Giurgola, Romaldo. In *Contemporary Architects.*
Harvard. "Interview. Robert Venturi and Denise Scott Brown." 1 (Spring 1980).
McGroarty, Jane, and Susana Torre. In *Women in American Architecture: A Historic and Contemporary Perspective.* New York, 1977.
von Moos, Stanislaus. In Macmillan.
van Schiak, Leon. "Three Strands of Urbanism." *Transition* 41 (1993).
Schulze, Franz. "Chaos in Architecture." *ArtA* 58 (July 1970).
Stern, Robert A. M., ed. "American Architecture: After Modernism." *a + u* Extra issue (March 1981).
Werk. "Venturi and Rauch: 25. 'Offentliche Bauten'." 7–8 (1977). The whole issue.

Bibliographical

Doumato, Lamia. *Architecture and Women.* New York, 1994.
Vance: Lamia Doumato, A25, 1978; A702, 1982; [Robert] Venturi, [John] Rauch, &
 [Denise] Scott Brown, A840, 1982.

HARRY SEIDLER. 1923 (Vienna, Austria)– . With the threat of war looming
in 1938 the Seidler family left Vienna for Paris en route to England, where they
were soon interned and then transported to Canada. Seidler received an archi-
tecture degree from the University of Manitoba, in Winnipeg (1944), and com-
pleted a second degree in Walter Gropius's* master's class at Harvard University
(1945–1946). Seidler then attended design courses held by Josef Albers at Black
Mountain College in North Carolina (1946), worked for Marcel Breuer* in New
York City (1947–1948), and worked briefly with Oscar Niemeyer* in Rio de
Janeiro, Brazil (1948). On the invitation of his parents, who had migrated to
Sydney, to design a new house, Seidler moved to Australia (1948) where he
immediately established a private practice. He was naturalized in 1958. Seidler
has received national and international honorary degrees, visiting teaching po-
sitions, and awards including gold medals from the Royal Australian Institute
of Architects (1976) and the RIBA (1996).

&

 In his first published article, Seidler laid out a philosophy about relationships
between modern painting and the sculptural arts and architecture.[1] Oft repeated,
he has never wavered from its outline, which is derived from Gropius's design
program directed almost exclusively to visual elements (mass, transparency, ten-
sion, polarity, and so on) that architecturally evolved in some measure from
structural exploitation. Seidler's early houses were dedicated to this visual de-
termination and showed a noticeable diversity as a result of experimentations
with structure knitted to easy formal architectonic considerations, such as plan
and simple shape. The famous prizewinning house for his mother (1950) was
among those first works that immediately received worldwide attention. They
were recognized as an apogee of architectural refinement and dynamic sensibility
as promoted by emigré designers from central Europe.
 From Gropius Seidler learned a language of architectural thought; from Breuer
he learned to manipulate solid masses, rather coarsely textured materials and
constructional diversity; from Albers he learned ''to think in visual terms''; from
Niemeyer he discovered form and mass, sun control, how to express structure,
and attention to site conditions. His early work was derivative—he never made
an apology for this—and it reached a formal epitome in a block of apartments
at Diamond Bay, Sydney (1962).
 Collaboration with Italian structural engineer Pier Luigi Nervi* was to change
the nature of Seidler's designs for large and tall buildings. The Australia Square
development, in Sydney (1960–1967), contained a tall, round tower constructed
in precast elements, repetitive floor to floor. It was a lesson in constructional

efficiency. Parallel to this experience Seidler referred to the paintings of Frank Stella and the use of normal geometrical segments, and he reexamined Albers's nonobjective free-forms. The result was the introduction of an overtly Baroque character. This was first explored in the Condominium Apartments in Acapulco, Mexico (1969–1970).

The 1970s were an expansive period with the completion of a number of major commissions, including the Trade Group Offices, in Canberra (1970–1974), which used Nervi's long-span constructional system to a schemata based on the ideas of Louis I. Kahn*; the MLC Centre, in Sydney (1972–1978), a significant urban pedestrian precinct and office tower; and the Australian Embassy, in Paris (1973–1974, with Breuer as consultant), a bipartite scheme that showed a maturity and constructional style that would prevail in the 1990s. Seidler maintained a variety of commissions ranging from medium-sized houses to civic centers (such as Waverley, in Melbourne, 1982–1984), to large urban planning schemes. Of the latter the New World Development project in Singapore (1982) and the CRA urban development for Melbourne (project 1972) are exceptional.

For the most part Seidler's current architectural practice is directed to solving the design of tall buildings in urban situations. The most notable of these have been the Riverside Development, in Brisbane (1983–1986), typical of his concrete and sun control aesthetic; the Capita Centre, in Sydney (1984–1989), with a full-height, open central space/core with now and then landscaped terraces; and the elegant, sophisticated Hong Kong Club and Office Building (1980–1984), whose Baroque plan and interior spaces meld perfectly with an expressive and exposed concrete structural system developed by Nervi and Seidler (Plates 38 and 39). The exclusive club occupies the lower four floors with seventeen floors of rental above. Of this design Seidler has said,

The aim to instill an aura of timeless serenity and yet elegance and pleasure led to the use of curvilinear geometry and forms throughout.... The curved forms, however, are used within the geometric disciplines imposed by structural considerations [and] harks back to the way flamboyant forms were achieved . . . in the Baroque era of the 17th and 18th centuries.

This building's ''poetic geometry'' suggests how his Hong Kong and Shanghai Banking headquarters might have appeared if he rather than Norman Foster* had won the commission.

In early 1995 Seidler's design for the tallest building in the world was presented. Well over half a kilometer high (100 meters higher than the Sears Tower in Chicago by Skidmore, Owings, and Merrill*), the Grollo Tower of Melbourne is to have an irregular hexagonal plan occupying an area equivalent to four city blocks (but straddling rail yards), six mechanical equipment floors, and a massive solar panel array at the top. Big it is.

As Seidler has implied, it is reasonable to compare his work with that of a colleague of his student days at Harvard, I. M. Pei.* Both exhibit a clarity of concept, a high level of sophistication, a love of fluid geometry, plain forms, a

certain monumentality, and a correct and economical use of expertly detailed materials; Seidler shows a preference for structural effect.

Beginning in the 1980s, Seidler's "evident commitment" was "to draw together the fragmented and disparate functions of the city heart into a civilized setting for urban life that is at once coherent and ordered."[3] In that cause he has matured beyond limited visual precepts to extend modernism and engage in a most lively, holistic architecture.

NOTES

1. Seidler (1949); see also Johnson (1978).
2. Drew in *Contemporary Architects.*
3. Seidler project notes.

BIBLIOGRAPHY

Seidler's buildings have been consistently and repetitively published in more than 100 professional magazines throughout the world since 1950.

Writings

Australia Square. Sydney, 1969.
Harry Seidler 1955–63. Sydney/Paris/Stuttgart, 1963.
Houses, Interiors, Projects, Harry Seidler. Sydney, 1954; 2d ed., 1959.
Marcel Breuer and Oscar Niemeyer. In *Contemporary Architects.*
"Painting toward Architecture." *Architecture* (Sydney) 37 (October 1949).
"A Perspective on Planning and Architectural Directions." *Architect* (Sydney) 27 (April 1987).
Towers in the City. Milan, 1988.

Biographical

"Biographical Chronology." In Drew, Frampton, and Seidler (1992).
Drew, Philip. In *Contemporary Architects.*
Internment. The Diaries of Harry Seidler, May 1940–Oct. 1941, edited by Janis Wilton. Sydney, 1986.

Assessment

a + u. "Harry Seidler & Associates." 291 (December 1988).
Abercrombie, Stanley. "Four by Seidler." *InteriorD* 61 (May 1990).
Architecture Australia. "Waverley Civic Centre." 77 (July 1988).
Blake, Peter. *Architecture for the New World. The Work of Harry Seidler.* Sydney/NY/ Stuttgart 1973.
———. *Australian Embassy Ambassade d'Australia Paris.* Sydney/NY/Stuttgart, 1979.
Constructional Review. "No 1 Spring Street." (Sydney) 62 (November 1989).
———. "Riverside Centre." 61 (February 1988).
Coomber, Scott. "Icon or Eyesore? . . . Tall Tower Plans." *The Weekend Australian* (6–7 May 1995).
Drew, Philip. "Harry Seidler. Australian Embassy, Paris." *a + u* 100 (January 1979).
———. "Sydney Seidler." *AAQ* 6 (January 1974).
———. *Two Towers.* Sydney/Stuttgart, 1980.
Farrelly, E. M. "Capita Centre." *AReview* 189 (August 1992).
Frampton, Kenneth. *Riverside Centre.* Sydney/Stuttgart, 1988.

Frampton, Kenneth, Philip Drew [and Harry Seidler]. *Four Decades of Architecture.* London, 1992.

Fromonot, F. "Une tour de Seidler." *Aujourd'hui* 285 (February 1993). Anthology.

Geran, M. "Harry Seidler." *InteriorD* 65 (January 1994).

Greenberg, Stephen. "Master of the Concrete." *AJournal* 197 (February 1993).

Jahn, Graham, and Scott Frances. *Contemporary Australian Architecture.* Sydney, 1994.

Johnson, Donald Leslie. *Australian Architecture 1901–51. Sources of Modernism.* Sydney, 1980.

———. "Bauhaus, Breuer, Seidler. An Australian Synthesis." *Australian Journal of Art* 1 (1978).

———. In Macmillan.

Klasmann, Jaan. [Vienna]. A3 Bau. *Vienna* 1/2 (1995).

Tasarim. "QV1 ofis Kulesi." (Ankara) 39 (November 1993).

Taylor, Jennifer. *Australian Architecture since 1960.* Sydney, 1986.

Towndrow, Jennifer. "Seidler's Poetic Geometry." *RIBAJ* 96 (July 1989).

Tsakalos, Vasilios. "Vienna Housing." *Architecture Australia* 83 (May 1994).

World Architecture. "Harry Seidler." 7 (1990).

Bibliographical

Drew, Philip, Kenneth Frampton and [Harry Seidler]. *Four Decades of Architecture.* London, 1992.

LOUIS SKIDMORE. 1897 (Lawrenceburg, Indiana)–1962. Locally raised and educated, he graduated from Bradley University (1917, then Bradley Polytechnic Institute) in Peoria, Illinois, and served in the U.S. Army in England (1918–1919). Skidmore received a bachelor of architecture degree from the Massachusetts Institute of Technology, in Cambridge (1921–1924), and a Rotch Traveling Fellowship (1926–1929), and he was a visiting scholar at the American Academy, in Rome (1927). He worked for Charles D. Maginnus (1924–1926) and became chief of design (1929–1935) of Chicago's 1933 Century of Progress Exposition where he worked with, among others, Nat Owings.* At his suggestion he and Owings formed a partnership in 1936 in Chicago, and then Skidmore opened a New York office in 1937. Their stated aim was to secure government and corporate commissions. John Merrill joined the partnership in 1939 to form the office of Skidmore, Owings, and Merrill,* or SOM, from which Skidmore retired in 1955. He has received awards and honors including the AIA Gold Medal (1957). Literary works by Skidmore include "The Hall of Science . . . Details of Structure and Equipment," *AForum* 57 (October 1932); "Expositions Always Influence Architecture," *AmericanA* 141 (May 1932); and "NY Proposes a World Capital for the United Nations," *AForum* 85 (November 1946). See also [Portrait], *AForum* 86 (February 1947).

See Bunshaft; Skidmore, Owings, and Merrill (SOM).

SKIDMORE, OWINGS, AND MERRILL (SOM). Nat Owings* joined Louis Skidmore* to form a partnership in 1936 with an office in Chicago; Skidmore opened a branch in New York (1937) and immediately hired Gordon Bunshaft.*

In 1939 and with the principal task of organizing engineering, John Merrill joined to form the partnership Skidmore, Owings, and Merrill, or SOM. By 1968 the firm also had offices in San Francisco and Portland, Oregon (where they bought out Pietro Belluschi's* office), and a staff of 1,020 people. Offices in other American cities soon followed. While Merrill attended to engineering needs Owings managed the various offices and with Skidmore obtained the commissions and placated clients.[1]

After a slow start, the SOM practice soon acquired major wartime projects. One of these was for the government, Oak Ridge, the "Atomic City" in Tennessee, a completely new town serving the Manhattan Project to develop the atomic bomb. Thousands of houses of popular design were built there (1942–1946). Another of the same period was Aero Acres at Middle River, Maryland, for 2,000 families, not much different from the housing at Oak Ridge. And there were also other commissions or projects of little note.

In 1950 Owings introduced the team approach to design. The three principal partners played subsumed roles to the development of the firm for national recognition, obtaining large corporate and government commissions, and managing the teams. Basically, the firm was committed to Modernism and, through it, to the improvement of the built environment. The ideal of internal professional cooperation as envisaged by Owings was instituted where a core group or team was composed of an administrative partner, a design partner, a project manager, senior designers, and technical personnel: all carried forth from beginning to the end of *one* commission.

As it turned out, and much as SOM may have discouraged it, the team system also advanced the firm's partners, including Bunshaft, Myron Goldsmith (engineering and architecture), Walter Netsch, Natalie de Blois, Bruce Graham, Diane Legge-Kemp, Adrian Smith, Richard Keating, and the engineer Fazlur R. Khan. Skidmore had the nous for identifying talent. Indeed, it was the infusion of new talent into the firm, in particular Bunshaft at the New York office, that raised design standards.

Much as Albert Kahn's* office had, SOM set out to provide complete professional services within one firm. The Kahn office, however, was organized vertically in hierarchies. One net result was a noticeable lack of design imagination, a repetitiveness. The same verticality was true for the quasi-"collective" design approach operated by Walter Gropius* with his The Architects Collaborative (TAC). For the most part the same net result was obtained.

SOM allowed each team to operate as an independent entity within the firm thereby encouraging responsibility, innovation, and superior design. The team system proved viable and was accorded success by receipt of an AIA award for excellence in design (1962), the first such award to a firm rather than to an individual. Regardless of one's liking for their designs, SOM's buildings were and are synonymous with excellence in all aspects. As one result their architecture was widely imitated, particularly in Germany in the late 1950s and 1960s, perhaps because their designs owed much to the aesthetic characteristics of the

buildings at the Illinois Institute of Technology (IIT), designed by Ludwig Mies van der Rohe.* Many of the SOM staff were graduates of IIT or the Harvard Graduate School of Design under Gropius.

Although they received little public attention, two buildings announced aesthetic principles that became the frame of reference for much that followed within SOM and in the wider profession. The first was the H. J. Heinz warehouse and vinegar plant in Pittsburgh, Pennsylvania (1950–1952). An exacting plan was housed in a structural frame and exterior geometric expression that, although more brilliantly colored, recalls the German factories of the 1920s and much earlier those of Albert Kahn. More elementally refined and adaptable than Mies's designs, this particular factory aesthetic was used for almost every conceivable building type thereafter. The other is the U.S. Navy Gunners' Mates School at Great Lakes, Illinois (1952–1954). The four-story, symmetrical, tripartite plan is roofed by steel trusses spanning the three parts. On two facades the steel posts holding the principal trusses are exposed—although flush on the exterior—while the other two facades carry a pattern of dark glass stopped in steel framing with horizontality dominant. Despite being publicly overshadowed by Charles and Ray Eames's own house of similar appearance, the expression and detailing of the Gunnery building's all-glass facades were also paradigmatic of much architecture from the 1960s onward.

In 1950 began what historian Christopher Woodward has described as SOM's "canonical buildings."[2] That was due primarily to their popular and professional press; at least it was more noticeable than for the Heinz and Gunnery buildings. The Lever House in New York City (1952, by Bunshaft), SOM's first tall building, was followed immediately by Manufacturers Hanover Trust (1952–1954), also in New York and by Bunshaft. A four-story building with full-height glass walls allowing vision of the great vault (traditionally hidden in a basement), the interior is highly illuminated by ceiling-lighted panels.

This was followed by the Connecticut General Life offices outside Hartford, Connecticut (1954–1957, by Bunshaft) and then the Inland Steel headquarters building in Chicago (1955–1958), SOM's second tall building and again by Bunshaft. Conceptually, the Inland Steel building is different from the Lever House. There are two elements: the vertical service core is to the rear of seventeen office floors uninterrupted by structure because the fire-proofed steel piers stand outside the skin and support beams spanning sixty feet. The concept was unambiguous and expertly executed. These buildings established the firm's reputation with corporate clients and fellow architects.

Within the various teams, the tall building has undergone dramatic changes. Structure integrated with vertical expression has always been a constant theme. One example is the Inland Steel building. Another is Graham's and the late Khan's tall John Hancock Center in Chicago (1965–1970), where a giant, three-dimensional Core-ten steel space frame is cantilevered from the earth and tapers as it reaches skyward. (On Cor-ten see John Dinkeloo.) Giant X-bracing frames eighteen stories in height are exposed on the exterior and a Miesian window

wall fits between. This was repeated on the Alcoa Corporation offices in San Francisco, California (1965–1968), and once again but *expressed* in the flush exterior fenestration system for 780 Third Ave., New York City (1983). The idea was dramatically extended in the 1980s by such architects as I. M. Pei* and Harry Seidler.* The Sears Tower, in Chicago (1974, Graham design), became the tallest building in the world and nearly broke its owner. Structurally it is interesting for it is a bundle of nine structures that move independently yet brace each other against lateral forces.

Concrete was used for tall buildings where the exterior structure was integral with the shear walls of the core, an idea promoted by Marcel Breuer.* Perhaps the earliest was the First City National Bank offices in Houston, Texas (1957–1961, with Wilson, Morris, Crain, and Anderson), where the exterior concrete is exposed and white in contrast to the recessed glass. This exterior framing was also used for Banque Lambert (see Bunshaft) and the Brunswick Corporation office in Chicago (1965).

In the 1980s SOM tended to follow—rather than pace—trends in tall buildings where for the most part the glass skin surface receives a variety of forms and shapes. The rather postmodernist Texas Commerce Tower in Dallas, Texas (1986–1987, by Richard Keating), is one example; Adrian Smith's massive residential complex of Rowes Wharf Complex in Boston, Massachusetts (1985–1987), is a spreadout version with a pair of sixteen-story buildings. Rowes Wharf uses less glass and more precast concrete, brick and copper, and colors in high contrast effectively suggesting forms emerging from other disparate forms. A giant Italian Renaissance arch announces the central arcaded space, a small tempietto resides on waterside piers, and other elements refer to architecture's past; an eclectic pastiche typical of one aspect of postmodernism.

Perhaps SOM's most controversial design was the U.S. Air Force Academy, in Colorado Springs (1956–1962). A sloping pediment of the high Rocky Mountains was shaved to form two basic earth platforms upon which, for the classrooms and quarters, three- and four-story aluminum and glass buildings reminiscent of the Connecticut Life building were arranged about courtyards in an L-shaped sequence. Service buildings such as the dining hall, the two-level chapel, the social center, and the sports hall, are within or beside the L. Controversy centered on the site plan (which ignored the terrain and dramatic situation before the Rockies); the buildings more generally (their lack of reflection of traditional military buildings); the chapel, which is a series of three-dimensional trusses leaned together to form in one direction a triangle (a big metal tent some have said) and in the other a series of sharp points, but the Jewish and Catholic chapels are located underneath the larger Protestant chapel. And so on.

In spite of some critics and observers who seem to be overwhelmed by SOM's volume of work, the scale of the commissions, and an inability to cope with each of SOM's products as an individuated entity, one cannot escape the fact that the firm executes a wide variety of large-sized buildings that continue to

exhibit a wealth of organizational and design skills, a conceptual clarity, a dazzling perpetual newness, a certain heavy monumentality, and a challenge to technical and aesthetic sensibilities.

It is those characteristics that identify the firm of (A. Eugene) Kohn, (William) Pederson, and (Sheldon) Fox, or KPF. As well, KPF started with the same purposes as SOM: to attract large corporate commissions.[3] Their office organization is not much different and, interestingly, the architectural products have the same effect by using the ideas of others but raising them to a slick, expert, and high standard of finish. The same can be said when Helmut Jahn took over C. E. Murphy of Chicago. The most spatially and technically spirited of Jahn's buildings so far is the dynamic State of Illinois Center in Chicago (1979–1985, and see "Coda" herein). KPF, Burgee and Johnson,* Murphy and Jahn, and now and then Cesar Pelli seem to have joined SOM as preferred large corporate architectural practices for large corporations.[4]

See Bunschaft; Owings; and Skidmore.

NOTES

1. Richard Guy Wilson, *The AIA Gold Medal* (New York, 1984), 226.

2. Woodward (1970), 12.

3. On KPF and SOM, see Magali Sarfatti Larson, *Behind the Postmodern Facade* (Berkeley, California, 1993). John (Ogden) Merrill attended the University of Wisconsin (1914–1916), served in the U.S. Army Coast Artillery Corps (1917–1919), and received an architecture degree from the Massachusetts Institute of Technology (1921). After working in the Chicago area he joined Skidmore and Owings as a principal partner in Chicago to form SOM. His major contribution was overseeing engineering aspects that came to constitute a major focus of the firm's architecture. He retired in 1958.

4. Cf. Zukowsky (1993).

BIBLIOGRAPHY

Publications by, about, or that significantly include SOM number well over 1,000 and continue to proliferate. SOM is used below.

Writings

"The Architects from 'Skid's Row'." *Fortune* (New York) 57 (January 1958).

Graham, Bruce. "The Architecture of SOM." *Transactions* (RIBA) 4 (1983).

Khan, Fazular R. "The Islamic Environment." In *Toward an Architecture of the Spirit of Islam.* [Geneva], 1978.

[————.] "Campus City Chicago." *AForum* 123 (September 1965).

————. "Case Study. The University of Bilda." In *Places of Public Gathering in Islam.* Geneva, 1980.

Khan, Fazular R., and Walter A. Netsch, Jr. "Comprehensive Buildings Systems." *Building Research* (London) 3 (September 1966). The whole issue.

Owings, Nathaniel. *The Spaces Between. An Architect's Journey.* Boston, 1973.

SOM. New York, 1960.

SOM. 1936–1980. New York, 1981.

Assessment

a + u. "SOM." 4 (January 1974). The whole issue; and 150 (March 1983).

AForum. "Atom City, Oak Ridge, Tenn." 83 (October 1945).

———. "Houses for Defense." 75 (November 1941).

———. "Pepsi's Palace." 112 (March 1960).

———. "SOM's Details of Distinction." 112 (June 1960).

ARecord. "Four Office Buildings." 125 (April 1959).

———. "In Praise of a Monument to Lyndon B. Johnson." 150 (November 1971).

Betsky, A. "Fire and Ice." *ARecord* 180 (May 1992).

Boyle, Bernard Michael. In *The Architect. Chapters in the History of the Profession,* edited by Spiro Kostof. New York, 1977.

Bruegmann, Robert, ed. *Modernism at Mid-Century: The Architecture of the United States Air Force Academy.* Chicago, 1995.

Bruschiazzo, Mario José. *SOM.* Buenos Aires, 1958.

Builder. "Atom City. Oak Ridge, Tennessee." (London) 170 (1946).

Bush-Brown, Albert. *SOM. Architecture and Urbanism 1973–1983.* London, 1984.

Childs, David. "David M. Childs/SOM 1976–1993." *a + u.* Special issue (September 1993).

Cohen, E. "City Club." *InteriorD* 63 (February 1992).

Crosbie, John. "Urban Anchor." *AIAJ* 80 (September 1991).

Danz, Ernst, and H.-R. Hitchcock. *The Architecture of SOM. 1950–62.* Stuttgart, 1962; London, 1963; Madrid, 1975.

Dixon, John. "Civics Lesson." *PA* 74 (June 1993).

Gaskie, M. "Strong Medicine." *ARecord* 179 (October 1991).

Giedion, Sigfreid. "The Experiment of S.O.M." *Bauen* 12 (April 1957).

Gorman, J. "Foreign Exchange." *Interiors* 152 (May 1993).

Hartmann, W. E. "S.O.M. Organization." *Bauen* 12 (April 1957).

Kliment, Steven. "Manhattan Mosque." *ARecord* 180 (August 1992).

Landecker, H. "Harbor Model [Baltimore]." *AIAJ* 81 (November 1992).

Linn, C. D. "Two Faces Forward." *ARecord* 181 (July 1993).

Lueder, Christoph. "Exchange House." *Deutsche Bauzeitschrift* 41 (July 1993).

Marlin, William. "Sears Tower." *AForum* 140 (January 1974).

Menges, Axel. *The Architecture of SOM. 1963–73.* New York, 1974.

Mirmar. "Saudi Arabia: The Haj[j] Terminal." 40 (September 1991).

Museum of Modern Art Bulletin. "SOM Architects U.S.A." (New York) 18 (Fall 1950). The whole issue.

Nairn, J. "High-rise Office Buildings." *ARecord* 169 (March 1981).

PA. "High-Rise Office Buildings." 39 (June 1957).

———. "SOM's Landscape Architecture." 43 (June 1962).

Russell, B. "Western Star." *Interiors* 153 (January 1994).

SpaceD. "SOM." Special number (May 1979). The whole issue.

Strauss, Susan. In Macmillan.

Tasarim. "SOM." (Ankara) 40 (December 1993).

Winter, John. In *Contemporary Architects.*

Woodward, Christopher. *SOM.* London/New York, 1968, 1970.

Zukowsky, John, ed. *Chicago Architecture and Design 1923–1993.* Munich/Chicago, 1993.

Bibliographical

Vance: Frances C. Gretes, A1160, 1984.

ALISON AND PETER SMITHSON. This husband and wife partnership (1950–1993) of English architects is as important for its polemical writings as for its

comparatively few buildings. Their insistence upon the absolute equality within the team meant that they usually had one voice, writing authoritatively in books and international journals (1953–1993). They married (1949) soon after both graduated in architecture. After working as technical assistants in the London County Council Architects Office they set up practice as Alison and Peter Smithson (1950). They were part of the London Independent Group (1956) and co-founders of Team 10 (1956), which replaced the Congrès Internationaux d'Architecture Moderne* (CIAM) in 1959. They have exhibited in London (1953+), Milan (1968), Edinburgh (1976), Venice (1976, 1983), and Paris (1982). Through their involvement with the AA, they have influenced younger architects including Denise Scott Brown* and Archigram* members Peter Cook,* Dennis Crompton, and David Greene. Among the "most articulate of recent architectural polemicists," through their writings, lectures, exhibitions, and buildings, the Smithsons were major contributors of ideas to British architecture and urbanism, especially between 1950 and 1970. In the later 1970s and 1980s, they seemed to become "rather isolated in the wake of . . . architectural events."

Alison Margaret Smithson (née Gill) (1928 [Sheffield, England]–1993) was educated at Church High School, in Sunderland (1934–1939), George Watson's Ladies College, in Edinburgh (1939–1943), and South Shields Girls High School (1943–1944). She studied architecture at the University of Durham (1944–1949), where she became impressed by the work and writings of Le Corbusier.* She was a visiting professor at the Munich Technical University (1985) and the University of California, Berkeley (1990).

Peter Denham Smithson (1923 [Stockton-on-Tees, England]–) was educated at the local grammar school (1934–1939) before studying architecture at the University of Durham (1939–1942). Interrupted by World War II, when he served as a lieutenant in India and Burma (1942–1945), he returned to complete his studies (1945–1947). He was influenced early by the ideas of Le Corbusier* and Ludwig Mies van der Rohe.* Smithson commenced a course in the Town Planning Department at Durham (1946–1948) and studied town planning at the Royal Academy Schools (1948–1949). He has taught at the AA school in London (1955–1960) and has been a visiting professor at the Munich Technical University (1985) and the University of California, Berkeley (1990).

<p style="text-align:center">✑</p>

In the early 1950s Peter and Alison Smithson consciously and deliberately propounded the relinquishing of the canon of the 'white modern' (their own term). With a new brutalism they wanted to defeat the English postwar trend . . . and to counterpose a new, limited viewpoint against the functionalist fixation on the generalization of universally valid norms.[1]

"The most obstinate protagonists of [Brutalist] architecture were Alison and Peter Smithson . . . because they were prepared to make something serious of it."[2]

What *was* the English "postwar trend"? The Smithsons commenced practice

when architectural ideas in London were dominated by an intense vernacular Expressionism, reacting to Britain's conservatism: the "correct" but amorphous and dull architecture of those years, epitomized in the work of Frederick Gibberd; New Town policy constructed on the obsolescent ideas of Howard and the highly architectonic yet socially unresponsive ideas of CIAM; and models for housing and public buildings promulgated by bureaucrats in the London County Council.

Similar dissatisfaction throughout Western Europe led, at CIAM's 1956 Dubrovnik conference, to the formation of Team 10, a "loose association of friends" of the modern movement: Aldo van Eyck,* J. B. Bakema, Shadrach Woods, Alexis Josic, Georges Candilis, Giancarlo de Carlo, and the Smithsons. At the next conference (Otterlo 1959) CIAM's regime was overthrown by this group, who set goals for socially responsible, more humane housing and city planning. As Charles Jencks has noted,

instead of a Platonic architecture with some conceptual scale there was to be an architectural equivalent to the present cosmology of endless and continual space. Instead of a Virgilian dream of urbanity, there was to be a direct, realist approach to existing city situations.[3]

The first important building of the Smithsons was the "revolutionary" Hunstanton Secondary School, in Norfolk (1949–1954), a two-story, rectilinear, almost Palladian building highly evocative of Mies van der Rohe's recent Alumni Hall at Illinois Institute of Technology (1945–1947). Hardly fitting the popular image of New Brutalism, the school was categorized as just that by its designers and expressed their youthful and absolutist belief that architecture can be "made out of the relationships of brute materials." Structure, materials, and services were honestly and unambiguously revealed; today that approach could be expressed in computer jargon as "what you see is what you get." It would lead a generation of architects toward a style which Reyner Banham later formally dubbed as Brutalism. Critic Dennis Sharp rejects that "ill-defined and unwarranted term" in favor of an "early kind of technological minimalism."[4] Whatever its name, the style was emulated by copyists but also embraced by such architects as James Stirling* and James Gowan* in their earliest works.

While Hunstanton was being built the Smithsons submitted an entry for the Golden Lane Housing Estate competition (1952), welcomed by their peers as a model and conceived as a repudiation of the urbanistic ideas enshrined in CIAM's Athens Charter. The unrealized design for a block of four layers of two-story apartments, with suspended "streets" (really access galleries), was in some ways redolent of the Unite d'Habitation Marseilles (1946–1952) by Le Corbusier, a Smithson hero, and in other ways by Michiel Brinkman's Spangen housing, in Rotterdam (1919–1920). Thereafter, the Smithsons followed Le Corbusier; as they later said, "Mies is great but Corb communicates."[5] The Golden Lane precepts were again applied in an unbuilt competition entry for Berlin Haupstadt (with Peter Sigmond, 1957–1958), where the proposed "urban fabric

was to be suspended over the old one, connected to the ground with relational spaces and towers freely disposed within the elastic superstructure."[6] Many, but not all, of the themes of Golden Lane and Berlin were finally realized in the Robin Hood Gardens workers' housing estate, in London (1966–1972). But the flats, arranged along elevated, exterior "streets," failed to fulfill the intention of humanizing highrise housing.

The *Economist* building on Saint James Street, London (1960–1964) is possibly the Smithsons' most significant built work. Architectural historian John Furse calls it "one of the most sophisticated complexes in twentieth century architecture" and one of the most important postwar buildings in England.[7] It embodies the ideals formed by the Smithsons a decade earlier: an architecture to serve the day-to-day movements and interactions of its occupants, its neighbors, and the passers-by. The Smithsons were able to replace the hitherto accepted high monolithic slab with a grouping of smaller masses in harmony with the preexisting urban environment. The *Economist* office was followed by the Garden Building at Saint Hilda's College, Oxford (1970); the Robin Hood estate; and after 1978, a series of buildings at the University of Bath, culminating in the School of Architecture (1988–1989).

Despite this influential built oeuvre there is little doubt that the Smithsons' most important contribution to modern architecture has been in the realm of polemical writing and lecturing. Spanning about forty years, the scope and the detail of their well-articulated concerns about the contemporary arts, both within and beyond the ambit of Team 10, is daunting. As Furse puts it, "The continually provocative writing—especially in the early days of *Architectural Design*—has had a telling effect on those to whom the Smithsons embody the continuation of the progressive ideas of the Modern Movement."[8]

NOTES

1. Klotz (1988), 102.
2. Banham (1966), 10.
3. *Charles Jencks, Modern Movements in Architecture* (New York, 1985), 256.
4. Dennis Sharp in Sharp (1991).
5. As quoted in Kenneth Frampton, *Modern Architecture: A Critical History* (London, 1992), 266.
6. Manfredo Tafuri and Francesco Dal Co, *Modern Architecture* (London, 1986), 347.
7. John Furse in *Contemporary Architects.*
8. Ibid.

BIBLIOGRAPHY

Writings by Alison Smithson

AS in DS. Delft, 1983.
"CIAM 10. Habitat 1956." *Integral* (Barcelona) 8 (1956).
"Collective Design: Reappraisal of Concepts in Urbanism." *ADesign* 44 (July 1974).
Le Corbusier. Le Corbusier International Cultural Organization, 1967.
"Eredita: Carre Bleu." *Spazio e Societa* (Milan) 12 (January 1989).

"The Future of Furniture." *ADesign* 28 (April 1958).
"Hole in the City, Damascus Gate, Jerusalem." *Mac Nine* (Glasgow) (April 1981).
"The Legacy of the Modern Movement." *Spazio e Societa* 5 (December 1982).
"Louis Kahn." *Architects' Yearbook* (London) 9 (1960).
Portrait of the Female Mind as a Young Girl. London, 1966. Novel.
"Team 10 at Royaumont, 1962." *ADesign* 45 (November 1975).
As editor. *Team 10 Primer.* London, 1962, 1965; MIT Press, 1968.
————. *Team 10 out of CIAM.* London, 1982.

Writings by Peter Smithson

"Aesthetics of Change." *Architects' Yearbook* (London) 8 (1957).
"Education for Town Planning." *AA Journal* (London) (January 1961).
"Interactions and Transformations: Urban Structure and Urban Form." *ADesign* 44 (January 1974).
"Restez couverts." *Aujourd'hui* 265 (October 1989).
"Simple Thoughts on Repetition." *ADesign* 41 (August 1971).
"Social Foci and Social Space." *ADesign* 30 (December 1960).
"Space is the American Mediator" *Harvard* 2 (Spring 1981).
[Talks to A.A. students.] *AJournal* 129 (21 May 1959).

Joint Writings

"Alternative to the Garden City Idea." *ADesign* 26 (July 1956).
"Architecture and Art." *Le Carré Bleu* 2 Paris (1960).
"The Built World: Urban Reidentification." *ADesign* 25 (June 1955).
The Euston Arch and the Growth of London. London, 1968.
The Heroic Period of Modern Architecture. New York, 1981.
"The Heroic Period of Modern Architecture. 1917–1937." *ADesign* 35 (December 1965).
Mies van der Rohe. Berlin, 1968.
"The Nature of Retreat." *Places* (Berkeley) 7 (Spring 1991).
The 1930s. Berlin, 1985.
Ordinariness and Light. Urban Theories '52–'60. MIT Press, 1970.
The Shift in Our Aesthetic, 1950–1978. London, 1982.
"The Theme of CIAM 10." *Architects' Yearbook* (London) 7 (1956).
Uppercase. London, 1960; *Urban Structuring.* 2d ed. London 1967.
"An Urban Project (Golden Lane)." *Architects' Yearbook* (London) 5 (1953).
Without Rhetoric: An Architectural Aesthetic 1955–1972. MIT Press, 1973.
Working with Shadow: Damascus Gate, Jerusalem." *Via* (Philadelphia) 11 (1990).
As editors, "CIAM—Team 10." *ADesign* 30 (May 1960).
With others, *Parallel of Life and Art.* London, 1953.

Biographical

Furse, John. In *Contemporary Architects.*

Assessment

AA. *Climate Register: Four Words by Alison and Peter Smithson.* London, 1994.
ADesign. "Death of Alison Smithson." 40 (March 1994).
————. "The Pursuit of Ordinariness: Garden Building, Oxford." 41 (February 1971).
————. "The Work of Team 10." 34 (August 1964). The whole issue.

AJournal. "*Economist* Building." 150 (3 September 1969).

Alison and Peter Smithson. London, 1982.

Architects' Yearbook. "Hunstanton Secondary Modern School, Norfolk." (London) 6 (1955).

ARecord. "Two New Buildings for the University of Bath." 167 (January 1980).

AReview. "Secondary School at Hunstanton, Norfolk." 116 (September 1954).

———. "Two Building Designs for the University of Bath." 167 (January 1980).

Baker, Jeremy. "A Smithson File." *AA Journal* 81 (February 1966). The whole issue.

Banham, Reyner. *The New Brutalism: Ethic or Aesthetic?* New York, 1966.

Brades, Peter. "A Disposition to Observe." *International Architect* (London) 6 (1984).

Casabella. "The Death of Alison Smithson." 58 (March 1994).

Cook, Peter. "Time and Contemplation: Regarding the Smithsons." *AReview* 172 (July 1982).

De Carlo, Giancarlo, et al. "Alison Smithson: Courageous Utopian." *AJournal* 198 (1 September 1993).

Eisenman, Peter. "From Golden Lane to Robin Hood Gardens." *Oppositions* 1 (September 1973).

———. "Robin Hood Gardens, London E14." *ADesign* 42 (September 1972).

Fisher, Thomas. "The (Dis)unity of the Arts." *PA* 69 (February 1988).

Greenberg, Stephen. "Parallel aims." *AJournal* 195 (4 March 1992).

Klotz, Heinrich. *The History of Postmodern Architecture.* New York, 1988.

Powers, Alan. In Macmillan.

Quoidbach, Tracy. "Bringing the Smithsons Back." *Archis* (Doetinchem). (July 1993).

Robbins, D., ed. *The Independent Group: Postwar Britain and the Aesthetics of Plenty.* MIT Press, 1990.

Sasaki, Hiroshi. "[The Smithsons]: New Brutalism." *Kokusai Kenchiku* (Tokyo) 27 (June 1960).

Schoning, Pascal. "Berlin 750." *AAFiles* 15 (Summer 1987).

Soriano, Federico, and A. Nicolau. "Alison & Peter Smithson." *Arquitectura* (Madrid) 73 (July 1992).

Turnbull, David. "Architecture School 3." *AJournal* 188 (30 November 1988).

Vidotto, Marco, et al. *A + P Smithson: Pensieri, progetti e frammenti fino al 1990.* Genoa, 1991.

Bibliographical

Smithson, Alison, and Peter Smithson. *Bibliography of the Works of [the Smithsons].* London, 1975– .

———. "A Free Plastic Starter Whistle." *Modulus* (Charlottesville, Va.) 4 (1968).

Vance: Lamia Doumato, A833, 1982.

MART(INUS ADRIANUS) STAM. 1899 (Purmerend, the Netherlands)–1986. While studying drawing at the National School for Art Education in Amsterdam (1917–1919), where he gained a diploma in building studies, Stam was employed in the office of J. M. van der Meij. After moving to Rotterdam he worked for M. J. Granpré Molière, Verhagen, and Kok (1919–1922) before seeking

experience outside Holland. Over the next few years he successively entered the
Berlin offices of Hans Poelzig* and Bruno Taut (1922), Werner Moser in Zurich
(1923–1924); and A. Itten in Thun, Switzerland (1924–1925) before he returned
to Rotterdam, where he was employed by Johannes Andreas Brinkman and
Leendert Cornelis van der Vlugt* (1925–1928). Stam was a key figure in the
establishment (1928) of the Congrès Internationaux d'Architecture Moderne*
(CIAM) at La Sarraz, Switzerland. Returning to Germany and thence to Eastern
Europe, he worked with Ernst May on various town planning projects in the
Soviet Union (1930–1934) before forming a partnership in Amsterdam (1935–
1939) with his architect wife Lotte Beese (m. 1934) and Willem van Tijen. In
1937 he became the director of the Institute for Industrial Arts Education, in
Amsterdam. He resigned to become the director of the Dresden Academy of
Arts (1948–1950) and soon moved to an equivalent post at the Kunsthochschule,
in East Berlin (1950–1952). Stam formed an association with the Dutch mod-
ernists Merkelbach and Elling (1953–1956) in Amsterdam, and next conducted
his own practice (1956–1966). In 1966 Stam closed his Amsterdam office and
moved to Switzerland. Apart from two exhibitions of his work (The Hague,
1969; and Eindhoven, 1971), his final twenty years were spent in obscurity.
When he died in 1986 there was an unsubstantiated rumor abroad in Holland
that it was at the hands of the Soviet KGB.

Stam's career as an archmodernist had an unlikely start. His first practical
experience was gained in the Amsterdam office of an Expressionist architect
and reinforced by three years in the highly conservative Rotterdam firm headed
by Marinus Jan Granpré Molière, "father" of the reactionary Delft School.
None of that would have prepared him for revolutionary architecture. While
traveling in Germany and Switzerland over the next four years he met Poelzig,
Max and Bruno Taut, and the Constructivist, El Lissitzky. Like many of his
peers, he caught a political vision of architecture, and in the spirit of the Inter-
nationale his contribution was universal. In Zurich with Hannes Meyer, Hans
Schmidt, Werner Moser, Lissitzky, and others, he founded the journal *ABC*
(1924–1928), destined in its short life to become "the foremost Constructivist
network outside the Soviet Union." Just when Theo van Doesburg* was prop-
agating De Stijl* Neoplasticism, Stam took a new road.

Influenced by Italian Futurism and Russian Constructivism he became a lead-
ing spokesman for Functionalism and one of the radical left wing of the avant-
garde. In 1920, with Moser, Stam had won a competition for the Budge
Foundation Old People's Home, in Frankfurt. In subsequent years he undertook
many more projects including a collaboration with Bruno Taut on the Berlin
offices of the German Bookprinters Association (1922). But none was more
significant than the 1923 competition entry for a reinforced concrete and glass
office building in Königsberg (with W. von Walthausen). As in the unbuilt
Moscow Wolkenbugel Building Project (with Lissitzky, 1924) Stam explored

the expressive possibilities of structure, "the glass surfaces [being] counterbalanced by the volumetric articulation obtained by [opposing] scaled planes."[1]

The same Constructivist approach is evident in his later projects, including the Rokin and Dam redevelopment, in Amsterdam, of 1926. And there is little doubt that his Dutch peers were influenced, too. Back in Holland, Stam joined Brinkman and van der Vlugt (1925–1928), where he made a major contribution to the design of the Van Nelle Factory in Rotterdam. Although there has been debate over authorship, one contemporary insists that Stam's hand is imprinted upon the sweeping curve of the main block, recalling: "Mart was simply unable to draw a straight line."[2] Be that as it may, there were many Constructivist-inspired buildings in Holland over the next decade, including Bijvoet and Duiker's Zonnestraal tuberculosis sanatorium in Hilversum (1926–1932) and the Cliostraat School in Amsterdam (1929–1930), and Brinkman and van der Vlugt's Feyenoord football stadium (1934). All these buildings attracted international admiration.

Stam also came into early contact with the Bauhaus by taking part in its 1923 "Art and Technics" exhibition at Weimar. The links continued in the school's Dessau phase: among the first experiments with tubular steel, his famous chair was developed in 1924–1926. The design leapt beyond Rietveld's* Elementarist impasse, giving rise to the Marcel Breuer* type that has become almost a household word. In 1927 Stam was invited by Mies van der Rohe* to produce his most celebrated building, the row houses in the model Weissenhofsiedlung in Stuttgart. For those dwellings, Stam produced a cantilever, sprung tubular chair, an idea "borrowed" by Ludwig Mies van der Rohe.*

Spending most of his time in Holland, Stam was actively involved with the Rotterdam Modernist group Opbouw and served as its president (1926–1928). Those years saw a generally unproductive, if international, practice. In the incipient economic depression, none of his personal projects in Holland were realized. So he left in 1928 to work in Frankfurt with Ernst May. When Adolph Meyer replaced Gropius as director of the Bauhaus, Stam was appointed guest lecturer in city planning, a role that occupied him for several days a month for one semester (1928–1929).

In 1928 he was a cofounder of CIAM, an association that allowed him to give architectural expression to his socialistic internationalism. Arnulf Luchinger believed that Meyer, Stam, and Schmidt's "famous concluding declaration" prevented Le Corbusier* from "putting forward his own conceptions."[3]

In 1929 Stam secured the commission for the 1,600-dwelling "Hellerhof" garden suburb in Frankfurt, but before it was finished he went to Russia (1930). Many other young socialist architects had done the same thing, only to leave disillusioned with the stark reality behind the shining Soviet ideal. Stam stayed for about five years, undertaking town planning and architectural works in Magnitogrsk, Orsk, and Makejefka, before returning again to Holland in 1934. For the next thirty years his career was patchy. Sometimes self-employed, sometimes working for others; sometimes in Holland, sometimes in East Germany; sometimes practicing, sometimes teaching—but all the time restless. His major con-

tribution was made in the 1920s. Aside from his seminal work at the Weissenhofsiedlung, his major importance lies in his Constructivist and city planning projects and perhaps, above all, in his role as an outspoken protagonist of Functionalism.

NOTES

1. Fanelli (1978), 351.
2. Robert Magnée, interview with Donald Langmead, Naarden, July 1987.
3. Luchinger in *Contemporary Architects.*

BIBLIOGRAPHY

Writings

"Holland und die Baukunst unserer Zeit." *Schweizerische Bauzeitung* (Zurich) (13 March 1923).
"Kollektive Gestaltung." *ABC* 1, 1 (1924–1925).
"Modernes bauen 1." *ABC* 1, 2 (1924–1925).
"Modernes bauen 2." *ABC* 1, 3/4 (1924–1925).
"Modernes bauen 3." *ABC* 1, 3/4 (1924–1925).
"The Stam Houses" (1927) and "Away with the Furniture Artists" (1927). In *Form and Function: A Sourcebook for the History of Architecture,* edited by Tim Benton, et al. London, 1975.
With Jacob Bakema, et al. *L. C. van der Vlugt.* Amsterdam, 1968.
As editor, with others. *Open Oog.* Amsterdam, 1946.

Biographical

AJournal. "The Last of CIAM: Mart Stam 1899–1986." 183 (March 1986).
Luchinger, Arnulf. In *Contemporary Architects.*
Roth, Alfred. "Remembrances of Mart Stam." *Domus* 673 (June 1986).
Segal, Walter. "Mart Stam." *AJournal* 151 (3 June 1970).

Assessment

Behr, Adalbert. "Mart Stam—80 Years Old." *Architektur der DDR* (East Berlin) (August 1979).
Blijstra, Rien, ed. *Mart Stam: Documentation of his Work.* London, 1970.
Boot, Caroline. "Stam and the Arts and Crafts Movement." *Wonen TA/BK* (Heerlen) (June 1982).
Bosman, Jos. "Mart Stam Study Tour: . . . Drawn Work." *Archis* (Doetinchem) (January 1993).
Bouwkundig Weekblad. "Mart Stam—Overzicht van zijn werk." 87 (23 December 1969). The whole issue.
Fanelli, Giovanni. *Moderne Architectuur in Nederland 1910–1940.* The Hague, 1978.
Fisher, Thomas R. "P/A Technics: Low Cost, High Design." *PA* 69 (October 1988).
Ingerman, Sima. *ABC: International Constructivist Architecture 1922–1939.* MIT Press, 1994.
Joedicke, Jürgen, and Christian Plath. *Die Weissenhofsiedlung.* Stuttgart, 1968.
Metalen Buisstoelen 1925–1940 Delft, 1975. Catalog.
Oechslin, Werner, ed. *Mart Stam . . . in die Schweiz 1923–1925.* Zurich, 1991.
Russell, Frank, et al. *A Century of Chair Design.* London, 1980.
Sharp, Dennis, et al., eds. *Mart Stam, Documentation of His Work 1920–1965.* London, 1970.

Steinmann, Martin, ed. *CIAM; Dokumente 1928–39.* Basel, 1979.
Studio Yearbook. "The New Movement." London, 1929.
Wingler, Hans M. *The Bauhaus: Weimar, Dessau, Berlin, Chicago.* Cologne, 1962; MIT
 Press, 1969.
 Bibliographical
Fanelli, Giovanni. *Moderne Architectuur in Nederland 1900–1940.* The Hague, 1978.
Vance: Donald Langmead, A1671, 1986; A1672, 1986; A1773, 1987.

DE STIJL. The most important theoretical movement in Europe until its leadership was usurped by the Germans in the mid-1920s, De Stijl was peculiarly Dutch, a loose-knit group of architects and artists founded in 1916 under the leadership of painter Theo van Doesburg.* Membership fluctuated until 1925 when van Doesburg alone was left to conduct the radical polemical journal *De Stijl* (which was the "cement" of the group, so to speak) until his death in 1931. In terms of architecture, De Stijl, seeking a unity in the arts and between art and society, flirted with Constructivism and developed theories of Neoplasticism and what architect J.J.P. Oud* called Cubism. For all that, its members individually or collectively built very little that could accurately be described as De Stijl architecture. Nevertheless, it remains Holland's major contribution to art in the twentieth century.

De Stijl was only one of many small associations that blossomed in Holland between 1910 and 1925: others were the Expressionist Amsterdam School, the Modernist Rotterdam group Opbouw, and the reactionary so-called Delft School. Conflicting ideas and mutual disrespect developed together.

In 1916 Oud met van Doesburg. He introduced another young architect, Jan Wils (they had met through H. P. Berlage about four years earlier), to the painter. The three formed the artists' club De Sphinx in Leiden. Very soon they founded, with the painter Piet Mondrian and designers Bart van der Leck and expatriate Hungarian Vilmos Huszar, the group of avant-garde artists known as De Stijl. Others joined them: fiery architect Robert van 't Hoff and Belgian sculptor Georges Vantongerloo (both in 1917), furniture designer Gerrit Rietveld* (1918), architect Cor van Eesteren and German industrial designer Werner Graeff (both in 1922), painter Cesar Domela Nieuwenhuis (1924), and German designer Friedrich Vordemberge-Gildewart (1925). Most eventually left, often after falling out with the dictatorial van Doesburg. Van der Leck lasted only until 1918; Wils and van 't Hoff left in 1919; Oud and Vantongerloo in 1921; Mondrian in 1925. There were others who enjoyed (if that is the correct word) professional links with van Doesburg.

The first De Stijl manifesto was issued in November 1918, though not all members endorsed it. It should never be considered a group in the sense that, say, the Fauvists or the Cubists were groups. Its bonds, at best tenuous, were constantly stretched, often past breaking point. Its members never achieved any

unity of purpose; there were no meetings and membership lay rather in contributing to van Doesburg's jealously guarded magazine. Its intellectualized theories seldom had a chance to extend to architectural realities. But the few realized projects were spectacular: Rietveld's Schröder house of 1924 clearly expressed ideas developed within De Stijl, and is a landmark of European Modernism. Van Doesburg's Café Aubette in Strasbourg (1926–1927, with Jean and Sophie Arp) carried "painting into architecture, theory into practice." Because De Stijl is probably the best documented aspect of modern Dutch art, this short essay need only outline its impact upon modern architecture. To do that we need to consider the roles of van 't Hoff and Wils.

It may be seriously claimed that through De Stijl, the Dutch purveyed much theoretical and, to a lesser degree, practical, fodder to the Modern Movement. Not least, they were a major channel for Frank Lloyd Wright's* penetration of Europe by introducing and commenting upon the American to a wide European audience. In 1936 Alfred Barr of the New York Museum of Modern Art correctly observed that De Stijl had dominated German architecture and art in the mid-1920s. Moreover, had van Doesburg's attempted insinuation into the Dessau Bauhaus succeeded, that school would have turned toward Russian Constructivism.

Many De Stijl members were Calvinist-turned-Theosophist, who espoused a holistic worldview in which "the geometric is the essence of the real"—a universal unity, including the arts and culture, and the sociopolitical issues of life. Perhaps because it offered a palliative for the concomitant problems of burgeoning capitalism, Theosophy's combination of mysticism, religion, and philosophy appealed to many in the industrializing world at the fin de siècle. As its ideas permeated Dutch art, such otherwise irreconcilable groups as De Stijl and the Amsterdam School eagerly embraced it. This response exposes socialism as a linking factor at the time of De Stijl's birth. For some within the group, social issues were all.

As an extreme example, they so concerned van 't Hoff that, because much of his work was necessarily for the middle classes, he soon forsook architecture altogether. That ephemeral architect—"systematic, disciplined and businesslike," a perfectionist espousing ideals of socially responsible building and the inseparability of architecture and community life—was a key figure. To start with, he was the only Dutch architect to have *personal* contact with Wright before 1931. His houses at Huis ter Heide were startling for their time and were Europe's first built copies of Wright's work: the concrete Villa Henny (designed 1914), a clone of the American's cubic aesthetic, and the Verloop house, mimetic of his prairie houses. Around 1916 van 't Hoff met van Doesburg and, while circumstances remain obscure, there is no doubt that the Villa Henny was the point of attraction for the painter. In eighteen months with De Stijl van 't Hoff built only a houseboat. In 1918 he joined the Communist party and briefly turned to designing mass housing as an expression of his political convictions. None was built. He quit De Stijl in October 1919 because van Doesburg would

not fully support the communist cause. Van 't Hoff was a valuable resource in bringing Wright's post-1910 work to the attention of Europe. Although he said and wrote little about it, perhaps because his political views were so different from the American's, the task of propaganda was taken up by another De Stijl architect, Jan Wils.

Architectural historian Ezio Godoli identifies Wils's secondary role in Dutch Modernism (the first "a professional of quality") as "shelling out formal instances from Wright to . . . the neoplastic architecture program."[1] But Wils's sharing of his unique insights was never parsimonious; nor was it limited to the confines, too narrow for Wils, of Neoplasticism. Berlage had declared in stentorian tones, "Look at Wright's architecture!" Wils showed his Dutch peers and their French and German visitors exactly *what* to look for. When he designed the stadium for the 1928 Amsterdam Olympic Games his essays about the American were complete. His "Daal en Berg" housing estate in The Hague (1920), owing much to Wright, attracted attention in Italy and Germany. Yet his espousal of Wright was not greatly effective beyond his own country. His few internationally published writings promoted himself, not Wright. On the other hand his influence *within* Holland was unparalleled because he reached the widest public by contributing to journals beyond the narrow audience of De Stijl: *Levende Kunst, Elsevier's, Wendingen,* and *De Beweging.* All were in Dutch alone.

A cofounder of De Stijl, Wils contributed twice to its journal before withdrawing in 1919, not because of philosophical dissonance but because van Doesburg was "playing the little dictator."[2] Those short pieces about Wright were neither concise nor incisive, but his essay for the new art magazine *Levende Kunst* was much more substantial, anticipating De Stijl's *Manifesto V* and van Doesburg's influential "Towards a Plastic Architecture" of 1924 (see Plate 12). In Wright's writings Wils found and was wont to expound revelations of the essence of architecture, including the rejection of all historical, formal aesthetic for a new, elementary form simplified by function, mass, space, and material. Wright's emphasis upon economy of means and material would also be repeated in De Stijl's catechism, as was his idea about identifying space by the extension of planes. The list extends to integrated decoration and form, and the spatial achievement of what van Doesburg termed "monumentality." It is presumptuous (and inaccurate) to claim that De Stijl's criteria for plastic architecture came only from Wright and only through Wils. Wright's achievements were announced by Wils just as the group was being formed and were later transmitted to much of Europe by van Doesburg and to a lesser degree Oud.

The partisan division of Dutch architects limited the acceptance of De Stijl's ideas. Although its earlier volumes circulated among a largely Dutch readership, *De Stijl* eventually became an international journal (or sometimes by van Doesburg's legerdemain, an illusion of one). Through its pages and his personal evangelism he broadcast throughout Europe the message of an architectural consummation, most of the qualities of which Wright had achieved before 1910.

Sadly, for some the architect's role had been devolved in about 1922 by the rhetoric of the advanced guard of artistic theory and the political purpose of the Left. Often they were synonymous. Because of the steady exodus of its members, De Stijl was already moribund when van Doesburg died in 1931.

See van Doesburg; Oud; Rietveld.

NOTES

1. Ezio Godoli, *Jan Wils, Frank Lloyd Wright e De Stijl.* Florence, 1980; as quoted in Baroni (1988), 50.
2. Wils to H. Th. Wijdeveld, 20 December 1968. Wijdeveld Archive, Nederlands Architectuur Instituut, Rotterdam.

BIBLIOGRAPHY

Writings

van Doesburg, Theo. *Drie Voordrachten over de Nieuwe Beeldende Kunst.* Amsterdam, 1919; *Principles of Neoplastic Art.* London, 1969.
————. *Naar een Beeldende Architectuur.* Facsimile. Nijmegen, 1983.
————. *De Nieuwe Beweging in de Schilderkunst.* Delft, 1917.
————. *On European Architecture: . . . Essays from Het Bouwbedrijf 1924–1931.* Basel, 1990.
Motherwell, R. *P. Mondrian: Plastic Art and Pure Plastic Art 1937 and Other Essays.* New York, 1945.
Oud, J.J.P. "The European Movement towards a New Architecture." *Studio* (London) 105 (April 1933).
————. *Hollandische Architektur.* Munich, 1926; 2d ed., 1929; Mainz, 1976.
————. "The Influence of . . . Wright on the Architecture of Europe." *Wendingen* (Amsterdam) 7 (6, 1925).
De Stijl, edited by Ad Petersen. Facsimile. 1917–1932; 2 vol. Amsterdam, 1968.
Wils, Jan. "De nieuwe bouwkunst. Bij het werk van Frank Lloyd Wright." *Levende Kunst* (Amsterdam) 1 (1918).
As editor. *De Stijl.* Nos. 1–90 (1917–1932).

Assessment

van Adrichem, Jan. "The Introduction of Modern Art in Holland: Picasso as pars pro toto, 1910–1930." *Simiolus* (Amsterdam) 21 (March 1992).
Bann, Stephen, ed. *The Tradition of Constructivism.* London, 1974.
Baroni, Danielle. "Jan Wils." *Ottagono* (Milan) 84 (1988).
Blotkamp, Carel, et al. *De Beginjaren van De Stijl.* Utrecht, 1982; *De Stijl: the Formative Years.* MIT Press, 1986.
Bock, Manfred, et al. *De Stijl 1917–1931.* Amsterdam, 1982.
Boekraad, Cees, et al. *De Stijl: Neoplasticism in Architecture.* Delft, 1983.
Bulhof, Francis, ed. *Nijhoff, van Ostaijen, De Stijl: Modernism in the Netherlands and Belgium in the First Quarter of the Twentieth Century.* The Hague, 1976.
Friedman, Mildred, ed. *De Stijl: 1917–1931, Visions of Utopia.* New York, 1982.
Herwitz, Daniel. *Making Theory/Constructing Art: On the Authority of the Avant-garde.* Chicago, 1993.
Jaffe, Hans Ludwig C. *De Stijl 1917–1931.* Amsterdam, 1956.
————. *The 'De Stijl' Group. Dutch Plastic Art.* Amsterdam, 1965.

Langmead, Donald. "The Evanescent Architect: Robert van 't Hoff." *Exedra* (Geelong) 2 (Winter 1990).
Overy, Paul. *De Stijl.* London, 1969.
Purvis, Alston. "Renewal and Upheaval: Dutch Design between the Wars." *Print* (New York) 45 (November 1991).
Troy, Nancy J. *The De Stijl Environment.* MIT Press, 1983.
Warncke, Carsten-Peter. *De Stijl, 1917–1931.* Cologne, 1991.
Zevi, Bruno. *De Stijl: The Poetics of Neoplastic Architecture.* London, 1982.

Bibliographical

Fanelli, Giovanni. *Moderne Architectuur in Nederland 1910–1940.* The Hague, 1978.
Vance: Lamia Doumato, A954, 1983; Donald Langmead, A1671, 1986; A1672, 1986; A1773, 1987.

JAMES (FRAZER) STIRLING. 1926 (Glasgow, Scotland)–1992. Stirling's family moved to Liverpool (1927) because his father, a marine engineer, was based there. After a secondary education at Quarry Bank High School (until 1941), Stirling attended the Liverpool School of Art for a year before serving as a paratrooper with the British forces in Europe (1943–1945). He studied at Liverpool University's School of Architecture (1945–1950) in the days before it became England's modernist nursery, and received his diploma with distinction in 1950. As an exchange student in the United States (1949) he briefly worked in the New York office of O'Connor and Kilham before returning to study at the School of Town Planning and Regional Research in London (1950–1952). In 1953 he became a senior assistant in the practice of Lyons, Israel and Ellis before establishing a partnership with fellow employee James Gowan* (1956–1963). He next conducted a sole practice (1963–1971) until entering a partnership with Michael Wilford (1971–1992). From 1958, Stirling was actively involved with architectural education in Britain and elsewhere, notably at the Bartlett School in London (1968–1971), the Düsseldorf Kunstakademie (1977–1992), and Yale University (1960–1984). In 1977 he became Bannister Fletcher Professor at London University. After 1969 he was honored by many countries, including Germany, Finland, the United States, Italy, Japan, and of course Britain. In 1980 he won the Gold Medal of the RIBA, and America's Pritzker Prize in 1981. He is affectionately remembered as "Big Jim" Stirling.

"The architect who best parallels Schinkel's exuberance of invention in the twentieth century is . . . James Stirling."[1] "For a while Stirling belonged to the small number of innovators of modern architecture. . . . But he was also quick to appreciate the promising approaches of other architects and to appropriate them."[2]

Stirling set up the practice with Gowan to execute a private sector low-rise housing development in Ham Common, Middlesex (1957–1995). The scheme was based on Stirling's investigation of the Jaoul houses in Paris, designed several years earlier by Le Corbusier* (whom he admired) and on the work and

philosophy of Alison and Peter Smithson.* The Ham Common project, which started a trend in England for coarsely finished but carefully detailed brick and exposed concrete, was followed by their major work: the Engineering Faculty Building (1959–1963) at Leicester University. A groundbreaking building, it is comparable with Louis I. Kahn's* Richards Medical Research Center in Philadelphia (1958–1960). The Leicester building, balancing a "Constructivist" glazed office tower contrasted with red tile facings on the massive cantilevered auditoriums, and an expansive single-story workshop roofed with long angled glass prisms unlike any postwar architecture in Britain, gained for Stirling and Gowan an international reputation as protagonists of what critic Reyner Banham dubbed the Brutalist movement.

When Stirling began to work alone, that reputation was reinforced by a number of other buildings in the same manner. Awarded first prize in a competition, what some regard as his most controversial work was the pyramidal steel-and-glass History Building at Cambridge University, of 1964–1967. Vehemently attacked on both aesthetic and utilitarian grounds by critics (Nikolaus Pevsner called it "raw" and "actively ugly"[3]), the profession, the press, and the public (incidentally, the occupants defended it), in 1985 it was threatened with demolition, but survived. The Florey Building (1966–1971) at Queen's College, Oxford, was also modeled on the Leicester experiment, although it did not achieve the same notoriety as other works. Consistently bold in their use of metal, concrete, and vast areas of glass and exploitation of prefabricated elements, these works are either eulogized or condemned for their apparent commitment to technocracy. Other buildings of the decade, such as the high-tech building for Siemens AG in Munich (1969, project) and the Olivetti Training School in Haslemere (1969–1972), which used glass-reinforced polyester panels, have been described as "quintessentially 1960s"[4]: many architects were doing very similar things.

Despite so much activity in the 1960s, Stirling's practice was becalmed after he formed a partnership with his longtime assistant Wilford in 1971. There were no commissions in England, and they had no success in European competitions, some for art museums and mainly in West Germany. One journalist described him as then being the most important unsuccessful architect in the Western world, with less than a dozen completed buildings.[5] Although he was not building, Stirling's consummate draftsmanship, seen in his elegant presentation drawings for unrealized projects in Berlin, Munich, Cologne, and Düsseldorf, revealed a shift in his aesthetic which attracted some interest in Europe.

In 1977 Stirling and Wilford secured the commission for the addition to the Wurttemburgische Staatsgalerie in Stuttgart. While one writer scathingly dismissed it as a "melange of arbitrary-seeming modern construction and randomized quotation of historical elements,"[6] the museum demonstrates that Stirling was able to synthesize comfortably those multifarious and often contradictory forms into a satisfying entity. At first slated by the German press because it was not a formal modernist design, the building (completed 1984) has become a

great public success—the most significant measure of the quality of architecture. Whereas some have seen his earlier work as influenced by De Stijl* and Le Corbusier, the Staatsgalerie evokes those sources, as well as Alvar Aalto* and Karl Friedrich Schinkel. Robert Packard writes that "Stirling had brought off a project which reinterpreted the past in a brilliant new way."[7]

The Clore Gallery (1980–1987), an extension to hold the J.M.W. Turner collection of London's Tate Gallery and part of the firm's master plan for enlarging the Tate, was Stirling's first important commission in the metropolis. About contemporary with it was the Arthur M. Sackler Museum (1979–1985) at Harvard University. Failing to win total community acceptance, the complete Sackler proposal was not built. Among later works were the Mansion House scheme in London (1988)—it won the epithet "art deco radio cabinet"—and "Jim's ship," a delightful linear bookshop for the 1989 Venice *Biennale*.

Stirling clearly converted to the more formal, history-dipping aesthetic of postmodernism in his last works. Most observers of his architecture have recognized his inconsistency of approach; some would rather call it an openness of mind. However, Tim Clarke comments that Stirling, perhaps because of his beaux-arts training at Liverpool, "always admitted to this essential wilful nature of his creative decisions, so that the historicity of his 'late work' is no more contrived than the modernity of his former work."[8] Udo Kultermann believes that through his architecture, Stirling was concerned with humanizing the environment, a process which overrode any technological, economic, or aesthetic preconceptions and ideologies. To achieve it, he needed to create harmony with common sense, tradition, the existing environment, and a concern for people. That established in his mind new criteria for evaluating architecture.[9]

Critic Robert Maxwell writes that there is a "genial quality in the outcome, a genuine concern for the user and for function as source of new form [and] a sense of exploration in the purely architectural realm, that is, in the discourse of architecture as an essential part of the expression of an epoch" and adds that it is "extraordinary to find in one firm's work such a versatility in dealing with circumstances, and such a steadfast pursuit of the purely architectural."[10] Following Stirling's death in June 1992 Wilford became the principal in the firm, which continues to practice from its London office.[11]

See Gowan.

NOTES

1. Klotz (1988), 331.
2. Maxwell (1994), 7.
3. As quoted in ibid.
4. Tim Clarke in Sharp (1991).
5. Douglas Davis, "Master of Inconsistency." *Newsweek* (New York) 97 (29 June 1981).
6. Clarke in Sharp.
7. Robert Packard in Wilkes.
8. Clarke in Sharp.

9. Kultermann in *Contemporary Architects.*

10. Maxwell (1994), 11.

11. Wilford (b. 1938 [Surbiton, England]) was educated at the Kingston Technical School and gained an Honors Diploma at London's Northern Polytechnic, London (1955–1962). He undertook postgraduate study at the Regent Street Polytechnic Planning School (1967). He was senior assistant with Stirling and Gowan and continued in Stirling's sole practice, becoming an associate (1965–1971) and a partner in James Stirling, Michael Wilford and Associates (1971). He has taught in several British architecture schools (1969 +) and been a visiting critic/professor in England, Canada, and the United States.

See Stephen Varady and Davina Jackson, [Interview] *Architecture Australia* (Sydney) 82 (March 1993); Nick Wates, "Looking to the Future." *RIBAJ* 100 (March 1993); and Barry Maitland, "Red in the bush." *AReview* 193 (June 1993).

BIBLIOGRAPHY

Writings

"Antistructure." *Zodiac* (Milan) 18 (1968).
"Conversations with Students." *Perspecta* 12 (1967).
"The Functional Tradition and Expression." *Perspecta* 6 (1960).
James Stirling. Buildings and Projects 1950–1974, edited by John Jacobus. London, 1975.
"James Stirling, Michael Wilford and Associates." *ADesign* 60 (May 1990).
"Die Neue Staatsgalerie, Stuttgart." *Domus* (June 1984).
"Regionalism and Modern Architecture." *Architects' Yearbook* (London) 8 (1957).
"Ronchamp: Le Corbusier's Chapel and the Crisis of Rationalism." *AReview* 191 (December 1992)
With Leon Krier. *Buildings and Projects of James Stirling.* London, 1975.
With Joseph Rykwert. "Collezioni manipolate." *Casabella* 48 (January 1984).

Biographical

AReview. "James Frazer Stirling 1926–1992: In Memoriam." 191 (December 1992). The whole issue.
Kultermann, Udo. In *Contemporary Architects.*

Assessment

a + u. "James Stirling, Michael Wilford and Associates." 228 (September 1989).
———. "Stirling since Stuttgart." 194 (November 1986).
ADesign. "James Stirling and Michael Wilford: Kyoto Station." 62 (January 1992).
AReview. "Democratic Monument." 176 (December 1984).
Arnell, Peter, and Ted Bickford. *James Stirling, Buildings and Projects, 1950–1980.* London, 1984; New York, 1985.
Baker, Geoffrey H. "Stirling's . . . National Gallery Extension, London." *ADesign* 57 (January 1987).
Blomeyer, Gewrald, and David Mackay. "Learning and Stirling." *AReview* 185 (March 1989)
Blundell Jones, Peter. "James Stirling e l'arena fantasma." *Spazio e Societa* (Milan) 9 (June 1986).
Buchanan, Peter. "L'Heritage de Big Jim." *Architecture Intérieure Crée* (Paris) 250 (October 1992).

Clarke, Tim. In *Illustrated Dictionary of Architects and Architecture,* edited by Dennis Sharp. London, 1991.

Clore and Tate Galleries, UK. London, 1993.

The Clore Gallery for the Turner Collection. London, 1987.

Curtis, William J. R. "Principle versus Pastiche" *AReview* 176 (August 1984).

Dal Co, Francesco. "Among Stirling's Museums: The Clore Gallery." *Lotus* 55 (1987).

———. *Padiglioni del libro della Biennale di Venezia.* Milan, 1991.

———. "Where Things Start: The Wissenschaftszentrum in Berlin." *Lotus* 58 (1988).

Davis, Douglas. "Master of Inconsistency." *Newsweek* (New York) 97 (29 June 1981).

Dennis, Michael. "Sackler Sequence." *AReview* 180 (July 1986).

Fisher, Thomas. "Projects: James Stirling . . . Wilford and Associates." *PA* 71 (December 1990).

Frampton, Kenneth. "On James Stirling: A Premature Critique." *AA Files* 26 (Autumn 1993).

GADoc. "Center for the Performing Arts [Cornell University]." 26 (1990).

Gandee, Charles, and Colin Rowe. "Sackler Museum, Harvard." *ARecord* 174 (March 1986).

Irace, Fulvio. "The Electa Book Pavilion . . . Jim's Ship." *Abitare* 301 (November 1991).

Isozaki, Arata. "Remembering Jim Stirling." *GADoc* 35 (1992).

James Stirling, Michael Wilford and Associates. New York, 1984.

James Stirling: Die Neue Staatsgalerie Stuttgart. Stuttgart, 1984.

Kelly, Brian. "In Search of a Critical Middle Ground." *Reflections* (Urbana) (Spring 1991).

Klotz, Heinrich. *The History of Postmodern Architecture.* MIT Press, 1988.

Korn, Arthur. [Gowan and Stirling]. *Architect and Building News* 215 (7 January 1959).

Loriers, Marie-Christine, et al. "Échanges Européens." *Techniques* 409 (August 1993).

Maxwell, Robert. "Braun Headquarters." *a + u* 269 (February 1993).

———. "Cinque architetture, un'idea." *Casabella* 57 (June 1993).

———. "James Stirling: Un modernismo esteso." *Casabella* 56 (December 1992).

Maxwell, Robert, and T. Muirhead. *James Stirling and Michael Wilford.* London, 1993.

———. *James Stirling, Michael Wilford and Associates. Buildings and Projects 1975– 1992.* London, 1994.

Mendini, Alessandro. "Colloquio con James Stirling." *Domus* 651 (June 1984).

Merkel, Jane. "Beyond Harvard Yard." *LandscapeA.* 77 (March 1987).

Morteo, Enrico. "L'architettura in un' epoca di transizione." *Domus* 741 (September 1992).

The Museums of James Stirling, Michael Wilford and Associates. Milan, 1990.

PA. "Stirling in Stuttgart." 65 (October 1984).

Packard, Robert. In Wilkes.

Pawley, Martin. "Building Revisits: Leicester Engineering." *AJournal* 179 (6 June 1984).

Pelissier, Alain. "James Stirling: Sa conception du musée." *Techniques* 368 (October 1986).

Scalbert, Irenee. "Cerebral Functionalism" *Archis* (Doetinchem) (May 1994).

Stirling/Wilford: Recent Works. Tokyo, 1990.

Sudjic, Deyan. *Norman Foster; Richard Rogers; James Stirling.* London, 1986.

Umo, Motumo. "On Architecture and Engineering." *Kenchiku Bunka* (Tokyo) 47 (February 1992).

Werner, Frank. "Industry as Memory: A Legacy of Stirling's Laboratory." *Lotus* 76 (1993).

Bibliographical

Vance: Robert Harmon, A606, 1981; Valerie Nurcombe, A1403, 1985.

T

KENZO TANGE. 1913 (Imabari, Japan)– . With a degree in architecture from the University of Tokyo (1938), Tange began working with Kunio Maekawa, a former employee of Antonin Raymond* and Le Corbusier.* Tange undertook graduate studies at the university (1942–1945) and in 1946 began teaching architectural design and soon obtained a professorship (1949–1974). In 1949 he won a competition for a Peace Center at Hiroshima and with that commission opened a private practice. In 1959 he received a doctorate from the University of Tokyo and a visiting professorship at the Massachusetts Institute of Technology (1959–1960). Beginning in 1961 he referred to his office as URTEC (Urbanists and Architects Team), based loosely on Walter Gropius's* team concept of office practice. Between university and practice, he was to influence a host of aspiring architects. Tange has received many national and international prizes, honors, degrees, and awards including the Order of the Yugoslavian Star, gold medals from Italy, France, the RIBA (1965), and AIA (1966), and the Pritzker Prize (1987).

⌇

In early years Tange made a specialty of winning competitions, but none were realized. He won the Hiroshima Peace Museum, and it became his first commission to be realized (1949–1956). He then won the Tokyo Town Hall competition, and it too was built (1952–1957). Both betrayed a certain delicacy typical of his early work: simple plans, repetitive steel or concrete, and glass geometric facades to simple plans, all recalling the vogue of Le Corbusier or Ludwig Mies van der Rohe.*

After Raymond, Tange was the first Japanese modernist recognized interna-

tionally, and in his architecture one can observe the course of Japanese architecture as it developed into the 1990s. His initial fame was due in part to his Peace Memorial and was enhanced by his association with Metabolism,* most of whose members were his former students at Tokyo University and worked on his plan for Tokyo (1961). Extensions to the city were to sit on stilts above the water of Tokyo Bay between Tokyo and the port of Yokohama. Its architecture was to be a coarse *béton brute* that characterized his design beginning with the Shizuoka Convention Hall (1955–1957) and onward to the 1990s. In all this concrete work there is a debt to Raymond and something of Le Corbusier, yet it is more graceful than the awkward proportions of Maekawa or Junzo Sakakura, who spent eight years in Le Corbusier's Paris office. This can be observed in Tange's Kagawa Prefectural Offices, in Takamatsu (1955–1958), and in the Imabari City Hall (1958–1959), which melds the Modern Movement's facadism with that of Le Corbusier in plan and facade. Something of the type of buildings proposed for the 1961 Tokyo plan can be gleaned from his project for the United Nation's World Health Organization headquarters for Geneva (1959).

Up to 1960 Tange made his proportions reflective of Japanese traditional architecture: rather squarish. Tradition plays a "part in creation, but it does not of itself create." Tange adds that "Only those who adopt a forward-looking attitude realize that tradition exists and is alive."[1] Echoing the Metabolists he noted that the great confrontation is "technology versus humanity, and the task of today's architects and city planners is to build a bridge between these two things."[2]

A debt to Raymond and Le Corbusier became more pronounced with the Golf Club House, in Totsuka (1960–1963), in roof and plan configurations. The most daring of this period was his Sports Arena, in Takamatsu (1962–1964), which appears as a grounded, large, double-ended concrete junk. While the plan and section make much sense, the ultimate form appears contrived. More successful of his exploration of form and structure were the swimming pool and small stadium buildings for the 18th Olympics held in Tokyo in 1964. From great masts or giant concrete beams, steel catenary wires span to edge trusses, all fitting nicely with internal functions. The buildings became symbolic of the games.

Three towers define the progress of the evolution of the building type generally and for Tange of outside influences that suggest a slackening of creative vigor. The Akasaka Hotel, in Tokyo (1972–1982), is in plan an open U with a spandrel (silver in color) and glass duo-tone curtain wall typical worldwide in the 1960s. The Overseas Union Bank, in Singapore (1980–1986), shows an element of I. M. Pei's* work in the severely flush, plain and solid facades with simple "holes" for windows in a checkerboard pattern. In plan, two triangles of differing size butted to one another with the smaller the shorter. The Tokyo City Hall (1986–1992), a commission won in competition, is essentially a pair of tall towers that have a complex curtain wall system and termini that recall

popular highrise architecture like that of Helmut Jahn. The towers' plans present many corner windows and raised mullions "to avoid monotony," Tange has said. And further he wished "an expression of high-technology" that befits twentieth-century Tokyo.[3] The same scale and technology are found in the mammoth Prince Hotel, in Otsu (1989).

The City Hall's formality and monumental scale are statements highly suggestive of the authoritarianism of samurai culture, and they are characteristic throughout his oeuvre, even in the Tokyo plan of 1961 and other community planning including that for Skopje, Yugoslavia (1965). Perhaps this naturally follows upon his formative years under an Imperial Japan. In any event, that formalism is most suitable for such projects as palaces: the Royal State Palace in Jeddah, Saudi Arabia (1977–1978), and the king's palaces for Syria and Qatar (1977). Tange has managed many commissions in the Arab region as well as in the Asian Pacific Coast.

NOTES

1. As quoted in Boyd (1962), 18.
2. In September 1959, as quoted in Boyd (1962), 15.
3. As quoted in Charles Jencks, *Architecture Today* (London, 1988), 235.

BIBLIOGRAPHY

Works by, about, or that significantly include Tange number around 1,000.

Writings

"Creating a Contemporary System of Aesthetics," and "Works." *JapanA* 65 (January 1990).
"Creation in Present Day Architecture and the Japanese Architectural Tradition." *JapanA* 31 (June 1956); reprint Boyd (1962).
"Five Errors of Architects Today." *JapanA* 53 (January 1978).
"Frei Otto at Work." *ADesign* 41 (March 1971).
Kenzo Tange 1946–1969 Architecture and Urban Design, edited by Udo Kultermann. Zurich, 1970; Barcelona, 1989.
A Plan for Tokyo, 1960. Tokyo, 1961; reprint in *Kenzo Tange 1946–1969 Architecture and Urban Design*, edited by Udo Kultermann. Zurich, 1970; Barcelona, 1989.
"Recollections." *JapanA* 60 (May 1985).
"[Tange] . . . on Residential Design." *JapanA* 117 (March 1966).
With Yasuhiro Ishimoto. *Katsura. Tradition and Creation in Japanese Architecture.* New Haven, 1960; 2d ed., 1972.
With Arata Isozaki. "Directions in Today's Architecture." *JapanA* 45 (July 1970).
With Noboru Kawazoe. *Ise—Prototype of Japanese Architecture.* MIT Press, 1962, 1965.

Biographical

Boyd, Robin. *Kenzo Tange.* New York, 1962.
Kenzo Tange 1946–1969 Architecture and Urban Design, edited by Udo Kultermann. Zurich, 1970; Barcelona, 1989.
Watanabe, Hiroshi. In *Contemporary Architects*.

Assessment

ADesign. "Japanese Architecture," edited by Botond Bognar. 58 (May–June 1988). The whole issue.

——. "Most Magnificent. Kenzo Tange's . . . Expo '70." 40 (June 1970).

Bognar, Botond. *Contemporary Japanese Architecture.* New York, ca. 1985.

——. *The New Japanese Architecture.* New York, 1990.

Burchard, John E. "New Currents in Japanese Architecture—Kenzo Tange." *ARecord* 129 (April 1961).

Hozumi, Nobuo, and Jeremy Dodd, comps. "Junzo Sakakura, Kunio Maekawa and Kenzo Tange." *ADesign* 35 (May 1965). The whole issue.

JapanA. "Grand Ecran." 9 (Summer 1993).

——. "Kenzo Tange and URTEC." 51 (August–September 1979). The whole issue.

——. "New Tokyo City Hall." 3 (Summer 1991); and 5 (Winter 1992).

——. "Special Issue: Lineage of Urban Design." 46 (September 1971).

Jodido, P. "Japon: L'empire du sud." *Connaissance* 497 (July 1993).

Kurokawa, N. "National Gymnasia and Roman Catholic Cathedral, Tokyo." *World Architecture 3.* (London) (1966).

Ross, Michael Franklin. *Beyond Metabolism: The New Japanese Architecture.* New York, 1978.

Smithson, Peter. "The Rebirth of Japanese Architecture." *ADesign* 30 (February 1961).

Stewart, David R. *Making of a Modern Japanese Architecture 1868 to the Present.* Tokyo, 1987.

Strauss, Susan. In Macmillan.

Tempel, Egon [and Norio Nishimura]. *New Japanese Architecture.* Stuttgart, 1969.

Bibliographical

Vance: James Noffsinger, A305, 1980; Anthony White, A2349, 1990.

U

JØRN UTZON. 1918 (Copenhagen, Denmark)– . Following his basic education at Alborg Cathedral School in Copenhagen, Utzon studied architecture at the Danish Royal Academy of Arts (1937–1942) under Kay Fisker and Steen Eiler Rasmussen. After receiving his diploma he worked in Stockholm as an assistant architect with Paul Hedquist and Erik Gunnar Asplund* (1942–1945) and in Helsinki with Alvar Aalto* (1946). He then traveled in Europe and North Africa (1947–1948), as well as in Mexico and the United States, where he worked briefly at both Taliesins under Frank Lloyd Wright* (1949) before returning to establish a practice in Copenhagen (1950). In 1952 he won the international competition for the Sydney Opera House and moved to Australia in 1962. Unresolvable difficulties with the New South Wales government led to his resignation in 1966. In 1972 Utzon moved to Mallorca, Spain, and continued to practice in Denmark, Switzerland, and the United States. In 1988 he formed Utzon Association with his children Jan and Kim, whose architectural practice continues. Among other honors, mostly Scandinavian, he has been awarded the Gold Medals of the Royal Australian Institute of Architects (1973) and the RIBA (1978).

❧

 "It is a measure of Jørn Utzon's creativity that he has escaped the gravitational pull of his Scandinavian heritage, taking ideas from outside (Mayan, Aztec and Japanese architecture) in pursuance of his own necessities."[1] So wrote Philip Drew in 1972. His view was later modified: Utzon "gave modern architecture a new poetic dimension that marked an influential departure from the functionalism of the 1950s while it built on the broad Scandinavian foundation

of Asplund, Jacobsen and Aalto."[2] Kenneth Frampton praises Utzon's success in a process of "assimilation and reinterpretation" that generated "vital forms of regional culture while appropriating alien influences"[3] which he achieved in the beautiful Bagsvaerd Church in Copenhagen (1976).

His practice in the 1950s was parochial and minor; he produced a few single houses including his own at Helleack (1952) and another at Holte (1953) and residential schemes including the Kingo houses near Elsinore (1956–1960) where he first experimented with the "additive architecture" he had seen in Morocco. Otherwise he built no public buildings and had no success in the architectural competitions that he entered, often with other architects. Utzon's early association with Fisker, and his experience with Asplund, steeped him in the peculiarly Scandinavian tradition of modernism—apolitical in purpose and "alien to avant-gardism . . . a sort of natural updating" of the region's twentieth-century Neoclassicism.[4] To that he added a great respect for nature, the site, and building materials gained from Asplund and Aalto, which was reinforced during his brief sojourn with Wright and can be seen in his care for craftsmanship, the use of materials, and his affection for timber and concrete, all eventually and consummately expressed in the Bagsvaerd Church. His American experiences also left him with a preoccupation with the platform—he called it "the backbone of architectural compositions"—found in pre-Columbian architecture. He employed it for his own house and the magnificently sited Sydney Opera House.

Utzon will be remembered for the Opera House. First place in the international competition (1957) was given to his rather sketchy scheme through the persistent lobbying of the Finnish-American architect Eero Saarinen*—perhaps not least because the proposal was sculptural like much of Saarinen's own work—after the rest of the jury had rejected it. The project was realized in partnership with the engineers Ove Arup and Partners and fraught with difficulties of many kinds. For mainly political reasons, conflicts after 1966 between the Conservative government client and Utzon passed the point of resolution. Attributing the disruption to "malice in blunderland," the architect resigned, leaving much of the execution of his magnum opus in the hands of others.[5] Much of the building, including the interiors, did not follow Utzon's design. Completed in 1973, the Opera House has become, through its uniqueness, grace, and beauty (and self-conscious tourist promotion), emblematic of Sydney, if not all Australia. Despite the carping criticisms of economic rationalists, the design by committee aspects of the project, and the arrogant dismissiveness of critics like Charles Jencks,[6] the building stands among the greatest monuments of modern architecture. Fellow architect Romaldo Giurgiola has called it the "most outstanding building designed in modern times."[7]

Utzon concentrated upon his Danish practice after 1967, although Australia had not demanded his exclusive attention through the decade. Further developing the Kingo/Morocco model, he had built a series of courtyard houses on a gently sloping site at Fredensborg, North Zealand (1962–1963) and the Birkehoj hous-

ing estate at Elsinore (1963), an art gallery at Silkeborg (1963), and a town center for Farum (1966). In 1969 he produced carefully thought out designs for stressed-skin system houses. Asserting that Utzon "is at his best when designing beside water" Drew cites, in addition to the Opera House, the architect's own house, Can Lis, on Mallorca, of 1971. It is suggested that impression is colored by the magnitude and the fame of the Opera House. Drew's other summation of the Dane's work is more complimentary and more apposite: "The extreme sensitivity of Utzon's response to landscape and people and his sympathy for the anonymous client [of his housing schemes] imbue his architecture with an enduring quality of human richness. . . . It is surely a human architecture full of possibilities."[8]

NOTES

1. Drew (1972), 44.
2. Drew in Sharp (1991).
3. Kenneth Frampton, *Modern Architecture: A Critical History* (London, 1992), 315.
4. Manfredo Tafuri and Francesco Dal Co, *Modern Architecture* (London, 1986), 250–51.
5. Drew (1972), 44.
6. Charles Jencks, *Modern Movements in Architecture* (New York, 1985), 66–67.
7. Giurgiola in *Contemporary Architects*.
8. Drew in Sharp (1991).

BIBLIOGRAPHY

Writings

GA 6I: Church at Bagsvaerd. Tokyo, 1981.
"La importancia de los arquitectos." *Croquis* 8 (December 1989).
"Jørn Utzon on Architecture." *Living Architecture* (Copenhagen) 8 (1989).
"Platforms and Plateaus: Ideas of a Danish Architect." *Zodiac* 10 (1962).
Sydney Opera House. Sydney, 1962.

Biographical

Giurgiola, Romaldo. In *Contemporary Architects*.
Utzon, Jan. *Three Generations*. Rungsted Kyst, 1988.

Assessment

Architects' Yearbook. "Denmark: Three Houses." 6 (1955).
ARecord. "The Sydney Opera House: What Happened and Why." 141 (May 1967).
Arkitekten. "Utzon." (Copenhagen) 95 (April 1993).
Arquitectura. "Casa en Porto Petro, Mallorca." (Madrid) 68 (July 1987).
Boyd, Robin. "Utzon: The End." *AForum* 124 (June 1966).
Drew, Philip. In *Illustrated Dictionary of Architects and Architecture,* edited by Dennis Sharp. London, 1991.
———. *Third Generation. The Changing Meaning of Architecture.* London, 1972.
Faber, Tobias. *Jørn Utzon, Opus 2: Houses in Fredensborg.* Weinheim, 1992.
———. "Jørn Utzon: The Vision of Nature." *World Architecture* (London) 15 (1991).
Giedion, Siegfried. "Jørn Utzon and the Third Generation." *Zodiac* (Milan) 14 (1965).

Frampton, Kenneth. "La corona y la ciudad." *Arquitectura* (Madrid) 68 (July 1987).
Helmer-Peterson, Keld. "Jørn Utzon: A New Personality." *Zodiac* (Milan) 5 (1959).
Lampugnani, Vittorio M. *Visionary Architecture of the Twentieth Century.* Stuttgart, 1982.
Meyers, Peter. "Une histoire inachevée." *Aujourd'hui* 285 (February 1993).
Moller, Henrik Sten. " 'Can Lis' Jørn Utzon's Own House." *Living Architecture* (London) 8 (1989).
———. "The Light of Heaven." *Living Architecture* (London) 1 (1983).
Norberg-Schulz, Christian. "Church at Bagsvaerd . . . Denmark." *GlobalA* (Tokyo) 61 (1981).
———. "The House That Utzon Built." *World Architecture* (London) 15 (1991).
———. "Sydney Opera House." *GlobalA* (Tokyo) 54 (1980).
Rice, Peter. *An Engineer Imagines.* London, 1994.
Sharp, Dennis. "The Ubiquitous Monument." *World Architecture* (London) 15 (1991).
Thurell, Soren. "P.S. Jørn Utzon: Utzon pa nytt." *Arkitektur* (Stockholm) 90 (May 1990).
Werk. "Atriumhauser bei Helsingor, Danemark." 48 (February 1961).
Wilson, Forrest. "The Sydney Opera House: A Survivor." *AIAJ* 78 (September 1989).
World Architecture. "The Next Generation." (London) 15 (1991).
Zunz, Jack. "Sydney Revisited." *Arup Journal* (London) 23 (Spring 1988).

Bibliographical

Vance: Lamia Doumato, A1243, 1985; Anthony White, A800, 1982.

V

ROBERT (CHARLES) VENTURI. 1925 (Philadelphia, Pennsylvania)– . After studying architecture at Princeton University, New Jersey, and receiving a B.A. (1947) and a master of fine arts degree (1950), Venturi worked successively for Oscar Stonorov, Eero Saarinen,* and Louis I. Kahn* (1950–1958) with an important byway as a fellow at the American Academy in Rome (1954–1956). He was a partner with Paul Copper and H. Mather Lippincott (1958–1961) and with William Short (1961–1964), both in Philadelphia. A lasting partnership was formed with John Rauch in 1964. In 1967 he married Denise Scott Brown* who became a partner of the Venturi/Rauch firm. Since 1990 Venturi Scott Brown and Associates have carried on. Venturi taught at the University of Pennsylvania (1957–1965) and at Yale University (1966–1970), and was a State Department lecturer in the Soviet Union (1965) and architect in residence at the American Academy in Rome (1966). He since has been a visiting critic at a number of American universities. The partnership's work has been often exhibited since 1965. Venturi has received national and international honors and awards, including the Pritzker Prize (1991).

❧

Venturi:

I speak of a complex and contradictory architecture based on the richness and ambiguity of modern experience. . . . I am for richness of meaning rather than clarity of meaning; for the implicit function as well as the explicit function. I prefer 'both-and' to 'either-or'. . . . A valid architecture evokes many levels of meaning and combinations of focus: its space and its elements become readable and workable in several ways at once.

A valid architecture in "its truth must be in its totality or its implications of totality. It must embody the difficult unity of inclusion rather than the easy unity of exclusion. More is not less."[1] Less is a bore?

Historian Vincent Scully hailed Venturi's book *Complexity and Contradiction in Architecture* (1966) as the most important book on architecture since Le Corbusier's* *Vers une Architecture*. This may be true in Europe, but Le Corbusier's 1923 book had zero impact on American architecture. Venturi's polemics, however, and early buildings have been most important on the evolution of modernism, particularly in Japan and Europe. The polemicist von Moos has said that "At a time of growing discontent with some of the assets of orthodox modern" Venturi's works "helped to redefine the territory of architecture by emphasizing issues such as history, language, form, symbolism, and the dialectics of high and popular art."[2]

During the 1960s and with experiences of Italian historical Mannerism, Venturi became disturbed by the direction modernism was taking toward formally presented, high-tech monumentalism and with the withdrawal of architecture from public participation. With this concern he never spoke directly to Kahn's architecture, but in the early 1960s he evidenced worries more generally.[3] His rather academic political lean to the left vibrantly mixes with Scott Brown's hybridized political and sociological interests. The artistic result is in contrast to current practice and has been correctly identified by Philip Johnson* as "marking the 'watershed' that separates the modernist past from the 'absolutely delightful' postmodernist future."[4]

"Our Brighton Beach Housing" (Brooklyn, New York), Venturi has said, and their Fire Station in Columbus, Indiana, "turned out 'ugly and ordinary,' as two such divergent critics as Philip Johnson and Gordon Bunshaft[*] have described our work. 'Ugly' or 'beautiful' is perhaps a question of semantics in this context, but these two architects did catch the spirit, in a way."[5] The dedication of Venturi and Rauch to the "ordinary" and their "identification with pop culture challenges the view of architecture as the prerogative of a cultured elite."[6] But the fact is that Scott Brown, Venturi, and Rauch appropriated common or vernacular art and visual expression and attempted to *institute* them within the realm of elitist or "high design." It can be argued that if successful, vernacular would be greatly diminished.

Rather distinct from early, small-scaled commissions, their architecture of the 1980s and 1990s for institutions, such as government, schools, and universities, has more of orthodoxy and tradition within it (except for rather tortured plans and subdued yet lively colors) than their signboard designs for street-side. This is evidenced at Wu Hall, Butler College, at Princeton University (1983–1985); the new city building with wonderful interiors for the Seattle Art Museum (1987–1991); and the inelegant and indelicate Sainsbury Wing, National Gallery of Art, in London (1991).

Romaldo Giurgola, a teaching colleague and close friend, has described Venturi's contribution as opening "a window on the contradictory and yet extraor-

dinary landscape of built America.'' His architecture remains ''bound'' to
functionalist ''tenets'' while giving importance of the site, to the ''juxtaposition
of textures and materials,'' without relying on mere aesthetics.[7] Perhaps. Their
work is often blatantly pictorial and not without humor or caprice. The Western
Plaza, on Pennsylvania Avenue, in Washington, D.C., is paved as the street plan
of that part of Washington with a miniature model of the capitol building as it
was in the nineteenth century.

NOTES

John Rauch—the Rock—served in the U.S. Army (1951–1953) during the Korean
War after studying at Wesleyan University, Connecticut (1951). He then obtained an
architecture degree from the University of Pennsylvania (1957) where Romaldo Giurgola
and Louis Kahn were teaching design. He taught at the University of Pennsylvania
(1967–1969) and served on various local and national AIA committees.

1. ''A Gentle Manifesto'' in Venturi (1966), 22.
2. von Moos in Macmillan.
3. D. L. Johnson's recollections of studio critiques.
4. In *Time,* 8 January 1979.
5. Venturi, Scott Brown, and Izenour (1972), 84–85.
6. Drew (1972), 156.
7. Giurgola in *Contemporary Architects.*

BIBLIOGRAPHY

Writings

''Architecture as Elemental Shelter.'' *ADesign* 61 (November 1991).
Complexity and Contradiction in Architecture. New York, 1966; Tokyo, 1969; Paris,
 1971; Barcelona, 1972. Previewed in *Perspecta* 9/10 (1965). 2d ed. with Denise
 Scott Brown, New York, 1977.
''A Definition of Architecture as Shelter with Decoration on It.'' *a+u* (January 1978).
''Diversity, Relevance and Representation.'' *ARecord* 170 (June 1982).
''Interview: Robert Venturi and Denise Scott Brown.'' *Harvard Architecture Review* 1
 (Spring 1980).
''Sweet and Sour.'' *AIAJ* 83 (May 1994).
Transition. ''Interview: Steven Izenour.'' 3 (April 1984).
With Steven Izenour. ''Learning from Atlantic City.'' *AIAJ* 71 (November 1982).
With John Rauch and Denise Scott Brown. ''A Study for Washington Avenue . . . Flor-
 ida/1978.'' In ''American Architecture: After Modernism,'' edited by Robert A.
 M. Stern. *a+u* Extra edition (March 1981).
With Denise Scott Brown. ''Salk Additions . . . Anshen & Allen.'' *AIAJ* 84 (July 1993).
———. ''Salk Additions: Pro and Con.'' *PA* 82 (July 1993).
———. ''Some Houses of Ill-Repute.'' *Perspecta* 13/14 (1971).
———. *A View from The Campidoglio . . . 1953–1984.* New York, 1985.
With Denise Scott Brown and Steven Izenour. *Learning from Las Vegas.* MIT Press,
 1972; 2d ed., 1977.

Biographical

Giurgola, Romaldo. In *Contemporary Architects.*

Larsen, Jonathan Z. "Portrait. Robert Venturi and Denise Scott Brown." *Life* (New York) 7 (November 1984).

Scott Brown, Denise. "Between Three Stools." *ADesign* 60 (January 1990).

Assessment

Abitare. "Learning from Philadelphia." 312 (November 1992).

Arcidi, P. "Mending a Difficult Whole." *PA* 72 (May 1991).

ARecord. "Interiors. Knoll Center." 167 (March 1980).

———. "Two of a Kind." 179 (May 1991).

Aujourd'hui. "Project de mosquée nationale à Bagdad." 228 (September 1983).

Bierman, M. "Arcadian Acropolis." *AIAJ* 83 (February 1994).

Canty, Donald. "New VSBA Museum Opens in Seattle." *PA* 73 (February 1992).

Chimacoff, Alan, and Alan Plattus. "Learning from Venturi." *ARecord* 171 (September 1983).

Cohen, Stuart. "Physical Context/Cultural Context. Including It All." *Oppositions* 2 (1974).

Cook, John W., and Heinrich Klotz. *Conversations with Architects.* New York, 1973.

Diamonstein, Barbaralee, ed. *American Architecture Now II.* New York, 1985.

Drew, Philip. *Third Generation. The Changing Meaning of Architecture.* New York, 1972.

Dunster, David. *Venturi and Rauch.* London, 1978.

Fitch, James Marsten. "Single Point Perspective." *AForum* 140 (March 1974).

Goldberger, Paul, and Yukio Futagawa. *Venturi and Rauch.* Tokyo, 1976.

Irace, F. "London: Sainsbury Wing." *Abitare* 300 (October 1991).

Lindeer, M. "Contingency . . . Sainsbury Wing." *a+u* 260 (May 1991).

Lotus. "This New Building." 58 (1988).

Mead, Christopher. *The Architecture of Rauch & Venturi.* Albuquerque, 1989.

von Moos, Stanislaus. In Macmillan.

———. *Venturi, Rauch and Scott Brown. Buildings and Projects.* Fribourg, 1987.

Nakamura. T. "Robert Venturi and Denise Scott Brown." *JapanA* 65 (May 1990).

Sanmartin, A., ed. *Venturi, Rauch & Scott Brown. Works and Projects.* Barcelona, 1986.

Schulze, Franz. "Chaos in Architecture." *Art in America* (New York) 58 (July 1970).

Scott Brown. Denise. "Worm's Eye View of Recent Architectural History." *ARecord* 172 (February 1984).

Stein, Karen D. "Animal House." *ARecord* 175 (February 1987).

Swenarton, Mark. "Venturi in Princeton." *Building Design* (London) (2 December 1983).

Vogel, C. "Celebrating American Design." NYTM (15 September 1985).

Bibliographical

Vance: Lamia Doumato, A25, 1978, [Robert] Venturi, [John] Rauch & [Denise] Scott Brown, A840, 1982; Dale Casper, A2036, 1988.

VESNIN BROTHERS (LEONID, VIKTOR, and ALEXANDR). *Leonid Aleksandrovich Vesnin.* 1880 (Yur'evets, Russia)–1933. Leonid studied architecture at the Academy of Fine Arts in Saint Petersburg (1901–1909). Rather more

academic than his brothers, he may have played a major design role for the neo-Romanesque Myasnitskaya Post Office (1911) and the neoclassical villa for D. V. Sirotkin, now the Gorky Museum. Leonid became a professor of architectural design at the Moscow Higher Technical College and in 1922 was elected joint president of the Moscow Association of Architects. He received awards and the Order of the Red Banner.

Viktor Aleksandrovich Vesnin. 1882 (Yur'evets, Russia)–1950. In 1912 Viktor graduated in architecture from the Institute of Civil Engineering in Saint Petersburg. When formed in 1920, Viktor began teaching at the Higher Artistic and Technical Studios (VKhUTEMAS) in Moscow until it closed in 1930. He became deputy head of the Higher Technical College and remained an academic. His early career was maintained by a few industrial building commissions, mainly chemical plants, and in the 1920s he secured government projects. Viktor received a number of awards including the Order of Lenin and the RIBA Gold Medal (1945).

Aleksandr Aleksandrovich Vesnin. 1883 (Yur'evets, Russia)–1959. After painting studies, Aleksandr attended the Saint Petersburg Institute of Civil Engineering and graduated in architecture (1912). He worked with sculptor Vladimir Tatlin and then traveled to Italy, perhaps to contact the Futurists, and with all this became radicalized and played a seminal role in promulgating Constructivism. In Moscow he taught at the VKhUTEMAS and became founding president of the Constructivist Association of Contemporary Architects (OSA) (1925–1930), which maintained close contact with the Bauhaus and Le Corbusier.* Aleksandr was editor, with Moisei Ginsburg, of its journal *Sovremenia Architektur* (Contemporary architecture) (1925–1929) which included work and articles about Frank Lloyd Wright,* De Stijl,* and Le Corbusier. With Viktor he founded the October Group (All-State Workers' Association in New Fields of Fine Art) in 1928 hoping to reinvigorate the arts. Aleksandr's set designs included a few for the inventive dramatist Vsevelod Meyerhold. All were mainly angular, open structures dramatically filling the stage.

Upon each finishing their architectural education the brothers maintained a loose but dedicated professional association in Moscow. Their designs before the 1917 revolution were in debt to the historical eclecticism of the day; after, the brothers were committed to Constructivist radicalism influenced by Cubo-Futurism (a modest but unique Russian experiment from 1911 to 1919 prompted by the French and Italian avant-garde), the "Realistic Manifest" of artist brothers Gabo and Pevsner in 1920, De Stijl, and Tatlin.

☙

One of the first projects to extend Constructivism was a notional proposition by Alexandr and Lubov Popova for a mass festival setting called "Struggle and Victory of the Soviets" (1920). Between two distant and immense constructions (owing a debt to Tatlin's angular products), dirigibles were to be stationary above the ground, held by diagonal wires between which stretched banners with

slogans. The agitprop scheme has an obvious affinity with the "Instant City" project (1969) by Archigram.*

The *Leningrad Pravda* newspaper building (1924), by Aleksandr and Viktor, has been described by Kenneth Frampton as the "canonical project of Russian Constructivist architecture . . . which emphasized the extra-tectonic elements of its form such as the elevators, the loud speaker, the searchlight, the digital clock, and so on"[1] (see Plate 14). It drew some of its architectonics from the two-dimensional designs and paintings of the previous four years by Aleksandr and other artists. With a love of Henry Ford's pragmatism and industrial genius and of American architecture as enabled by technical expertise, Soviet architects developed an expressionism of technology expertly revealed in this theoretical project.[2] The designs and politics of Constructivism greatly influenced the Bauhaus in the mid-1920s and that connection was a major reason for instability and the final demise of the German school.

In a proposed Lenin Library for Moscow (1927–1928), there is a discernible mellowing with characteristics of the Dutch architect Willem Marinus Dudok* in the plainer treatment of facades, and of Le Corbusier in massing and structure (and in drawing). Yet Vesnin manners are retained especially in window treatment. Gone is the brusque hard edge and expressive definition of structure and form so typical of De Stijl. This softening carried on in such projects as the state theater project for Kharkov (1931). In plan, it drew inspiration from Aleksandr and Leonid's complex for the rather famous Palace of Work project (1922–1923), a design that influenced Walter Gropius's* "Total Theatre" (1927). A mellowing is also noted in the power station project at the Dneiper dam, a design that won in competition (1927–1932, with N. Koli, G. Orlov, S. Andriyevsky, and V. Corchinsky).

There is an almost capricious exuberance in the early work of the Vesnins. Beginning around 1929, and like Soviet architecture in general, their designs began to appear repetitively staid. By the 1930s the brilliance of the 1920s was gone not to revive in type until the 1980s—outside Russia—with Deconstructivism: if not the political, the artistic and motivational parallels are striking. Some current architects, like Arquitectonica, readily admit a fondness for Russian/Soviet Constructivism.

The brothers were at the very front of radicalism, steadfastly professional, noble in compromise under Stalinist repression that began earnestly in 1932. Aleksandr and Viktor "attempted a difficult path between classical eclecticism [as demanded by Stalin] and some form of modernism."[3] Aleksandr severely restricted his architectural activity, continued to teach, and finally returned to painting in the 1940s. Other modernist Soviet architects were more prolific in publishing or offering building *projects,* but through architectural productivity and ideas none had such a significant practical influence internally and externally as the Vesnins. In 1928 and 1930, *L'Architecture Vivante* (Paris) devoted whole issues to the Soviet Union, the most complete coverage until the 1980s. In these the Vesnins were prominent. There are good architectural reasons why Viktor

received the RIBA's Gold Medal. Another may have been to further stabilize relations among Allied nations during the 1939–45 European War.

NOTES

1. Frampton in Macmillan. See also Kenneth Frampton, *Modern Architecture,* 2d ed. (London, 1985), chapter 19.
2. Johnson (1990), 131–39; and Anatole Senkevitch, Jr., in Andrews and Kalinovska (1991), 185–86.
3. Johnson (1990), 389; see also chapter 17. Cf. Andrews and Kalinovska (1991), 269.

BIBLIOGRAPHY

Writings

Ginzburg, Moisei, with Viktor Aleksandr Vesnin. "Tvorcheskaia Tribuna." (Creative tribune). *Arkhitektura SSR* 2 (1934).
Vesnin, Aleksandr. "Credo." In Andrews and Kalinovska (1991).
Vesnin, Viktor. "Anglo-Soviet Bonds in Architecture." *RIBAJ* 49 (August 1942).
———. "Letter from. . . ." *RIBAJ* 52 (July 1945).
———. "Letter from Russia." *AForum* 81 (September 1944).
———. "Working out Style Worthy of Socialist Epoch." *Moscow Daily News,* 16 June 1937.

Biographical

Barkhin, Mikhail Grigor'evich. *Mastera Sovetskoi arkhitektury ob arkhitecture.* Vol. 2. Moscow, 1975.
Chinyakov, Aleksei G. "Brat'ya Vesniny." *Arkhitektura SSR* 3 (1967). Digested as "The Brothers Vesnin" in Shvidkovsky (1971).
———. *Brat'ia Vesniny.* Moscow, 1970.
Il'in, Mikhail A. *Vesniny.* Moscow, 1960.
Khan-Magomedov, Selim O. *Alexander Vesnin and Russian Constructivism.* New York, 1986.

Assessment

ADesign. "The Avant Garde." 61 (September–October 1991). The whole issue.
AReview. "Socialist Realism." 95 (January 1944).
———. R. Byron, and Berthold Lubetkin, eds. "Russian Architecture." 95 (May 1932).
Andrews, Richard, and Milena Kalinovska, eds. *Art into Life. Russian Constructivism 1914–1932.* Seattle, 1991.
Badovici, Jean. "Le moment architecture en URSS." *AVivante* Part 2 (1930).
Cohen, J. L. "Architecture . . . Soviet Union 1900–1937—Part 1." *a+u* 246 (March 1991); *Part 2,* 246 (June 1991); *Part 3,* 251 (August 1991); *Part 4,* 353 (October 1991).
———. "Avant Garde . . . Drawings." *Print Collectors Newsletter* 22 (May 1991).
Cook, Catherine. "The Lessons of the Russian Avant-garde." *ADesign* 58 (March–April 1989).
Barron, Stephanie, and Maurice Tuchman, eds. *The Avant Garde in Russia 1910–1930. New Perspectives.* Los Angeles, 1980.
Brumfield, William Craft. *A History of Russian Architecture.* Cambridge, England, 1993.
Chinyakov, Aleksei G. "Le Korbuz'e i Vesniny." *Sovietskaia arkhitektura* 18 (1969).

Frampton, Kenneth. In Macmillan.

Gabo, Naum, and Noton Pevsner. "Realistic Manifesto." Reprinted in Andrews and Kalinovska (1991).

Gray, Camilla. *The Great Experiment. Russian Art 1863–1922.* London, 1962; reissued as *The Russian Experiment in Art 1863–1922.* New York/London, 1971.

Huijts, Johan. "On Socialist Realism in Architecture." *ADesign* 29 (January 1959).

Johnson, Donald Leslie. *Frank Lloyd Wright versus America. The 1930s.* MIT Press, 1990.

Jung, Karen C., and Dietrich Worbs. "Die Brüder Vesnin." *Werk* 72 (April 1985).

Khan-Mahmedov, Selim O. "Creative Trends, 1917–1932 in Russia." *ADesign* 1 (February 1970).

Kopp, Anatole. "Alexandre Vesnine." *Aujourd'hui* 235 (October 1984).

———. *Constructivist Architecture in the USSR.* London, 1985.

———. *Town and Revolution. Soviet Architecture . . . 1917–1935.* New York, 1970.

RIBAJ. "Recipient of . . ." 52 (December 1944); and 53 (August 1946).

Shvidkovsky, O. A., ed. *Building in the USSR 1917–1932.* London/NY, 1971; edited reprint of "Constructivist Architecture in the USSR." *ADesign* Special no. (February 1970).

Voyce, Arthur. *Russian Architecture.* New York, 1948.

Willett, John. *The New Sobriety 1917–1933. Art and Politics in the Weimar Period.* London, 1978.

Wolin, Judy. "Multi Media Machine Building." *Perspecta* 13–14 (1971).

Bibliographical

Senkevitch, Anatole, Jr. *Soviet Architecture 1917–1962. A Bibliographical Guide.* Charlottesville, 1974.

W

FRANK LLOYD WRIGHT. 1867 (Richland Center, Wisconsin)–1959. Early schooling in Wisconsin and Massachusetts and several drafting jobs were followed by two terms at the University of Wisconsin, Madison. Wright apprenticed to Chicago architect Joseph Lyman Silsbee and then in the firm of Dankmar Adler and Louis Sullivan; he was otherwise self-taught (1886–1893). He established a private practice in Chicago/Oak Park (1893–1911) and Madison (1911–1959) and operated temporary offices in Tokyo (1916–1922) and Los Angeles (1919–1924). He had a brief partnership with Webster Tomlinson (1901–1902), acted in association with but a few other architects, and opened a second office called Taliesin West outside Scottsdale, Arizona (1937–1959). In 1932 he formed an apprenticeship program he called the Taliesin Fellowship. Wright's practice is carried on by followers. Two of his sons became capable architects: John Lloyd Wright and Frank Lloyd Wright, Jr. Wright received national and international honorary degrees, awards, and honors, including Gold Medals from the RIBA (1941) and, belatedly, the AIA (1949).

Wright in 1928:

Not only do I intend to be the greatest architect who has yet lived, but the greatest who will ever live. Yes, . . . and I do hereunto affix 'the red square' and sign my name to this warning.[1]

Wright's architecture leading to the German publications of his work in 1910–1911 was influenced by the people for whom he worked before 1893, to the implications of British arts and crafts as a movement in America, to historicism

in the Americas and Europe, to the theoretical utterances of the Frenchman E. E. Viollet-le-Duc, and to all else about him. Prior to 1898 his architecture of varied bold forms and ornament was wrought from a variety of rather mimetic plans. The one exception is the Winslow stables in River Forest, Illinois (ca. 1895), a plain building but strongly horizontal in form and detailing. When he reused the horizontal theme (with a shallow gabled roof) in the River Forest, Illinois, Golf Club building (1898), the external character of the well-known and highly influential prairie houses was established. That aesthetic in turn was applied to house plans derived from his schooling with Silsbee. The plans were informal, as with the Darwin Martin house (1902), or quite formal, as with the Barton house of the same year and same building site (see Plate 1). The Wright style was soon emulated and adapted to become the Wright School.

At this same moment he realized that nondomestic architecture required a different aesthetic. For this, he took the idea of "Cubic Purism," then just being promoted, and applied it first to the Larkin Administration building, in Buffalo, New York (1903–1906), shown in Plate 2, then to Unity Temple, in Oak Park, Illinois (1904–1906). From these initial designs around the turn of the century, the character of his buildings remained consistent until the late 1920s.

The most prescient buildings of this period were the Larkin Building, whose plan and exterior character were so influential on Europeans, the Gale house (1909), whose exterior forms and massing not only influenced Europeans but also his own design of Fallingwater (1935), and the plan for his own home he called Taliesin (1911), which became the foundation of all future house plans.

It is true that on returning from Europe in 1910, where he escaped with his mistress Mamah Borthwick and saw to the publication of the Berlin monographs, his architecture took a more cubic appearance with subtle hints of Italian ornament. But Wright proceeded with his own geometric rationale of almost exaggerated articulation (as in the plan of the Martin house or the Larkin Building), a fluidity and openness of space, and of plain form. The best examples are the Midway Gardens, Chicago (1913–1914), shown in Plate 5, and his houses in Southern California from 1922 to 1924.

It was in the late 1910s that Wright became interested in exploring the forms of American Indian architecture. He apparently sensed that his quest for an American architecture not derived from European precedents might be gained, over and above his own earlier work, from a study of the elegantly plain *adobe* buildings of the Southwest Indians. And to further that exploration, inspired by—if not copying—a concrete block system (called "Knitlock") devised by Walter Burley Griffin* and Marion Mahony Griffin,* Wright designed his own adobe masonry of concrete blocks (called "Textile"). Their inherent geometry fit the rectilinearity of the Southwest, and he exploited that character in those California houses all located in and around Los Angeles: Barnsdall (1919–1923), Freeman (1922–1923), and Ennis (1923–1925) are examples; the Ennis house bears the articulation of basic cubic elements as found in the Martin house (1902).

To some extent his experiences in Japan (1916–1922) may have condensed his thoughts about indigenous architecture. He would have had time to experience the cultural intimacy of all aspects of traditional Japanese design and would have seen that his own architectural design for the Imperial Hotel (1916–1923), although masterful, failed to respond to Japanese traditional sensibility. Returning now and then to the United States and being attracted to Los Angeles by the Barnsdall commission gave him an opportunity to experiment. But it was a fleeting moment in a long and singular career.

The period of the 1920s has been described with some accuracy as Wright's wilderness years because of his personal difficulties with a second marriage that failed, a new mistress, a struggle to obtain commissions, and the general disappointment—in his own mind—of the sojourn in Japan: all combined to discourage clients and depress creative activity.

In the late 1920s Wright was in the process of preparing a book on a theory of architecture to—of course—focus on his work, tentatively entitled "In the Nature of Materials." In 1927 and 1928 *Architectural Record* published a number of his essays as a series about some aspects of the anticipated theoretical treatise; most were devoted to the use of building materials. They became just a part of his polemics against the neutered box of European modernism. Materials properly applied and detailed were one salvation from what Wright perceived as Europe's new hegemony and formalism: "Inevitable implication! This new machine age resource requires that all buildings do *not* resemble each other."[2] Although not realized in book form, the arguments appeared in lectures as published, in his 1932 *An Autobiography* and other publications. In the 1930s, each of Wright's buildings was expressed as *inherently* different.

The second flowering of Frank Lloyd Wright's extraordinary career began in 1928 at the age of sixty-one, when he married his young mistress Olga Lazovich. Together they planned a future that, if it was to be successful, required the recreation of Wright the active man supported by the semimythical legend. With only a few architectural commissions since the early 1920s, Wright's image had to be reconstructed and revitalized. The fabled life of his first golden age to 1913 had to be reevaluated and the nightmare of the recent past put behind. All was exposed in an autobiography.

Wright's second life was anticipated in a number of ways but primarily by the formation of an institute, so to speak, for young people. As finally settled, it owed much to the thoughts of the Dutch architect Henrik Wijdeveld. Here the Wrights practiced their notions of *paideia,* work and thought united in a community of apprentices they called the Taliesin Fellows. The Wrights had developed a holism that revolved about their idea of an organic life marked by its architecture. They vigorously promoted both the idea and the fact that their daily lives, in concert with the lives of the Fellows, were devoted to its practice. Their concerns were not just for buildings in cities, but for new Broadacre villages; not just villages but organically complete personal lives; and most important, a healthier, refurbished, and philosophically unified America.

The means to these ends were focused on Wright's talent and life as paradigms incorporating an interpretation of the great American dream of individual liberty. The Wrights therefore argued against the doctrines that supported European hegemony, against traditional prejudice, and against the political left.

As lord and lady they broadcast their ideas from a manor, a modern castle moated by grain fields and psychological privacy. The word also went forth from lecture platforms (a few lectures were published), in exhibitions, and on to pages of magazines and books. The Europeans, the English, and the Soviets were impressed and intrigued, but fellow Americans soon became confused. In emphasizing his philosophy Wright's rhetoric seemed to damn everything American—history, cities, home, and nearly all else. Wright could not be ignored.

Desperate for work for many years he finally acquired two major architectural commissions. For them he composed two seemingly opposite concepts of architecture for dissimilar sites. When the buildings were complete the world again took note. The first commission became one of the most beautiful houses of any century, the Kaufmann country home, known as Fallingwater, on Bear Run Creek in Pennsylvania (1935–1937) (see Plate 18). The second was the Johnson's Wax Administration Building in Racine, Wisconsin (1937–1939). Both were theoretically clear, not a part of his earlier design mannerisms, although the Racine building owed much to his radical *Capitol Journal* project of 1932. Wright's second solitary castle, called Taliesin West (1937+), low in profile, abstract in plan, built of in situ stone on a pediment overlooking the Arizona desert, was a place in the West: the frontier. Wright's new summer lasted from the late 1930s until his death in 1959.

Slowly commissions were obtained, mainly for houses. His response was a series of finely wrought homes of lasting significance: open plans, sensitive use of materials, sometimes complex massing and form. They were designed for Hanna, Jacobs, Pope, Rosenbaum, Pew, Goetsch and Winckler, Pauson, and others.[3] And then came a campus plan for Florida Southern College (1938+) with a few related buildings of questionable virtue, a housing project, and more.

Elsewhere in the world the 1930s was a period of turmoil in the Soviet Union and rising political tensions and threats of physical conflict in Europe. The Wrights became involved in those social fractures only parenthetically and with no meaningful satisfaction. Because of his revival, during the tension-filled months of 1938 he was invited to Moscow. Before Britain's entry into the 1939–45 war he was persuaded by the prestigious Sulgrave Manor Board to give a series of lectures in London, published as *An Organic Architecture*. Almost immediately thereafter the RIBA presented him with their Gold Medal. With the war, commissions dropped off dramatically, and none came as a result of the American government's war effort, mainly because of his outspoken antiwar sentiments.[4]

Expression of inherent dissimilarities of a building continued, if with less philosophic rigor but more geometric experimentation. In 1949 he was commissioned to design a Guggenheim Art Museum (completed 1961) of plainly

finished cylindrical and rectilinear shapes. Indeed the circle was found in many of his designs of the 1950s, like that for Marilyn Monroe and Arthur Miller (project 1957) or the Marin County Civic Center, California (1957–1962) where a rational structure was hidden by fake arches. The 1950s was Wright's most productive decade, his most idiosyncratic, and the least influential. His mainstay was houses and, as wildly different as they appear externally, their plans were based on his own 1911 house as later developed in the early 1930s. There were houses of triangles, circles, squares, rectangles; of concrete, concrete block, plaster, masonry—all as mixed as were the nondomestic buildings.

Perhaps the epitome of his wayward exploration of mere aesthetics and rejection of rational planning, previously so important to theoretical sustenance, was the Gammage Memorial Auditorium at Arizona State University, in Tempe (1959+), where in a riot of curvilinear lines and form there was—among other follies—draped concrete as exterior curtains. One of the more distinguished of the post-1945 designs was the Annunciation Greek Orthodox Church, in the Wauwatosa section of Milwaukee, Wisconsin (1955–1961), a wonderful array of curvilinear form and line in concrete and stucco dominated by a shallow blue dome. Another, in quite an opposite manner, was the modest Brandes house in Issaquah, Washington (1952), of plain concrete blocks, wood, and glass.

See also the introduction, ''Whither We Went.''

NOTES

1. Frank Lloyd Wright (1928), as quoted in Johnson (1990), xiii.
2. Wright (Autobiography, 1932), 357.
3. Cf Sergeant (1976).
4. The outline of events in the 1930s is based on Johnson (1990).

BIBLIOGRAPHY

Publications by, about, and that significantly include Wright number about 5,000 and continue to proliferate. The abbreviation FLW is used below.

Writings

An American Architecture, edited by Edgar Kaufmann, Jr. New York, 1955; London, 1956.

''Architecture and Life in the U.S.S.R.'' *Soviet Russia Today* (Washington, D.C.) 6 (October 1937).

Architecture and Modern Life, with Baker Brownell. New York, 1937.

Ausgeführte Bauten. See Ashbee (1911).

An Autobiography. New York, 1932; 2d ed. New York, 1943; reprint, New York, 1991; Toronto/London, 1945; Milan, 1955; Paris, 1955; 3d ed., New York, 1977. See also Linn Cowles. *An Index and Guide to An Autobiography the 1943 Edition.* Hopkins, Minnesota, 1976.

''Broadacre City. A New Community Plan.'' *ARecord* 77 (April 1935).

The Disappearing City. New York, 1932; 2d ed., *When Democracy Builds.* New York, 1945, and Berlin, 1950; 3d ed., *The Industrial Revolution Runs Away.* New York,

1969. 4th ed., *The Living City*. New York, 1958, 1963, 1970; Buenos Aires, 1961; Turin, Italy, 1966; Tokyo, 1968.

"FLW." *AForum* 68 (January 1938), the whole issue; and 88 (January 1948), the whole issue.

Genius and the Mobocracy. New York, 1949; New York, 1971; London, 1972.

In the Cause of Architecture. Essays by FLW for ARecord 1908–1952, with others. New York, 1975.

The Japanese Print. An Interpretation. Chicago, 1912; reprint in *The Japanese Print*. New York, 1967.

Modern Architecture. Being the Kahn Lectures for 1930. Princeton/Oxford, 1931; Milan, 1945; Reprint, Champaigne, 1987.

An Organic Architecture. London, 1939; Milan, 1945; reprint, MIT Press, 1970.

Studies and Executed Buildings by FLW. 2 vol. folio. Chicago, 1910; reprint, Chicago, 1975; reprint in part as *Buildings, Plans and Designs*. New York, 1963; reprint as *Drawings and Plans . . . The Early Period (1893–1909)*. New York, 1983; German edition as *Ausgeführte Bauten und Entwürfe von FLW* (aka the Wasmuth portfolios). 2 vol. folio. Berlin, 1910.

Biographical

Barney, Maginel Wright. *The Valley of the God-Almighty Joneses*. New York, 1965.

Brooks, H. Allen. In *Contemporary Architects*.

Gill, Brendan. *Many Masks*. New York, 1987.

Henning, Randolph C. *"At Taliesin"* . . . *1934–1937*. Carbondale, 1992.

Johnson, Donald Leslie. "Notes on Frank Lloyd Wright's Paternal Family." *FLW Newsletter* (Chicago) 3 (February 1980).

Meehan, Patrick J., ed. *FLW Remembered*. Washington, D.C., 1991.

Secrest, Meryle. *FLW*. New York, 1992; reissued as *FLW: A Biography*. New York, 1993.

Tafel, Edgar. *About Wright*. New York, 1993.

———. *Apprentice to Genius. Years with FLW*. New York, 1979; reprint, New York, 1985.

Twombly, Robert C. *FLW. An Interpretive Biography*. New York, 1973; 2d ed. as *FLW: His Life and His Architecture*. New York, 1979.

Wright, John Lloyd. *My Father Who Is on Earth*. New York, 1946; reprint as *My Father FLW*. New York, 1992; Carbondale, 1993.

Assessment

Alofsin, Anthony. *FLW. The Lost Years 1910–1922*. Chicago, 1992.

Ashbee, C. R. *FLW. Eine Study zu seiner Wèrdigung*. Berlin, 1911. Aka *Ausgeführte Bauten*. Reprinted revised *FLW. The Early Work*. New York, 1968; without essay, 1982. For translations, additions, deletions, corrections to 1911 text see "C. R. Ashbee, FLW: A Study and an Appreciation," in Leland M. Roth, *America Builds*. New York, 1983.

Bandes, Susan J., ed. *Affordable Dreams. The Goetsch-Winckler House and FLW*. East Lansing, 1991.

Barr, Alfred H., Jr., et al. *Modern Architects*. New York, 1932.

Brooks, H. Allen. "FLW at MoMA." *CanadaA* 39 (April 1994).

————. *The Prairie School. FLW and His Midwest Contemporaries.* Toronto, 1972; reprint, New York, 1976.

Ciucci, Giorgio. "The City in Agrarian Ideology and FLW." In *The American City from the Civil War to the New Deal,* edited by Giorgio Ciucci, et al. MIT Press, 1978.

Eaton, Leonard K. *Two Chicago Architects and Their Clients. FLW and Howard Van Doren Shaw.* MIT Press, 1969.

Etlin, Richard A. *FLW and Le Corbusier. The Romantic Legacy.* Manchester, England, 1994.

Fishman, Robert. *Urban Utopias in the Twentieth Century. Ebenezer Howard, FLW and Le Corbusier.* New York, 1977.

Fitch, James Martson. *Architecture and the Esthetics of Plenty.* New York/London, 1961.

Gorvy, Brett. "The Wright Stuff." *Antique Collector* (London) 65 (February 1994).

Grabow, Stephan. "FLW and the American City. The Broadacres Debate." *Journal of the American Institute of Planners* (Washington, D.C.) 93 (April 1977).

Green, Aaron G. *An Architecture for Democracy. The Marin County Civic Center.* San Francisco, 1990.

Hanks, David A. *The Decorative Designs of FLW.* New York, 1979.

Haskell, Douglas. "Organic Architecture: FLW." *Creative Art* (New York) 3 (November 1928).

Heinz, Thomas. *FLW Interiors and Furniture.* London/Berlin, 1994.

Hildebrand, Grant. *The Wright Space. Pattern and Meaning in FLW's Houses.* Seattle, 1991.

Hitchcock, Henry-Russell. *In the Nature of Materials 1887–1941. The Buildings of FLW.* New York, 1942; reprint, New York, 1975.

Hoffman, Donald. *FLW's Fallingwater. The House and Its History.* New York, 1978.

————. *FLW's Robie House.* New York, 1984.

Johnson, Donald Leslie. "FLW in the Northwest: The Show, 1931." *Pacific Northwest Quarterly* (Seattle) 78 (July 1987).

————. *FLW versus America. The 1930s.* MIT Press, 1990; reissued as paperback, 1994.

————. "FLW's Architectural Projects in the Bitterroot Valley, 1909–1910." *Montana* 37 (Summer 1987).

Kaufmann, Edgar, Jr. *Fallingwater. A FLW Country House.* New York, 1986.

————. In Macmillan.

McCarter, Robert, ed. "Essays on Residential Masterpieces." *GAHouse* (Tokyo) 40 (1994).

————. *FLW. A Primer on Architectural Principles.* New York, 1991.

Manson, Grant Carpenter. *FLW to 1910.* New York/London, 1958; Rome, 1969; reprint, New York, 1979.

Mumford, Lewis. *The Brown Decades. A Study of the Arts in American 1865–1895.* New York, 1931; 2d ed., New York, 1955.

Nute, Kevin. *FLW and Japan.* New York, 1993.

Laseau, Paul, and James Tice. *FLW. Between Principle and Form.* New York, 1992.

Lipman, Jonathan. *FLW and the Johnson Wax Buildings.* New York, 1986.

O'Gorman, James F. *Three American Architects. Richardson, Sullivan, and Wright, 1865–1915.* Chicago, 1991.

Quinan, Jack. *FLW's Larkin Building. Myth and Fact.* MIT Press, 1987.

Riley, Terrance, with Peter Reed, ed. *FLW, Architect.* New York, 1994.

Sergeant, John. *FLW's Usonian Houses. The Case for Organic Architecture.* New York, 1976.

Siry, Joseph. "The Abraham Lincoln Center in Chicago." *JSAH* 50 (September 1991).

Smith, Kathryn. *FLW. Hollyhock House and Olive Hill.* New York, 1992.

Spencer, Robert C. "The Work of FLW." *AReview* (Boston) 7 (June 1900); reprint . . . *1893 to 1900.* Park Forest, Illinois, 1964.

Sprague, Paul E. *Guide to FLW and Prairie School Architecture in Oak Park.* Oak Park, 1976.

Storrer, William Allin. *FLW Companion.* Chicago, 1993.

Sweeney, Robert L. *Wright in Hollywood. Visions of a New Architecture.* MIT Press, 1993.

"Taliesin 1911–1914." *Wright Studies.* Vol. 1. Carbondale, 1992.

Tanigawa, Masami. *Measured Drawing. FLW in Japan.* Tokyo, 1980.

Turner, Paul Venable. "FLW and the Young Le Corbusier." *JSAH* 42 (December 1983).

Wijdeveld, H. Th., ed. *The Life-Work of the American Architect FLW* (aka the *Wendingen* compilation). Santpoort, Netherlands, 1925; reprint, Chicago, 1948; New York, 1965; reprint as *The Complete 1925 "Wendingen" Series.* New York, 1992.

Wright, John Lloyd. "An Appreciation of FLW." *ADesign* 30 (January 1960).

Zevi, Bruno. *Towards an Organic Architecture.* London, 1949.

Bibliographical

AAAB: James Muggenberg, no. 9, 1972.

CPL: Patrick Joseph Meehan, 1444, 1978.

Sweeney, Robert L. *FLW. An Annotated Bibliography.* Los Angeles, 1978.

Vance: Cortus Koehler, A19, 1978; Patrick Meehan, A254, 1980; A991 (filmography), 1983; James Noffsinger, A372, 1980; [general update] A1053, 1983; Lamia Doumato, A1783, 1987; Mary Vance, A1849, 1987.

Archival

Alofsin, Anthony, ed. *FLW. An Index to the Taliesin Correspondence.* 5 vols. New York, 1988.

Drexler, Arthur, ed. *The Drawings of FLW.* New York, 1962.

Gutheim, Frederick, ed. *FLW on Architecture.* New York, 1941.

Izzo, Alberto, and Camillo Gubitosi. *FLW. Three Quarters of a Century of Drawings.* Florence, 1976; London, 1981.

Kaufmann, Edgar, Jr., Ben Raeburn, and Bruce Radda, comps. *FLW. Writings and Buildings.* New York, 1960; Buenos Aires, 1962; Munich, 1963.

Meehan, Patrick J. *FLW. A Research Guide to Archival Sources.* New York, 1983.

Pfeiffer, Bruce Brooks, ed. *FLW.* 12 vols. Various subtitles. Tokyo, 1984–1988.

———. *FLW Collected Writings.* Vol. 1. *1894–1930.* Vol. 2. *1930–1932.* Vol. 3. *1931–1939.* Vol. 4. *1939–1959.* Vol. 5. *1949–1959.* New York, 1992–1994.

———. *FLW. Letters to Apprentices. Letters to Architects. Letters to Clients. The Crowning Decade, 1949–1959. The Guggenheim Correspondence.* Fresno, California, 1982–1986.

CODA

When a person becomes a legend in his time, his life is controlled by that legend.

Victor Hugo

Life demands that we go
forward with wisdom and
understanding. To remain
dependent upon the personality
that the person himself
transcended through struggle,
rather than upon the ideal,
is to stagnate.[1]

John Lloyd Wright, 1960

The head of a New York architecture school reached me on the phone because Bob was unavailable: "Denise, I'm embarrassed to be speaking to you because we're giving a party for X [a well-known local architect] and we're asking Bob but not you. You see, you *are* a friend of X and you *are* an architect, but you're also a wife, and we're not asking wives."[2]

Denise Scott Brown

[A] work of architecture does not have to be good to be popular, or to be tolerated, or to be promoted, or to be important. People do not always apply moral standards to its evaluation; they can like things of which they do not approve.[3]

Carol Herselle Krinsky

More than any of the other 20th century arts, architecture has exhibited a greater sense of responsibility, reached a more homogeneous crystallization of style, and achieved a wider popular acceptance. . . . Today's architect is no mere stone mason—he is an engineer of society, a social philosopher, a poet and idealist, as well as a practical builder.

[Our] relative world . . . can be understood only in terms of many frames of reference. Any absolutism—such a totalitarian society as Plato's *Republic* [or Stalin's USSR], for instance—insists on a maximum of conformity; a relativism—such as that of a modern democracy—allows for many different images of man. . . .

The volatility and violence of the 20th century are of explosive proportions. In addition to atomic explosions, modern man has to contend with population and cultural [ethnic] explosions. The revolution in electronic communications is more far reaching than the invention of Gutenberg's printing press in the 15th century. . . .

Finding poetry where no one saw it before is the eternal role of the artist. . . . [4]

William Fleming

[A] critical architecture can talk to other architecture, but finds it rather difficult to talk to the public. . . . [5] [see Plate 36.]

Manfredo Tafuri

Play it for kicks: that is the mannerist motto, and like all forms of indecency, it's irresistible.[6]

Kenneth Clark

Architecture is praised as a knowledge combining aesthetics and technique, theory and practice. It is often praised today for its distinctive, critical, and holistic pedagogy. From the modernist phase onward, it has also presented a model for the enlightened exercise of expertise. The high-rise buildings and the postwar new towns have tarnished that model, although there too the case is neither one-dimensional nor closed.[7]

Magali Sarfatti Larson

A comparison of construction costs of three buildings contemporary to one another:

Norman Foster's Hong Kong and Shanghai Banking Corporation headquarters in Hong Kong (1979–1986) cost $640 per square foot;

Richard Roger's Lloyd's of London headquarters in London (1979–1986) cost $375/sqft;

Helmut Jahn's State of Illinois Center in Chicago (1979–1985) cost $160/sqft.[8]

There are a number of reasons for the differences but an easily assembled all-glass exterior skin, like that for the Illinois Center, is a principal factor. However . . . about Jahn's building note the following observation:

Ambitious architects . . . often expose themselves to public risks. In the nauseating colors of every 1950s suburban high school, Jahn created [a] . . . building where workers baked in summer and froze in winter until the problems were partially corrected. The brilliance of the form is subverted by the mad ecology of the huge unsheltered spaces, happily gorging on an endless diet of electricity. No one has yet been able to get a decent accounting of the cost overruns and yearly operating expenses.[9]

Ross Miller

NOTES

1. J. L. Wright in 1960, as quoted in Donald Leslie Johnson, *Frank Lloyd Wright versus America. The 1930s* (MIT Press, 1990), 345.

2. As recalled in Ellen Perry Berkeley and Matilda McQuaid, eds., *Architecture. A Place for Women* (Washington, D.C., 1989), 246.

3. Carol Herselle Krinsky, "St Petersburg-on-the-Hudson. The Albany Mall," in *Art the Ape of Nature,* edited by Moshe Barsch and Lucy Friedman (New York, 1981), 785.

4. William Fleming, *Art and Ideas.* 3d ed. (New York, n.d.), 541, 503.

5. Manfredo Tafuri, *Theories and History of Architecture.* 4th ed. (New York, 1980), 138 n36.

6. Kenneth Clark, [Western] *Civilization* (London, 1969), 61.

7. Magali Sarfatti Larson, *Behind the Postmodern Facade* (Berkeley, California, 1993), 283.

8. Source: Charles Jencks, *Architecture Today* (London, 1993), 15.

9. "Helmut Jahn and the Line of Succession," in *Chicago Architecture and Design 1923–1993,* edited by John Zukowsky (Munich/Chicago, 1993), 308.

CHRONOLOGY AND FOUNDERS

Architects, firms, or confederations are arranged below by the decade when their most influential activity began. Of course their work thereafter continued to be more or less persuasive. The great transitional figures such as Sullivan, Berlage, Wagner and MacKintosh (to a lesser degree) who heralded a yet formalized modernism are discussed in this book's introduction.

Those names in **bold** type are considered founders of twentieth-century modernism. We see "founding" on two levels. First, there are those who introduced a viable, enduring modernism by word and more important, by deed. These would be not just innovators but originators. So *originating founders* are Wright, Albert Kahn, Loos (who reacted to Art Nouveau and his experiences with American pragmatism and industrial buildings), Gropius (who reacted to Wright and the likes of Kahn's architecture) and his circle, van Doesburg and the De Stijl circle, architects and theoreticians of the Futurist group, and, to a lesser degree, Le Corbusier.

We then find those architects who changed modernism by initiating new directions that led to transforming early twentieth-century modernism in unexpected ways, thereby revitalizing it. They are also in **bold** type and include the Vesnin Brothers, Mies van der Rohe, Dudok, Louis Kahn especially, Eisenman, Ando, and engineers Nervi and Calatrava. They may or may not have been— or be—protegés or disciples: perhaps just followers of a founder's theoretical position or captivated by the look of a certain kind of architecture. This is also true of the third group (not in bold type), which contains three women (Smithson, Griffin, and Scott Brown) and engineers Prouvé, Candela, Otto, and Bar-

ragán, who enlivened and refined modernist fundamentals by infusing them with possible innovations and certainly persuasive meaning.

1900s	Behrens		
	Hoffmann		
	Albert Kahn		
	Loos		
	Wright		

1910s	**van Doesburg & De Stijl**		
	Futurists		
	Griffin & Griffin		
	Gropius		
	de Klerk		

1920s	Brinkman & van der Vlugt	**Mies van der Rohe**	**Rietveld**
	Le Corbusier	**Oud**	Eliel Saarinen
	Dudok	Perret	**Vesnin Brothers**
	Mendelsohn	Poelzig	
		Raymond	

1930s	**Aalto**	Nervi	
	Asplund	Neutra	
	Belluschi	Scharoun	
	CIAM	Stam	
	Fuller		

1940s	Breuer		
	Niemeyer		

1950s	Barragán	Johnson	Seidler
	Bunshaft	**Louis Kahn**	A & P Smithson
	Candela	Prouvé	SOM
	van Eyck	Rudolph	Tange
	Goff	Eero Saarinen	

1960s	**Archigram** (Cook/ Herron)	Hollein	Roche & Dinkerloo
	Bofill	Kurokawa	Stirling (& Gowan)
		Metabolists	Utzon

Doxiadis	Moore		
Fathy	Pei		
1970s	**Eisenman**	**Meier**	Scarpa
	Foster	Otto	**Venturi** & Scott
	Hertzberger	Piano	Brown
	Isozaki	Rogers	
	Krier Brothers	Rossi	

1980s **Ando**
 Botta
 Gehry
 Koolhaas/OMA
 Maki

1990s **Calatrava**
 Coop Himmelblau
 Libeskind

The number of influential architects in the 1930s and 1940s may be explained by the consumptions of Depression and War. The number in the 1980s reflects an acceptance of a pluralism that, oddly, tended to recognize certain stylistic types and acknowledge that there were few architects with newly influential thoughts, let alone expertise. In other words most of what happened in the 1980s had been announced earlier. The 1990s continues that reflection with some isolated, individually innovative designs.

We are aware of the cult figure Steven Holl and his lumpy forms; of Zaha Hadid's monochromatic Vitra Fire Station (1993), which shows promise (though less than the paper architecture of her darkly colored drawings); of Rafel Moneo's and Jean Nouvel's interesting, even fascinating formalism; of Toyo Ito's light, ephemeral forms; of Nicholas Grimshaw's struggles to incorporate the forms or structures of Eisenman, Maki, Foster, and Kurokawa; of Philip Cox's structural rationalism; of Nigel Coates's subjective form-making and interiors that exude a surreal sexuality similar to but more obvious than Bruce Goff's interiors; of Bernard Tschumi's proposals for mystical dislocations; of Kazuo Shinohara's "school" and urbanistic designs; of Glenn Murcutt's—and hundreds of others'—profound association with regional and historical identity; and of others self-promoted or taken up by the professional press. There are, however, few with proof in deed and thereby a measure of influence beyond mere camaraderie and/or admiration. (Is this also not true of the decades before 1990?) In 2021 it will be interesting to see if our judgments are correct.

Early this century there existed among architects in disparate parts of the
world an element of isolation from architectural, scientific (as related to society,
structural engineering, and materials), and theoretical events. Beginning around
1930 that was no longer true because of an increase in the number and com-
prehensiveness of architectural magazines and since ca. 1970 in the quick pro-
duction of slick monographs.

Kurokawa's thoughts in the 1980s about a desire for a friendly global culture
infused by an architectural symbiosis and, with Ando's lessons, a concomitant
professional responsibility—spiritual, social, and environmental—is theoreti-
cally and practically valuable. Well, in at least one respect: witness the number
of architects of many nations, and not necessarily large firms, who now practice
worldwide. However . . . while there is scientific and applicable nous there is no
will—save with a minority—to address squarely social and environmental *re-
sponsibilities*. Sadly, they are ignored.

ACKNOWLEDGMENTS

This project could not have been accomplished without valuable assistance willingly given. It is therefore a pleasure to thank the following people.

For research: Glenys Letcher, Librarian, Built Environment Library, University of South Australia; and the reference staff at Flinders University, Adelaide.

For advice: the architects who on request supplied additional data: Botond Bognar in Tokyo and Champaigne; Bridget Jolly in Adelaide; Rachel Hurst in Adelaide; Steve Harfield in Sydney; Michael Tawa in Adelaide, then Sydney; a reticent Tod A. Marder in New Brunswick; and John Morris Dixon in Connecticut was most helpful. Over the ten decades covered by this study there were many authors of critical and historical studies who essayed cogent analyses based on empirical knowledge and/or careful research thereby easing our work and they are noted throughout the book. Judgments of selection and within the texts, of course, are those of the authors. Because architecture has been well served since 1960 by competent research and by public and professional presentation, we sought advice and counsel from only a select few.

For illustrations: those architects, photographers, magazine or journal editors, publishers, and others who generously supplied material. They are acknowledged where such information properly belongs, within the individual captions.

At the offices of the Greenwood Publishing Group, Marilyn Brownstein initiated the project with Don Johnson and Alicia S. Merritt, with calm and understanding, supported and together with Maureen Melino and especially Desirée Bermani, guided the book from its earliest stages.

To Sonya and Coby: thank you again for quiet patience.

NAME INDEX

Personal names and page numbers in **bold** refer to an architect's biocritical profile. Numbers in *italics* refer to plate numbers.

PLACE INDEX

Cities and other locales can be found under the name of the specific country as can the country's architects and engineers as well as those involved with the structures themselves.

The Authors

DONALD LESLIE JOHNSON was born and raised in Washington State, received his professional architectural degree from the University of Washington, and was a member of Louis Kahn's master's class (1959–1960). He taught architectural design, theory, or history at universities in America and Australia, taking early retirement in 1988 from Flinders University in Adelaide, South Australia, where he founded the Australian Studies program. He also founded and is a director of the Architecture Archives, which now has a permanent home at the University of South Australia. His more important books are *Frank Lloyd Wright versus America: The 1930s* (1990); *The Adelaide City Plan* (with Don Langmead, 1986); *Australian Architecture 1901–51*; *Sources of Modernism* (1980); and *The Architecture of Walter Burley Griffin* (1977). Articles on architectural history, mainly about Walt Griffin and Wright, appear in many journals in England, Australia, and throughout America. He has been a curator for a number of exhibitions and his research has been supported by national, private, and university grants in India, Australia, and the United States.

DONALD LANGMEAD was born and raised in Adelaide, South Australia, and received his professional architectural degree from the University of South Australia (formerly the South Australian Institute of Technology), where he subsequently taught and is now head of the School of Architecture and a director of the Architecture Archives. He obtained a master's degree in architectural history under Bruce Allsopp at the University of Newcastle-upon-Tyne in England, and a doctorate from Flinders University in Adelaide, South Australia. His more important books are *Accidental Architect* (1994) and *The Adelaide City Plan* (with Don Johnson, 1986). His articles on architectural history, mainly on Dutch and South Australian architecture, have appeared in journals in Europe and Australia.

ISBN 0-313-29353-8

90000>

EAN

9 780313 293535

HARDCOVER BAR CODE